W9-AXC-949

THE PELICAN HISTORY OF ART
Founding Editor: Nikolaus Pevsner
Joint Editors: Peter Lasko and Judy Nairn

George Kubler
THE ART AND ARCHITECTURE OF ANCIENT AMERICA
The Mexican, Maya and Andean Peoples

George Kubler has since 1983 been Senior Research Scholar at Yale University. He was for many years Professor of the History of Art at Yale, where he has lectured on the fields which are the subject of this book. He has also served as Professor at the Center for Advanced Studies in the Visual Arts at the National Gallery in Washington; as Arts Council Professor at the University of California in Los Angeles; and as Scholar at the Getty Center in Santa Monica. A recipient of the Alice Davis Hitchcock Prize of the Society of Architectural Historians, he is the co-author of another volume of The Pelican History of Art: *Art and Architecture in Spain and Portugal and their American Dominions 1500–1800.*

George Kubler

The Art and Architecture of Ancient America

The Mexican, Maya and Andean Peoples

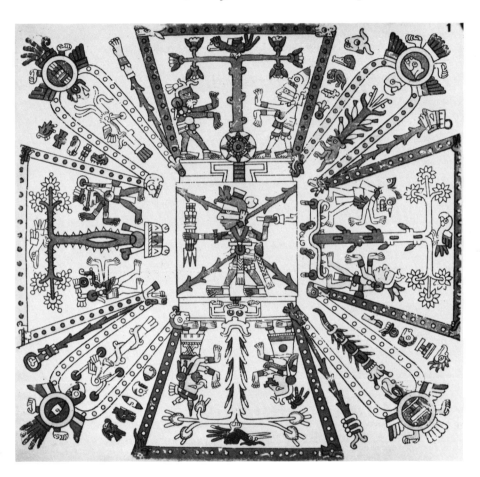

Penguin Books

PENGUIN BOOKS

Published by the Penguin Group
27 Wrights Lane, London w8 5TZ, England
Viking Penguin Inc., 40 West 23rd Street, New York, New York 10010, USA
Penguin Books Australia Ltd, Ringwood, Victoria, Australia
Penguin Books Canada Ltd, 2801 John Street, Markham, Ontario, Canada L3R 1B4
Penguin Books (NZ) Ltd, 182–190 Wairau Road, Auckland 10, New Zealand

Penguin Books Ltd, Registered Offices: Harmondsworth, Middlesex, England

First published 1962
Second edition 1975
Third (integrated) edition 1984
Reprinted with additional bibliography in narrative form 1990
Copyright © George Kubler, 1962, 1975, 1984, 1990
All rights reserved

LIBRARY OF CONGRESS CATALOGING IN PUBLICATION DATA
Kubler, George, 1912–
 The art and architecture of ancient America.
 (The Pelican history of art)
 Bibliography: p. 525
 Includes index.
 1. Indians—Art. 2. Indians—Architecture.
3. Indians—Antiquities. 4. Latin America—
Antiquities. I. Title. II. Series.
E59.A7K8 1983 709'.72 81–10525
ISBN 0 14 0561.21 8 AACR2

Printed and bound in Great Britain by
Butler & Tanner Ltd, Frome and London
Set in Monophoto Ehrhardt

Series design by Gerald Cinamon
This volume designed by Bob Wright

To the Memory of
Wendell Clark Bennett
1905–1953

CONTENTS

The greater part of these chapters was originally prepared for lectures and seminars beginning in 1938 at Yale University, where the opportunity for studies of the art of American antiquity was first made possible by the late Dean E. V. Meeks and my colleagues in the Department of the History of Art. Other occasions to develop the treatment of the pre-Columbian past, as part of the history of art rather than as anthropology, which is the more usual treatment in American universities, were afforded me at Columbia University, the University of Chicago, at the Universidad Nacional Mayor de San Marcos, in Lima, and at the Universidad Nacional Autónoma in Mexico City.

Various visits to Peru, Guatemala, and Mexico were made possible by the Smithsonian Institution in 1948–9, when I represented the Institute of Social Anthropology in Lima; in 1951 and 1956, when Unesco engaged me to study the reconstruction of the monuments devastated in Cuzco by the earthquake of 1950; and in 1958 when I held a Smith-Mundt award for Mexico.

I am grateful to Professor Nikolaus Pevsner and the publishers for their generous efforts in securing new drawings for many text figures from K. F. Rowland, M.S.I.A., drawings for the maps from Donald Bell-Scott, and for the chronological tables from Sheila Waters. Professor Pevsner showed great patience as Editor of the Pelican History of Art in waiting so long for this manuscript, of which the first deadline fell in 1951. To him I am further indebted for an introduction at Cambridge University, where I was able to work in 1957 as a guest of King's College and where G. H. S. Bushnell, Curator of the University Museum of Archaeology and Ethnology, kindly let me have the run of the Haddon Library, during the last months of a Guggenheim Foundation Fellowship awarded in 1956–7.

For advice and correction on many points I have benefited from conversations and correspondence with Junius Bird, G. H. S. Bushnell, Donald Collier, Gordon Ekholm, Alfred Kidder II, Tatiana Proskouriakoff, John H. Rowe, Linton Satterthwaite, Jr, W. Duncan Strong, and Gordon Willey, whose views have an authority gained in many years' field experience. The outsider from other fields of study never can assume this authority: it belongs only to the field archaeologist who works both in detail and in broad reconnaissance, and it may appear more in his conversation than in his writings.

Much complicated correspondence about photographs was carried on for me by Mary Margaret Collier, and I am obliged to Mrs H. Gordon Sweet for her aid in clarifying the text. Mrs Patricia Shillabeer Beach and Mrs Amelia Sudela typed long hours. Friends and students in Yale College – Colin Eisler, Terence Keenan, Joseph Baird, and Joseph Lyman – helped with many matters of detail. John Hoag, the Art Librarian at Yale, helped in negotiations for photographs, and Helen Chillman allowed me to borrow negatives and prints from the University collections for many of these illustrations.

In Lima, my friend Abraham Guillén was the most reliable source of photographs. In Mexico City, the head archivist of the photograph collections in the Instituto Nacional de Antropología e Historia, Señor Ramón Sánchez Espinosa, was unfailingly helpful.

To many other persons and institutions full acknowledgement for the use of photographs and drawings is made in the list of illustrations; here, nevertheless, the exceptional courtesies shown by Luis Aveleyra A. de Anda, Eusebio Davalos, Ignacio Bernal, Alfonso Caso, Jorge Muelle, John Glass, Frank H. Boos, Carmen Cook de Leonard and Juan Leonard, Robert Willson, René Millon, and Lic. Jorge Gurría require special thanks.

FOREWORD TO THE SECOND EDITION

The manuscript which was first published in 1962 was actually delivered to the publishers in May 1959. No significant changes were made after that time, until Sir Nikolaus Pevsner finally persuaded me in 1972 that a complete revision and *aggiornamento* were justified. In effect the text was then thirteen years old – years which saw intense archaeological activity and revaluation. These newer publications are now embedded in text and notes, together with the older references, which were retained in order to continue giving students some sense of that 'history of archaeological recovery' which the excitement of new discoveries often obscures. Recent archaeological writing in Americanist fields rarely assesses older theories and excavations that have continuing value. The substitution of new names for older ones is also frequent, without reference to the older work and the older nomenclature. It seemed worthwhile to retain some of this history of the recovery of the remote American past in the footnotes, all while bringing them up to date. Indeed it has perennially been the task of humanistic learning, to examine the long record of the search for enduring answers.

The original text presented the extremes of opinion on chronology. In 1972–3, the wide swing between extremes has narrowed closer to final rest, but much uncertainty still surrounds many questions, uncertainties which I have tried to convey wherever they are unavoidable.

The illustrations are increased by many new photographs and drawings, and some drawings in the first edition have been corrected and augmented.

To Yale University I am grateful for triennial leave of absence. In Mexico the Instituto Nacional de Antropología e Historia, both at the Museo and at the archives in Culhuacán, as well as in the offices at Córdova 45, cooperated generously in the search for photographs. My special thanks go there to Carlos Chanfón, Mariano Monterrosa, and Constantino Reyes; to Beatriz de la Fuente and Marta Foncerrada de Molina in Mexico City; and in London to Susan Stow, Rosa Brennan, and Judy Nairn who 'accomplished the impossible in the least possible time'.

New Haven, June 1973

FOREWORD TO THE THIRD EDITION

In revising for the second edition during 1973, my attention was drawn more to new discoveries than now for the third, when a rising interest in inter-regional relationships is apparent. In 1973 dynastic histories were still a centre of attention, but these chronologies are now again clouded by disagreements. Today the main novelty is to use fragmentary archaeological indications to buttress 'models' based on Old World parallels of social and economic development. In chronological studies it is notable that sidereal time, in the sense of firmly dated historical 'periods', like centuries, is being substituted for the vaguer and longer 'stages' and phases of developmental archaeology.

As to the framework and method of the book, it seemed best to retain the original structure, which reflected an effort to record some of the history of archaeological thought. That effort is continued in the Notes at the end, where older books and articles of merit are cited together with recent work. In effect, the principal changes in Americanist thought do not contradict the positions taken here when the original text was delivered to the publishers in 1959.

The additions to the bibliographical references number nearly 300,* of which a notably higher percentage is by art historians than in 1973. Their effect is noticeable also in the attention now given by social scientists to matters of artistic technique, style, iconography, and expression.

My special thanks are to Hasso von Winning for bibliographical assistance, and to Judy Nairn for keeping the revisions in order. Susan Rose-Smith helped with photographs and drawings.

New Haven, September 1980

* For the 1990 reprint, additional bibliography has been provided in narrative form to bring the coverage up to date (pp. 543–8).

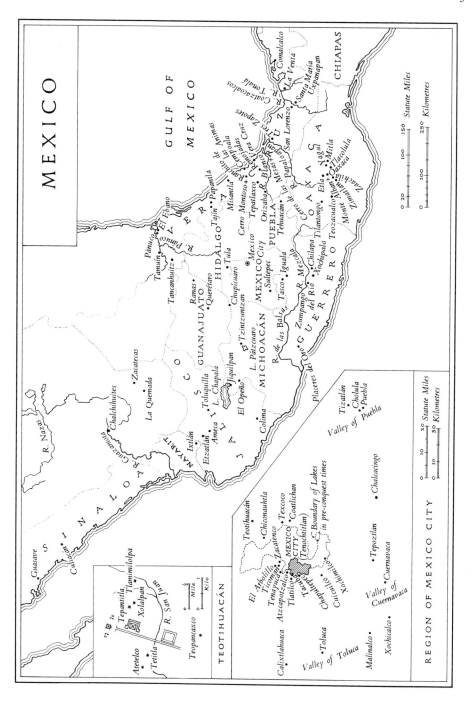

MEXICO

GULF OF MEXICO

R. Nazas

Guasave•
•Chalchihuites
Zacatecas•
La Quemada•

S I N A L O A

Culiacán•
Guazamota•

N A Y A R I T

Ixtlán•
Erzatlán•
Ameca•
L. Chapala
Toluquilla•
Tiquilpan•

C O L I M A

El Opeño•
Colima•

J A L I S C O

G U A N A J U A T O

Ranas•
Querétaro•

Tzintzuntzan•
L. Pátzcuaro

M I C H O A C Á N

R. de las Balsas

Chupícuaro•

H I D A L G O

Tula•

MEXICO City⊙
•Sultepec

Tasco• Iguala•

R. Mezcala
R. Zumpango
O. del Río•
Placeres del Oro•

G U E R R E R O

Pánuco•
Tamuín•
Tancanhuitz•

R. Pánuco
El Ebano•

Tajín•
Papantla•

Misantla•

Cerro Montoso•
Tepatlaxco•
Orizaba•
R. Blanco

Cempoala•
Remojadas•
Cerro de las Mesas•

La Vega Cruz•

Tepeaca•
P U E B L A

Tehuacán•

O A X A C A

Teozacualco•
Xochipala•
Tilantongo•
Monte Albán
Zaachila•

Etla•
Oaxaca•
Yagul•
Mitla•
Tlacolula•

Coatzacoalcos•
R. Tonalá
La Venta•
Santa María Uxpanapan•
Comalcalco•

C H I A P A S

San Lorenzo•
Tres Zapotes•
R. Papaloapan

Statute Miles
0 20 100 150
0 100 250 Kilometres

REGION OF MEXICO CITY

Tizatlán•
Cholula•
Puebla•

Valley of Puebla

•Chalcacingo

Statute Miles
0 10 20
0 10 30 Kilometres

Teotihuacán•
Chiconauhtla•
Zacatenco• •Texcoco
MEXICO
CITY} •Coatlichan
(Tenochtitlan)

Boundary of Lakes
in pre-conquest times

El Arbolillo•
Ticoman•
Tenayucan•
Atzcapotzalco•
Tlatilco•
Tlacopan•
Culhuacan•
Xochimilco•

•Tepoztlan

•Cuernavaca

*Valley of
Cuernavaca*

Calixtlahuaca•

•Toluca

Valley of Toluca

Malinalco•
Xochicalco•

TEOTIHUACÁN

Tepantitla•
Tlamimilolpa•
Xolalpan•

Atetelco•
Tetitla•

R. San Juan

Teopancaxco•

Mile Kilo.

CENTRAL AMERICA

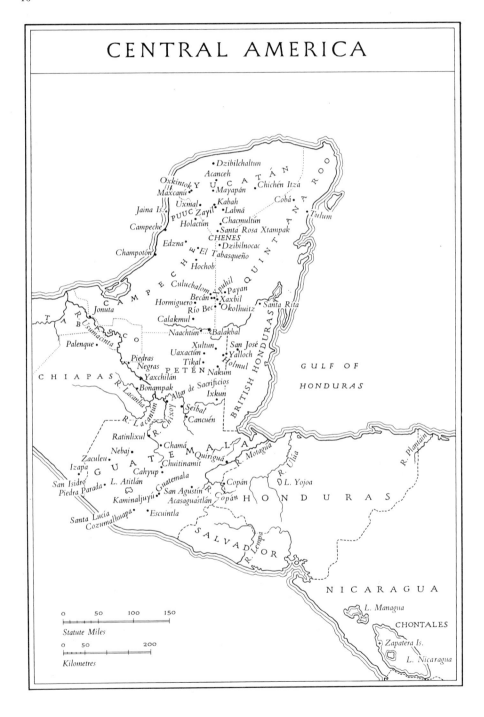

- Dzibilchaltun
- Acanceh
- Oxkintok
- Maxcanú
- Y U C A T Á N
- Mayapán
- Chichén Itzá
- Cobá
- Kabah
- Uxmal
- Jaina Is.
- PUUC Zayil
- Labná
- Chacmultún
- Campeche
- Holactún
- Santa Rosa Xtampak
- CHENES
- Edzna
- Dzibilnocac
- Champotón
- El Tabasqueño
- Hochob
- Culuchalom
- Apuhil
- Payan
- Becán
- Xaxbil
- Hormiguero
- Río Bec
- Okolhuitz
- Santa Rita
- Jonuta
- Calakmul
- Naachtún
- Balakbal
- Xultun
- San José
- Uaxactún
- Yalloch
- Piedras
- Tikal
- Holmul
- Negras
- PETÉN
- Nakum
- Yaxchilán
- Bonampak
- Altar de Sacrificios
- Ixkun
- Seibal
- Cancuén
- Palenque
- Ratinlixul
- Chamá
- Nebaj
- Quiriguá
- Zaculeu
- Chuitinamit
- Izapa
- Cahyup
- San Isidro
- L. Atitlán
- Piedra Parada
- Guatemala
- San Agustín
- Copán
- L. Yojoa
- Kaminaljuyú
- Acasaguastlán
- Copán
- Santa Lucía
- Escuintla
- Cozumalhuapa

T A B A S C O

R. Usumacinta

C H I A P A S

R. Lacantía

R. Lacantún

CHIXOY

CAMPECHE

QUINTANA ROO

Tulum

BRITISH HONDURAS

GULF OF
HONDURAS

G U A T E M A L A

R. Motagua

R. Ulúa

R. Copán

H O N D U R A S

R. Plantain

S A L V A D O R

R. Lempa

N I C A R A G U A

L. Managua

CHONTALES

Zapatera Is.

L. Nicaragua

```
0        50       100      150
|--------|--------|--------|
Statute Miles

0       50              200
|-------|-------|-------|
Kilometres
```

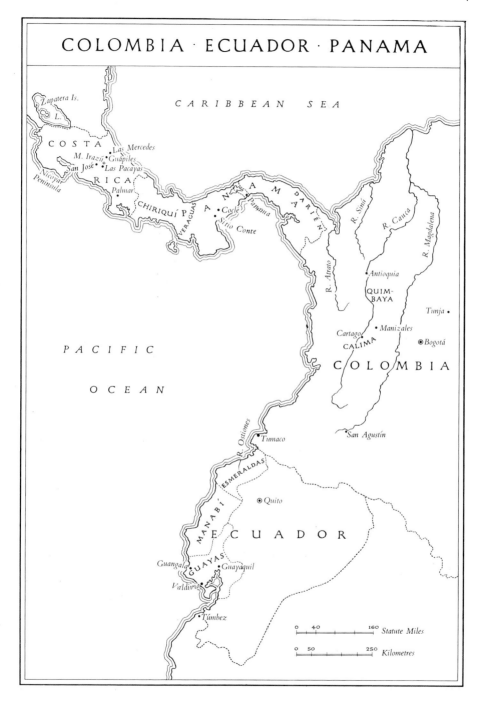

COLOMBIA · ECUADOR · PANAMA

CARIBBEAN SEA

Zapatera Is.
L.

COSTA
Las Mercedes
M. Irazú • Guápiles
San José • Las Pacayas
Nicoya
Peninsula
RICA
Palmar
CHIRIQUÍ
P A N A M A
VERAGUAS
• Coclé
Panamá
Sitio Conte
D A R I E N

R. Sinú
R. Cauca
R. Magdalena
R. Atrato

• Antioquia
QUIM-
BAYA
Tunja •

Cartago
CALIMA
• Manizales
⊙ Bogotá

C O L O M B I A

PACIFIC

OCEAN

R. Ostiones
• Tumaco

• San Agustín

ESMERALDAS
MANABÍ
⊙ Quito

E C U A D O R

Guangala
GUAYAS
• Guayaquil
Valdivia

• Túmbez

0 40 160 Statute Miles

0 50 250 Kilometres

18

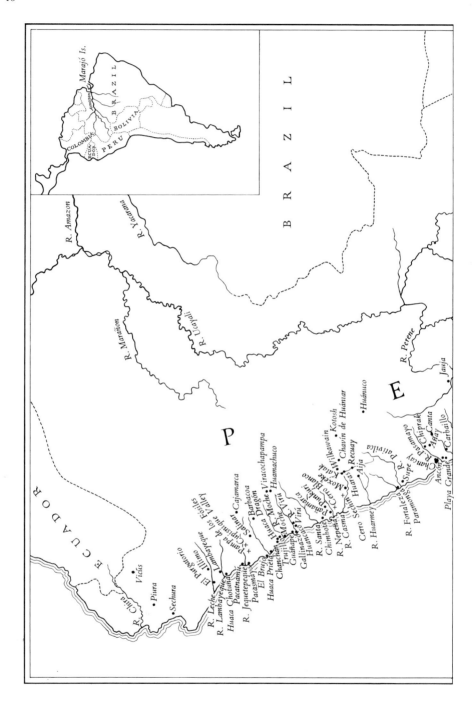

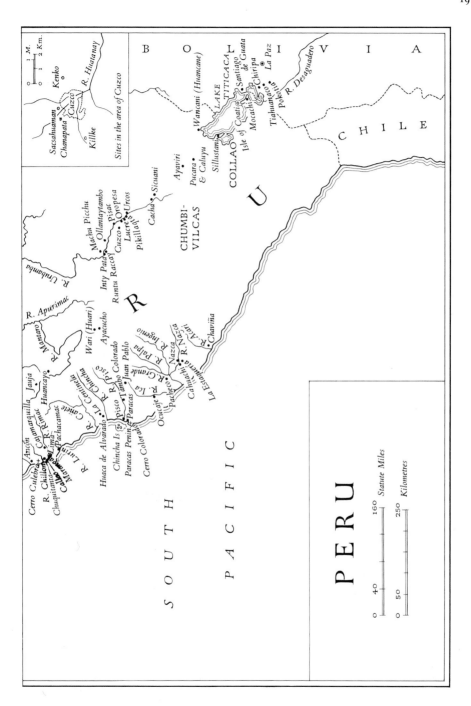

Sites in the area of Cuzco

Sacsahuaman
Chanapata
Kenko
Cuzco
Killke
R. Huatanay

BOLIVIA

CHILE

LAKE TITICACA

COLLAO

Wancani (Huancane)
Isle of Coati
Santiago de Guata
La Paz
Chiripa
Mocachi
Tiahuanaco
Pokotia
R. Desaguadero

Ayaviri
Pucara & Caluyu
Sillustani

Cacha Sicuani

CHUMBI-VILCAS

PERU

Machu Picchu
Ollantaytambo
Pisac
Oropesa
Urcos
Lucre
Pikillaqta
Cuzco
Inty Pata
Runtu Raccay

R. Urubamba

R. Apurimac

R. Mantaro

Wari (Huari)
Ayaucho

Jauja
Huancayo

R. Ingenio
R. Palpa
Nazca
R. Nazca
Aceri
Chaviña

Pachacamac
Cerro Culebra
Ancón
Cajamarquilla
R. Chillon
R. Rimac
Lima
Chuquitanta
Lurin
Cerro Colorado
Paracas Penin.
Paracas
Chincha Is.
Pisco
Tambo Colorado
Juan Pablo
Huaca de Alvarado
La Centinela
R. Cañete
R. Chincha
R. Pisco
R. Ica
Ica
Ocucaje
Pacheco
Callwaqui
La Estaquería
R. Grande

SOUTH PACIFIC

PERU

Statute Miles
0 40 160

Kilometres
0 50 250

NOTE ON CHRONOLOGIES

The tables seek to place sites and classes of objects in time: the criterion of selection is more by quality than quantity, and more by expressions than by serial events. All the placements prior to A.D. 1300 should be regarded as elastic at least in the degree required now by the margin of error used in radiocarbon measurements (± 200 years).

Roman capitals = ethnic groups
Italic capitals = archaeological phases
Lower-case roman = places, areas
Lower-case italic = archaeological phases by sites

L. A. Pavlish and E. B. Banning, *Am. A.*, XLV (1980), no. 2, 290, 297, report that direct detection of Carbon 14 atoms now can measure a radiocarbon age of about 75,000 years, from milligram samples, in minutes rather than days for 10,000-year-old samples. No dates relevant to this volume are as yet available.

	CENTRAL MEXICO	EASTERN MEXICO	SOUTHERN MEXICO	WESTERN MEXICO
1500 POST-CLASSIC	AZTEC	Zempoala		Tzintzuntzan
			MIXTEC DYNASTIES IV / V Monte Alban periods	Culiacán
1300	CHICHIMEC		Zaachila III	
	Tula TOLTEC			Guasave
1100		XII Tajín periods		
		Tamuín	II	
				TARASCA
900 CLASSIC	Xochicalco		IV Lambityeco I? Mitla	Aztatlán
	Cacaxtla			
700	Teotihuacán IV	VII		Toluquilla – Ranas
		VI		Jiquilpan
			III B pre-I?	
		V		
500	Teotihuacán III	IV Upper Remojadas	Ñuiñe	Ixtlán del Río
		III Upper Tres Zapotes	III A	Ortices
300	Teotihuacán II			
	Teotihuacán I	II		Chinesca figures
100 PRE-CLASSIC		I	II	
0		OLMEC III		Mezcala
100		Cerro de las Mesas		
		Middle Tres Zapotes	I B	
			Dainzú	
300	Ticoman	Lower Remojadas		Chupícuaro
	Cuicuilco		I A	
500		OLMEC II	Rosario	
700	Tlatilco		Guadalupe	El Opeño
900		El Ébano		
		La Venta Lower Tres Zapotes		
1000			San José	
		San Lorenzo OLMEC I		
1300	Zacatenco		Tierras Largas	Xochipala
	El Arbolillo			
1500				

22

	LOWLAND MAYA		HIGHLAND MAYA AND PACIFIC SLOPES	EASTERN CENTRAL AMERICA
	NORTH	SOUTH — Pottery periods (Uaxactún) / Sculpture (Initial Series)		
1500 **POST-CLASSIC**				*Coclé*
1300	Mayapán		*TOHIL*	
1100	Chichén III	PLUMBATE		*Lake Nicaragua* / *Reventazón*
900 **CLASSIC**	LATE PUUC Río Bec / Chichén II / Edzná	TEPEU 3 — 10.4.0.0.0 = A.D. 909 / 10.0.0.0.0 = A.D. 830		*Ulúa COPADOR* / *Mercedes*
700	EARLY PUUC Becán	TEPEU 2 — 9.15.0.0.0 = A.D. 731	Cotzumalhuapa	
	Uxmal Chichén I	TEPEU 1 — 9.10.0.0.0 = A.D. 633	Escuintla	
500	PROTO-PUUC	TZAKOL 3 — 9.5.0.0.0 = A.D. 534	Kaminaljuyú	
	OXKINTOK	TZAKOL 2 — 9.0.0.0.0 = A.D. 435	ESPERANZA	*Nicoya*
300		TZAKOL 1 — 8.14.0.0.0 = A.D. 317		
100 **PRE-CLASSIC** **0**		MATZANEL		
100		CHICANEL		
300			Kaminaljuyú / MIRAFLORES	
500			Izapa	
700		MAMOM		
900		XE (Seibal)	Kaminaljuyú / LAS CHARCAS	
	Dzibilchaltun			
1100				
1300			Chiapa de Corzo I / Ocós	
1500				

	NORTHERN ANDES		CENTRAL ANDES				
	Colombia	Ecuador	Northern Peru coast highland	Central Peru	Southern Peru and Bolivia coast highland		
1534	CHIBCHA	INCA	INCA			CUZCO	Late Horizon
	Darién		CHIMÚ LAMBAYEQUE	CHANCAY	ICA		
		Esmeraldas					
1000	QUIMBAYA			Pachacamac Huari			Late Intermediate
	Tierradentro	Manabí	HUARI	Huari	VIÑAQUE Tiahuanaco		
	San Agustín		V MOCHICA		NAZCA 9		Middle Horizon
Integration 500				LIMA	8 QEYA		
	CALIMA		IV		7		
	TOLIMA		III		6 / 5		
			II		4		
0			I		3 Pucará		Early Intermediate
			Recuay		2		
Regional Developmental 500		GUANGALA	SALINAR		1 / PARACAS 10 Chiripa		
					9 Chanapata / 8		
			CUPISNIQUE		7		Early Horizon
			Moxeke Chavín / Cerro Sechín		6		
1000					5 / 4		
			Huaca de los Reyes		3 / 2		
		CHORRERA	Kotosh		1		
Late 1500 Formative		MACHALILLA		Chuquitanta			Initial Period
2000							
2500							Preceramic VI
			Huaca Prieta				
Early Formative 3000	Puerto Hormiga	Valdivia					

THE ART AND ARCHITECTURE

OF ANCIENT AMERICA

CHAPTER I

INTRODUCTION

The purpose of an introduction is to identify its bearer to his host in a phrase or two that solicit mutual understanding. In this book, products of aesthetic value are the principal theme. I have at all points sought to avoid the suggestion that works of art are mere illustrations to civilizations, preferring to present the artistic object itself as the unit of study. I have written about 'cultures' only when such topics were required to illuminate the objects, which are after all the principal proof of the 'culture's' existence. Hence my text will not satisfy students of 'cultures' alone; it is written for people whose main interest attaches to works of art.

THE LANDS AND THE PEOPLES

With this proviso in mind, we can approach the history of the various peoples of ancient America. Only their works tell us about them. We deduce that some were simple villagers, while others were priestly rulers or professional warriors. A few literary sources of pre-Conquest date confirm these rarefied deductions. Occasionally a city like Chanchan (p. 401) speaks to us of complicated dynastic politics; Palenque must have been a courtly centre of exquisite refinement (p. 219). But beyond these affirmations we cannot reconstruct any web of events without written records. Chanchan came into being without benefit of writing as we know it, and more than half the written signs of Maya civilization are still undeciphered. Only very occasionally the traces of an identifiable individual artist are legible; for instance in the sculpture of Palenque (p. 261) or in the pottery portraits of the north coast of Peru (p. 390). Hence the artistic identities are remote and unclear: they emerge indistinctly from their works, and if it were not for these works, we could not apprehend personalities at all.

The lands to be omitted are far more extensive than the ones to be discussed. There is nothing here about North America above the 24th north parallel of latitude, nor in South America below 20 degrees south. Our western limit lies on the Pacific coast of Mexico at about longitude 105 degrees west, Our eastern boundary, in the Andean *altiplano* of Bolivia at longitude 75 degrees west, excludes all lowland South America. The reason for these exclusions is a simple one: in the vast lands of eastern South America and of ancient North America there were few people. Less than 20,000,000 persons were alive in America in 1492,[1] and half of these lived in the region defined by the scope of this book. Only the Mexican, Maya, and Andean peoples were numerous enough to live in large cities, producing the economic surplus that allows specialized craftsmen to build great temples and to fashion works of art. The rest enjoyed the protective isolation of aboriginal living to the point of producing very few things for us to study. If the ancient manufactures of many of these tiny, scattered tribes were beautiful, we do not know it; for very little has survived.

My scope embraces only the principal urban civilizations of ancient America, from the Tropic of Cancer to the Tropic of Capricorn, in a quadrant as wide as from Lisbon to Istanbul, and as high as from Cairo to Leningrad. It lies upon the latitudes of Central Africa, and is about equal in size to western Europe. As in western Europe, the coastlines define several seas, but the American land area is far smaller, and its river systems separate the regions more than they connect them. Much of the land surrounds a great Atlantic body of water, of which the western (Gulf of Mexico) and the eastern (Caribbean Ocean) parts are analogous to the eastern and western Mediterranean.

A convenient if equivocal recent name for the total region is Nuclear America, and we retain it here for the moment because it is a historical term, and because no better term has been coined. The northern half, which is more thickly settled than any other part of ancient America, includes the Mexican, Maya, and Central American peoples. If the Caribbean Islands are included, this northern portion is usually called Middle America. The mainland territories alone, without the islands, are called Mesoamerica. These new names correspond more to historical than to geographical groupings, and they avoid the awkward traditional demarcation, drawn between North America and Central America at the Isthmus of Tehuantepec, which was always a thoroughfare more than a frontier in human affairs. The true cultural division between Mesoamerica and South America is at the Isthmus of Panama.

The southern part of the Nuclear American quadrant comprises the northern and central Andean peoples, with the most dense populations clustering in the Pacific Coast valleys of Peru. The Mexican, the Maya, and the Andean peoples probably maintained intermittent contacts by land and sea, but these were certainly much less frequent and much less productive than ancient commerce between Imperial Rome and the Han dynasty in China.[2]

An early draft of this book, written in 1950–1 and later discarded, was an attempt to treat Nuclear America as a unit, with the main divisions by architecture, sculpture, and painting. Each main division in turn was divided by topics, with examples drawn from the appropriate regional divisions of the quadrant. The effort was premature, and the effect was like that of a jigsaw puzzle, making the reader put together examples from many parts of America in order to produce the desired picture. It corresponded to a tendency then in vogue to lessen the differences between regional styles, and to increase the impression of unity and equivalence among the arts of various unconnected regions. It gave the impression that, in the Andes and in highland Mexico, the same kinds

of races towards the same goals were being run by men unaware of each other's existence, yet running at the same speeds, and marking laps of equal length at the same times.[3] This tendency to reduce the complexity of American prehistory came about in reaction from the despair of students in the years before 1945, when every valley and every site seemed to yield new 'cultures' unconnected with anything else.[4]

Fifteen years later, such a simplistic view was untenable as the evidence gathered in favour of varying time-scales in each of the principal regions. How is the matter best presented for students of art? The choice lies between two methods of discussing events in time: we may cut across the face of time at intervals in the past; or we may unravel the rope of time into its separate geographical strands, and treat each in a chapter or two to itself. The difference is like that between crosscut and ripsaw woodcutting. With the crosscut saw we can make synchronous sections; with the ripsaw we make diachronous cuts (through time in depth) at various places.

The crosscut method has many of the disadvantages of the jigsaw puzzle: it is misleading to arrange the matter so that the cuts will measure evenly; and it is confusing to have to hold so many examples in synchronous balance. I therefore resolved in 1957 to rewrite the entire text, using geographical divisions as the main parts and chapters, with a complete chronological review of the principal artistic events in each region. The archaeological region is the building-block of the present volume, and the tables are provided to guide the reader in correlating the probable cross-ties in time between the blocks. The size of the geographical blocks is a function of the length of the book. If it were longer, they could be smaller, but as it is geographical units have been kept at twelve: four in Mexico, three in Central America, and five in western South America.

Mesoamerica

Mexico is a plateau country laced by mountain ranges and rimmed by narrow coastal shelves.

The Pacific half is dry and sparsely settled. The Atlantic half enjoys wet winds, and it is more hospitable to dense human occupation. Midway between them is the metropolitan Valley of Mexico, the eternal capital. In the south the highlands are bare and austere, but the deeply carved, wide river valleys nourished civilizations of great age and remarkable achievements. Northern Mexico is a desert belt 500 miles wide, insulating the more southerly valleys from the continental spread of the rest of North America, into which only the eastern coastal plains funnelled a thin trickle of Mexican highland influences during antiquity.

Central Mexico for our purposes is a plateau country about 6500 ft high. It surrounds the capital in a circle roughly 100 miles in diameter. It was always metropolitan, even when its achievements were overshadowed by those of other regions, just as Rome remained somehow a world capital even at the lowest ebb of its fortunes. The hundred-mile circle includes Cholula, Tula, and Xochicalco in a connected group of broad, high, well-watered valleys that attracted dense settlement from the earliest days of human immigration. Its climatic history shows great fluctuations, and they are reflected in the rise and fall of civilizations, as well as in the Toltec and Aztec cosmogony of successive world ages terminating by flood or in fire. The dominant language of the region was Náhuatl, spoken by the Aztecs as well as by their Toltec predecessors.

The East or Gulf Coast has three ethnic divisions, like the Atlantic coast of France with its Basque, Breton, and Norman peoples. It is a narrow lowland coastal plain of tropical climate, narrow in the north and widening at the southern end, with placid rivers winding slowly through dense vegetation in nearly flat country. In the southern rain-forests lived the Olmec peoples, whose name signifies 'the dwellers in the land of rubber'. The central coast is more variegated and it was the magnet for a sequence of invasions, of which the Totonac people were the last to occupy the region before the Spanish Conquest. In the north are the Huastec people, whose language is an archaic form of the Maya tongue, separated from the main stock in Yucatán and Guatemala by enclaves of Olmec and other peoples.

Southern Mexico includes the states of Oaxaca, Tehuantepec, and Chiapas. The historic centre lay in the great valleys of central Oaxaca surrounding Monte Alban. As climate varies with altitude in Mexico, these lower valleys enjoy a milder climate and a more tropical vegetation than the plateau, without the steaming discomfort of the Atlantic coastal plains. In western Oaxaca, however, the arid mountain settlements of the Mixtecs harboured tribes of a cultural tradition like that of the central-plateau peoples. The centuries-long conflict between the Mixtecs and the Zapotecs in the valleys of central and eastern Oaxaca eventually reshaped the course of Mesoamerican history, when the victorious Mixtecs extended their dynastic rule and religion to other regions (pp. 155, 168).

Mexico becomes more arid closer to the Pacific, and more specifically west of the 100th parallel of longitude, because of dry winds and because of the rarity of great river basins. Only isolated pockets receive the rainfall necessary for dense human occupation. Ancient habits of early village life survived far longer than in the east. From Michoacán and Guerrero westwards, the sparsely-populated plateaus and mountain valleys lack great monumental centres or temple clusters. There are a few exceptions in the late Tarasca towns of the lake region in north-eastern Michoacán (p. 197), or the western colonies of the peoples at Toluquilla and Las Ranas (p. 198), but, in general, the great upheavals that transformed the more metropolitan eastern half of ancient Mexico seem to have registered only faint effects in the west. The Aztec expansion in the fifteenth century, which embraced all other regions of Mesoamerica, never penetrated west of the valley of Toluca.

The boundary is partly determined by the climatic frontier between the steppe and desert of Mexico west of longitude 100°, and the more densely settled intermont valleys east of 100°

longitude and south of latitude 23° north. This arid zone boundary (or isohyet line connecting places of equal rainfall)[5] and any map of the major pre-Columbian cities, demarcate a division of Mesoamerica into inner and outer areas. Inner Mesoamerica extends south and east from the Valley of Mexico, from Tula deep into Central America. Outer Mesoamerica includes western Mexico and the north above the Tropic of Cancer. Thus the thinly settled west and north are frontier zones bordering the densely urban southern and eastern divisions of Inner Mesoamerica. At their convergence the Valley of Mexico was both magnet to attract wandering peoples and spearhead to repel their attacks. Inner Mesoamerica is divided into eastern (Maya lowlands) and western (Mexican highlands) extremes, separated by the intervening peripheral coastal lowlands from Panuco to Honduras.[6]

*

The Isthmus of Tehuantepec divides the North American continent, of which mainland Mexico forms a part, from Central America, which in turn divides into three main archaeological regions: (1) the Pacific highlands of Chiapas, Guatemala, and Salvador; (2) the Maya region north of the highlands, including northern Guatemala, British Honduras, several Mexican states (Chiapas, Tabasco, Campeche, Yucatán, and Quintana Roo), and parts of western Honduras; and (3) eastern Central America, which embraces eastern Honduras, part of Salvador, and all of Nicaragua, Costa Rica, and Panamá. The Isthmus also was a place of passage between the Gulf Coast of Veracruz and the Pacific coastal plains of Mexico and Guatemala in the cultural area of the peripheral coastal lowlands (see maps, pp. 15 ff.), which intersect at the Olmec heartland.

Maya civilization, enduring from before 500 B.C. until the fifteenth century, occupied the second of these regions as the metropolitan focus to which both the Pacific highlands and the rest of Central America were either provincial or marginal after A.D. 300. The Maya peoples, like the Greeks in the ancient world, set the pitch in pre-Conquest America. Their intellectual achievements provided the foundations for the culture of their contemporaries and successors. Like the Greeks again, the Maya peoples appeared late upon the scene, profiting from the attainments of their predecessors, and imposing upon the history of civilization a pattern of behaviour both novel and durable, and different from what had preceded. It crumbled under invasion by more aggressive peoples, who yet retained among their traditions large portions of Maya learning and Maya sensibility.

There were exceptions to this rule. In the Pacific highlands, the pre-Maya and post-Maya peoples were more significant than those of the era of Maya ascendancy. Thereafter, as before the rise of the Maya, Mexican peoples of diverse origins were in control.

Eastern Central America likewise flourished independently both before and after Maya ascendancy. After A.D. 1000, various Mexican intrusions altered the history of the land, but old sculptural traditions in stone survived until the Spanish Conquest. Costa Rica and Panamá were important in transmitting to Mesoamerica the knowledge of metallurgy that probably originated in western South America. Panamanian gold-work is an extension of northern South American styles and techniques, so that it is correct to consider the Isthmus both as a frontier and as a place of passage.

The Andean Environment

Western South America above 20 degrees south sheltered several urban civilizations in the lower portion of our 'nuclear' quadrant. The contrast with Mesoamerica is antipodal. The Mexican and Maya peoples were preoccupied with the figure, the nature, and the position of man, much like the peoples of the Mediterranean, who marked out the humanistic tradition of western Europe by phrasing all experience in the human shape.

In the Andes, utility was the superior consideration. The conquest of the environment by

irrigation and terracing, by metallurgy and material techniques of all kinds, and by social discipline at the expense of individual man, gave Andean society a harsh tone, closer both to the present and to the rigours of tribal life than the more urbane view of existence maintained by the societies of Mesoamerica.

The small tribal units of the northern Andes, in Colombia and Ecuador, are similar in number, in linguistic affiliation, and in general cultural attainments to those of eastern Central America. The central Andes on the other hand sheltered human groups whose collective efforts were repeatedly organized into large states under unified control. The best-known example is the Inca Empire, formed near the conclusion of the independent native history of the continent, and extending about the year 1500 from Quito to northern Chile and north-west Argentina. Modern knowledge of the central Andes did not penetrate beyond the Inca state until the present century, when many earlier cultural stages were gradually recovered by archaeological methods.

Today, coastal and highland varieties of central Andean civilization can be distinguished. Northern, central, and southern provinces are clearly delimited by distinct styles of building and manufactures: the northern peoples preferred sculpture and large works of architecture; the southern peoples inclined towards painting and the textile arts; and in central Peru northern and southern traditions blended, upon an armature of local preferences varying widely from valley to valley.

THE CHRONOLOGICAL PROBLEM

Reconstructing the time-scales of American antiquity has been a main concern of archaeologists since the beginning of the century. Stratigraphic methods were first employed by Thomas Jefferson in Virginia,[7] and are today systematically amplified in thousands of observations. These yielded the first main sequences, based usually upon pottery types and styles. Textual studies have also allowed many chronological deductions. The most rewarding suggestions for dating come from the method of radiocarbon measurement of the residues of natural radioactive Carbon 14 in organic remains.[8] Invented in 1947, the method still requires further refinement, and its results are far from unequivocal. It permits absolute dating only with statistical errors which still exceed a century, and which often leave a margin of doubt as broad as a millennium.

It is instructive to rank the main regions of American antiquity by the reliability and the exactness of our chronological knowledge. Maya studies lead the field, because of the incomparable epigraphic material carved upon buildings and relief sculpture. Many archaeological ties allow Mexican materials to be dated in relation to the Maya series, and there are reliable texts of pre-Conquest origin which pin down the events of the last few pre-Columbian centuries. Lowest in the order of chronological fineness and credibility are the Andean sequences, where gross relations are sure, but not the intermediate positions. It is as if we knew only that Carolingian art preceded the Renaissance, but not how many centuries intervened, or whether the sequence was valid for Spain and England too.

Much of our knowledge of Andean antiquity is based upon pottery styles, and we have no sure knowledge that continuous pottery-making traditions reflect continuity in other fields of historical activity, or that non-symbolic changes in pottery styles really correspond to anything outside the domain of the potter's art. When symbolic shifts are apparent, and when these coincide with major changes in building activity, it is reasonable to suppose that ethnic re-alignments by conquest or conversion are involved, but their exact nature cannot easily be deduced when there is no text of any kind to guide us.

Deductions of this sort nevertheless colour our understanding of the American past with exaggerated hues and contrasts. For example, the prevailing division of Mesoamerican antiquity by pre-Classic, Classic, and post-Classic

eras, as used in this book, corresponds in most investigators' minds to a sequence of stages in the economic and political organization of the American Indian peoples. Pre-Classic times, prior to the Christian Era in our normal chronological thinking, were the age of early village societies; the Classic era witnessed the rise and fall of theocratic states: and in the post-Classic period feudal aristocracies dominated, under dynastic rulers engaged in military expansion. The pattern is assumed to be the same wherever large urban populations thrived, with only minor variations of terminology, such as the term 'florescent', which means the same quality in Andean studies as 'Classic' in Maya archaeology. The American evidence is sometimes instructive about stages on which Old World archaeology has little to say. An example is the architecture of the ritual concourse centre, for which Maya, Mexican, and Andean examples are abundant. Old World examples are few and incomplete, like Stonehenge or Avebury.

I have no alternative to offer for this grand neo-evolutionary scheme. It is probable that early American civilizations did not evolve very differently from those of the Old World; but my interest in style precluded arrangement by evolutionary stages.

Archaeologists trained in anthropology usually produce reconstructions diagrammed into separate compartments. Art historians trained as humanists usually produce descriptions of complex flow. The differences between these operations are the differences between packages and tapes. The two kinds of description of the past may be complementary, in the sense of Niels Bohr, who declared that the integrity of human cultures requires an 'overlay of different descriptions that incorporate apparently contradictory notions'.[9]

To Mesoamericanists, 'Classic' is the key period name. Andeanists prefer 'Horizon'. Classic carries a judgement of quality; Horizon indicates an estimate of political unity, as suggested by the archaeological record. The two key terms reflect differences in both artifacts

and attitudes. Mesoamericanists are pointing, when they say Classic, to the Mediterranean affinities of their world. Andeanists are pointing, when they say Horizon, to the political structure of their world, in the alternation of 'pan-Peruvian' periods of unity with the diversity of regional periods and styles.

Several Mesoamericanists recently proposed the adoption of a 'neutral value' terminology like that of the Andeanists, in order to avoid the developmental implications of words like 'Formative' and 'Classic'. But they ignore the value-laden aspects of such terms as 'Horizon' and 'Intermediate', which are equally judgmental and only replace 300-year periods by coarser 500-year ones that blur even more in synchronic studies than 'Classic' and its divisions as early, middle, and late.

The concept of a Middle Classic period (A.D. 400–700) has recently appeared in a volume of essays under that name. Esther Pasztory calls it comparable to the European Renaissance of the fifteenth and sixteenth centuries. Her exposition of the artistic traditions of the Middle Classic is divided by architecture, art style, and iconography. These are treated geographically by highland and lowland, and the coastal axis between them, each reviewed by sub-periods of the Middle Classic (early, 400–550; late, 550–700), early being a 'simplifying Teotihuacán' influence but late being 'multiplicity' in Mesoamerica.[10]

ANTHROPOLOGY
AND AMERICAN ANTIQUITY

It is a striking fact that the study of Old World antiquity was from its beginnings in the Italian Renaissance a branch of humanistic learning, while the study of New World antiquity, which has been systematically pursued only since about 1850, soon took a scientific turn, relating it more closely to anthropology than to humanistic studies.

An explanation of this split is easily provided. Archaeology began in Europe as an auxiliary method. Wherever the written word was miss-

ing, the earth itself could be searched for inscriptions, coins, and similar literary evidence. From being the last recourse of the philologists, archaeology became first the diversion and then the obsession of those students of language and literature whose aim was to enrich the fund of monuments illustrating the literatures of the ancient world. Soon after 1850, archaeology escaped its philological servitude to become an instrument for the reconstruction of periods of time less vast than those of biology, yet far ampler than those of recorded history, and embracing the whole history of mankind. Enriched by typology (series of similar objects) and stratigraphy (the layering of remains in chronological sequence), archaeology soon parted company with the humanities, and in America its workers joined forces with those busy in the social sciences. Among these anthropology has aimed to govern an enormous range, including the biological, linguistic, societal, and historical attainments of mankind in all phases of development.

Today an archaeological report on an American site is a 'scientific' production of graphs, statistics, and impersonal language purporting to reach proven and repeatable conclusions. Such a report has nothing to do with the interpretation of literary works; on the contrary, philology has almost been forgotten by archaeological science. Where the excavation finds are unblessed by writing, philology entirely disappears. Indeed, the 'scientific' connexions of archaeological work, whether in Europe or America, increase as the material culture under study approaches early, i.e. non-literate, art.

Hence archaeology in America joins with ethnology (the study of living peoples) and with linguistic science as a section of anthropology, dedicated to the study of 'primitive' peoples. Archaeology is a scientific technique rather than a fully autonomous discipline. It is important whenever documents fail to yield direct evidence of the past. In the hands of the anthropologists, it is applied to the recovery of information about social structure and economic life. In this context works of art are used as sources of information rather than as expressive realities.

Of course the tradition of collecting information about exotic societies has a long past in America. The classic example is the work of the Franciscan friar, Bernardino de Sahagún. For twelve years, from 1558 to 1570, he consulted with native informants in central Mexico to compile a great encyclopaedia of the native peoples in the Náhuatl language. Another compiler was the bishop of Yucatán, Fray Diego de Landa.[11] On Peru we have among many others the sixteenth-century work by Pedro Cieza de León.[12]

All these sources may be described as a literature of economic and political purpose. When monuments are mentioned, it is not for the sake of their form or expression, but to indicate that important centres of population were present, or that treasure might be latent. The notion of any artistic value beyond magnitude of enterprise, strangeness of form, and rarity of material was absent from most sixteenth-century commentaries upon pre-Conquest manufactures.

In the seventeenth century a new kind of writing about Indian matters made its appearance. Civilian colonists and clergy alike, in their concern for the spiritual advancement of the native peoples, found it necessary to extirpate the ancient idolatrous practices that still flourished in countless towns.[13] Many reports tell of sites and cult objects, giving explanations of their use and describing their destruction. The major destruction of Indian symbolic expressions was completed in the seventeenth century.

Later writers were reduced to collating the early sources. In the eighteenth century the Jesuit historian Francisco Clavigero wrote an account of antiquities that served long as a handbook of Mexican archaeology.[14] The historians of the Enlightenment, such as Raynal, Robertson, or de Pauw, who wrote of America, added little that was new to these prior accumulations.

A vast expansion of exact knowledge accompanied the opening of Spanish America to European travellers following the Wars of Independence. Alexander von Humboldt and Alcide d'Orbigny were among the earliest. Baron Waldeck and J. L. Stephens published the principal Maya monuments before 1845; in South America, J. J. von Tschudi and W. Bollaert presented many linguistic and archaeological discoveries to the European public. Their successors, E. G. Squier, T. J. Hutchinson, Charles Wiener, and E. W. Middendorf, covered Peru with a further network of explorations.

A generation of field archaeologists appeared after 1890 – A. Bandelier, W. H. Holmes, A. P. Maudslay, Max Uhle, and T. Maler. Their immense apparatus of field reports and excavation accounts laid the foundations of modern archaeological knowledge about pre-Columbian America. At the same time in Germany the philologist Eduard Seler patiently collated the textual sources for Mexican and Maya history in many essays and commentaries.

Between the World Wars the responsibility for American archaeology was assumed entirely by governments, foundations, public museums, and universities. Corporate campaigns of research, like those of the Carnegie Institution of Washington, yielded hundreds of books and papers on all aspects of Maya civilization. Since 1945, however, financial support by great institutions to American archaeology has dwindled away, and it is a rare event when sustained effort by a numerous field party is dedicated to a programme of excavations such as the one at Tikal in Guatemala under the auspices of the University Museum in Philadelphia.

One consequence of the disappearance of massive financial support for new excavation has been a renewed effort by anthropologists to generate fresh interpretations of the historical meaning of American Indian cultural history. Since these ideas arise more from works of art and architecture than from any other evidence, we should here examine them with care in order to correct our own course if necessary.

In the attempt to study the whole configuration of culture, anthropological science has been concerned with aesthetic activity only as a component of culture. The question at once arises whether 'culture' indeed 'includes' aesthetic activity. The anthropologist usually assumes that every aesthetic choice made by the members of a culture must be determined by that culture itself. But when we apprehend any culture as a whole, its axioms or postulates resemble aesthetic preferences. Thus two peoples living under similar environmental conditions may exhibit contrasting attitudes in respect to the total ordering or integration of their lives. At every point in the long, unconscious adaptation to environment, people have the faculty of choice. They can reject some alternatives, and accept others, more often than not for reasons of pleasure and dislike rather than necessity. To be sure, many people's choices are conventional, but we are here discussing the significant choices of the minority élite whose decisions become conventions. In all epochs, artists have been foremost in channelling the future along these fateful ways of pleasure and displeasure.

The history of art cannot entirely be included by anthropological science, despite the fact that the history of art treats only a fraction of the material culture which is a main object of anthropological research. Anthropological conclusions about a culture do not automatically account for the art of that culture. As Jakob Burckhardt long ago remarked, on the State as a work of art, the culture itself can be regarded as an aesthetic product, brought into being by the same non-rational choices that mark a work of art. On the other hand, the work of art is of course incapable of being made to explain all the culture in which it was produced. No explanation of culture ever fully accounts for its works of art because aesthetic activity lies in part outside culture, and because it is anterior to culture as a possible agent in the processes of change.

Another consequence of this reification of culture by anthropologists is the rigid

evolutionary scheme of cultural development in fashion since about 1950. If culture is a real entity, then its existence in time must have had segments, separated by determinable historic dates.[15] This kind of thinking is familiar enough in historical studies, where numerous documents require the introduction of nuances into the artificial device of historical periods. In archaeology, however, there is always present the temptation to adjust the durations to preconceived ideas of their content;[16] for example, the style of pottery painting found at Wari in Peru and Tiahuanaco in Bolivia (p. 453) reappears throughout the central Andes, seeming to displace earlier local manners. No texts explain these events, and archaeologists have supposed firstly that the Andean diffusion of the style corresponds to military conquest or religious conversion by dynamic highland peoples, and secondly that these events occupied a narrow span of time after A.D. 600 (Chapter 16). Today, however, more and more lines of evidence converge to suggest that the centre of diffusion was not at Tiahuanaco but in the Mantaro basin, and that the spread of the style lasted many centuries, antedating the putative 'expansionist' period and beginning as early as 200 B.C.

In short, ceramic frequencies give reliable information only about very coarse time relationships: about the history of the craft itself, and perhaps about economic conditions if other evidence is available. But sherd frequencies are unsatisfactory evidence for political or sociological reconstructions. Pottery sequences reflect other orders of events only after delays and with much levelling of a more agitated reality. If we had to rely upon ceramic history alone for our knowledge of Hellenic events in the period 550–450 B.C., the shift from black-figure to red-figure painting would probably be interpreted as a political or sociological event rather than as a transformation within the craft.

The general effect of the imposition of rigid developmental categories has been to stress discontinuity and rupture, rather than continuity in regional and local traditions. For instance, each major change in the pottery style of a valley is hailed as a new 'culture', even when the older literary sources, closer to the events, report continuity. As an example, Sahagún recorded the Aztec tradition of Old Toltecs and New Toltecs in central Mexico,[17] referring to a continuity which today has been broken by scholars into separate 'cultures'. Thus 'cultures' have been multiplied inordinately; local groupings receive more attention than the main traditions; and 'crosscut' comparisons (p. 28) have become the principal method of historical reconstruction.

A century ago W. H. Prescott wrote of the conquest of Mexico and Peru by Spain, and he prefaced the narrative with a luminous account of Aztec and Inca life based upon Spanish eyewitness accounts and on their records of the events of the fifteenth and sixteenth centuries. Behind that horizon nothing was known. Today the curtain has been pushed back to disclose the continuous existence of peoples changing from the nomadic lives of palaeolithic big-game hunters into sedentary villagers and ultimately to great religious communities and dynastic states. This reconstruction of the river bed without its river has been among the great achievements of the anthropologists in this century.[18]

DIFFUSION OR POLYGENESIS?

The other main theme in recent anthropological discussion concerns the diffusion of culture from the Old World to the New. Two schools of thought are present: the diffusionists, who exclude the possibility of independent invention; and the Americanists, who defend the thesis of independent origins for New World civilizations. Diffusionism has had defenders since the sixteenth century, when the lost tribes of Israel were invoked to account for the racial origins of the American Indian peoples.[19]

The thesis of independent origins was first stated in the 1840s, by F. Kugler in Germany, and by J. L. Stephens in the United States.[20] Both men independently destroyed the arguments for Old World origins of American In-

dian art by demonstrating the autonomous and self-contained character of the principal artistic traditions, and by showing that resemblances to the arts of other regions of the world, such as India or Egypt, could be explained as convergences rather than as borrowings by Americans from Old World sources.

In our century, the topic was dormant for a generation, from about 1925 to 1950, when the thesis of the independent origins of the New World civilizations was the orthodox view among North American archaeologists, working mainly under the leadership of A. V. Kidder at the Carnegie Institution of Washington. Their hypothesis was that America received its first settlers from north-east Asia near the close of the last Ice Age, and that migration was thereafter cut off by physiographic changes at Bering Strait. All American Indian civilizations were believed to have developed independently upon this palaeolithic base, without further influences from the Old World. The hope was to prove that the human species, if cut off in a favouring environment near the beginnings of history, would spontaneously develop cultures parallel to those of the other races of mankind, but owing nothing to them by way of historical influences beyond the original palaeolithic fund of knowledge.

The independent inventionists have never denied the occurrence of small-scale intermittent migrations from Asia or Europe, like those of Scandinavian sailors after 1000 to the coasts of Massachusetts and Rhode Island. But they have rightly regarded these episodes as insignificant in the large framework of indigenous development. More important is the absence of major Old World traits from the technological repertory of the New World peoples: traits such as horses and wheeled vehicles. The diffusionists have not provided any explanation of these absences.[21]

This problem of the origins of American Indian civilizations remains one of the great open questions in world history. The linked sequences of Old World history afford no opportunity to verify the thesis of distinct cultural traditions arising from independent origins. Only America provides the possibility of establishing a case for independent invention. We must therefore weigh with extreme care any assertion pretending to resolve the issue. We cannot here test the racial and agricultural evidence, but we should be prepared to question the visual comparisons upon which the new diffusionists have based certain recent arguments.[22]

For example, Ekholm has supposed that a centre of Asiatic influences flourished after the eighth century A.D. on the western border of the Maya peoples, bringing into Mesoamerica traits imported from the art and architecture of southeast Asia. For nearly every one of these forms, however, still other Old World origins can be suggested. The trefoil arch of Maya architecture occurs not only in western Pakistan about A.D. 400, but also in Islamic and Romanesque architecture. The miniature roofed building inside a temple recurs not only at Ajanta in India, but in Hellenistic architecture. Sacred-tree or cross forms are obviously of Early Christian significance, in addition to the late Javanese or Cambodian examples adduced by Ekholm. Court scenes like those of Bonampak or Piedras Negras are common in Byzantine art. Colonnette decorations on façades pertain to Romanesque art as well as to Khmer temples. Corbel-vaulted galleries are Mycenaean as well as Cambodian. Serpent forms, Atlantean figures, and phallic statues are not restricted to south-east Asia, but recur throughout the art of the ancient Mediterranean. Doorways framed by monstrous mouths stand in Christian art for the gate to Hell. The Chacmool figure can be compared to classical river gods as well as to figures of Brahma. In other words, for nearly every item adduced in this list, an older European parallel can also be proposed. The thesis of Asiatic origins is thus easily diluted to include the entire Old World, and the Asiatic 'focus' loses precision.

In addition, these forms all belong to autonomous American iconographic types. The famous comparison between Shang or Chou

Dynasty bronze scrolls and the scrolls upon Ulúa valley vases of about A.D. 1000, first pointed out by C. Hentze and revived a generation later by M. Covarrubias, belongs to this class. Chinese bronze scrolls belong to one iconographic series; Ulúa valley scrolls pertain to another series. Both series depart from dissimilar sources to converge in an adventitious resemblance that has misled all students who were unaware of the separate typological series embracing each term of the comparison. The argument is like assuming a close blood relationship between persons who look alike, although born many centuries apart, of different races and on different continents. The resemblance is accidentally convergent, and it cannot be used to establish a genetic connexion without supplementary proofs.

THE HISTORY OF ART

This modern academic discipline of collecting, selecting, interpreting, and evaluating works of art and architecture owes its origins as a humanistic study to Renaissance historiography (Vasari) and to classical archaeology. Its connexions with anthropology have never been close. In the realm of aesthetic choice the history of art treats roughly one-third of all possible human activity. This realm is the main theatre of human volition: it is neither of the senses nor of the intellect, but between them and participating in both. We have already discussed the anthropologist's restrictive view of the cultural place of artistic activity: let us now look at the art historians' view of the materials of American archaeology.

In general, they regard aesthetic products as furnishing symbolic values rather than useful information: they are concerned with intrinsic being more than with applications. The first explicit statement about the history of ancient American art was written c. 1840 by a German historian of art, Franz Kugler. He prepared the earliest general history of world art, written for the Prussian king and published in 1842.[23] The American section was composed before the ap-

pearance of J. L. Stephens's path-finding views on the origin of Maya civilization. Kugler first stated the 'independent inventionist' doctrine, which is still fundamental, if controversial, in American anthropological theory. He accepted east Asiatic origins for American man. More important, he insisted upon the independence of the art forms from Old World influences posterior to the basic Ice Age migrations. He regarded ancient American art much as I shall do here – as an autonomous and independent development, but lacking great antiquity. These principles occurred to Kugler solely from the study of those works of art which he knew in Germany from plates published with the works of d'Orbigny, Humboldt, Kingsborough, Dupaix, Nebel, and Waldeck. He deduced that American Indian art was 'thoroughly different from the artistic achievements of all other known peoples of the earth'. This proposition led him to assert autonomous and independent development as the necessary conclusion. Modern anthropological theory, to be sure, owes nothing to Kugler, whose work has had little influence outside the history of art. But it is of real interest that a specialist's judgement of forms in art expressed about 1840 anticipated the independent conclusions of the members of another discipline in a much later generation.

In other respects Kugler was less adventurous. His taste for neo-Classic correctness and severity, then already old-fashioned but still characteristic of his generation, kept him from enjoying the expressive power of Mexican sculpture. After Kugler few historians of art in the nineteenth century returned to the subject; one of the rare exceptions was Viollet-le-Duc, who hurriedly studied the rationale of the Maya ruins reported by Désiré Charnay.[24]

In retrospect, historians of art were very slow in turning to the study of American antiquity. Political reasons may be the explanation. Twentieth-century sensibility, as a quest for expressive power independently of representation, was at first channelled by the political geography of nineteenth-century colonial expansion in its search for non-European sources

of inspiration.[25] Africa and Oceania, as the colonial empires of France, Germany, and Britain, yielded the first great ethnographical collections, and it was they that stimulated Gauguin and Munch, Braque and Picasso. The Latin American peoples, who attained independence from Spain before the formation of the European colonial empires, could rarely contribute from their rich resources to these ethnographical collections. In addition, the materials of American archaeology, although rich in 'primitive' suggestions, also include representational styles of a degree of verism that made them, like Egyptian or Minoan archaeology, unsuitable for formal experiments in search of great intensity of expression.

The art historians' adaptation to these contrasting values in American archaeology is well documented. In 1842 Kugler correctly noted the Aztec sculptor's search for the 'inner meaning of organically animated form', and his command of the 'expressions of the life of the soul'. But Kugler was ill at ease with the 'deformed proportions', the 'excessive symbolic ornament', the 'architectonic conventions' of Aztec sculpture, with its 'gloomy, arbitrary, and adventurously synthetic fantasy'. Like Waldeck, who claimed to be Jacques-Louis David's pupil, Kugler preferred the 'lively sense for nature, excellent musculature, slender forms, and soft motions' of Maya sculpture at Palenque.

Nearly sixty years later Karl Woermann, writing of American archaeology in 1900, was still unable to resolve the same conflict in judgement.[26] He wrote that American Indian sculptors, in spite of their wide technical command, lacked 'full understanding of the forms of representation', and suffered from 'incompletion and a barbarian overloading, although they were able to make their forms occupy space with unmatched monumentality'. In other words, the nineteenth-century critic could not bring himself to credit the expressive strength of American Indian art, nor again could he rank it high by Occidental standards of verisimilitude. Faithful representation was for these critics the touchstone of value, and the

representation to which they were accustomed is uncommon in ancient American art.

Hence it was not until about 1910 that critics appeared who were able to penetrate the expressive devices of the figural art of ancient America, and to comprehend the spatial purpose of the architecture. These new students, among whom one of the earliest was H. J. Spinden, belonged to a generation already familiar with non-representational expression. In Spinden's case the training of an anthropologist was united with the insight of a gifted critic, who had been influenced by 'technicist' interpretations of primitive art from Semper to Haddon.[27] Spinden, however, was mainly an anthropologist concerned with culture, and his work used Maya art to extract information about the civilization. It remained for others, such as Pál Kelemen and José Pijoan,[28] to consider ancient American art for its own sake rather than as a documentary file on cultural themes.

The task is a difficult one. My volume, like others before it, falls far short of the avowed aim, to explain the principal archaeological objects as works of art. The term itself, 'work of art', is already a qualitative ranking, as it separates products of aesthetic intention from products for use. After selecting the works for discussion, we must say how, when, and by whom they were made. Then we must translate their meaning from visual into verbal terms. Finally we have to extract from the historical series of works of art those 'deviational' meanings that were not apparent to the people themselves who made and used the objects, and which appear only to the historian after the series is completed.

In making my selection I have retained the traditional classification by architecture, sculpture, and painting, in spite of appearing to omit many crafts. This difficulty is only verbal; for all crafts can be treated as parts of sculpture or painting. Textiles are paintings on flexible supports. Most pottery vessels are sculptural forms, and some are paintings on curved surfaces.

A more urgent objection is that the threefold division into architecture, sculpture, and painting reasserts the ancient distinction between 'fine' and 'useful' arts in relation to civilizations whose entire artistic production consists of objects for use. In this context, the gigantic European literature of right academic practice is bereft of meaning. Arts of representation that recognize no convention of European one-point perspective cannot be bound by academic legislation on the 'rightness' of the Albertian construction. Sculpture that is only occasionally concerned with geometry cannot be criticized by Greco-Roman canons of proportion. An architecture to which the column is an occasional relief in the rhythm of voids and solids cannot be contained by regulations derived from Vitruvius and Vignola.[29]

What then could be my guide in the selection of some objects and the rejection of others from this text? The valuation of whole cultures yields no criterion; for when cultures are ranked, the ranking does not apply to arts: when arts are ranked, the ranking does not apply to cultures. To present knowledge the connexion between excellent art and its necessary or adequate social conditions is completely and entirely unexplained. The historian can occasionally point to favouring circumstances, but he cannot identify them as sufficient causes. In short, we know of no type of society in which excellent art inevitably and necessarily appears.

When a building or an object is discussed and illustrated here, it is because of a peculiar perceptual quality. Unlike physical or chemical properties, this perceptual quality cannot be measured. Its presence is unmistakable. It is altogether absent from no artifact. Works of art display it more than utilitarian objects. It is present in nature wherever humans have been active, as in pure-bred animals, and in some landscapes. It appears in scenes and things called beautiful as well as in those that arouse disgust.

It is a special intricacy in several dimensions: technical, symbolic, and individual. In the technical dimension, we are aware, in the presence of such objects, of a long cumulative tradition of stock forms and craft learning, in which the maker's every gesture arises from many generations of experimentation and selection. In the symbolic dimension, we are presented with a cluster of meanings infinitely more complex than the single functional meaning that attaches to a tool or to a bit of information. In the individual or personal dimension we become aware of the maker's sensibility. Through it the technical tradition and the symbolic matter have filtered, undergoing alterations leading to a unique expression.[30]

The net we are using has a mesh that lets the useful forms of material culture pass through it, retaining only those which the field archaeologist calls 'fancy' forms. His net, on the other hand, best retains tools and instruments. It lets works of art pass through after only their useful message has been read. Thus we are working over the leavings of the field archaeologist, like the prospectors who find rare minerals in the tailings of an earlier mine.

The true tool has only one function, and only one meaning. Many tools of course come under close scrutiny as works of art, because of their high degree of useless elaboration. Conversely, many objects of ornamental purpose have a residue of functional form. I have therefore included under the rubric of ornamental forms large numbers of utilitarian objects. Their elegance and symbolic value are self-evident. In the history of European art they would be called 'decorative arts': here they are taken closer to the core of aesthetic activity, and classed as modes of sculpture and painting. The ordinary tool is to a work of art as everyday speech is to music, but some tools are like songs.

Some comment is in order on the conception of meaning used in this volume. Iconography, which is the study of 'the subject matter or meaning of works of art',[31] embraces three kinds of meaning: natural subject matter (representations of objects, of events, of expressions); conventional subject matter (representations of concepts, stories and allegories); and intrinsic meaning (the work of art as cultural symptom or as revealing essential

tendencies of the human mind). All works of art possess intrinsic meaning, even when they lack both conventional and natural meanings. Much textile art, for instance, represents nothing, yet it is symptomatic of its culture by virtue of intrinsic meaning alone. In ancient American art, intrinsic meaning is often more easily established than either conventional or natural meanings (pp. 394–5, 423).

Our greatest difficulties arise with conventional meanings, especially when we are dealing with pre-literate societies. The key to conventional meanings can come only from literary sources; pictorial conventions can rarely be deciphered by examination of the pictorial materials alone. Literary sources for the understanding of ancient American civilizations are lacking for all societies other than those recorded by Spanish observers and by Indian survivors at the time of discovery and conquest. Hence we have intelligible and circumstantial literary sources only for Aztec civilization, for late Maya culture under Mexican influence, and for Andean society in its terminal phases. We have no auxiliary sources whatever to decipher Mochica art, or Classic Zapotec, or Nazca or Tiahuanaco styles of conventional meaning.

It is often erroneously supposed that intrinsic meaning cannot be known before natural and conventional meanings are established. In actual practice, however, we constantly make correct assessments of intrinsic meanings without knowing either the natural or the conventional meanings of the form under inspection. For example, J. L. Stephens correctly assessed an intrinsic meaning of Maya writing, as a system having no connexion with any other Old World writing, some fifty years before its partial decipherment by Förstemann and Goodman. And whenever one assigns an object without provenance to a specific time and place, it is in part on the strength of an intuition about intrinsic meaning. Thus we are obliged, like all previous students, to concentrate upon natural and intrinsic meanings. The galaxies of conventional meaning for the most part still lie beyond the range of our instruments of knowledge.

Many anthropologists urge the use of ethnohistory as a main instrument of archaeological reconstruction. But to assume that the archaeological past resembles the ethnological present, is to believe that the present can explain the past, instead of seeking an explanation of the past in its own terms. The archaeologist who uses ethnological aids assumes an unchanging past. Instead of guaranteeing the purity of the past under reconstruction, he converts the past into its present.[32]

If the history of art were merely a matter of solving puzzles of date and authorship, and of explaining works of art, it would be only another antiquarian pursuit among innumerable varieties of gourmandizing over the past, along with philately and genealogy. The problem of knowledge itself arises here. The history of art is a historical discipline because the seriation of works of art permits one to transcend the knowledge of even the artists themselves about their own work. Despite all the imperfections of his sources, the modern student of the sculpture of Phidias knows many things about Phidias that neither Phidias nor his contemporaries could know. He who knows the envelope surrounding the events of antiquity, can deduce from this awareness of durational meaning such estimates as the relative age of any form in a given class of forms, and the significance of an individual artist in a connected series of artists.

In American antiquity many groups of monuments and objects still require seriation, although some anthropological archaeologists have achieved great precision with ceramic stratigraphy and the quantitative analysis of stylistic traits. When it is unlikely that field excavations can solve the problem because the sites are too disturbed, these undifferentiated groups of objects can still be subjected to a stylistic analysis of an art-historical type. Assuming that early and late positions in a series correspond to distinct and definable formal qualities,[33] we can provisionally put the objects in series, as with colossal Olmec stone heads (p. 122), west Mexican clay sculpture (p. 191), or Toltec Maya buildings (p. 298). These

approximations, however coarse and inexact, are still better than no sequence; for it is upon sequence that our awareness of artistic problems must ultimately rest. The chain of solutions discloses the problem. From many such disclosures we can derive an idea of the guiding configurations of behaviour at different times and places. The labour ahead requires selection, explanation, and disclosures of objects which are usually treated only as sources of practical information. Here it is fitting also to consider them as experiences corresponding to the aesthetic function in human affairs.

The term 'function' needs explanation. In Western thought the concept derives from Kant's dissection of experience, whence we have the idea of the 'pure' artist, the 'pure' religious, the 'pure' politician, and all the special vocations of the modern age. To be contrasted with such specialized isolates is the relative unity of the functions of the soul elsewhere than in the modern Occident and previous to it:[34] a whole in which religious, ethical, aesthetic, and social functions were all experienced as a seamless entity and conveyed in a single system of metaphors.

Earlier men could not readily divide the unity of the functions. The men of today cannot bring them back together; for we are required to distinguish the functions by the society that has arisen upon their separation. The separation itself permits us to establish an aesthetic function for every experience. Every experience has a sense; it is rationalized; it is laden with emotion. Aesthetic behaviour is concerned with emotional states, and it marks the production of every artifact, however simple or useful it may be. Hence an aesthetic function is present in every human product, and, by extension, in all cultural behaviour.

This extension of an artistic franchise to all artifacts allows a resolution of one great difficulty. In anthropological studies aesthetic value is held to evolve by gradual articulation from the primitive unity of experience along a gradient leading to art as we understand it today. From this evolutionist point of view,

aesthetic values are lacking in primitive societies. Because all value is regarded as having biological origins, what looks like art in primitive life is believed to have been motivated by utilitarian needs, or by fear, sex, or other 'biological drives'. Especially favoured among social scientists is the theory that art derives from play impulses, and that it serves as a training activity in the struggle for existence.[35] More recently, class struggle has emerged as a dominant theme in the 'hard' materialist interpretations of ancient American societies by such scholars as J. Broda and C. Klein. Their views have the merit of introducing materialist realism at the rank of the shrewd rulers, who used myth and ritual to mystify or dominate the lower ranks of Mesoamerican societies by religious manipulations within the structure of organized states. Here again, however, the place of art is reduced, this time to propaganda for the state.

The opposing point of view is idealist. Here it is a postulate that comprehension of another being is possible only under conditions of similarity between object and subject. Hence we may not restrict the understanding of primitive persons whom we pretend to comprehend, to values only of biological significance, but we must concede them innate values of aesthetic and intellectual bearing essentially akin to our own.[36] Both primitive persons and their modern students share in aesthetic behaviour. It is a condition of psychic equilibrium between subject and object. The world is known through emotional states rather than by rational constructs. Natural phenomena are apprehended as states of feeling rather than as events outside consciousness. Unlike the evolutionist, the apriorist apprehends a nucleus of aesthetic value that is the same in all arts: always essential; always definable; always resistant to materialist reductions of its scope. He thus escapes the embarrassment of the evolutionist who, when confronted with early artifacts that look like art, must explain them as non-art.

This conception of the continuum of art can be articulated by the idea of configurations as well as by the evolutionist's conception of

stages. 'Period' rather than 'stage' is the key to the differences between artistic groupings. Cultural configurations have been charted and measured by the phenomenon of style.[37] Different configurations co-exist and succeed one another: each has its own content and its own developmental pattern.

Configurationism, however, is an incomplete and perplexing concept. It is grounded in Gestalt psychology and in structuralism. It transforms the problems into postulates, and it elevates the axioms to the rank of explanatory principles.[38] Confronted with the choice between idealist and materialist interpretations, the student of aesthetic behaviour must of necessity prefer configurationism to the arbitrary stages of evolutionist thought; for in the latter, aesthetic behaviour loses autonomy and becomes only the mechanical reflection of other processes. The difference between them justifies once again this book's preference of diachronous to synchronous discussion (p. 28).

THE PLACE OF THE ARTIST

Works of art are produced by individual persons whose unique sensibilities transform the stream of tradition. Configurations and cultural stages – which are ways of classing these products in the absence of documented artistic personalities – differ as to scale. A stylistic configuration occupies less time than an evolutionary sequence. When we are confronted with a total lack of biographical information, as in the history of ancient American art, the gaps can be closed by overlooking them, and by choosing the broadest possible chronological scale. Hence the stages of an evolutionist view of the American past provide our only scaffolding for a reconstruction of the probable position of the artist in ancient society.

A few general observations hold good regardless of stage or period. In the first place, artistic change in these societies probably resembles those slow processes of linguistic 'drift' which escape the notice of the participants, more than it resembles the self-conscious dedication to

change affected by European artists since the Renaissance. The architect, the painter, and the sculptor were given fewer occasions for invention than their modern colleagues because of small populations and because of the gigantic expenditures of time required by Stone Age technology. A clear conception of the individual as the unit in a social process was probably lacking. Each generation added its ritual obedience to the 'cake of custom' that evens out the rate of change in small and isolated societies. As these layers of tradition became more and more weighty, they exceeded the capacity of the individual to transform them.

Hence the American past seems stagnant and sluggish, with Neolithic durations altogether different from the staccato transformations of European time. In such a slowed-down temporal perspective[39] the position of the artist must have been far less distinct than we are accustomed to consider it. The occasions for artistic production were distributed more evenly through the entire society than in the specialized crafts and guilds of European civilization. Each household was a producing unit for many manufactures. Each village tended because of environmental differences towards traditional specialities like those which survive today in parts of Guatemala and Peru.

The Early Hunters

What was the artist's position among the Pleistocene hunters[40] in the final phases of continental glaciation? As in Europe, we know of bone and wood implements and pressure-flaked stones. Hides and skins were dressed; rude shelters must have been built, and a body of useful empirical knowledge had already been acquired and transmitted during hundreds of generations. Two rude works of art in America are assigned to these times: an elephant tooth from Tepexpan in the Valley of Mexico, carved as a miniature human foot;[41] and the sacrum of an extinct species of llama, carved to represent the face of a coyote, and found at Tequixquiac near Mexico City in 1870 [1].[42]

1. Camelid sacrum carved as an animal head from Tequixquiac, *c.* 10,000 B.C.
Mexico City, Museo Nacional de Antropología

The lives of such hunter-artists were exposed to unending dangers, for which the proper psychological preparation was as important as food. Ritual and magic provided this preparation. Those energies which we invest in recreation and contemplation were spent by early men upon exercises that keyed the faculties to the tension needed for successful hunting. In the round of exposure to danger, recuperation, and psychic preparation for renewed dangers, the short nomadic life of the prehistoric huntsman passed. His ritual preparation probably included rhythmic sounds and dancing. In these arts of filling time with significant action, the body itself is the material, worked by aesthetic intention into fugitive figures that leave no permanent record. Such rituals imitated the behaviour of the hunted animal, and the dancer himself reviewed his own motions, discarding wasted efforts, inventing more efficient sequences, and refining his craft by mimesis. These moments of detached mimicry, away from danger and performed in recollection, border upon aesthetic contemplation.

Early Villagers

A drier climate closed the Pleistocene epoch, when the large grass-eating animals died out

with the disappearance of pluvial vegetation. Early man then turned to small game and to the exploitation of drought-resisting plants. During these five thousand years until the emergence of urban societies before the first millennium A.D., plants and animals were domesticated and village life became the normal mode of human congregation. Among Pleistocene hunters all the forms of activity were aimed at the destruction of animals. But among early farmers the household animal is fed and the plant is tended. Man played the part of a force set over nature instead of against it.

Unlike the hunters, who wandered through a succession of virgin environments, the early villagers gradually surrounded themselves with artifacts of their own making. This accumulation of things channelled the tradition into divergent patterns. In one village bulbous water vessels of fired clay might serve as fertility symbols, while another nearby village might satisfy the same symbolic requirement with effigy vessels. Early commerce would offer the artisans further choices requiring aesthetic decisions. At the same time the increasing accumulations of man-made things formed a historical record attesting the tradition and conditioning present choices.

With the village cushioning its dwellers from the hard pressures of the environment, men could begin to explore the 'useless' items in their surroundings. This attitude of contemplative freedom opened a new domain of inventive behaviour entirely separated from the struggle to survive. Under village life the earlier rigorous selection and reduction of human temperaments to a single hunting standard was no longer necessary. The spectrum of temperaments from melancholy and phlegmatic through sanguine and choleric gradations could all survive under the easy vegetative routine of early agricultural existence.

The professional exercise of the fundamental crafts of the potter, weaver, builder, and metalsmith in turn may have reinforced the separation of the temperaments, calling upon patient and withdrawn souls for textile invention, and

upon gregarious and commanding persons for builders, and so on through the full range of village arts. The exact history of the earliest steps in any traditional craft will never be known; for we cannot learn when and where clay was first scooped into hollow shapes, or reeds were first tied together. Certainly these things were done by many men in many places. And among the first men temperamental differences of a genotypic order must have impelled them rapidly to different specializations.

Beyond a certain moment the self-sufficient isolation of the earliest villages could not continue. Artifacts create needs, and when these needs have been satisfied, any excess can be traded to neighbours. But early commerce provoked changes that ultimately wrecked the primitive autarchy of village life. With wealth, obsolescence became a problem. An artifact creates needs not only for others like it, but eventually for improved versions of itself. The producer must eliminate some of the inherited equipment, if he is to continue to make new versions. Here is one among several explanations for the elaborate funeral gifts in many early village tombs. Piety was of course the accepted motive, but a great additional advantage was gained in allowing the survivors to renew their household tools and ornaments. Village wealth was also dedicated to the temple, to the 'household of the god', much as in the ancient Mediterranean lands, as a clearing-house for all the intricate social problems of the continuing production of wealth. The result in the end was a priesthood. This new social class had a special interest in the enlargement of village society in the direction of theocracy, the priestly state.

Ideas about Amerindian cities began in the 1830s, when ancient sites were rightly regarded as having been thickly inhabited places, and after 1911 as complex social and political organizations. Under ethnographical influence after 1930, however, archaeologists assumed that the ruins had been 'ceremonial centres' occupied infrequently and only for religious purposes. Only twenty-five years later, after

1956, did Americanists begin to study occupational specialization, dynastic rulerships, and social stratification, at settlements engaged in extensive long-distance trade.[43]

The Theocracies

The effects of priestly rule upon artistic activity were radical during the first millennium A.D. The temple corporation represented a dual order of being, whereby events in this world reflect events in another world of supernatural forces, enabling the men living by the law of the temple to mark a frontier between civilization and barbarism in a new great community. It expanded by teaching and example conveyed in a new class of works of art. Hence one condition for the spread of the new order was a clear difference between early village styles and the expressions of the temple law. The new symbolic art avoided everyday secular experience, and it suggested terror or awe at first by the monstrous shapes of other-worldly forces. The earlier village art was looked upon as rustic, retarded, and devoid of learning or morality.

Gradually the stiff code of the early symbolic system softened, with the repetitive utterances of many generations, into gentler forms enriched by a renewed study of nature. In each region a different variant of this classic style took form, but the earlier tradition of household crafts yielded to the professional artist,[44] who was maintained by the community to give all his time to the production of imposing works of art. The corollary of the professional craftsman is the passive spectator. Here the cleft between works of art and 'utility wares' first opened deeply. Here also the work of art became a social tool, useful in the concentration of public power through widely shared symbols.

The Terminal Stages

Towards the end of the first millennium A.D., signs of violence, crisis, and rupture appear in the archaeological record at all the main centres of civilization. In each region the succeeding

period is characterized by the emergence of warrior aristocracies. These new states were the result of the intrusion of nomadic peoples, who succeeded in taking control from the ancient theocratic corporations.[45] The Toltec, Mixtec, and Chimu states all exemplify this replacement of theocracy by military aristocracy. The process was probably a double one. The new barbarian masters of the old societies brought with them as their own heritage many archaic traits of behaviour. On the other hand the destruction of priestly rule brought to the surface many submerged expressions of the ancient stratum of early village society, long repressed under the burden of hierarchic government. Large cities, differing from the earlier ritual concourses for dispersed farmers, became common in the period after 1200.

The simultaneous appearance of 'empires' after 1300, both in Mesoamerica and in the central Andes, is not easy to explain. Possibly they resulted from *vis a tergo*, from the compelling power of antecedent circumstances. The empire was a new society large enough to absorb the useless warfare of the petty aristocracies. It

also afforded possibilities for public works and the colonization of new lands. On the whole, warfare rather than art produced the empires.

The craftsman became more and more a professional specialist of decreasing status in a society dominated by the warrior class. His services were necessary but his rewards diminished. His loss of status and his subordination to a military class are apparent in the declining quality of the workmanship. There are important exceptions, among which Aztec sculpture is the most notable.

In review, the place of the artist in ancient America can perhaps be made clear by a simile taken from weaving. Civilization is like a cloth in progress on the loom. The various institutional functions, political, economic, and military, are like the warp strung from end to end of the projected fabric. They are made of the same fibre as the weft thread, which is like the continuous production of art, binding the warp into a strong weave with a figured pattern. In America the design at first was carried by the weft alone, but near the end it was carried more and more by the warp.

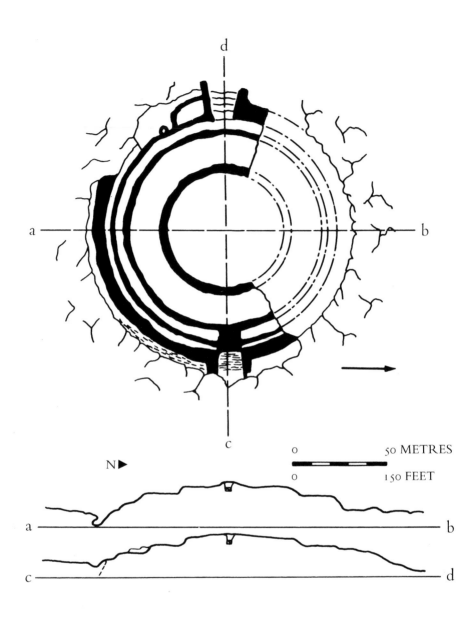

2. Cuicuilco, pyramid, after 500 B.C.
Plan and section

THE MEXICAN CIVILIZATIONS

EARLY CENTRAL MEXICO

About 2500 years ago the fertile adjoining valleys of Mexico, Puebla, Cuernavaca, and Toluca were already a metropolitan nucleus for the entire northern continent. Other regions in Oaxaca, on the southern Gulf Coast, and in Maya territory were in touch with central Mexico, giving and receiving each in its time. The dominant centre of ancient urban life eventually became the three high intermontane plateau valleys of central southern Mexico, in the quadrant bounded by Tula, Xochicalco, Cholula, and Malinalco. Both Tula and Malinalco bordered the unsettled lands of nomad tribes. Cholula marks a frontier with sedentary peoples of different traditions to the south and east. Xochicalco is an intrusive enclave of Maya and Gulf Coast styles.

Within this quadrant the ancient inhabitants, stimulated by fertile soil, by temperate climate, and by the continual renewal of population through immigration from less favoured regions, changed from nomadic big game hunting (*c.* 9000 B.C.) to life in early agricultural villages (3000–1000 B.C.). Such settlements yielded before 500 B.C. to urban societies not unlike those of ancient Mesopotamia, Egypt, Pakistan, or China.[1] Other regions of America transcended central Mexico in elaborating portions of the fabric of its civilization, but none shows a cultural record of such duration, continuity, or involvement with the rest of ancient America. From central Mexico, styles of art were carried to the south-eastern and south-western United States; to the Maya region; and

probably even to the west coast of northern South America.[2] No other region of ancient America exerted so continual or so expansive an influence upon its neighbours both near and far.

FORMATIVE: 3000–500 B.C.

An early example of monumental architecture in central Mexico is the circular platform of Cuicuilco [2] in the Pedregal, near the new University of Mexico. Its four conical stages faced with stone slabs laid in clay originally had a diameter of 135 m. (440 feet) and they rose about 20 m. (65 feet). Near the close of the pre-Classic[3] a sheet of lava enfolded the platform together with the adjoining burial grounds, which have yielded early village manufactures of pottery and clay figurines. The construction of the platform shows two campaigns: two lower stages were built with an altar on top, which was later embedded in two smaller stages. On the east-west diameter ramps and three short flights of stairs led to the uppermost platform from the west, and on the east four flights descended in a striking anticipation of later temple stairs both in Mexico and in the Maya region. Red pigment (cinnabar) on the altar suggests mortuary or sacrificial use. The circular form recurs in the Huasteca region and at Zempoala on the Gulf Coast,[4] both early and late, and again in Toltec, Tarascan, Chichimec, and Aztec sites after A.D. 1000, perhaps as an archaism and in association with the cult of Quetzalcoatl.[5]

Cuicuilco was built in the terminal stage of early village civilization in the Valley of Mexico, soon after 500 B.C. Its chronological position is given not by radiocarbon dating alone, but also by the style of the clay figurines and pottery in the associated burials. Small clay figurines representing humans, animals, and birds occur throughout Middle America, beginning in the early villages, and continuing until after the Spanish Conquest. In some western provinces the tribespeople never made any other sculpture. Valley-of-Mexico figurines are so abundant that the archaeological history of the region

3. Pottery figurine (type D 1) from Tlatilco, before 500 B.C. *New Haven, Yale University Art Gallery, Olsen Collection*

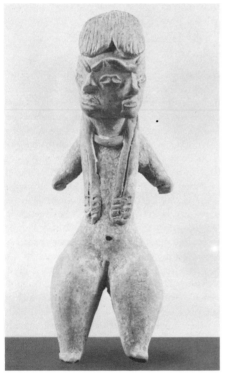

is based upon their classification [3, 19].[6] Their function is unknown, and complete specimens with bodies are rare. Seated and standing female figures predominate, usually composed of three

parts:[7] the stem (or neck); the pellet (or face) pressed upon the stem; and the frame (representing hair or a head-dress) covering the joint between stem and face. Features were added by buttons and fillets of clay, and by incision and punching. Features rendered by fillets and buttons are earlier than features rendered by modelling and incision (as at Cuicuilco). Paint added after firing, or a polished slip of fine clay, completed the figurine.[8]

The finest examples, some centuries earlier than Cuicuilco, have been uncovered at Tlatilco near Tacuba, west of Mexico City.[9] Affinities with the Olmec 'baby-face' style [70] of the southern Gulf Coast (p. 120) and with the Chavín jaguar stylizations of Peru support the conception, first advanced by H. J. Spinden, of an 'archaic continuum' in America, a name modernized as the 'inter-American formative horizon'.[10] Many Tlatilco figurines represent steatopygous women [3],[11] sometimes with two heads, or with two heads sharing three eyes, wearing flaring skirts or ornate leggings. The swollen thighs taper to pointed feet. Unlike the steatopygous figure of central Europe, the Tlatilco examples seem to dance and caper. The curves of the thigh end in tiny waists, and there are abbreviated dancers' arms, held in pirouette position.

Another example from Atlihuayán (Morelos) [4] presents a human seated in the traditional Olmec jaguar pose. He wears a feathered serpent-skin mantle with serpent jaws forming a hood bordered by serpent teeth. These elements incorporate the idea of using serpent teeth or mouths to define sacred places and persons, and they recur many generations later at Monte Alban or Mitla [114, 127] in more and more geometrized formulas.

The proto-history of Mexican painting has been reconstructed in the ceramic wares of the central zone, at the key sites of El Arbolillo, Zacatenco, and Ticoman. Vaillant[12] determined the sequence of development for pottery decoration. The red, black, and white clays of the Valley of Mexico were tempered with crystalline sand and slipped with a wash of the same

clay as the paste. Composite rather than simple vessel forms were favoured at all times. Controlled firing allowed the preparation of black, white, red, and orange wares. The decorative experiments followed one another roughly as follows. (1) Incision before firing, in geometric style on black-ware. White paint designs on red slip (abandoned in 2). (2) Grooving, increased range of paint colours, red designs painted on white slips. (3) Incision with cursive forms after firing. Incised outlines surrounding painted areas. Red and white paint

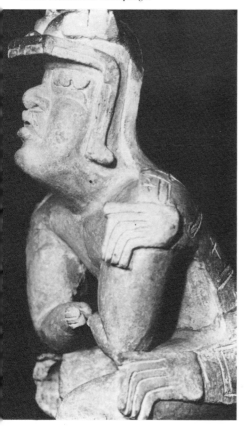

4. Pottery figurine of human seated in jaguar pose, wearing a serpent-headed cloak, from Atlihuayán (Morelos). *Mexico City, Museo Nacional de Antropología*

on yellow ground. (4) Negative painting, by a lost-wax method related to textile technology. Stucco finish applied after firing and painted.[13] Pottery masks and timbrels or tambourines are known as well as stamps for body-painting in animal and geometric designs. Whistles of fired clay are also common in the pre-Classic age. Small mirrors of hematite found at Tlatilco resemble those of coastal Olmec sites. Turquoise mosaic plaques are known from El Arbolillo and Tlatilco.

TEOTIHUACÁN: 100 B.C. – A.D. 750

Teotihuacán [5],[14] Cholula, and Xochicalco, each with its own traditions and affiliations, were the principal urban centres of the Classic epoch. Xochicalco [25–7] was in many respects a transplantation from Classic Maya civilization of a later epoch than Teotihuacán. Cholula, on the other hand, has had the longest continuous history of any central Mexican site, flourishing from Formative times without interruption to the present, and appearing during the Classic era [13] as a concourse rivalling Teotihuacán.

The discovery of architecture in the Teotihuacán style at Kaminaljuyú [6B, 271] in the Guatemala highlands,[15] associated with Maya remains of Early Classic date, and dated by radiocarbon before A.D. 500, justifies treating Teotihuacán proper as the dominant Middle American site of the first half of the Classic era. Xochicalco [25–7], because of its stylistic resemblances to such lowland sites as Uaxactún, Tajín, and Piedras Negras, reverses the relationship between central Mexico and the Classic Maya region in favour of a possible lowland Maya ascendancy at Xochicalco c. A.D. 500–900.

The structural traits that distinguish Teotihuacán from Formative building are the use of burnt-lime plaster and the cantilevered panels jutting out from the inclined talus at the platform base [9]. In formal organization, the Teotihuacán style differs from previous architecture by grandiloquent proportions using straight axes and rectangular platforms.

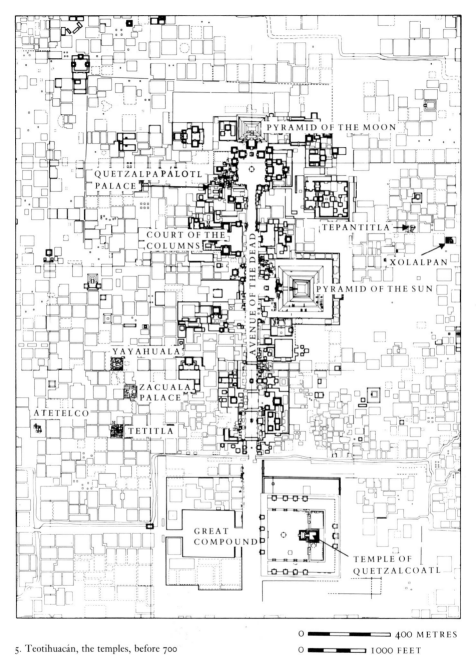

PYRAMID OF THE MOON

QUETZALPAPALOTL
PALACE

TEPANTITLA

COURT OF THE
COLUMNS

XOLALPAN

AVENUE OF THE DEAD

PYRAMID OF THE SUN

YAYAHUALA

ZACUALA
PALACE

ATETELCO

TETITLA

GREAT
COMPOUND

TEMPLE OF
QUETZALCOATL

5. Teotihuacán, the temples, before 700

0 ⬛⬛⬛⬛⬛⬜⬜⬜⬜ 400 METRES

0 ⬛⬛⬛⬛⬜⬜⬜ 1000 FEET

Chronology

The history of Teotihuacán, though fixed neither at the beginning nor at the end, when great fires burned out the timbers and glazed the clay walls, can be divided into early, middle, and late stages.[16] The early stage (I) includes the beginning of the pyramids. Their completion (II) occurred from the first to third centuries A.D. Then, *c*. 400–700, the outlying suburbs were built (III). The destruction by fire and abandonment may be dated before 700. The transplanted settlements (IV) on the west shore of Lake Texcoco flourished thereafter.

The eastern or Sun Pyramid [5] is the largest and oldest structure at Teotihuacán. It stands over a natural cave ending in a four-leaf-clover chamber near the centre of the pyramid, discovered in 1971 by Jorge Acosta, and described by Doris Heyden.[17] Like the circular platform at Cuicuilco, it is made of horizontal layers of clay faced with unshaped stones. All the sherds and figurines in its fill are of Late Formative dates. Like many later central Mexican platforms, the eastern pyramid faces 15 degrees 30 minutes north of west, so that the

sun sets on axis with the edifice upon the day of zenith passage.[18] The Sun Pyramid governs the axial arrangement of all other buildings at the site. For several centuries early in its history Teotihuacán probably consisted mainly of this pyramid and a few adjoining platforms.

Later on the site was enlarged by the addition of the Moon Pyramid [6A], north of the older structure, and the south pyramid ('Temple of Quetzalcoatl'). These two edifices were built by a new and more stable method of construction used before *c*. A.D. 300. The core is made of piers built of slabs of tufa (*tepetate*), with shafts left between the piers, into which loose earth and rock were dumped [9]. On the terraces, fin walls held the sloping talus in place. After the lattice skeleton of piers and fin walls had been built, the filling out of the mass with unshaped earth proceeded more rapidly than by the earlier method of layered accumulation.

These three principal pyramids define the Miccaotli ('Road of the Dead') as a north-south roadway, 40 m. (130 feet) wide and about a mile and a half long, lined on both sides by hundreds of small platforms and by clusters or files of chambered buildings. At least two older levels of construction underlie the present top layer of

6 (A). Teotihuacán, Pyramid of the Moon, before 200.
Perspective diagram; (B) Kaminaljuyú, Mound B4, after 400.
Perspective diagram

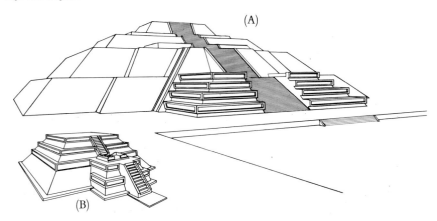

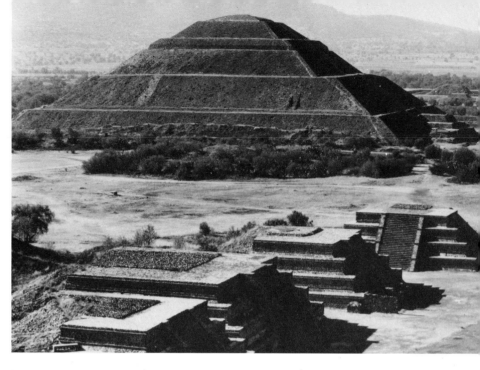

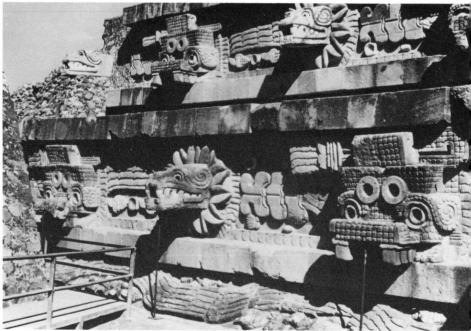

7 (*opposite, above*). Teotihuacán, Ciudadela court, before 600. From the south

8 (*opposite, below*). Teotihuacán, Ciudadela, inner face of the central pyramid, before 300

9 (*below*). Teotihuacán, Ciudadela, inner core of the central platform, before 300.
Diagram of assembly and section of tablero

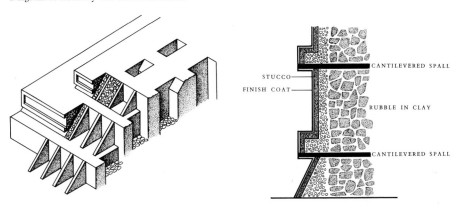

ruined edifices. Their depth is greatest at the south, so that the site, which gradually drops 100 feet, is today much flatter than it was at the beginning of construction.

The later phases of the architectural history of Teotihuacán include two principal types of construction. The first consists of dwellings arranged upon platforms to surround square or rectangular depressed courtyards in a modular grid based upon a unit of about 57 m. (190 feet).[19] The second has many ceremonial platforms of low elevation and great extent, with the customary talus-and-tablero profiles, but devoid of the sculptural decoration that characterized the middle period. The principal example is the Ciudadela – a hollow-rectangle platform surrounding the southern pyramid [7–9].[20] This older edifice was encased in an outer shell of austere talus-and-tablero profiles, completely concealing the older sculpture [8]. Both the dwellings and the talus-and-tablero platforms were stuccoed and painted with figures.

Thus the early period was marked by gigantic construction; before A.D. 300 great sculptural

friezes, as at the citadel, were carved; and the centuries before 700 saw the triumph of mural painting. Painted exterior walls had been common since the earliest centuries at Teotihuacán, when decoration was confined to geometric meanders, bands, and chequerboards in red, yellow, grey, and green, often applied *al fresco* to the wet plaster. In the middle period, ideographic signs and large forms representing water, seashells, and marine plants were painted in colours on dry plaster with black outlines. In the last period, scenes were painted with many small personages, with roads, buildings, animals, and symbolic conventions for speech or song, as well as for religious sacrifices and for the other world [22–4].[21]

In other words, each successive century at Teotihuacán witnessed a more and more prodigal consumption of burnt-lime products for cement-like floors, stuccoed walls, and the finely plastered surfaces required for mural painting. The technique of burning limestone was probably introduced from Yucatán and Guatemala, where calcareous rocks and tropical

woods abounded.[22] In Mexico the burning of the forest cover for lime certainly contributed to the desiccation of the climate.[23] The paintings describe the joys of water with a prolixity born of anxiety. The abandonment of the site before A.D. 750 was final. No great centre of civilization arose again in its neighbourhood, for its ecological ruin was probably irreversible as early as A.D. 500–600, and today the countryside around Teotihuacán supports only a fraction of the great populations that erected the pyramids.

During its early history, Teotihuacán was less a city than a ceremonial centre for the periodic rituals of an agrarian calendar. The pyramids were built and used by farmers from widely dispersed villages.[24] For centuries there were few habitations at the ritual centre itself.[25] Eventually the priesthoods, as custodians and as masters of the ritual, assumed power. The wall paintings at Atetelco, Tetitla, Tepantitla, Zacuala, and Teopancaxco, and among the dwellings in the ritual centre itself, mirror the power and affluence of a theocratic caste, who governed the scattered farming communities by means of calendrical rituals, and who probably became more and more numerous (estimated by Millon in 1966 as 85,000 in A.D. 450–650) as the environment was impoverished by deforestation. Their rise to power is reflected, as elsewhere in ancient America, by the chambered dwellings which replaced the great pyramids in the building programme.

Architecture

Our conception of architecture has been dominated for so long by the need for shelter, that we lack the sense of building as monumental form apart from shelter. As monumental form, architecture commemorates a valuable experience, distinguishing one space from others in an ample and durable edifice. It is not necessary to enclose rooms: it suffices, as in ancient America, to mark out a space by solid masses, or to inscribe the space with a system of lines and shapes. The fundamental modes of monumental architecture are therefore the

precinct, the cairn, the path, and the hut. The precinct marks a memorable area; the cairn makes it visible from afar to many; the path signals a direction; and the hut shelters a sacred portion. From precinct to stadium is one typological series; from hut to cathedral, path to arcaded boulevard, and cairn to pyramid are others. The combinations of cairn, precinct, path, and hut yield all the possibilities of monumental form, not in terms of the solids alone, but also in terms of the space bathing the solids. The architects of ancient America were far more attentive to the spaces engendered among the elements than their European contemporaries, and they excelled all peoples in the composition of large and rhythmically ordered open volumes. Teotihuacán is the most regular and the largest of all ancient American ritual centres, with a coherent composition ordering the elements in a central area $2\frac{1}{2}$ km ($1\frac{1}{2}$ miles) long by 1 km (about $\frac{1}{2}$ mile) in width [5]. Tikal and Chichén Itza, the next in size, are less than half as big.[26]

A principal and original function of Teotihuacán was as a geomantic position to observe the relation of the earth to the sun, by the annual zenith setting (21 June) on axis with the largest pyramid. The orderly distribution of hundreds of smaller platforms along a roadway determined by the eastern or Sun Pyramid therefore obeys relationships of a cosmic order, and the spatial arrangement reflects the rhythm of the universe. The main axis of the principal pyramid intersects the roadway; a smaller pyramid blocks the north end of the road; and the south end has no monumental definition. The road ends without a destination. Thus the roadway connected nothing: it afforded axial order, without leading from one place to another. Each unit along the roadway is connected with the universe more than with its neighbours: the south court and the east pyramid face the setting sun; the north pyramid is alone in its direct axial position on the roadway [10].[27]

This isolation of the groups, apart from their common cosmic orientation, is stressed by the precincts surrounding each major unit. The

necessary counterpart to the pyramid in open-volume composition is the precinct boundary, which defines scope, while the pyramid marks importance. The principal pyramids of Teotihuacán were built smaller as time passed: their precinct boundaries, however, became more imposing [5]. At the east pyramid, a low U-shaped platform, open to the west, defines a moat-like enclosure at the base of the great square pyramid. The north pyramid is symmetrically flanked by two triangular groups of platforms on a cross-axis about half a mile long. The north precinct is further defined by a square courtyard formed of twenty-two platforms. The south pyramid, finally, occupies a closed oblong formed by a continuous primary platform [7], bearing fifteen square secondary platforms spaced about 80 feet apart. The oblong precinct (inner dimensions 270 by 235 m.; 295 by 255 yards) has a shallow rear court behind the pyramid, containing house groups. The front court (235 by 195 m.; 255 by 215 yards) was probably used for rituals of a calendrical nature.[28] Its west side, entered by a stairway 30 m. (100 feet) wide, is lower than the north and south sides, where the primary platform is twice the height of the western platform.

The design is one of the most impressive open-volume compositions in the entire history of architecture. On this gigantic scale, the relation of all parts is clearly evident, and each member, though not immense, plays its full role in the concert of forms. The grandeur of the south court arises from its proportions and from the economy of its components, which vary only enough, as in the doubling of the north and south platforms, to animate the design, without obscuring its fundamental simplicity.

The whole assembly, with completely open approaches from all sides, lacks any trace of military defences. The precinct platforms surrounding the eastern and southern pyramids are non-military, serving ritual rather than defensive needs.

10. Teotihuacán, northern ('Moon') pyramid and plaza, before 200. From the south

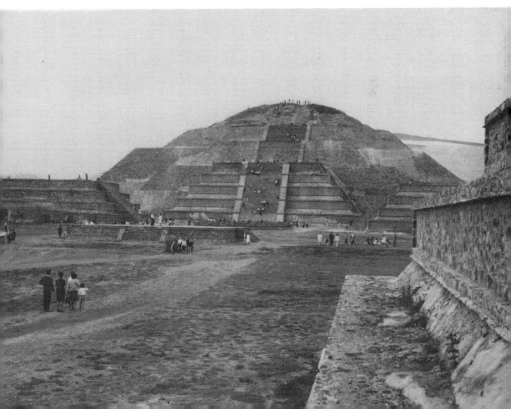

The dwellings of Classic date scattered throughout the region also lack defensive arrangements. The group at Atetelco (or La Presa), south-west of the pyramids, is typical: surrounding a sunken oblong courtyard four stairways rise each to an edifice with a colonnaded porch of two piers [11]. At the open angles of this cruciform system small inner courts are formed, each flanked on two sides by second flights of stairs and by other prostyle chambers.

11. Atetelco, near Teotihuacán, dwelling group, c. 500. Plan and elevation

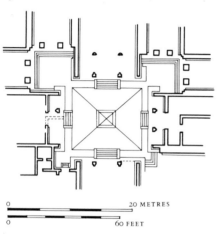

```
0                    20 METRES
0                    60 FEET
```

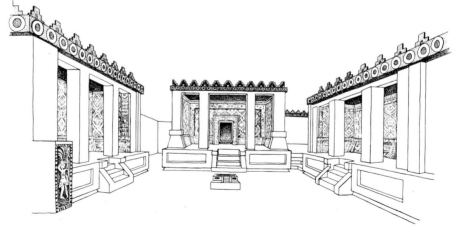

Among the latest buildings at Teotihuacán is the enclosed courtyard, resembling a medieval cloister, called the Quetzalpapálotl palace [12]. It has reliefs on the piers representing the owl of warfare and the quetzal. As an enclosed court, unlike the open-cornered residential yards of the Mesoamerican tradition, it may prefigure the warrior societies of the Toltec era at Tula and finally in Aztec life.[29]

The temple platforms and the dwelling platforms use the same vocabulary of architectural forms. The differences between the two are differences of size and number more than of type. To account for this type, we need first to consider the nature of the solid platform in ancient American use. As in Mesopotamia and the Nile valley, where the first village civilizations arose on earthen platforms in the swampy floodplains, some early central Mexican villages stood upon artificial mounds (tlateles) laboriously built in shallow lake waters, of which modern survivals (chinampas) are still in use at Xochimilco.[30] Cuicuilco, Teotihuacán, and Tenochtitlán all inherited this ancient mode of securing dry footing by building a mound among the fertile shallow waters at the edge of a lake or in the flood-plains of a river. Every ancient building, whether domestic or religious, stands upon a platform of solid earth or masonry. Even on hilltop sites such as Monte

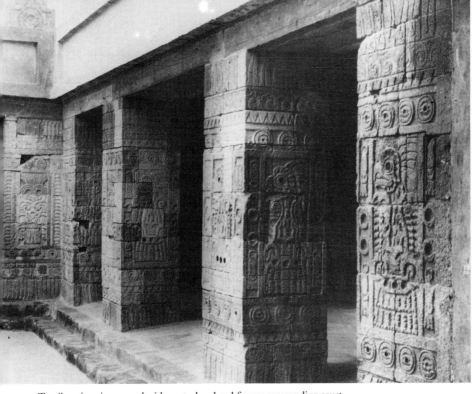

12. Teotihuacán, piers carved with quetzal and owl figures surrounding court
of Quetzalpapálotl building, before 700

Alban or Xochicalco, where the danger of flood-
ing was not even a memory, the ancient com-
pulsion to build a pedestal continued in full
strength.

At Teotihuacán and related sites,[31] the plat-
forms usually have a sloping component, here
called the talus, at the base of the platform [9].
Cantilevered on stone slabs from the sloping
talus face, a vertical panel, called the tablero, is
framed by rectangular mouldings. Frequently
the rear planes of both the tablero and the talus
are decorated with sculpture or painting. The
effect is that of a box hung upon a pyramid. The
sloping talus is always shadowed by the tablero.
From a distance, the tablero appears to float
upon a cushion of shadow. The form is an un-
stable one, and when the cantilevering collapses
the tableros crumble. The larger the tablero, the

more unstable it is. The modern drawings of the
Pyramids of the Sun and Moon, which show
giant tableros, are improbable reconstructions.

Indeed, the tablero profile may have been
invented only in the middle period of
Teotihuacán history (II), when the building of
the great pyramids, which are like continuations
of archaic architecture, had ceased. This
hypothesis is supported by the appearance of
tablero profiles on the topmost stages of the
archaic platform begun c. 200 B.C. within the
main pyramid at Cholula'[13 at D]. One Cholula
variant of the Teotihuacán form adds a concave-
ly curved talus and an extra inner moulding to
the tablero frame. This scheme appears in the
recent excavations at the Court of the Altars
[14, 15] adjoining the south flank of the 'hand-
made hill' (Tlachihualtepetl in Náhuatl). Here

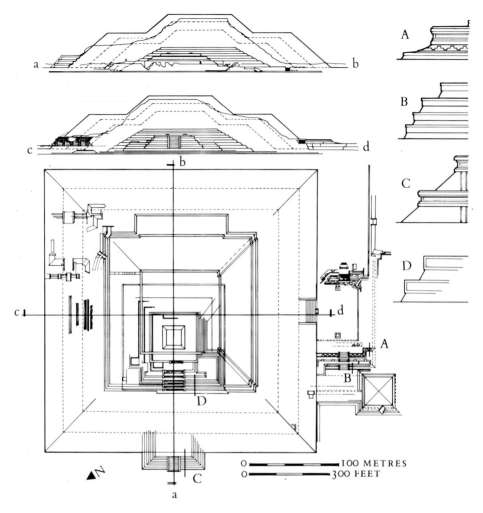

13. Cholula, main pyramid, c. 900.
Sections, plan, and tablero profiles of nucleus

three large slabs carved with Tajín scrolls form the centres of interest, surrounded on all sides by terraced platforms with the curved and step-fretted talus, which also may be related to the architectural ornament of the Gulf Coast peoples [cf. 93]. The curved talus profile is apparently a local trait, and it appears in several of the successive rebuildings of the Court terraces. At the west approach the tablero is clearly a Classic addition in Teotihuacán style to an early pyramid of rectangular plan facing the zenith setting of the sun. The next campaigns of enlargement at Cholula used terraces of Tajín and Toltec profiles [13 at B].[32]

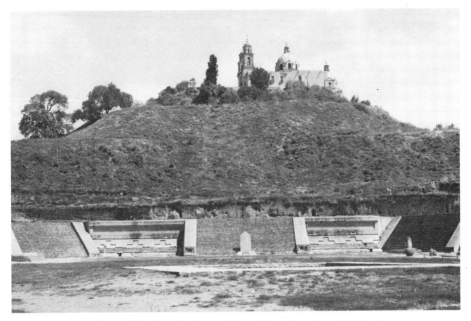

14 and 15. Cholula, Court of the Altars, before 200. General view from the south (*above*)
and detail of talus and tablero (*below*)

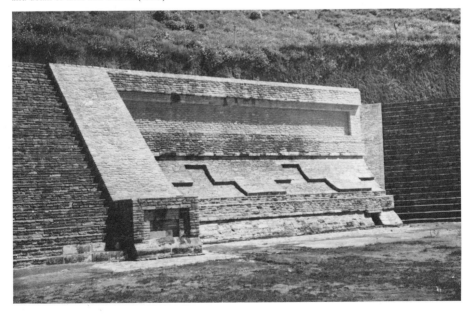

Sculpture

Metal tools did not enter Middle America until long after the destruction and abandonment of Teotihuacán. The retarded technological character of American Indian civilization is doubly meaningful. The small populations[33] and the slow rate of change were conditioned by insignificant reserves of food for livestock, and by the lack of energy-saving inventions, such as wheels and draught animals. No trace of wheeled vehicles appears until after the Classic period, and then only in pottery toys,[34] and there were no beasts of burden at any time until the Spanish Conquest. On the other hand, the American peoples of antiquity explored and developed the ultimate possibilities of Stone Age technology. The mechanical learning of American Indians before A.D. 1000 is like that of Neolithic peoples on other continents. But the great difference is in the aesthetic quality of their achievements. American Indian sculpture, worked by Stone Age methods, is frequently of such formal and expressive complexity as to belong among outstanding works of world art.

The techniques of stone-working were unchanged even by the introduction of metals after 1000. The tools were of stone and bone, used to fracture, crumble, abrade, incise, and pierce. At the quarry the outcrop was channelled and undercut with stone picks, mauls, celts, and hammers until wedges could be driven into the channels to break the block loose. Percussion fracture by hammering stone upon stone yielded the blank forms, followed by pressure fracture with tools of bone or horn, to secure detailed form by flaking the surface in small chips and splinters. The final finish was given by abrasion, with water and sand in scraping, grinding, sawing, and drilling operations. The saws were of stone, wood, bone, fibre, or rawhide. Tubular drills were made of bird-bones: such a drill, broken, was found in an onyx slab of Classic style from the Valley of Mexico.[35] The work of hollowing eyes or mouths was done by close-set drilling with tubular bits. The cores were then broken off and the cavity smoothed.

Teotihuacán sculpture divides by function into three categories: architectural elements, funerary masks, and household figurines. The largest known example of figural sculpture was probably an architectural support: it is the colossal water deity of basaltic lava [16], standing 3.19 m. (10½ feet) high, and found in the courtyard at the foot of the north pyramid.[36] Its pier-like forms suggest use as a caryatid, to support a wooden-beamed roof of the trabeated type common throughout Teotihuacán. The profiles approach cubical forms, and the body parts are all rendered in orthogonal projections upon the front plane, as in an engineer's drawing of the human figure. This technique of rendering is similar to that of the murals showing frontal ceremonial figures, such as the Tetitla panel of rain figures.[37] The water deity is generally thought to be an extremely early example of the Teotihuacán style,[38] although its association with the Pyramid of the Moon should fix its date about the middle phase of the Classic period. The pectoral cavity for the insertion of a stone symbolic of the heart is an early Mexican example of this convention.[39] The identification as a water deity (Aztec 'Chalchiuhtlicue') is supported only by the meander hems of the skirt and cape, which bear a repeating scroll that signifies liquid in the murals and vase-paintings. The oval-rimmed eyes and the protuberant mouth invite comparison with a smaller statue in the Philadelphia Museum of Art.[40] Of a similar arbitrary reduction to geometric form is an alabaster jaguar vessel (British Museum). On the sprawling animal's forepaws there is a glyph-form; the mane of the cat is likewise stylized into a serrated glyph-like form, and the muzzle is reduced to a linear glyphic convention, [17].

These figures both reflect a major tendency of this era in the archaeological history of central Mexico: to define and diffuse conventional forms that approach the status of a written system. That such a system was being elaborated

16. Water deity, colossal basalt figure from Teotihuacán, Period II, before 300. *Mexico City, Museo Nacional de Antropología*

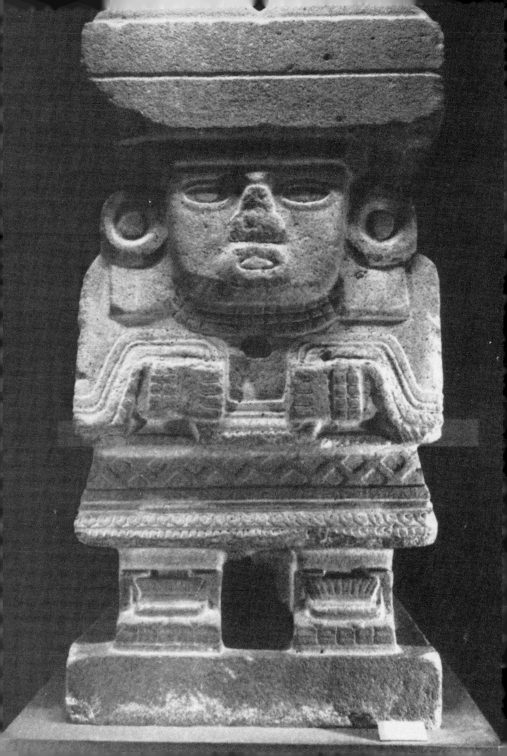

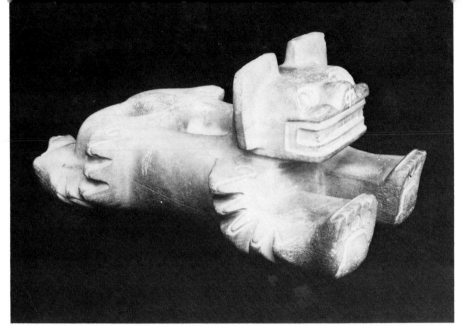

17. Stone jaguar-vessel from the foot of the Pyramid of the Sun at Teotihuacán, Period II, before 300(?). *London, British Museum*

cannot be doubted, but it was much less complete and more tentative than Maya writing of the same period. Art and writing at Teotihuacán were still enmeshed in one another [21]. The glyph-forms repeatedly approach being works of art, and their coherence as written communication is dubious. In respect to sculpture, the semantic limitation, which reduces plastic form to ideographic conventions without much freedom of choice for the designer, adds to the technical limitation of Neolithic methods of work. The sculptor's tools limited his effects, and his language of conventional signs likewise restricted the choices open to him, since he was obliged to make communications which in literate societies are carried much more economically by the written word.

The funerary masks of pottery and of semi-precious stone are thin slabs with marginal perforations for suspension on the outside of a mummy bundle [18].[41] The eyes and mouth were encrusted with coloured materials, and the facial planes also were painted or encrusted with

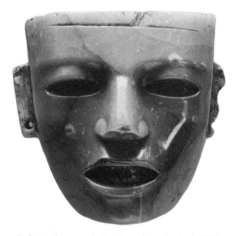

18. Stone face panel, Teotihuacán style, Period III, before 550. *Florence, Officina Pietre Dure*

geometric designs relating to the status of the dead wearer. Clay examples, painted with bright earth colours after firing, have been excavated at Teotihuacán.[42] The masks of fine

stone (basalt, onyx, jadeite, obsidian) are such obvious works of art that all have been eagerly collected. The origin and the archaeological associations of these museum pieces are usually unknown. They command high prices, and there has long been an illicit trade in them, with many falsifications reaching the market. Their origin is usually given as central, southern, or eastern Mexico. The type is of indubitable Teotihuacán origin. Metropolitan and provincial styles of manufacture can be distinguished. As with funeral sculpture in general, the type probably changed more slowly than the forms associated with everyday life. The masks of Teotihuacán origin differ from those of later periods by the abstract ear flanges and the squarish proportions of the face, with chin and forehead boundaries treated as flat, parallel planes. This geometric conception of the human face is dictated by the technique of working the stone. The eyes, the nose, and the mouth are defined by six fundamental saw-cuts. One horizontal cut marks the parted lips. Two converging cuts define the triangle of nose and mouth. Two more horizontal cuts mark out each of the eyes. No example can be exactly dated, but a clear progression towards fleshy modelling, from more linear early features, can be noted. The geometric refinement of the proportions and the avoidance of portrait recall Greek archaic sculpture.

The clay figurines of Teotihuacán [19] are surely the popular background for the aristocratic and impersonal art of the funerary masks. Both emerge from the millennial background of early village figurines. Caso believes the figurines were ancestor images, venerated in each household. Others hold that they were images of the gods and symbols of fertility, put in the earth to ensure each year's crop. The earliest Teotihuacán figurines (I) are like those of Cuicuilco and Ticoman, triangular pinches of clay with coffee-bean eyes and incised mouths. They occur in the filling of the Sun Pyramid, coming probably from early village sites obliterated by the great ritual centre. In the next type (II), the squarish and flattened head shapes of the funerary masks make their first appearance.

The middle period (III) shows a technical change. Hand-made figurines were replaced by moulded heads of a few standard types, with delicately modelled features. One type is bald;[43] the others have more or less ornate hair-styles or tufted or conical shapes. The technical change probably coincided in time roughly with the new pillar-and-shaft system in the pyramids [9], with the appearance of the talus-and-panel profile for platforms, and the ample groups of dwellings like Zacuala surrounding the ritual centre [11]. The final phases of Teotihuacán figurines (IV and V) probably post-date the

19. Pottery figurines from Teotihuacán, Periods I–V, c. 300 B.C.–A.D. 700 (different scales). New York, American Museum of Natural History

I II III IV V

destruction of Teotihuacán proper; for these ornate and jointed specimens with elaborate costumes and complicated postures come also from Atzcapotzalco and San Miguel Amantla on the west side of Lake Texcoco.

Certain habits of expression, peculiar to work in clay, were dominant in sculpture of the middle period. The reliefs of the terraces of the southern pyramid ('Quetzalcoatl') clearly show the technical primacy of fictile art, especially when these ductile forms are contrasted with the quarry-block shapes of the colossal water deity. The southern pyramid was originally square in plan, with six stages rising to a burial platform. This probably bore a temple with stone walls and wood-and-thatch roofing. Only the central portions of four terraces flanking the west stair[44] have survived, by having been covered over in an enlargement of the third period, when the talus-and-panel terraces were painted red.

Middle-period relief sculpture was of finely fitted stone veneer [8]. Over the veneer, painted plaster masked the joints. In the talus of each stage, low relief and feathered serpent forms face inward towards the stairs, with carved conch and pecten shells suggesting a watery environment in the undulant loops. Above the talus, a larger undulant and feathered rattlesnake occupies the tablero. Here, too, seashells are strewn over the rear plane. At three-metre (ten-foot) intervals large stone heads project at right angles from the tablero.[45] The effect of carved clay decorations, as of terracotta revetments, is striking. The heads are of two kinds: a geometric head of cubical forms, perhaps a rain spirit (Tlaloc in the much later Aztec cosmology); and a feathered serpent. Their alternation upon the undulant serpent relief corresponds to the heraldic composition of Early Classic painting, both in the murals and in vase-painting.

Painting

The exact chronological sequence of individual murals[46] is uncertain, but the assumption is warranted that painted wall decoration began early in the Classic period with geometric designs and banded schemes.

Recent discoveries at Cholula [20] require discussion here because of their style, related to the scenic murals at Teotihuacán [22–4], and their date in Period II, before 300. The paintings, in red, ochre, black, and blue, adorn a terraced platform facing east, and flanking a buried central stairway. The paintings are in registers one above another in fragments totalling 32 m. (105 feet) long, and comprising

20. Cholula, inner pyramid, detail of wall painting of drinkers, c. 200

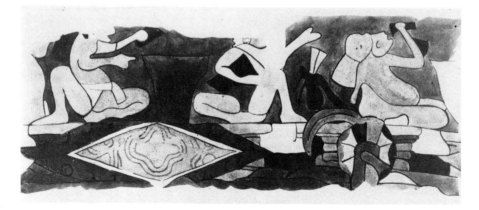

scenes of seated and reclining drinkers being served beakers of pulque on patterned floor-lines. The drinkers are shown in abandoned postures; some wear animal heads, and many seem drunk. Differences in execution suggest the inebriation of the painter; one figure vomits, another defecates, but no sex is shown, although the drinkers are both men and women. Servants, a dog, and possibly a bee appear among the drinkers.

In Late Classic times, heraldic friezes of repeating glyph-like forms became common, as well as processional files of profile figures engaged in ritual activities. During the same period, many conventions of landscape painting became fixed. In outlying sites large wall-paintings with ritually symbolic subject-matter and landscape scenes were the preferred mode of expression. Pottery painting, within obvious limitations, followed roughly the same pattern of development, without, however, attempting the elaborate landscape scenes of the late period.

Demonstrably early are the murals painted upon a buried platform north-west of the little stream that separates the south pyramid from the other edifices. This platform belongs to a lower level, anciently filled and used as a foundation for the upper buildings. To these circumstances we owe the preservation of the painted surfaces. The tablero frame is painted with roundels representing green stones on a red ground. The tablero itself is painted with inter-laced volutes like those of Classic Veracruz sculpture.[47] An upper panel has heraldic repeating trifid pendants, probably represent-ing nose-ornaments. This system of repeating symbols recurs at the south pyramid in the relief sculpture. It derives from the carved and pain-ted decoration of coeval pottery, on cylindrical tripod shapes [21], where these repetitions were governed by the difficulty of seeing all the surface at once. The painter repeated the form often enough to be sure that the whole form would be visible from any angle of view.

Similarly related to pottery decoration are the murals of Teopancaxco, a suburb of Teoti-huacán. One altar is painted with costumed

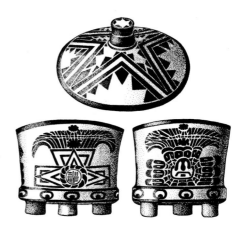

21. Cylindrical tripod vessel, Teotihuacán style, after 300

priests in profile with flowered speech-scrolls, symmetrically advancing upon a sun-like disk. These compositions of confronted figures also occur in paint applied after firing[48] on cylin-drical tripod pottery.

At Tetitla, a suburb south-west of the ritual centre, a painted tablero framed by interlaced serpents contains frontal repeating rain-god figures, from whose outstretched hands flow streams of water in which various ideographs float. Another tablero displays jaguar and coyote figures in profile, as if upon the cylin-drical walls of a pottery vessel, in a wide frame of interlacing jaguar and coyote legs.

By type, the earliest known landscape paint-ing is the sacrificial scene from the 'Temple of Agriculture' near the north pyramid, discovered in 1884 and known only by a copy of that time [22]. A watery foreground in two scalloped zones of waves stretches across the bottom. The picture space closes at both sides with identical pyre-like forms, surrounded by scrolls of smoke and flame, heaped in front of colossal pier-statues similar to the water deity described above. Between the statues, three uneven regis-ters of small human figures mark the planes of landscape space in a conceptual perspective like that of Egyptian painting. The figures bear

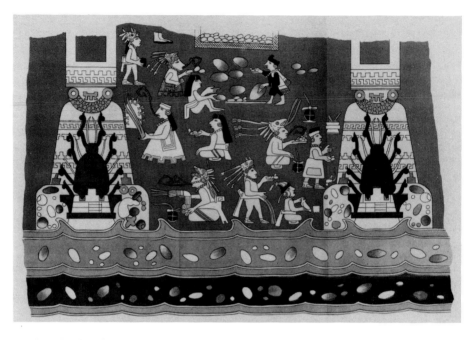

22 (*above*). Teotihuacán, wall painting from the 'Temple of Agriculture',
Period II, before 300(?)

23 and 24 (*opposite*). Tepantitla (Teotihuacán), wall painting, Period IV, before 700,
restoration in the Museo Nacional de Antropología, Mexico City (*above*), and detail of lower wall

offerings. Some kneel or sit, others walk, and
three priest-like figures in rich costumes and
with animal head-dresses have scrolls of speech
or song issuing from their mouths.[49]

Of much freer and more animated com-
position is the mural, presumably later, at
Tepantitla, east of the principal pyramid. The
wall has two registers. In the upper half a water
image, flanked by confronted priests, is the cleft
source for two wavy floods filled with star-fish,
jelly-fish, frogs, and seashells. A frame of inter-
weaving serpent forms separates the more con-
ventional upper register from the animated
landscape below [23, 24]. From a mountain
source two rivers emerge to flow in opposite
directions through verdant fields to tree-
bordered lakes. The space above this scene is
filled with surging and dancing figurines,

among butterflies and flowering trees. Caso
interprets the scene as the souls of the blessed
in the land of the Aztec rain god (Tlalocan).[50]
The body movements are like those of the clay
figurines of Teotihuacán III style. The linear
conventions mingle direct observation with
abstract ideographic signs. In the river-source,
for instance, a figure is swimming in childish
animation among the traditional serpent-body
signs for flowing water.

The crowded symbolism of the art of
Teotihuacán[51] bears many resemblances to the
metaphorical system of the Nazca people of the
south Andean coast (p. 426). It also contains
about fifteen signs recurring often enough to
suggest glyph-like use. They differ, however,
from Maya glyphs by their rarity and isolation.
Maya glyphs appear in long sequences to make

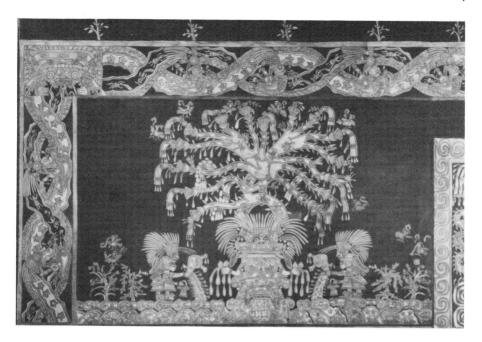

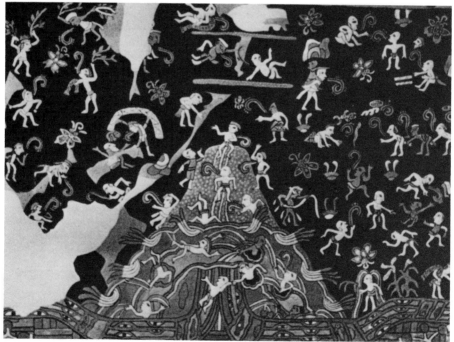

statements of complex and indecipherable meaning. At Teotihuacán, two or three signs at most combine in ornamental bands or friezes. Certain signs seem to stand for cult objects. Many signs are costume elements. Probably the entire 'writing' of Teotihuacán consists of names, time-markers, astral signs, directional symbols, and a few bar-and-dot numerals.[52]

The study of these glyph-like forms has been rewarding in respect of chronological relations with other civilizations.[53] With Classic Maya art, Teotihuacán shares a trapezoid sign interlaced with a triangle; it reappears in Mixtec manuscripts as a sign for the solar year. Other Maya forms are the long-nosed upper jaw of a serpent head, and a human head framed by serpent jaws. With Classic Zapotec art, Teotihuacán has in common a treble scroll, a trilobed drop, and a mountain sign [21]. The Classic Veracruz style of the Gulf Coast shares with Teotihuacán the figure of a fat god; angular scrollwork; smiling figurines; and head-dresses inscribed with signs.

The water-deity heads wearing goggles are divided by Pasztory into types A (jaguar attributes) and B (plant or crocodile attributes), of which A is identified with war and sacrifice, and B with earth and water. The netted jaguar forms are connected to a sacrificial warrior cult. Certain among the goggled figures wear tasselled headdresses which have been thought to identify the 'ruling establishment or the bureaucracy of the Teotihuacán state', both at home and abroad, according to Clara Millon. The 'tassels', however, also may represent mountains in some contexts, where they may be stylizations both of cloud-wrapped mountains and of the butterfly symbols of the soul after death, seen at Tepantitla [24]. Thus the butterfly may reappear in the tablero motif as well as in a geometrical stylization as a nose-ornament and as being the feet of certain cylindrical tripod vessels, all as part of a central metaphor of death and resurrection.[54]

The iconographic system at Teotihuacán allows a few inferences about intrinsic meaning. Representations of aggressive behaviour are absent until near the end. Early signs represent flowers, water, mountains, and other items of peaceful agrarian experience. The figurines are devoid of individuality. The masks conform to a tranquil and opaque ideal of generalized beauty. The art of Teotihuacán is impersonal, relying for expression only upon the animated aspects of a benevolent and watery nature. It is altogether lacking in direct erotic symbolism. The images of flowers, of twining strands of water, and the song and speech scrolls of flowered contour all bespeak a peaceful and poetic worship of nature, through which there runs a strong current of anxiety concerning flood and drought, conveyed by the insistent references to water.

XOCHICALCO

Xochicalco, south-west of Cuernavaca, rose to importance about the time of the abandonment of Teotihuacán. If it obstructed trade to the south, as suggested by Litvak, it was a rival to Teotihuacán, like Cholula and Tajin. It is a hilltop ritual centre related to Veracruz and Classic Maya architecture,[55] specifically to Piedras Negras. The ceramic chronology shows early settlement, with archaic pottery of a type encountered throughout southern and eastern Mexico, as well as in the southern and central Maya districts.[56] Relationships with the Valley of Mexico are surprisingly few. From the pottery it seems that Xochicalco was the north-western frontier outpost for a Maya cultural tradition, with historical antecedents and of a geographical spread altogether unlike Teotihuacán. The most likely avenue of communication with the Maya territory was through the state of Guerrero and along the Gulf coast.

The people of Xochicalco and its vicinity probably made important contributions to the formation of Toltec civilization in the ninth and tenth centuries A.D. The site was fortified,[57] but the excavations brought forth no weapons. The hilltop contours were levelled and terraced to form a fairly regular network of platforms, courtyards, and esplanades [25]. The main

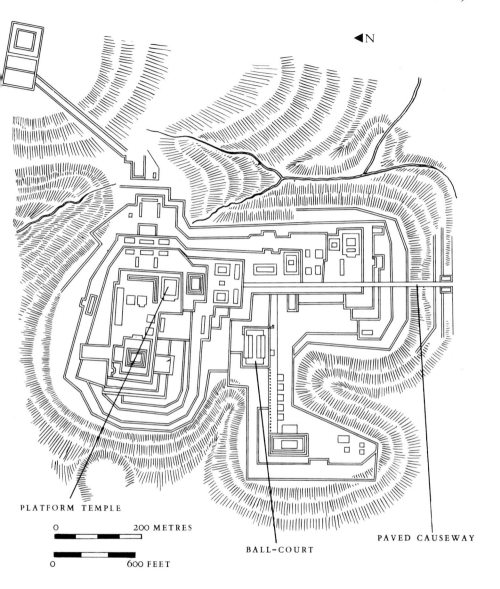

◀N

PLATFORM TEMPLE

0 200 METRES

0 600 FEET

BALL-COURT

PAVED CAUSEWAY

25 (A). Xochicalco, general plan, before 900

axes are on the cardinal points. Three distinct groups—northern, western, and eastern—occupy the hilltop shoulders, connected by paved causeways and esplanades. The north, or highest, shoulder is crowned by a sculptured platform. The east group is aligned along a paved road dropping away to the south. The west group consists of a ball-court, a dwelling group containing a sweat-bath, and a pyramidal platform aligned along a level east-west esplanade.[58] The ball-court, where a game of Middle Pre-Classic antiquity was played, is probably the oldest surviving edifice of its kind in central Mexico,[59] closely resembling the Classic Maya ball-courts at Cobá, Piedras Negras, and Copán, with slanting playing-walls,

25 (B). Xochicalco, south-west group with ball-court, before 900.

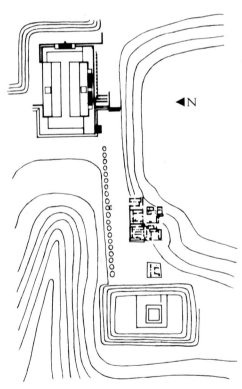

◀ N

of a shape and size repeated at Tula under Toltec rule. Connecting the ball-court and the western pyramidal platform is a causeway 20 m. (65 feet) wide, lined on the north side with the foundations of twenty cylindrical constructions, possibly altars or pillars. Near its centre are the foundations of a dwelling on a chequerboard plan of four courts on ground sloping away to the south-east. The group includes inner rooms with platform benches like the central Maya sweat-bath disposition.[60]

The most striking edifice is the sculptured platform temple[61] in the highest court on the northern cross-axis. Upon a solid platform measuring 19.60 by 21 m. (64 by 69 feet) rise the roofless walls of a square cella entered from the west, up a stairway with carved serpent balustrades. The platform of rocks and clay is revetted with a veneer of finely cut and sculptured andesite blocks [26]. The platform profiles are designed to carry across great distances. They consist of the familiar talus and panel, augmented by a cornice of upward-slanting section.[62] The proportional relations differ radically from those of Teotihuacán. At Xochicalco, the talus and panel are related as 4:9, while the usual proportion at Teotihuacán is close to 3:8. The high talus and the slanting cornice between them reduce the panel to an entablature. The suppression of the panel frame, which was so strong a form at Teotihuacán, further stresses the importance of the talus. From a distance, the Xochicalco silhouette reads clearly as an energetic form of concave vertical profiles, unlike the Teotihuacán effect of oblong slabs cushioned upon layers of shadow. The Xochicalco scheme was designed to give great importance to the sculptural programme, which at Teotihuacán never invaded or diminished the tectonic effect of the architecture. Here, the principal figural compositions occupy the talus instead of the panel, which displays small oblong scenes. The cella exterior had the same arrangement, today much mutilated.

The spatial order of the relief carvings recalls the leaves of a screenfold manuscript like Codex

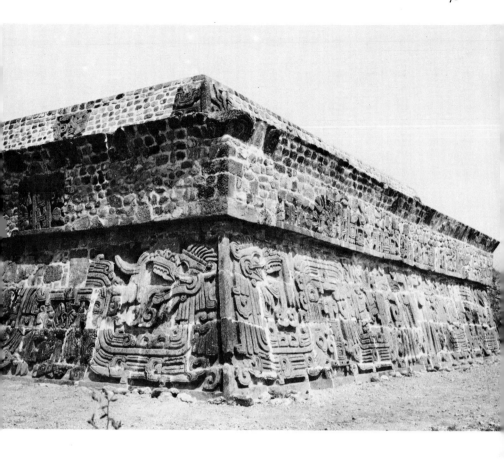

26. Xochicalco, main pyramid, angle of lower platform, before 900

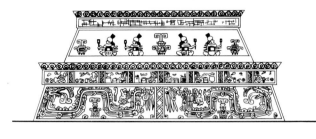

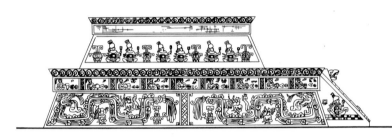

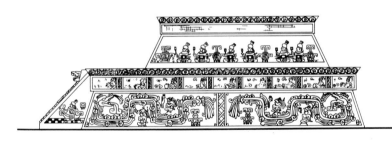

Féjerváry or Codex Laud (see p. 181). The reliefs show traces of red, green, yellow, blue, black, and white paint, much as in the manuscripts. They were later covered with a uniform coat of red pigment. The platform talus is divided as if into eight pages, each oblong, and each containing an undulant feathered rattlesnake [27]. The overhead loops surround flaming calendrical glyphs, and the troughs enclose six seated men wearing animal head-dress. The frieze-panel above the talus divides into thirty oblong page-like compartments. Each contains a seated warrior and several glyphic signs, in two sequences beginning at the centre of the rear façade, where files facing left and right carry around the building to end at the cheeks of the stairway. The cella talus displays similar files of seated men, beginning on the rear wall, and ending on the stairway cheeks. The figures are in pairs, separated by calendrical signs. Each of these twenty priests or gods wears a bulbous turban and carries a fan-like object, which may denote high rank, as in Maya and Aztec iconography. In each zone the seated men may be the patron deities of the corresponding time-periods denoted by the accompanying glyphs. The turbaned men of the cella wall have also been compared to the congress of persons shown on Altar 2 at Copán. The talus panels flanking the stairs are thought to commemorate

27 (*opposite*). Xochicalco, platform temple, east, north, and south façades, before 900

28 (*below*). Group of stelae from Xochicalco. *Mexico City, Museo Nacional de Antropología*

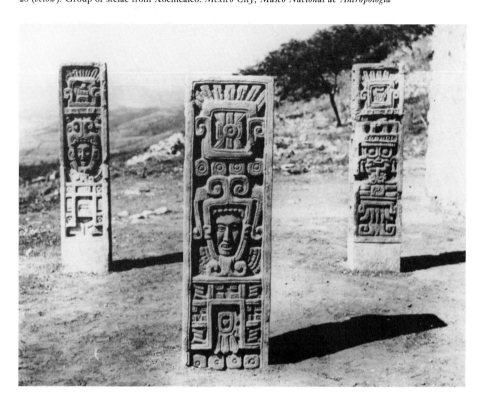

a correction of calendar periods on the occasion of a New Fire ceremony.[63] The glyph-forms are like Aztec day-signs, but they are enclosed by the typical Maya cartouche, and the numerals resemble those of the Zapotec inscriptions of Monte Alban III.[64] These distinctive Xochicalco glyphs appear in systematic order on three stelae unearthed in 1961 at Xochicalco [28], where they are recognized as the earliest known true stelae in the central Mexican region, possibly as early as Xochicalco II (before 700). Stelae 1 and 2 portray human faces enframed by the jaguar-serpent mask common at Teotihuacán, Tula, and Chichén Itza. Reminiscent of Piedras Negras is the angular sky band in the

lower third of stelae 1 and 3, enframing signs of Teotihuacán derivation. Stela 3 represents the goggled rain-deity face (Tlaloc). On sides and backs, each stela bears columns of glyphs pertaining to names, places, motions, and dates, reminiscent both of Classic Maya and Monte Alban inscriptions.

Cacaxtla

Like Xochicalco, another mountain-top settlement is Cacaxtla [29] in south-western Tlaxcala, where important mural paintings were discovered in 1975. A temple doorway and an adjoining platform base, painted before A.D.

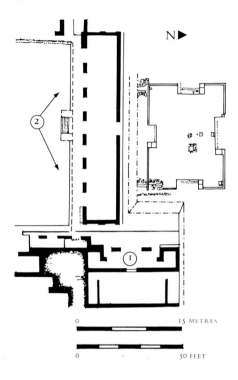

29 (*left*). Cacaxtla, before 900.
Plan of temple (1) and talus (2) bearing murals

30 (*opposite, above*). Cacaxtla, before 900,
section of battle mural, east of stairway

31 (*opposite, below*). Cacaxtla, before 900,
mural panel on south wall of temple doorway,
showing a bird-helmeted personage
standing on a feathered-serpent body

750, show scenes portraying supernatural beings and a battle among forty-eight nearly life-size figures [30]. The associated sherds are of Teotihuacán III date, but the paintings contain a variety of styles recognizable as of Xochicalco, Veracruz, Teotihuacán, and the southern Maya lowlands. Radiocarbon and iconographic clues suggest a dating about A.D. 800. The portico murals recall the style of Bonampak at the same date as well as framing of Teotihuacano style, with glyphs like those of Xochicalco and Monte Alban. A red plaster relief on the door jamb is close to Tajín interlaces in stone. The battle mural portrays two groups. The victorious warriors wear round shells in their headbands, and the victims labour under large bird helmets [31]. The painting in eight colours, including blue grounds, is by at least four different hands, in drawing of a style like that of the Late Classic Usumacinta vase and mural painters. Whether Maya painters are among the participants is uncertain, but Maya models may be supposed, together with several others in this important record of eclectic and syncretistic character. The area has long been identified with the Olmeca–Xicalanca peoples in the valley of Puebla, who are associated with Gulf Coast origins.[65]

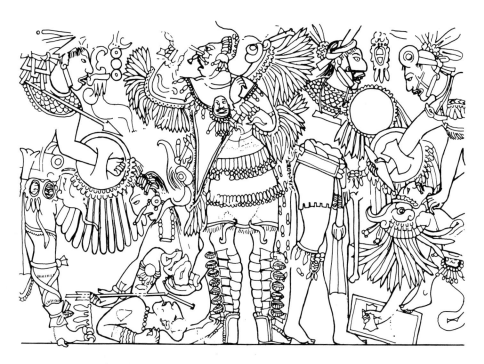

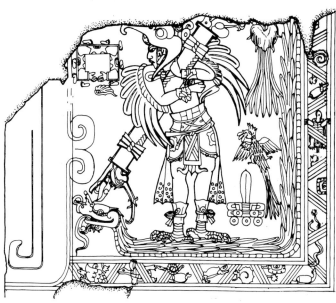

CENTRAL MEXICO AFTER A.D. 800

Teotihuacán exemplified Classic priestly government, but Tula is a type-site for the warrior aristocracies of Middle America after about A.D. 1000. As the capital of the Toltec ('builder') dynasty, Tula flourished from the ninth to the thirteenth centuries,[1] ruled by fighters rather than priests, who restricted political control to as few families as possible. Religion centred upon human sacrifice, in an aggressive, expansionist relationship to neighbouring tribes. Toltec skills included an early Middle American use of metallurgy, probably relayed via Central America and Oaxaca from the central Andean coast.

Tula is about 40 miles north-west of both Mexico City and Teotihuacán, upon a natural frontier separating the rich Valley of Mexico from the desert plains of the north. The stratigraphy of the site confirms its chronological position of c. A.D. 750–1200, after Teotihuacán and before the Chichimec invasions.[2] The ceramic remains are of types (Coyotlatelco and Mazapan) found also at Teotihuacán, but intrusive upon the burned and deserted remnants of the Classic centre. At Tula, finally, the burned and deserted city of the Toltecs was reoccupied by later inhabitants of Chichimec (barbarian) origin, whose presence is attested by ceramics of Tenayuca type (Aztec II) in the fourteenth century.

The sources of Toltec civilization are still obscure. The exploitative character of the small, nomadic warrior aristocracy probably took shape during the eighth and ninth centuries, when the theocracies collapsed owing to some combination of climatic, institutional, and demographic disorders. The fullest record of the early history of such a warrior group is found in the Mixtec genealogical manuscripts of southern Mexico, which give a dynastic history beginning in the eighth or ninth centuries A.D. These manuscripts, compiled after about 1300, record early customs among the Mixtec tribes [131–7], customs strikingly like those recorded in Toltec sculpture. Either Toltec historiography derives from Mixtec antecedents, or the Mixtec chroniclers modelled their histories upon Toltec sources. The former is more likely, because the traces of Mixtec expansion throughout Middle America are on the whole earlier than the Toltec horizon, and they are reinforced by the Mixtecs' own pictorial chronicles.

The architectural forms of Toltec civilizations come from other sources. The pyramidal platforms, the composition of large open spaces as ritual centres, and the colossal statues have precedents in the style of Teotihuacán. A direct Maya influence upon the art of Tula owing to Toltec domination in Yucatán after A.D. 1000 should not be overlooked. The case of Xochicalco affords precedent for art of Mayan derivation in central Mexican territory. The possibility that elements of the style of Tula are transplanted from Chichén Itza will be considered in Chapter 9. This clearest example of the political expansion of Toltec civilization, with the military domination of the Maya people by Mexicans at Chichén Itza during the tenth to thirteenth centuries,[3] is reflected in the close parallels between the art and architecture of the two cities after 1000. Other examples of 'Toltec' conquest and expansion are less certain. Their enumeration depends upon texts in which the meaning of the term reflects many layers of revision, and compilation from many conflicting sources.[4]

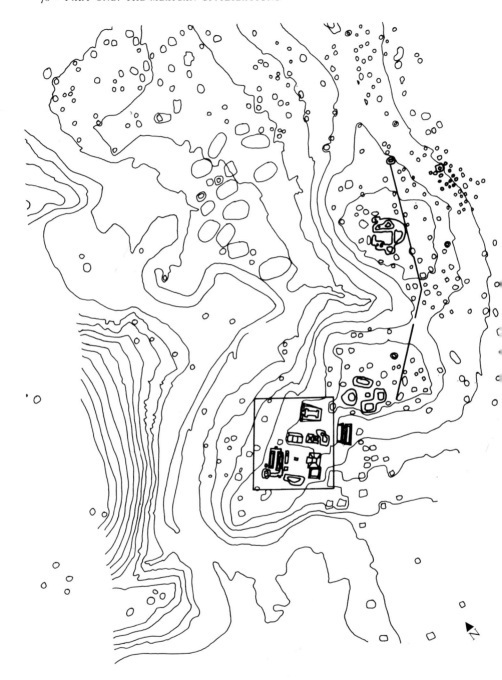

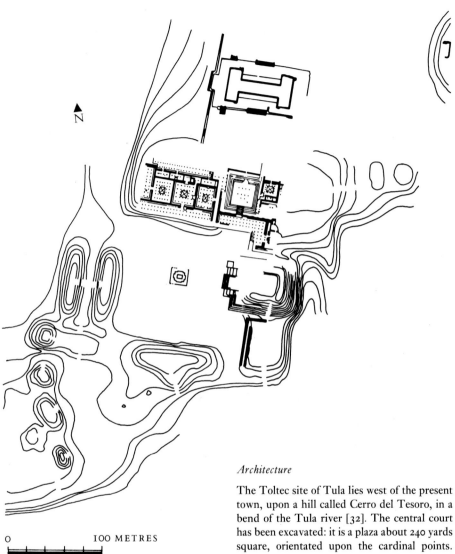

0 100 METRES

0 300 FEET

32. Tula, before 1200. General plan (*opposite*), and detail of south group

Architecture

The Toltec site of Tula lies west of the present town, upon a hill called Cerro del Tesoro, in a bend of the Tula river [32]. The central court has been excavated: it is a plaza about 240 yards square, orientated upon the cardinal points. The north side is a long platform bounded at the east corner by a colonnaded portico and a terraced pyramid. The pyramid is flanked by other colonnaded enclosures. Behind it is a ball-court of the same size, shape, and orientation as the one at Xochicalco. Dwelling groups to the south-west and north-east of the main court were excavated in the nineteenth century.

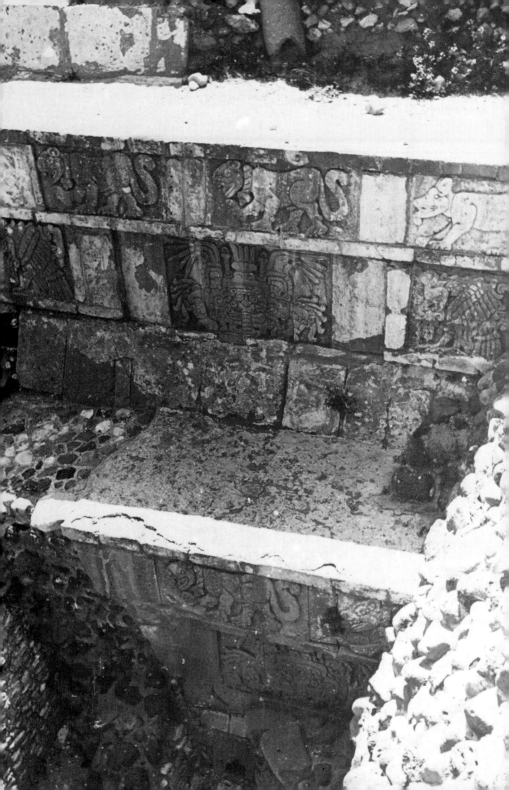

Sanders refers to the 'colonnaded salons' and adjoining rooms as possibly part of the palace of the ruler of Tula. Recent excavations suggest that Tula may have been of major importance (30,000 inhabitants?) with a large artisans' quarter near the Cerro de la Malinche.[5]

The absence of all fortification is immediately striking. Like Teotihuacán in its last phase, Tula was a ritual centre surrounded and invaded by dwellings. Some, like Roman houses, faced inward, upon central courtyards. The differences between Tula and Teotihuacán are important, but the resemblances have been underestimated because of the long confusion whereby Teotihuacán was identified with Tollan (i.e. Tula of the historical texts) in philological commentaries by the German school of Americanists.[6] This confusion has required an extreme differentiation of the two sites. But there can be no doubt that the Toltec overlords, coming after the theocracy of Teotihuacán, perpetuated certain urban forms of their more pacific predecessors, and that the fortress cities of Middle America[7] belong to a later horizon than the Toltec. Indeed, the building history of Tula probably repeated that of Teotihuacán, beginning with pyramids, and ending with dwelling groups.

No major innovations appear in structural technique, which seems poorer than at Teotihuacán, lacking the latticed structure and the cantilevered panels. The principal pyramid is the eastern one, about 65 m. (215 feet) square, like the southern pyramid at Teotihuacán, but augmented here by conical aprons flanking the stairway. The aprons make a transition between the pitch of the stairs and the steeper pitch of the terraced profile. The process leading to their design can be studied in the pyramid at Tenayuca [41], where analogous aprons were added in the fifth phase, about A.D. 1400 (p. 88).

More completely known is the form of the smaller north pyramid [33], which is 38 m. (125

feet) square, of five stages, with a stairway on its south front.[8] The core of stone and earth has a stone facing from which tenons project to hold in place the veneer of thin stone plates forming the outer surface. Cylindrical stone drains are built into the terraces behind the veneer. The terrace profiles are novel, consisting of three roughly equal portions: a talus (55–60 cm., or about 2 feet, high), an entablature of salient and recessed double-square panels (70 cm.), and a crowning frieze (60 cm.). Entablature and frieze are horizontally marked by three wide, flat, raised mouldings like the panel frames of Teotihuacán. The panelled frieze and entablature compartments are carved with reliefs of jaguars in the friezes, and Venus masks, eagles, and buzzards in the entablatures. The stone reliefs are thickly caked with plaster facing, originally painted in descriptive solid tones. The figural character of this scheme is clearly in debt to the processional and heraldic wall decorations at Teotihuacán. The frieze of jaguars, for instance, should be compared with the Atetelco[9] murals both as to conception and style. On the other hand, the in-and-out-composition of the entablature blocks relates to the rich chiaroscuro system of the terrace panelling at Monte Alban and Mitla in southern Mexico (p. 173). The Tula version of the projecting and receding panels is more linear, and designed more for close inspection than the long-distance effects of Monte Alban. The viewing distance was imposed, of course, by the figural sculpture at Tula.

Only the buried supports of the destroyed cella have been recovered [36, 37]. It was probably a beam-roofed chamber, entered by a triple doorway possibly with serpent columns, and divided by rows of four Atlantean columns [35–7] and four piers each 4.6 m. (15 feet) high [38]. Columns and piers were assembled of mortised and tenoned drums. The Atlantean columns have their precedent in the colossal anthropomorphic support from the north pyramid [16] at Teotihuacán, where the idea of square piers was in common use.

The south front of Mound B was bordered

33 (*opposite*). Tula, north pyramid facing, before 1200

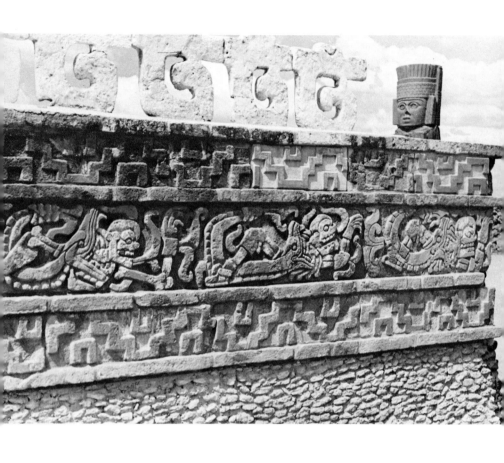

34. Tula, *coatepantli* (serpent wall),
before 1200

by a colonnaded portico of three files of four-teen square piers each, turning the north-east corner of the plaza, to continue south in a short section three bays long. To the east and west of the north pyramid are several colonnaded courtyards. Of later construction than the pyramid, these probably adjoined dwellings of insubstantial construction.[10] The portico and the patio buildings both mark a bold step in ancient American architectural thought. All previous designs in Middle America were open courtyard enclosures, sometimes closed at the corners, and always composed as external masses for effects in open-space design. The Tula designer and his contemporaries at Chichén Itza [239] were the first to treat the building more as a hollow volume, with interiors to be carried around corners, as in the cloistered ranges of medieval architecture in Europe.

Another striking form at Tula is a free-standing wall about 15 feet north of the north pyramid, defining an open corridor at its base. Called the *coatepantli* (serpent wall) because of its decoration, it rises 2.6 m. (8½ feet), and is carved in relief on both faces [34]. The base is a double talus, 90 cm. (3 feet) wide at ground level, and 80 cm. high. Upon this base is the two-faced relief band of rattlesnakes devouring skeletal humans. The theme alludes to the souls of dead warriors. Wide borders above and below this figural band are adorned with geometric meander forms of textile origin. The closest parallel to these border designs is in Mixtec manuscripts, where such forms are used in paintings of architectural platforms to identify place-names (e.g. Tilantongo is represented by this very meander, painted in black and white).[11] The *coatepantli* is crowned by crenellations. These perforated slabs of stone represent sections of conch-shells. As heraldic forms they derive from the stones used as crenellations at Teotihuacán.[12] The south face shows more hurried workmanship: the talus is faced with plaster, and the reliefs are executed in a cursive and slovenly manner, contrasting with the more detailed workmanship of the north face.

Sculpture

The expression attained by the sculptors of Tula differs from that of their predecessors at Teotihuacán by the choice of deliberately harsh forms, which avoided grace and sought only aggressive asperities, gritty surfaces, and bellicose symbols. The technique, like that of the earlier age, remains Neolithic, although the ornamental use of gold is attested during the Toltec era. The sculptors relied more upon deep linear incisions than their contemporaries in Yucatán. The enumeration of the parts of ar-mour and costume [38] has an ideogrammatic clarity lacking in the painted reliefs of Toltec date at Chichén Itza.

The architectural setting, as we have just seen, offered no fundamental novelties. There are caryatid figures, large and small, serpent-columns, piers, and panel reliefs in the tectonic repertory. The only examples of free-standing sculpture are reclining male figures [39] and chunky human standard-bearers, but their placing was strictly governed by the architec-tural situation.

The Atlantean figures, 4.6 m. (15 feet) tall, are the most theatrical works produced at Tula [35–7]. The four columns of four tenoned drums each are identical, representing warriors or hunters, imprisoned by the shallow relief of the nearly cylindrical drums.[13] They carry throwing-sticks (*atlatl*) and hunting bags. Their costume consists of wrapped garments: an apron, which leaves the buttocks bare, garters on calves and ankles, a bib over the chest, arm-wrappings, and a headband of fur or mosaic. In all these wrappings the knots and binders are portrayed with loving military care; the rear is like an exemplar of the knot-maker's art. An immense butterfly pectoral, a disk surrounding a human trophy-head at the small of the back, and a quiver of darts lashed to the head-band complete the savage panoply. The fourfold repetition conveys the effect of a frightening palace-guard.

On the four piers, of four carved faces each, which stood in the rear row of the cella, the

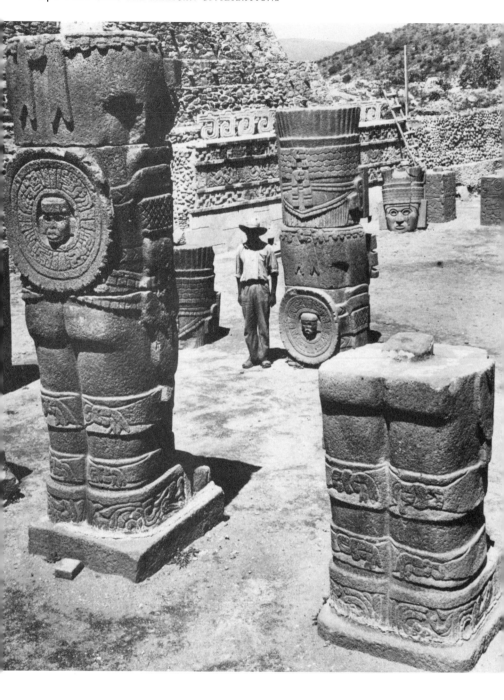

35-7. Tula, basalt Atlantean figures with detail of feet, before 1200

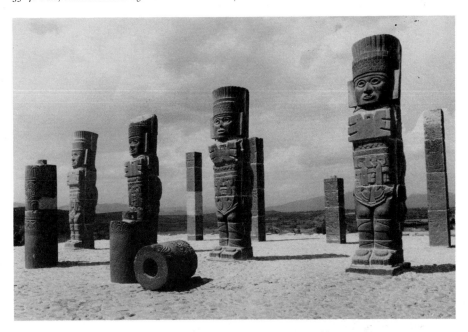

palace-guard continues in very flat relief, confined by upright rectangular compartments, in which bundles of arrows alternate with standing warriors in profile [38]. These warriors, with their brandishing gestures and their lean, loose-limbed gait, convey a more animated version of

38. Tula, basalt pier relief of Toltec warrior, before 1200

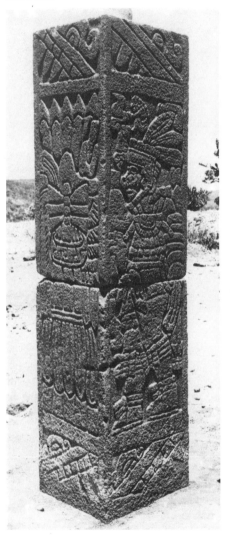

the Toltec military caste than the Atlantean figures.

At the entrance to the cella, the three doorways were separated by two serpent-columns of which only the feathered body drums have been found.[14] They were probably like those of Chichén Itza [242, 248], with open-fanged heads as bases, and the tail rattlers as lintel-supports. This reversal of the usual expressive character of the tectonic support is unique in the history of architecture, in the substitution of a flexible form for a rigid one, and in the inversion of the head and the base. It is as if an Ionic or Corinthian order were used upside down, with the capital on the ground. If the directional interpretation of this serpent support is correct, it may have served the purpose of connecting upper and lower zones of the universe. Instead of supporting a load, the Toltec serpent-column descends from the skies to spread celestial gifts upon the earth. In this form, surrounded by the images of warriors and hunters, instead of the priests of the older theocracy, the feathered serpent of the Teotihuacán people survived, a god of vegetation and rain,[15] among barbarian protectors in the feudal age of American antiquity.

The discovery at Tula of reclining male figures carved in dark basaltic stone, of the type fancifully named Chacmool [39], further completes the parallel between Tula and Chichén Itza. At Chichén [251] such figures are very common, and have some of the same attributes as the colossal figures of Tula.[16] The figure reclines in an uneasy position, with raised knees and torso, looking over his left shoulder, and bearing a vessel for offerings on his abdomen. The type has been interpreted as a heavenly messenger taking the blood-gifts of humans to the gods. As at the Temple of the Warriors in Chichén Itza, the Chacmool probably occupied the cella terrace, athwart the doorway axis.

Below the cella terrace were processional jaguar figures on the various cornices [33] and eagles and vultures devouring human hearts. In Aztec society, and probably among the Toltecs, the warrior moieties were called jaguars and eagles. Their mission was to secure human

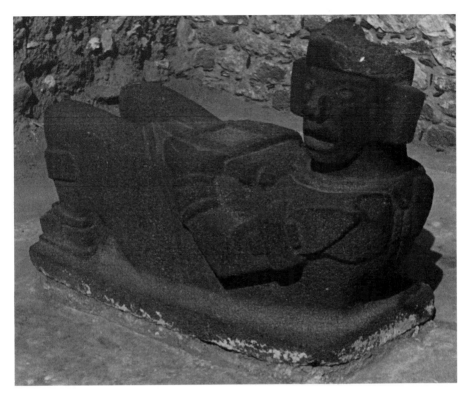

39. Tula, basalt Chacmool, before 1200

sacrifices for the nourishment of the gods, necessary to maintain the rhythm of the universe (see pp. 91–2).

Between the pairs of eagles in the entablature of the Tula pyramid are heraldic figures which recur at Chichén Itza: from the open gullet of a frontal feathered monster appears a human head. At Chichén Itza [253], accessory signs clarify this form as a symbol of the planet Venus, whose period of 584 days correlates with the vague solar year of 365 days by the equation $5 \times 584 = 2920 = 8 \times 365$.[17] In the cella, the caryatids, as huntsmen-warriors, may also relate to the complex of forms connected with the worship of the morning star (Tlahuizcalpan-tecutli, Lord of the House of Dawn).

Thus the north pyramid at Tula (now called Tlahuizcalpantecutli) seems to declare the com-bination of two systems. The older animistic worship of rain and fertility, represented by the feathered serpent, combines with the cult of the planet Venus, whose representative is a hunting god (Mixcoatl) of nomadic tribal origin, and whose cult requires human sacrifices.

At ground level, in the colonnade below the north pyramid, is a bench carved with processional figures exactly analogous to those of Chichén Itza in the Mercado colonnade [252], and in the colonnade of the Temple of the Warriors. The Tula procession is of more stunted proportions and coarser execution, but the meaning is clearly the same as at Chichén. The processional type reappears in Aztec sculpture of the fifteenth century, on friezes and slabs in the National Museum, notably the Tizoc Stone [48]. The procession of files of individuals

converging from left and right upon an image of the god, or upon a symbol of blood sacrifice, is the recurrent theme. The costumes, attributes, and physical types differ enough in these processions to justify their identification as historical figures, perhaps a convocation of tribal leaders allied under the unifying cult of the Morning Star deity.[18]

Across the river from Tula are rock-carvings, presumably of Toltec date, on the Cerro de la Malinche. One shows a feathered serpent (Quetzalcoatl) in the form of an angular Z-scroll as the priestly name-glyph of a striding male figure. He draws blood from his left ear lobe with a jewelled bone [40]. Above him a date-

40. Tula, Cerro de la Malinche, rock carving of Ce acatl, after 1200(?)

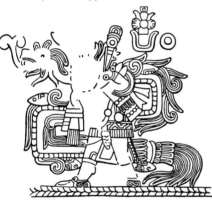

glyph indicates his historical calendar-name, One Reed (Ce acatl).[19]

In Aztec sources, One Reed was the legendary founder and hero of Tula, the inventor of writing and many crafts, the priest-king, the builder of the serpent-columns, the lord Quetzalcoatl. Driven from Tula by the intrigues of rival magicians, he fled to the east, where his body changed after cremation into the Morning Star. These particulars reflect a long mythopoetic elaboration and fusion of many distinct themes. The myths became so intricate in Aztec sources that their historical reduction seems

impossible. But wherever one turns, the figure of Quetzalcoatl (Kukulcan in Maya language) reappears to suggest yet becloud the apparent unity of post-Classic religious beliefs throughout Mesoamerica.[20]

THE CHICHIMEC INTERLUDE

The fall of Tula in the twelfth to thirteenth century was precipitated by nomadic (Chichimec) tribes moving in upon the rich lands of the central plateau, a process that had been under way for millennia.[21] The end of Teotihuacán and the rise of Tula were probably brought on by these same nomadic waves from the north; for the history of Tula, though called Toltec, displays many survivals of the culture of nomadic huntsmen.[22] It is now the agreed convention to designate the tribal history of the central region, from the end of Tula to the creation of Aztec hegemony, as the Chichimec period (c. 1250–1430). The Aztec people regarded themselves as the descendants of Chichimecs. The term, however, may signify 'barbarian', and it includes peoples of the most diverse geographic origins.

The last generations to know the theocratic regime of Teotihuacán probably called the immigrant bands of their day Chichimecs, until these had earned the name of Toltecs (builders) in the renewed tradition of urban life at Tula.[23] But between the fall of Tula and the rise of Tenochtitlan, several generations lived without knowing domination by an economic power, like Tenochtitlan, or by a single warrior dynasty, such as the Toltec lineage. This interlude between great states, when the central valleys were in dispute among many tribes of more or less recent arrival, all seeking territory and alliances among the ruins of Toltec civilization, is the Chichimec period of the history of the central zone.[24]

Tenayuca, today a district in the northwestern suburbs of Mexico City, was the principal religious centre of the period until about 1300, when the capital moved to Texcoco on the eastern shore of the lake. The complete archaeo-

logical excavation of the Tenayuca pyramid [41], together with the Chichimec dynastic histories, are the chief sources of knowledge. These pictorial histories allow a detailed reconstruction of the events following the fall of Tula from about the mid thirteenth century until the Spanish Conquest. Full genealogical sequences and pictorial accounts of the principal occurrences in all the main settlements of the valley appear on the map-like sheets of Codex Xolotl,[25] and in the pictorial annals called Mapa Tlotzin and Mapa Quinatzin.[26]

For example, the introduction of writing and goldsmithing among the Chichimecs about 1300, by a band who emigrated to the Mixteca territory in southern Mexico, and who returned to the valley (their name, Tlailotlac, signifies the returners), is clearly recorded in Codex Xolotl [65]. The name-glyph of the tribe shows a path re-curved upon itself with footsteps, attached to an artisan busily making signs with a stylus upon a block or sheet of paper. Thus the pictorial conventions in the Chichimec histories repeat and enlarge upon those of the Mixtec genealogies.

The main outline of Chichimec history is accordingly much clearer than that of all the preceding epochs in the history of the valley. The nomad hunters settled in the valley by force of arms. By marrying their daughters to Toltec husbands, they became valley dwellers with a culture strongly affected by south Mexican influences, principally from western Oaxaca. The first three Chichimec rulers, Xolotl, Nopaltzin, and Tlotzin, lived at Tenayuca. Quinatzin, the fourth king, moved to Texcoco,[27] and under his successor, Techotlala, Chichimec power waned, passing to the Tepanec lineage of Atzcapotzalco,[28] at about the time (c. 1350) of the rise to importance of the Tenochca tribe, later known as 'the Aztecs'.

The pyramid of Tenayuca [41], facing the zenith setting of the sun (p. 51), shows eight campaigns of enlargement and remodelling.[29] The earliest edifice of four vertical terraces (31 by 12 by 8 m.; 102 by 39 by 26 feet) supported two adjacent temples each with its own stair.

This disposition persisted to the end, in the eighth enlargement, when the platform measured 62 by 50 by 16 m. (204 by 164 by 52 feet). The doubling of the width and height lasted about three centuries. Each of the six major campaigns may have been prompted by the conclusion of the fifty-two-year calendrical cycle (p. 113) by which Middle American tribes regulated their affairs. By this reckoning, only the first two layers of the onion-skin growth belong to the Chichimec period prior to the shift of the centre of government to Texcoco, and the emergence of the Tenochca as the new masters of the valley. If the earliest two stages belong to the century before 1350, the end of the Chichimec period is perhaps reflected in the third layer, where the number of terraces is reduced to three large talus elements of sloping profile, continued in the sloping profiles of the twin temples. The twin temples upon a platform characterize the temples of the Aztec confederacy, where they were dedicated to the rain god, Tlaloc,[30] and the tribal war god, Huitzilopochtli, in an arrangement honouring both the ancient animism of the valley and the tribal fetish of the new masters of the land. This arrangement is of Chichimec origin, and it exemplifies one of the main historical traditions on which Aztec society was founded. It in turn reflects, by its orientation upon the zenith setting of the sun (17 degrees north of west), the continuation of priestly ceremonials at least as old as the east (Sun) pyramid at Teotihuacán.

Many other edifices of the Chichimec period adorned the valley: of these only the platforms and house groups of the Matlatzinca tribe at Calixtlahuaca in the Toluca Valley have been fully excavated.[31] Here, the round pyramid [42] contains four layers, of which the nucleus is pre-Toltec. The second and third layers had stones projecting to retain a plaster coating, as at Tula or Tenayuca. The fourth and outermost layer of red and black *tezontle* (pumice) is surely of Aztec date, built after the conquest by Ahuitzol in 1476. The cylindrical terraced form with an east stair was retained in all four versions; only the second version lacked cornice profiles.

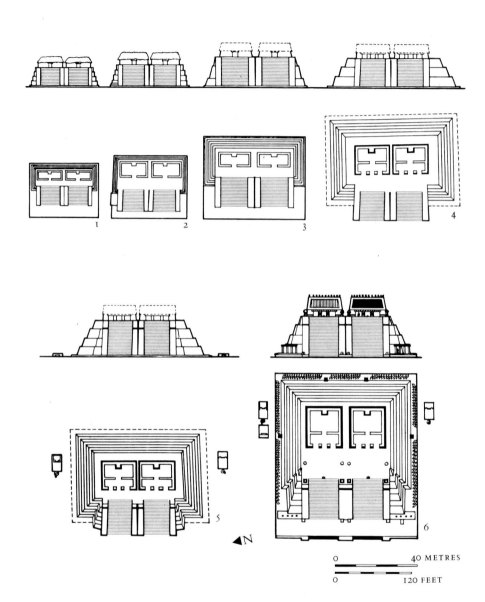

41. Tenayuca, pyramid.
Plans and elevations showing enlargements
of *c.* 1300–1500

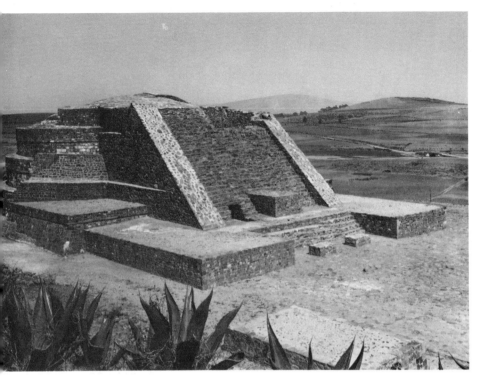

42. Calixtlahuaca, round pyramid, after 1476

THE AZTEC CONFEDERACY

A few families of nomadic huntsmen, the Náhuatl-speaking followers of Tenoch, who worshipped Huitzilopochtli,[32] arrived in the Valley of Mexico about 1250 as one of many Chichimec bands from the north. Like gypsies they settled along the lakeside at Chapultepec on the lands of the lord of Colhuacan. To escape his oppression they fled after 1350 to an island refuge, Tenochtitlan,[33] where they prospered, enlarging the site with *chinampas* interlaced by canals, until in 1520 the island capital housed at least 75,000 people. Like other Chichimec bands of Náhuatl-speaking nomads, the Tenochca, or Mexica, as they called themselves, married into the lineages of the lake-shore cities,

and thought of their dynastic line as descended via Xolotl from the Toltec dynasty of Quetzalcoatl of Tula.[34] About 1430, the islanders, under Itzcoatl, allied with Texcoco to destroy the power of the principal west shore city, Atzcapotzalco. Thereafter the Aztec rulers, as dominant partners in a triple alliance with Texcoco and Tacuba, extended their conquests to the east coast, to southern Mexico, and into Central America, until the network of subject tribes included thirty-eight provinces held by Aztec garrisons and paying tribute[35] to the cities of the Valley of Mexico.

To explain the rapid rise of the Aztecs to this imperial power, and to account for the expressiveness of Aztec art – in short, to understand both their worldly expansion and their

metaphysical motivation – we must discuss the central rite of Aztec life: human sacrifice.[36] The festivals of the calendar were celebrated with countless immolations. War had the supply of sacrificial victims as one of its main objects; in civil life, men and women selected for sacrifice submitted to its rituals without complaint. From birth to adult age, every facet of education prepared Aztec youth for the eventuality of sacrifice. Death by sacrifice came to be an expected and even desirable end, for which art, poetry, and religion all prepared the victims with an endless, pervasive justification of its necessity. The youth chosen for his beauty to impersonate the god Tezcatlipoca in the annual Toxcatl festival of the sun played his role for a year, surrounded by luxury, before being sacrificed by heart removal. The inevitable by-product of the total discipline for death required by the institution of human sacrifice was the formation of military organizations which, when confronting tribal warriors of a looser social training, were invincible. But the purpose of human sacrifice was not to train death-despising soldiers. The contempt of death arose from an altogether different motivation, connected with Aztec myths of the origin and purpose of mankind. These myths formed an explanatory metaphor for the nature of the cosmos so coherent and convincing to its communicants that the enormity of sacrificial death was acceptable.

The Aztec cosmos was anchored upon the idea of sacrificial creation. Four imperfect ages of the universe, each ending in catastrophe, had preceded the present age, which began by an act of sacrifice when two gods threw themselves into the fire, emerging as sun and moon, set in motion by further sacrifices of the other gods.[37] The first men then were kneaded of bonemeal mixed with the sacrificial blood of the gods. This genesis both left the gods incomplete, and conferred godlike properties upon men, establishing human responsibility for the maintenance of the universe. Without men the power of the gods wanes until they cannot renew the annual cycle of fertility on earth. The sun, the earth, the moon, and the gods of vegetation and animal life all need annual rejuvenation by draughts of human blood. Without human sacrifices the earth's fruits wither and men perish, so that the continuation of the universe hangs upon the payment of the blood debt. By this cyclical conception of the exchanges of vitality, with the gods renewing the cycle of plant and animal growth to feed humans, and the gods feeding on human blood, the ritual of human sacrifice was justified to its devotees.[38]

These beliefs are as old as the Toltec revolution. Rites of human sacrifice like those portrayed in Aztec sources are shown on a golden plate of Toltec date from Chichén Itza. The origin-myth recurs among the Náhua-speaking Pipil tribes of Central America, who reached their present habitat in Toltec times, and among whom the theme of the archetypal blood-debt has its oldest recorded version.[39] But the Aztecs developed these beliefs most fully.

Architecture

The metropolitan concentration of the Aztec state is apparent from descriptions of the capital, Tenochtitlan, which underlies Mexico City, and which was destroyed in the Spanish siege during the spring and summer of 1521. Written accounts by eye-witnesses, Indian plans, and twentieth-century excavations allow us to form a fairly complete idea of the city [44].[40] The island was connected to the mainland by causeways bearing traffic across the shallow lake to the north, west, and south shores.[41] A double aqueduct from Chapultepec brought fresh water to augment the springs of the island. An older Tepanec settlement at Tlatelolco, in the north-western quarter, was finally absorbed into the new Tenochca state in 1473;[42] its configuration gave the status of a double city to the Aztec capital, with two distinct commercial centres and two main groups of religious edifices, recorded by the chroniclers, which affected the strategy of the siege of 1521.

In Tenochtitlan, whose rapid growth enveloped the older twin city, the causeways to the mainland boldly marked the co-ordinates of a grid plan, guided by the rectangular growth pattern of the artificial *chinampa* lands, a growth pattern which is conserved in an Indian plan of a portion of Atzcapotzalco [43] misnamed the *Plano en Papel de Maguey* (Museo Nacional).[43]

43. Tenochtitlan, detail from a sixteenth-century plan of a pre-Conquest portion.
Mexico City, Museo Nacional de Antropología

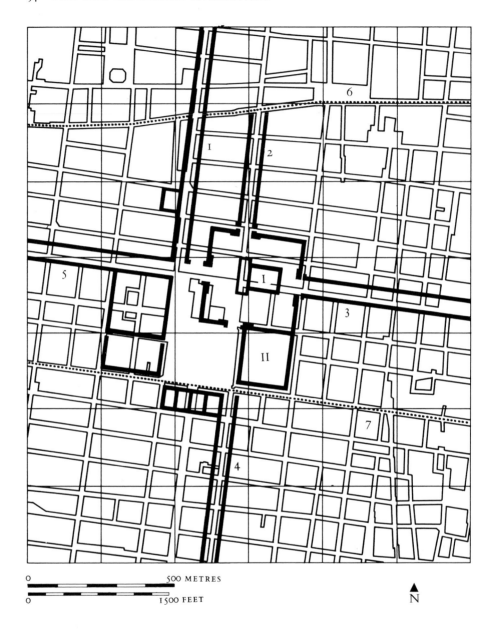

0 500 METRES

0 1500 FEET

N

44. Tenochtitlan. Plan *c.* 1510 showing relation of the Aztec capital to the present centre of Mexico City. I main temple; II Montezuma's palace; 1–5 principal streets; 6 and 7 canals

At the intersection of the co-ordinate cause-ways near the centre of Tenochtitlan rose the pyramids and temples of the main ritual area, enclosed in a wall of carved serpents' heads, and covering an area of about 350 by 300 m. (380 by .330 yards). This scheme, of cardinal roads inter-secting at the walled ritual centre [44], was repeated in other Aztec cities, as we know from a description written about 1540.[44]

Tenochtitlan differs from all previous urban layouts in the Valley of Mexico by two features: the sacred precinct is walled, and it is over-shadowed by a vastly larger residential city and suburbs. This layout reverses the plan of the ritual centres of Teotihuacán and Tula, where the dwellings fitted into the interstices and around the edges of a large ritual centre. The city of the gods at Tenochtitlan shrank to a central space dedicated to temples, among the dwellings of men. The temples, as described by Sahagún, honoured the gods of all the tribes under Aztec rule.

Tenayuca (p. 88) and Teopanzolco[45] (near Cuernavaca) are the chief surviving examples of Aztec temple architecture in the central region. The formula is stereotyped: a pyramidal plat-form, symbolic of the heavens, rises with stair-ways facing west [41]. On the top terrace, twin shrines dedicated to the ancient rain god and to the Aztec tribal god symbolize the coupling of sedentary and nomadic traditions, of agricul-tural and military vocations, in Aztec society. The pyramidal profiles are plain, save for the stairways, where the pitch of the balustrades changes near the top to give the effect of a steep crowning cornice, and to make the top dozen steps seem more abrupt. The walls of the temple cella, of tapered profiles, continue the silhouette of the pyramidal platform.

Another type of temple was built in moun-tainous country. At Tepoztlán, twelve miles from Cuernavaca, the temple cella stood upon a steep platform of two terraces. Before the inner chamber was a deep porch with two piers in the entrance. Upon a pedestal in the rear chamber stood the stone figure of the local god, Tepoztecatl, destroyed during the sixteenth century by the Dominican missionaries in the region. Date- and reign-glyphs place the con-struction between 1502 and 1510.[46]

To the west of Tepoztlán, 28 km. (17 miles) away, are the rock-carved temples of Malinalco, begun about 1476 and still in progress in 1520.[47] The principal shrine is a circular cham-ber opening to the south by a doorway carved as a serpent mask [45]. The round cella bench has

45. Malinalco, rock-cut temple, after 1476. From the south-west

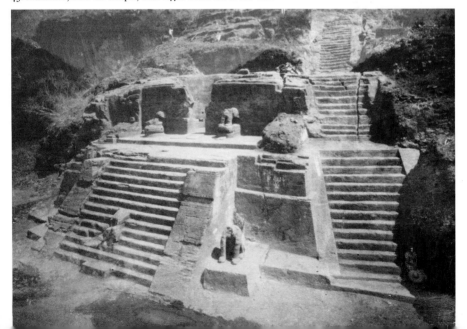

jaguar and eagle bodies carved upon its surface. In another of the rock-cut chambers are wall paintings of warriors or deities shown marching in profile upon a ground-line of stylized feathers and tiger fur [62], again an allusion to the jaguar and eagle warrior societies to whose cult Malinalco was probably dedicated.

Ball-court edifices, introduced from the lowlands in Late Classic times, were common in Aztec religious precincts. One of the principal buildings in the temple enclosure of Tenochtitlan was a *tlachtli*. The movement of the rubber ball in the court was more than a game: it was a cult-drama of the passage of the sun across the sky,[48] intended to mirror celestial in earthly

events. According to one sixteenth-century chronicler, a ball-court adorned every Aztec city. None has survived.

Aztec palace architecture is now known only through the Conquest texts of eye-witnesses, which describe the dwellings of Moctezuma and Axayacatl in Tenochtitlan, and of Nezahualcoyotl in Texcoco. Parts of the Texcoco palace are described in sixteenth-century drawings, which show rows of chambers aligned upon platforms surrounding a courtyard [46]. The excavation of a more ordinary house-group at Chiconauhtla near Texcoco [47] showed the same disposition of small chambers with porch-like, colonnaded vestibules surrounding a dim-

46. Texcoco, palace court. Sixteenth-century drawing after Mapa Quinatzin

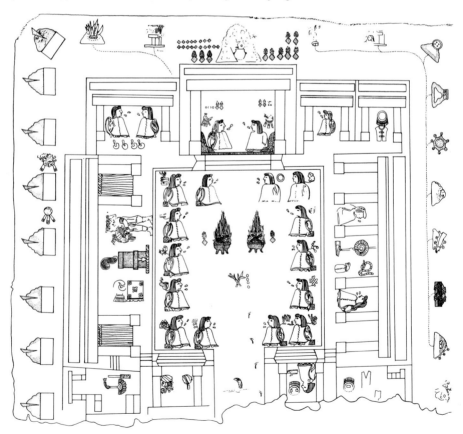

inutive court.[49] Similar arrangements, identified as the buildings of a priestly school ('Calmecac'), have been uncovered at Calixtlahuaca, where a maze of small chambers surrounds a terraced courtyard on several levels of modest height.[50]

Aztec architecture is not remarkable for important structural innovations. The use of fired bricks at Tizatlán, in Tlaxcala, for walls, stairs, altars, and benches is reported. Bricks are also known at Tula and in the south-west Maya area, at Comalcalco, as well as in British Honduras (Corozal), and at Zacualpa in the Guatemala highlands.[51] The Maya examples are all of Late Classic date. At Tenayuca [41] and elsewhere, the corners of the pyramids are bonded by alternating header and stretcher stones of an agreeable appearance, but the technique is not of special structural importance.

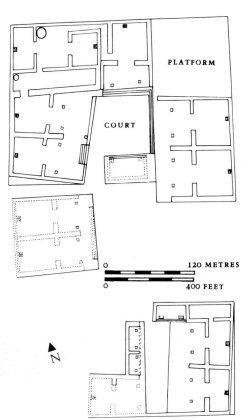

47. Chiconauhtla.
Plan of upper-class dwelling,
c. 1500

Sculpture

The conventional division of sculpture into reliefs and full-round statues is awkward, because Aztec statues are often collections of scenes and figures in relief. Conversely, many reliefs lose meaning when isolated from the sculptural masses which they articulate [51]. A more suitable division is by functions – semantic, instrumental, and expressive. The division by functions also has the merit of corresponding roughly to the historical sequence of Aztec sculpture. As a distinct Middle American style of recognizable identity, Aztec sculpture emerged only after A.D. 1450. The style drew upon traditions and craftsmen from the conquered eastern and southern regions, and it emerged as a new expression moulded by the sublime importance of human sacrifice and by the guilt-ridden conception of duty in Aztec life. Much Aztec sculpture assumed the functions of written communication. It also often enriched tools or instruments. These utilitarian requirements frequently reinforced the expressive power of the composition.

The explicative character of some Aztec sculpture can be assigned to the persistence of Toltec pictorial traditions, and to the influence of Mixtec manuscript illumination and pottery decoration. On the other hand, richly sculptured tools and instruments characterize the productions of the Gulf Coast peoples, as in the 'Totonac' yokes, blades, and other ball-game accoutrements [98]. Finally the sculptors who, from antiquity, excelled all others in the achievement of the modelling of flesh and in animated body movements were the 'Olmec' artisans of southern Veracruz and Tabasco, whose ethnic name at least persisted intact until the Spanish Conquest.[52]

It will seem adventurous to those who regard 'Olmec' art only as of mid-pre-Classic date, to

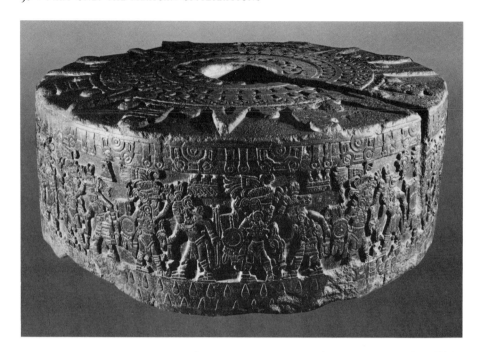

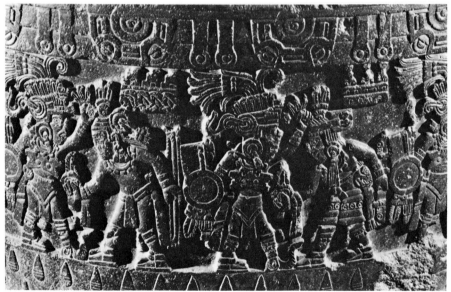

48. Cylindrical stone of Tizoc (with detail) from main temple enclosure, Tenochtitlan, after 1486(?).
Mexico City, Museo Nacional de Antropología

consider the retention of these habits in Aztec sculpture. But we have no evidence that 'Olmec' art is not of extremely long duration, nor have we any proof of the early historical date of such masterpieces as the seated athlete [87]. Certainly there is no other tradition of Middle American sculpture with which Aztec sculptural accomplishments, such as the isolated heads and the expressive modelling of the parturition figure [57], can be compared. Whether or not direct 'Olmec' contributions by living craftsmen are involved remains unproved. But it is possible that Aztec and Olmec sculptural expressions are connected, if only by an archaeological nexus, like that of Roman and Renaissance sculpture.

Among carvings of explicative character, the square stone discovered at the south-west corner of the cathedral plaza in Mexico City[53] marks the importance of Toltec traditions; for the stone was probably carved at Tula in Toltec times, and moved to Tenochtitlan some two centuries later. It is akin to the processional reliefs lining the colonnaded portico at Tula. In Mexico City, it relates to processional reliefs of Aztec style, such as those which surround the circumference of the cylindrical slab, 2.65 m. (8¼ feet) in diameter, called the Tizoc Stone [48]. The seventh Aztec monarch (1483–6) is portrayed as a conqueror and war-god impersonator triumphant over fifteen chiefs, whose dominions are indicated by place-name glyphs. These conquests appear in other records as spreading over several reigns previous to Tizoc's. The iconography, representing Tizoc as the inheritor of many conquests, and as the lord of all between earth and heaven, probably corresponds to one of the decisive moments in the transformation of the concept of kingship, from tribal leader to deified dynastic ruler.[54]

Tizoc[55] was portrayed once again in 1487 with his brother and successor, Ahuitzol (1486–1502), in a scene showing the brothers symmetrically flanking a matted ball of cactus fibre [49]. Here, as upon a pin-cushion, the cactus needles and bones used in sacrificial blood-letting were kept. From the ear-lobes of the two

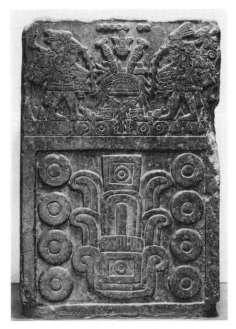

49. Stone slab commemorating Tizoc and Ahuitzol from main temple enclosure, Tenochtitlan, dated Eight Reed (1487). *Mexico City, Museo Nacional de Antropología*

kings streams of blood wind upward around the heads to fall upon the stylized mouth of the earth-crocodile beneath their feet. The year-sign, Eight Reed, in the square lower portion of the stela, refers to 1487, the date of the completion of the rebuilding of the main pyramid at Tenochtitlan, when war-captives from the east and south were sacrificed.

These two Tizoc scenes are the principal Aztec reliefs showing historical matter.[56] They derive from Toltec processional forms, and from manuscript illuminations of Mixtec origin. Their character as historical documents is invaded by symbols of the cosmic and religious meaning of kingship: they serve more as documents of Aztec ceremonial life than as strictly descriptive or narrative representations.

Other Aztec sculptures avoid the detailed characterization of historical time. The calendar

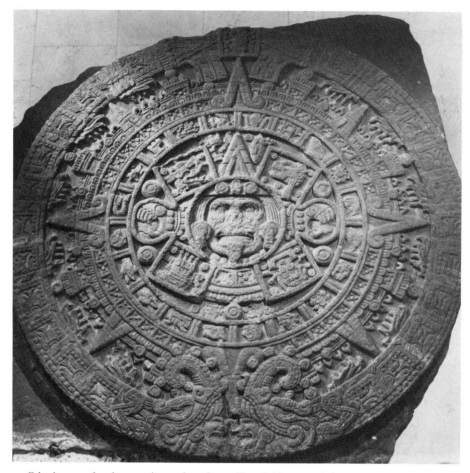

50. Calendar stone found near main temple enclosure, Tenochtitlan, carved after 1502.
Mexico City, Museo Nacional de Antropología

stone[57] of the National Museum in Mexico City, 3.5 m. (11½ feet) in diameter and carved after 1502 under Moctezuma II, displays the face of the sun god surrounded by symbols of the five ages of the universe in a central ring [50]. The ring of twenty day-signs and the outer circumference of two sky serpents (Xiuhcoatl) signify time and space, but no detail identifies the historical present.

Another monument of sun-worship is the stone model, 1.2 m. (4 feet) high, of a pyramid

[51] found in 1926 in the foundations of the National Palace, once the palace of Moctezuma II.[58] It codifies the mythical history of the sun together with the ethical conceptions of sacrificial warfare in a dense and massive symbolic exposition. Upon the temple front, the sun disk is flanked by figures in profile symbolizing the day and night skies in the divine persons of Tezcatlipoca and Huitzilopochtli. The stairway ramps, and the flat surfaces on top of the temple and in front of it, are carved with sacrificial

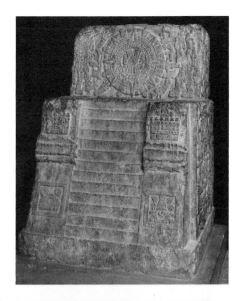

symbols: vessels for the hearts of human victims (*cuauhxicalli*); the crouching earth goddess shown as a skeletal toad; the ball of cactus fibre for the sacrificial needles.

On the pyramid sides, and as if supporting the temple platform, are the figures of four gods shown as penitents – the gods whose self-sacrifice set the sun in motion. On the rear, an eagle alights upon a cactus bearing fruit of human hearts. This scheme not only represents Tenochtitlan; it symbolizes day and night skies, as well as war for the sake of sacrificial victims. The figures of the six gods and of the eagle all bear speech-scrolls signifying war. The pyramid explains human sacrifice and ritual war

51. Stone model (with detail) of a Pyramid of Sacred Warfare found on site of Moctezuma's Palace, Tenochtitlan. *Mexico City, Museo Nacional de Antropología*

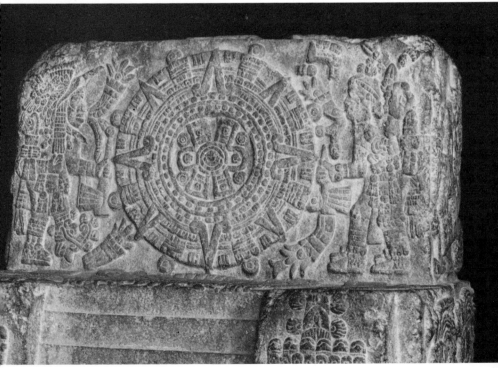

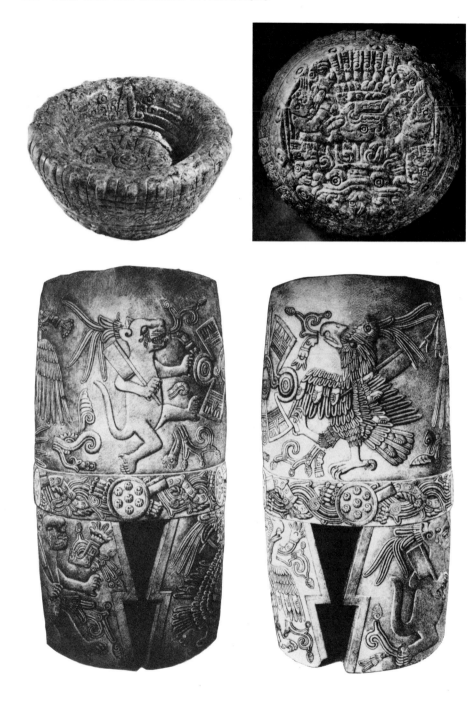

in terms of the repayment of the divine sacrifice whereby the present universe was set in motion.

Many ritual instruments carved of stone display these same cosmic symbols, always buttressing the central ritual of human sacrifice.

52 (*opposite, above*). Stone vessel for heart sacrifices, probably from Tenochtitlan, *c.* 1500.
Vienna, Museum für Völkerkunde

53 (*opposite, below*). Wooden drum from Malinalco, *c.* 1500. *Mexico City, Museo Nacional de Antropología*

54 (*below*). Wooden drum from Toluca, *c.* 1500. *Toluca, Museo*

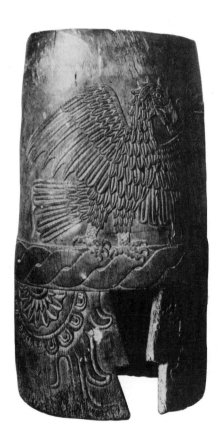

to maintain the gods and, through them, the universe. The 'eagle vessels' (*cuauhxicalli*) were used to hold the hearts of human sacrifices [52].[59] The earth toad on the base, the glyph of the present universe in the bottom (*nahui ollin* = Four Motion, a day sign), stylized eagle feathers on the sides, human hearts on the rim, and signs signifying 'jewelled water' (blood) embody the litany of human sacrifice. The slowly curving surfaces and the incised contours, reduced to ideographic clarity, all betray the persistence of the ancient technique of carving stone with stone tools.

These forms, produced more by splitting and abrasion than by cutting, recur in the rare wood carvings of Aztec date that have survived.[60] The standing wooden drum from Malinalco [53; cf. 54] portrays eagles and tigers in two registers of crisp and linear relief carved by stone tools. As on the stone model of the Pyramid of Sacred Warfare [51], the dancing eagles and jaguars have speech-scrolls signifying war. This theme of interlacing streams of water and fire (*atl-tlachinolli*) also separates the two registers. The dominant glyph of the drum is the four *ollin* sign of the present sun or age of the universe, so that sacred warfare is again the theme carved by an artisan in whose work ancient tradition and virtuosity of technique combine in figured surfaces of changing rhythms. The scale of the registers and the size of the forms are carefully chosen to give a full image from any point of view, and an image that has authority from a distance.

In Mesoamerica a south Mexican ritual of growth and vegetation was associated with the cult of the god Xipe Totec ('Our Lord the Flayed One'). In the spring months, at planting time, a youth chosen to represent Xipe was sacrificed and flayed.[61] His skin was then worn as a costume by a living person, in a symbolic enactment of the live seed within the dead husk, designed to induce and compel the renewal of the earth's fertility. In the Valley of Mexico, a terracotta figure, nearly life-size, and of Toltec date,[62] is among the larger expressions of this cult, which originated in Oaxaca and on the Pacific coast of southern Mexico.

The statues of the gods, whether standing, kneeling, or sitting, reflect this masked interpretation of the god and a human representative. The god's presence appeared as an impersonator clad in godly attributes, who, during the festivals of the god, mingled with the people, a living and moving cult image, of which the stone replicas were immobile representations, kept like capital reserves in the vault-like temple chambers. The full-round statues of the standing or kneeling Xipe Totec are the most obvious examples of the cult image that was both alive and inanimate, of the statue circulating among the people as a token of future growth [55]. The edges of the skin, the stitched seams at the heart incision, and the tie-strings at the back fastening the skin garment upon its live wearer are portrayed with an obsessive fidelity,

55. Lava statuette of Xipe Totec from the Valley of Mexico, c. 1500. *Basel, Museum für Völkerkunde*

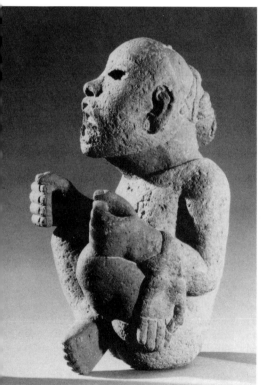
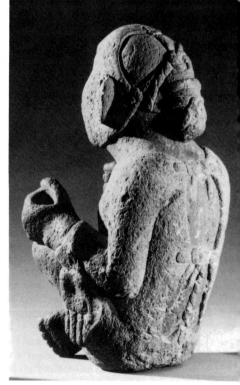

recalling the careful images of knots and binders on the colossal caryatids of Tula.

Since clothing is symbolic of the magical alteration of reality, these layers and attachments pertain to magical compulsion through the change of appearances. The extreme elaboration of costumes and their accessories, both in the written post-Conquest sources and in the sculpture, have long been used as the principal evidence of Aztec religion. Knowledge of this religion centres upon fixed attributes such as skirt-forms, hair-styles, jewellery, and face-paint, by which the interpenetrating identities of the gods can be known. These identities reflect the history of the Aztec conquests, with many cults surviving from older civilizations alongside the new tribal versions of the Tenochca immigrants. The earth goddess is an example: different tribal and historic forms of her double cult, both life-giving and life-destroying, can be identified. These various tribal images overlap with other conceptions of fertility gods and lunar deities, in protean confusion.[63]

The truth is that we are ignorant of all but the main outlines of Aztec religion. Popular worship and priestly lore were different. The priest-hoods were concerned with political power; for the monarch was a priest, and the state was served by the performance of religious duties. The confused and confusing notices of Aztec religion collected during the sixteenth century by Spanish scholars from native sources suggest that Aztec political life in its entirety unfolded within the rituals and ceremonies of the festival calendar, under the direction of priestly corporations with conflicting interests and ambitions.[64] Yet it is misleading to suppose that religion was merely a mask for politics. The conceptions were mingled: political rights and religious rites contained each other completely in Aztec mentality, and the occasions for separating them never occurred to these stone-age priests, among whom the use of metals was still restricted to ornament, and to whom human sacrifice ensured the continuation of being.

The primitive character of Aztec tribal life found its most tremendous expression in the gigantic stone figures called Coatlicue (serpent-skirt) and Yolotlicue (heart-skirt).[65] Both are variants of a decapitated earth-goddess figure peculiar to the Tenochca tribe, who introduced her cult to the Valley of Mexico as the mother of the war-god, Huitzilopochtli. Two great rattlesnake heads confront each other on top of the figure, as if arising from the headless trunk [56]. Serpent fangs adorn her shoulder and elbow joints. She wears a necklace of human hands and hearts. The skirt in one version is woven of serpents, and of hearts in the other. Front and rear views are notably different, not only as images, but also in tectonic effect. The front leans over the spectator as if about to topple upon him. The rear view slopes away from him like a mountainside. The profiles have cave-like recesses under the elbows that once again suggest a geological phenomenon rather than a work of art.

Less forbidding than the cult statues, and more directly expressive of the moral tone of Aztec life, are the sculptural images of men, animals, and plants. Among the figures of humans, many allude to the deities invoked by the actions shown. The stone parturition figure [57] has a calendrical meaning, for the birth of a time-period is represented,[66] at the same time as a woman in childbirth – the equivalent in Aztec belief of a warrior capturing a sacrificial victim. The figure was endowed by the sculptor with deeply expressive particulars conveying the pain and nausea of parturition. The greenish stone has a surface like skin in cold sweat. The tendons of the neck stand out in a grimace of pain. But from her lap a full-grown man's head, the symbol of a new time-period, emerges into life. The piece unites the domains of observation, of expression, and of calendrical ritual.[67]

Expressive power was the distinctive attainment of Aztec sculptors. Their faculty of charging the particulars of experience with clear and coherent emotional tone is most apparent in images of plant and animal forms. An organ cactus, a gourd, a grasshopper, a dog, a hyena,

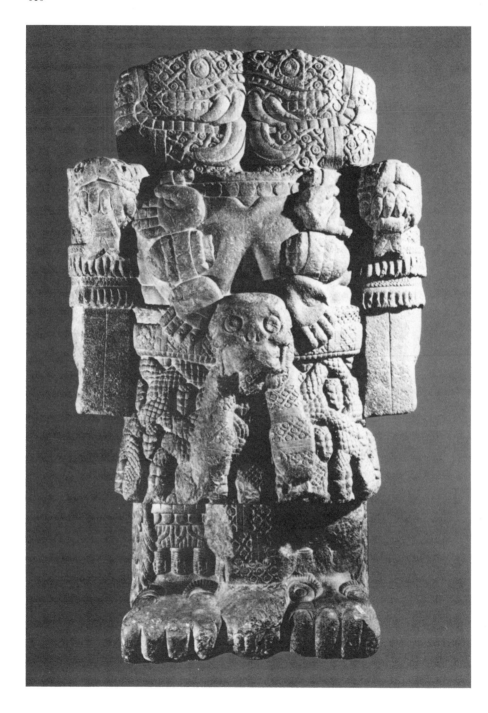

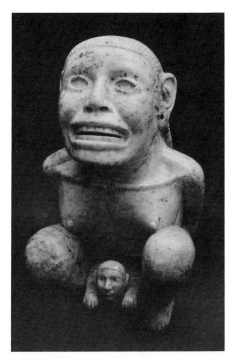

a jaguar [58], or a serpent's coiled body are examples of this art of seizing the most vital aspect of each species. The portraits of humans represent either dead people or people in attitudes of suppliant surrender. Examples of the first are the depictions of Coyolxauhqui, the dismembered sister of Huitzilopochtli [59], on a large relief at the foot of the main temple stairs. From the same excavation comes another relief sculpture in olivine or nephrite representing Mayahuel, a deity of the moon and pulque.[68]

56 (*opposite*). Andesite statue of the goddess Coatlicue, found in main plaza, Mexico City, late fifteenth century. *Mexico City, Museo Nacional de Antropología*

57 (*left*). Deity in parturition from the Valley of Mexico(?), *c.* 1500. *Washington, Dumbarton Oaks*

58 (*below*). Stone jaguar-vessel for blood sacrifices, from Tenochtitlan, *c.* 1500. *Mexico City, Museo Nacional de Antropología*

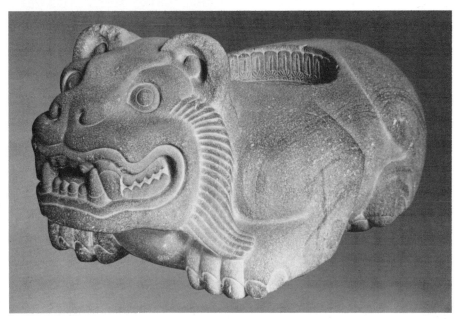

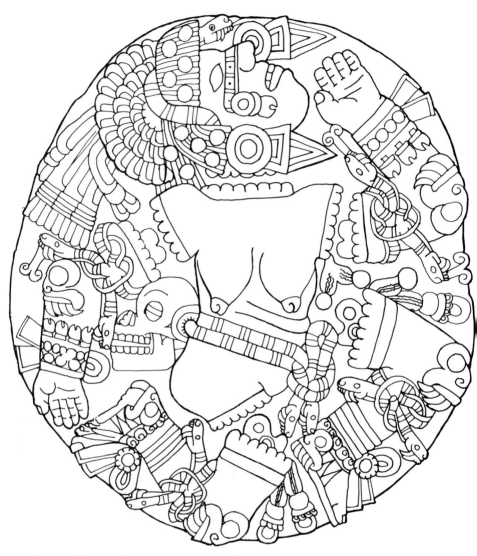

59. Drawing of the monolith portraying Coyolxauhqui,
found at the foot of the main temple stairs of Tenochtitlan, *c.* 1500

Then there is the (severed?) basalt head of a
warrior, which belongs among the great sculp-
ture of the world. This head [60], larger than
life, conveys the sacrificial burden borne by
Aztec humanity, in the belief that through

sacrifice the continuation of the universe might
be assured. Among the portraits of the living the
figure of a kneeling woman in basalt [61] sub-
missively awaits her destiny. The posture, as in
many other Aztec statues, expresses the passive

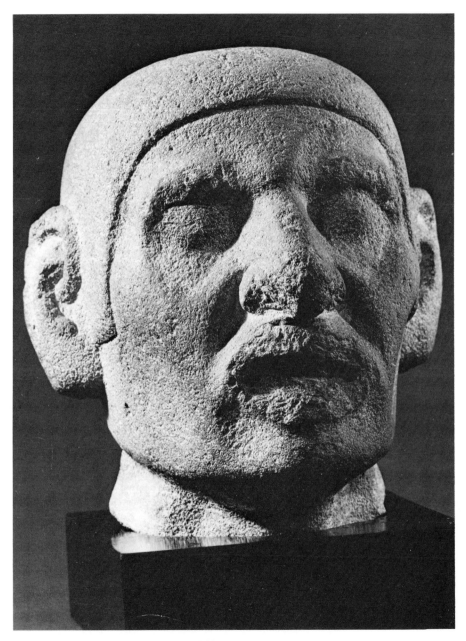

60. Basalt head of a dead warrior from Tenochtitlan, *c.* 1500.
Mexico City, Museo Nacional de Antropología

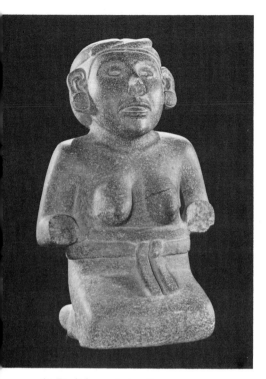

61. Basalt figure of a kneeling woman,
Valley of Mexico(?), *c.* 1500.
New York, American Museum of Natural History

compliance of humans whose death was re-quired in order that the gods might live to endow the earth with renewed vitality.

The lapidary arts concern only small specimens of fine workmanship, because of the rarity and minute size of the raw material. Stones like chalcedony, jasper, obsidian, agate, quartz, and hematite were all valued for weapons and cutting tools more than as orna-ments, though jadeite and turquoise were prized for colour. American jadeite comes in water-worn pebbles from alluvial deposits.[69]

In Aztec society, Xochimilco was the prin-cipal centre of lapidary crafts. Rock crystal, amethyst, and jadeite pebbles were shaved to size with flint adzes. The surfaces were polished with abrasive powders, bamboo fibres, and tools

of hardened copper. For drilling, the work was mounted in a clamp of bamboo, and perforated with tubular bits of copper or of bird bones. Certain hard flints from Toluca were favoured for working turquoise. Opal was polished with sand.[70]

The work of the Aztec gem cutters obeys the stylistic lead of monumental sculpture, with a conservative character that also marks the precious arts of other civilizations. For instance, a jadeite head of Coyolxauhqui[71] in the Peabody Museum at Harvard University copies the forms of the giant diorite head in the National Museum in Mexico City. Aztec metalwork is likewise *retardataire*. The rare examples of gold-work[72] that have survived the Conquest are derivative from Mixtec models and from the forms of monumental sculpture or from manuscript paintings.

Painting

Pre-Conquest Aztec paintings survive only in a few murals, in ceramic decoration, and in featherwork ornaments. We have no certain early specimen of Tenochca manuscript paint-ing. All the painted books[73] known to come from the Valley of Mexico are now accepted as colonial documents, more or less remote from native tradition. Aztec pictorial conventions are nevertheless easily defined; for they continue the tradition of the murals of Teotihuacán and of south Mexican manuscript painting, and they differ fundamentally from European conventions.[74] We may reconstruct the lost book-paintings of Tenochtitlan and Texcoco only by referring to surviving manuscripts produced before the Conquest [131-7] in the region bounded by Cholula and Oaxaca (the 'Mixteca-Puebla' territory), and by using post-Conquest illustrations which retain native tradition.

As among all peoples to whom complete writ-ing was not available,[75] a double burden of re-presenting and of signifying fell upon painters and sculptors. Pictures were expected, in effect, to carry the whole burden later taken by writing.

Hence the painter's conventions gave conceptual images rather than visual impressions of things. The earth (Tlaltecutli) was shown as an open-jawed monster rather than as a gentle or stormy landscape, and certain other conventions for the earth were equally remote from any visible aspect of the thing meant. The morphology of such paintings shows no fundamental changes until the Conquest: the styles vary as the different civilizations change and vanish, but the formal scheme common to Maya and Mexican paintings always remained the same.

This scheme, like dynastic Egyptian drawing, consisted of uniformly coloured areas with unvarying linear boundaries, describing only the most easily recognizable silhouettes.[76] Sometimes a profile is selected; sometimes a frontal view; sometimes front and side views are compounded to give an organically impossible but conceptually clear representation of body motions. Hollow objects and places are shown in cross-section to indicate their interiors. Thus a lake, a boat, or a pot are shown as U-shaped forms; caves are shown in schematic section; houses are rendered as □-shapes to indicate support, load, and interior space all at once [131]. The lower frame of the picture, or of the register, generally equals the ground line, and the upper frame is the sky. The bottom may also be read as near, and the top as far distance. Figures may overlap without marking any intended distance in depth. Distances among shapes are always signified by intervals in width or in height, and never by perspective diminution in an imaginary third dimension [135]. Three-quarter views and foreshortening were never employed. Gradated tones to indicate roundness or shaded forms were also never used. A change in colour usually signifies a change of symbol. The compositional schemes always associate the general ideas of things, and they never purport to describe visual entities under instantaneous conditions. Compositional movement over the surface of many-figured scenes usually means movement in time. Radial compositions generally mean rotating sequences in time, as when the four quarters of a panel or page illustrate calendrical periods by identical figures wearing different colours and costumes [136].

Most murals of the capital were destroyed when the city was besieged, and then rebuilt. Country examples of Aztec wall painting come from the eastern and western boundaries of the central region, from Tizatlán, near Tlaxcala,[77] and from Malinalco [62]. These fragments

62. Malinalco, mural representing warriors or hunting deities, late fifteenth century

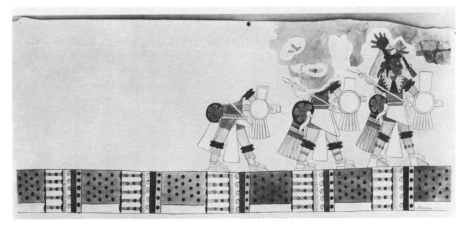

demonstrate an eclectic character. The mural at Malinalco shows three warriors or hunting deities.[78] The proportions and the details of costume relate them to Toltec traditions, as in the columnar figures at Tula. The Tizatlán altars[79] are decorated by small-figure panels [63] derived from Mixtec manuscript traditions.

63. Tizatlán, altar paintings showing Mictlantecuhtli (*above*) and Tezcatlipoca (*below*), after 1000

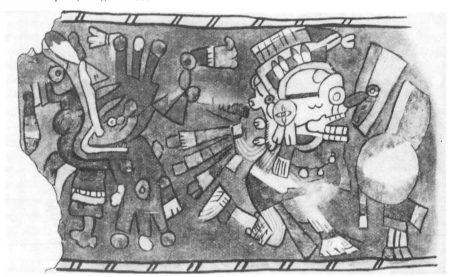

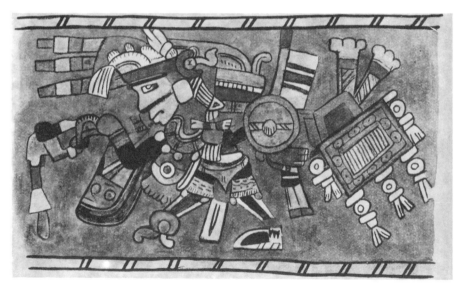

This eclectic situation in painting parallels the variety of metropolitan sculptural styles. The great difference is that the components of Aztec sculpture seem to cohere in the attainment of expressive power, while the paintings adhere faithfully to older traditions, especially in the case of the Tizatlán wall decorations, without a recognizable Aztec reformulation. The Tizatlán figure of Tezcatlipoca, 35 cm. (14 inches) high, is like a page in the Codex Borgia (e.g. p. 21), which in turn is related to south Mexican manuscripts of Mixtec origin (p. 181). Other scenes at Tizatlán, showing deities near bodies of water, also recall the Codex Borgia (e.g. p. 14, ed. Seler-Loubat).

The pre-Conquest schools of Aztec manuscript painting continued long after the Spanish destruction of the libraries, until European conventions of draughtsmanship replaced the native ones. This replacement had already occurred when Indian artists illustrated the ethnographical manuscripts of Fray Bernardino de Sahagún, about 1560. At least two principal styles are known. The manuscripts illustrated with large figures in a more or less cursive style may be ascribed to artists trained in the church schools of the Franciscans at Tenochtitlan and Tlaltelolco. Another early colonial style, of extremely small, glyph-like figures, has been assigned to Texcoco, the Chichimec capital of the fourteenth century on the east shore of the lake. Codex Borbonicus and Codex Telleriano-Remensis are examples of the style of the capital. Codex Xolotl [65] or the Codex en Croix exemplify Texcocan style, which is less animated and more schematic than that of the capital, but closer to Mixtec antecedents.

It should be remarked that the term 'codex', signifying a gathering of leaves sewn or glued together at one side, is often misused in Mexican studies. Codex Borbonicus, for instance, is better described as a screenfold. Its pages are hinged alternately left and right, opening like accordion pleats. Several readers may open in different places at once. Separated passages may easily be brought together for comparison. The pictures are not limited to single pages, and may spread over many panels. The pages often divide into registers arranged in a meander pattern that marks time and imposes direction.

The picture-books of Aztec date, whose existence may be deduced from early colonial versions and from pre-Conquest Mixtec examples, were of several sorts. One group, called Tonalamatl, or 'book of days', served to make astrological forecasts on a ritual calendar of 260 days. Certain manuscripts in this group also illustrate the monthly festivals of the solar year. Codex Borbonicus contains pages devoted to both calendars.[80] From the ritual calendar of 260 days, the eleventh division of thirteen days is illustrated [64]. Patecatl (a pulque god) wears blood sacrifice in his headdress, facing eagle and jaguar emblems. The disk stands for twilight, over offerings and sacrifices. The scene is bordered by day signs and their symbolic birds and night lords. Such manuscripts probably served to regulate festivals, sacrifices, and auguries. Another division portrays the festivals of the 365-day year of 19 months. The 260-day calendar is like those of the Codex Borgia group [137].

A second class of native documents illustrates genealogical sequences, reporting the marriages, issue, and domains of the principal lineages. Codex Xolotl [65] is an example of the Aztec recension of Chichimec lineages along the lines of the Mixtec genealogies of pre-Conquest date (p. 178). The pictorial annals, which describe yearly events in numbered sequence, are represented by several variants: Codex en Croix gives fifty-two years radially arranged on each sheet.[81] Codex Telleriano-Remensis shows a few years to a page, with the number of years per page varying inversely with the importance of the events chronicled.[82] Finally there are administrative documents, such as Codex Mendoza, compiled in 1548 from pre-Conquest Aztec tribute lists for the guidance of colonial administrative officers, listing all kinds and amounts of payment, as well as the towns providing the tribute.[83] All these manuscripts, with the possible exception of Codex Bor-

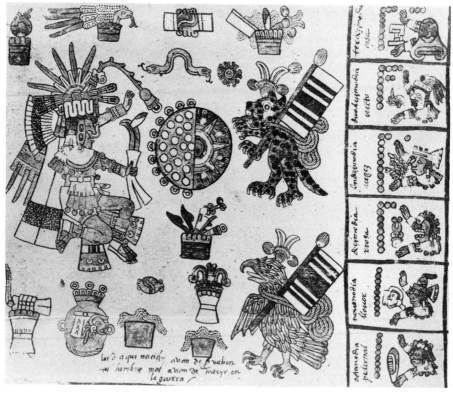

64. Codex Borbonicus, eleventh *trecena*, early sixteenth century.
Paris, Palais Bourbon, Bibliothèque

bonicus, are of historical and ethnological rather than artistic interest.

The archaeological history of ordinary Mexican textiles is unknown because of poor preservation. Yet certain colonial manuscripts[84] describe a great variety of Aztec textile ornaments. Decorated shoulder-blankets were emblems of rank, and Aztec tribute lists report the textiles produced in certain provinces.

Feather garments are luxurious examples of an art of painting characteristic of the last century of pre-Conquest life.[85] The craft of mounting feathers on cloth became common after Montezuma the Elder (1440–69) created the wide network of trade relations maintained by travelling merchants. The feather-workers lived in groups assigned to special quarters of the capital. One group manufactured the garments of the war god, Huitzilopochtli, another prepared only the gifts for Montezuma to present to his allies, a third group worked on Montezuma's own apparel, and a fourth on military insignia for the warriors. The feathers sent as tribute from distant provinces were both glued and tied to the cloth, in designs prepared by painters. The drawings on glued layers of cotton cloth and agave paper were cut out with copper knives, to serve as templates for the

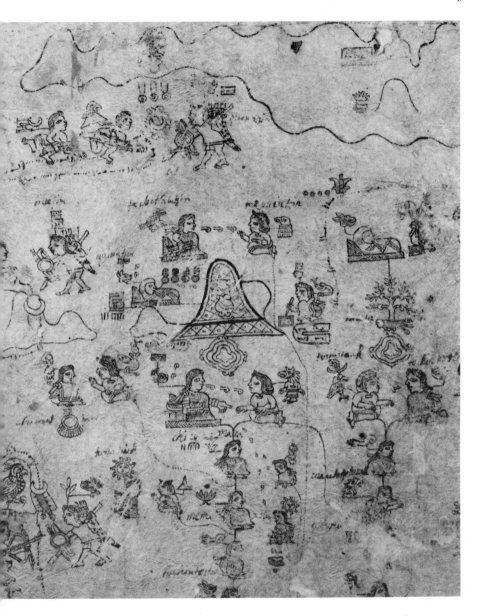

65. Codex Xolotl: The Tlailotlac.
Chichimec chronicle, sixteenth century.
Paris, Bibliothèque Nationale

shaping of the feathers. The shaped feathers were glued to another cotton-and-agave support, in coarse and fine layers. These layers secured mixed tones in the colouring, which intensified the bold effects of the painters. An example in Vienna shows a coyote of cotinga feathers, outlined in gold, on a pink ground.[86]

Painting on Aztec pottery from the Valley of Mexico is distinctly retrograde in comparison with the manufactures of neighbouring peoples, such as the decorated polychrome vessels of Mixtec derivation in the adjacent valley of Puebla. Thin-walled vessels on tripod legs, and bowls painted in cursive black designs on a brown or red ground, are the most common wares.[87] Only a few late examples bear figural designs of birds, fish, and plants in loose brushwork. The appeal of the best Aztec pottery is tactile rather than visual, as in the fragile quality of the eggshell-thin paste.

CHAPTER 4

THE GULF COAST

From south to north, the coastal plains with their dense forests can be divided into three archaeological regions.

(1) The deltas of the rivers of southern Veracruz and Tabasco, on the gulf side of the isthmus of Tehuantepec. These were occupied by the main trunk of Olmec civilization, which had other manifestations from pre-Classic times onwards, in Central America, in Oaxaca, in the Guerrero and Puebla highlands, and in the Valley of Mexico.

(2) Central Veracruz, including the Mistequilla district in the south. This is bounded on the north by the Pánuco river. The district about Zempoala was inhabited at the time of the Spanish Conquest by Totonac tribes. Their name is often, but inaccurately, used to describe the artifacts of the whole central region.

(3) The Huasteca territory, north of the Pánuco river. This is named from tribes speaking an archaic form of Maya, tribes who were separated from their Maya relatives before 1000 B.C.[1]

The southern, or Olmec, peoples were dominant in pre-Classic times. The central coast was most active in the Classic and post-Classic eras. The Huasteca region produced its distinctive forms of art under Toltec influence and later. The three regions are usually discussed together because of geographical and climatic similarities, rather than because of resemblance in culture. Indeed, the external relationships of the three regions were usually closer to the highland territories of central and southern Mexico, or to the lowland Maya, than to one another. The result is a chequered history, reflecting many cross-currents of migration and trade.

THE OLMEC STYLE

The term signifies the rubber-people, the dwellers in Olman. To the Aztecs, whose history is limited to the fifteenth and sixteenth centuries, the name signified an ethnic group strewn to the south, but it included many tribes and several historical transformations, which have still to be elucidated.[2] Archaeological knowledge of Olmec culture is restricted to the Formative period, especially in southern Veracruz and western Tabasco, on the sites of Tres Zapotes, La Venta, and San Lorenzo. M. D. Coe's excavations at San Lorenzo in Veracruz revealed an Olmec-style occupation from before 1200 to 750 B.C., interrupted by an episode of ceremonial destruction at 900 B.C. The island of La Venta in the Tonalá River on the boundary between Veracruz and Tabasco is the other major site in the Gulf Coast 'heartland' of Olmec culture. It likewise was occupied before 1200 B.C., enduring until about 600 B.C.[3] Other sites are Tres Zapotes, north-west of Potrero Nuevo, and Río Chiquito near San Lorenzo. Laguna de los Cerros[4] and others remain to be excavated. Like the art of Teotihuacán and of the central Maya peoples, Olmec art is a recognizable and definable entity. It appears in the highlands of Guerrero, Oaxaca, Morelos, and Puebla, as well as in the Valley of Mexico. Traces of it are evident in the art of the central Maya. The style centres upon anthropomorphic representations of jaguars [69], in sharp contrast to the later Maya and Mexican highland preoccupation with plumed serpent forms [26]. On the Gulf Coast, it is primarily a sculptural style, unlike Maya art, of which the technical origins may be supposed in painting and drawing. The representation of vigorous motions of the body is common. A distinct ethnic type is commonly represented, with pear-

shaped heads, thick everted lips, broad noses, and elliptical eyes [74–6].

As reviewed and systematized by Ignacio Bernal, the Carbon 14 measurements for Olmec I include ancestral pre-Olmec platforms and pottery used in an early jaguar cult antedating 1200 B.C. at San Lorenzo. Its monumental expressions in building and sculpture continued from 1200 B.C. to 600 as Olmec II at San Lorenzo, La Venta, and Tres Zapotes. Olmec objects continued to be made during Olmec III (600 B.C.–100 B.C.) at La Venta and Tres

It probably housed only the priesthood, or temple corporation. La Venta stands on an island in the Tonalá river among the mangrove swamps of northern Tabasco. The principal elevation is a rounded and fluted mound about 420 feet in diameter and 103 feet high. It may originally have been a radially symmetrical platform with four stairways as at Uaxactún (E VII sub) or Chichén Itza (Castillo).[6] The north face overlooks two adjacent courts. The first is framed by parallel mounds. The second or northernmost court was a sunken rectangle paved with

66. La Venta.
Plan before 400 B.C.

▲N

Zapotes. After 100 B.C. Olmec products continued to be made, concurrently with traits either innovative or alien, such as dated writings and dragon volutes, but the Olmec traits are rare and show amalgamation with other configurations (Teotihuacán, Maya, Classic Veracruz).[5]

Olmec architecture is known mainly at lowland gulf coast sites in great river basins. At La Venta [66], the excavations have uncovered part of a large ritual assembly of pre-Classic mounds and enclosures with deep occupational deposits. These indicate a small resident population, supported by dispersed farmers for whom the buildings served as a religious and civil centre.

0 ▬▬▬▬ 300 FEET
0 ▬▬▬▬ 100 METRES

coloured clays and fenced with close-set pillars of natural columnar basalt. These were probably brought by raft from volcanic quarries about 60 miles to the west. Two platforms flank the south entrance to the sunken court; both are floored with mosaics of serpentine slabs and coloured clays, representing angular jaguar masks [67]. The circular mound on the north side of the sunken court covered an elaborate tomb lined and roofed with basalt columns. As if guarding the approaches to this nucleus of enclosures and mounds, four colossal heads of basalt [75] faced out from the precinct like apotropaic figures. The northern row of three heads faced north, and the south head looked south. To the south-east another Olmec site, called the Stirling Group, contains a possible ball-court, carbon-dated *c*. 760 B.C.,[7] and San Lorenzo may have another of later date before 400 B.C.

Two sharply contrasting modes of sculpture appear on the Olmec sites. One tradition, represented by the mosaic floor, approaches cipher-like abstraction. The other, exemplified by the colossal heads, is a tradition of veristic sculpture leading to the most faithful possible transposition of appearances. Full-round figures are often incised with glyph-like notations and figures.[8] Some may represent body designs applied in paint with carved clay or stone stamps; others may denote details of costume; still others appear to be ideographs.

Full-round sculpture, like the colossal-head type, is most abundant in Bernal's Olmec II (San Lorenzo phase). Narrative and scenic reliefs became common during Olmec III (La Venta phase) after 900 B.C., in a tradition continuing at Izapa, at Monte Alban, and later in the Early Classic arts of Teotihuacán and the Maya lowlands.[9]

67. La Venta, mosaic floor beneath east platform at entrance to northern court, before 600 B.C.

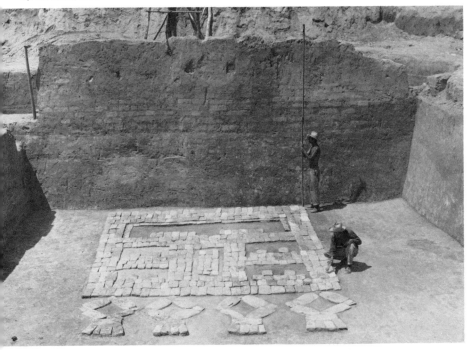

Ideographic Forms

The abstract designs often resemble glyphic notations in an ideographic mode. Altar I and the stone sarcophagus of La Venta (Monument 6) are monumental examples. Altar I is a cubical stone about 6 feet high with jaguar features gathered upon the flat front. Wing-like head-dress panels spread symmetrically over the sides of the block. The general form resembles the stucco masks of the pre-Classic pyramid (Chicanel period) at Uaxactún. The wings repeat a motif used at Tlatilco in the Valley of Mexico.[10] The oblong eyes with rounded corners are like the signs used in Olmec jade-carvings. At Tres Zapotes, Stela C bears a jaguar-mask of the same abstract design. This mask is even more geometric in the mosaic floor [67] of La Venta. Stela C [68] bears numbers written in Maya notation. They have been identified as referring at the earliest to the third century B.C. (Spinden) or 31 B.C. (Thompson).[11]

Further examples of the ideographic style are common in the statuettes and jade celts found throughout the highlands of Guerrero, Oaxaca, Chiapas, and Puebla [69, 70].[12] The use of jade is pre-Classic, as is the technique of shaping and carving the surfaces, which is evident in Olmec figural celts.[13] Two distinct personages are shown on these stone knives. One is an almond-eyed man-jaguar, wearing a helmet like the colossal heads, and having feline fangs protruding from thick and everted lips. The other personage is a slit-eyed infant, characterized by toothless gums within the same everted and trapezoidal mouth, as well as by a split skull, cloven sagitally in frontal representations, and transversally in profiles. This 'baby-face' image on jade celts often displays tufted, flame-like eyebrows. Only one baby-face celt appears at La Venta.[14] The two personages become one on the Gulf Coast sites: Monument 10 at San Lorenzo shows a seated figure with cleft skull and jaguar teeth. The destroyed coffin (Monu-

68. Tres Zapotes, Stela C (31 B.C.?), relief carving of figure seated on jaguar-mask and reverse

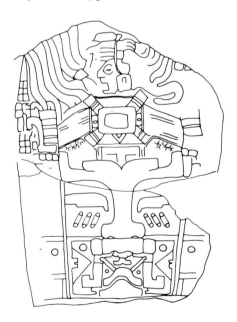
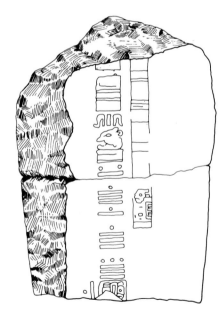

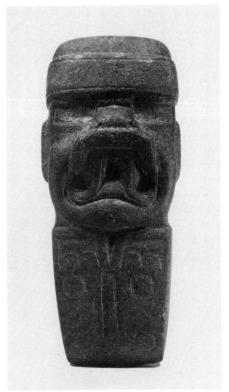

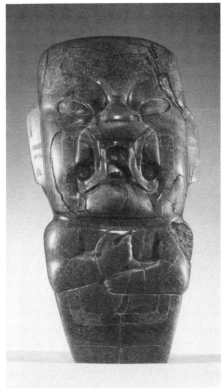

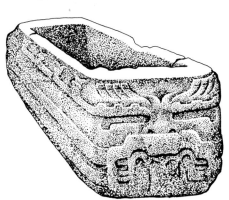

69 (*above, left*). Stone celt from the Gulf Coast(?), before 600 B.C. *Cleveland Museum of Art, Gift of Hanna Fund*

70 (*above, right*). Jade celt from the state of Oaxaca(?), before 600 B.C. *New York, American Museum of Natural History*

71 (*left*). La Venta, sandstone sarcophagus (Monument 6), before 600 B.C.

ment 6) at La Venta had flame eyebrows, oblong eyes, and jaguar fangs [71].[15] The ideographic mode of the Olmec style often contains forms which recall line engravings on close-grained wood [88], and ribboned planes of relief as in wood-carving. These may owe their origin to a vanished early art of shallow sculpture in tropical woods.[16]

Colossal Heads

Accurate anatomical relations and visually faithful modelling are the distinguishing traits of the colossal heads. Sixteen are at present known: one at Tres Zapotes, another from Cerro Nestepe, four at La Venta, nine at San Lorenzo, and one in the Tuxtla mountains. Some San Lorenzo heads [72] were long ago

Cobata in 1970, high on Cerro Vigia among mounds in a ravine.[18] Its conical profile is like that of the Cerro Nestepe head, and its puffy coffee-bean eyes are unique. The ox-yoke brow seems typologically earlier than the brows of the heads at La Venta or San Lorenzo, and closest to the head from Tres Zapotes [74]. Two heads are almost spherical, and nearly devoid of animation: Tres Zapotes and La Venta 1. The

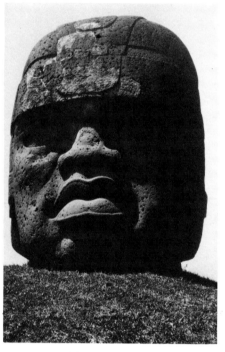

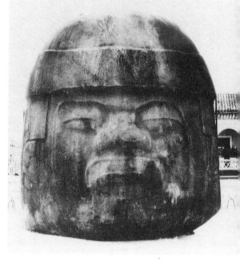

72 (*left*). Colossal head No. 1 from San Lorenzo Tenochtitlan, after 1200 B.C.(?). *Jalapa, Museo de Antropologia de la Universidad de Veracruz*

73 (*above*). Colossal basalt head found near Cobata, now at San Andrés Tuxtla (Veracruz)

mutilated and buried.[17] They probably once stood, like the head at Tres Zapotes, upon foundations of unmarked stones. All may once have been coated with smooth purple-red paint on a white clay base, of which traces survive on part of the north-west head (No. 4) at La Venta.

These heads occur throughout at least two, and possibly more, generations of sculptors, working with stone tools, repeating the same theme with varying skill and power. The largest of them all [73] may be the oldest, found near

first seems arbitrarily rotund, with the features protected from accident by the beetling projection of the helmet across the brow and along the cheeks. The eyes are rimmed with heavy borders, and the eyeballs have a marked convex curvature. The ears are abstract ciphers. The expression is grim and hard, without the supple modelling of all the other heads. La Venta 1 is also spherical, but the helmet meets the face in a less harsh line. The modelling of lips and eyes, though puffy, is more vivacious.

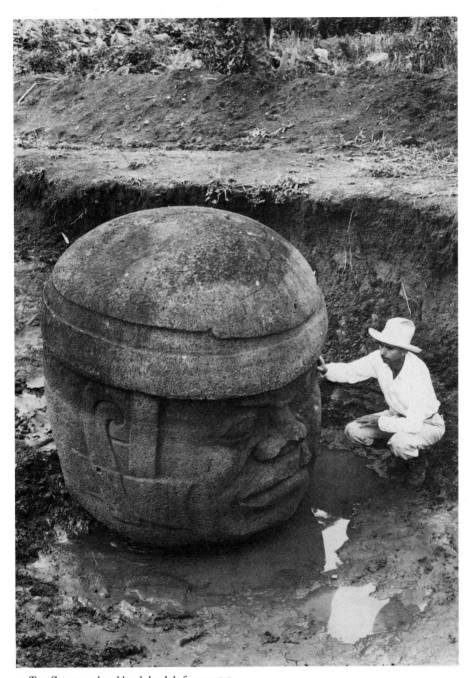

74. Tres Zapotes, colossal basalt head, before 400 B.C.

A second group of four is distinguished by parted lips, communicating an expression of speaking animation. Two in this group are spherical, and two are long-headed. The long heads (La Venta 3 and San Lorenzo 1, 2, 3, 4, and 7) are more lively than the round heads (La Venta 2 [75] and 4 and San Lorenzo 5 [76], 6, and 9). La Venta 3 has deeply shadowed eyes and lips, suggestive of emotional tension, as in Greek sculpture under the influence of Scopas. The round heads (La Venta 2 and 4) are perhaps more animated in the open mouths, but the

75. Colossal basalt head No. 2 from La Venta, before 400 B.C. *Villahermosa, Parque Olmeca*

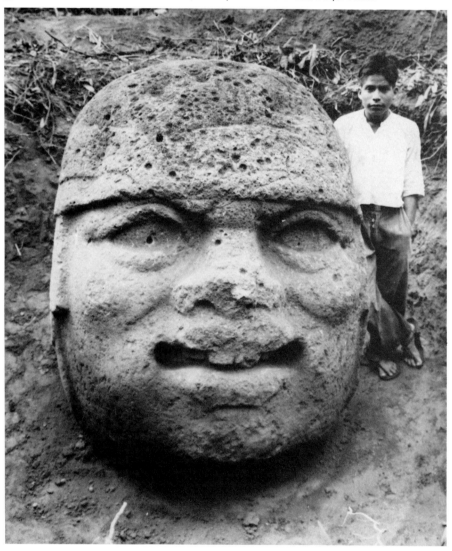

total effect of an inner emotional state is less apparent.

Many heads have the iris flattened, or in raised relief or incised upon the eyeball, in a commanding expression of focused gaze. All are like ideal portraits expressed in firm flesh, heavy muscles, and articulated profiles. An effect of majestic willpower and discipline is achieved by studied proportions and contours, in a composition of idealized physiognomic parts.

The round heads of grim aspect [74] may be earlier than long heads of majestic expression [72]. An intermediate group of long heads and round heads is characterized by parted lips [75]. Such a progression might require no less than one century of connected efforts by specialized

76. Colossal basalt head No. 5 from San Lorenzo Tenochtitlan, after 1200 B.C.(?).
Jalapa, Museo de Antropología de la Universidad de Veracruz

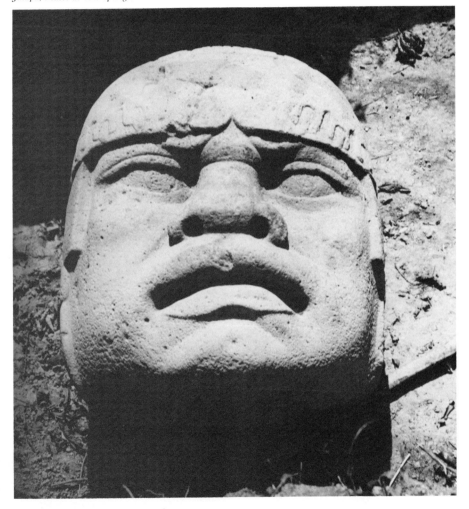

craftsmen giving all their time to the work, possibly with interruptions of undetermined length.[19] The span is not easy to date, because of possible removals of the heads to different sites, as well as their burial and re-use during many centuries. From these data alone it is impossible now to seriate the heads, but it remains significant that the stones were buried on purpose at different depths. Given their intrusive position in the strata of San Lorenzo, the problem is like that of dating the sculpture in a museum by the architecture of the museum building which houses it.[20]

Relief Sculpture

At Tres Zapotes, Stela D [77] is an example of the relief sculpture that was possible in the Olmec centres perhaps as late as Olmec III (600–100 B.C.). The three standing figures are framed within the jaws of an animal mask. Their kneeling, standing, and striding postures show the legs in separated profile, and the torsos in frontal view, as at Izapa, and on the Leyden Plate and in the Cycle 8 reliefs from Uaxactún.[21] Stela A from Tres Zapotes presents a similar formula beneath a stylized jaguar-mask of Olmec type.

Many immense altar stones show a spirited enlargement of the possibilities of portraying space and action in relief. Seven are at La Venta, and others appeared at Potrero Nuevo [81] and San Lorenzo. At La Venta, Altars 4 and 5 are the best preserved, with human figures emerging from rounded niches beneath the flat top. On Altar 4, a carved rope connects the seated figure in the niche with another seated figure in profile relief at the side. On Altar 5 the emerging figure bears a reclining infant. The four seated figures on the sides restrain dwarfs or infants of

77. Stela D from Tres Zapotes, before 100 B.C. Basalt. *Mexico City, Museo Nacional de Antropología*

78. Altar 5 from La Venta, side, before 400 B.C. Basalt. *Villahermosa, Parque Olmeca*

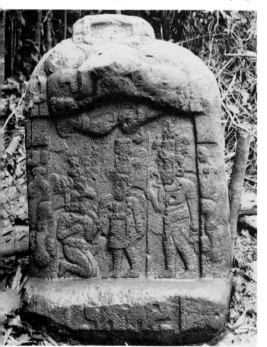

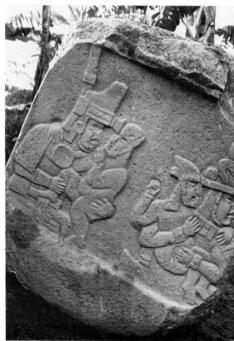

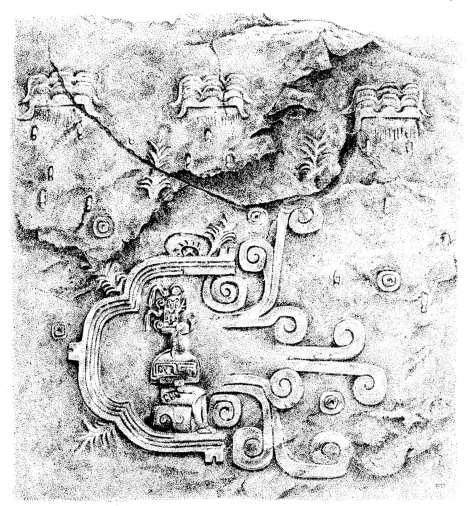

79. Chalcacingo (Morelos), Petroglyph 1, before 100 B.C.

Olmec profile, with slit eyes, everted lips, and deformed or notched skulls [78]. Seated reliefs of this type do not appear in Maya sculpture until the seventh century A.D. at Palenque.[22]

The large relief carved on a cliff at Chalcacingo [79] has invited many explanations, among which the common elements are the representation of a cave in ideographic profile, containing a seated figure and surrounded by scrolls of smoke or sound, beneath banked cloud signs discharging raindrops. The scene resembles Stela 2 at La Venta and Stela D from Tres Zapotes [77], both of Olmec III date.[23]

Vigorous body motions are most ambitiously combined on Stelas 2 and 3 [80] at La Venta. The principal figures are on stiff parade, but they are surrounded by flying or leaping jaguar- and bird-men, strangely evocative of those on Mochica pottery. They bear axes or poles and wear armour.[24] In Maya reliefs, these animated

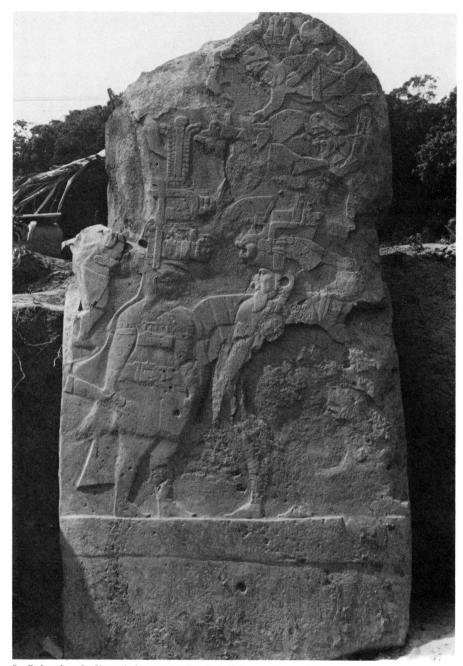

80. Stela 3 from La Venta, before 400 B.C. Basalt. *Villahermosa, Parque Olmeca*

secondary figures were common during the Early Classic period (before 400). The ornate basalt box from Tres Zapotes, with armed warriors of this type, shown fighting among scrolls,[25] probably belongs to a terminal phase of Olmec sculpture. The scroll theme with scalloped outlines is prominent at the Chalcacingo cave relief in eastern Morelos [79], where such scrolls emanate from a stylized cave or mouth. Olmec iconography can best be studied in these complex scenes, where the meaning of the component elements is suggested or revealed by context. Many Olmec themes reappear in later periods of Mesoamerican art, but as in the ancient Mediterranean world, such similarities of

form do not guarantee identities of meaning. An Olmec example is the seat or pedestal from Potrero Nuevo, supported by atlantean figures in high relief. These atlantean dwarfs recur in a similar context as supporters beneath a dais or platform at Chichén Itza in the cella of the Temple of the Warriors [246], but their meaning is probably different. The Potrero Nuevo seat [81] bears a carved edge, resting on the supporters' hands, which represents stylized and geometric serpent fangs, like those of the serpent-head cloak shown on the Atlihuayán figure [4]. These may connote the sky and thereby the celestial nature of the person on the dais.

81. Monument 2 from Potrero Nuevo (Veracruz), Olmec Atlantean table, after 900 B.C. *Villahermosa, Parque-Museo La Venta*

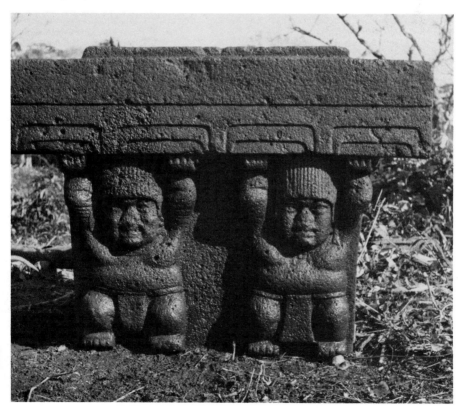

Figurines of Clay and Jade

Drucker distinguishes three technical varieties of clay figurine manufacture: with features made by punching, by slitting, and by modelling.[26] All the figurines show a stem, to which the face plane was joined. The turban or hair is a third piece, added to cover the joint between the stem and the face. Common to nearly all Tres Zapotes and La Venta figurines is a vivacious convention for the eyes, with deep central punctations at the iris, flanked by triangular punches. Each eye is an inverted V, so that the glance is upward or to one side [82, 83]. As these techniques of figurine manufacture occur in the lowest strata of the Tres Zapotes excavations, they antedate the monumental stone sculpture. They show nothing of the linear abbreviation and shorthand pictorial symbolism of the ideographic manner. They are related, however, to the colossal heads. The group with parted lips, in particular, and the heads of San Lorenzo with incised iris and upward gaze [76], clearly belong to the tradition of the figurines with animated gaze. Dwarfs, hunchbacks, babies, and women are among them.

The broken fragments of bodies[27] belonging to the figurine heads likewise give a clue to the history of the jade carvings, which show such mastery of bodily motions and anatomical relations. Several seated figurines show a remarkable equilibrium of weights and motions. The legs are folded in under the seat; the upper torso leans forward, with the hands grasping the knees. The front view is oblong, the profile is triangular, and the ground plan is trapezoidal.[28]

82 (*below*). Pottery figurine heads from La Venta, various periods. *Mexico City, Stavenhagen Collection*

83 (*opposite*). Olmec pottery figurine from La Venta, before 400 B.C. *Mexico City, Museo Nacional de Antropología*

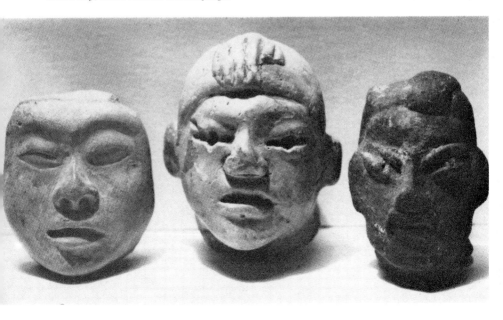

The jade figurines of La Venta, from the tomb lined with basalt columns, are certainly pre-Classic in date, like all the La Venta sculpture. One represents a seated woman, with a small hematite mirror mounted on the chest. This is carved of whitish jade mottled with blue-grey patches [84]. The other figure, of green and white jade, shows a dwarf-like male, modelled in supple planes. More stereotyped are the standing jade figures, with undifferen-

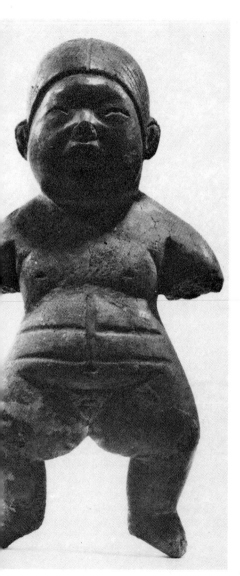

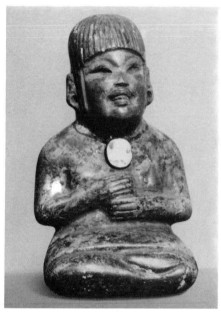

84. Seated woman from Tomb A, La Venta, before 600 B.C. Jade and ilmenite.
Mexico City, Museo Nacional de Antropología

tiated arm and leg endings and an undulant body profile, like a warped slab. These La Venta jades may come either from different periods (as heirlooms?), or from different workshops of greater and less refinement during the same period. Their appearance together in the same deposits shows a general La Venta style of jade working.

They raise the question of the mutual dependence of the clay and jade traditions of figurine manufacture. Certainly the clay figurines are an older tradition, but they are so hastily made, and so conventional [82], that one is reminded of the diminutive replicas of famous monuments

executed in ordinary materials which pilgrims or tourists acquire as souvenirs of travel today. Indeed most clay figurines from La Venta and Tres Zapotes can be loosely associated with a corresponding piece of monumental sculpture or with a jade carving. The types are few, and the general style is the same.

The relationship between the makers of clay figurines and the sculptors of stone and jade must have been one of reciprocal exchanges. The clay figurines came first. In Early Classic centuries, the sculptors and lapidaries acquired the technique for translating the postures and expressions of clay figurines into stone and jade. These new forms of monumental or jewel-like character then affected the work of the artisans in clay, who cannot have avoided making diminutive replicas of the colossal heads and jade statuettes.[29]

Olmec culture on the Gulf Coast is marked by a preference for permanent materials: in a region of tropical hardwoods the ceremonial court and the principal tomb of La Venta were walled about with basalt columns. The colossal heads manifest a pharaonic desire for eternity, for survival beyond all the accidents of time.

But basalt and jade not only induce permanent form; they permit the sculptor to investigate kinds of form that are not so easily available to the potter. The brilliance and deep translucence of polished jade called for a special organization of the surfaces, by curving planes smoothly passing around the shape. At the other extreme, the Stone Age sculptor could experiment with visual effects of skin texture and muscular interplay only when working on the colossal scale of the great basalt blocks. The coarse scale of his stone tools could be overcome at first only by magnifying the scale of the work. Like Stonehenge, the early work is immense because the tools are simple. Their furrows could only gradually be made small enough for working jade. By this hypothesis of primitive macrotechnics, colossal heads might pre-date diminutive jade sculpture.

Working in jade and basalt, the Olmec sculptors gradually learned a most extraordinary

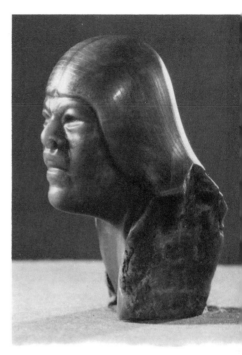

85. Head and shoulders of a woman (fragment) from southern Veracruz, before 400 B.C. Jade. *Washington, Dumbarton Oaks*

realistic technique. Three jades in the Bliss Collection demonstrate this stage of lapidary art: the fragmentary head and shoulders of a middle-aged woman [85] and the statuettes, in aggressive poses, of a jaguar and of a middle-aged gladiator [86]. The woman is shown as if sobbing, with dilated nostrils and furrowed brow. The translucent surfaces enhance an expression of deep emotional disturbance by their suggestion of wetted skin. The bald athlete has the musculature of a hominid; his belly and forearms are lined with bulging veins, and his posture is aggressive. The blackish-green colour and the opaque brilliance of the stone reinforce the expression of bestiality and violence. The statuettes are surely Olmec, and they are probably late, perhaps related to the San Lorenzo heads.

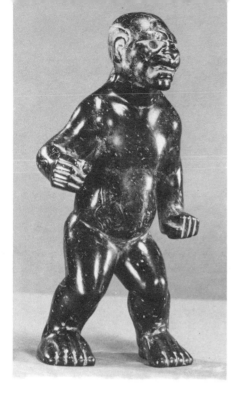

An Olmec statue is a bearded and seated athlete, slightly less than life-size [87]. The spiralling motion of the body, the multiplicity of profile, the coherent muscles, and the expressive restraint of the work set it apart as among the great works of sculpture of all ages. In it several kinds of technique meet: the study of expression possible in jade; the study of movement possible in clay; and the large surfaces of the colossal-head tradition.

Miguel Covarrubias,[30] the Mexican painter, first ventured to interpret the conventional meaning of these forms. He believed that the figures of jaguars, dwarfs, and babies were stylized representations of an 'Olmec ethnic type' of Asiatic origin and of great antiquity, modified by pathological, infantile, and feline

86 (left). Gladiator from southern Veracruz(?), before 400 B.C. Jade. *Washington, Dumbarton Oaks*

87 (below). Seated athlete from Santa María Uxpanapan, before 400 B.C.(?). Stone. *Mexico City, Museo Nacional de Antropología*

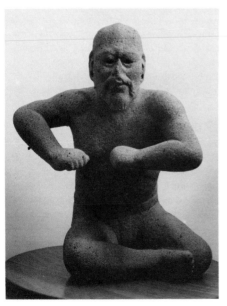

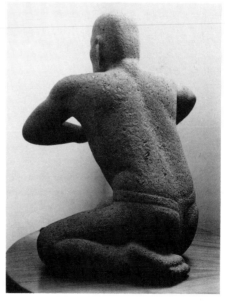

traits. According to Covarrubias the figures may represent jungle spirits, called *chaneques* by the modern inhabitants of the Veracruz coast. The *chaneques* are mischievous old dwarfs with baby faces, who play pranks on human beings and provide rain if propitiated. In the tiger-traits Covarrubias saw a totem symbol,[31] perhaps related to later Mexican cults of a tiger as earth god and symbol of the night. On these assumptions, Covarrubias constructed an iconographic genealogy, progressing from the archetypal baby-face to Maya serpent-masks and the Aztec rain god. The flame-like eyebrows of the Olmec faces became the eye-rings of the Maya and the Mexican rain-god figures, Chac and Tlaloc. Covarrubias laid much stress upon the intrinsic simplicity of the Olmec style. Maya, Zapotec, and Teotihuacán styles, he maintained, all show Olmec traits in their oldest artifacts,[32] but Olmec art contains the traits of no other styles.

Certain parallels have been drawn between Olmec and Chavín art in the Andes. Both represent anthropomorphized feline monsters by incisions and flat low reliefs of ideographic character. Both use few fundamental forms. In both there is a peculiar convention of ending or articulating an organic form with smaller repetitions of the same organic form. For instance, the profile baby-face on a jade plaque [88] has the same profile repeating on the forehead and in the skull. It is repeated twice more on the cheek. The main profile not only contains itself at various places; it is built up of connected repetitions. The same method appears in Chavín art,[33] where a feline body may consist of jointed and repetitious statements of a profile feline mask [321]. Both styles are probably related to the same kind of social organization, in which the earlier villages of farmer-artisans were brought under the control of priests. In such theocracies, stratified into peasant and hierarchic groups, the priests shaped and defined a life increasingly ruled by auguries and sanctions. Temple corporations, holding and manipulating the wealth of the new ritual community, were probably the characteristic political institution. The style sponsored by the temples shows an aversion to everyday secular experience. It suggests terror and awe by monstrous forms. This art not only illustrated a cosmology: it was an evangelical method of instruction. Under the economic order of the temple theocracy, specialized and professional artisans came into being. The colossal heads and the jades can have been carved only by professional sculptors relieved from all other work, and maintained by the community.[34]

88. Incised jade plaque from southern Veracruz(?), before 400 B.C. *Mexico City, Museo Nacional de Antropología*

Painting

Important discoveries at two highland caves in Guerrero, Justlahuaca (1966) and Oxtotitlán (1968), have revealed extensive areas of richly polychrome parietal decorations in Olmec style.[35] The caves are about 30 km. (20 miles) apart: at Justlahuaca the paintings begin 3,400 feet from the cave entrance. They are executed in red and yellow ochre and black, showing a human standing 5 feet 5 ins. high over a figure seated in the 'jaguar-pose' common in Olmec sculpture. Other drawings may portray a building, jaguar heads, and a plumed serpent.

89. Oxtotitlán,
cave painting of figure seated on jaguar-mask,
after 900 B.C.(?)

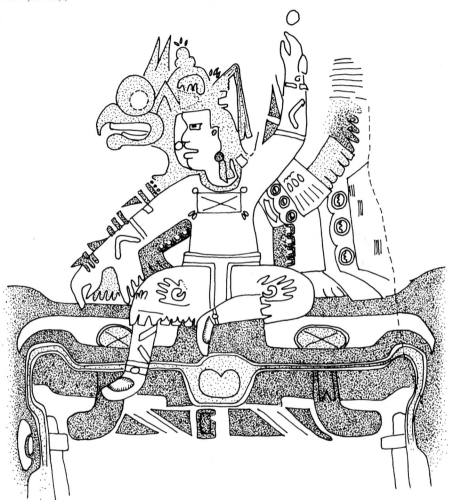

At Oxtotitlán two shallow grottoes in the face of a cliff are painted with mineral pigments in an oil base. Mural 1 (3.8 by 2.5 m.; 11½ by 8¼ ft) shows a frontal human seated on a jaguar-head dais [89]. Another painting shows a standing ithyphallic human close behind a jaguar. Similar scenes in sculpture are known from the district around San Lorenzo on the Gulf Coast. Other paintings show feathered serpents, and a baby-face, in a style closer to La Venta than to San Lorenzo. Grove suggests an underworld union between man and jaguar, producing the jaguar-rulers who are shown at La Venta seated in the jaguar-cave mouth.[36]

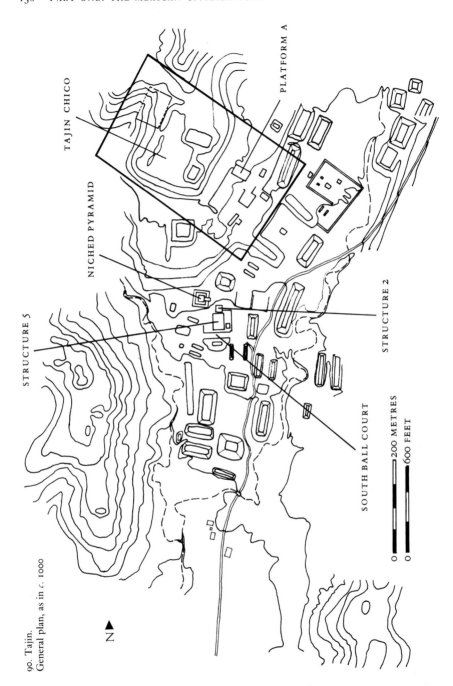

90. Tajín.
General plan, as in c. 1000

N

THE CENTRAL COAST

The region from the Mistequilla to Papantla – from the sandy coastal plain south-east of Veracruz to the tropical forest 120 miles farther north – is usually identified as the seat of the Totonac civilization.[37] The only historical notices of this people, gathered soon after the Conquest, make it clear that the Totonacs then lived only in the southern district between the Tuxpan and Antigua rivers. No clue survives as to the identity of the peoples occupying the northern sites during the Classic era. For these reasons it is less misleading to refer to the region by chronological terms – Classic Veracruz, and post-Classic – than by ethno-historical names of doubtful relevance. This usage excludes Olmec sites in southern Veracruz. It embraces both central and northern Veracruz as the central sector of the Gulf Coast, spanning the region between the Papaloapan and the Pánuco rivers.

Architecture

Tajín, near Papantla in the north, is an archaeological centre of the same order of magnitude as Uxmal, Monte Alban, or Copán.[38] Its recently defined archaeological history spans about 1000 years from the first to the eleventh century after Christ, in twelve building periods.[39] Tajín II (second century) shows the earliest terraced pyramidal platforms at the site, associated with pottery characterizing periods I and II at Teotihuacán. Fretted friezes carved in ashlar masonry occur at Tajín III before 400. The early ball-courts are assigned to Tajín IV, *c.* 500, followed by the Pyramid of the Niches in Tajín V before 600. The North Ball-Court is dated in Tajín VI as of 600. Construction at Tajín Chico began about 700 in Tajín VII, continuing through Tajín VIII–XII, from before 800, until *c.* 1100, when the site was abandoned after destruction.

In plan Tajín comprises two distinct zones [90]. The southernmost group of square and oblong platforms faces the cardinal points, and it includes old constructions like the Early

Classic niched pyramid. A Late Classic zone, Tajín Chico, lies on higher land north of the early edifices, and is orientated upon different co-ordinates. The main axis runs north-west to south-east, intersecting the north-south axis of the first group at an angle of about 60 degrees. This difference in orientation may obey topographic limitations. All the newer platforms and buildings of Tajín Chico cluster along a shoulder of the north-western hill. On still higher ground is the latest building at Tajín. This columnar structure stands upon the platform dominating the entire system. Its chronological position in Period XII at the end of Tajín is fixed by sherds in the masonry, pottery from the older building-periods.

The square pyramid of Tajín [91] is probably the oldest edifice (before 200–600 A.D.) on the

91. Tajín, principal pyramid, before 600. Elevation and plan

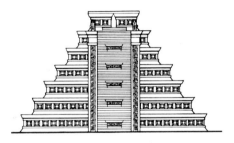

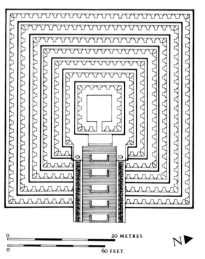

0 _____ 20 METRES
0 _____ 60 FEET

N▶

92. Tajín Chico, Platform A, seventh century(?)

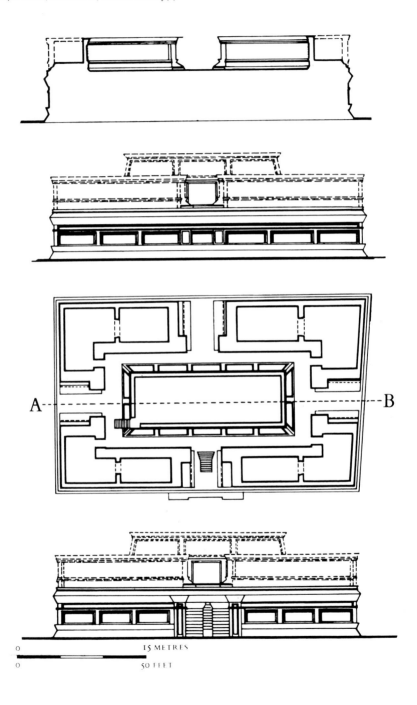

0 15 METRES

0 50 FEET

site, and it is the most imposing one, facing east, and rising in seven stages. Each terrace riser is deeply shadowed by window-like niches in seven chain-like girdles, completely surrounding the pyramid on all four sides, and continuing beneath the eastern stairway, to number 364 or more. The nucleus of river boulders and clay is faced with small slabs of sedimentary rock. Upon these terraces, the superstructure of niches, built of flat sandstone spalls, rises with slanted cornices casting deep and angular shadows. The niches are volumes of about cubical shape, over two feet deep, opening out upon the terrace risers by stepped frames of two or three reveals. The section reappears in terrace profiles at Cholula [13]. Here, however, the vertical face is shadowed by the immense overhanging cornice, reflecting the talus as an inverted incline. The purpose is to enrich the composition of the shadows with animated rhythms, and to stress the vertical components in the silhouette. The slanting overhangs are like the re-curved eaves of Japanese roofs: the silhouette and the surfaces flicker with chequered shadows as the sun swings over the building.

The slanted cornice overhanging a band of niches reappears on other platforms in the older part of Tajin. At Structures 2 and 5, on the southern side of the main plaza dominated by the niched pyramid, the effect is different. The band of niches is like a jewelled belt encircling the platform. The standing cornice projects, while the talus below spreads out like a billowing skirt. Both the proportions and the vertical separations in the nicheband are altered to stress its horizontal continuity. This continuous effect reappears in the balustrades, worked with terraced meanders, flanking the stairs of the main pyramid.

Tajín Chico has much more complicated buildings, erected probably after A.D. 600. Platform A may be described as a pedestal, built before 800, bearing a small truncated platform, in the centre of four two-room apartments [92]. The scheme resembles the pyramid at Xochicalco [26] in its exterior massing. The plan

evokes the courtyard buildings of Mitla [125]. In the south façade, a true stair-shaft rises within a symbolic façade stair of nearly vertical plane, flanked by the same terraced meanders as at the niched pyramid to the south. This symbolic stair resembles those of the Maya temples of the Río Bec area in the centre of Yucatán [183].

At Tajín Chico the resemblance of Platform A to Maya architecture is strengthened by the massive roof slabs, now ruined, made of lime and pumice-stone poured like concrete on a temporary armature [92]. At the façade stair, overhanging cornices of Tajin style meet over the stairway, to make a triangular arch-head like the corbelled vault section of the Maya. This device reappears on a larger scale in the facing of the immense courtyard opening eastward from Tajín Chico below the level of Platform A. The entire court is faced with alternating niches and Mayoid doorways, formed by the meeting profiles of adjoining niche-cornices. Buildings D (before A.D. 1000) and K, on the other hand, recall the battered profiles, geometric decoration, and trabeated interiors[40] of the 'palace' buildings of Mitla.

At Tajín Chico as well, these resemblances both to Yucatán and Mitla appear repeatedly. Such architectural efforts to compose elaborate inner spaces with ornate geometric exteriors, at Mitla, in the Puuc district and Río Bec in Yucatán, at Xochicalco and Tajin, characterize the centuries from the close of the Classic era until the rise of Toltec-Maya civilization, from about A.D. 600 until 900 or 1000. Tajín Chico stood on the periphery, receiving and transforming ideas of which the origins were both Maya and Oaxacan. The originality of the style of Tajín lies in the bold chiaroscuro, achieved by the flaring cornices, the deep niches, and the many planes of geometric ornament.

The most recent edifice of Tajín Chico may be the columnar building [93] which dominates both its own western plaza and the entire sweep of the lower buildings. The east façade was a colonnade of six cylindrical shafts built of thin carved drums, supporting a gently curved vault

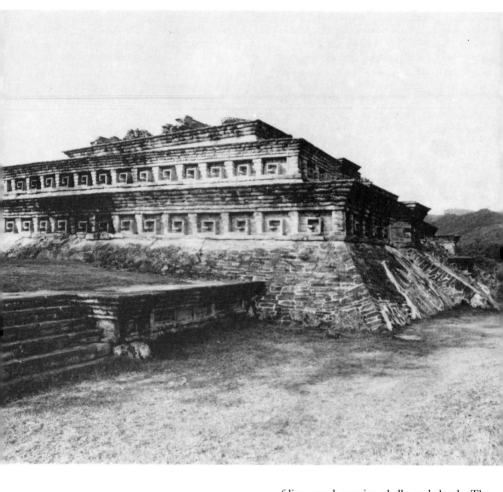

93. Tajín Chico, columnar building, tenth century(?)

of lime, sand, pumice, shells, and sherds. The stairway rising to this platform has stuccoed balustrades with rectilinear decoration derived from snake (*crotalus*) rattlers. The stair itself is flanked by retaining walls decorated with immense rectilinear stepped frets in deep relief. The scale and the proportions of this ornament were designed to be visible from great distances. The columnar edifice is separated from the early monuments by many generations of connected experiments. These tended to enclose space more ambitiously, and to achieve brilliant chiaroscuro effects of surface with recessed geometric decoration.

Architecture of a presumed Tajín date on the central coast has been identified at Misantla.[41] The flaring cornices, imposed upon a sloping talus, simplify the Tajín formula, and prefigure the Aztec balustrades rising at a steeper angle near the head of the stairs. Beneath the Misantla stairway (Mound B) is a tomb on a T-plan in the core of the platform, like those of Mitla in Oaxaca [126].

Later than Tajín are the Totonac ruins of Zempoala, 20 miles north-west of Veracruz, where the Spaniards in 1519 saw a great Mexican city of 30,000 inhabitants. The ruins cover many courtyards, but only a few sections have been excavated.[42] Near by are sites yielding older remains: Las Animas, with its clay figurines of Teotihuacán style, Remojadas, yielding 'smiling' figurines of Classic date, and Cerro Montoso, abounding in pottery of Mixteca-Cholula style.[43] Zempoala itself contains traces of archaic settlement, but its great period was as a Totonac centre, subject to Tenochtitlan, occupying a focal point on the trade routes connecting the coast, the highland, and Yucatán. The roomy, many-chambered temples recall Maya edifices; the wide pyramidal platforms resemble Cholula; and the stairway profiles are like those of Aztec design, with an abrupt change of angle near the top.

Stone Sculpture

The origins of the Classic Veracruz scrollwork style now are recognized as having antecedents in Chiapas (Chiapa de Corzo VI) as well as at Kaminaljuyú (Miraflores phase), i.e. c. 250 B.C. – A.D. 100,[44] in the late pre-Classic period. Later monumental sculpture on the central coast is known from Cerro de las Mesas in the Río Blanco basin of southern Veracruz,[45] bearing dates of the type known as the Initial Series, with relief carvings related to Early Classic Maya. The dates (Katuns 1 and 4 in Cycle 9 – c. A.D. 455 and 514) and the style agree.[46] The profile stances of the figures, with the aprons shown in frontal view, are the principal evidence confirming the Early Classic dates on Stelas 6 [94] and 8.

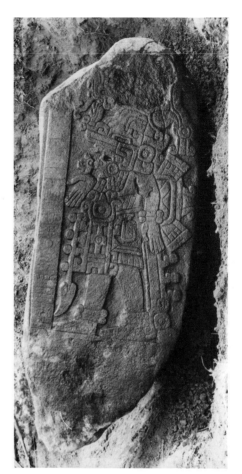

94. Cerro de las Mesas, Stela 6, dated 468. Basalt

Two kinds of carving appear on these basalt stelas. The bounding profiles between the figure and the ground are vertical cuts. The inner contours are bevelled, showing overlapping planes in shallow depth; for instance, where the apron and the flesh of the legs meet. Conceptual clarity was the sculptor's first concern. The left hand of the figure is correctly shown, but the right palm turns out with fingernails showing, like another left hand, in an anatomically impossible position. In effect, both hands show palms and fingernails as if in a simultaneous

cubistic image of different body-states. All accessories are preternaturally enlarged for the sake of clarity. The derivation of this art from a linear draughtsmanship invented by painters is clear. The squat proportions, the heavy body parts, and the magnified scale of all costume elements resemble the Monte Alban reliefs[47] and tomb murals as much as they do Maya art of Early Classic date.

Nothing earlier has been identified among the reliefs and instrumental forms associated with Tajín. These carvings have wrongly been designated as 'Totonac', and, more recently, as terminal 'Classic Central Veracruz'. The architectural reliefs at Tajín have recently been catalogued. A serviceable chronology still is lacking, but M. E. Kampen reasonably has suggested this series: (1) the sculptures buried in the pyramid, (2) the South Ball-Court reliefs, and (3) those of the North Ball-Court (these he compares to Late Classic Maya sculpture). The

final reliefs are (4) the column drums at Tajín Chico, where Tuggle (Note 59) identifies dynastic and ritual scenes of sacrifice, rites of fertility, and mythological events.[48] In addition to the Tajín reliefs, the style includes yokes, heads, figural stone blades called *hachas*, and finials called *palmas*.

Crested heads of stone, probably symbolic of human trophy heads, occur in southern Veracruz.[49] Miss Proskouriakoff notes two kinds, with slight and heavy forehead crests. The lesser crests she believes are early. The protuberant crests [95] appear in Oaxaca and Guatemala, probably later. The crested heads may be early forms of the *hachas* and *palmas*. Miss Proskouriakoff's tentative sequence is (1) lightly crested heads, (2) heavily crested heads, (3) *hachas* [96], (4) *palmas* [97], with 2 and 3 overlapping. The entire sequence may span a period from before the Classic era until after its close.

95. Crested marble head
from southern Veracruz, second century(?).
Washington, Dumbarton Oaks

96. Stone blade (*hacha*)
from central Veracruz, fourth century(?).
Washington, Dumbarton Oaks

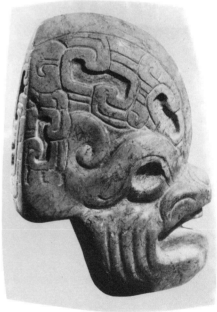

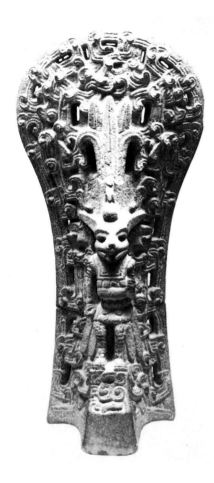

97 (*left*). Palmate stone from central Veracruz, ninth century(?). *Cleveland Museum of Art, Tishman Collection*

98 (*below*). Stone yoke from Veracruz, third or fourth century(?). *New York, American Museum of Natural History*

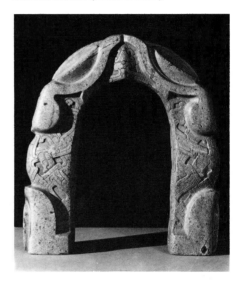

As for the scrollwork decoration of Classic Veracruz sculpture, Miss Proskouriakoff distinguishes two modes. In the first mode, the *hachas*, or figural blades, are coeval with Group A among the yokes with an ornament based upon simple coupled scrolls. The scrolls recur upon a stratigraphically dated mirror back of carved slate, from the end of the Early Classic period at Kaminaljuyú in highland Guatemala. This connexion allows Group A to be placed with Teotihuacán III, Monte Alban IIIa, and late Tzakol, upon a horizon at the end of the third century A.D. Group B yokes [98] bear the same scrolls in more ornately interlaced or linked oblique bands: these are assigned to mid-Classic or early Late Classic dates (seventh-eighth centuries A.D.). At Tajín, two reliefs from Structure 5 are associated by their scrollwork with these Early and Late Classic yokes: a single-figure slab with A-type scrolls and a monument carved with B-type scrolls.[50]

The second mode defined by Proskouriakoff includes the ball-court reliefs at Tajín [100, 101], the *palmas* [97], and two reliefs from the

neighbourhood of Misantla.[51] The scroll ornament she identifies as of a later type. The *palmas* were not in general use until the close of the mid-Classic period. The scenes portrayed on the ball-court reliefs and *palmas* show human sacrifice in a manner commonly associated only with Toltec and later ceremonial customs. However, nothing in the ceramic evidence at Tajín allows us to suppose that these reliefs were carved in Toltec times; on the contrary, it requires us to date Tajín sculpture earlier than the Toltec era (absence of plumbate and X-Fine Orange wares).

The two modes are clearly separate in time, as early and late, with some overlap. They are probably also separate in space. Yokes and *hachas* may correspond to south Mexican centres of style. *Palmas* come from around Jalapa and the region to the north of it, while the pictorial reliefs are at Tajín and Misantla. A diagram of these assumed relationships follows:

surrounds the cranium at the rear. This flange may have served to lash the head to the yoke. The heavy-crested heads [95] retain it, and one basalt example, purchased near Tres Zapotes,[53] has a perforation running across the head behind the temples, as if to fasten it to the wearer by a belt. The slack expression of these heads is perhaps a fundamental trait of Gulf Coast expression, from the Mistequilla to the Huasteca; it reappears in the *hachas* and *palmas*, and in the Tajín reliefs, as well as in Huastec figural sculpture, so that it is a constant from early to late, and from south to north.

The yokes [98] display three other features of Classic Veracruz sculpture: the predominance of animal over human representation; the dissociation of the body parts; and their reorganization upon the instrumental field. The typical stone yoke weighs about forty pounds. It can be worn as armour to protect the abdomen from the impact of the heavy, solid rubber ball

	SOUTHERN VERACRUZ	NORTHERN VERACRUZ
PRE-CLASSIC	Ridged stone heads [95]	
EARLY CLASSIC	*Hachas* and yokes Group A [96, 98]	
MID-CLASSIC	Yokes Group B	Yokes Group B
LATE CLASSIC		*Palmas* [97]
		Tajín ball-court reliefs [100, 101]

(Proskouriakoff's analyses refrain from such chronological suggestions.)

Yokes, crested heads, *palmas*, and *hachas* compose a group of instruments used as body gear in a ritual ball-game [99].[52] They are associated in this context on a relief panel at the southern ball-court of Tajín [100], and on a variety of figurines and representations from Maya and non-Maya sources. One of the Tajín reliefs shows two players standing between the sloping benches of a ball-court, both wearing yokes with *palmas* resting upon the yokes.

The 'early' crested heads have sagging eyelids, flaccid muscles, and relaxed mouths of indeterminate expression. To Proskouriakoff they suggest dead people. Often a halo-like flange

during play. Human figures imprisoned among the interlaces are characteristic of the A-group yokes; their legs and arms sometimes enmesh the features of a reptilian or feline monster. The articulations of this abstract figure in B-group yokes give an undulant appearance, and the monster displaces the human forms.[54]

The *hacha* forms were the most widely distributed ones of the entire ball-game panoply. The thin, flat blades [96] must have been strapped as tools, as badges, or as emblems upon the persons or in the territory of the players. A stela from Tepatlaxco near Orizaba in Veracruz [99] shows the dressing of a ball-player: his

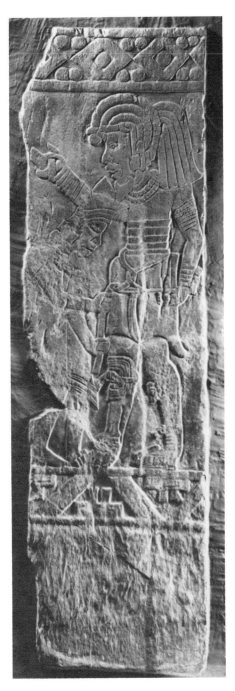

99. Stone stela from Tepatlaxco
showing the dressing of a ball-player,
before 300(?). *Mexico City, Museo Nacional
de Antropología*

hands are both bound with tapes as if to affix *hachas* like rackets. Proskouriakoff has suggested that the iconography of the yokes, with their narrow and stable range of forms, probably represented religious ideas held by the community of participants, while the flat *hachas* may have been more personal symbols of heraldic character, designating individuals, families, or teams. They have been found at Teotihuacán, in Oaxaca, and in south-eastern Guatemala. Some have an angular notch at the neck; others are tenoned (Oaxaca); still others, especially from Guatemala, have neither tenon nor notch. The forms of dead men and bare skulls are common, as if to recall a trophy-head origin; parrot, owl, and vulture profiles occur; sometimes a vulture appears feeding on the body or skull of a dead man. A tiger head, an acrobat, and a sacrificial victim stretched upon a pyramidal stair are known. Not uncommon, and probably late in date, are *hachas* with cut-out backgrounds perforating the thin blade.

The *palmas* are functionally different. A *hacha* blade usually cannot be made to stand upon its lower edge; a *palma*, however, has a broad triangular base, concavely curved underneath as if to fit a yoke [97]. From this base a broad fan-shaped finial rises, carved with a variety of themes: scrollwork; human figures and parts of the human body; sacrificial scenes; musicians; bundles of arrows; and turkeys and iguanas. Indeed the interpretation as personal emblems describes the thematic variety of the *palmas* better than it does the *hachas*. The *palmas* are much less widely distributed, and their style is more homogeneous, containing an apparent progression from squat to elongated shapes,[55] and from static single figures to pictorial scenes with many figures in a specified setting.

The ball-court panoply, and the accompanying ritual of human sacrifice, are described on two reliefs [100, 101] which decorate the ends of the parallel playing surfaces of the larger, south ball-court at Tajín.[56] Four scenes are shown, each flanked by a skeletal torso rising from a pot. Below and above each panel are interlacing scrolls. In the upper borders, these resolve into monster heads and tails. The south panels [101]

south wall, as at Xochicalco, the fleshy parts of the bodies have a ridged outline,[57] in the scroll-work system of the backgrounds, filled with flying figures and plumed forms. The north-west panels lack these outlines, and may therefore be the earliest work of the four.

Both scenes on the north wall take place in a ball-court, indicated by lateral platforms of Tajín profile. The west panel shows two stand-

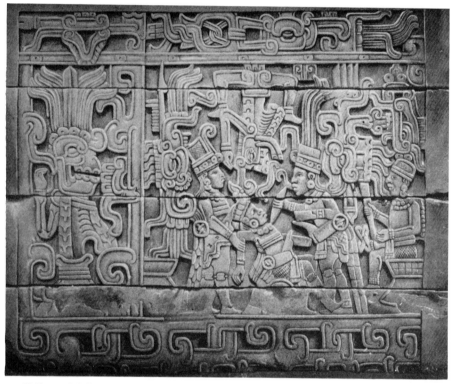

100. Tajín, south ball-court, north-east panel with sacrifice scene, c. 900

are more ornate in general and in detail than the north panels [100], so that difference in time may be supposed, with the south wall carved later than the north. For instance, the south-east panel has one seated figure carelessly dangling his feet over the lower frame of scroll interlaces. On the south wall [101], furthermore, the lower scrolls are enriched by feathered insertions, which are lacking on the north wall. On the

ing players. Between them are the ball and an interlocking or crossed-band sign like the Aztec symbol for war, called 'burning water'. The east panel shows two players excising the heart of a third [100]. On the right is a seated, cross-legged figure, dressed like the left-hand personage on the west panel. A skeletal manikin descends as if to receive the soul of the immolated player.

On the south wall there is no explicit reference to the ball-game. The east panel has a standing figure between two seated ones. The left-hand one grasps a bundle of three downward-pointing arrows, in a gesture signifying war in Aztec usage. The west panel is flanked by musicians with a drum and a rattle. Upon a couch between them, a reclining figure is covered by an eagle with human hands [101].

by heart excision antedates Toltec examples at Chichén Itza. We do not know the source from which the people at Tajín took the ritual. The cult of death and the preoccupation with its physical appearance, which is so pronounced in post-Classic Gulf Coast art[58] north of the Mistequilla, is perhaps an argument for local origin, either in Veracruz or the Huasteca.

Recent iconographic studies, devoted to the

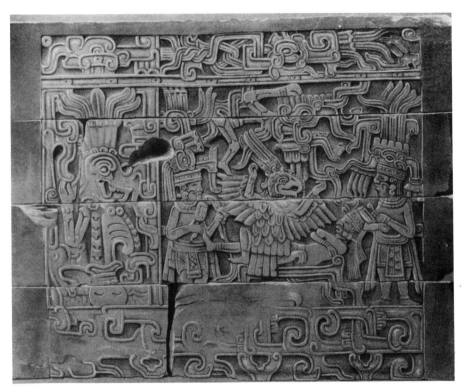

101. Tajín, south-ball court, south-west panel with eagle warrior ritual, c. 900

The smaller ball-court reliefs portray an eagle warrior and a throned figure. The technique of relief carving stresses the background pattern: it recalls cut-out sculpture. The ridged profiles of the reliefs in the main court reappear, but the scrollwork is much coarser and more schematic.

The pre-Toltec date ascribed to these reliefs is not contradicted by archaeological or stylistic evidence. The representation of human sacrifice

Tajín reliefs and ball-game sculptures, stress the conception of complementary forces represented as opposing elements balanced in a dual universe.[59] This dualistic concept found expression in the ball-game itself, as well as in the oppositions of light and shade in geometric ornament, and in the prevalence of interlocking bands within the *ollin* sign denoting movement.

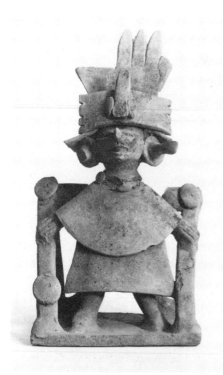

Clay Figurines and Heads

Two main groups of pottery sculpture occur in the semi-arid area of central Veracruz: the Remojadas tradition, from late pre-Classic (150 B.C.–A.D. 700) to Late Classic,[60] and the Nopiloa tradition (before A.D. 600–c. 900) of post-Classic date. Early Remojadas types are usually modelled by hand; Nopiloa figures are likely to be mould-made, although mould-made faces occur as early as the third century A.D.[61] The easily recognized shiny black body paint called *chapopote* appears in all periods.

Las Animas (north of Veracruz Port) and the 'Laughing Figurines' of the Nopiloa district south of the Río Blanco[62] appear to be related by their expressive content. Of sixth-century date, the Las Animas bodies [102] are hand-made with moulded heads, those of the Nopiloa district are moulded [103]. They resemble each other in the lively movements; the filed front teeth; the animated if conventional smiles; and the broad sculptural simplifications used to represent the elaborate costumes. Las Animas figurines are associated with Early Classic periods, while the Nopiloa figurines occur with yokes and *hachas* in Late Classic levels after 600.[63]

Las Animas figurines, coated with white slip, achieve a remarkable translation of drapery, hair, jewellery, feather decoration, and facial expressions into simple ribbons and sheets of brownish clay. The stereotyped smile is usually conveyed by a mask applied to the lower face, beginning below the eyes and spanning the cheekbones. The lips of this half-mask open in a rictus, and the front teeth show prominently. In profile, the nose is bulbous and protuberant

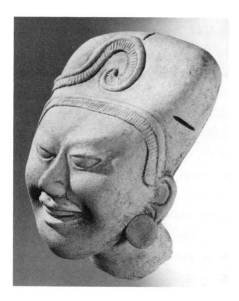

102 (*above*). Seated pottery figure from central Veracruz, Las Animas or Guajitos type, second century(?). *New Haven, Yale University Art Gallery, Olsen Collection*

103 (*left*). Pottery figurine head, laughing Nopiloa type, from southern Veracruz, ninth century(?). *New York, American Museum of Natural History*

at the tip: the half-mask may have been affixed by a pince-nez clamp. The head-dress, shown as a broad turban rendered by a strip of clay across the forehead, often has a bird in downward flight, given by four pats of clay. Conical cape and skirt simplify the anatomical relations. Hands and feet are shown as summary stumps. Pairs of figures, seated upon platforms, strike poses as if conversing or singing. Strebel assumed that many of the heads were ornaments on flutes or whistles. Several types of eye appear. In the group just described, the eyes are rimmed by raised ridges; in another they are rendered by slit incisions. In Strebel's plates are several examples of triangular heads with punctate eyes. These groups suggest a long development from an archaic base.

The 'laughing' Nopiloa figures continue this tradition farther south, in moulded technique, at a later period.[64] The Remojadas site has a pre-Classic lower level and a Classic upper level. In the latter, figurines with smiling faces are common, showing a development beginning possibly before that of Teotihuacán and paralleling it chronologically. The large moulded heads, with glyphic reliefs on the forehead [103], are of Late Classic date. The clothes bear a stamped ornament not unrelated to scrolls of Tajín style. The filed teeth and the flat-featured smile upon a triangular face [103] are like those of the Las Animas figurines, although the half-mask has disappeared.

Recently discovered are the life-size, hollow-clay, standing-figure sculptures of Zapotal [104], in the Mixtequilla, adjoining the Olmec 'heartland' on the north. Although they have been identified as Aztec deities, their expressive power seems related to the dramatic art and musical performance for which the East Coast peoples were celebrated.[65]

THE HUASTECA

From Papantla north, the Huasteca province retained archaic linguistic, ritual, and artistic habits. From this coastal corridor between the Mexican highland and eastern Texas also came important contributions to the mainstream of Mexican cultural history. For instance, in the fifteenth century, when Axayacatl brought the north coast under Aztec domination, some traits of Huastec origin entered highland life, along with the tribute taken from the coast. Since cotton was the most important product of the Huasteca, many associated traits like the worship of Tlaçolteotl (Goddess of dirt, i.e. sin) in syncretistic Aztec religion are of Huastec derivation. Tlaçolteotl, or Tlaelquani (Eater of Excrement, i.e. Remitter of Sins), was a moon, fertility, harvest, and earth goddess, shown in Codex Borbonicus as the mother of the corn god. Her attributes include cotton cloths and spindles. Rites of the confession of sins were administered by her priests.

Another Huastec trait was the habit, as old as pre-Classic village civilization, of building round houses and temple platforms. At El Ébano (San Luis Potosí) the circular mound is probably older than the one at Cuicuilco [2]. It has a burnt-clay facing,[66] perhaps of accidental firing. A round stone structure, built of inclined conical rings like Cuicuilco, stands at Tancanhuitz. Ekholm concludes that these round structures may be the earliest in Middle America, and that their use may have entered highland archaeological history at about the time of the Toltec expansion.

This connexion is proved by the mural decorations of a conical platform at Tamuín,[67] painted with red, white, and green processional figures of deities [105]. Among them the wind aspect of Quetzalcoatl is prominent. This image is usually associated with the round structures of the highland provinces.[68] The Tamuín murals are perhaps of the eleventh century. Their style is at least as much Mixtec as Toltec. The costumes and accessories of the figures resemble those of the Mixtec genealogical manuscripts, as do the terraced scrolls of the frieze at the top. Specifically Huastec is the densely patterned surface of the figural composition – so dense that it is difficult to separate figure, accessory, and background from one another.

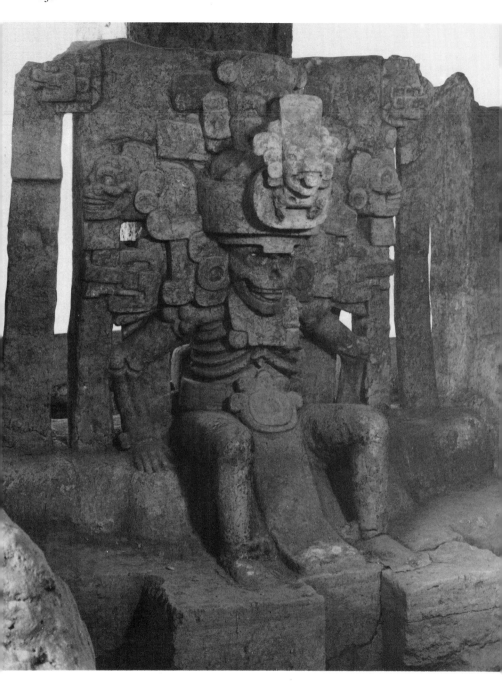

104 (*opposite*). Zapotal, death deity of hollow clay, after 1000

105 (*below*). Tamuín, wall painting representing Huastec figures, eleventh century(?)

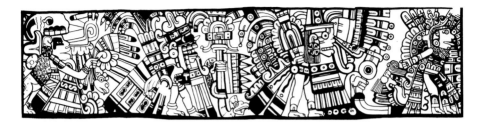

The style of the murals recurs in a number of carved shell ornaments of Huastec origin [106]. The backgrounds are cut away, and the surfaces are incised with complicated sacrificial scenes. These have been elucidated by parallels from the ritual manuscripts of the Codex Borgia group (p. 181).[69] The shell ornaments also point by their technique and material to North American parallels in the shell gorgets of the Southern Cult, where the diffusion, via the Huasteca, of Middle American warrior cults and sacrificial symbolism can be dated to the centuries after 1200. In the Huastec shell ornaments, the composition is fully adapted to the trapezoidal field of the gorget, and to the circular forms of the ear-lobe plugs. One is not reminded of borrowings from book illustration, as so often with Maya ceramic painting of figural scenes, but the figures suit the objects as if specially designed, quite as in the Hopewellian shell ornaments. One of the Huastec ear-disks shows the hunting and fire god, Mixcoatl, kindling a fire with a drill. From the point of the drill, and flanking it, rise symmetrical curls of smoke. This theme is the basis of the complicated designs of Huastec black-on-white pottery of Aztec date.[70]

Huastec monumental sculpture belongs to about the same post-Classic or Toltec periods as the shell ornaments. Comparable are the

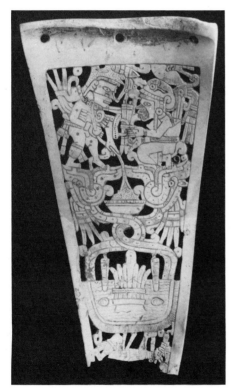

106. Huastec shell gorget
from northern Veracruz(?), after 1000.
New Orleans, Middle American Research Institute

Tamuín statue [107] and the Arensberg head at Philadelphia: both reflect a sacrificial view of existence. This reappears in relief sculpture, as in the Huilocintla stela, where the rite of blood-letting from the tongue is shown in forms like those of the perforated shell gorgets.[71] The tattooings on both the Tamuín statue and the Huilocintla relief were probably marks of noble

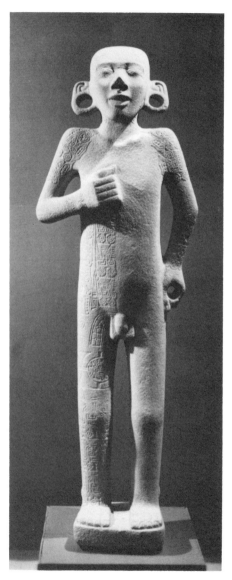

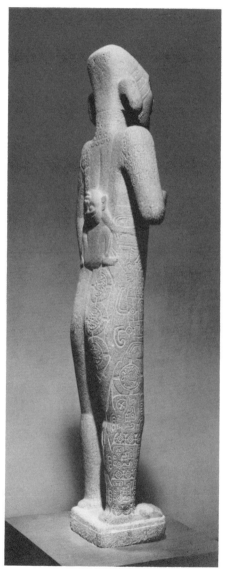

rank, as among the Maya. A dualistic manifestation, like those of Tajín, are the 'apotheosis' statues of Huastec origin [108, 109], which show a live figure in rigid pose on one face, and on the reverse of the statue[72] a skeletal figure which is worn like a classic Petén-Maya back mask. Their nudity perhaps relates to the Toltec dress which exposed genitals and buttocks [35, 257].

107 (*opposite*). Huastec stone statue from Tamuín, after 1000. *Mexico City, Museo Nacional de Antropología*

108 and 109 (*below*). Huastec 'apotheosis' statue from Tancuayalab (San Luis Potosí), front and rear. *Brooklyn Museum*

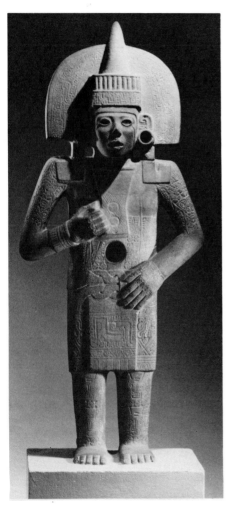
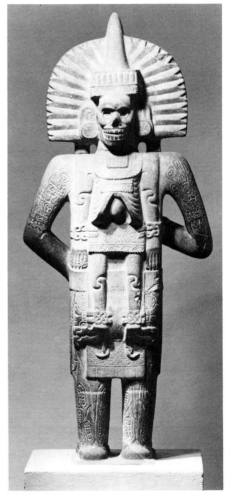

MOUND X

MOUND B

MOUND A

SYSTEM IV

BALL-COURT

WEST STAIRS

NORTH BARRIER MOUND

MOUND H

DANZANTES MOUND

MOUND J

MOUND P

GROUP M

MOUND S

MOUND Q

N

SOUTH PLATFORM

40 METRES

120 FEET

110. Monte Alban. Plan before 900

SOUTHERN MEXICO

The most numerous Southern Indian peoples, west of the Maya, are today the Zapotec and Mixtec, who occupy Guerrero, Puebla, Oaxaca, and Tehuantepec. Oaxaca proper is divided into the western highland, or Mixteca, and the eastern valleys, where Zapotec is spoken. Oaxaca is the most central of all the regions of ancient Mesoamerica, having neighbours to west, north, east, north-east, and south-east, and overland communications to all these regions, fixing Oaxaca as the least marginal or peripheral territory of pre-Columbian archaeological history. The archaeological history of the region is related to the ceramic sequence[1] established by Alfonso Caso for Monte Alban near Oaxaca City. The record of Formative and Classic occupancy is continuous in this immense assembly of buildings. Its courtyards and tombs [110] spread over the contours and shoulders of the isolated mountain at the T-shaped meeting of three valleys, which converge at Oaxaca City from the north, the east, and the south. Monte Alban I and II correspond to the earliest monumental art of the region, which resembles Olmec sculpture. Monte Alban IIIa composes the Classic era, commonly called Zapotec. Monte Alban IIIb, IV, and V spread from about the seventh century A.D. to the Spanish Conquest. They correspond to Mixteč and later Aztec domination at Monte Alban.

Mitla [125] arose during the earlier centuries of Mixtec civilization from about A.D. 700 until 900 (Note 20 and p. 168). The art of the later centuries, after 900, is characterized by metal objects, polychrome pottery, and painted manuscripts. For the Mixtec era, our main source of knowledge is the group of pictorial genealogies [131-7], recording about eight hundred years of dynastic history from the seventh century until after the Spanish Conquest.[2] The Mixteca Alta, in western Oaxaca, was the highland seat of these warrior aristocracies, who overran the sedentary and theocratic society of the Classic age, much as the Toltecs later overran the post-Classic civilizations of Yucatán and Teotihuacán. Various lines of evidence confirm the age of the Mixtec tribal dynasties, but their exact historical relationships, both to the theocratic rulers of Monte Alban and to the Toltec lineages in the north, are still obscure.

Mitla was built in the eighth century, when Mixtec society separated from a parent culture of Classic date at about the time of the earliest dynastic chiefs recorded in the genealogies. Mixtec traits pervaded the material culture of central Mexico at the time of the Spanish Conquest. The polychrome painted ceramics and the manuscript illuminations of fifteenth-century Aztec art probably owe more to Mixteca-Puebla sources than to any other tradition, so that we must review Mixtec origins in the Classic Zapotec period, recalling that Mixtec art may have had no separate identity until the eighth century. John Paddock first suggested that a possible source of Mixtec art lies in the Mixteca Baja (part of the upper Balsas River drainage) where distinctive prefigurations appear during the Classic era, under the label of the Ñuiñe (or Hot Land in Mixtec language) style, comprising Thin Orange ware, carved reliefs, and urns bearing interlaces and stepped frets, of Early and Mid Classic date (A.D. 200-700).[3]

THE CLASSIC ZAPOTEC STYLE

Architecture

Monte Alban is the most grandiose of all American temple centres, rising from the valley floor as an acropolis, studded with courts and pyramidal clusters [110]. Trabeated wooden roofs were the rule, although stone vaults of peaked profile like those of Mycenaean con-

struction are known, in Mound J and in some subterranean tombs. Stucco facings were less common than at Teotihuacán. The pyramidal platforms were finished with roughly shaped stones set in sun-dried clay. The terrace faces are dominated by wide stairways with broad balustrades. The principal surfaces are inclined; the vertical faces were generally interrupted by a variety of receding and layered planes. On these platforms stood buildings with earthen walls and columns of rubble, resting upon stone foundation courses profiled like the terraces, by laminated planes and inclined faces. The present surfaces were nearly all refaced under Alfonso Caso's direction before 1940.

The mountain-top acropolis surrounds an oblong court. Its narrow south end is highest in elevation, rising as an asymmetrical cluster of pyramids.[4] At the north end, another cluster of pyramids surrounds a sunken court separated from the main plaza by a barrier-platform. The east side of the main plaza is lined with great

stairways; the west side has three free-standing temple groups; and the centre of the plaza is enriched by an oblong platform faced with stairways and buildings which reflect or echo the surrounding edifices.

The plaza looks entirely regular, but the symmetry of the sides is only approximate; the intervals between platforms vary greatly, and the main angles are either acute or obtuse. The idea, rather than the exact measure, of a rectangular enclosure is conveyed. These variations from geometric regularity suggest the archaeological history of the site. The oldest edifices[5] on the western side of the plaza (e.g. the Danzantes Temple) share an orientation some degrees south of east, while the other three sides of the plaza face the cardinal points more squarely, and probably belong to a later campaign of construction.

The design of the spatial enclosures of Monte Alban resembles that of the Ciudadela group at Teotihuacán [5]. The assemblage of edifices

111. Monte Alban, Mound X, after 300, showing rubble columns set in entrances

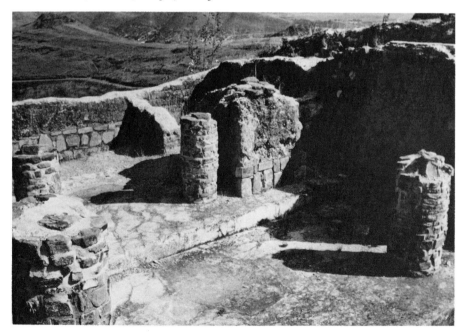

might be described as an amphitheatre, affording privacy and enclosure to gatherings of people whose attention centres upon a dominant stairway and temple at the end or in the centre of the enclosure. The essential parts are barrier-platforms at the front and sides, and a stage-like composition either at the rear or in the centre. The enclosure is usually open at the corners, allowing the spectators to feel separated from other areas, yet connected with them by the openings between edifices. The main plaza of Monte Alban is itself such an amphitheatre, surrounded by lesser ones, especially on the north side, and by Group M [112] and System IV on the west side.

During Monte Alban II, in the pre-Classic era (c. 300–0 B.C.), the use of masonry columns was already common, as in Mound X [111] from Period II, at the north-eastern edge of the archaeological zone. Here, beneath a more recent and simpler rebuilding, Caso discovered a two-chambered cella. Two cylindrical columns *in antis* (within the plane of the façade) stood in each of the doorways.[6] The 8 m. (25–foot) span of the outer doorway was reduced by the columns to three intervals: a central one 5 m. (15 feet) wide, flanked by narrow side-intercolumniations. This lively and inviting rhythm was repeated on a smaller scale at the entrance to the inner chamber. It reappears in the large portico on top of the barrier-mound on the north side of the main plaza, where the three intercolumniations are borne upon oblong pylons and doubled pairs of columns *in antis*. This simple and powerful massing, of great clarity, still dominates the entire site of Monte Alban. At the south-west corner of the main plaza, the temple of Group M is entered by a portico borne upon four cylindrical columns [112]: similar two-column porches preceded the cellae of the lateral shrines on Mound H. Another design, as at Mound X, sets two masonry columns in a doorway, to emphasize its width while reducing the span.

112. Monte Alban, Group M, after 300

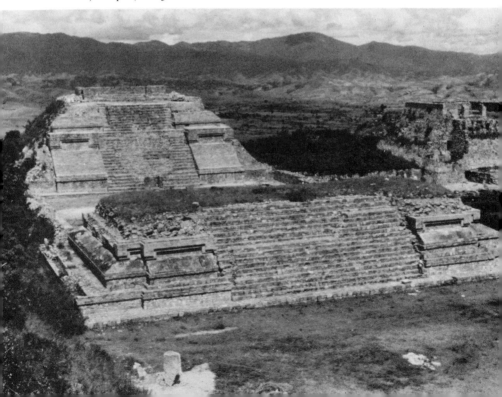

Of the dwellings at Monte Alban, only foundations survive. They are chambered structures, surrounding square sunken courtyards like the patio assemblies of Teotihuacán, with the difference that the Oaxaca dwellings are isolated quadrangles, while those of Teotihuacán are parts of larger systems. The largest at Monte Alban occupies Mound S on the east side of the main plaza, with more than a dozen rooms. Facing it across the plaza is the so-called Danzantes building, of eight small chambers round a courtyard. North-west of the plaza are more dwellings, containing underground tombs with painted walls with square courtyard structures above. These, like the mound over Tomb 105, consist of four main chambers, each projecting into the square courtyard sufficiently to define small corner courts [113]. The four-chambered courtyard assemblages are probably earlier than the more

113. Monte Alban, house group and Tomb 105, after 600(?). Plans and section

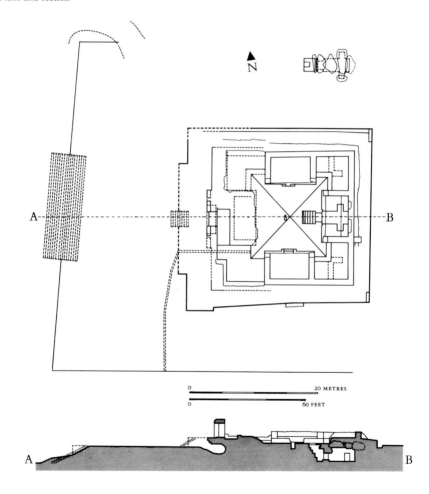

elaborate quadrangle buildings (Mound S), which resemble the edifices of Mitla. Large monolithic lintels and jambs like those of Mitla, however, were used in the group of Tomb 105, so that no great interval of time need separate the latest edifices of Monte Alban from the Mitla quadrangles. As at Teotihuacán [11], substantial dwellings were first built during the last centuries of the Classic age, to continue as a tradition of domestic architecture in post-Classic times.

The appearance of the façades of Monte Alban is preserved in a few native models of stone. One of these represents a façade elevation lintel cornice, a sloping talus, panelled frieze, and flaring cornice at the top. The scheme of talus and flaring cornice, separated by a panelled frieze, repeats the composition of the base platform. Every form serves to variegate and diversify the simple trabeated structure. On the site of the quadrangular structure on the Danzantes mound, the foundations of such an ornate façade have been cleared: it was evidently a shell encasing a plain older façade.

There is no clear evidence of panelled friezes in the earliest architecture at Monte Alban. The form began in the Early Classic era (Monte Alban IIIa) as a system for the decoration of

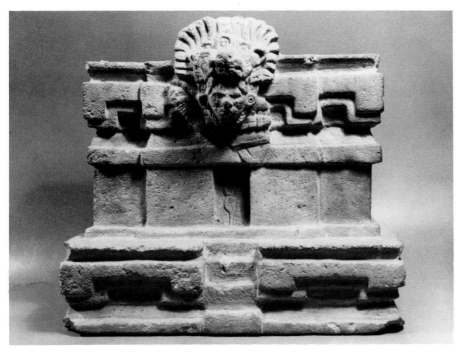

114. Stone model of a temple from Monte Alban, after 300(?).
Mexico City, Museo Nacional de Antropología

[114].[7] The platform and stairway support a small temple chamber. Its front has a salient centre panel repeating the profiles of the main silhouette. These are the base moulding, the pyramidal platform terraces. Before that period the earthen platforms were encased by flat slabs, incised with dancing figures [116, 117]. Mound J, with its reliefs of Monte Alban II date, is the

most complete example. In Period III, the group known as System IV, which closely resembles Group M in plan, may well be the earlier of the two 'amphitheatre' designs, because of the tentative and experimental character of the panelled friezes. In System IV the terraced platforms are horizontal accumulations, stressed by ample sloping aprons which overwhelm the unprepossessing panelled friezes. The stairways and the balustrades are so timidly proportioned that one is more aware of the angular massing of the platforms than of their directional organization. Group M [112], on almost the same plan as System IV, reverses the relationship between horizontal and vertical stresses, by a most ingenious rephrasing of the panelled friezes. The frieze is treated as a brief horizontal measure, like a bracket, and the brackets are vertically tiered to stress the ascending lines in both the barrier and the proscenium pyramids.[8]

The panelled friezes themselves carry the eye upward by their profiles and by their contour in the plane. Each frieze consists of two or more layers of masonry built out from the wall face. These profile projections give great importance to the short vertical distances between terraces, and they, more than anything else, contribute to the vertical effect. In façades of extreme length, their effect in series is to break the horizontal by a *pointillé* succession of lights and shadows, like a dotted line.

Another principal device of the architects of Monte Alban was the wide balustrade, far more generously proportioned than in other Mexican or Maya styles of Classic date. The balustrades of Monte Alban are immense ramps, quite unlike the linear borders of Teotihuacán, Tajín, or the central Maya stairways. At the north barrier-mound, for example, the ramps occupy almost two-fifths of the width of the great stairway mound, and at the ball-court, the west stair ramps are each about half the width of the centre flight. This west mound was enlarged at least four times. When the stairs were lengthened, the balustrades were widened.

Underground tombs in great numbers appear throughout Monte Alban, under the main courts and smaller patios, as well as on the spurs and foothills surrounding the principal group. The oldest tombs (Nos 33, 43) are rectangular pits lined and roofed with flat stone slabs; those of Period II have entrance stairs and secondary chambers or niches forming a cruciform plan (Nos 77, 118), often with peaked vaults of slabs leaning upon each other. Monte Alban III tombs are the largest, with wall paintings and panelled frieze façades (No. 82). Tomb 7, reused by later Mixtec occupants at Monte Alban, is of this type, like Tomb 104, erected late in Period III, and Tomb 105 [113]. Under Mixtec influence in Periods IV and V are tombs like Nos 59 and 93, smaller than those of III, with tiny niches instead of secondary chambers. The main edifices of these periods were built, however, not at Monte Alban, but at Mitla, Yagul, Zaachila, and Lambityeco, where the underground tombs are elaborate cruciform structures [126], larger than those of the mountain centre.

Stone Sculpture

Four distinct styles of monumental sculpture have been discovered in Oaxaca.[9] The first includes the Danzantes slabs of Monte Alban and the slab reliefs at Dainzú, which belong to Periods I and II [115–17]. The second comprises the incised 'triumphal' stelae of Monte Alban, corresponding to Period III [118]. The third class belongs to the Zapotec valley towns of central Oaxaca, such as Etla, Zaachila, and Tlacolula. The slabs represent a man and woman seated beneath a sky symbol: frequently a single enthroned figure is shown. This class probably relates to Periods IIIb and IV of the Monte Alban chronology. The fourth class is exemplified by a slab at Tilantongo, which represents a warrior named 'Five Death'. It corresponds to the style of the Mixtec genealogical manuscripts, and it is usually dated after A.D. 1400 (Monte Alban V).

The Dainzú slabs originally revetted a terraced mound facing westward: they number

115. Dainzú (Oaxaca),
facing-slab relief, *c.* 300 B.C.

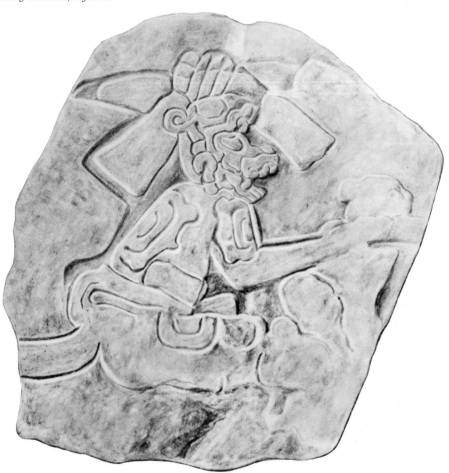

about fifty and correspond to Period I of Monte Alban with resemblances to Izapa sculpture. Masked humans and jaguar-headed humans appear. These have been called ball-players, but the stones in their hands, and their postures as fallen and reclining figures [115], in relation to a standing victor shown in a relief at the top of the hill, suggest a battle by defeated challengers.

The Danzantes slabs[10] are named from the animated postures of the standing, floating, and seated figures, which are grooved upon the stone by abrasion with a rounded hand-axe [115–17]. Within body contours, flesh portions are lightly modelled as swelling or concave surfaces. The buried position of the slabs at the south-east corner of Mound L, enlarged in Period III, and their association with modelled pottery decoration of Monte Alban I[11] are proof

of antiquity. In all, forty-two slabs have been recovered, which lined the re-entrant angle between a pyramidal platform and the projecting face of its stairway. Caso has pointed to differences of style among slabs facing the pyramid, noting a variant group of extremely elongated figures, which he assigns to Period II.

A marked general difference of style between the slabs lining the pyramid and those of the stairway is more easily discerned. The pyramid figures [116] are gross and large. The stairway slabs recall the animated elegance of the flying figures of Olmec reliefs. They point to a connexion with the commemorative slabs in the facing of Mound J [117]. There, heads of Olmec style appeared in characteristic clusters of signs, which consist of an inverted human head beneath a locative glyph of terraced profile,

116 and 117. Monte Alban, architectural facing slabs on the pyramid base, Mound L (*opposite*) and Mound J (*below*) (with drawing), carved in countersunk relief, before 300 B.C.(?)

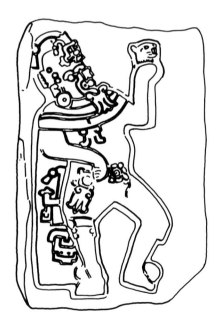

denoting a specific town, near a string of glyphs probably indicating the year, month, and day of a conquest. The inverted human heads probably refer to defeated tribes.

The glyphs of these early carvings resemble the Maya system of writing with cartouche frames and numerals formed of bars (fives) and dots (units). Both the glyphs and the numerals are too few to permit the complicated statements of Maya writing. In all likelihood the Monte Alban glyphs, like those of the later Mixtec, Toltec, and Aztec peoples, treat of only the simplest calendrical, personal, and historical facts, without venturing into the complicated astronomical cycles of Classic Maya inscriptions.

The stelae lack both the daemonic quality of the Danzantes slabs and the compositional harmony of Classic Maya reliefs. Classic Zapotec stone sculpture is certainly not abundant. The Zapotec carvers never again recovered the powerful line or the expressive control shown in the Danzantes figures. The formula is simple: upon a terraced place-name sign stands a dressed-up warrior or god-impersonator, surrounded by coarse glyphs of immense size, designating the date of the event and the name of the personage. The persistence of the glyphic formula of the conquest slabs on Mound J is apparent. In Stela 2, a warrior in jaguar dress stands nonchalantly on one foot with the postural freedom of the Danzantes figures [118]. The elaborate head-dress and the speech-scroll are related to the conventions of the art of Teotihuacán. Posture and costume are doubtless of the same generation as the murals of Tombs 104 and 105 [122, 123]. On a large flat incised onyx slab [119],[12] the resemblances to Teotihuacán murals are even more marked: a tiger-impersonator stands in profile; behind him is a priest in a costume. In general, this rather simplified art of relief representation reflects a sumptuous life of religious pageantry. Processions in costume were probably the living sculpture which moved over the platforms and stairways of Monte Alban, dimly reflected in the captains and priests on the stelae.

Clay Sculpture

Much more powerful, both as sculptural expression and as a visual record of the ranks and orders of Classic Zapotec life, are the anthropomorphic vessels of fired clay which were part of the tomb furniture both at Monte Alban and in the valley towns, as well as on Mixteca Alta sites. Probably each region of the Classic Zapotec civilization supported distinctive local styles in the manufacture of funerary pottery. The fundamental types are numerous,[13] and their development from simple to complex forms must span about a thousand years, embracing both the Formative and Classic Zapotec eras.

Caso and Bernal have sought to relate them all to representations of the gods and to personifications of the deities of the 260-day calendar.[14] Their early sequence – Stage I (effigy vessels) correlated to the grooved Danzantes figures and Stage II containing early funerary urns – is marked by striking Gulf Coast, pre-Classic Maya, and Central American connexions in morphology and iconography. A Transitional period, following the Formative era and preceding the Classic Zapotec stages, was strongly affected by influences from Teotihuacán, which are evident in the sculptural vocabulary as well as in the system of 'written' signs. The fully developed range of Classic themes occupies Stages IIIa and IIIb. Monte Alban IIIa corresponds to the peak period of residential occupation at the mountain citadel. After IIIb the site became a necropolis. The ceramic styles of these two periods are marked by increasing elaboration and complication of the simple fundamental stock of glyph-forms and god-types; and during IIIb, many valley towns, such as Etla or Zaachila, produced their own funerary wares. Several architectural decorations in plaster have been excavated at Lambityeco near Tlacolula: their forms resemble Classic pottery and stone lintels. They are assigned on evidence of six radiocarbon dates (A.D. $640 \pm 100 - 755 \pm 90$) to Monte Alban IV.[15]

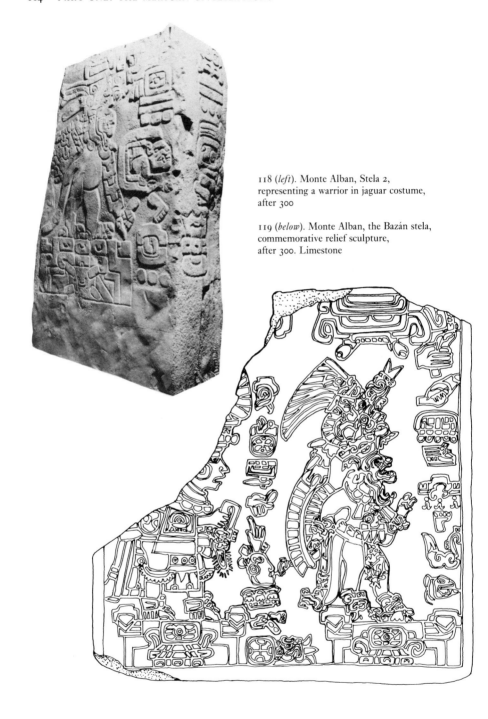

118 (*left*). Monte Alban, Stela 2, representing a warrior in jaguar costume, after 300

119 (*below*). Monte Alban, the Bazán stela, commemorative relief sculpture, after 300. Limestone

All local styles display from beginning to end the same succulent treatment of the clay. The Zapotec potters translated all forms into sheets, rolls, drops, and lattices of wet-carved details. No other American potters ever explored so completely the plastic conditions of wet clay, or retained its forms so completely after firing. The Zapotec never forced the clay or plaster to resemble stone or wood or metal; he used its wet and ductile nature for fundamental geometric modelling, and he cut the material, when half-dry, into smooth planes with sharp edges of an unmatched brilliance and suggestiveness of form.

These properties of Zapotec form were already evident in Monte Alban II pottery, and they persisted in Period III. Two examples will

earlier example uses overlapping ochre and green plates of clay to construct a symbolic geometric frame of concave and convex planes for the powerful middle-aged portrait face within the helmet. In the late example, the sculptor spent more effort upon the head-dress and costume than upon the human subject. Close-set rhythms are prominent. The interplay of feathers, beads, olivella shells, knotted thongs, and jade ear-plugs, made in forms that respect the nature of clay, all while conveying the tactile identity of each original substance, dominates the composition. The early urn conveys a genuine human identity; the later one communicates only rank and status. One is reminded of the differences between pharaonic Middle Kingdom and New Empire portraits:

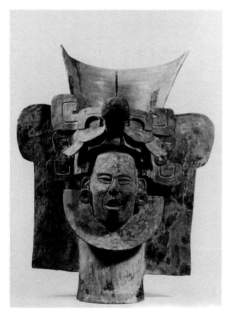

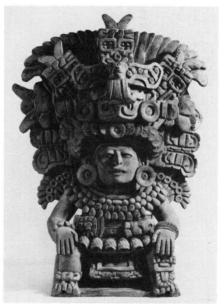

120. Pottery urn, Monte Alban II, third century B.C.(?). *Mexico City, Museo Nacional de Antropología*

121. Pottery urn, Monte Alban IIIb, after 500. *Mexico City, Van Rhijn Collection*

illustrate the tendency common to both periods: the face urn [120] from Monte Alban (Tomb 77), and a large effigy urn [121] of Period IIIb which also displays a human figure encased in an imposing broad-billed bird helmet. The

between care-worn individuals and remote demigods smothered by regalia. A closer parallel is to the early and late figurines of Teotihuacán, where the same sequence holds from portraiture to ceremonial mannequins.

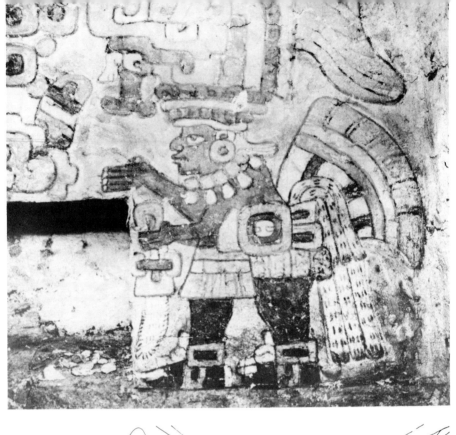

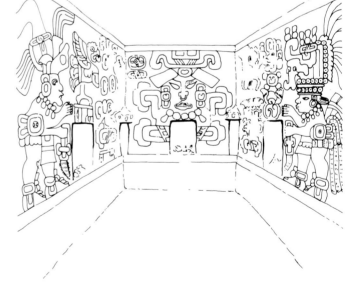

122 (*opposite*). Monte Alban, Tomb 104, end wall and niches with wall painting, *c.* 600, with perspective drawing

123 (*below*). Monte Alban, Tomb 105, wall painting (replica), after 600. *Mexico City, Museo Nacional de Antropología*

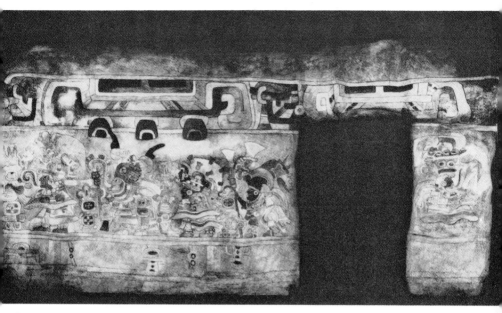

Wall Painting

The murals of Tombs 104 and 105 [122, 123] are painted with earth colours in a dry fresco technique upon a stucco ground. Both tombs belong to Period III, with processional scenes of figures in profile on both walls, leading symmetrically towards a large scene of heraldically regular composition spread across the rear wall. Tomb 104 is simpler and less slovenly. By parallels with the ceramic development, Tomb 104 probably antedates 105.[16] In Tomb 104, the glyph-forms and the vast head-dresses, stuffed and hung with attributes, dwarf the human figures, whose stunted proportions (head: height = 1:4) makes them into accessories to the panoply of day-signs, numerals, and god-masks.

In the bodies, stunted limbs, arbitrary articulations, concavely curved profiles, and angular joints mark different stages in the loosening of the line. The figures of Tomb 105 are drowned among the complications of costume accessories. Beneath painted sky-frieze cornices, eight figures of alternating sex, four on each wall, march in profile towards the end wall, where a glyph recording the day 'Thirteen Death' dominates the entire space. On this end wall, three successive layers of paint are visible. Each later coat enlarged the dimensions of the sky frieze, and the last coat substituted the huge heraldic day-sign for the singing figures of celebrants in costumes that filled this space in Tomb 104.

THE MIXTECS

Unique circumstances complicate the study of Mixtec art. The native genealogical records account for at least five centuries of pre-Conquest history in southern Mexico, beginning *c.* 1000.[17] This astonishing pictorial chronicle is internally consistent and historically credible. The intricate narrative tells of the rise to power of a few families of highlanders in western Oaxaca. Their dynastic alliances and the wide conquests of their military leaders are the principal matter of these manuscripts. But the narrative lacks confirmation either from other tribal sources, or from the archaeological record. The Aztec histories mention the Mixtecs only in connexion with the conquest of Oaxaca by the captains of Moctezuma I in 1461. Excavations in western Oaxaca yield sites and objects of Classic Zapotec style in the older strata.[18] More recent stages of Mixtec archaeology are Tombs 1 and 2 at Zaachila and the intrusive contents of Tomb 7 [142, 144] at Monte Alban. Tomb 1 at Zaachila contains modelled stucco wall-reliefs, including one of a man named Nine Flower [124], whom Caso identifies with the person of that name wearing the same costume in Codex Nuttall. Nine Flower lived before A.D. 1269, and his rulership coincides with the local tradition that Mixtec rule at Zaachila began with a marriage before 1280. Nine Flower's presence allows the tomb and its contents to be assigned to the later thirteenth century. Between the goldwork of Zaachila and Tomb 7 at Monte Alban, the resemblances are so close as to suggest manufacture by the same shop of artisans. If this is the case, Tomb 7 and the Mixtec occupation of Monte Alban may need redating, not in the fifteenth but in the thirteenth century.[19] Also of late date are the gold, jewellery, jades, turquoise mosaics, and brightly painted ceramics found in Mixteca sites and at Cholula, as well as on the East Coast, and as trade objects in Tenochtitlan. Both the manuscripts and these archaeological finds are currently ascribed to *c.* 1300–1500. The Classic Zapotec strata, on the other hand, antedate the

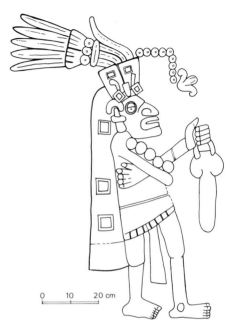

124. Zaachila, Tomb 1, stucco relief of Lord Nine Flower, before 1300(?)

eighth century A.D. We are therefore confronted with an archaeological void for Mixtec history, spanning six centuries, from before 700 until the fourteenth century. This is two thirds of the time so richly portrayed in the genealogical histories.

With what can we fill this void? Many have suspected that the buildings of Mitla, about 30 miles east of Monte Alban, are Mixtec constructions. The fragments of pottery in the walls are of Mixtec types; the burials beneath the floors contain Mixtec artifacts; the wall paintings [130] resemble Mixtec manuscripts; and a local tradition, first collected in 1580, holds that the 'palaces' of Mitla were then about 800 years old, i.e. of the eighth century. Similar courtyard buildings at Yagul, near Mitla, also contain Mixtec pottery fragments and burials. As we shall see, the architectural forms of Mitla and Yagul are sufficiently like those of the main

plaza buildings of Monte Alban to allow the belief that they are not too far separated in time from Monte Alban.[20]

As a working guess, then, the art of Mitla and Yagul may be placed in a three-hundred-year period spanning the eighth and eleventh centuries, as an Early Mixtec style corresponding to the first and second dynasties of Mixtec princes recorded for Tilantongo in the genealogical manuscripts (p. 178). In this chronological position, the courtyard structures at Mitla [127], with the mosaic stone panels on their façades, are coeval with analogous edifices in the Puuc district of Yucatán, at Uxmal [193], Kabah, and Zayil, as well as with the buildings of Xochicalco and Tajín Chico [93]. It is a pre-Toltec and post-Classic horizon, like the fourth and terminal stage of Teotihuacán archaeology, after the abandonment of the pyramid site at Teotihuacán proper.

For the eleventh to fourteenth centuries, the gap is not easy to close. We can suppose that Toltec expansion had important consequences in Oaxaca, consequences for which we may search the pages of the Mixtec genealogies, since we lack any field archaeology relating to these three centuries. Thus the manuscripts will be our chief evidence for the history of the art of the Toltec era in Oaxaca, as Mitla is the principal monument of the preceding three centuries. For the years after 1300, we have the polychrome pottery, the late manuscripts, and jewellery of late Mixtec style.

Mitla

This cluster of courtyard structures [125], strewn along the banks of a dry stream at irregular intervals, without striking varieties of level and without clear relationships among groups of buildings, is completely opposite to the grandiose design of Monte Alban, where every edifice adds to the unified effect of the total pageant-space. At Mitla the isolated edifices give the effect of suburban villas, jealous of their privacy, turning closed walls upon one another, walls which display wealth without inviting the spectator, without attempting to share a coherent space with the neighbouring edifices. The buildings of Mitla have in common only their excessive individuality and their cardinal orientation. They reflect a social organization and a conception of the public areas radically different from those of the Classic Zapotec theocracy.

For these reasons alone one is justified in ascribing them to a different ethnic group and to another period. The differences also extend to the materials. The quartzite blocks of Monte Alban [112] are irregular and difficult to shape, unlike the smooth-grained trachyte slabs of Mitla [127]. The plans are unrelated as well – there is no precedent at Monte Alban for the linked courtyards of residential buildings at Mitla – and the courtyard dwellings of Monte Alban (e.g. the house foundations above Tomb 105 [113]) resemble those of Teotihuacán more than Mitla.

The arrangement of the surfaces at Mitla nevertheless betrays close dependence upon the decorative system of the panelled friezes at Monte Alban. There can be no question that Mitla, however different in purpose and plan, continues the Classic Zapotec tradition of ornamentation. Another proof of relationship is the occurrence of cruciform tombs built beneath the groups of dwellings, and repeating in their decoration the motifs of the buildings above.[21] The Mitla tombs [126], to be sure, are more evolved; they are larger and more ornate than those of Monte Alban.

The chronological sequence at Mitla [125] is clear in its main outlines. The southernmost group of four mounds contains a tomb (No. 7) in the east platform; it is of Monte Alban III type, with slab walls and roof, and ceramics of the Classic Zapotec style.[22] The same open quadrangle of four platforms recurs in the westernmost group, which may therefore be of the same date as the south court. All other edifices belong to a later period, which we have here attempted to identify as before 900.

These later buildings form three groups, each composed of three quadrangles. They are all

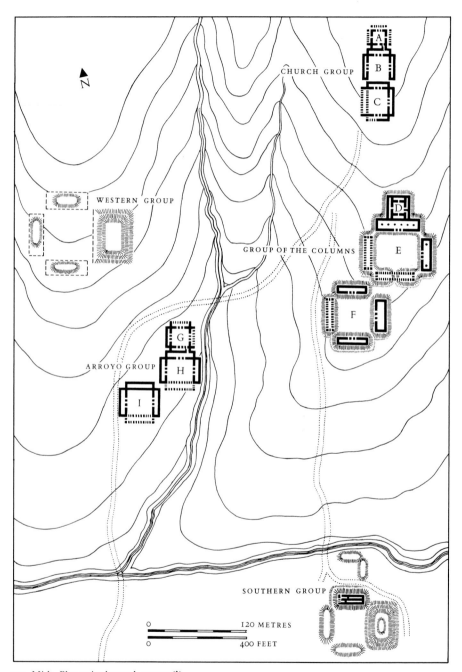

125. Mitla. Plan as in the tenth century(?)

orientated upon the cardinal points, like the older courts. The smallest is the Arroyo Group, with large stone lintels, and it is the worst preserved. The northernmost group contains the colonial church of Mitla. The largest and most ornate quadrangle assembly is the central one, called the Group of the Columns, because of the cylindrical stone shafts that supported the flat roofs of the buildings lining the centre court.

A similar site has been studied at Yagul near Mitla.[23] Yagul, however, has a ball-court like Monte Alban. The quadrangle buildings of Yagul resemble the smallest group at the Arroyo in Mitla. The quality of the fret mosaics at Yagul is much coarser, and the excavations show possible progression from assemblies of large units to finer workmanship in later periods. A hypothetical sequence can be taken as follows: Monte Alban, Yagul, Mitla. The builders of Mitla would have inherited the finest technique, laying out the largest and most complicated courtyards, presumably near the end of a period of undetermined duration. The evidence is most incomplete, and a case can also be made for Yagul as a poor imitation of Mitla, like Mayapán in relation to Chichén Itza.

At Mitla, the chronological sequence of the three courtyard buildings has never been established beyond question. If, however, we distinguish loose organizations from ornate and difficult ones, and massive forms from their alternated and stereotyped versions, two stylistic phases emerge distinctly: one is the Group of the Columns, and the other includes both the Arroyo and the Church Groups. These differences appear in the plans [125]. The Group of the Columns consists of two open-corner quadrangles (E, F) which draw together only at one corner. All the corners are suggested, but not closed, so that the eye has an escape from the court at each of the open corners. In the Arroyo and Church Groups, however, the courtyard corners are closed. In the Arroyo Group the two quadrangles (H, I) approached a meeting by the corners, as in the Group of the Columns, but this expansive interpenetration is forgone at the Church Group, where the southern quadrangle (C) shares one whole side with an adjoining quadrangle (B).

Thus the Group of the Columns with its eight separate pyramidal platforms still belongs to the tradition of ceremonial plaza design by means of massing open blocks. The other two groups, which lack platforms, suggest privacy and introversion by their closed corners and forbidding exteriors. That the designers were still unconcerned with interior commodity appears from the lack of connexion between the chambers framing the rectangular courts. Their main aim was to compose the exteriors, by closed inner courts, and by the re-entrant corners indenting the outer envelope of each quadrangle. From the Group of the Columns to the other two groups, therefore, a progression seems apparent, from clusters of pyramidal platforms of Monte Alban type, to the tightly planned rectangular buildings standing directly on the ground.

The family likeness between the mounds of Monte Alban and the Group of the Columns at Mitla reappears, as noted before, in the cruciform tombs built into the platforms [126]. But at Mitla a new sense of space characterizes the tombs: they are like crossroads intersecting at right angles and lined by imposing façades which repeat the composition of the palace fronts on top of the mounds. It is as if the corners of a square enclosure, like the inner quadrangle of the Column Group (D), had been inverted, to become projecting instead of re-entrant angles; as if the corners of the square court had become outdoor corners rather than inside angles. This conversion of the space of a room into the space of intersecting corridors is embellished in the tombs of Quadrangle F with all the profiles and fret ornaments of exterior façades: one seems to stand among clustered building fronts in the underground chambers. In the ritual manuscripts (e.g. Codex Laud, etc.) such a form is common, with footsteps painted in each arm of the cruciform plan. The Náhuatl name of the form is *otlamaxac*, signifying the crossroads, where Tezcatlipoca and

126. Mitla, Quadrangle F,
tombs, before 900(?).
Section of north building
and plan of court

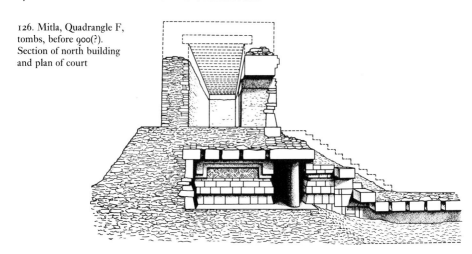

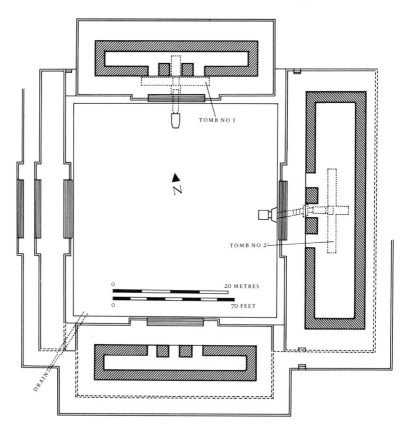

other night gods made their appearances as magicians. A Maya parallel occurs in the small cruciform vaults beneath certain Late Classic stelae at Copán, lined with stone slabs and filled with votive offerings.[24]

The fretted decorations of the walls of Mitla [128] reinforce our division into early and late groups. In the quadrangles of the Group of the Columns, the façades were completely revetted with registers of panelled friezes containing mosaics of fret ornaments, sheltered by projecting mouldings. In the Church Group, only the cornice zones were thus enriched, with frets in diagonal composition, of a much more mechanical quality of execution. The recessed overdoor lintels [130] in both Arroyo and Church Groups, moreover, are painted with scenes like those of the Mixtec ritual manuscripts: the placing and the style of the paintings strongly confirm the impression of a date later than the Group of the Columns, where there is no trace of such pictorial decoration.

The outer façades of the Group of the Columns [127] display one important refinement, lacking in the other buildings: the vertical profiles at the ends of the long horizontal blocks are cut to lean outward. This 'negative batter' also characterizes many post-Classic buildings in Yucatán, especially at Uxmal, but it was never used with more subtlety and grace than at Mitla. The profile slopes inward at the base of the wall: above this constriction the upper three panelled friezes lean out, each overhanging the one beneath it by several inches. This visual correction not only restores the authority of the vertical lines in the long and low block, but also allows light reflected from ground level to bathe the wall from below. In addition, the mosaic panels are protected from weather, both by the overhang and by the protuberant mouldings.

The fret decoration is of two kinds. Some were carved in relief on immense slabs of stone, as upon certain lintels and in parts of the cruciform tombs. Others were assembled like mosaics from small shaped elements set in clay. Nothing suggests that these techniques belong

127. Mitla, Hall of the Columns, façade *c.* 1900, before restoration, as of before 900(?)

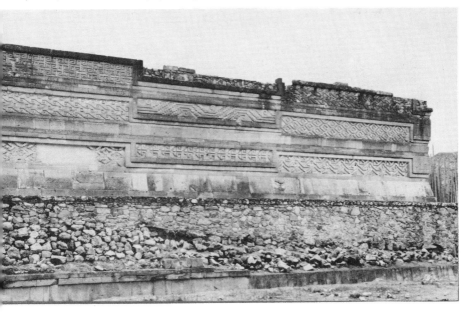

128. Mitla, façade mosaics, typical forms, 800–1000(?)

to different periods; the shaping of very large and very small stones flourished together. Some striking differences in theme and composition may mark early and late buildings: for example, the friezes of the Church Group present only diagonally fitted key fret bands of a dry and monotonous execution, which, taken together with other indications, seem to be late in the development of the style. Bits of colour still adhering to the protected surfaces show red and pink tones laid upon a priming of cream or white.

Some 150 panels of mosaic and carving survive [128], drawing upon a vocabulary of eight typical forms, all elaborated upon primary key fret and spiral fret patterns.[25] They key forms are reversing (I), stepped (II), rinceau (III), serrated (IV), and meander (VII); the spiral frets (VI) are all of meander type. Diamond forms (V) occasionally combine with key motifs (VIII). Key frets and spiral frets are contemporary, because of their close association on the walls of the Group of the Columns. The tilted key frets (I) at the Church Group look late, possibly as dynamic variations upon the more static serrated key (IV), which is one of the most common forms at the Group of the Columns.

The meaning of these beautifully fashioned panels of fretted decoration is lost. In the genealogical and ritual manuscripts, such fretted patterns often designate towns or temples. Thus a frieze of stepped terraces, painted black and white, means the town of Tilantongo in the genealogies.[26] It is not unlikely that each of the frieze types had a geographical meaning, referring to the different Mixtec principalities. If so, their combination on the walls of the Group of the Columns may have distinguished the building as a symbol of the Mixtec people.[27]

The Marriage Reliefs

Figural sculpture which can be assigned to the period of the buildings at Mitla does not come from Mitla, but from the other valley towns, and the date is problematic. These relief slabs, which represent seated couples [129], resemble

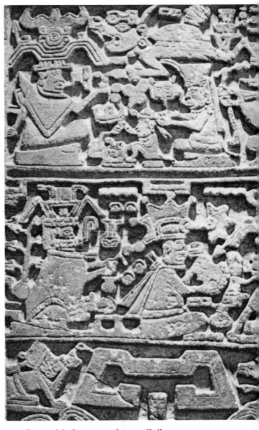

129. Stone slab from a tomb near Cuilapan, after 600. *Mexico City, Museo Nacional de Antropología*

the subject matter of the Mixtec genealogical manuscripts of the sixteenth century, but their glyph-forms and several conventions of figural representation relate to the Classic Zapotec style of the type of the murals in Tombs 104 and 105 at Monte Alban [122, 123]. The recurrent scheme of the marriage reliefs shows two couples seated facing each other in upper and lower panels.[28] Above the upper couple a sky symbol of doubled serpent jaws, like those painted in the tombs of Monte Alban, disgorges a head, or hands bearing jewels. The name-glyphs are calendrical, in the Classic Zapotec

system of bar-dot numerals and day signs; all other glyphs are also Zapotec. The terraced place-name signs in the lower register resemble those of the Zapotec stelae. But the postures and costumes of the seated figures, especially the women's, are those of the Mixtec genealogies.

The entire compositional scheme and the subject matter are paralleled only in Mixtec manuscripts. Codex Zouche (or Nuttall), a deerhide painting of the sixteenth century, records the same arrangement of a couple, presumably the dynastic founders, seated above another couple shown as the legitimate descendants and rulers [131]. This interpretation is reinforced by certain variants in the marriage reliefs: for instance, on the circular stone from Ciénaga near Zimatlan, only one couple is shown enthroned. Above them are two skeletal figures with name-glyphs, hovering as ancestors below the sky symbol from which the symbols of secular rule emerge. Another relief reduces the ancestral couple to heads shown behind the reigning pair. Another group of related reliefs shows single enthroned figures, dressed as in the marriage reliefs, and wearing serpent-mask head-dresses. Thus the forms are Zapotec, but the content is Mixtec, in a mode that parallels the mixture of themes and forms in the architecture of Mitla.

Murals

The lintels in the courtyards of the Arroyo and Church Groups at Mitla are painted with small scenes in manuscript style [130].[29] Although they are almost certainly pre-Conquest, the pictorial conventions and the iconography of solar themes cannot be earlier than the Toltec age. They are usually assumed to be of Aztec date, that is, after 1450, when Oaxaca was subjected to garrison rule by armies from the Valley of Mexico. This assumption is difficult to prove, for many traits, like the year-signs of interlaced A and O forms, are specifically Mixtec, reappearing in the jewellery of Tomb 7 at Monte Alban and in the Mixtec genealogical manuscripts and polychrome pottery. For the

present, the date can be fixed only between the eleventh and sixteenth centuries, and the mural decoration regarded as added to older buildings.

The technique is simple: over a grey plaster film, the outlines are painted in red pigment, upon recessed lintel-panels which were designed and cut to protect the pictures from weathering. Several different hands are evident, a calligraphic style of ornate outlines and richly textured surfaces appearing on the east side of the Church Court [130 B], a much coarser and more hurried style of simpler and fewer forms and hasty draughtsmanship adorning the Arroyo Court [130 A], and, in the remaining pictures on the north, west, and south sides of the Church Court [130, C and D], a style between the finish of the first hand and the rapidity of the second, with a tendency to turn each part of a body into a distinct ornamental figure of extremely conventional character. In this last, large group, several hands are evident. To assign any chronological order is at present impossible, on account of the fragmentary condition of the murals and the general ruin of the buildings. Most nearly Aztec in style and content are the paintings on the west side of the Church Court [130 D], which may be compared with the sixteenth-century mural at Malinalco in central Mexico [62]. In both, huntsmen armed with throwing-sticks, and wearing the face paint of the hunting god, Mixcoatl, appear in processional order. Most closely related to Mixtec manuscripts are the paintings of the east side of the Church Court [130 B]. They invite comparison with such manuscripts as Codex Colombino-Becker [135].

The Mitla painter uses an interesting convention. From the sky band of the upper border, profile heads look down upon the scenes below, each flanked by a pair of hands, pushing down the darkness of the backgrounds. This theme relates to the principal scene on the north side of the Arroyo Court [130 A]: the sun-disk here appears centrally, as if rising between terraced ball-court platforms. Here, too, the sky figures push down the darkness. Star-studded ropes from the sun are handled by figures who emerge

130. Mitla, painting on lintels in Arroyo and Church Groups, after 1000.
(A) Arroyo north; (B) Church east; (C) Church north; (D) Church west

from the sky band; they perhaps are raising the sun. Elsewhere, sleeping figures are shown in the Arroyo Court, which was perhaps dedicated to the theme of the rising sun. The dawn theme is repeated once more in the sky band on the east side of the Church Court [130 B]. The north side [130 C] relates to day-time events, the west side probably to nocturnal scenes beneath a canopy of stars [130 D].

Painted Books and Maps

The manuscripts of southern Mexico usually pertain to Mixtec towns and to Mixtec rituals.[30] One group consists of deerhide screenfolds. Another group, of post-Conquest date, is painted on large sheets of cloth or on European paper. The cloths are called *lienzos*; the paper records *mapas*. The screenfolds, also misnamed

'codices',[31] have the advantage, as pleated narrative ribbons, of allowing one to open the book at several places simultaneously, and to consult front and back together (by twisting the opened ribbon). According to a seventeenth-century Dominican chronicler, the screenfolds were hung as wall ornaments around the dwellings of the lords.[32] The soft deerhide strips, sewn or glued together, sized with a chalky varnish, and then painted, have retained much of their brilliance, even though the panels tend to flake at the borders. The pages usually divide into bands, which are read in a meander-pattern.

The books from southern Mexico share many other conventions: the numeration is usually by dots alone, without the bars signifying five; the day signs of the calendar are the same as those of the twenty Aztec days; and the sign for the solar year of 365 days is an interlacing A and O

cipher. The deities all resemble those of the central Mexican pantheon in Aztec sources. The genealogical conventions also resemble those of the Aztec genealogies, such as Codex Xolotl.[33] Indeed, the pictorial writing of the Aztecs is credited in Codex Xolotl to the Tlailotlacs [65], a Náhua-speaking band emigrating to Oaxaca, learning these and other arts there, and returning to the Valley of Mexico about 1300. Thus a Texcocan source (p. 113) supports the general indebtedness of late Mexican civilization to the Mixtec peoples of the post-Classic era, although the Aztec histories themselves give little account of the debt, which we can reconstruct only by indirect means.

Caso's reconstruction of the Mixtec genealogical record is based upon a land-map of 1580 portraying the Mixtec district of Teozacualco in Oaxaca, together with a list of all its rulers, and their predecessors at nearby Tilantongo, for eight hundred years. It is arranged in columns of couples, seated upon mats and named by ideographic signs. These couples all recur in the genealogical manuscripts on deerhide, where many further particulars are supplied. Caso has fitted the various accounts together in the following reconstruction of Mixtec dynastic history as recorded for Tilantongo.[34] The dynasties reflect the principal ruptures and crises of Middle American archaeological history.

Pre-dynastic	c. 600–c. 855 ⎱	Late Classic
1st dynasty	855–992 ⎰	(Mitla)
2nd dynasty	992–1289	Toltec
3rd dynasty	1289–c. 1375	Chichimec
4th dynasty	1375–1580	Aztec and
		Conquest

The first two periods correspond to the era we have assumed for the buildings of Mitla. The second dynasty was coeval with Toltec domination in central Mexico and northern Yucatán. The third dynasty corresponds to the Chichimec period, and the fourth to Aztec hegemony. Recent studies by Troike, Rabin, and others suggest that Caso began the dynastic lists too early, at a date which they advance to the tenth century.

The dates of the various manuscripts can be deduced from their genealogical content. The front of the Vienna screenfold[35] [132], completely painted in fifty-two panels, is ostensibly earlier than the reverse. The front deals both

131. Codex Zouche-Nuttall, 18: Dynastic Couples. Mixtec, before 1350(?). *London, British Museum*

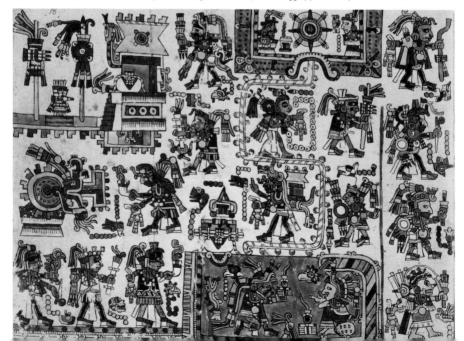

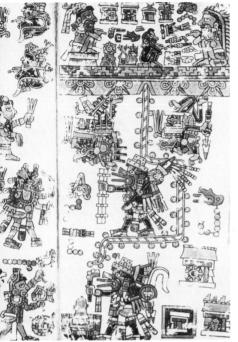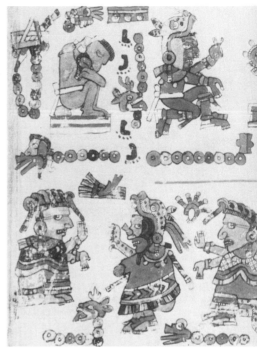

132 and 133. Vienna Codex, 48a: (*left*) Heavenly Couple and Messengers. Mixtec, before 1350(?); (*right*) reverse, ix: The Marriage and Death of Eight Deer (eleventh century). Mixtec, after 1350(?). *Vienna, Hofbibliotek*

with mythical and with historical genealogies, as well as with ritual matters, such as New Fire ceremonies. The reverse is incomplete [133], covering only thirteen panels and breaking off abruptly with a generation alive in 1350. The Zouche-Nuttall screenfold [131] likewise terminates with the generation alive in 1350, and ruling at Teozacualco. It includes different styles of drawing which possibly reflect a lapse of time in composition. Thus the Vienna and Zouche-Nuttall screenfolds can be tentatively ascribed to a period before 1350.

The second group is much later, including the Bodley and Selden screenfolds in Oxford. Both carry the genealogical account into post-Conquest times. Most of the Bodley narrative [134], like the back of the Vienna manuscript, concerns the dynasty of Tilantongo. The Selden screenfold treats mainly of an unidentified town pictured as a smoking mouth, and ruled by a family intermarrying with those of Tilantongo and Teozacualco.[36] These screenfolds break off about 1550, but their narrative is continued and amplified in other native colonial documents, especially the genealogies of the type of the Teozacualco map, such as the Lienzo de Zacatepeque and the Rickards map, both on cloth.[37]

If we now consider style, other possibilities of grouping arise. The front and the back of the Vienna manuscript are very different. The front is almost mechanical in the regularity of the line, the clarity of colour, and the orthogonal rigour of the projections of round bodies upon the flat plane [132]. The back is executed with a scratchy line, muddy colour, and unkempt contours [133]. The contrast between the two sides seems to be not only the contrast between cul-

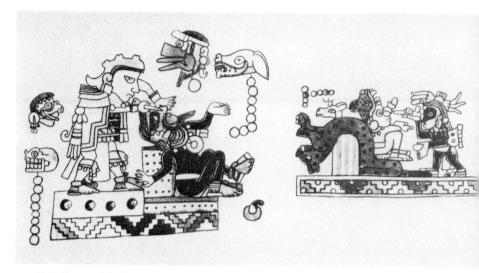

134. Eight Deer receiving honours of rank, according to (*left*) Codex Zouche-Nuttall (*London, British Museum*) and (*right*) Codex Bodley (*Oxford*)

135. Codex Colombino: Travellers crossing a Body of Water. Mixtec, before 1350(?). *Mexico City, Museo Nacional de Antropología*

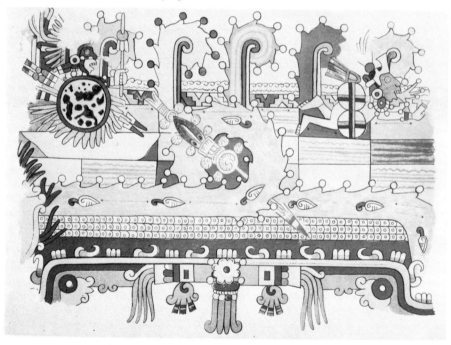

tivated and cursive forms and between careful and hasty execution, but also between widely separated historical stages in the development of a graphic style. By this criterion, the reverse of the Vienna manuscript may be regarded as a late recension of early subject matter.

In the Zouche-Nuttall manuscript, the front and back sides likewise display differences of execution, though less pronounced than in the Vienna deerhide. The front, which treats of early genealogies in rapid succession on pages 1–41, changes at page 42 to a more open and spacious composition, in a brighter range of colours, with bigger shapes and more detailed sequences of narration [134] relating the life of the eleventh-century conqueror known as Eight Deer and Tiger Claw.[38]

Thus one is tempted to postulate early (pre-1350) and late (sixteenth-century) styles, characterized by prolixity and redundancy in the early group, and by compact, swift narrative conventions in the late group. The styles are further differentiated by the ample linear descriptions and brilliant colour of the early group, in contrast to the stenographic linear character and narrow colour range of the late group. With this in mind, we may assign the manuscripts known as Codex Colombino [135] and Codex Becker,[39] which bear upon the eleventh-century portions of Mixtec history, to the early group, because of their broad and prolix narrative as well as the high colour and ornate linear precision of the figural descriptions.

The south Mexican ritual manuscripts[40] include the Borgia [137], the Vaticanus B, Cospi-Bologna, Féjerváry-Mayer [136], and the Laud screenfolds. These screenfolds are made of deerhide. Their graphic conventions as well as their figural vocabularies resemble the Mixtec genealogical group closely enough[41] to warrant discussion at this point, although the question of their individual geographic origins is unsolved. Seler thought they came from the region between Tehuacán and Oaxaca. Others relate them to Cholula polychrome pottery, which was prized in all provinces of Aztec Mexico and which may have originated in western Oaxaca.[42]

Two sub-groups are clearly marked. Borgia, Cospi, and Vaticanus B belong together in content and in style. Féjerváry and Laud both contain bar numerals, and their graphic style has qualities of elegance and precision missing in the more redundant, angular, and squat figures of the Borgia group. Féjerváry and Laud are drawn as if with fine metal wire bent and shaped to surround the figures. There is little description of textures, whereas in the Borgia group many kinds of hatching and striping reinforce the colour distinctions. In the Féjerváry-Laud group, the scheme of the Five World Regions [136] in the form of a Maltese cross (Féjerváry 1; Laud 43) closely parallels a cruciform arrangement of the 260 days of the ritual calendar in the Maya post-Classic manuscript called Troano-Cortesianus (Codex Madrid). Féjerváry and Laud are probably older than the Borgia group, as demonstrated by such affinities with Maya and Classic Zapotec figural or arithmetical conventions.[43] The close resemblances between the Borgia group and Aztec manuscripts, like Borbonicus, Vaticanus A, and Telleriano-Remensis, in the strips showing the twenty weeks,[44] relate them to the fifteenth-century art of central Mexico. But Féjerváry and Laud belong to an older stage of history, coeval with the earlier genealogies as to types, if not as to execution and style. We thus arrive at the following provisional arrangement for the chronology of south Mexican pictorial sources:[45]

	RITUAL BOOKS	GENEALOGIES
Pre-1350	Laud	Vienna front [132], Zouche-Nuttall [131]
	Féjerváry-Mayer [136]	Colombino-Becker [135]
Post-1350	Borgia [137], Cospi, Vaticanus B	Bodley [134], Selden, Vienna back [133]

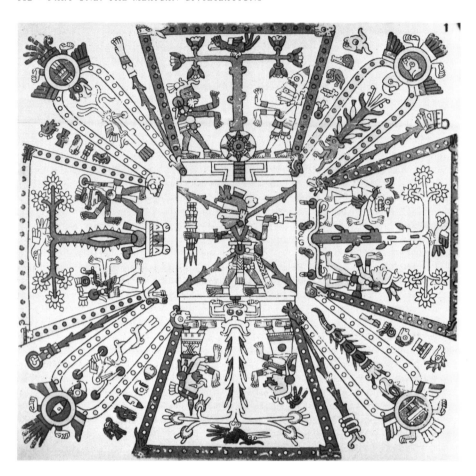

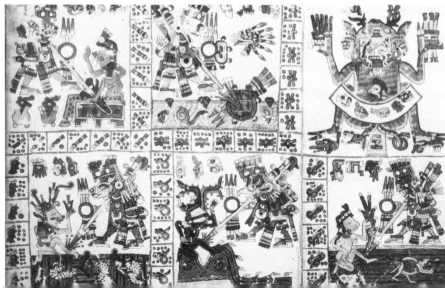

136 (*opposite, above*). Codex Féjerváry-Mayer, 1: The Five World Regions. Mixtec, before 1350(?).
Liverpool, Free Public Museum, Mayer Collection

137 (*opposite, below*). Codex Borgia, 53–4: The Five Venus Periods. Fifteenth century(?).
Rome, Vatican Library

The content of the ritual books is double: as cosmogonic illustrations, and as augural schemes. The powers of the gods and the rhythm of their influences upon human affairs are illustrated by images using a few fundamental motifs in many combinations. The screenfold strips are cyclical, either as radial panels or as sequences of panels. Both forms enumerate the divisions of recurrent time-periods, and illustrate the changing regencies of each division. The principal time periods are the 20 day-names, the augural year of 260 days (with 20 weeks of 13 days), the solar year (18 months of 20 days and a 19th month of 5 days), and the Venus year of 584 days [137]. Their cyclical coincidences are marked. Their divisions and combinations refer to space by the symbolism of the cardinal points. A change of direction accompanies each change of regency, so that the passage from one quarter of the year to the next occurs under new regencies, and in another direction, symbolized by colours, and by god-, tree-, and bird-forms appropriate to the space-time combinations of the moment. As Soustelle remarks, every place-moment is represented by a cluster or hive of hierarchically ordered images of cosmic import.[46] Their endless permutation gave priestly auguries for the main events of public and private life.

Illustration 136 shows a scheme symbolic of the calendar, with which the Féjerváry manuscript opens. The trapezoidal arms of a Maltese cross alternate with elongated loops in a figure reminiscent of the Maya glyph for the Zero of completion. Its outline contains 260 positions in anti-clockwise movement, punctuated at every change of direction, and at intervals of thirteen positions, by the initial day-signs of the twenty weeks of the ritual calendar. Large cartouches at the corners contain the four year-bearer days of the solar year sequence. Each trapezoidal panel contains two deities flanking a tree symbolic of that direction. The east is at the top. The central deity completes the cycle of the nine Lords of the Night. Their rotating regencies combine with those of the days, weeks, months, year divisions, and years to compose the peculiar properties of each and every moment of time.

Another cycle, based upon the planet Venus, comprises 584 days. Its combination with the ritual calendar of 260 days is implicit in many cyclical schemes, especially in tables stressing every fifth sign or presenting the ritual calendar by columns of five days.[47] Thus illustration 137, from the Borgia manuscript, sets forth one figure spearing another, in five variants surrounded by numbered day-signs. The day-signs are only 5 in number, each with 13 coefficients, marking the 65 Venus-year bearers, which corresponds to 104 solar years and 146 ritual years ($65 \times 584 = 104 \times 365 = 146 \times 260$). The page commemorates the remarkable cyclical combination of these large numbers.

Ceramics

Mixtec pottery has not yet received the minute analysis that characterizes the study of Maya, central Mexican, or East Coast ceramic types. Paddock, however, identified a style he called Ñuiñe (Mixtec for Hot Land) in the upper Balsas River valley, between Acatlán (southern Puebla), Huajuapan (western Oaxaca), and the Guerrero border. Its elements are Thin Orange pottery, figurine heads lacking bodies, and distinctive clay urns portraying wrinkled old men. Ñuiñe art began perhaps before 500, and continued until the rise of Tula, as a predecessor of Mixteca-Puebla style. An example is the

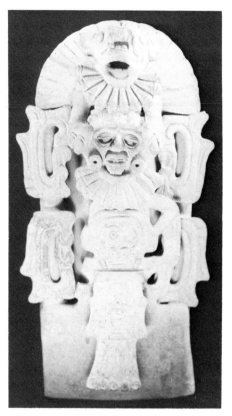

from Sinaloa into Nicaragua and Costa Rica. The connexion among them all can be established by the vessel forms and by their iconography. The finest is Mixtec by subject-matter, although its manufacture is commonly ascribed to the vicinity of Cholula in the state of Puebla, and its date is commonly taken as Aztec.[50]

Noguera distinguishes three varieties of polychrome pottery at Cholula – lacquered, matt, and hard-fired (*laca, mate, firme*) – which occur in chronological sequence as early, middle, and late, evolving from a stuccoed

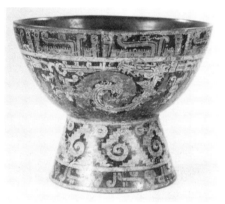

138. Pottery urn from Huajuapan (Oaxaca), Ñuiñe style, after 500. *Mitla, Museo Frissell*

139. Polychrome pottery vessel from western Oaxaca, Mixtec style, after 1250(?).
Cleveland Museum of Art, Severance Collection

Huajuapan urn [138] which shares characteristics both of Teotihuacán and Monte Alban urns. At Yagul the tomb pottery of post-Classic date is orange-red ware with blackish graphite decoration. Among the shapes were an effigy jar, tripod censers with walls perforated in a geometric frieze decoration, pitchers, and a dough-nut-shaped vase.[48] These shapes reappear in the polychrome vessels [139], painted with scenes and motifs almost identical with those of the deerhide ritual manuscripts. Such types of polychrome vessels were widely distributed throughout Middle America[49] from the Atlantic to the Pacific coastal provinces, and

prototype whose decoration was applied after firing, like that of Teotihuacán and Kaminaljuyú.[51] The stuccoed decoration was of Classic date; the lacquered, matt, and hard-fired varieties are post-Classic and of undetermined durations. The lacquered wares, painted after firing, were polished and then fired anew. The colours were applied upon a white ground of gesso-like consistency, which flakes away with light wear or pressure. Mixtec examples of lac-quered polychrome pottery [139] are easily dis-tinguished from the Cholula versions by their more elongated legs, by the clear articulation of the flaring rims, and by the draughtsmanship,

which is larger and freer than in the Cholula examples, and better adapted to rhythmic decoration of the bowl-shape.

Mixtec sculpture survives mainly in wood-carvings, bone reliefs, turquoise mosaic masks and instruments, and other lapidary works.[52] Mixtec jades are stereotyped productions, with anatomical features reduced to the simplest shorthand of straight saw-cuts and tubular drill marks. In the wood and bone carvings, the manuscript style of conventional figures and calendrical inscriptions is as dominant as in polychrome pottery painting, so that one can properly characterize all Mixtec figural art as derivative from the workshops of the manu-script illuminators.

A two-tongued cylindrical wooden drum (*teponaztli*) in the British Museum is carved in low relief, recounting a battle between two towns in the year Three Flint [140]. The carv-ing, in only two planes, is more linear than sculptural, the frontal plane being incised with

origin resemble pebbly sharkskin [141]. This texture is given by the use of curvilinear and convex chips, surrounding figural designs in large pieces cut to the desired outlines, as in the seventeen specimens found in a Mixteca cave in the state of Puebla.[55] Seven of these may be the work of one hand, in light and dark turquoise chips, surrounding brown and black stones, and bits of red shell. Of the same technique, and showing scenes of manuscript style, are shields in New York (Museum of the American

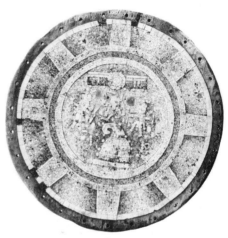

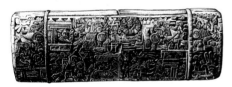

140. Wooden drum, Mixtec style, fourteenth century(?). *London, British Museum*

141. Mosaic disk from the state of Puebla, Mixtec, fourteenth-fifteenth centuries.
New York, Museum of the American Indian

conventional contours and textures. The carved jaguar bones from Tomb 7 at Monte Alban and the gilded wooden throwing-sticks in Florence (National Museum of Anthropology and Eth-nology) show a similar transposition of drawings into low relief carving.

Mosaic decoration of turquoise chips glued to a wooden support is of post-Classic date in both highland Mexico and Yucatán.[53] Toltec and Mixtec techniques differ in the shaping of the tiny chips. Examples of Toltec date (e.g. the plaque from the Chacmool temple at Chichén Itza) have straight-sided polygonal chips ground to a flat plane.[54] Examples of Mixtec

Indian), Vienna (Naturhistorisches Museum), and London (British Museum).[56]

Metallurgy appeared late in Middle America. The earliest known example is of *tumbaga*, dated *c*. A.D. 500, occurring as an import from the Coclé region of Panamá at Altun Ha in the Maya area. The Toltecs of Tula and Chichén Itza produced metal objects in important quantities, from the tenth to the thirteenth centuries.[57] It is generally supposed that the Mixtec metal-workers learned the craft and developed their art only after the disintegration of Toltec civil-ization, that is, from about 1300 on. The most important discoveries of Mixtec metal are the

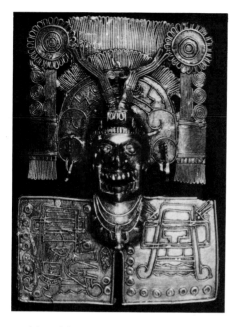
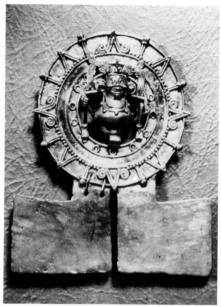

142 (*above, left*). Gold pendant, the 'Death Knight', from Tomb 7, Monte Alban, after 1250(?). *Oaxaca, Museo Regional*

143 (*above, right*). Zaachila, gold pendant, Tomb 1, after 1250

144 (*opposite*). Cast gold pendant from Tomb 7, Monte Alban, after 1250(?). *Oaxaca, Museo Regional*

treasures of Tomb 1 at Zaachila and Tomb 7 at Monte Alban.[58] *Cire perdue* castings, filigree objects, repoussé technique, alloying, plating, and soldering all appear. Their association with carved bones, of a figural style like that of the genealogical manuscripts, supports a fourteenth-century dating. The representation, however, of gold ornaments in the pre-1350 group of manuscripts (e.g. Vienna 47c–48a, showing gold or copper bells on the dog-headed acolytes) suggests that the Mixtecs were also metal-workers at an earlier date.

The shape of several metal objects in Tomb 7 reflects Central American connexions. For instance, the gold breast-pendants of illustrations 142 and 143 represent a skeletal figure and a sun-disk as open-mould castings, rising from two broad flanges which stabilize the heavy ornament in a flat position on the chest of the wearer. This form of pendant is Panamanian.[59] Another gold ornament from Tomb 7 is hinged together [144] of sixteen cast elements in six stages: at the top is a ball-court with two players. Hanging below are a sun disk, then a fiery flint, and an earth monster with bell pendants. The whole assembly probably pertains to the ball game as a symbol of the diurnal passages of the sun.

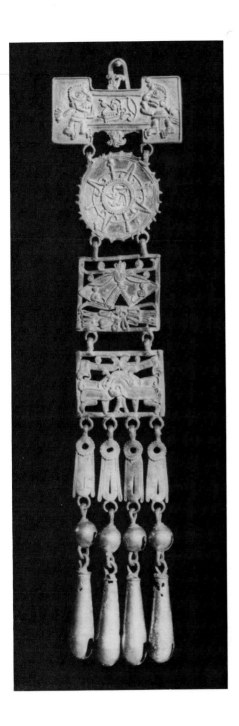

145. Pottery figurine group
from Xochipala, before 1200 B.C.(?).
Princeton University Art Museum

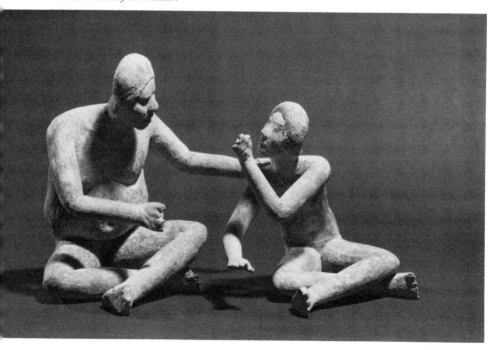

WESTERN MEXICO

The hundredth meridian, or a line drawn north and south near Toluca, divides ancient Mexico into an eastern half, of high civilizations in densely populated regions, and a western half, of scattered, small, and isolated tribal groupings, whose archaeological history has been recovered only in the last twenty years. In the main, this western history comprises four principal stages: (1) an early era of Olmec style which endured many centuries in Guerrero, with sporadic manifestations farther west; (2) a middle period when many traits of a village art in the style of the Formative period were amplified in the funeral pottery of Colima, Jalisco, and Nayarit; (3) post-Classic intrusions of Toltec and Mixtec ceremonial forms in Michoacán and in the pottery of Sinaloa on the north-west coast; and finally, (4) coeval with the state which resulted from the Aztec conquest, the Tarasca civilization centring upon the lake district of Michoacán.

Save in Guerrero, all these western styles of art were of recent origin, not antedating Teotihuacán III. In Guerrero, the lithic industries seem more abundant than in the rest of western Mexico, where pottery products carry the record, almost to the exclusion of stone. The recent discovery of a veristic figurine style at Xochipala [145], with Olmec aspects, but perhaps antedating the earliest Olmec expressions, has revived the possibility that an early highland cultural expression was antecedent to Olmec art. Firm dates and excavation data still are lacking, but authenticity may be claimed for one piece collected in 1896 by W. Niven. Thus Guerrero alone is rich in stone manufactures. In other western regions, the artifacts are predominantly ceramic in character. Guerrero belongs together with Olmec, Maya, and central Mexican art; the regions to the north and west of it belong to another order of civilization which perpetuated early

village art rather than the styles of the great ceremonial centres.[1]

THE STONE-WORKERS OF GUERRERO

South-west of Mexico City lie Tasco and Iguala, on the highway which crosses an ancient archaeological province. This province centres upon the middle course of the Mezcala river. The mining area of Sultepec marks its northwest boundary; Zumpango del Río and Chilapa define its south-eastern limit. Stone objects in great numbers come from the region without specific provenience, casually or illegally excavated and marketed.[2] One class is of Olmec style; another reflects Teotihuacán influence in the area; still another group of small face panels of stone is related to post-Classic funeral customs. Diminutive temple models [146] are not

146. Stone model of a temple from the Mezcala region, after 300(?)

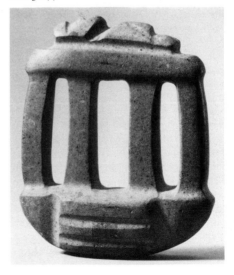

uncommon, representing colonnaded façades, some with staircases and human figures, and others as full models with columns at the corners. Gay assigns them to the middle range of Mezcala time, *c.* 100 B.C.–A.D. 100. They may reflect pilgrimages to Monte Alban and related sites in Oaxaca in the central valleys.

Many hand-axes are carved to resemble standing human figures looking like insects. This raises a crucial question concerning the origins of stone sculpture.[3] To present knowledge, the Olmec style is the oldest dated style of stonework in Mexico. As suggested earlier (p. 120), the Olmec instrumental forms, such as hand-axes, are perhaps earlier than the free-standing figurines which lack any obvious instrumental function. The Olmec axes frequently occur in the Guerrero-Puebla region, and their material – sea-green and blue-grey jade – is typical of the Mezcala river basin, especially in the southern portion around Zumpango del Río. A case can be made for great antiquity in the Guerrero hand-axes, both because of their abundance, and because of the primeval character of their workmanship, which reduces the human figure to the simplest number of fundamental planes. Covarrubias believed that these axes from Guerrero were derived from Olmec types; they differ greatly, however, from Olmec as well as Teotihuacán styles of lapidary work.

The Mezcala axes [147] are utilitarian rather than ceremonial, usually between 4 and 8 inches long, with cutting edges, both at the feet and head, often heavily worn and scarred. The articulation by head, torso, and legs is intended for grasping. All the profiles and cuts betray economical design, to secure the most expressive and utilitarian form with the least expenditure of energy upon the cutting of the stone. The heads are usually cut in three planes: one curving plane for the forehead, and two planes beneath it, meeting at an obtuse angle to define the nose and eye hollows. The mouth and neck are rounded cuts. The legs are claw-hammer or chisel shapes, intended to strip flesh from bones or bark from branches. Even if their eventual dating should support Covarrubias's

contention that they are derivative, the Mezcala axes will still afford the clearest demonstration of the basic system of the Stone Age lapidaries of Mexico. Geometric analysis recurs both in Olmec and in Teotihuacán types of jade-cutting, and it produces in other styles as well that abstract nobility of generalized expression so reminiscent of the early ages of Mediterranean sculpture.

The Olmec and Teotihuacán types in Guerrero have been discussed elsewhere (pp. 117 and 60) and in other connexions: here it is necessary only to mark Guerrero as a lapidary centre during both pre-Classic and Classic eras, in the

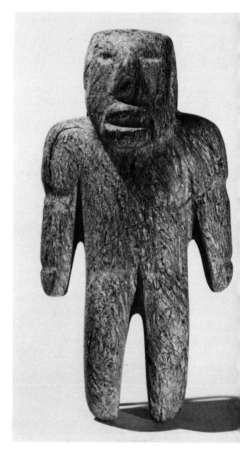

production of hand-axes in the Olmec style, and of stone figurines in the Teotihuacán style, noting that both are rare at their respective type-sites. Covarrubias has rightly insisted upon such hyphenated designations as Olmec-Guerrero and Teotihuacán-Guerrero, in discussing such pieces.

Covarrubias has also identified another style of small stone figures and face panels, which he assigns to the Mezcala river valley. They have in common a rectangular mode of cutting, which leaves a T-shaped ridge to define nose and eyes, island-like cheek areas, and thick-rimmed oval mouths [148]. Their date is

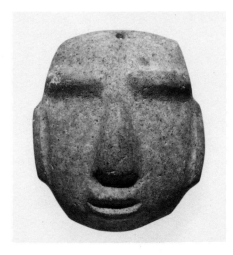

147 (*opposite*). Stone axe in human form from the Mezcala region, before 600 B.C.(?). *New Haven, Yale University Art Gallery, Olsen Collection*

148 (*above*). Stone face panel from the state of Guerrero, *c.* 500(?). *New Haven, Yale University Art Gallery, Olsen Collection*

probably post-Classic. Some examples have perforated eyes and mouths, suggesting their use as masks by living wearers.[4]

From farther north, between Tasco and Sultepec (the Chontal district), come still other stylized head-forms with immense noses projecting like sails from boat-shaped faces. One example in the Diego Rivera Collection is laterally compressed like an East Coast *hacha*; the chin and nose are almost equivalent, so that the profile reads equally well whichever way up the piece is held.[5]

THE POTTERS OF COLIMA, JALISCO, AND NAYARIT

The immense and variegated landscapes of western Mexico have been under intense archaeological study for nearly forty years.[6] The Nayarit-Colima zone shows early Classic occupation only at the time of Teotihuacán III, which is the period of manufacture of the large pottery tomb figures now scattered throughout the museums and private collections of the entire western world. Illegal excavation for commercial purposes has so long been the rule that an exact report on architectural form is available on few sites.[7] One plundered tomb is near Etzatlán in Jalisco. Three underground chambers, connected by tunnels and entered by a vertical shaft, were dug in the dense soil during the Classic period (A.D. 200–300). In the process, vault-like roofs with groined intersections were carved in the earth. These chambers resemble the shafted tombs of the upper Cauca river in Colombia [292].

The contents of the burials of the region cannot now be re-assembled,[8] although it is supposed that the custom of building large underground tombs was restricted to the Ortices phase (equivalent to Teotihuacán III: Kelly) and that the large hollow red-ware figures and small, solid figurines in action were of the same era throughout the region from Nayarit and western Jalisco into Colima. Miss Kelly did not venture any further distinctions among the figural types in the absence of all associations with graves, but it is evident that several generations of connected sculptural efforts are present, and that a simple typological seriation by technique, modelling, texture, and action can be attempted, with a good chance

that the seriation will correspond to sequence in time.[9] The attempt is made more difficult by the likelihood that many local schools of potters are represented in the collections. Ixtlán, Ameca-Zacualco, and Colima made probably only a small part of the huge production we know today.

Many pieces, nevertheless, share a predilection for the representation of figures in action, shown at an instantly recognizable moment of some kind of energetic behaviour. In Colima and Jalisco individual figurines appear in poses of lifeless frontality, but these are perhaps characteristic only of the early period of the craft and of a certain iconographic type. The eyes are rendered by pellets of coffee-bean shape. Organic forms and costume ornaments appear as added fillets or pats of clay. The groups in action consist of two or more figures with coffee-bean eyes circling around seated musicians, to indicate a dance [149], or as a gathering of several figures to mark a household or temple ritual. Lovers are shown, and maternity groups, as well as acrobats, persons borne on litters, and warriors in aggressive posture.[10]

In another group of Colima figures, the coffee-bean eyes are replaced by puffy, slit eyes, giving a somnolent look.[11] The proportions of the parts of the body are governed by a conception of the total movement to be shown. If great dignity and reserve are to be portrayed, the arms are stiff and rod-like and the back is rigid. If, however, dancers or musicians are shown, all the forms of the body undulate in interlacing rhythms. The puffy-eyed Colima figures probably followed the coffee-bean eyes, and in turn may have been replaced by the anatomically accurate modelling of spherical eyeballs on hollow red-ware figurines representing warriors, hunchbacks, and dogs and other fauna.

149. Pottery group of dancers from Colima, first century(?).
New Haven, Yale University Art Gallery

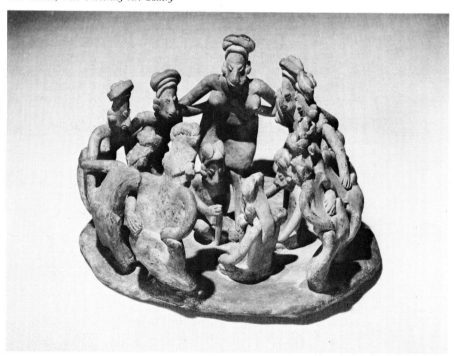

Groups are infrequent, and the figures are much larger in this last class. It is unlikely that these profound technical and formal differences are local in origin; they should correspond to an evolution, lasting as long as the closely parallel sequence from El Arbolillo to Ticoman in the Valley of Mexico. This may have covered some five centuries, and several centres could have participated in all or part of the development.

The Ameca Valley figures constitute a recognizable group within the Colima style [150], although the tombs yielding them are in the state of Jalisco, west of Lake Chapala. The clay is beige-grey, unlike the buff-brown and red-slipped Colima wares. The heads are much elongated, with long noses and large eyeballs. Early and late figures can again be distinguished. The early examples are sheep-faced. The late ones are more distinctly divided by an organic conception of the parts of the body. Early figures seem eroded or melted, in the continuous passages of modelling that unite rather than divide the parts of the body. Late figures are more animated, and more incisively articulated.[12]

Such differences also mark divisions among the Nayarit figures. The best known examples come from Ixtlán in the southern part of the state. One group, of hurried manufacture, shows animated figures assembled in thatched houses or upon the terraces of a ball-court.[13] They are of red or buff paste, painted in geometric lines of resist-colour, or in red, white, and orange textile-patterns. The technique and the modelling recall the Colima groups. It is possible that they both are of the same late pre-Classic date. The village ceremony shown in illustration 151 resembles the acrobatic *volador*

150. Long-headed pottery figure from the Ameca Valley, second century(?). *Philadelphia, Museum of Art, Arensberg Collection*

151. Pottery group showing village pole ritual from southern Nayarit. *New Haven, Yale University Art Gallery, Olsen Collection*

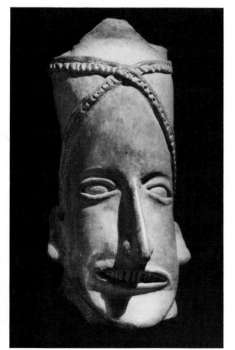

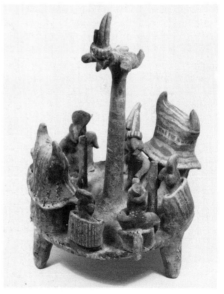

ritual of eastern Mexico. The Gulf Coast ritual, however, has strong calendrical symbolism in the acrobats rotating on ropes as a human wheel,

whereas the western and central Mexican pole scenes as represented in *Codex Borbonicus* [64] may represent rise and descent as linking sky and earth. Here the pole stands between two houses, and the acrobat performs on its top in a head-dress of feathers or reeds, perhaps marking him as a bird-impersonator.

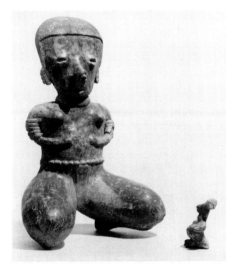

The second Nayarit group, of nude figures with puffy, slit eyes carefully blended into the faces, corresponds to the 'somnolent' Colima group, but the Nayarit figures are of superior execution, with variegated textures and a great range of figural poses and occupational types. After 1960 these figures began to be called 'Chinesca' among collectors. They are said to come from Early Classic shaft tombs in southern and central Nayarit, and a radiocarbon date fixes the type about A.D. 100.[14] The massing of heads and bodies bears little relation to visual impressions. The heads, with their balancing projections and the rich textures of straight hair and shell ornaments for ear and nose, and the bulbous bodies with limbs like filaments, form a most original rhythmic organization [152]. Indeed one has the impression that the sculptors of this group were the innovators in the Early Classic middle period. Their work intervenes between the production of small figures in action with coffee-bean eyes, and of the large, hollow figures with fully modelled eyeballs.

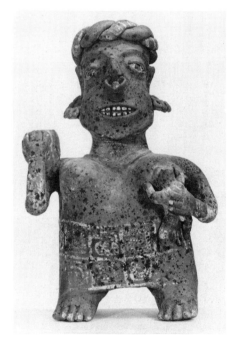

This last group is the best known of the Nayarit figures, and it has drawn both the praise and the abuse that attend the discussion of modern art. Gifford, for example, regards them as caricatures, while Salvador Toscano ascribed to them an 'energetic beauty', in spite of their defective firing and casual polychromy.[15] Indeed the square bodies, grimacing mouths, and staring eyes convey a disturbing expression which is only in part resolved by the animation and plastic energy of the turgid forms. Two notably different manners appear in the Ixtlán group of the fully modelled eyes, and they may pertain to the work of different generations [153, 154]. One is adorned with four-colour painting in textile patterns, and the faces, whether of men or women, display a toothy rictus of savage ugliness, in long and angular countenances. The other Ixtlán group is far gentler in expression, with round, plump faces, raised eyebrows, round eyes, and a childlike

152 (*opposite, above*). Pottery 'Chinesca type' figures from the state of Nayarit, after 100 B.C.(?). *Philadelphia, Museum of Art, Arensberg Collection*

153 (*opposite, below*). Polychrome pottery figure, long-headed type, from near Ixtlán, after 100(?). *New Haven, Yale University Art Gallery, Olsen Collection*

154 (*below*). Polychrome pottery figure, round-headed type, from near Ixtlán, after 100(?). *Mexico City, Museo Nacional de Antropología*

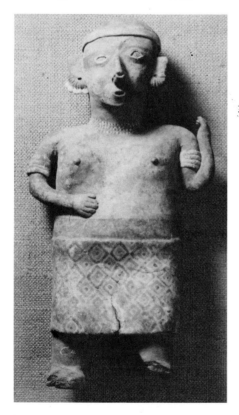

expression of delighted anticipation, in opposition to the fiercely grimacing long-heads.

In review, each of the three regions produced different versions of the same style, in a developmental sequence of perhaps five centuries' duration that runs parallel to the events of the Valley of Mexico or the Pánuco series on the Gulf Coast. Each region, however, achieved outstanding quality at a different period. The Colima figurines in action, with their coffee-bean eyes, are the most animated ceramic expression of their era in western Mexico [149]. The slit-eyed figures of Ixtlán in Nayarit[16] excel by plastic and rhythmic inventiveness [153]. The fully modelled warriors and crouching figures from Ameca in Jalisco [150] are superior in technique and modelling, when one considers the stereotyped, hurried execution of so much Ixtlán pottery. Striking iconographic differences also separate the art of these three regions. The fattened and edible dogs of Colima, which reputedly were the guides of the dead in the other world,[17] are lacking in Jalisco and Nayarit. The Ameca figures of Jalisco abound in crouching and kneeling poses. The Ixtlán potters in Nayarit recorded a singularly graceful seated posture of the women: the legs are drawn in to the body as parallel and supporting elements across the base, a posture portrayed rarely elsewhere.

It has often been thought that west Mexican art, in its protective aboriginal isolation, escaped much of the tyranny by ritual that characterizes other Mesoamerican regions, and that its manufacturers merely 'report' daily village life. Recently, however, P. Furst has sought to connect living Cora and Huichol ethnography with west Mexican archaeology, on the score of shamanism and the ritual use of hallucinogenic plants. The hypothesis is attractively simple, but it presupposes that ancient peoples were less changeable and more alike than the archaeological finds warrant. It also avoids the possibility that modern shamanism is a recent rustic development among peoples of Catholic tradition in isolated environments.[18]

MICHOACÁN

Both in the highlands and on the coast, Michoacán was occupied at least as early as the middle pre-Classic period (750–350 B.C.). The

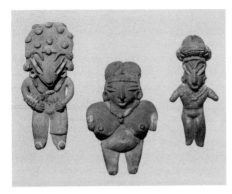

155. Pottery figurines from Chupícuaro,
H 4 types, before 200 B.C.
Mexico City, Museo Nacional de Antropología

types, related to those of Zacatenco (prior to 500 B.C.) in the Valley of Mexico, are found in abundance. Another archaic centre is Chupícuaro in the north-east, where early and late phases occur.[19] The early pottery correlates with Ticoman II (*c.* 500 B.C. -A.D. 300). The origins of rectilinear geometric Chupícuaro pottery painting probably lie in north central Mexico. The early sculptural style appears in clay figurines with long, slanted coffee-bean eyes [155]: the late figurines wear heavy neck ornaments or chokers. Both types are slab-like. The choker figures were shaped upon a flat working surface, as if in an early endeavour towards the invention of the mould. The early examples have greater rhythmic and expressive properties than the late ones.

region not only lacks cultural unity, but it differs from the rest of Mesoamerica. The oldest known village sites are in the lower Balsas basin at Infiernillo, and in the north-western part of the state, at El Opeño and at the foot of Cerro Curutrán. Pottery and figurines of pre-Classic

The western spread of the style of Teotihuacán is apparent in manufactures of the Classic period found at Jiquilpan in western Michoacán.[20] The most notable examples are two spherical vessels of pottery [156], decorated in the peculiar technique of lacquer inlay, prob-

156. Spherical polychrome pottery vessel from Jiquilpan, sixth-seventh centuries(?).
Mexico City, Museo Nacional de Antropología

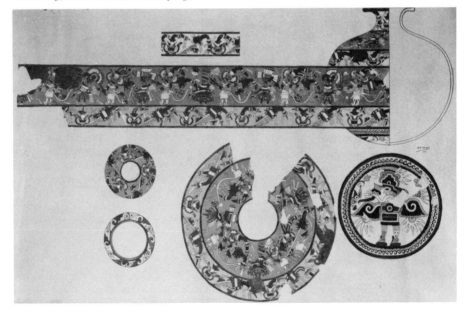

ably native to western Mexico, which survives in the lacquered gourds of colonial and modern manufacture. The technique is usually called *cloisonné* or *alfresco* decoration in archaeological writing, but neither term is fortunate, as both already possess exact meanings, one in metal-work, the other in mural painting.

The Mexican lacquer-worker coated an inert, stucco-like support with pigments carried in a resinous and oily medium.[21] The thick foundation coat of pigment was carved away in recessed patterns, then filled with other colours. The analogy to enamel technique ('cloisonné') is less close than the comparison to marquetry or inlay. The Jiquilpan vessels are painted in six hues as well as grey and white, in five friezes of processional figures. On the rounded bases are medallions of a winged human and a bird-like decoration. Covarrubias maintains that these vessels were lacquered, and that their present powdery aspect, as of fresco painting, is due to the decay of the organic matter in the lacquer medium. With Jiquilpan and its objects in the Teotihuacán style, a few other sites in Michoacán can be associated to form an 'Early Lake' style. There is no metalwork, and the pottery may antedate the first appearance of a recognizable Tarasca culture.

For many years the term 'Tarascan' was indiscriminately applied to practically all ancient western Mexican products. Today the Tarascan civilization is believed not to antedate the tenth century.[22] Two phases, limited to the lake region, are known archaeologically: the early one perhaps antedates the Toltec horizon, with an architecture consisting of round and rectangular platforms, called *yácatas* [157]. The use of tobacco pipes has been taken to show Tarascan origins in the far north. Metalworking (possibly of South American origins) was limited to the manufacture of needles and hooks of copper wire. The later phase of Tarascan political expansion is post-Toltec.[23] Among its productions are Chacmool figures, elaborate lapidary work in obsidian and turquoise, and lost-wax casting of objects in gold, silver, and copper.

The *yácatas* of Tzintzuntzan on the eastern shore of Lake Patzcuaro are five burial platforms aligned in a row [157]. Each had twelve stages of rubble faced with stone slabs and all

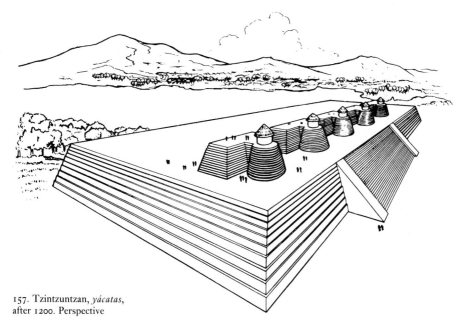

157. Tzintzuntzan, *yácatas*, after 1200. Perspective

stood upon a primary platform ten stages high (13 m.; 43 feet) which in its day was among the most imposing monuments of America.

The whole configuration of Tarascan art is eclectic. The circular platforms probably relate to the Huasteca and central Mexico (Cuicuilco). Resist-painting and tobacco pipes may reflect northern associations as far afield as the south-western United States. The metalworking and the ritual sculpture (Chacmool figures) suggest debts to Toltec and Mixtec sources, possibly connected with the exploitation of Tarascan mines, as portrayed in the Lienzo de Jucutacato.[24]

A parallel debt to Mixtec art is apparent in the far north-west, at Guasave in Sinaloa. The tentative date assigned to this 'Aztatlán poly-chrome' pottery is about A.D. 1350, on the strength of the parallels with pottery in the Cholula area.[25] The Mixtec-influenced decoration in Sinaloa includes such elements as feathered serpents, sun disks, wind-god symbols, flint knife motifs, and heart and blood conventions which all relate more directly to post-Classic book illumination and wall painting than to any other sources. The figure painted in the bowl shown in illustration 158 represents a

158. Painted pottery bowl from Guasave, before 1350. *New York, American Museum of Natural History*

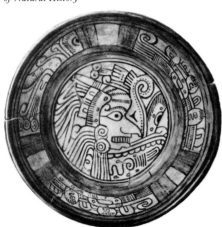

human head wearing feathers, resembling Tlahuizcalpantecutli, the Aztec god of the morning star, whose cult is shown in Mixtec and Aztec manuscripts. The transposition of this motif from central to north-western Mexico was, according to Ekholm's deductions, through actual migration of religious groups. In Sinaloa, however, no monumental sculpture, no clay figurines, and no stone architecture are evident: only painted pottery of faintly Mixtec style persists. The 'Atzatlán Group' was succeeded by a simpler polychrome style in Culiacán, with early, middle, and late stages, to which very short durations were at first given (1400–1520).[26] As these durations were expanded, the position of the Guasave pottery under Mixtec influence was moved back correspondingly to 1150–1350.

THE NORTHERN PLATEAUS

North of the Valley of Mexico, architectural sites are few and widely scattered. Toluquilla and Ranas in north-eastern Querétaro are in the Atlantic watershed of the Moctezuma river, which flows into the Gulf at Pánuco. Farther north-west are La Quemada and Chalchihuites in Zacatecas on the Pacific watershed. Toluquilla and Ranas display affinities with Tajín, Xochicalco, and the Maya region. La Quemada and Chalchihuites may be related to Tula and Toltec architecture.

Toluquilla and Ranas [159], about 50 miles north of Querétaro, are alignments of terraced platforms and buildings along narrow ridges rising abruptly from the surrounding plains. Las Ranas has five ball-courts set among many square and oblong platforms of steep vertical profiles. The combination of tall talus profiles, capped by prominent bevelled cornices, belongs to the architectural style of Tajín. Half a ball-game yoke of basalt, carved in the Classic Veracruz style, with a profile head upon the heel, and interlaced scrolls upon one flank, was found at Ranas,[27] confirming the relationship with Tajín as well as the Late Classic date of these sites. They probably defended the head-

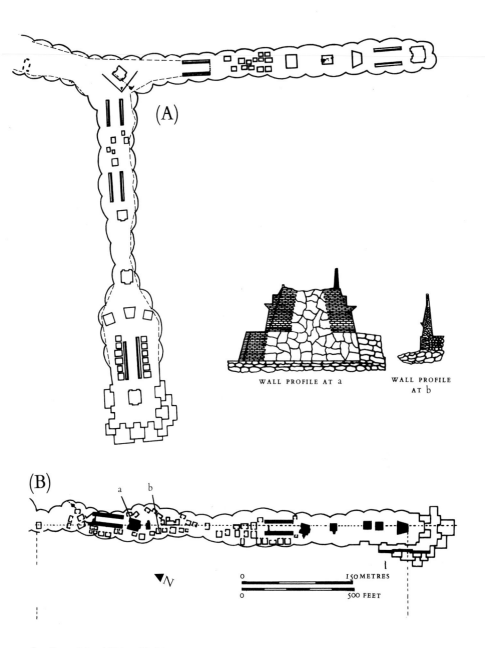

WALL PROFILE AT a

WALL PROFILE
AT b

N

0 150 METRES

0 500 FEET

159. Las Ranas (A) and Toluquilla (B), 700–1000.
Plans and profiles of walls

waters of the valleys giving access to the coastal civilizations from attack by highland invaders, more by their presence than by overtly defensive arrangements, which characterize a stage of Middle American architectural development after the Toltec era.[28]

Such fortifications, with circumvallations, on inaccessible sites dominating their surroundings, appear at La Quemada and Chalchihuites in the state of Zacatecas.[29] La Quemada is a walled hilltop town approached from the west by a causeway 100 yards wide. The most distinctive enclosure is a rectangular walled platform, lined on all four sides by eleven round columns of shaped spalls of feldspar, in the manner of a colonnaded court, like the Mercado buildings at Chichén Itza [239] and Tula. A similar colonnaded enclosure at Chalchihuites has twenty-eight columns in four rows of unevenly spaced and irregularly proportioned shafts of stone, clay, and adobe bricks. These architectural forms strongly suggest a building date during the Toltec era. Kelley regards La Quemada as the 'maximum advance of the Mesoamerican farming-based economy' into the northern plateaus.[30]

THE MAYA AND THEIR NEIGHBOURS

THE MAYA TRADITION: ARCHITECTURE

CLASSIC MAYA

The Classic Maya peoples produced objects both of use and of pleasure with tools of stone alone. The Marxist stereotype, that cultural behaviour is determined by the instruments of production, finds no confirmation in Maya art. Its forms, though comparable to those made by the metal-using civilizations of Mediterranean antiquity, belong technologically to much older, Neolithic horizons of prehistory.

Classic Maya art spanned the centuries from the time of Christ until about 1000, and had its home in central Yucatán, bounded on the south by the Guatemalan highlands and on the north by a flat and dry limestone plain. The term 'Classic' distinguishes monuments exactly dated by inscriptions in Maya calendrical notation from pre-Maya, from non-Maya, and from Toltec Maya manufactures after 1000. Classic Maya art[1] consists of stone architecture using corbelled vaults and burnt-lime cement or concrete; of stela-like slabs and prisms of stone carved in low relief commemorating the priests, the warriors, and the various periods of Maya history; and of calendrical inscriptions which permit exact dating, to the day, within a 700-year range. Other products, such as painted pottery and jade carving, are often part of manufactures of the Classic style, but they are not constitutive or diagnostic, in the sense of the corbelled vault, the stela, and the calendrical inscription, which define Classic Maya art.[2]

The corbelled vault [160] is a system of cantilevered stones, each placed to overhang the course immediately underneath. The Maya vault consists of bearing walls, capped by the overhanging vault, which is of about the same height as the bearing walls. The spatial enclosure is attained simply by the inclination of two or more walls towards one another. The system is inherently unstable. Its equilibrium depends upon a nice adjustment among the unstable overhangs, and upon various devices of counter-balance. Burnt-lime mortar, cement cores, wooden tie-rods, and special stereotomic forms, such as the boot-shaped stones used in late vaults, contributed to stability.[3] End walls and cross partitions also played a part [160 B]. The use of cement or concrete bonding is a Maya habit, absent from non-Maya examples of corbelled vaulting from the south-eastern United States to southern South America.[4] The central Maya roof decoration, called roof-combs [160 A], and the north Maya false fronts, or flying façades [160 E], were regarded as loads, and thus were meant yet further to counter-balance the bearing walls against the unstable overhangs. Usually the Maya vault is set with thick wooden tie-rods spanning the interior overhangs. They were probably inserted as construction went on, in order to keep the overhangs apart during the long hardening period of Maya mortar, and they later served as rods from which to hang the belongings and the hammocks of the occupants. The buildings of stone

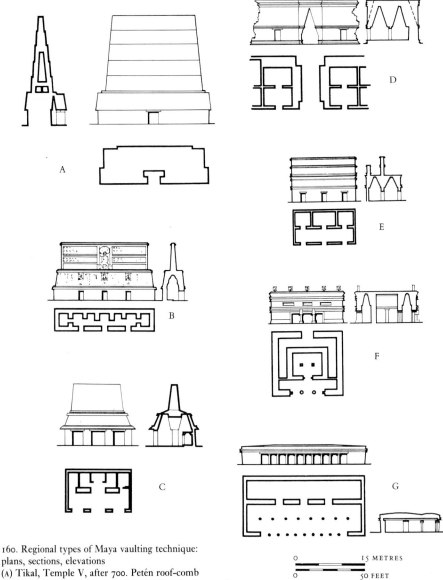

160. Regional types of Maya vaulting technique:
plans, sections, elevations

(A) Tikal, Temple V, after 700. Petén roof-comb
(B) Yaxchilán, Structure 33, after 760. Interior buttressing
(C) Palenque, Temple of the Cross, before 700. Mansard roof
(D) Uxmal, Governor's Palace, c. 900. Cleavages in vault mass
(E) Chichén Itza, Red House, tenth century. Flying façade
(F) Chichén Itza, Castillo, c. 1200. Platform building
(G) Tulum, Castillo substructure. Mortar-beam roof

0 15 METRES
0 50 FEET

and mortar were principally for religious use. As dwellings, houses of wattle and thatch were preferred because of their good ventilation and easy replacement.[5]

The stela of Classic Maya art is a free-standing monument having the shape of a slab or prism, often rounded at the top, and occasionally approaching human contours. The stelae usually recorded the passage of time by elaborate inscriptions [161]. Wooden stelae may have preceded those of stone, which mark the known duration of central Maya civilization, and many districts may never have erected anything but wooden ones. In any case, the 'Stela cult' records priestly computations of historical time and of astronomical events, and it delimits the spread of Classic Maya art. The figural themes of the stelae are usually standing male figures elaborately dressed, representing warriors, rulers, priests, or god-impersonators. They are often accompanied by minor accessory figures as well as by sky bands, masks of symbolic monsters, and extensive inscriptions.

Maya writing[6] consists of framed and composite signs, which are still called 'hieroglyphs' (obscure or unintelligible writings) because only one-third to one-half of a total of about 820 signs are at all intelligible. Pre-Columbian texts are of two kinds and of two eras. The earlier are epigraphic, consisting of monumental inscriptions upon stelae and buildings, all of Early to Late Classic date. The later texts consist of screenfold manuscripts of bark-paper [162, 268–70]. Only three of these are preserved. (A fourth, the Grolier Codex, is in modern writing on pre-Columbian paper.) The inscriptions record historical and mythical events. The manuscripts[7] contain dates, astronomic tables and computations, references to deities, ritual prescriptions, and directional symbols. The writing has been recognized as a composite system, neither purely ideographic nor purely phonetic, but containing statements in both modes.

A typical written expression of the Classic era is a date inscribed on stone or in plaster, giving the number of days which have elapsed since an arbitrary starting-point [161]. The inscriptions of this type are called Initial-Series statements,[8] and they usually record the date of erection, by enumerating the 400-year periods that have elapsed since zero, as well as the 20-year periods of the current 400-year cycle. The dating of the actual monument in the current 20-year period and in the 360-day ritual calendar are also given. Additional particulars concerning the age of the moon, and specifying the divine regencies engaged in the astrological composition of the moment, appear on other glyph blocks. Computations relating the vague solar year to the actual position of the earth in relation to the sun may occupy another series. The system includes glyphs for numbers, for periods, for deities, for directions, and for ritual prescriptions, as well as for augural declarations. The chronographic record is accurate, for no Initial-Series date could recur until after 374,440 years, and it is durable, for the Initial-Series inscription is so redundant that its main message can be reconstructed even when two-thirds of the glyph blocks are destroyed. In Classic Maya history each time-period, down to the single day, was personified and deified. The worship and ritual of the time-periods still continues in an attenuated tradition among remote highland communities of Guatemala and southern Mexico.

These Initial-Series dates and briefer ones, called Calendar Round expressions, are often separated by distance numbers, stating the days elapsed between dates. Such dates often refer to persons, titles, events, and places. From these readings the dynastic history of many Classic Maya sites will eventually be recovered. This historical approach to Maya inscriptions began only in 1958, and many of the new discoveries are still under verification, but their validity has been accepted in principle by the majority of Mayanists.

The three remaining manuscripts are at Dresden, in Paris, and in Madrid. They are painted on screenfolded fig-bark paper. They treat of astronomical tables and calculations, of horoscopes, and of ritual prescriptions. The characteristic subjects of the Dresden and

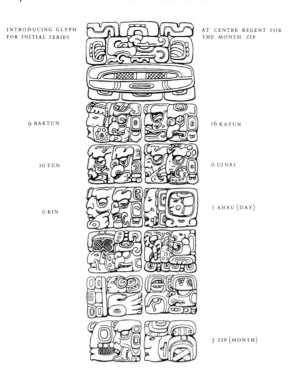

INTRODUCING GLYPH
FOR INITIAL SERIES

AT CENTRE REGENT FOR
THE MONTH ZIP

9 BAKTUN

16 KATUN

10 TUN

0 UINAL

0 KIN

1 AHAU (DAY)

3 ZIP (MONTH)

161 (*above*). Quiriguá, Stela F, with transcription
of Initial-Series and Supplementary-Series dates.
Stela F at Quiriguá uses face numerals; namely,
those of the gods who preside over numbers.

The reading here is:

9 ×	144,000	1,296,000 days
16 ×	7,200	115,200 days
10 ×	360	3,600 days
0 ×	20	0 days
0 ×	1	0 days

162 (*right*). Dresden Codex:
260-day ritual calendar, after 1000(?).
Dresden, Sächsische Landesbibliotek

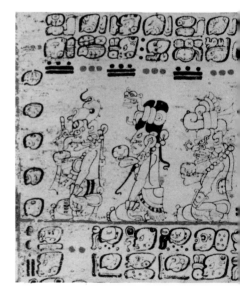

Madrid manuscripts are divinatory tables based upon various intervals in the 260-day ritual calendar [162]. This calendar, which governed the auguries, arose from the combination of the 20 day-names with a week of 13 positions, and it is distinct from the solar calendar, which had 18 months of 20 days with a 19th month 5 days long. The ritual calendar of 260 days gave any day its name and its week position; and the solar calendar gave it a month position. No day-name (e.g. Ahau, occupying the fourth day in a 13-day week) could recur until after 260 days, and its combination with a month position (e.g. 8 Cumhu) recurred only after 18,980 days, or 52 years less 13 days of our time.[9]

The three distinguishing traits of Classic Maya tradition – the vault, the stela, and the dated inscription – all attest an obsession with recorded permanence. More than any other civilization of America, the Maya peoples of antiquity left their conception of themselves and of the universe in an indelible record of monuments marking historical intervals. The dated sequence of Maya monuments is the most complete of its type in older human experience. All other historical records of the same era are less detailed and less extensive. No ancient people kept more complete tallies of time than the Maya, whose technological equipment resembled that of the Neolithic flint-knackers and pottery-makers of prehistoric Europe and Asia.

Geographical Divisions

By analogy with Egypt, students used to divide Maya history into 'Old Empire' in the south and 'New Empire' in the north, separated by a 'Transition' in the west.[10] The 'Old Empire' sites were thought to have been abandoned because of the wasteful and destructive *milpa* system[11] of burning the forest to secure fields, and it was believed that the northern plain was not settled until an exodus from the 'Old Empire', marked by the abrupt cessation of the Initial-Series inscriptions early in the tenth century. Since about 1930, and owing to the researches of the Carnegie Institution of Washington, these conceptions have altered.[12] The tradition now referred to as Classic Maya differs from 'Old Empire' by its spread throughout the peninsula, as at Cobá, Dzibil-chaltun, or the southern parts of Chichén Itza. Toltec Maya differs from 'New Empire' by much more limited geographic and historical definitions. The older conception of a 'Transition' period and province has been absorbed into Classic Maya, on the evidence of dated inscriptions and ceramic remains. Classic Maya therefore has become synonymous with the Maya tradition. Its regional variants, which used to be treated as different historical epochs, can now be examined as ecological types, as adaptations to differing environmental conditions. Three such types seem warranted: the central Petén district of Guatemala, where the ancient cities stood upon or near the forested shores of connecting lakes that today are swamps called *bajos*; the river valleys, such as the Usumacinta and the Motagua; and the cities of the plain in central and northern Yucatán.

The three types, lake-shore cities, fluvial cities, and the cities of the plain, refer to ritual concourses rather than to habitation centres with clustered dwellings. This separation between dwelling and ritual centres is typical of the Classic era throughout ancient America. At Copán [170], for example, the immense ritual platform assembly displaced an earlier village cluster of dwellings.[13] It suggests the domination by a religious hierarchy among agrarian peoples with a lay culture distinct from that of the priests. The hierarchy was homogeneous, but the subject agrarian peoples may have been of quite distinct and various local origins in each of the principal districts.

The Petén today is mostly uninhabited. Its population in antiquity numbered about 270 persons per square mile, or slightly less than modern New York State.[14] In physical conformation, the Petén is a region of troughs separated by hilly ranges descending from the Guatemalan cordillera. Each of the parallel ranges of hills has steep escarpments facing south. Run-off water accumulates between the

ranges in what are now swamps. Some *bajos* may have been lakes, which slowly silted up by erosion following the destruction of the forest cover by farmers and builders of the Classic era.[15] Today sites like Tikal are thus uninhabitable largely because of the scarcity of drinking water (in a land of tropical rainfall). In antiquity some concourse centres were approached and connected by bodies of inland water. Their shores today are marked by the ruins of the classic Maya cities. The only survival of an ancient physiographic setting of the Petén Maya type is the cluster of lakes surrounded by ruined temples and courts at Cobá in north-eastern Yucatán.

The equally desolate river cities of the Usumacinta and Motagua drainages cannot, however, be explained by water shortage, since the supply never failed in those broad streams or in their confluents, which flow past the river-bank courts and terraces. Possibly the mode of agriculture is to be blamed, although it is not clear whether the modern *milpa* system of Yucatán prevailed, with its burning and planting cycle, or an intensive cultivation on terraced and permanently cleared fields. Nor is it known who smashed the heads and faces of the Piedras Negras reliefs, although the fact of wilful destruction may indicate some social catastrophe.

The limestone plain of Yucatán, covered with a thick low bush, unlike the high forest of the Petén, lacks important bodies of surface water. Its settlements all depended upon the underground water table, reached through breaks and openings in the limestone crust. A range of low hills divides the western half of Yucatán into a southern district called the Chenes (well country), and the Puuc (hill country) in the north and west. The Chenes territory is the northern continuation of the Petén, with close stylistic ties to the Petén, although the physical environment is categorically different. The Puuc district was probably the most fertile and the most thickly peopled part of the peninsula, depending for water on storage in underground cisterns of natural origin, called *chultunes*. Open

cisterns, where the limestone crust has collapsed, are *cenotes*, like the 'well of sacrifice' at Chichén Itza in northern Yucatán.

The east coast is a distinct archaeological province of Yucatán. Its vegetation, like that of the entire east coast, is dominated by forests rather than by the dry scrub of western Yucatán. It contains both Early Classic and late stages of Maya civilization, represented respectively by monuments of southern lowland types (Cobá, Altun Ha) and by Toltec buildings. A late style of small temples has been assigned to the end of the fifteenth century.

Temporal Divisions

The reconstruction of the periods of Maya history is based upon inscriptions, manuscripts, ceramic evidence, and radiocarbon measurements of age.[16] Each class of sources permits a partial sequence. The epigraphy yields a day-to-day chronology for the Classic era spanning more than 600 years. The colonial chronicles (Books of Chilam Balam) contain Toltec Maya history arranged by twenty-year periods. The ceramic sequence allows only a very coarse time-scale, with large overlapping gradations. The radiocarbon dates still do not finally clarify the correlation of Maya and Christian time. Some Carbon 14 measurements now are known to be as much as seven centuries in error, by comparison with tree-ring dates. The widely fluctuating natural rate of $c14$ production is thought to be related to changes in the strength of the earth's magnetic field.[17] The Spinden correlation (12.9.0.0.0) has lost ground to the Thompson correlation (11.16.0.0.0) on the strength of Carbon 14 dates from Tikal. These correlations key the same event to earlier and later positions in Christian time, about 260 years apart.[18]

The stylistic sequences of Maya architecture, sculpture, and painting indicate a geographical progression. The various regions rose to dominance each in its turn, beginning with the pre-Classic monuments in the Petén. The southern river valleys assumed the lead towards the end

of the Early Classic period, and yielded it to the Puuc region in Late Classic times. Following the Late Classic Puuc period, the Mexican domination of Maya culture by Toltec masters, treated in Chapter 9, endured at Chichén Itza for about three centuries. The pre-Conquest history of the Maya peoples terminated in a long era of disunity and cultural decline, of which the archaeological record is given by Mayapán, in the fourteenth and fifteenth centuries.[19] At this time the lake and river cities farther south had stood empty and ruined for about 700 years.

CLASSIC ARCHITECTURE

The Petén

The Petén[20] contains the most ancient Classic Maya sites. Their form is best described as 'island cities' or 'archipelago cities', consisting of many groups of platforms and buildings on knolls and shoulders of hilly land rising above the surrounding swamps, which may have been lakes or water-holes in antiquity. The different groups on one site are connected by causeways, as at Uaxactún where they extend for 3 km. (nearly 2 miles) from north-west to south-west, with each of the six groups orientated approximately upon the cardinal points. One purpose of the causeways is to extend the ordered space of the plazas. At Uaxactún Groups A and B face each other from south and north across a ravine, with about 275 yards between the centres of the two groups. Group A has the higher and larger plaza of the two U-shaped courts opening at the ends of the inclined causeway.

Tikal [163], 12 miles south of Uaxactún, has nine groups of courts and plazas, separated by ravines but connected by causeways and ramps. At Nakum the subordinate northern enclosure connects with a southern main plaza by a roadway about 80 feet wide. It runs between parallel rows of long, narrow, and discontinuous platform mounds. But the plazas are not reciprocating, as at Uaxactún, for the vistas in the roadway are blocked at both ends, and the assemblage has a bifold rotational symmetry, or a Z-form.

Ixkun displays a northern variant on the pathway site: a north-south road about 800 yards long connects the temples on two small hills. Midway between them, and opening on both sides of the roadway axis, is a connected system of small courts.

Cobá, in north-eastern Yucatán, is a site of Petén type, with ruined groups of buildings clustering near a chain of small lakes, all connected by raised roads of roughly shaped stone.[21] At several points these causeways separate small bays or inlets from the body of the lake, making tanks or reservoirs like those between Groups A and E, or A and B at Tikal in the Petén [163], where the ravines were dammed by causeways.[22]

Within the courtyards, it is difficult to identify the functions of the various platforms and buildings. In Petén Maya architecture, the rooms were always much less important than the masses. The design of an edifice was secured less by the enclosure of rooms in an articulated envelope than by the ponderous combination of vast masses, solid throughout, sculpturally related, and structurally static. Thus the idea of a unit of architecture differs greatly from our own. The greatest uncertainty surrounds the identification of the functional types. The alleged 'palaces' and 'temples' merge into one another by continuous gradations. Probably a cardinal objective of the Maya architect was to achieve differentiation by height, in many levels marking the rank of the vague functions to which the edifices were dedicated. At the same time he was always extremely sensitive to the spaces engendered between and among edifices, seeking to achieve large and rhythmically ordered open volumes. Such open volumes with storeyed changes of level are the most striking formal achievements of Maya architectural history.

The free-standing pyramid was the dominant form among platform types used by Maya architects. In the Petén, the oldest extant pyramid, called E VII sub, at Uaxactún, is of pre-Classic date, built about the first century A.D. [164 A]. Of radial symmetry, its axes of reflection are the

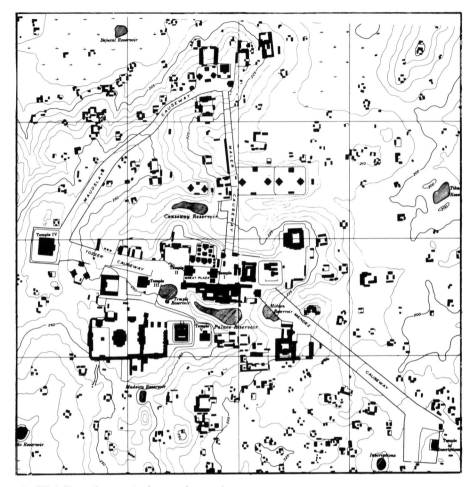

163. Tikal. Plan as in *c*. 900 (each square is 500 m.)

four staircases and the four inset corners. Its plan recurs at Acanceh [164B], at Hochob, and in Toltec Maya pyramids, a thousand years later, at Chichén Itza, in the Castillo [237], and at Mayapán in northern Yucatán. Each of the four fronts suggests and requires a monumental environment. Every approach is of equal value, and the form itself induces further symmetry among its neighbours, It is a rare form in America, used sparingly even by Maya architects. Other large pyramids display only bilateral or mirror symmetry. The axis of reflection is a central stairway. At best, this form commands two environments, and usually only one, as at Tikal, where the main pyramids have but one main stair, with forbiddingly steep

A

B

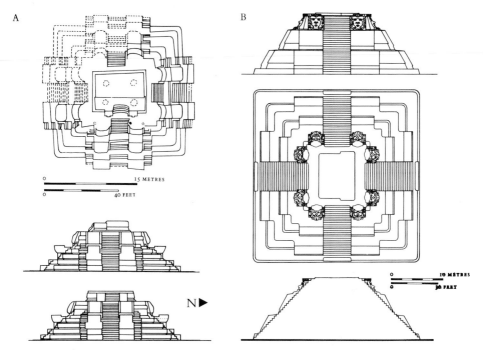

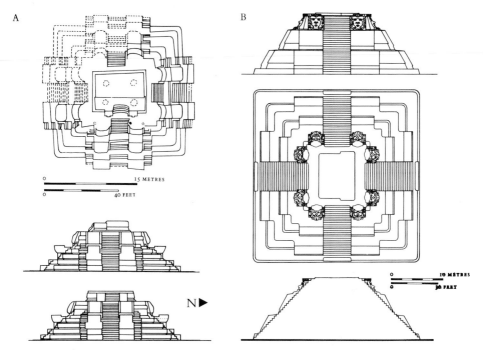

0 15 METRES

0 40 FEET

N▶

0 10 METRES

0 30 FEET

164. Radially symmetrical platform plans, with elevations. (A) Uaxactún, Platform E VII sub, first century(?); (B) Acanceh, before 1000(?)

angles on the side and rear façades. At Balakbal (Structure VI), the stairways at front and rear command two approaches.

Often the pyramids are grouped around a courtyard, as at the centre of the layout of Tikal [165]. Near by two great pyramid-temples,

165. Tikal, Structure 5D-34, before 700. Restoration drawing

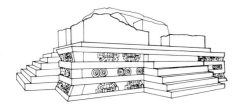

facing east and west, delimit the Great Plaza bounded also by the North Acropolis and the palace building of the Central Acropolis. This ancient arrangement, whose construction lasted a thousand years, was repeated in simpler form several times at twenty-year intervals in the eighth century in the twin-pyramid complexes, as if to replicate the ceremonial architecture of the centre for the use of an expanding population at the margins. In these twin-pyramid centres, a northern precinct faces a southern chambered building, and the east-west axis is defined by identical radial-stair platforms [166]. The same layout reappears at Yaxhá on Lake Flores, and it may reappear in modified but still unrecognized versions at other sites, as in the southern temple district of Palenque.[23]

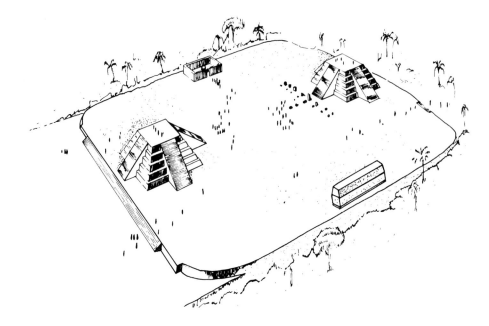

166. Tikal, twin-pyramid complex, erected 771

Assemblages of several buildings in the Petén can often be identified as geomantic groups, serving as monuments of significant horizon positions of the sun and perhaps the stars. About eighteen such groupings between Ixkun and Río Bec have been identified. Many may have been merely ritual rather than for observational astronomy. Group E at Uaxactún has a pyramid facing east. Across the court, three temples stand upon a narrow north-south terrace. From the pyramid stairs the rising sun emerged over the northernmost temple on the equinox (21 March, 21 September) and over the southern temple on the December solstice. Such arrangements obeyed celestial relationships, and they reflected the order of the cosmos in the spatial design of the little courtyards surrounded by platforms and temples, keyed together by astronomical sight-lines.[24]

The Petén Maya architect habitually thought in groups of platforms and buildings, rather than single and isolated units. He preferred the long, narrow platform, bearing a chain of narrow rooms, and serving with other platforms to enclose a court. Thus, at Nakum Structure D marks the south side of the main plaza by a façade over 130 m. (425 feet) long and 10 m. (35 feet) wide, containing about forty-four rooms opening north and south by narrow doorways.[25] At Tikal, Group F is a quadrangle of four buildings (Structures 74, 77)[26] forming an open-cornered quadrangle. Structure 1 in G, due south of F, makes a closed-corner quadrangle, probably of late date, resembling the 'palace' of Palenque, but lacking its permeable structure of wide doorways separated by narrow piers.

At Uaxactún, Structure A V[27] is the best studied assemblage of this type [167]. The successive efforts of many generations to enrich, variegate, and recompose the quadrangular entity have been dissected by careful excavation. The progression is from separate temples

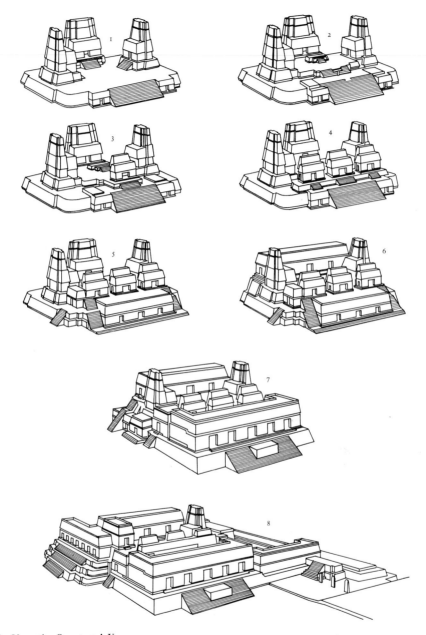

167. Uaxactún, Structure A V,
showing eight stages of enlargement,
c. 200–900

168. Tikal, Temple I (Giant Jaguar), before 800

assembled around a small platform court, through seven stages of remodelling, with chambered 'palace' structures replacing or overlaying the earlier single-chamber edifices. The interlocking levels, unified by sweeping stairs, are characteristic of Petén architecture, reflecting influences from neighbouring Maya regions, without loss of the conservative Petén style of massive effects.

Of the ball-courts so common in the river-valley sites farther south [171], there is one certain example in the Petén: at Tikal. Ball-court markers occur, such as circular slabs with reliefs portraying players,[28] but the court platforms appear only at Cobá and at Tikal. Perhaps the Petén, like Teotihuacán, flourished and settled upon definitive architectural types before the spread of the monumental ball-game court, which on this reasoning might be ascribed to mid-Classic time.

The structural history of Maya architecture is concerned with four items: the stones, the mortar, the support, and the vault. The general line of development is from block masonry to a concrete core veneered with ashlar slabs, from massive wall structure to slender piers or columns, and from narrow, slot-like chambers to intricate combinations of rooms which afford one another mutual support.[29] But in the architecture of the Petén, we find only the more conservative moments of the development, limited both by older traditions and by the absence of the concrete which characterizes later stages in Usumacinta and Puuc cities.

Petén buildings usually have stone cores faced with stucco. The core changed from early unshaped stone to block masonry in mid-Classic times. At Tikal, massive walls and trimmed vault spans assured a stability that has survived even the removal of the *zapote* wood lintels from the temple structures. Lime coatings were more lavishly used in early periods than later on, presumably because of the gradual exhaustion of easily available supplies, and also because of improvements in stone-cutting techniques.

Columnar supports, whether cylindrical or rectangular, are absent in the Petén. Only heavy piers, really portions of wall, separate the doorways of multi-chambered buildings. It is often implicitly assumed that pier, square column, and round column represent a development sequence. Actually the three types should be regarded as geographical peculiarities rather than as evolutionary steps. Wooden supports were used in the earliest stages. Since the shafted support of wood is archetypal, its replica in stone or clay is not much later. On the Petén and Motagua sites, however, the builders were chiefly interested in the massive design of space, and the doorways were minor incidents in the sculptural treatment of the façades.

The enrichment of the profiles by inset corners, by mouldings, batters, crenellations, and by the vertical façade projections called roof-combs are all indigenous to the Petén, appearing there early and persisting late. A chamfered talus moulding in the pyramid faces is both very old and very common. The chamfer is a horizontal groove or channel in the lower part of each sloping talus component. The earliest example is in the lower terrace corners of Pyramid E VII sub at Uaxactún [169]. At Tikal [168] the chamfer cuts deeply into the base of each of the huge aprons of the temple pyramids. Its visual purpose is to underline by shadow the brilliantly sunlit apron face. In fact it secures a double effect: it stresses the divisions between terraces, and levitates each apron mass.

Re-entrant, inset corners on pyramidal platforms are a trait shared by buildings in both lake and river cities. In ground plan these edifices show an 'internal' rectangle or square, of which

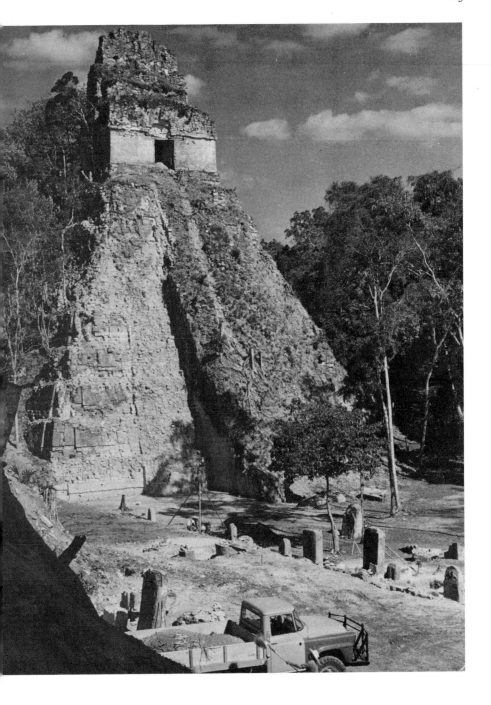

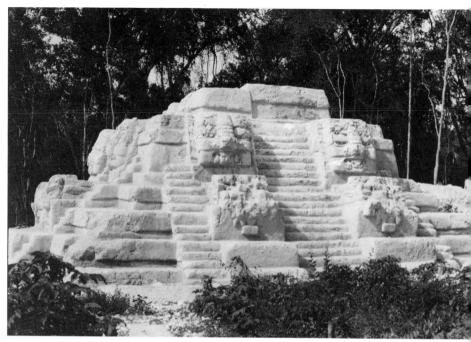

169. Uaxactún, Platform E VII sub, first century(?)

the presence is revealed only at the corners. The centre of each sloping face is augmented by substantial buttress-like increments, which furnish vertical accents binding the horizontal components. Pyramid E VII sub at Uaxactún is the earliest example [164A, 169], with triple-ramped stairs and tiered mask-panels. The inset corners interlock in a weaving of vertical and horizontal accents. The main temple pyramids of Tikal are classic examples, where the recessed corners function as powerful shadowed verticals [168]. The temple pyramids of Cobá are closely related to those of Tikal, but their corners are rounded insets like those of Piedras Negras in the Usumacinta Valley [179]. Outside the central Maya territory re-entrant corners are rare, recurring to present knowledge only in the terminal generations of Aztec architectural history.

The aproned roof profile, usually called 'mansard' [160 C], is another trait shared by Petén and Usumacinta architecture. Northern instances, as in the top stage of the Nunnery at Chichén Itza, are rare. In the Petén, the apron usually overhangs the bearing wall, protecting its surfaces from the weather [168]. The angle of inclination is never as extreme as in the Usumacinta buildings. It usually repeats the chamfered apron profiling of the pyramidal substructure, and it enhances the massive aspect of the building. Structurally the device recalls the thick, overhanging mat of thatch on housemound dwellings.

The roof-comb is peculiar to Maya architecture.[30] It served to identify and to mark the importance of certain buildings by a vertical enlargement of the silhouette. In the Petén, roof-combs are usually of solid wall construction, often loaded upon the rear bearing wall, and even upon the capstones of the tiny vaults within the temple [160 A]. The Petén roof-comb is like the back of a throne. The building itself

is the seat, and the pyramid the dais [168]. Dark figures enthroned in the interlaced decorations of the roof-comb often complete the scheme of seated majesty. In the Petén and in the river valleys, such figures are framed by the building, both in the pre-Classic pyramid at Uaxactún and in the latest monuments of mid-Classic date. In western and northern Yucatán, on the other hand, the sculpture sometimes invades the tectonic field, as in the serpent-mask façades of the Puuc and Chenes districts in the Late Classic centuries.

Certain geometric and proportional habits require comment. Maya architectural symmetry is never rigorous, though it always indicates correspondence with the masses distributed in rough balance to left and right. When exactly measured, the angles are rarely true. Apparent right angles invariably lack or add a few degrees. Only the visual effect is regular, and it was secured without close calculation. Classic Maya buildings also display strong variations in their proportional composition according to region and period. The essential parts of the elevation are the bearing zone and the vault zone. In the Petén, the roof apron and the bearing wall are as 1:1, although late buildings favour the roof over the bearing, in a proportion like the 5:4 ratio of late buildings in the river cities.

The River Cities

The base of the peninsula of Yucatán is traversed by two principal river drainages flowing in opposite directions. The Motagua and its confluents mark a south-eastern province of Maya civilization; the Usumacinta and its tributaries flow towards the north-west to empty into the Gulf of Mexico. The central stretches of the Usumacinta river are narrow rapids, not easily navigable. The lower Usumacinta faces the flat Tabasco lowlands and the Gulf Coast of Mexico. Thus four distinct geographic groups of river cities are indicated: those of the eastern Motagua basin (Copán and Quiriguá); the Pasión river (Altar de Sacrificios, Seibal); the central Usumacinta (Yaxchilán and Piedras Negras); and the lower Usumacinta (Palenque and Comalcalco). These sites have all been under expert archaeological study in recent decades.[31]

The three groups mark the land boundary of Classic Maya civilization, as well as the history of its early expansion. The occurrence of Initial-Series inscriptions usually charts the spread of theocratic Maya social organization. The union of monumental corbel-vaulted architecture with such inscriptions has repeatedly been established. The earliest Initial-Series dates commence at Copán about A.D. 465 (9.1.10.0.0). In the central Usumacinta, at Yaxchilán and Piedras Negras, the stela cult with dated inscriptions began about two generations later, c. 514 (9.4.0.0.0), and in the western cities, as at Palenque, the inscriptions record dates beginning about 642 (9.10.10.0.0). The sequence suggests a westward and river-channelled expansion of Petén Maya culture, although the profound stylistic differences among Copán, Piedras Negras, and Palenque reflect ecological and ethnic differences in the reception of Petén influences, as well as rapid historical development of the basic forms of Maya art and architecture.

These environmental differences are quickly enumerated. Copán and Quiriguá, which are peripheral to a Central American region extending south and east as far as the Lempa river, probably transmitted the Classic Maya style to many provinces in Honduras, functioning as a metropolitan relay-area between the Petén and eastern central America. On the other side of Yucatán the lower Usumacinta Valley, with Palenque as its metropolis, served the same function for the lowlands of the Gulf Coast. Between them, the cities of the middle Usumacinta, such as Piedras Negras, were metropolitan relay points for the Guatemalan foothills and highland ranges. The navigable upper confluents of the Usumacinta – the Pasión, the Chixoy, and the Lacantún rivers – all converge upstream of Yaxchilán, and most probably bore light water traffic in antiquity, as they do today.

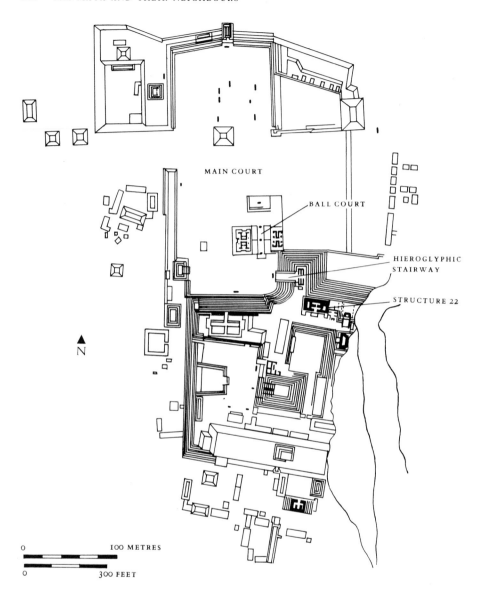

170. Copán. Plan as in c. 900.
The southern half represents the acropolis

Copán is the most southerly and the highest (600 m.) of the major Classic Maya sites [170]. A primary platform, rightly called the acropolis, covers twelve acres and supports many secondary platforms, which in turn bear other platforms, pyramids, and courts, all faced with block masonry, and merging in a continuous spatial design of many courts on the level floodplain of the Copán river.[32] The river gave the setting for this artificial hill, more than 100 feet high, and the river has destroyed a great part of it, washing away the grand stairway which once formed its east bank.

At Copán, large deposits of tufa, i.e. volcanic ash, yield a building stone of greenish colour. Limestone and andesite also are available. The technique of construction varies according to period. In pre-Classic and Early Classic times, the people used river boulders laid in mud and faced with burnt-lime stucco. Later on, during the mid-Classic period, blocks of the easily shaped tufa, laid in mud, reflect the introduction of quarrying and cutting techniques, perhaps because shaped stone was less costly than the preparation of lime-cement and stucco. In both periods, stucco concealed the imperfections of bonding, which was never a strong point in Maya architecture at any period.

Copán is an assembly of open volumes rather than a collection of buildings. Its plazas are large concourses, studded with sculpture standing on many levels and terraces, but the buildings are few, and erected near the end of the Classic occupation, about the sixth century. The nucleus is an artificial hill, raised not only to mark a high place, but also to mark a plaza at its foot. At Copán this acropolis rises above a lower northern platform. Both define the main court, bounded on the south by the acropolis stairway, 90 m. (300 feet) wide. Both provide a theatrical setting for the ball-court [171], surrounded by stepped terraces, and for the collec-

171. Copán, main ball-court, as in c. 800

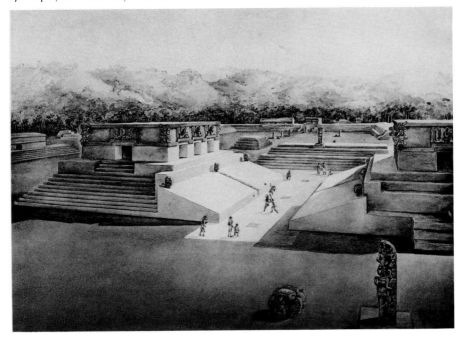

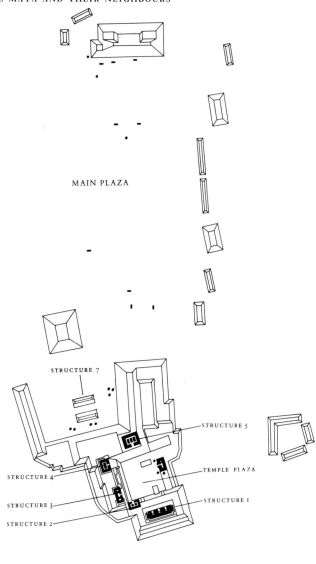

MAIN PLAZA

STRUCTURE 7

STRUCTURE 5

STRUCTURE 4

TEMPLE PLAZA

STRUCTURE 3

STRUCTURE I

STRUCTURE 2

N

172. Quiriguá, *c.* 550–850.
General plan as in *c.* 900

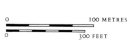

0 100 METRES

0 300 FEET

tion of stelae and altars, commemorating the passage of the five-, ten-, and twenty-year units of the Maya calendar. The towering roof-combs of Tikal are absent. The door-frames received that ornament which in the Petén adorned the roofs. Structure 22, for example, has the inner doorway framed by serpent coils and interlaced human figures. The grand stairways, like the Hieroglyphic Stairway, were heavily charged with relief and full-round sculpture.[33]

At near-by Quiriguá [172], on the north bank of the Motagua river, the building material is sandstone of a close and even texture. It was extracted from ledges in the surrounding hills, where sedimentary stone splits readily into prisms, shafts, and blocks.[34] As at Copán, the masonry was bonded with mud rather than lime-cement. Sunken, stair-bordered plazas facing north and east are the principal architectural elements. The chambered buildings framing the sides and corners are incidental enrichments of the south court. As in the Petén, heavy piers like portions of wall separate the doorways of the many-chambered buildings. Structure 1, built about 810 (9.19.0.0.0), is the last of the dated Quiriguá monuments, and it may have been a dwelling of three small apartments raised on an inner platform above door-sill level. The south-east corner of the plaza is marked by two small houses (Structures 2 and 3), containing hearths for making steam on hot river boulders.[35] These steam-bath buildings are less highly specialized than those of the Usumacinta cities, and they indicate once more the conservative nature of the south-eastern style.

The corner edifice is older than the bath-houses on the east terrace, but both show the same structural timidity, in massive walls surrounding diminutive chambers. Structures 4 and 5 have a core of solid masonry surrounded by a corridor of tiny chambers between it and the massive exterior walls. The only detail showing any degree of structural boldness is the interior stairway of Structure 4, which rose to the roof. This arrangement is characteristic of the Maya preference for regular exterior envelopes, unbroken by any asymmetrically placed functional shape like an exterior stair.

The antithesis of the conservative Petén style of massive effects is seen at Palenque [173] in the lower Usumacinta basin, where dwellings with double-range galleries, colonnaded façades, storeyed towers, and burial pyramids extended and diversified the range of Maya architectural achievements.

Palenque lies in the first range of limestone hills rising from the Tabasco lowlands, about 30 miles south of the Usumacinta river. Some have called it a necropolis because of its many burial temples, but by the same token, Yaxchilán and many others would also be 'cities of the dead'. Closer to reality is an economic consideration, of Palenque as an inland port of trade, like Tajín, at the meeting of highland with coastal plain, where mercantile interests gave rise to wealthy and cosmopolitan cities.[36] A small stream, the Otolum, runs between the principal monuments in a corbel-vaulted underground aqueduct northward through the ruins. Both sides of the covered stream are terraced with esplanades and platforms topped by chambered buildings with latticed roof-combs. The terraces are of soft local limestone laid rough in mud, with cut-stone surfaces, and lime-stucco finish. Wooden lintels were used in every edifice, but they disintegrated long ago in the humid tropical climate.

Recent excavations and reconnaissance on the site show three principal periods. The first is Early Classic, lacking both inscriptions and important vaulted buildings. The second is Middle Classic, and it includes all the principal groups. The third is Late Classic, when the site was defended by terraced lines of fortification, probably during an occupation by Mexican intruders from the region of the central Gulf Coast, who left among the ruins fragments of ball-game yokes and carvings of flattened heads. At this time the buildings were remodelled as if for a siege or blockade, and many doorways were walled up.[37]

The plans of the various buildings at Palenque cannot yet be placed in a secure chronological sequence.[38] All, however, use the

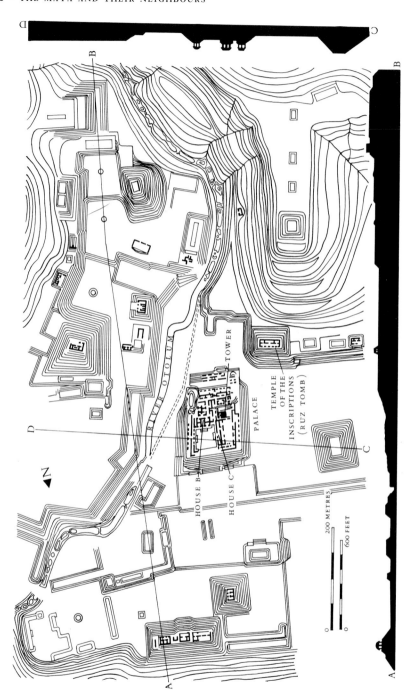

173. Palenque. General plan as in c. 900

principle of double-range parallel chambers, in order that the two outer vault masses may abut a central Y-shaped vault-mass common to both chambers. Upon this central support rises the latticed roof-comb; its stability also permits a pronounced mansard slope in the upper façades, as well as the attenuation of the piers between façade doorways. The net result of the systematic use of parallel vaults keyed to a central supporting wall is an architecture of unprecedented lightness and permeability, allowing the construction of wide spans in long chambers of continuous spatial effects. The small temples on top of their pyramids, like the galleries in the northern portion of the Palace, all exploit this extremely stable and economical system, rather than the ponderous massing of the Petén style [160 A]. The principal change is in the centre support: the Petén builders treated it as a static core of great mass; the Palenque architects convert it into a membrane, perforated by doors and transoms, yet capable of serving as a core, stabilized by the weight of the roof-comb [160 C].

One can perhaps define early and late versions of the scheme at Palenque. The temple plans, for instance, can be arranged in a sequence from simple two-chamber shrines to elaborate combinations with inner vaulted chambers inside the shrine [175]. The Palace, the most complex edifice of mid-Classic date in the entire Maya world, also contains Early and Late structures.[39] The southern half of its rectangular platform has various levels of close-ranked structures which approach a galleried form without completely achieving it. House B, for instance, entered from both south and north courts, contains five chambers. The walls are thicker than elsewhere at Palenque, and one is reminded of a temple structure surrounded by later dwellings.

The northern half of the Palace platform, dated about 721 (9.14.10.0.0), is much more open and spacious, with two courts defined by parallel ranges of chambers, carried around approximate right angles, in a bold solution which has no precedent in the Petén or at Copán. It is in effect a closed-corner quadrangle, particularly at the north-east corner, and is probably the earliest extant example of the type in Maya architecture. The crowded southern half may have housed the servants and a palace guard; the spacious northern courts and galleries were probably dwellings for persons of high rank. Near the tower, towards a small inner court, two lavatories, arranged over a subterranean stream, and a steam-bath give some idea of the degree of cleanliness maintained by the Maya nobles.[40]

The tower, on an almost square plan, rises four storeys above the palace [174]. It reverts to

174. Palenque, Palace tower, eighth century(?). Section and plan

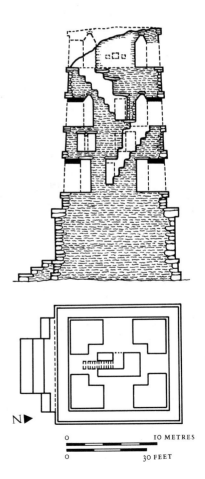

0 10 METRES

0 30 FEET

175. Palenque, Temple of Inscriptions
with section showing crypt, *c.* 700

the massive central core of Petén design, in order to accommodate the two straight flights of stairs connecting three corbel-vaulted storeys. Between the vaulted storeys the customary attic is kept, although the interior construction does not need it. This inaccessible attic forms a chambered passage between the floors, presumably to lighten the masonry while reassuring the Maya eye that the customary proportions between bearing wall and vault-zone are respected. The incoherence of inner and outer forms is characteristic of the general Maya concern for exterior symmetry and regularity, at the expense of interior commodity.

Another remarkable edifice at Palenque is the Temple of Inscriptions [175]. Its pyramidal platform contains a large vaulted crypt at ground-level, entered by a stair shaft of about sixty-five steps on two ramps, covered by ten levels of corbelled vaults in stepped ascent. The Maya architects apparently never attempted to build corbel-vaults with slanting imposts and capstones. Their idea of stability required level vault-masses.

The crypt and stairs of the Temple of Inscriptions also have stone tie-rods spanning the upper vaults instead of the customary wooden members, as if displaying the architect's mistrust of perishable wood, and his conviction that the tie-rods were indispensable under these conditions of exceptional stress. In the crypt, a monolithic sarcophagus rests upon six piers, and its carved walls are covered by buttress-like masses of masonry nearly filling the lower level of the crypt chamber. These buttresses were probably built in order to move the slab lid of the sarcophagus into place on rollers. They were never removed,[41] and the entire stair shaft was filled with rubble to close access to the crypt.

The southern 'Cross group' of four dynastic temples, dominated at the north by the Temple of the Cross, belongs to the end of the seventh century, not long after the burial Temple of Inscriptions containing the tomb of Sun Shield (Pacal), who may have died in 683. Cohodas has studied the Cross group as expressing the structure of the cosmos, the underworld journey of

the sun, and the divinity of a new ruler, Jaguar Snake (Chan Bahlum), who commissioned the work, which was dedicated in 692.[42]

Comalcalco,[43] in the state of Tabasco, is closely related to Palenque in its architectural style, and it is situated near the westernmost limit of Maya culture, only about 90 miles from the Olmec site of La Venta, where contact with non-Maya Gulf Coast peoples was maintained. The ruins of a large palace and of a tomb with stucco reliefs like those of Palenque have long been known. The corbel-vaulted structures are built of good fired bricks, measuring 19 by 25 by 24 cm. ($7\frac{1}{2}$ by 10 by $1\frac{1}{2}$ inches), laid in lime-mortar made of burned oyster shells and thickly stuccoed.[44]

Half-way between Palenque and Copán are the middle river cities, Piedras Negras in Guatemala and Yaxchilán in Mexico. They stand on opposite banks of the Usumacinta, only 45 km. (28 miles) apart as the crow flies. Yet Yaxchilán belongs to a conservative Petén tradition, while the Piedras Negras buildings are open, light and airy, like those of Palenque. The site of Yaxchilán [176] is a long, curved river bank on a nearly circular loop. Along it the city extends upon an esplanade rimmed by platforms and building groups. The site has been much damaged by floods, and the ruins of washed-away structures are visible at the river's edge. Rising from the esplanade are narrow hillsides separated by shallow ravines.[45] The western hill descends to a bench-like hollow completely covered with platforms, terraces, and buildings. The eastern hillside descends more gradually to the river, and its flanks are terraced in a long curving sequence of platforms, stairs, and building groups which all command views of the river.

Yaxchilán can be compared to the Petén plans of waterhole sites, with groups of buildings standing upon ridges and knolls. Close resemblances to the Petén style appear in several platforms with inset and re-entrant corners (Burial Pyramids Nos 35 and 36) as at Tikal, and in the single-vault plans with thick bounding walls, like Structures 20 and 42. Other edifices

STRUCTURE 20

STRUCTURE 23

STRUCTURE 33

STRUCTURE 42

STRUCTURE 30

PYRAMID 36

PYRAMID 35

N

100 200 METRES

0

300 600 FEET

0

176. Yaxchilán. General plan before 900

177. Yaxchilán, Structure 33, *c.* 750.
Elevation, section, and plan

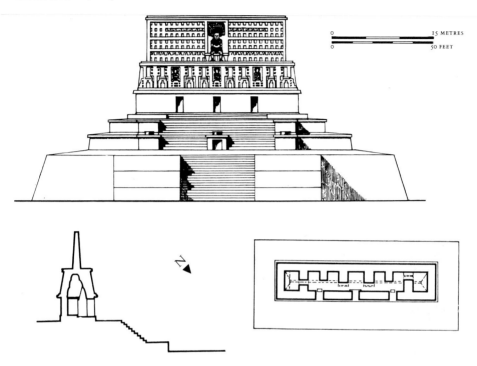

recall the galleried parallel vaults of Palenque and Piedras Negras, although their doorways are separated by wall-sections rather than piers. Examples of this type are Structures 30 or 23, with the roof-combs resting upon the median wall, as at Palenque. Structure 23 was built *c.* A.D. 726 (9.14.15.0.0).

Structure 33 has lintels dated around 750 (9.16.0.0.0): this type flourished soon after the parallel-chamber system just described. The new Yaxchilán type is but one vault wide, with the roof-comb resting upon the capstone. The length of the vault is divided into chambers by masonry partitions and interior doorways with corbel-vaulted arches. The façades open by an odd number of doorways between wall segments. The latticed roof-comb upon the capstone actually loads the weakest point of the

vault [177], and its weight would buckle the supports if they were not reinforced by the partitions, which function like interior buttresses. Why the architects should thus have risked the collapse of their work is difficult to establish. That they knew better is shown by the concurrent use of parallel vaults keyed to a median support [160 C]. The artistic problem may have required the co-ordination of a single-vault plan beneath a roof-comb of symmetrical properties in both front and side elevations. Interior buttressing appears only at Yaxchilán, as a local trait. Roof-combs charging the capstones reappear on the north-east coast at a very late period. Probably their combination at Yaxchilán obeys local ritual needs, all the while making possible an exterior envelope of complete symmetry on both axes. The extension of

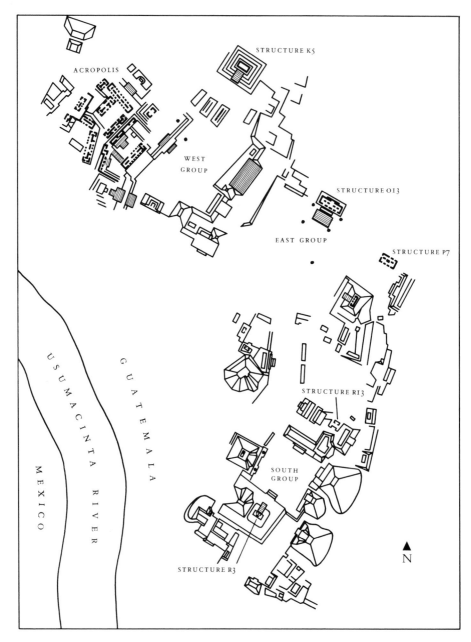

178. Piedras Negras. General plan as in *c.* 900

an exterior design with parallel vaults to single-vault structures may have been the guiding aim.

Piedras Negras[46] in Guatemala occupies a sloping plateau descending from an altitude of about 200 feet at the western acropolis, to 100 feet above the river level in the southern groups. The buildings do not face the river view: in fact they turn away from the water [178], and the various groups cluster around the hollows or along the slopes of several little valleys, rather than upon the hill crests as at Yaxchilán.

Three principal building types are notable. As at Yaxchilán, certain edifices reflect Petén custom in the retention of massive plans, enclosing diminutive chambers beneath great roof-combs, upon platforms with chamfered apron mouldings and rounded inset corners. Structures K 5, O 13, and R 3 are of this type.[47] R 3, dated by associated inscriptions *c.* 554

(9.6.0.0.0), is one of the oldest vaulted edifices on the site, and its plan reappears in K 5, a temple pyramid completed before 677 (9.12.5.0.0). All the buildings of this group differ from Petén prototypes only in the lower heights of the platforms, the gentler pitch of the aproned profiles, and the triple doorways separated by square piers. At K 5, the large stucco masks flanking the stairs recall the pre-Classic form of E VII sub at Uaxactún [169].

The second group, represented by the double-range parallel vaults and galleried chambers of the acropolis [179], resembles the Palenque palace in the colonnaded façade of many doorways separated by piers, as well as in the grouping by ample closed residential courts. At Piedras Negras, the vaulted galleries seem to be amplifications of an early unvaulted architecture with mortar-and-beam or thatch roofs. If

179. Piedras Negras, acropolis, as in *c.* 900

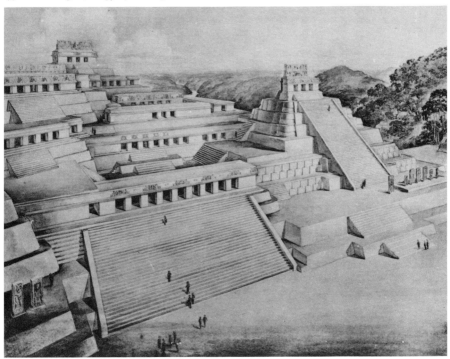

so, the type of the Usumacinta palace reflects ancient local house-mound dwellings, of which a colonnaded form such as O 13 is a probable example.

The most specialized of known buildings at Piedras Negras is a group of steam-baths with chambered plans.[48] The most elaborate, P 7, resembles a double-range galleried unit. The building encloses a small vaulted fire- and sweat-chamber at the centre. The outer rooms were probably for dressing and resting. Eight were excavated at Piedras Negras: one of them, R 13, adjoins the ball-court.

180. Calakmul, Structure III, before 700(?). Plan and elevation

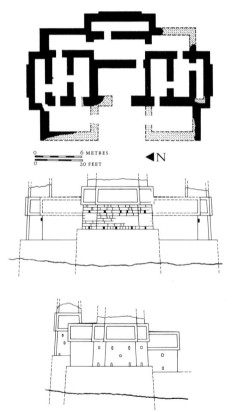

The Dry Forest: Río Bec

Southern Campeche[49] is a thinly inhabited region of many ruins at the heart of the peninsula. It has less rainfall than its neighbours; there are no rivers; and it once had extensive shallow lagoons, which today are forest swamps with silted clay bottoms. It is surrounded on east, west, and south by rain-forest country. On the north is the dry scrub forest of populous northern Yucatán.

The archaeology of the southern portion is an extension or subdivision of Petén architecture. At Calakmul, Naachtún, or Balakbal, the 'island' groupings, the steep mansard roofs, and the plans of Petén style are associated with an abundance of Initial-Series inscriptions, marking the same time range as in the Petén. The most complicated plan at Calakmul is Structure III [180], with at least twelve rooms interlocking to make a central roof-comb unit flanked by symmetrical *avant-corps*, which also bear roof-combs. This three-towered scheme has no direct precedent in the Petén proper. One must look to the region surrounding Río Bec, about 60 miles north-east, and as far afield as Bécan and Xpuhil, for similar designs. Structure III, however, has none of the ornate decoration that characterizes the Río Bec style, and its mansarded profiles recall the Petén silhouette, with a suggestion as well of Teotihuacán *tablero* forms. The dated inscriptions of Calakmul allow us to ascribe Structure III to mid-Classic times, perhaps as the archetype or, at least, as an early example of the towered *avant-corps* designs of the Río Bec style.

Río Bec, Xpuhil [183], El Hormiguero, Becán [182], and others within a region about 60 miles in diameter are the principal examples of this new type, in which the temple pyramid coalesces with a chambered palace structure at or near ground level. The date of the style is still unsettled, for no legible inscriptions accompany the buildings. At Becán a moat (built before 450[50]) more than a mile in perimeter surrounds the city [181]. Within this unique cincture are several edifices of Río Bec type. At the southern

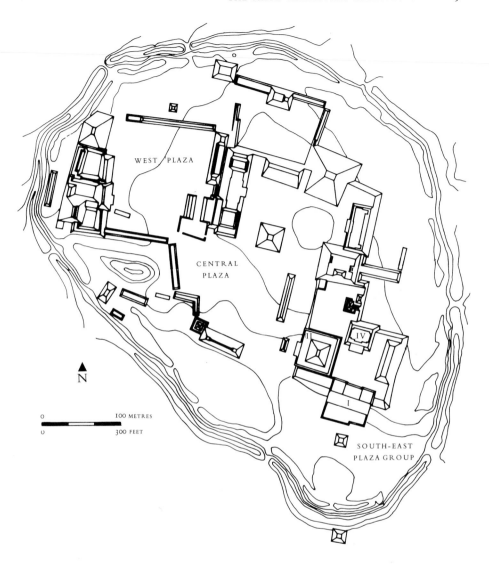

181. Becán, plan, showing moat as after 450,
buildings as in c. 900

end of the moated enclosure are Structures I and II, forming two sides of a raised quadrangle. Structure II is a pyramidal platform surrounded on all four sides by chambered buildings, and approached by a western stairway.

The south side of this primary platform is bordered by another curious edifice, Structure I (Carbon 14 dates between limits of 560

Palenque. Above this façade, the two four-stage pyramids display typical Río Bec vertical profiles, with wide band mouldings at the top and bottom of each component. In Structure I, the pyramids and the chambered buildings have equal importance: neither is clearly subordinate. But Structure II alters the order: the pyramids are ornamental imitations of the steep Tikal prototype, and they are built on a dimi-

182. Becán, Structure I, before 900(?).
Plan, elevation, and section

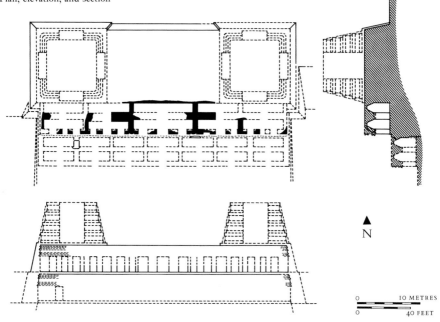

N

| 0 | | 10 METRES |
| 0 | | 40 FEET |

and 815),[51] which also faces away from its quadrangle with two double ranges of chambers opening south upon lower levels than the twin pyramidal platforms overlooking the upper court [182]. The mansards of the upper double range open to the south by pierced façades. The widths of the doorways, diminishing from the centre towards the ends, recall the gracefully proportioned apertures of the palace façades at

nutive scale as ornaments of the west façade. Structure IV combines palace and temple with a chambered courtyard crowning a three-stage platform bearing thirty-two vaulted rooms and an interior stairway to the ground from the top level.

At El Hormiguero and at Río Bec, such 'harmonic façades', reminiscent of Christian church fronts with towers, reappear with minor vari-

183. Xpuhil, Structure I, before 900(?).
Plan and elevation

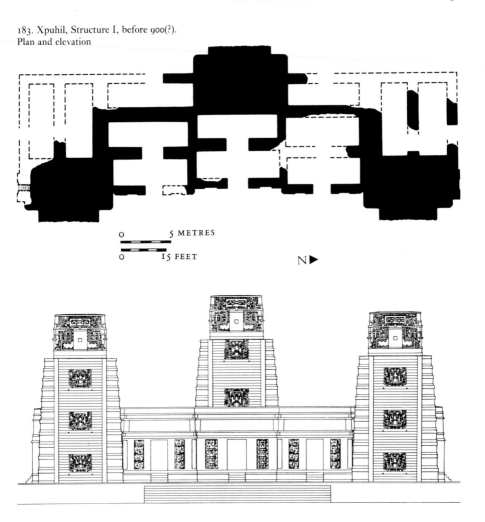

ations. At Xpuhil, finally, Structure I repeats (or prefigures) the type of three-towered composition [183] already described at Calakmul. Instead of the roof-combs of Calakmul, three fully profiled small-scale pyramids of Tikal type adorn the chambered cluster of twelve inter-buttressing vaults. In the south tower a vaulted stairway leads to the roof of the chambered block, but there is no access to the diminutive temples on top of the three tiny pyramidal towers. Each tower, to be sure, has front and rear stairs, with normal risers 25 cm. (10 inches) high, but the treads are ledges too narrow to use.

The radiocarbon dates from Becán suggest a placement of the Río Bec style after the Middle Classic period, and extending at least from 600 to 800 (see Note 49 to this chapter).

The Well Country: Los Chenes

In Maya place names the suffix -*chen* signifies location at or near a natural well. Many such places lie south of the foothills called the Puuc, and directly north of the Río Bec district. [52] Indeed the Chenes country may be termed a northern province of the Río Bec style of architecture. Major stylistic differences separate the Río Bec–Chenes group from the Calakmul-Petén group to the south. The boundary between them lies at about 18 degrees 15 minutes of north latitude. Morley regarded the Río Bec monuments as being in Chenes territory,[53] more for architectural than for geographical reasons. His principal argument was that Río Bec and Chenes buildings are both faced with cut stone, unlike the stucco finish of the Petén monuments. The Río Bec sites, however, are usually more elaborate and much larger than the Chenes settlements, so that it is useful to retain a distinction between them.

In the Chenes territory proper, Hochob is perhaps the largest site, set upon a modest rise with three courts surrounded by small buildings and platforms. The principal edifice lacks the Río Bec towers [184]. Instead, a central vaulted chamber, symmetrically flanked by two lesser chambers on lower levels, as at Culucbalom in the Río Bec province, dominates the little court. The flanking chambers are treated as *avant-corps*. All three façades bear an intricate decoration of cut stone, representing stylized serpent-masks, framing the doorways.[54] Other examples of these mask-façades are at Dzibilnocac and El Tabasqueño in Chenes country, as well as at Uxmal in the Puuc (House of the Magician) and Old Chichén (the Iglesia) in northern Yucatán.[55] Antecedents (or parallels) in the Petén are the serpent façades of Temple 22 at Copán and Building A at Holmul in Group II [216].[56] Since the most elaborate expression – the serpent-framed doorway – is in the Chenes, it is usually taken as the characteristic trait of the Chenes style.

Other features of Chenes practice also command attention. At Hochob, the stones on the vault soffits are carefully shaped, with deep

184. Hochob, main building, *c.* 800(?)

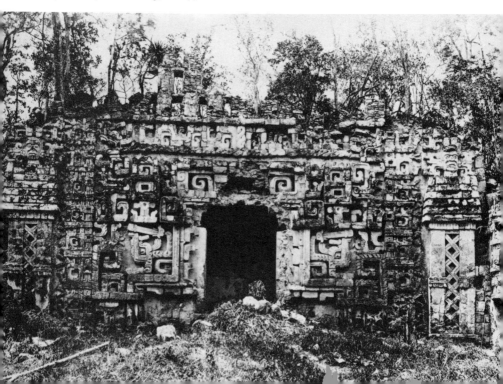

tenons and rectangular faces. The outer wall surfaces are faced with blocks of limestone.[57] The façade of the central chamber of the main building continues upward in a false front, decorated with rows and columns of human figures. In other Chenes buildings, an aproned moulding marks the level of the impost of the vault. All these traits so closely resemble the architectural practice of the Puuc district that any great chronological separation between the Chenes and Puuc styles seems unwarranted. The Río Bec, Chenes, and Puuc styles are probably roughly contemporary, belonging all three to a Late Classic period, after the close of the Initial-Series inscriptions, and prior to the Toltec intrusion. This period used to be called the Maya 'Renaissance', but the ceramic and stylistic evidence accumulated in the past three decades invalidates the idea of separate civilizations, which the use of the term Renaissance was intended to convey. Succession is present, from mid to Late Classic periods, and also displacement, from the lake and river cities to Yucatán, but at no point can a long era of degeneration separating 'Classic' from 'Renaissance' be clearly established.

The Hill Country: the Puuc

Low hills called the Puuc, not more than 350 feet high, interrupt the flat country north of Champotón. A thick accumulation of ruins occurs in this part of the peninsula. The ancient settlements all flourished near underground cisterns, typical of the Puuc, each holding enough water for the needs of the near-by farmers[58] during the six-month dry season in each year. These cisterns, called *chultunes*, were bottle-shaped tanks, carved into the limestone plain or built in the stone fill of the plazas. They were plastered inside to collect the rain-water that ran off. The occupancy of the Puuc sites, north-eastward from Champotón to Maxcanú, and south-east from Maxcanú almost to Lake Chichankanab, depended upon the construction and maintenance of the cisterns. The dated sculpture and the remains of pottery indicate

settlements in Middle Classic times, and prosperity until the rise to power of the Toltec invaders, after A.D. 900, at the end of the Late Classic era.

The Puuc architects of the Late Classic era transformed all previous Maya practice.[59] Earlier Maya buildings, whether in Yucatán or in the Petén and Usumacinta regions, were built of slabs and blocks, faced with stucco. The Puuc builders, like their Petén contemporaries, used rubble cores, faced by a veneer of thin squares of cut stone. The heavy piers of the southern façades were replaced with round and square columns [186], to vary the rhythm of the openings and to improve the lighting inside the heavy walls. The stucco exteriors of the southern provinces were abandoned for geometric designs of carved stone, assembled like mosaics in the upper zones of the façade. The mansarded profiles were replaced by more stable vertical façades [196]. In the vault soffits, specialized facing-stones appeared, allowing greater spans in the rooms, and more finished surfaces.

These innovations all reflect major changes in Maya life. The builders no longer planned great courtyards rimmed with temples and studded with calendrical records carved in stone. Habitations rather than temples were the aim. A few stelae were set up, but the main effort was invested more and more in the new style, with its geometric decoration keyed to the vertical upper zone of the façade and to the single roof-combs on the vertical walls, which are called 'flying façades' [160 E], to distinguish them from the double-wall constructions of the south. The proportions, the mouldings, and the system of decoration all diverge from Petén and Usumacinta practice.

It is not unreasonable to postulate three centuries for the duration of this architectural style. The orthodox view[60] that the Puuc stelae are later than 9.16.0.0.0 (491 Spinden=751 Thompson)[61] also fixes the date of the architectural and ceramic remains. There is no doubt that the stelae are of Classic date, but there is also no proof that they are coeval with Puuc

architecture and pottery. The orthodox correlation of Classic Maya and Christian calendars (i.e. Initial-Series, 10.3.0.0.0, equated with 889) necessitated tying the Puuc buildings to the stelae of Cycle 9, because of firm textual evidence for the beginning of the Toltec domination so soon after the close of the Initial-Series inscriptions, in the tenth century. The radiocarbon dates from Yucatán,[62] however, also allow a correlation equating 10.3.0.0.0 with A.D. 629 and they allow a reasonable duration for the architectural and ceramic forms of the Puuc style, without driving their date far back into Cycle 9. Our chronology, by marking a Puuc period equivalent to 'Late Classic', recognizes the stylistic autonomy of Puuc architecture as well as its Initial-Series and pre-Toltec position. It also meets the requirement of contemporaneity between Puuc and Mexican events such as Mitla, Lambityeco, Xochicalco, and Tajín Chico, where spatial and decorative analogies to the Puuc cannot be disregarded.[63]

The architectural remains define two distinct provinces in north-western Yucatán, coinciding approximately with the eastern and western branches of the inverted V of the Puuc country. In general, the western sites[64] are small and residential, plain, and much older than the large, ornate, and ceremonial eastern sites. The differences between them are best seen by comparing Edzná with Kabah, or Holactún with Uxmal. Edzná, covering about 250 acres with scattered groups of buildings, was built during perhaps two millennia. It has clearly defined pre-Classic levels of occupancy, as well as Classic and post-Classic remains.[65] Kabah, though twice as large, was built mainly during a 200-year period before A.D. 1000, estimated by ceramic evidence.[66] Holactún, also called Xcalumkin, has a court surrounded by four small buildings. The group, though small, is a large one for the western district, in contrast to the extended clusters of important buildings at Uxmal [187], Labná, Sayil [186], or Chacmultún. Characteristic among Puuc settlements are suggestions, as at Labná, of 'strong dyadic contacts between equivalent human groups', in addition to the 'hierarchical arrange-

ments within and between settlements' which most observers note.[67]

In the west, block masonry carved in large units of decoration is not uncommon. In the east, veneered rubble cores and mosaic decorations of small units easily re-used in new combinations are the rule. These differences probably correspond to early and late phases of Late Classic architectural history. Of course, late traits of construction and ornament are common in many western buildings, but the early traits, which resemble Río Bec and Chenes forms, do not appear in the western Puuc. For example, columns or piers with *atadura* capitals, or binder-mouldings, resembling a girdle of tightly belted thatch flaring out both above and below the belt, are common from the Río Bec district westward,[68] but in the eastern Puuc they occur only in the oldest portions of the Nunnery at Uxmal [189]. Cylindrical columns, on the other hand, appear in both eastern and western Puuc buildings, though more commonly in the east,[69] so that the form may be taken as late, occurring in remodellings and late constructions in the western group. At Edzná [185], the plain band mouldings and the single slant-faced mouldings are close to those of Río Bec or Xpuhil [183]. There is nothing like them now known in the eastern groups.

The Puuc style of architecture is therefore best apprehended in the eastern sites from Chacmultún to Uxmal, as a Late Classic transformation of Maya practice which occurred in the two or three centuries before 1000. Certain forms characterize its early and its late manifestations: the storeyed or chambered pyramid [186]; the monumental archway; the vertical façade; the monolithic core veneered with thin stone plates; the use of *atadura* (binder) mouldings; and the apertures framed by columns.

The chambered pyramids of the Puuc are not unlike Becán, Structure IV [181]. In the Puuc, from Edzná to Chichén Itza, the architects, by building set-back ranges of chambers upon each pyramidal stage, achieved a storeyed effect. The oldest of these chambered pyramids may be the one at Edzná [185]. It is roughly square, about

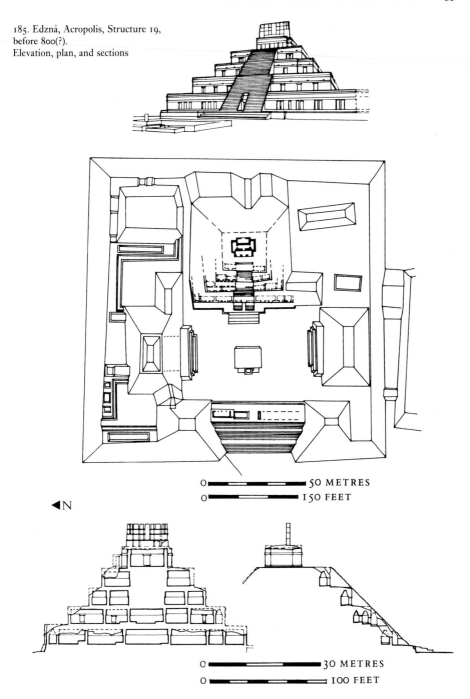

185. Edzná, Acropolis, Structure 19, before 800(?).
Elevation, plan, and sections

0 ▬▬▬▬▬ 50 METRES
0 ▬▬▬▬▬ 150 FEET

◀N

0 ▬▬▬▬▬ 30 METRES
0 ▬▬▬▬▬ 100 FEET

60 m. (200 feet) long on each side, and rising 30 m. (100 feet) to the top of the flying façade. Four of its five stages bear files of chambers in set-back levels on the west face and of undetermined extent on north and south faces. The chambers on the second and third stages are double ranges;[70] on the fourth and fifth they are single. Early and late features combine everywhere. There are no binder mouldings, but columnar supports appear in the fifth-storey chamber façades. The entire edifice overlies an older, smaller pyramid of Early Classic Petén type with re-entrant, inset corners. Two modes of construction coexist: slab masonry in some chambers, and veneered rubble with special vault stones in others.

On other Puuc sites, the pyramidal core shrinks to a terraced support for the files of rooms, as at Chacmultún, where core and stair ramp in the main edifice form a T-shaped nucleus, or in the Sayil palace [186], with three terraces of chambers surrounding a solid core approximately 100 by 230 feet in ground plan.[71]

Other traits of the Puuc style are best discussed in connexion with Uxmal, the most intactly beautiful of all Maya cities. Uxmal is also the least typical, having, like most masterpieces, transcendent properties and qualities. For example at Uxmal cylindrical columns are rare, although they characterize the Puuc style in both western and eastern variants. Another peculiarity of Uxmal architecture is the open-corner quadrangle, composed of free-standing blocks [187]. It is an exceptional form in Puuc design. This trait, like the mosaic decoration in the upper façades, recalls the architecture of Mitla in southern Mexico [125]. A further parallel between Uxmal and Mitla is the outward lean (negative batter) of the façade walls. Other affinities between the Puuc and Oaxaca will appear below.

Uxmal occupies about 250 acres. The oldest edifice is perhaps the southernmost pyramid,[72] a square, four-stage mass not unlike the main pyramid at Edzná, and called the Pyramid of the Old Woman. At the other end of Uxmal stands

186. Sayil, palace, as before 1000

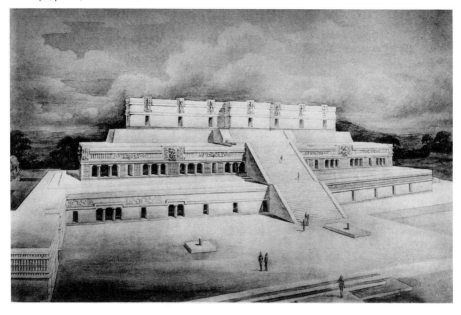

187. Uxmal. General plan *c.* 1000

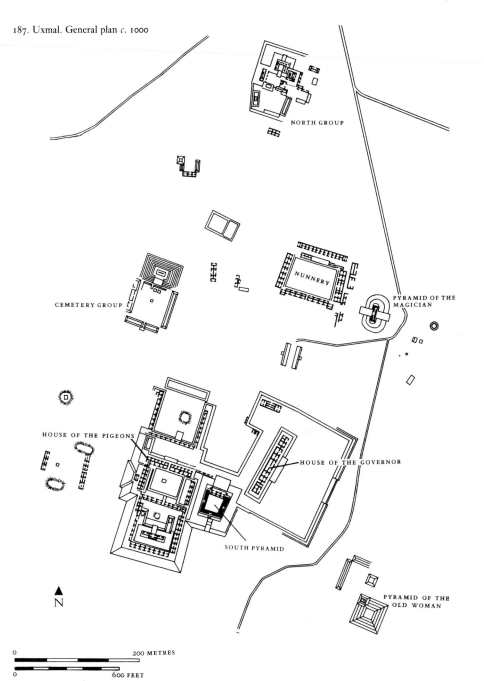

NORTH GROUP

NUNNERY

PYRAMID OF THE
MAGICIAN

CEMETERY GROUP

HOUSE OF THE PIGEONS

HOUSE OF THE GOVERNOR

SOUTH PYRAMID

PYRAMID OF THE
OLD WOMAN

N

| 0 | | 200 METRES |
| 0 | | 600 FEET |

the North Group, which is a chambered pyramid with a lower court and edifices on several levels. Between the North Group and the Old Woman are four principal edifices: the Pigeon Group, so named on account of its latticed and gabled façade resembling a dovecote [188]: the House of the Governor [196]; the Cemetery; and the Nunnery [189]. North, Cemetery, and Pigeon Groups all belong to the same family of 'amphitheatre' courts which we have examined at Monte Alban [110]. Barrier-mounds frame the courts on three sides. The fourth side with a stairway pyramid is like a stage. The Pigeon Group is the most complex of all, with three courts of diminishing size. The largest is the low outer court, followed by the middle court at the

foot of the south temple, where chambered pyramid and amphitheatre court merge. Seler, noting that the Pigeon Courts are more ruined than the Nunnery and the Governor's Palace, ascribed greater age to the former:[73] certainly the Pigeon Courts, both as amphitheatre enclosures and as chambered terraces with flying façades [188], are typologically older than the free-standing block designs of the Nunnery and Governor's Palace. The differences between the Pigeon Courts and the Nunnery are analogous to the differences between Monte Alban and Mitla, where we have supposed a lapse no longer than the passage between mid-Classic and Late Classic eras, i.e. no more than six, and no less than two centuries.

188. Uxmal, House of the Pigeons, before 900(?)

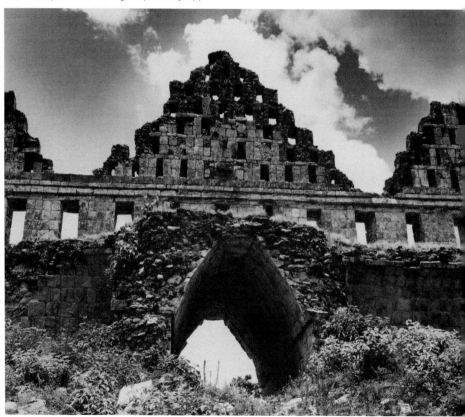

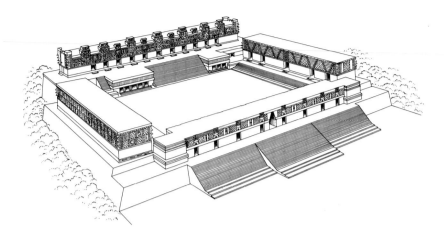

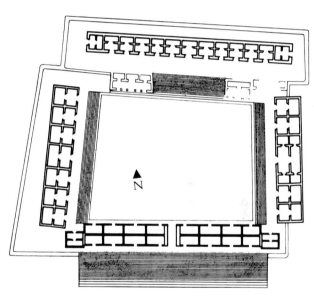

189. Uxmal, Nunnery, before 1000.
Isometric view and plan

0 40 METRES
0 120 FEET

One may consider the Nunnery [189] as an improved version of the earlier Pigeon Court. Like the Pigeons, it spreads at the foot of a lateral pyramid, it occupies platforms on several different levels, and it has a chambered terrace effect on the highest platform, as well as a ser-rated or castellated silhouette in the principal or north building. The functional uses of these groups are unknown: they may have been palace groups, or institutional dwellings, or even mere concourse centres with surrounding chambers for official ceremonies and for storage. The

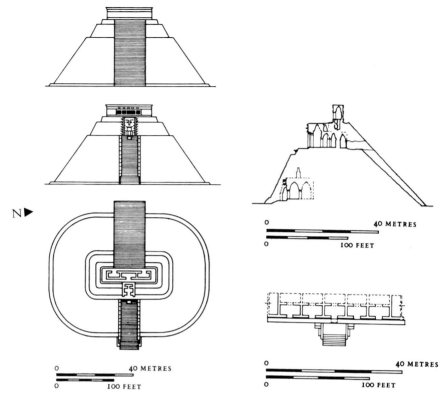

190. Uxmal, north-east pyramid ('Magician'), after 600. Elevations and plan (*left*), and section and plan of structure at ground level (*right*)

191. Uxmal, view *c.* 1933 of Nunnery (*left*) and Magician (*right*) before restoration

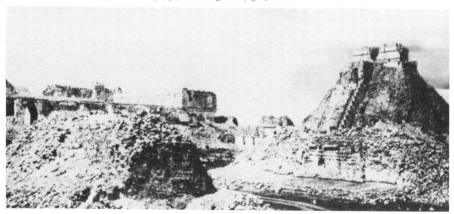

lateral pyramid, called the Magician [190], is an eclectic aggregate of styles produced during many generations, beginning in the sixth century and ending in the tenth. M. Foncerrada takes the building history of the Magician as the key to the stylistic development of Uxmal. Temple I (569 ± 50 by C14), part of a former quadrangle, resembles in plan Structure 74 at Tikal or Structure I at Yaxchilán (lintels dated 752–6), and its ornament influenced both Chenes and Río Bec styles. Goggled faces of Teotihuacán derivation in the upper façade support the sixth-century dating. Temple II, east façade, has monolithic columns and a flying façade rising from its rear wall. The column is rare at Uxmal. Temple III, buried behind II, has a mansard roof of classic southern type. Temple IV forms the west façade, and contains the serpent-mouth doorway, related to Structure I beneath the Governor (excavated by Ruz in 1947; illustrated in Pollock, 1970, figure 93) in Chenes style, resembling the nunnery at Chichén. Temple V, built under Toltec domination, surmounts Temples II and III [191]. The serpent-mask doorway on the penultimate stage of the west front [218] is in the Chenes style – a veneer over a mansarded inner façade of Petén or Usumacinta profiles.[74] The storeyed masks flanking the west stairs recall the tiered masks of Structure K5 at Piedras Negras. The temple on the summit is like the west building of the Nunnery [194]. The rounded ends of the pyramidal platform are unique in Maya architecture as now known.

Progressive mastery of the architectural possibilities of free-standing block design appears in the Nunnery buildings. It continues in the masterpiece of the genre, the Governor's Palace. In the Nunnery, the convergence of the lateral pavilions [189], as in Michelangelo's composition on the Capitol in Rome, may be due to careless or accidental design, but other refinements, such as the outward lean of the façades for visual correction of the long horizontals,[75] suggest a similar deliberate aim of perspective correction in the convergent eastern and western buildings.

The north building in the Nunnery [192] is probably the oldest, as we may deduce from the older encased structure,[76] from the vestigial roof-combs, and from the narrow vaults upon heavy supporting walls, as well as from the chambered terrace design on two levels. A radiocarbon date from this edifice (see Note 49, Chapter 8) reads 893 ± 100. If the ratio of wall to span is an index to age,[77] the south building is the next oldest, followed by the east pavilion [193], then the west building [194]. The south building has two striking features: the archway entrance on axis with the ball-court, and the variable spacing of the doorways in both façades. Such monumental archways appear at Labná, Kabah, and Oxkintok in the Puuc, as well as much later at Chichén Itza and Mayapán. The variable spacing of the façade doorways has an antecedent in the Palace façades at Palenque: the widest intervals are the central ones, diminishing towards the corners, as in Greek peripteral temples. This refinement is lacking in the north building, but it appears fully developed in the west building, and tentatively in the east building. These advances in rhythmic complication correspond to the sequence suggested by the ratios of wall to span.

The House of the Governor [195] is the most refined and perhaps the last achievement of the architects of Uxmal. In it many scattered solutions were brought together to make up an edifice of striking harmony and repose. Its profiles are adapted to the scale of the landscape, and its surfaces are adjusted to the hard light of Yucatán with an ease that reveals both a mature architectural tradition and the presence of an architect of great endowments. He probably had to conform to an eleven-entry plan [196] previously set out both in the north building of the Nunnery [189] and in the gabled House of the Pigeons. He broke the monotonous block of the Nunnery into three parts connected by two corbel-vaulted archways, in a solution anticipated by the *avant-corps* end-apartments in the south Nunnery building. This building also was broken by a corbelled archway. But the architect of the Governor's House boldly made

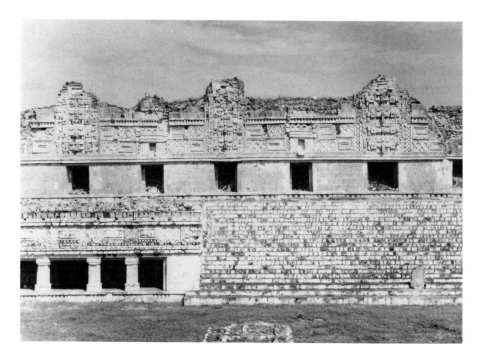

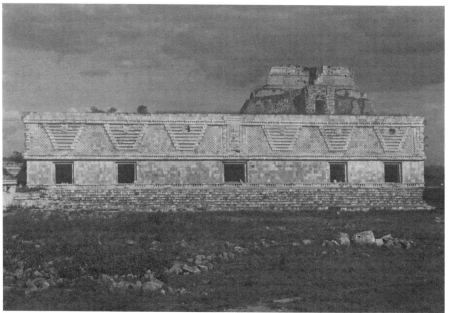

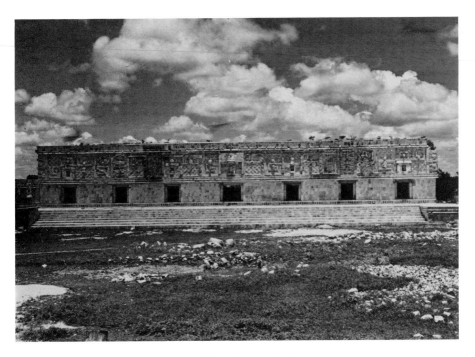

192–4. Uxmal, Nunnery quadrangle: north building (*opposite, above*),
east building (*opposite, below*), west building (*above*), before 1000

the best of the arch. In the Nunnery, the arch
is like a raw wound in the façade, incompletely
thought out either as an entrance or as a break
in the block. The architect of the Governor's
House, however, recessed the corbel-vaulted
arch behind the façade, and exaggerated the
vault overhangs, carrying them in convexly
curved soffits like curtains down nearly to
ground level, in order to accentuate the separa-
tion of the three pavilions by shadows and by
striking contours.[78]

The proportional groupings [195] have over-
lapping and contrapuntal rhythms that recall

the complexities of Maya time-division. The
doorways in the three pavilions yield the group-
ing 2-7-2. The main eastern stairway marks
another grouping: 3-5-3. Each corbelled arch-
way is flanked by mosaic decorations in the
frieze permitting the rhythm 5-3-5. The frieze,
finally, has its own rhythmic order of several
planes of geometric ornament in depth.

A more remote prototype may be the
thirteen-door, double-range Structure A-6B at
Altun Ha near the east coast, north of Belize
City, dated by radiocarbon as of about A.D. 465
[197].[79]

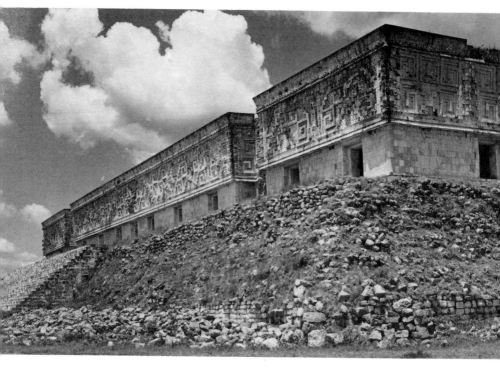

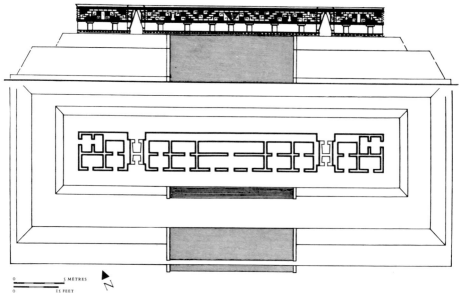

195 and 196 (*opposite*). Uxmal, House of the Governor, east façade, tenth century, elevation and plan *c.* 1000

197 (*below*). Altun Ha, Structure A–6 B, *c.* 465. Perspective reconstruction drawing and plan by S. Loten

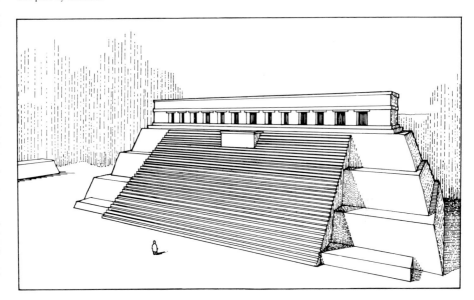

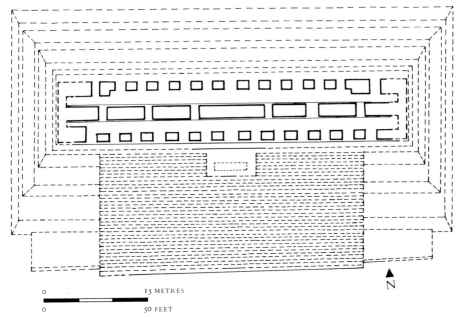

0 15 METRES

0 50 FEET

N

THE MAYA TRADITION: SCULPTURE AND PAINTING

SCULPTURE

Maya sculptors of the Classic era were Stone Age professionals moving from one site to another as demand required. Their figural art displays cultural unity during a thousand-year period. Limestone [203], sandstone [199], trachyte [198], stucco [210], wood [200], clay, and jade [213] were the customary materials, worked without knowledge of metal tools. The genres were architectural decoration, commemorative reliefs, figurines, pottery, and jewellery. All large monumental sculpture obeyed architectural lines of force in its placing. Low relief carving is predominant, full-round sculpture rare. The governing impression is of an art of linear contour, transferred from painting in order to secure more permanent effects, without investigation of the sculptural possibilities of bodies in space. Between the Leyden Plate of incised jade (A.D. 320) and an early stela from Tikal, the main differences are in scale and technique. The formula of linear silhouettes in the flat plane is common to both. Five hundred years later, the murals of Bonampak [221–6] and the figural reliefs of Piedras Negras [203] show similarities of the same order, although the reliefs have less pictorial scope than the murals, and a more rigid hieratic symbolism. Studied proportions, often with complex harmonic relations, characterize Maya sculpture, in a manner reflecting or echoing the obsession of the Maya mind with astronomical, mathematical, and ritual divisions of time.

A major morphological change in Maya sculpture occurred near the close of the Initial-Series inscriptions in the ninth century, after free-standing stelae [198] and altars with relief sculpture ceased to be made. Thereafter, from the eighth to the end of the tenth century, during the Puuc period, an architectural sculp-ture of geometric stylization [218], which was usually confined to the upper façades of Late Classic buildings, gradually replaced the old tradition of naturalistic and curvilinear relief sculpture. Instead of the priests and warriors and secondary figures of Early and mid-Classic art, geometric assemblies of serpent-mask mosaic forms, with panels of abstract ornament and curtains of stone colonnettes, surround the exteriors of the edifices [186]. The reasons for this great change are no better understood than those for the twentieth-century 'retreat from likeness'. We may suppose that a cultural crisis and an ethno-geographic shift, or a combination of them all, were involved with the advent of different conceptions of artistic form. The possibility of an autonomous stylistic renewal is also relevant, as in the European shift from the Romanesque to the Gothic style in the twelfth century. In order to describe the history of Maya sculpture, it will be convenient to divide the corpus into two main groups: figural compositions, which characterize the art of the Petén and of the river cities (first to ninth centuries); and geometric architectural decorations, which are typical of the cities of the plain in the Río Bec, Chenes, and Puuc regions (eighth to eleventh centuries).

Large, full-round figural sculpture in stone, occupying its own detached space, is most rare in Maya art. One remarkable example has recently come to light. This wood figure, $14\frac{3}{4}$ inches high, said to come from the middle Usumacinta region, is dated 537 ± 120 by radiocarbon, and it represents a kneeling figure holding on his forearms a platter containing a face-panel. The posture is one of reverence, in body forms of an authority like those of the Olmec wrestler. The theme, however, is Maya, being prefigured in a pottery version at Tikal of Early Classic date.

In general, Proskouriakoff has charted the chronological variations of Maya sculpture, and Haberland tabulates the regional migrations of several hundred specific forms in Maya sculpture.[1]

Commemorative Monuments and Figural Reliefs

The Classic Maya use of free-standing sculpture was restricted to low relief compositions upon tall slabs and prisms of stone (called stelae by transfer from Greek archaeology) as well as on low blocks, drums, and boulders, often associated with the stelae. The term *altar* is a misleading transfer from European liturgy, where it conveys 'a table of sacrifice', rather than 'the pedestal of rank' it signified for Maya peasants and nobles.[2]

The prismatic faces of the stela were often stressed by framed inscriptions and scenes on front, back, and sides [198]. The earliest stelae, like No. 9 at Uaxactún, are long and irregular splinters of stone. Later on, in the Petén and Motagua districts, shafts of nearly square section were usual. Thin slab stelae satisfied a need on the western river sites for many-figured compositions [206, 207]. After A.D. 514 (9.4.0.0.0), in the Usumacinta region, panel designs, more like illustrations than monuments, are common [203]. The placing of the reliefs also varies according to region. In the Petén, as at Tikal, the stelae are aligned like gravestones along the sides of the courts, but they do not stand at the centre. At Copán and Quiriguá [172], however, the slabs and prisms seem to be placed at random. Lines of sight, perhaps relating to important agricultural dates in the solar year, may be involved, as between Stelae 10 and 12 at Copán. In the west, at Piedras Negras [178] and Yaxchilán, the stelae are governed, as commemorations of dynastic rulers, by the groups of buildings, in their off-centre alignment on terraced levels.

The chief purpose of the stelae was to represent standing or seated human ruler figures, richly dressed and burdened with serpent symbols. Other functions of the stelae and altars were to commemorate in writing the passage of the units of Maya time, by five-, ten-, or twenty-year units. The inscriptions also record computations of the length of the solar year as well as of the motions of the moon. The discovery by T. Proskouriakoff that the figural stelae commemorate historical persons, was first established on monuments at Piedras Negras in 1960 and extended later with the series at Yaxchilán, while D. Kelley and H. Berlin established dynastic sequences for Quiriguá and Palenque in 1962 and 1968. At Piedras Negras the records concerned seven series of reigns marked by birth- and accession-dates spanning the period c. 600–800. Similar records at Yaxchilán were about events in the lives of rulers named Shield-Jaguar and Bird-Jaguar and their successors, during the span A.D. 647–807. Proskouriakoff also identified similar inscriptions of dynastic character at twelve other sites, including Palenque, Copán, Seibal, and Tikal. For Copán twelve rulers spanning 553–826 were identified in 1976.[3]

The personages probably represent successions of priest-rulers [198–200], whose rank is marked by the ornate serpent bar surrounding the figure, or carried in both hands. By this hypothesis, the bar symbolized the sky, and it conferred the status of 'sky-bearer', or temporal governor, upon its possessor;[4] after the fifth century, its use was less common, and an effigy sceptre replaced the bar, concurrently with the appearance of armed warrior figures in greater numbers than in Early Classic art. A glyph composed of saltire, shell, leaf, and *kin* (or day sign) has been identified as a badge of rulership.[5] Another has two glyphic compounds of the numbers 7 and 9, each joined to a skeletal serpent head.[6]

Proskouriakoff named this single human figure [200] the 'classic motif', and she has traced its variations in two Early Classic phases, and four Classic phases (formative, ornate, dynamic, and decadent).[7] In each period and phase she analyses the regional and local variants, always in order to reconcile the epigraphic and stylistic evidence, which in Morley's great work[8] were often in conflict. Her findings are categorical: pre-classic and Early

198. Copán, Stela N,
c. 760. Trachyte

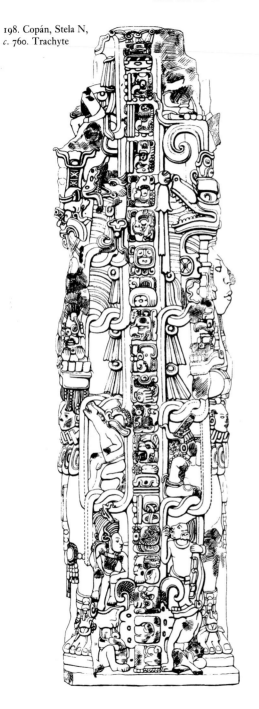

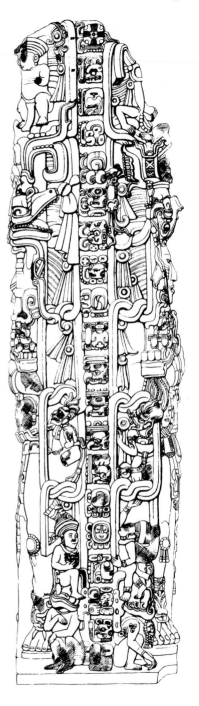

Classic versions of the stela figure show a profile outline with frontal shoulders, as in Egyptian dynastic art [275]. The turning of the shoulders into profile view occurred in the Petén during 475–514 (9.2.0.0.0–9.4.0.0.0, especially at Tikal). After a lapse of some sixty years, *c.* 600, when almost no sculpture was produced, the profile stance was abandoned in the principal figures and a new version, with full frontal torso and the feet turned outwards in opposite directions [e.g. 200], made its appearance, beginning about 593 (9.8.0.0.0) in the Petén. This form persisted, with local divergences, until the end of figural relief sculpture about 900. From about 711 (9.14.0.0.0), animated motions enliven its hieratic dignity, but the feet remain splayed out in opposing profile [206].

The scale of the figures in Early Classic reliefs varies, not according to perspective distances or to the actual size of persons and things, but according to their rank and importance. Tiny captives or victims cluster by the feet of the gigantic principals. In the eighth and ninth centuries this hierarchic conception of scale weakened and yielded to correct visual scale: thus Lintel 3 at Piedras Negras [203] has accessory figures on the foreground steps in the same scale as the principal enthroned personage (after 782). The Maya striving towards gigantic effect belongs to the same period. Stela 1 at Bonampak, dated *c.* 770 (9.17.0.0.0), is 5 m. (16 feet) high by 2·6 m. (8½ feet) wide, and it is carved with a single human figure.[9] At Quiriguá, the late prismatic stelae of sandstone have colossal dimensions; the largest is Stela E[10] (of the same date as the slab at Bonampak), 35 feet high, the largest monolith ever erected in Maya territory [199].

Proskouriakoff has traced many other generic and specific differences between early and later sculptural vocabularies. Early scrolls are of simple bifid or trifid outline; later (here 'mid-Classic') scrolls have tendrils and doubled outlines. Early head-dresses have large animal-

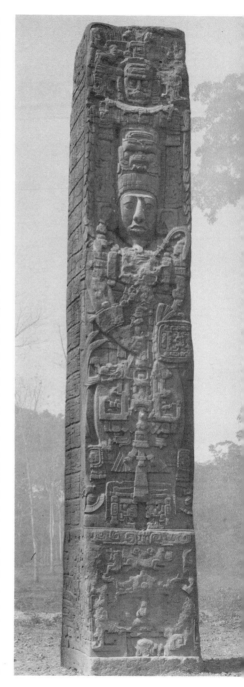

199. Quiriguá, Stela E,
c. 770. Sandstone

mask forms [275]; later head-dresses run to mosaic incrustations upon smaller, more stylized animal masks. Early ear-plugs are large disks; later ones are ornate squares [199]. The progression is never merely from plain to ornate forms; it is from ornate to ornamentally autonomous forms. A loin-cloth apron begins as an elaborate element, and it ends as an arbitrary form which defies imagining as a real part of costume. In other words, the earliest representations are of tropically luxuriant shapes, which progress towards arbitrary symbolic pre-eminence, often at the expense of the human subject of representation. The meaning of this symbolic system is far from sure, but its proliferant serpent-head elements suggest that the figures garbed in them have transcendental meaning: that they are not only rulers but also god-impersonators wearing

shreds of the space of this and other worlds, represented by serpent mouths, eyes, and fangs.

At this point we encounter an irreducible variety of local Maya expressions in sculpture. For instance the eastern regions – the Petén and the Motagua – differ from the western river cities by their stress upon cage-like costumes. But Tikal in the Petén, and Copán in Honduras, also differ from one another. Tikal sculptors never investigated the possibilities of relief rounded in depth; their work always adhered to close-set front and rear planes, separated by vertical-wall cuts, and differentiated by linear incision. At its best, as in the wooden ceilings from the inner chambers of the main temples [200], Tikal sculpture achieved ponderous rhythm in the linear surface, by two-dimensional extension rather than by any reliance upon effects in depth.[11]

200. Wooden lintel 3, relief from Temple IV at Tikal, c. 750. *Basel, Museum für Völkerkunde*

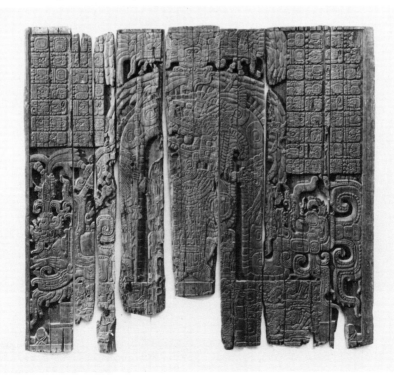

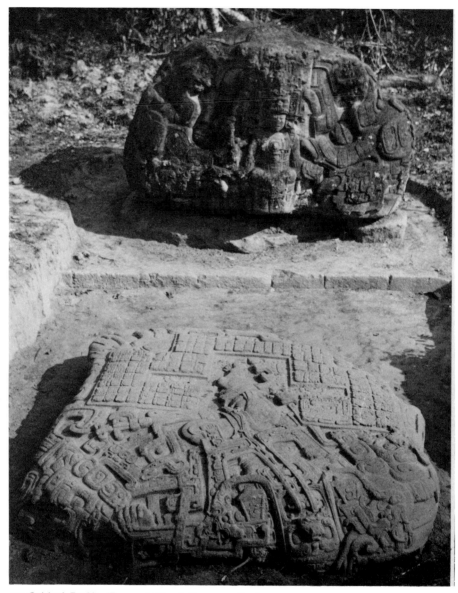

201. Quiriguá, Boulder (Zoomorph O) and altar, *c.* 790. Sandstone

At Copán, the sculptors boldly attempted to free the body from the stone block. Spinden[12] charted this evolution and his observations still hold good, with minor corrections. At Quiriguá, however, the progression towards free-standing bodies was restrained by the prismatic en-

velopes. Only the facial planes are cut back into the stone by supple passages of modelling. All other parts of bodies are imprisoned both by ornate costume and by the bounding planes of the prism [199].

The governing idea of the sculptors of Quiriguá was like that of a diamond-cutter: to conserve the weight and bulk of the stone at the expense of other aims. The great boulders, called zoomorphs, and the flat table stones near them, display this respect for the natural boundaries of the raw material. Zoomorph O and its 'altar', dated 795 (9.18.5.0.0), are the outstanding examples [201]. The boulder is carved with a variant of the double-headed sky symbol we have seen on the wooden lintel from Tikal, and on the stelae. Here the dragon-heads in profile confront each other as if to present between them the figure of a seated personage bearing an effigy sceptre. The flanks are carved with more serpent-heads, and the rear bears a geometric serpent-mask bordered by long inscriptions. The 'altars' associated with Zoomorphs O and P are likewise irregular boulders carved in relief [201, 202]. One part of the top represents a

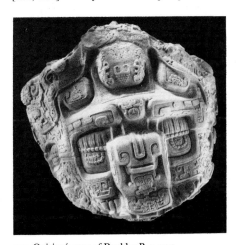

202. Quiriguá, rear of Boulder P, c. 795

dancer, bearing masks, and involved in coils and layers of serpentine ornament. On the rear part of each table an elaborate glyph-band forms a terraced shape recalling the ground plan of a temple in the Petén style. On Altar O, the dancer's foot penetrates the 'doorway' as if to show a performance on the temple platform [201].

On the Usumacinta valley sites, the narrative relief technique of Yaxchilán and Bonampak resembles that of Piedras Negras. But at Yaxchilán the portrayals of aggression, of visionary ecstasies, and of penitential rites of bloodletting compose an art of violence both against others and against the self which differs radically from the serene and contained palace art of Piedras Negras and Palenque. The earliest dated reliefs of Piedras Negras and Yaxchilán are assigned to the early sixth century; those of Bonampak and Palenque to the early seventh. The latest dated sculptures, showing Mexican intrusions, appear at Seibal in the ninth century.[13]

Some relief sculpture of the western river cities resembles the Petén stelae.[14] But an early divergence is seen about 535. These new narrative and pictorial interests are represented in the Petén style only by small accessory persons crushed beneath the feet of the huge principal figure, or relegated to small panels separated from the main area by bands of inscriptions (as on Stela 1 at Cobá, 9.12.10.0.0(?), or Stela 1 at Ixkun, 9.18.0.0.0).

The new pictorial manner of the Usumacinta cities is seen in Wall Panel 12 at Piedras Negras (9.5.0.0.0(?)) – which was probably incrusted upon a façade. A standing figure in profile of Early Classic style in one panel receives the kneeling homage of four others in another panel. The entire composition is of 7 : 3 proportion. Both the intaglio glyph forms and the proportions are novel. The intention is altogether opposite to that expressed in the arbitrary scale and restricted space of the upright stelae of the Petén style. The composition recalls Maya vase-painting, and mural decoration like that of Bonampak: traces of the green and red paint reinforcing these pictorial effects still adhere to much Piedras Negras sculpture.[15] Several other multiple-figure compositions at Piedras Negras show a unified pictorial space. Wall Panel ('Lintel') 3 (9.16.10.0.0(?), or after 782) portrays a

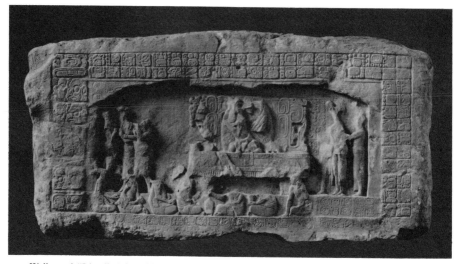

203. Wall panel ('Lintel' 3) from Piedras Negras, after 782. Limestone. *Guatemala, Museo Nacional*

princely figure seated upon a broad dais backed by a serpent-mask panel of perforated stone [203] like the actual throne discovered in Palace J 6 at Piedras Negras.[16] Seven figures, grouped four and three, flank the dais, and seven seated figures occupy the foreground. Across the room runs a terrace-like step, while a curved line above represents a furled cloth curtain gathered up by cords, as on Stelae 11 and 14. Several inner frames are marked by the glyph bands and by the various tectonic boundaries of the throne-room. At the intersections of the diagonals defined by these various frames are the chief points of interest, such as the full-round hand and arm of the principal figure. This hand rests upon the edge of the dais. The dais, whose width equals one-third the length of the panel, is itself not centred, as if to counter-balance the uneven groupings of figures. The space of an actual room seems to circulate around and among the figures. The front row is carved in low relief, and the more important figures of the rear plane are nearly detached from the plane of the background. Such a progression from shallow foreground to deeply cut background occurred about twenty years earlier (9.15.10.0.0) in stelae like No. 14 at Piedras

Negras, where the distinction between primary and secondary figures was carried, not by scale, but by depth of relief.

This virtuosity in complicated figural compositions reappears in Stela 12 [204],[17] executed about the same time as Panel 3. A warrior seated with one leg negligently raised upon his throne surveys a crowd of seated captives compressed in the narrow space of the stela, and guarded by standing profile figures. The body outlines carry from one to another in ascending wave-like surges recalling the battle scene at Bonampak [225]. Such bellicose subject matter is common in the Usumacinta region, as at Bonampak and Yaxchilán, but it disappears at Palenque.

Piedras Negras is both typical and exotic among Classic Maya sites, with strongly marked local characteristics,[18] such as the armed warrior figures (Stelae 26, 31, 35, 7, 8, and 9), frontal deities in niches,[19] and a scene representing human sacrifice by heart excision (Stela 11), as in Aztec or Mixtec representations. A scene shown at Piedras Negras portrays a priest sowing grains of maize: in one version (Stela 40, 9.15.15.0.0, or A.D. 746) the priest kneels in an upper register, and the grains shower upon the ornate bust of an anthropomorphic deity in the

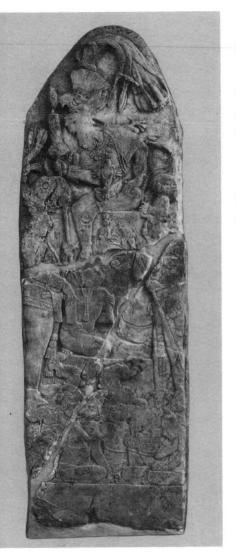 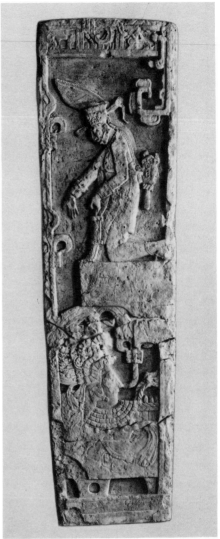

204 and 205. Stela 12 from Piedras Negras, *c.* 770, and (*right*) Stela 40 from Piedras Negras, *c.* 730. Limestone. *Guatemala, Museo Nacional*

lower or subterranean register [205].[20] This representation affords the closest approach by a Classic Maya sculptor to the representation of natural space: up and down, inside and out, front and rear are shown by arbitrary symbolic conventions rather than by reproducing the visual space of retinal impressions. The sculptor unified the upper and lower halves of his narrative by the linear rhythm of a rope, festooned with leaves and ears of corn. The rope emerges from the mouth of the lower figure, and terminates behind the kneeling priest's head.

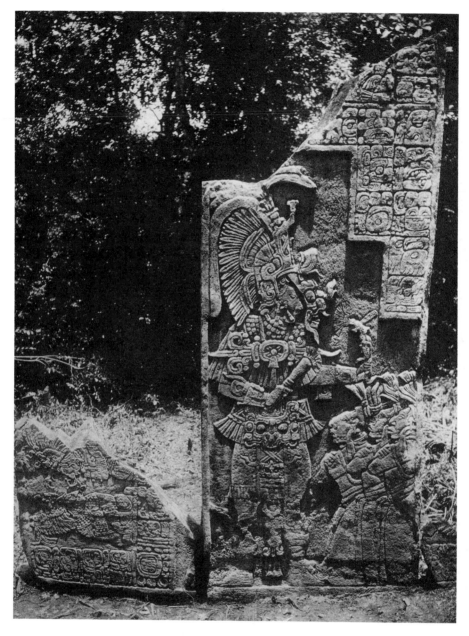

206 and 207. Yaxchilán, Stela 11, Bird-Jaguar and contemporaries, *c.* 770. Limestone.
Rear and front (*opposite*)

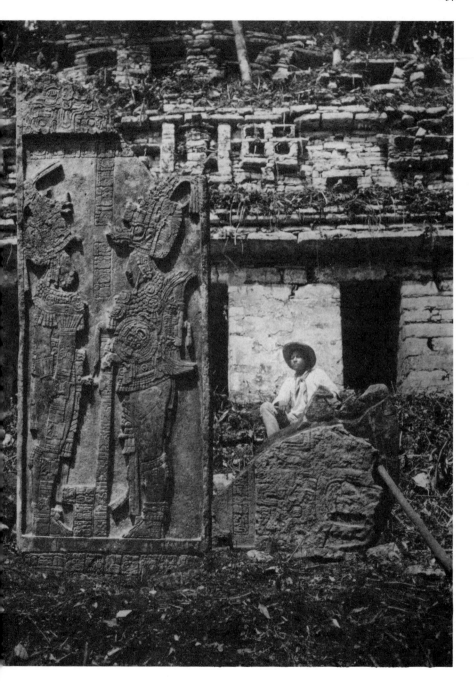

Thus the Piedras Negras sculptor, though he possessed a plausible system of pictorial space for terrestrial events, such as scenes of homage and fealty, or throne-room scenes, reverted to abstract conceptual conventions for the representation of vegetation rites. One marvels at the extraordinary range of artistic means at Piedras Negras: proportional harmonies, melodic decoration, visual pictorial space, and symbolic conventions all combine in an art of unparalleled suavity and power, both transcending and divergent from the rest of Maya sculpture.

At Yaxchilán, south-west and upstream from Piedras Negras, sculpture underwent a radical change in the closing centuries of Classic Usumacinta style.[21] Yaxchilán reliefs prior to 760 (9.16.10.0.0) are relatively tranquil single- and double-figure compositions. Hieratic scale is the rule, with the principal figures shown very large, and the accessory figures appearing very small. The principals are frontal, with the feet splayed out and only the heads in profile, as in Petén sculpture, while the accessory figures appear in full profile.

The rule that frontal figures are gradually replaced by profile figures in action seems to hold for Yaxchilán. Stelae 6 (*c.* 710, 9.14.0.0.0 ± 2 Katuns by style) and 13 (*c.* 750, 9.16.0.0.0 by style) are early examples of standing full-round figures in profile.[22] They are at rigid attention rather than in action. Scenes with recumbent victims, seated supplicants [206], and belligerent warriors, all in partial or full profile, appear after 760 (9.16.10.0.0). Both early and late Yaxchilán styles are less harmonious than that of Piedras Negras. The stereotype of Yaxchilán, with pear-shaped heads and bulbous profiles of long curves, is most striking. Body proportions are more ungainly; the abrupt relief in two planes with coarsely incised lines is less agreeable to the eye. The rhythmic grace of Piedras Negras work is absent.

Stela 11 proves the co-existence of two sharply distinct styles of relief. The back [206], facing a temple, shows a masked priest bran-dishing a sceptre over three kneeling suppliants. Carved in large units, every item of costume and jewellery is portrayed as if under magnification, on a scale larger then the scale of actual visual impressions. The front of Stela 11 is altogether different [207]: the figures are svelte and in profile upon an empty ground scored only by diminutive glyph blocks. The details of costume all keep to the visual scale, with each object keyed to an actual rather than to a conceptual size. The two faces of the stela, according to Miss Proskouriakoff's trait graphs, were carved at the same time (*c.* 770, or 9.17.0.0.0 ± 40 years), so that we may suppose the presence of two schools or generations, one retaining the traditional figure of Petén style in the back scene, and another possibly younger whose work in the front exhibits a flat relief style, visually correct scale, and postures of disciplined attention.[23]

At Yaxchilán the direct representations of visionary and penitential rites are unique. Both types of rite were carved on over-door lintels. In the penitential scenes a devotee draws blood from the tongue in the presence of a priest (Lintels 17 and 24). In the visions, one or two figures observe a serpent rising in standing coils from an altar. The head of a human being [208] emerges from the open jaws of the reptile (Lintels 18, 25, 13, and 14). The association of visions and penitence, of blood-letting and apparitions, occurs only at Yaxchilán, and it seems to prefigure innumerable Toltec and Aztec representations of human sacrifices and plumed serpent symbols. What most strikes us in relation to Maya conventions is the matter-of-fact visual record. Elsewhere, the factual representation of violent scenes was avoided (Piedras Negras), or translated into esoteric symbols (Quiriguá). Yaxchilán reliefs provide the plainest record of the military and religious aggressions in Maya life during the last centuries of Classic Usumacinta history. Peter Furst has assembled evidence on ritual blood-letting as serving to produce visions and supernatural confrontations in ecstatic trances attained through severe physical trauma.[24]

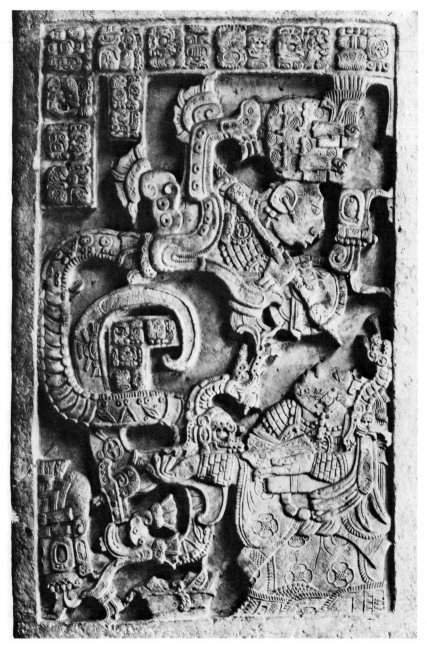

208. Lintel 25 from Yaxchilán, *c.* 780. Limestone. *London, British Museum*

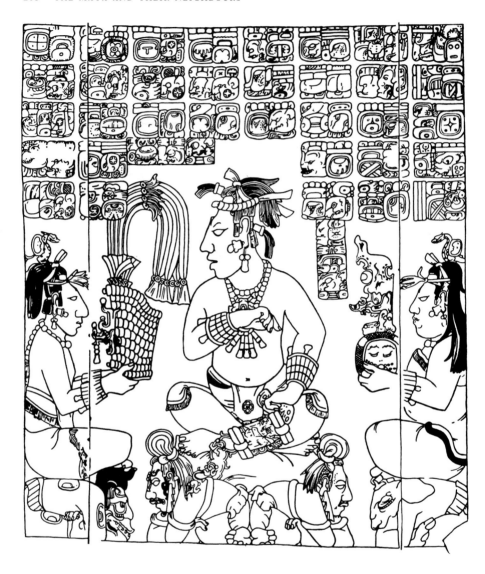

209. Palenque, Tablet of the Slaves,
showing presentation of regalia
to the new ruler, *c.* 723

Of all this nothing appears in the figural art of Palenque. Certain conventional forms, such as the slab and prism stelae, are entirely absent. The only stela-like figure at Palenque is a nearly full-round human form, more like a statue than any even in the Copán series. It bears a date about 692 (9.13.0.0.0, by inscription).[25] The reliefs at Palenque in stucco and stone are sometimes like fine drawings with conscious refinement of line and with gradations of modelling, occasionally so delicate as to approach shading. These relief panels are all in tectonic positions, at the piers of the façades, upon the inner shrine walls, and on the terrace faces [212] and mansard roofs of the graceful little buildings.[26] None of the reliefs shows violent action; only static symbolic themes. There are profile devotees flanking the symbols of worship or might, and men holding infants framed by bands of planetary symbols, as well as scenes of homage and triumph. The postures, the faces, and the expressions are peculiar to Palenque, portraying a sequence of six dynastic rulers and their relatives both in full round and profile aspects from A.D. 602 to after 783.[27] The main variations among the repeating figures lie in attributes and costume. Occasionally, as in the Tablet of the Slaves, the modelling suggests individual identity without full characterization [209]. The subject shown is the continuity of rulership, with the presentation of regalia by relatives to the new ruler,[28] Rain-Bat (as englished from glyphs for an imagined eighth-century linguistic prototype of Chol, which is as yet unknown to science).

In general, the reliefs all describe a courtly life of intense discipline, expressed by exquisite motions and in stylized gestures. Some portraits are full-round stucco heads, originally attached to façade entablatures on certain buildings, or used for funeral offerings, as in the Ruz tomb [210]: such free-standing heads have been identified with sacrificial decapitation by Helfrich, Moser, and Foncerrada de Molina,[29] although portrait heads are never associated with decapitation in the Old World, where death masks and *imagines* were the 'origins' of

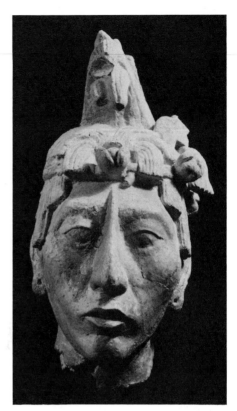

210. Stucco head from the Ruz tomb, Palenque, before 700. *Mexico City, Museo Nacional de Antropologia*

portraiture. The throne back [211] portraying a man and woman of about 800 (exhibited at the Metropolitan Museum in 1970) extends the idea of portraiture from the head to the total body posture, in a three-dimensional relief made possible by openwork carving in a thick slab.[30] Such three-quarter heads, used as architectural decoration, occur also at Piedras Negras, and in symbolic deformations like glyph-forms at Quiriguá. An almost caricatural quality appears in limestone reliefs applied as a facing to the terrace platform of House C in the palace [212]. There, on each slab, nearly nude figures with oversize heads crouch and cower, looking in

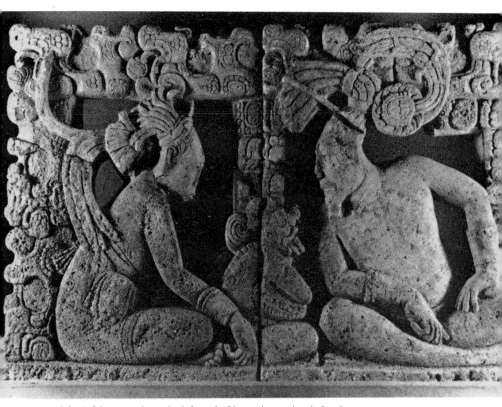

211 (*above*). Limestone throne back from the Usumacinta region, before 800.
Mexico City, Josué Sáenz Collection

212 (*opposite*). Palenque, House C, stone reliefs, after 780

terror towards the central stair leading down to the court. They are perhaps portraits of subject tribespeople, differing categorically from the graceful and impenetrable images of the priests and rulers of Palenque.[31]

The study of monumental sculpture tells much about Maya life, but like public sculpture in general it is always limited by the value system of the dominant class and by the existing conventions of representation. In effect, Maya sculpture may tell us more about the long-term history of sculpture as expression, than it dares to declare about everyday Maya life.

Correct identification of these historical portraits still is obscured by inconsistencies. Disagreement still surrounds the meaning and identity of many personages. Yet L. Schele has assembled four credible low-relief portraits of Jaguar Snake.[32]

Some sculptures have inscriptions reaching millions of years into past and future. These are generally cast in the form of historical records, and probably pertain to mythological and legendary matters, usually in connection with alleged ancestries of dynastic rulers in cosmological time.[33]

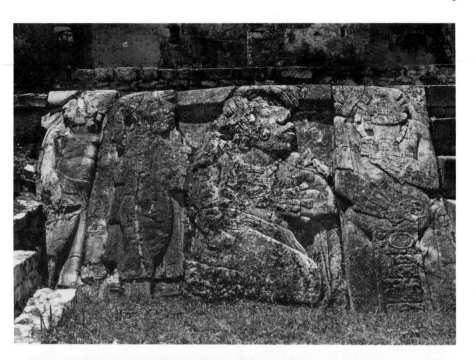

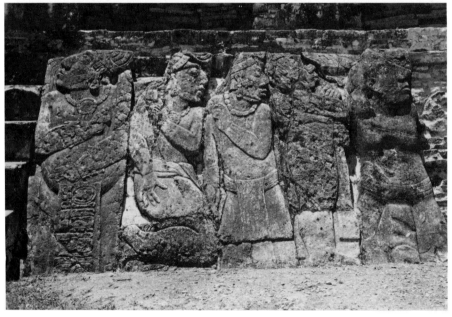

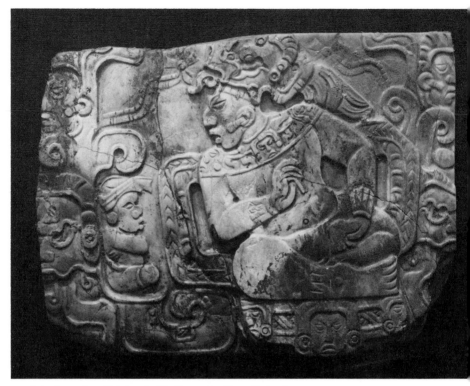

213. Jade plaque from Nebaj, *c.* 600(?). *Guatemala, Museo Nacional*

Jades

Classic Maya jade carvings repeat and condense the themes of monumental sculpture. The exact origin of Maya jade is unknown, although the principal sources of the material and of its workmanship were probably in the highlands of Guatemala. Important burial offerings have been found both at Kaminaljuyú, in one of the suburbs of Guatemala City, and at Nebaj in the western highlands.[34] Different varieties of jade occur: a jewel jade, a commoner pale green stone, and a dark green variety. The material was always worked with stone tools and occasionally with drills of bone. Abrasives helped the sculptor, but metal tools were lacking until the last few generations before the Spanish Conquest.

The debt of the Maya sculptors to their contemporary draughtsmen and painters is as apparent in the jades as in the monumental reliefs. Nowhere is it more striking than in the Leyden Plate,[35] a slab of pale green jade incised with the outlines of a standing figure resembling those on the early stelae of Tikal. The carving is essentially a drawing transferred to jade. The Initial-Series inscription, 8.14.3.1.12, refers to a time about 180 years earlier than the date of the carving, which Miss Proskouriakoff assigns by style to 9.3.0.0.0 (about 495).

The smaller, more sculptural examples of Early Classic Maya jade-carving are hesitant in their efforts to describe form, as if Neolithic limitations of technique were insuperable. The elements of form are all of about the same shape and size, all of the same degree of projection,

and similar in amount of detail. It is a soft-looking relief of schematic units, each unit reflecting the coarse tools and the difficulty of working the hard jade. Mid-Classic jade-carvers, from about 400 to 700, overcame these difficulties by the same means as in monumental relief sculpture: they varied the width of the cuts and their depth, and they modulated the surfaces more carefully. Certain examples, like the large plaque from Nebaj [213], evoke the narrative reliefs of Piedras Negras. The linear outlines have a precision and tautness such as if they were made of bent wire, and the vertical cuts between front and rear planes enhance these energetic contours. A skilful shift between profuse and sparse detail in the surface guides the eye to the narrative and expressive focal points in the composition: it is comparable to the techniques called plano-relief and modelled carving in pottery manufacture.

Pottery

These techniques of carved pottery decoration coincide in Maya archaeology with the cessation of large figural sculpture. They are ascribed to the Late Classic, or Puuc, period, and they were made both in the Guatemalan highlands and in the Puuc territory of north-western Yucatán. Figural carving often adorns the more ornate shapes, such as globular and pyriform vessels. These suddenly re-appeared in the Maya repertory much like revivals of ancient pre-Classic shapes. Such shapes perhaps originated in Central America.[36]

The invention of carved pottery is of Early Classic date, a technique called 'gouged-and-incised', in which scroll patterns were engraved in the clay and reinforced by slices or gouges repeating the main contours. A later development, called plano-relief carving, characterized the end of the Early Classic era, both in Maya wares and at Teotihuacán in the Valley of Mexico. In plano-relief, the background was carved to produce a design in two planes, front and rear, without modelled passages between the ground and the figure. Modelled carving is

the final Late Classic refinement, with stamped and mould-made versions, which reflect Mexican influences. Modelled carving was probably a luxury, comparable in value to the jades. Intact examples are very rare: an ornate one is the melon-shaped bowl [214] found at San Agustín Acasaguastlán, about 50 miles from

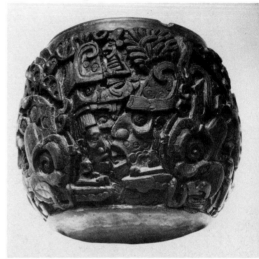

214. Carved pottery vase from San Agustín Acasaguastlán, *c.* 900(?). *New York, Museum of the American Indian*

Quiriguá.[37] It is carved in many planes of curved relief, comparable to the zoomorphs of Quiriguá. A central seated figure grasps in his arms the coils of two serpents, each double-headed. Their convolutions surround the vessel, with secondary figures engaged among the loops and feathered backgrounds.

The production of figurines was probably introduced to the Maya peoples from the Mexican mainland. Their occurrence is limited to early pre-Classic (Mamom) and to Middle and Late Classic periods after a lapse of about six centuries.[38] Surviving figurines are few, as were the centres of production. The pre-Classic examples have not been systematically published; the Middle and Late Classic burial

types have only recently attracted attention, especially at Jaina Island and in the lower Usumacinta valley. They usually incorporate whistles or clay pellets. The Jaina types are the most numerous, and their workmanship is superlative. Two main groups are evident: hand-made whistle figurines [215], dating from the opening generations of the mid-Classic phase (late Tzakol and early Tepeu in the Uaxactún chronology), and later mould-made rattle-figurines belonging to the Puuc period, that is Late Classic times.[39] Another centre, Jonuta, in the lower Usumacinta valley, has long occupied a shadowy place in the literature on Maya ceramics: possibly a style of mould-made figurines with hand-worked faces, represented by examples in Washington and Cambridge, Massachusetts, originated there.[40]

The hand-made figurines are 10–25 inches high, made of a fine orange clay, whitewashed, and painted in blues and ochres. At least three stages of development are evident in the Jaina examples: the earliest (c. A.D. 400?) have symmetrical postures, large disk ear-plugs, and bulbous heads with protuberant eyes. The costumes and jewellery are indicated by ample ribbons and fillets of clay.[41] The second group probably corresponds to the fifth and sixth centuries. The stance frequently repeats the splayed feet of the Petén stelae; the faces faithfully describe age, status, and expression by a technique of moulding, incision, and filleting, all on a jeweller's scale. The portraits are unforgettable, and the dress shows extravagant fashions. The third group, perhaps from Jonuta, has closed contours, as if mould-made, with whistle insertions at the backs. The heads show the exquisite workmanship of the second group. Animated movements and figures in groups occur: one example shows a woman with a smaller figure in her lap (from Chiapas, now Peabody Museum, Cambridge, Massachusetts); another represents an embracing couple [215]. This scene of an old lover and a young girl may have illustrated a myth or legend, for it was repeated in a much cruder technique in a hand-made figurine found in the

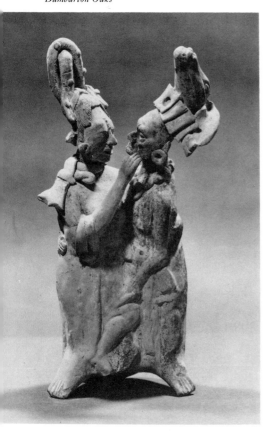

215. Painted pottery whistle figurine from Jaina Island, before 700(?). *Washington, Dumbarton Oaks*

Late Classic level at San José in British Honduras, on the other side of Yucatán. Finally, in Late Classic times, the Jaina figurines and those from the Usumacinta valley all show coarsening due to mass production based on moulding techniques.[42]

ARCHITECTURAL DECORATION

Monumental masks of geometric form occur on the earliest Maya pyramids, e.g. the faces of the stairway terrace of the pre-Classic pyramid at Uaxactún [169] or the pyramids of Acanceh in north-western Yucatán. Variants of these early mask-forms reappear as more or less curvilinear and natural versions in all the principal Early and Middle Classic centres, both in the Petén and in the river cities. The masks are encrusted upon the buildings or terraces, and only rarely can one observe their complete interaction with the structure itself.

Such an interaction of structure and ornament in geometrically regular forms characterizes the Puuc period, when rubble walls veneered with stone mosaics allowed the builders to redesign the decorative system. Two types of façade decoration accompany the new structural methods. The more elaborate form is the serpent-façade [218],[43] with the doorway treated as a serpent's gullet, framed by fangs, eyes, and ears to suggest the celestial character of the temple (Chenes). The more common form is a serpent-mask frieze of stereotyped mosaic panels alternating with colonnettes in the upper half of the façade [186]. At the corners of the façades, and on the stairway balustrades, isolated mask panels recall the ancient method of incrustation.

The oldest known serpent-façade is at Holmul in the Petén,[44] where Building A in Group II [216] is an Early Classic monument of a date earlier than A.D. 535 (9.5.0.0.0). The east face of the platform was a serpent-mask 10 m. (33 feet) wide and 4 m. (13 feet) high, built of coursed masonry in recessed and protruding planes. There was no doorway in the gullet of this gigantic mask. Two more half-size masks adorned the south corner façade.

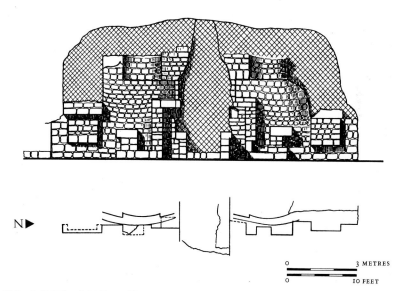

N▶

0 3 METRES
0 10 FEET

216. Holmul, Building A in Group II,
façade, before 535

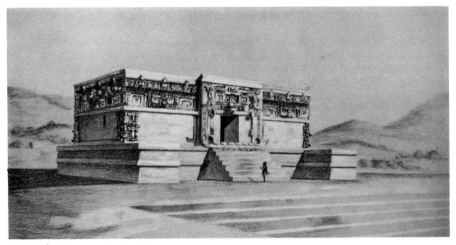

217. Copán, Temple 22, before 780

The façade of Temple 22 at Copán [217] incorporates a doorway as the gullet of a mask-panel. It was built before 780 (9.17.0.0.0) and is the most important single building at Copán, built of block masonry laid in mud.[45] The main façade looks south. Its serpent-mask doorway has teeth lining the sill and fangs protruding from the jambs, beneath geometric eye- and nose-forms in the upper façade. The four corners were adorned with two-tiered corner masks of curvilinear forms, and the upper façade bore more masks flanking the centre doorway panel. Both the doorway and the corner masks are curvilinear. Human torsos and heads in the late Cycle 9 style adorned the cornice. The entire edifice is homogeneous, belonging to the same period as Stela N. It is comparable to the serpent doorways which arose later in the Chenes and Puuc regions of Yucatán.

Possibly intermediate in time between the mid-Classic style of Copán and the Late Classic Chenes and Puuc façades are the Río Bec buildings, where two distinct modes of architectural sculpture can be defined. One is curvilinear, the other rectangular. The former is (by hypothesis) earlier, the latter, on account of its resemblance to the geometric style of the Puuc, late. Examples of the curvilinear masks are on the towers

at Hormiguero, Payán, and Xpuhil [183].[46] The last-named have, on top of the towers, diminutive sham temples with little serpent doorways composed of two profile masks beneath a frontal overdoor mask. The Xpuhil scheme derives from Copán, but its forms are less fluid and more stereotyped. The relief is deeply cut, and the components of the masks often include several blocks of the coursed facing. This method of design surely required carving in situ: at Río Bec it was supplemented by stucco portions.

Examples of the second, rectangular manner are at Becán [182], Xaxbil, and Okolhuitz.[47] These mask panels also consist of elements covering several blocks of the facing, but they were cut before setting, and assembled on the façade. The group is technically intermediate between the curvilinear masks and the mosaic masks of the Puuc region [186].

These differences between curved and straight modes of composing the serpent-masks re-appear in the Chenes and Puuc styles. The Chenes sculptor-architects preferred serpent-mask doorways of an intricate and dense composition [184], while the Puuc designers restricted their mask panels to the upper façades [186]. The Chenes masks retain large curved forms,

which virtually disappear in the Puuc mosaics. The Chenes designs also use elements covering many blocks of the facing, while the Puuc veneer comprises mainly small items of interchangeable units, easily prepared, and easily combined anew in fresh designs.[48] The Chenes-style façades at Hochob [184], Dzibilnocac, and El Tabasqueño differ from those of the Río Bec group more in architectural grouping than in the mode of decoration; in fact the Chenes system resembles the Río Bec system [183] closely enough to belong to the same sequence in time. On the other hand, the rectangular manner of the Río Bec decoration and the Puuc style differ. The rectilinear Río Bec ornaments are more tentative and hesitant than those of the Puuc; Río Bec Curvilinear and Chenes ornament may represent the earlier stage of a sequence leading to Río Bec Rectilinear and to Puuc mosaics. A hypothetical reconstruction of the chronology would be (1) Río Bec Curvilinear; (2) Chenes serpent-façades; (3) Río Bec Rectilinear; and (4) Puuc mosaics, lasting from the seventh century through the tenth, and ending with the mosaic façades of Uxmal [192–5].[49]

In the process several new ornamental forms appeared [186]: ribbed upper façades of close-set colonnettes; three-part *atadura* mouldings; and small-unit mosaic decoration. The colonnettes imitate the wooden construction of Maya house walls, whose closely set vertical saplings were woven together by horizontal binders,[50] like withes tightly drawn, and perhaps cushioned upon belts of thatch. This constriction would give the familiar three-part profile perpetuated in stone by the *atadura* mouldings. The *atadura* appeared in Río Bec architecture on capitals framing doorways and on recessed base and capital mouldings to mark the relief panels.[51]

The continuous *atadura* (or binder) moulding characterizes the Puuc style of building, and it may have originated in the middle Usumacinta drainage, as at Bonampak [220] and Yaxchilán (Structure 21), where it may be dated as early as A.D. 800 (9.18.10.0.0 at Structure I in Bonampak).[52] The Puuc version of the *atadura* frames the frieze with upper and lower boundaries: its purpose was to stress unity by continuous horizontal members visually binding or tying the façade together [186]. Both the colonnettes and the *atadura* mouldings produced brilliant contrasts of light and shade.

These effects of chiaroscuro were reinforced in the Puuc by the creation of the mosaic style of masonry. The Río Bec and Chenes architects relied upon ornamental forms covering several blocks of the facing. In the Puuc, each unit of ornament was reformulated. It is like typographical design: from a number of small units, each carved with a geometric shape, large pictures are formed [218]. In Río Bec and Chenes façades the serpent-masks are still unitary pictorial schemes, but in Puuc design they are like typewriter pictures, composed with key and ribbon from a small number of conventional signs available in quantities as needed.

At Uxmal, the oldest edifices, like the core of the Great South Pyramid,[53] show masks built up of such units. The penultimate stage of the Pyramid of the Magician is an imitation of the serpent-mask façades of the Chenes and Río Bec type, and it appears to be made of re-assembled 'typographical' elements, possibly salvaged from some older edifice [218]. Hence it is dif-

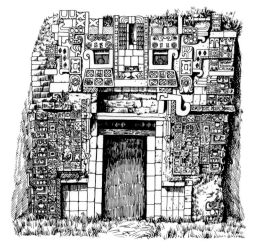

218. Uxmal, north-east pyramid,
House of the Magician, serpent-mask façade,
after 900(?)

ficult to date Uxmal façades by inspection of their sculptural components alone; for these were being re-combined and augmented on each new building site in a medley of old and new elements.

The modes of re-use, nevertheless, show distinct chronological changes, best seen in the Nunnery, where we have assumed (p. 241) that the sequence was north, south, east, and west, on the strength of the wall-span ratios, an ordering supported also by the ornamental programme on the upper façades. Serpent-masks in tiers like those of the older western Puuc sites appear in abundance only on the north pavilion [192].[54] These tiers of masks were avoided in the south building [189], where the only serpent-masks are like flaming or smoking coronations to the over-door reliefs showing model temples upon a latticed ground. The model temples are like those of Chacmultún, and the lattice ground resembles the Labná archway. The east pavilion is the least ornate [193], having masks in tiers only at the corners and over the central door. Most of the frieze has a lattice, enlivened on the court façade by six trapezoidal accumulations of eight stylized sky bands, each with double-end serpent-heads in profile.

The west building [194] is the most ornate in the Nunnery Court, showing serpent-masks in tiers at the corners and above the last but one doorways. Models of temples adorn the terminal doorways, and big key frets scaled to the changing intervals between doorways mark a broad rhythm across the entire length of the frieze. Full-round statues are affixed to several of these key frets. The five central doorways are bound together by feathered serpent forms whose bodies seem to disappear into the walls at the doorways, and interlace in spiral columns between the doorways. Three principal planes of relief are thus established: the ground plane

of latticed forms; the key frets of rectilinear units; and the rounded sculpture of serpent bodies and statues. A fourth plane is added by the over-door panels of serpent-masks in tiers near the ends of the building. The effort to diversify the internal rhythms of the façade is not altogether successful, because the various combinations of forms are inadequately differentiated, and their scale does not command attention from a distance.

These timid and irresolute efforts received a much bolder restatement on the façades of the Governor's Palace [195, 196]. Its three pavilions contain contrapuntal rhythms which are the most elaborate in all Maya architecture. Every corner is marked by a tier of five serpent-masks. These are the only vertical arrangements: every other repetition of the serpent-mask is diagonally staggered, so that an angular undulation of serpent-masks winds across the façades in five pyramidal outlines, one in each end pavilion, and three in the main pavilion. Key frets, like angular eyes, mark still different diagonal rhythms in this system. What was a stiff grid of verticals and horizontals in the Nunnery, here resembles a supple basket-weave of interlacing themes in distinct planes.

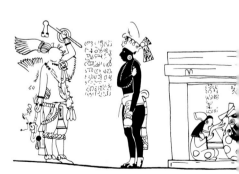

219. Uaxactún, Structure B XIII,
wall painting, before 600

PAINTING

Classic Maya pictorial traditions survive in only a few murals, vases, and manuscripts. Although they share a common fund of figural conventions, the murals and the manuscripts belong to different epochs. As in the ancient Mediterranean, figural scenes in wall painting preceded vase-painting, and both are older than the illustrations in manuscripts. Wall paintings of Early Classic date are known; the painted vases are Classic; and the three surviving manuscripts are ascribed to Late Classic times.

The Early Classic development of mural technique marks an important stage in the emancipation of Maya painting from sculptural decoration, and it precedes the appearance of a polychrome figural style in pottery painting. The pictorial system in both depends upon outline drawing, coloured in flat, local tones, without gradations of light and shade, and without the illusion of rounded bodies in gradated colour. The oldest known Maya mural was uncovered in 1937 at Uaxactún in Structure B XIII [219], on the wall of a small unvaulted room of Early Classic date (Tzakol, roughly before A.D. 600).[55] The painting measures 3.2 by 0.9 m. (10 feet 6 inches by 3 feet) and is composed in two registers. At least twenty-six human figures are shown, above a predella of seventy-two calendrical day-signs. The figures were painted in five colours on a brownish-pink ground, and their gestures have a dynamic animation not to be found in sculpture of the same period; for example, the posture of the dancing dwarf in the upper register appears in sculpture only after 700.[56] The mural contains three scenes: a conference between standing figures on the left; three seated persons inside the house; and four or possibly eight dancers on the right, moving to the sounds made by a seated drummer, and attended by a dozen or more spectators. All wear voluminous head-dresses and billowing garments, but only the two standing figures on the left have sandals. The left figure carries Mexican weapons and wears non-Maya dress, perhaps representing a group related to Teotihuacán. The right figure wears dark body paint and makes a gesture of respect, holding his right arm across the chest. The head-dress and copal bag may mark his priestly status. At least three scales appear – large, medium, and small – corresponding probably to the rank of the personages. Two

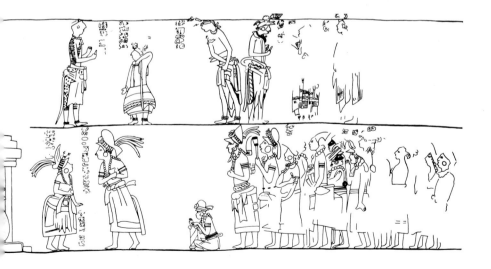

devices were used to show depth. Overlapping figures mark a correct visual collocation in space. Elsewhere the use of two registers to describe the dancers shows the persistence of conceptual conventions. The building is shown, as in Mexican manuscripts, in cross-section; it is a mortar-beam chamber two bays deep with the doorstep on the right.

Some two centuries later (*c.* 800, or 9.18.10.0.0), at Bonampak, substantially the same pictorial programme, with seated personages indoors attended by musicians and by dignitaries in conference, re-appears on the walls of Structure 1, greatly augmented with battle and dance scenes [221–6].[57] The tectonic order is much improved. At Uaxactún the figural friezes were like independent strips of illustration, while at Bonampak the different registers correspond to bearing wall, vault overhang, and capstone levels. The system of delineation remains unchanged, with fluid outlines enclosing flat local tones. The scale is more unified, with differences of size corresponding

to tall and short people rather than to principal and secondary personages. The figural poses show profile and frontal conventions as upon the stelae: only the battle scene [225] contains many new studies of figures falling or in violent action. The suggestions of deep space are much more insistent, especially in the terraced backgrounds and the multiplicity of pictorial planes, as when persons appear in Room 3 both in front and at the back of the throne-dais [222].

Preparatory drawings on the pure lime plaster were made in red strokes, and later reinforced with firm black lines. Whether true fresco on wet plaster, or dry plaster-painting was the process has not been satisfactorily determined. The pigments are all inorganic, with the possible exception of carbonaceous blacks.[58] Each room has a dais about 1.5 m. (5 feet) wide and 70 cm. (2 feet 3 inches) high. In Room 1, the risers of these bench-like platforms are painted with stepped key frets of equivalent ground-figure patterns [220]. Each dais surrounds a small sunken area at the doorway. Thus the

220. Bonampak, Temple 1, *c.* 800. Perspective view, elevation, and plan

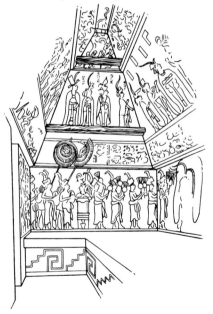

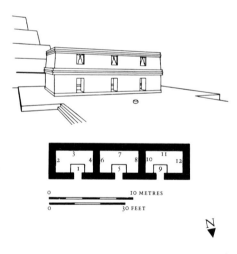

frescoes were protected by a barrier and by being on a higher level than persons standing at or just inside the doorway.

The scenes on the walls of the three adjoining chambers represent the same *dramatis personae*. The family group of a man and woman with children and servants recurs in both end rooms, upon the partitions (Walls 4 and 10) separating them from the central chamber with the battle scenes. Thus the family [222], though not central to the composition in any one chamber, appears in a privileged position of symmetry with respect to the total composition spanning the three rooms. Other recurrent personages are the three dignitaries of the robing scenes on Walls 1 and 3, who recur as warriors on Walls 5 and 7 in the central battle chamber [224], and once more on the top register of Wall 11 as principals in the dance. The white-robed figures with ornate head-dresses all on Wall 3 re-appear on Wall 9; many look like courtiers, councillors, or priests.

Four registers composing two narrative scenes cover the walls. The bottom register has a blue background which may signify outdoors: it can also signify night. This register begins at the doorway [220]. The files of musicians and attendants face away from the door to converge upon the three central personages on the centre of the opposite wall. On the narrow end walls, four long-handled feather fans extend beyond the frame of this register at the beginning and end of a narrow frieze of glyphic inscriptions on the base of the vault overhangs. Over the doorway, the space of the inscription frieze continues with seated servants who hold ready the jaguar hides, the jade ornaments, and the fans of the costumed persons being robed in the top register. Wall 4, as we have seen, displays the family group [222]. This action continues on the rear wall, where an attendant displays a child to the white-robed courtiers, who discuss the event with animated gestures. The ochre ground is believed to signify interior space; it may, however, indicate daytime action. In all three rooms, the spectator sees the rear wall first, before the doorway wall. In all rooms the action on the rear

wall seems to precede the action on the doorway wall. Thus the robing precedes the presentation in Room 1; the arraignment precedes the battle in Room 2; and the family sacrifice precedes the dance in Room 3.

The spaces in all these narrative scenes are continuous, with figural sequences which continue unbroken round the corners of the room. The upper register shows a time of robing and preparations prior to the public appearance in the bottom register, so that the scenes nearest the spectator are probably the closest in time as well. In the cap of the vault, bands of serpent-masks, frontal and in profile, confront one another to indicate a symbolic sky. This celestial zone is invaded by green feathers of the gigantic head-dresses below. Differences of size among the figures are visual rather than symbolic, and no trace of perspective diminution appears among the representations.

In Room 1 every detail conveys a sense of preparation and rehearsal. The upper registers concern the private life of the court, revolving about the family of the prince and focused upon preparations for a great ceremony. The tone of intimate description is kept throughout; the narrative is devoid of magniloquent rhetoric, and the artist has reported many homely details of actual experience, such as the servants adjusting the loin-cloth of a robed principal, or the gesture of command with which the prince upon the dais underlines his remarks to the person bearing the child at the south-east corner of Wall 3. Costumes, gestures, and expressions display a refined ritual of social behaviour, governed by luxurious tastes and by a rigidly stylized code of manners. We have nothing like this art of intimate narrative in the older Petén style: it is limited to the Usumacinta cities and to painting on pottery [229].

In the other two rooms, the composition by registers is much less evident. Registers are merely suggested in the big battles and terraces of the central chamber, and occur explicitly only on the north or entrance wall (No. 9) of the west chamber, where standing white-robed courtiers, seated nobles, and a procession of

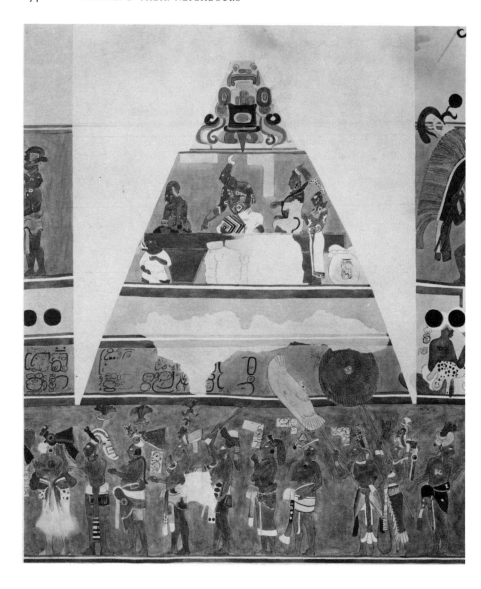

221 (*above*). Bonampak, Room 1, showing procession (lower register), *c.* 800

222 (*opposite, above*). Bonampak, Room 3, wall 10, the ruler performing penance with his family (detail), *c.* 800

223 (*opposite, below*). Bonampak, Room 3, wall 11, showing dancers, *c.* 800

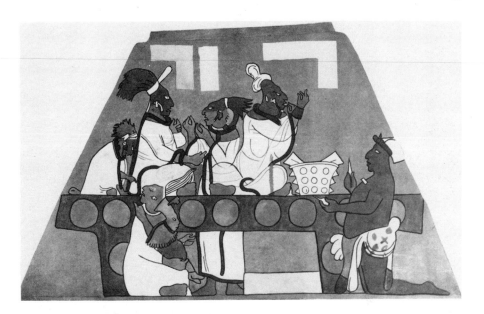

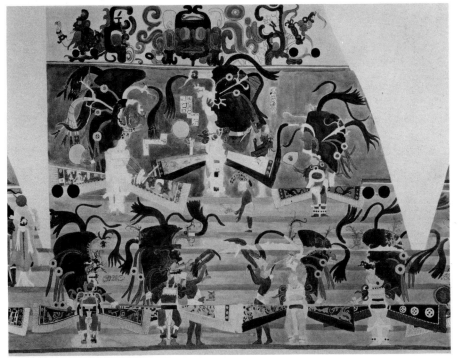

musicians and athletes occupy upper, central, and lower bands. Here, they are separated by red ground lines, all beneath a capstone band of star symbols and bird- and serpent-masks. The two registers in the vault overhang both have blue backgrounds, but their connexion in space and in time is not clear.

There has been some discussion of the chronological order of the three rooms. Proskouriakoff and Thompson suggested that Rooms 1, 2, and 3 were painted in that order, but Tozzer preferred to place 2 first, followed by 1 and 3. The question cannot be resolved definitely, but it appears reasonable to group the register compositions as the work of one artist or period, and the full-wall pictures as the work of later years or persons. In this conception, Rooms 1 and 3 preceded Room 2. Certainly the figural variety in Room 2 is the greatest, while Room 3 is less turbulent, and Room 1 is the most static.[59]

The paintings of Room 3 [223] are intermediate in time, according to this notion of the progressive unification of full-wall space. The residual use of registers and static figures on the north wall and the rarity of action figures, as well as the repetition of long-handled fans, both used to mark the limits of the upper zone and to unite it to the lower row, recall Room 1. Room 3 amplifies the triptych composition. In Room 1, the fans and the upper registers formed an audience scene on three walls (Nos 2, 3, and 4). In Room 3 the terraces of a pyramidal platform extend over three walls, and the scene thus formed even includes the files of figures in the lower register on Wall 12. The pyramid has eight stages, rising between other platforms. On the east (Wall 10) the prince upon his dais surveys the dance accompanied by his family and servants.[60] On the west (Wall 12) an ugly dwarf surveys the scene from a litter borne by a dense cluster of costumed men. The terraced steps of

224. Bonampak, Room 2, showing a battle, c. 800

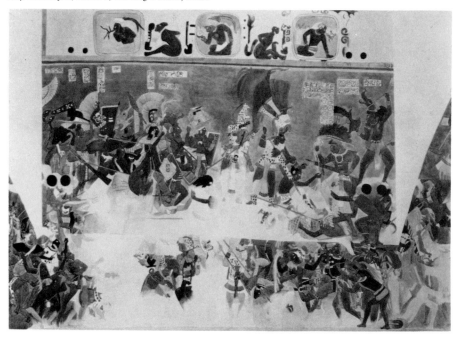

the pyramid swarm with winged human figures, ten in number, wearing *quetzal* feather head-dresses and trapezoidal wings protruding from their hips. At the centre are four plain figures. Two at ground level are raising or tossing the ankles and wrists of a supine third figure. Above the latter a fourth person holds a knife-like instrument.

The scene has been described as a sacrifice by heart removal, although the pictorial evidence for this interpretation is far from conclusive. The perspective conventions of the artist clearly indicate the position of the horizontal figure: he is shown in the air, with two men below. They are not leaning forward to tie the limbs of the victim; their bodies arch back, as if to toss or catch the body.[61] On Wall 9, near the south-west corner, an official with a fan, who may be the master of ceremonies, sits upon the fourth terrace with his right leg negligently hanging down. This clear indication of the stepped ter-racing of the ground plane finds no confirma-tion in the alleged sacrifice. To judge from the reproductions, Wall 10 is the most badly damaged. All the winged figures are flaked away, and one suspects either deliberate mutilation or an unstable technique differing from that of the other walls. The general impression is of music, dancing, and brilliant pageantry, witnessed by important personages, and centring upon a display of acrobats and tumblers, of whom others approach from the left. The first and second figures at the door wear ball-players' costume: the third and fourth bear fans. One whole act of the games or pageant is drawing to an end; another is about to begin.

The central room (Room 2) has the boldest and most unconventional studies of action [224]. Nothing like them is known in Maya art, although many groupings in Rooms 1 and 3 have analogies in relief sculpture, especially at Yaxchilán and Piedras Negras. Only the ball-court markers with studies of players in motion are comparable[62] to the battle scenes on Walls 6, 7, and 8. The three walls form a triptych, separated from the entrance wall (No. 5) by wide lines of brown paint at the corners. These

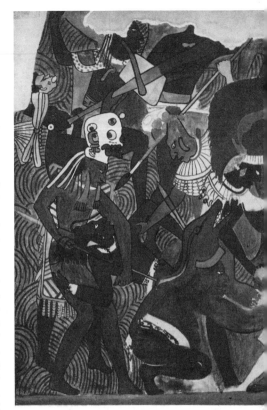

225. Bonampak, Room 2, wall 6, warriors in battle, *c.* 800

two pictures are entirely separate. The triptych describes a raid by Maya warriors upon a tribe of stringy-haired, dark-skinned folk who live among dense vegetation, shown by swirling red lines on a green ground [225]. On the entrance wall is a pyramidal terrace with the captives abjectly seated along the upper steps. In the battle, the victorious Mayas outnumber their victims by nearly ten to one: of a hundred figures, only about ten, crushed underfoot by the Maya hordes, belong to the enemy tribe. Only ten captives, one a severed head, appear in the opposite mural. The two scenes probably show related instants in the capture and public display of the same enemy. The triptych is filled

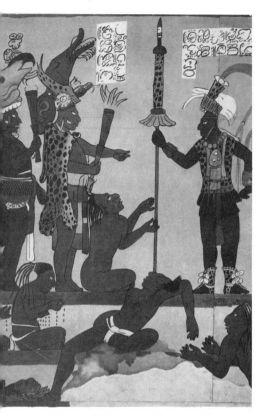

226. Bonampak, Room 2, wall 5, ruler, officers, and victims, c. 800

with agitation and noise. The arraignment is hushed and static, with all figures shown as if holding their breath to hear the order pronounced by the prince [226], pointing with his left hand and clad in a cape of jaguar skin. Above both scenes in the cap of the vault are seven cartouches. Three are rimmed in blue and separated by seated captives on the south wall; the north cartouches contain human and animal figures, perhaps representing constellations.

The battle scene centres upon an action by principals clad in jaguar skins, just to the right of the centre on the south wall (No. 7). On the end wall on the left, standard bearers and a trumpeter rally the attacking forces. On the

right end wall supplies of some projectile are brought up. Scores of violent hand-to-hand actions fill the lower registers, with six or more Maya warriors in full regalia, crushing the nude and helpless enemy in each group. The effect is of a punitive action rather than of a strategic contest. The stringy-haired nude enemy seems poor-spirited and defenceless. If the scene in Room 3 shows human sacrifice, as supposed by Thompson, the battle is probably a raid to take prisoners for it. One detail in the arrangement strongly favours the idea of a punitive action: three crouching captives clearly have blood dripping from their fingertips. They may be victims of an aggression for which they demand justice, and the battle-scene may show the corresponding punitive action. The theme of the arraignment of captives is known in relief sculpture at Piedras Negras (Stela 12 [204]) and the judgement theme appears there also on Lintel 3 [203]. But nowhere else have we so complete a context for these themes as in the Bonampak murals, which require an entirely fresh interpretation of the cultural meaning of Classic Maya art.

For many years the accepted symbol of Classic Maya civilization has been the image of a pacific priest-ruler [198, 199], first represented in the stelae of the Petén during Early Classic times. The historical opposite of this theocratic god-impersonator is the Toltec Maya warrior of the post-Classic era at Chichén Itza [259], where Maya and Mexican behaviour and culture are clearly contrasted. The line was drawn at about A.D. 1000 and north of Uxmal.

Now, however, it is clear from Bonampak and radiocarbon dating that these 'Mexican' modes of behaviour were current in the river cities before 800. Military leaders displaced priestly rulers in the middle Usumacinta cities some centuries earlier, and the traditional view of a pacific Maya ethos holds only for the Petén, and for pre-Classic and Early Classic periods. Classic Maya art therefore embraces and describes two quite different patterns of behaviour – theocratic and militaristic. Their historical separation probably antedates the middle

Usumacinta style of painted and sculptural scenes.

A Maya mural at Chacmultún in the Puuc[63] decorates a stone veneer structure with *atadura* mouldings. The figures do not overlap, and they form a procession in two registers. The body motions are stiff, and the work suggests a provincial and retardataire school of Late Classic date.

Pottery Painting

Pottery painted before firing is common throughout the archaeological history of the Maya peoples. Especial virtuosity in painted figural designs appears during the Early (Tzakol) and mid-Classic (Tepeu 1, 2) periods. At all times, however, only low firing temperatures (1350° C. maximum) could be produced, so that the vessel structure is heavy because of its poor tensile strength, the surfaces are soft, and the pigments are restricted to reds and oranges, browns and yellows.[64] The lustrous appearance of some vessels may have been produced by a lacquer-like coating of organic nature. As Miss Shepard puts it, Petén pottery 'inevitably gives the impression that potters were striving for effect at the expense of usefulness'.

During the Early Classic centuries, many Maya potters successfuly evaded the limitations of low-heat firing by applying a thin stucco or clay coat to the vessel, and painting upon the coat in vivid colours of a high key and wide variety. Examples have been excavated at many sites.[65] The most interesting specimens are from two tombs at Kaminaljuyú, where the same generation of painters produced mixed groups of mortuary vessels decorated in both Teotihuacán and Maya symbolic systems, at some time prior to 534 (9.5.0.0.0). The vessel shapes and the technique of painted stucco incrustation may be importations from highland Mexico, but the curvilinear outlines and the thematic matter are purely Maya, with body outlines and postures of a degree of conventionality also seen in glyph forms.

The pictorial space depends upon conceptual scale: on the cylindrical wall of one vessel large serpent-head masks alternate with seated figures in profile [227]. This 'Mayoid' blackware cylindrical tripod vase, stuccoed and

227. Cylinder tripod vessel from Burial A 31, Uaxactún (Tzakol 3), before 550(?). *Guatemala, Museo Nacional*

painted, was made before 550. It displays four different forms of a serpent head and a headless bird. These recur on a black-ground cylinder from near Uaxactún in more ornate form [231, 232] related to the sarcophagus lid at Palenque [228], commemorating the death of the ruler Pacal (Shield) in A.D. 683. The three designs combining serpent heads, rulers, and birds may be early and later forms of the same funereal theme.[66]

In other painted vessels of the Late Classic period, the manual conditions of the draughtsmanship, the cheerful pinks, yellows, and greens, and the appearance of glyph forms in the costumes and attributes strongly suggest a con-

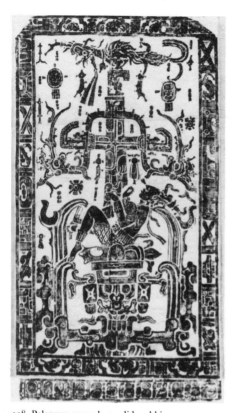

228. Palenque sarcophagus lid, rubbing

nexion between this art and a lost coeval school of manuscript illumination. All the works of this school are lost, but its existence is deduced from painted vessels and from the much later Maya manuscripts described below.

The general formal characteristics of the Maya pictorial system have already been discussed in the section on mural painting. On vases the cylindrical walls favoured continuous designs. The concave space of vision was inverted to fit the convex surfaces of the cylindrical vessels, whose field lacks a lateral frame. One solution was to align processional figures in a continuous band, which we may call re-entrant composition. Beginning, end, and centre are identical, in an equivalence impossible on flat

surfaces. Such images also appear in the pre-Classic art of Izapa near the Pacific coast.[67]

Maya painters of the Classic period also transferred the pagination of book-like compositions to pottery surfaces, as in the splendid stuccoed vessel from Burial A 31 at Uaxactún [227]. It has front and rear panels, each with paired figures in profile, seated among columns of glyphs. Pink and green fields bear glyphs and figures outlined in fine black lines drawn probably with a reed pen.

Scenes with intricate narrative content did not appear until mid-Classic (Tepeu) times. The principal centres of painted pottery with figural scenes cluster in the Chixoy drainage of the central and western highlands. The clay is tempered with volcanic ash, making a porous grey matrix under the white or orange slip. The Chamá style is the most celebrated example of this art. It embodies many traits of Classic Usumacinta expression, with ethnic types like those of Piedras Negras, Yaxchilán, and Bonampak. Chamá figural painting can be dated during the seventh and eighth centuries.[68]

Two types stand out. One group has repetitious figures, for example anthropomorphic bat gods with outspread wings; the other, less stereotyped scenes [229] are probably based on mythology and poetry, and scenes of audience or conference. Both groups have in common a chevron decoration on lip and base painted in deep blue or black upon the ochre slip. The backgrounds are generally orange in colour, and the figures are drawn with firm, continuous black contours surrounding body colours in deep orange, yellow, and brown. In the narrow range of fired Maya colours, blacks assume unusual importance, carrying the principal rhythms. A faithful visual record was the main aim of the painters. Calligraphic flourishes are absent, and the main departures from matter-of-fact reporting appear in symbolic substitutions and transformations, required for calendrical or theomorphic statements, as upon a vase with a rabbit impersonator seated in respectful attention before a jewelled glyph; his ears turn into tortoise shells. Others, like

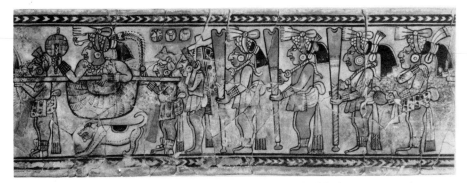

229. Cylinder vase, showing litter bearers and a princely person, from Ratinlixul, Chamá 3 style, after 600. *Philadelphia, University Museum*

the litter vase of Ratinlixul [229], convey a caricatural exaggeration of the pendulous Maya profile.[69] Even more hostile caricatures appear in the vase portraying a conference between two black-painted warriors and their thug-like attendants, documenting a strong ethnic prejudice against the subjects portrayed.

The burial vase [230] found at Altar de Sacrificios is dated 754 (9.16.3.0.0). Six figures include two dancers, a drummer, a singer, a god-impersonator, and a possible human self-sacrifice. The jaguar dancer is named by the glyphs: he may portray Bird-Jaguar, the ruler of Yaxchilán. A seated figure whose speech scroll suggests song, is identified as being from Tikal. Adams has supposed that the vase was imported from the Chamá region for an important funeral, and that its erudite painter knew the ruler of Yaxchilán. Also interpreted as a burial vase [231, 232] from an unknown Petén site, and as of before 700, is one with black background, drawn in forms recalling the sarcophagus lid at Palenque. According to Quirarte,[70] a dead ruler is portrayed as sun god reclining on a Cauac serpent head, and flanked by other gods on a ground line of Cauac heads, from which an interlace of two bicephalic serpents arises to scan and enframe the figures of this masterwork. The Cauac-head friezes at the base of the design may suggest that the mythological action occurs in the heavens above the clouds.

A cave find at Actun Balam in British Honduras shows a deer hunt by six persons including four priests, a woman, and a dwarf, assigned to the seventh century, and believed to be an import.[71]

No other polychrome vessels approach the brilliance of those of orange, red, and black Chamá style. In the Petén and in the western provinces, the tonality was dimmer. An example from Nebaj, only 70 km. (45 miles) south-west of Chamá, showing a prince seated among courtiers,[72] lacks the brilliance of colour and the firmness of Chamá line. A round-bottomed vase said to be from Jaina Island[73] is likewise indecisive of line and dim in colour. It has the archaeological interest of portraying an indoor hammock slung from a wooden post, as well as rounded vases of its own type, capped with knob-handled lids which may have been of wood. A meal is in progress. The entire scene rests upon a base frieze as a sky band.

Vase-paintings from the Petén and British Honduras show hieratic themes; they are graphic in execution, coarser in structural technique, and more elongated and narrow than other Maya ceramic shapes of the same period. The finds from the vaulted tomb at Uaxactún of the same date as Tepeu 1, from Holmul, and from Yalloch in British Honduras, are examples.[74] In one group (Holmul V and Tepeu 1) complicated scenes of ritual assembly are pictured, as in

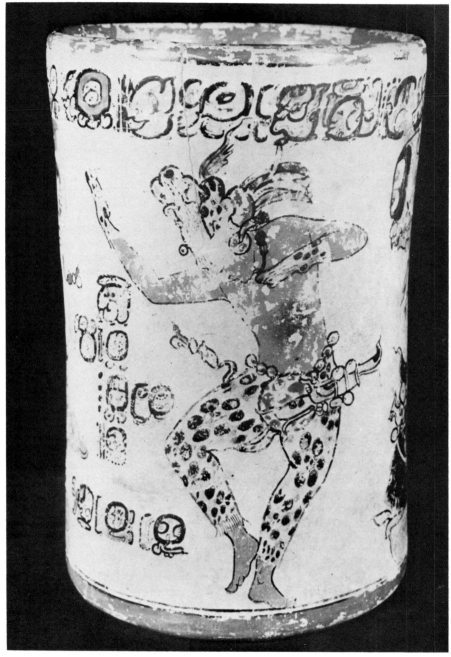

230. Cylinder vase from Altar de Sacrificios, Burial 96, showing dancers, painted after 750 (Late Pasión phase). *Guatemala, Museo Nacional*

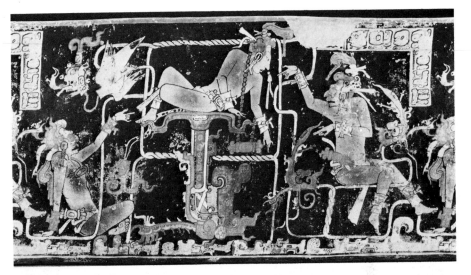

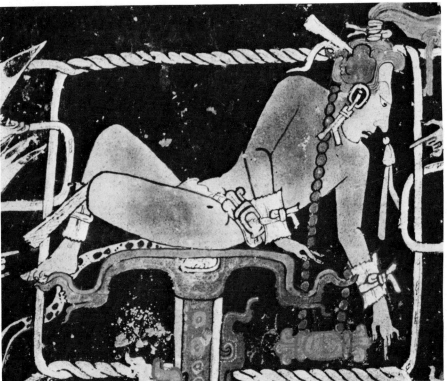

283

231 and 232. Black-background cylinder vase (with detail) showing a ruler in a mythological setting flanked by deities, origin unknown, before 700. *Private Collection*

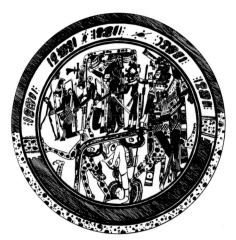

233. Tepeu 1 tripod bowl showing
a priestly dancer, from Uaxactún, after 600.
Guatemala, Museo Nacional

almost identical examples from Holmul and Yalloch, where priests stand by tree-like staffs with birds in the upper zones. In another group, a strong calligraphic tendency developed into free brushwork with a rhythmic structure almost independent of the image. Of early Tepeu date is the shallow tripod bowl from Uaxactún which shows a priest in costume, perhaps dancing [233]. The image dissolves into

radial brush-strokes in black and deep orange, swirling into the circular frame.

We have now mentioned the chief styles of western Maya figure-painting on pottery, in the Alta Verapaz, in western Yucatán, and in the Petén–British Honduras regions. Two eastern styles,[75] one centred upon Copán and Salvador, the other the Ulúa-Yojoa style of north-western Honduras, probably derive from these western prototypes. The Copador pottery of Copán [234] was not only exported to western El Salvador, but it was also imitated there. Its brilliant surface depends upon specular hematite pigments of glittering red, with cursive human figures and birds drawn in a few rigidly stylized types. Ulúa river figure-painting is more dense in composition with many black areas. From Lake Yojoa come heavy-walled barrel and cylindrical shapes with careful textural indications drawn in straight lines. The figural types and the processional compositions almost all recall Chamá and Petén models.

The iconographic study of vessels of clay, painted and carved with scenes and texts, has recently advanced in several studies.[76] One approach has been to assume that such pottery was all made for funeral use, and that its scenes and figures refer to the Maya underworld and to the twin deities named in the Popol Vuh.

234. Copador pottery vessel from Copán, before 800.
Cambridge, Mass., Harvard University, Peabody Museum

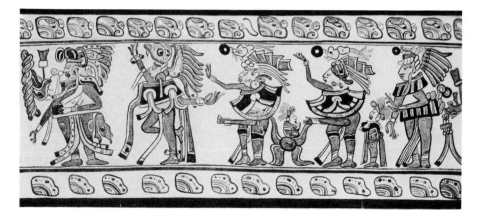

This colonial text of the Quiché Maya of Guatemala[77] is thought by the best scholarship to be of post-Classic origin, and its proven relevance to Classic inscriptions is doubtful. The pottery scenes of Classic date with glyphic texts are nevertheless proposed as referring to the underworld passage of the twins of the Popol Vuh. The scenes under discussion portray many other things, such as battles, or animal stories, or single human figures, while some vessels, with glyphic statements in the 'standard' format, bear no other figures on them. Hence it seems more plausible, given the variety of subjects accompanying the 'standard' text, to read these texts as a loose group of ritual phrases. These would refer not to the underworld, but to vows or dedications made by pottery craftsmen, and offered to supernatural beings such as fire and earth, who are the patron deities of potters, and whose assistance is invoked. Other such phrases may dedicate the vessel to a living person or to an institution.[78]

Iconographic study of Maya art began as long ago as the serious study of Maya history. Most of what is known comes from archaeological objects for which a more or less convincing agreement can be found with ancient inscriptions and post-Conquest writings.[79] Spinden, Thompson, Berlin, and Proskouriakoff laid the foundations: recent work has come from the annual meetings held at Dumbarton Oaks and at Palenque, as well as at the Society for American Archaeology and the International Congress of Americanists.

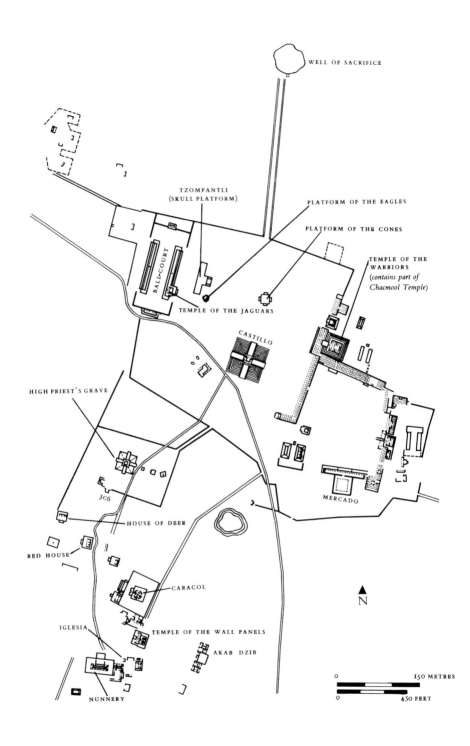

WELL OF SACRIFICE

TZOMPANTLI
(SKULL PLATFORM)

PLATFORM OF THE EAGLES

PLATFORM OF THE CONES

TEMPLE OF THE
WARRIORS
*(contains part of
Chacmool Temple)*

BALL-COURT

TEMPLE OF THE JAGUARS

CASTILLO

HIGH PRIEST'S GRAVE

3C6

MERCADO

HOUSE OF DEER

RED HOUSE

CARACOL

N

IGLESIA

TEMPLE OF THE WALL PANELS

AKAB DZIB

NUNNERY

0 150 METRES

0 450 FEET

FROM THE TOLTEC MAYA TO THE SPANIARDS

Chichén Itza, the metropolitan centre of civilization in Yucatán, was under foreign domination until the thirteenth century. Foreigners, some resident there since Early Classic time as at Dzibilchaltun or Acanceh, began to rule in Yucatán perhaps as early as the eighth century. The worship of a feathered serpent god of Mexican origin, the Mexican manner of human sacrifice by heart excision, with skull racks to display the sacrificial victims, and many other Mexican highland traits support ethnic identity between the Mexican overlords in Yucatán and the Toltec masters of Tula.[1] The architectural, sculptural, and ceramic resemblances between Toltec Chichén and Tula in the Valley of Mexico are so close that Chichén has long been treated as a colonial extension of the Toltec state, like Kaminaljuyú in the Guatemalan highlands, which was probably a colonial outpost of Teotihuacán about a millennium earlier.

In the thirteenth century the metropolis shifted to Mayapán, where dwellings and shrines for a large population were built within a walled precinct, governed by a confederacy of three regional lords, all still under Mexican highland influence. About 1450 this confederacy broke up, and Maya society reverted to local rule, as at Tulum, and to provincial arts of retrograde quality, enduring until the Spanish re-unification of Yucatán in 1544. This sequence has been archaeologically fixed by abundant evidence[2] which invalidates the earlier reconstructions based upon deformed and distorted literary sources. It contains three phases – Late Classic, to about 1000; Toltec Maya, continuing into the thirteenth century; and a Maya re-occupation period until the sixteenth century.[3]

235 (*opposite*). Chichén Itza.
General plan as in *c.* 1200

ARCHITECTURE

Chichén Itza

Chichén Itza [235] is a loose cluster of buildings occupying an area about 2 by $1\frac{1}{4}$ miles, half the size of Teotihuacán, and smaller than Tikal or Xochicalco. At intervals the limestone plain has collapsed into subterranean caverns to produce conical sinks, as well as open pools with steep walls called *cenotes*. The northernmost *cenote* is the famous Well of Sacrifice, whence E. H. Thompson dredged the cosmopolitan remains of many sacrificial offerings. South of this *cenote* rises an immense primary platform of Toltec date, bearing the principal Toltec edifices, the ball-court, the Castillo, the colonnades, and the Temple of the Warriors. To the south, again, about 550 yards from the Toltec buildings, are two Late Classic buildings in Puuc style, the Nunnery and the Akab Dzib. Other small buildings of the same early period are scattered throughout the bush to the south of these main groups. The two zones, Toltec Maya to the north and Puuc Maya to the south, have a common boundary in the neighbourhood of the cylindrical Caracol and the adjoining Temple of the Wall Panels.

The Akab Dzib ('Writing in the Dark') resembles in plan the storeyed edifices at Chacmultún. The Nunnery in turn distantly recalls the Pyramid of the Magician at Uxmal in its rounded platform corners, its two-storey edifice, and the Chenes style of the serpent-façade of its low wing protruding eastward from the main platform. The seventh-century Iglesia is a small separate temple facing west, as if to mark a court along the eastern flank of the Nunnery. Other Classic buildings are the seventh-century Red House and the House of the Deer, north-west of the Caracol. Another cluster, about 550 yards south of the Nunnery,

includes about six smaller groups, with edifices of both periods, Puuc Maya and Toltec Maya.[4]

The chronology of the principal Toltec buildings[5] is still far from complete, but the main sequence is clear, containing an early phase with recognizable Puuc traits, a middle phase of buildings with sloping bases, serpent-columns, narrative murals, and columnar reliefs, and a late phase of ornate narrative reliefs upon the walls of buildings with battered bases and complex mouldings. Each of the three phases lasted about 150 years, and the key buildings are as follows.

I (to 800). The Caracol includes Puuc Maya elements in its substructure, and it was probably remodelled in Toltec style [236]. The small inner Castillo platform belongs to the same period as the cylindrical Caracol, together with the original west colonnade[6] of which the foundations mirror the orientation of the Castillo. The structure of the lower Temple of the Jaguars at the main ball-court also may belong here.

II (800–1050). The pyramid of the Chacmool is inside the Warriors platform [238]. Its terrace profiling is identical with that of the outer shell of the Castillo. This profile resembles that of the platforms at Monte Alban [112], with the Petén trait of sloping faces. The Temple of the Warriors in turn enfolds the Chacmool Temple upon a platform with terrace profiles recalling those of Teotihuacán [9]. No great interval separates the Chacmool Temple from the Warriors. The High Priest's Grave (Note 14) may belong here, as well as the Temple of the Tables.

III (1050–1200). The main ball-court buildings [240] have not been finally keyed into the sequence,[7] but such details as profiling and the rich repertory of figural reliefs make it possible that the north and south temples, as well as the upper Temple of the Jaguars, are coeval with the Mercado [239]. To be considered in this phase, which may have extended into the thirteenth century, are the Platform of the Eagles, the Platform of the Cones, and the *tzompantli* (skull-rack).

The close resemblance between some of the buildings at Chichén Itza and those of Tula in the Mexican highland was first noted by Désiré Charnay about 1880, after he had visited both sites.[8] Charnay's observations were finally confirmed in 1940, when the Mexican government began excavations at Tula. Most students now accept the thesis that Náhua-speaking Toltecs of highland origin lived as masters at Chichén Itza, and that the evidence of their presence appears not only in representations of warriors, priests, and gods of non-Maya origin, but also in the use of serpent-columns, Atlantean columns, colonnaded edifices several ranks deep, battered wall bases, crenellated roofs outlined by carved emblems called *adornos*, serpent balustrades, recumbent human figures called Chacmools, incense burners portraying the Mexican rain god (Tlaloc), and narrative relief panels set in plain wall surfaces.[9]

A question concerning the direction of these influences is relevant. The excavations at Tula uncovered only the forms which characterize the second and third phases of Toltec ascendancy at Chichén Itza. The north pyramid [32] and colonnade at Tula resemble the Temple of the Warriors; other buildings enclose colonnaded courtyards like the Mercado. Chacmool [39] as well as serpent figures and Atlantean columns [38] have also been found, but there is nothing at Tula corresponding to the first phase of Toltec art at Chichén. Tula may be a stylistic outpost of Chichén rather than the reverse. This thesis was also proposed recently (1972) in Mexico by R. Piña Chan.

The conventional view today is still that an alien art was imposed upon the Maya artisans of Chichén Itza.[10] However, the formative stages of that art are lacking at Tula. They are fully accounted for only at Chichén. At Chichén, it is possible that alien rulers brought ideas rather than objects and artisans and eventually acquired an art from their Maya subjects (cf. p. 300). Thus Mexican ideas, clothed in Maya forms, were eventually implanted at Tula. The principal Toltec forms were temples of circular plan [236], and feathered serpents. Both relate

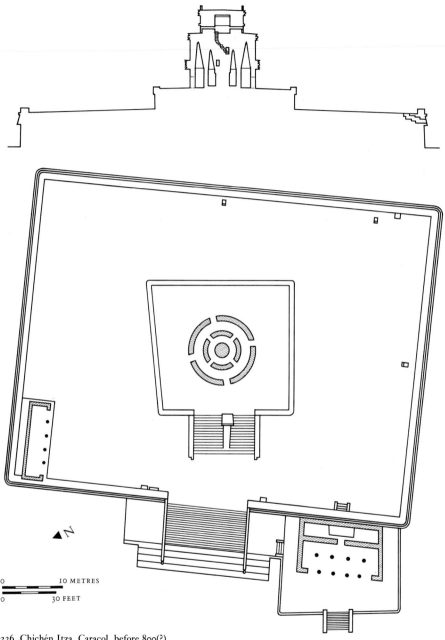

236. Chichén Itza, Caracol, before 800(?).
Section and plan

to the cult of Quetzalcoatl whose Náhua name in Maya became Kukulcan, signifying the feathered serpent, a wind god of vegetation and rain worshipped in round temples.[11]

In the Mexican highlands, feathered-serpent forms appeared at Teotihuacán long before their Toltec revival. The interpenetration of Mexican ideas and Maya forms is at least as old as the Early Classic art of Kaminaljuyú. At Xochicalco, the Late Classic investiture of Mexican symbols with Maya figural forms was another forerunner of the Toltec Maya union of highland symbol and lowland art.

The oldest and the most original manifestation of the cult of Quetzalcoatl-Kukulcan at Chichén appears to be the Caracol. Its cylindrical form, with double annular vaults and a winding stair in the upper storey [236], may represent the conch shell which was one of the attributes of Quetzalcoatl in his aspect as wind god. In the upper storey radial shafts emerge from the centre at angles that may have marked transit points in the observation of the sun and stars.[12] The ornament retains strong Puuc characteristics, especially in four serpent-mask panels above each doorway, made of mosaic elements in the technique of that period. Also in the Puuc style is the magnificent *atadura* moulding which marks the annular vault impost levels. It is a five-part moulding, unique in Maya architecture, made of deeply tenoned stones scaled to the exceptional size of the ring vaults. The outer vault circle rises more than 30 feet, the tallest of all Maya vaults.

Several campaigns of construction are evident. The primary platform, on a square plan, is the oldest element. The buried cylindrical base was next, followed by the construction of the secondary platform which enfolds the cylindrical base. Then the visible cylinder of the Caracol was built, with its double annular vault.[13] The west stair attained its present monumental size by the addition of serpent balustrades. Thus the conception of the Caracol is Mexican, but the technique and the governing forms of vaulted construction show Maya derivation.

The Castillo substructure with its nine stages is a much smaller pyramid than its outer shell, measuring only 32 m. (105 feet) on each side, as against 58–9 m. (190–5 feet) for the outer case, and 17 m. (56 feet) in height instead of 24 m. (79 feet). Like most pyramidal platforms of the Classic era, it had only one stairway. The outer platform, resembling the oldest pre-Classic pyramid at Uaxactún (E VII sub), as well as the four-stair platforms at Hochob or Tikal and Yaxhá, was built with four flights of stairs facing the cardinal points, upon a plan like the Maya sign for zero [237]. The profiles of the inner temple, like those of the Caracol, are closer to Puuc than to fully developed Toltec monuments: indeed the impost and cornice moulding evoke Río Bec models of an early Late Classic date (e.g. Xpuhil, Structure 1 [183]). In the upper façade of the little twin-chambered temple are relief figures of jaguars in profile in a procession underneath a series of round Mexican shields bearing heart-shaped designs. This whole ornamental programme seems hesitant and experimental, as if the sculptors were attempting to reproduce the forms from verbal descriptions rather than from visible models. No definite evidence fixes the chronological relationship between the Castillo substructure and the Caracol; both are close to the Puuc period, and the Caracol probably had a longer building history than the Castillo.

The mouldings of the Castillo and of the Chacmool platform buried inside the Warriors' Pyramid are so much alike that they may both be the work of one designer [238]. In addition they recall the panelled friezes of Monte Alban, with salient and recessed alternations of plane which adorn the sloping terrace faces like fringed head-bands, secured upon each talus by an upper moulding of simple profile [112]. As at Monte Alban, the device stresses the verticals in a horizontal system. But at Chichén, the sloping terrace faces are an innovation never attempted at Monte Alban. Another refinement at the Castillo is the changing scale of the panelled friezes in every stage [237]. All stages have eight salient panels on every façade, but the topmost

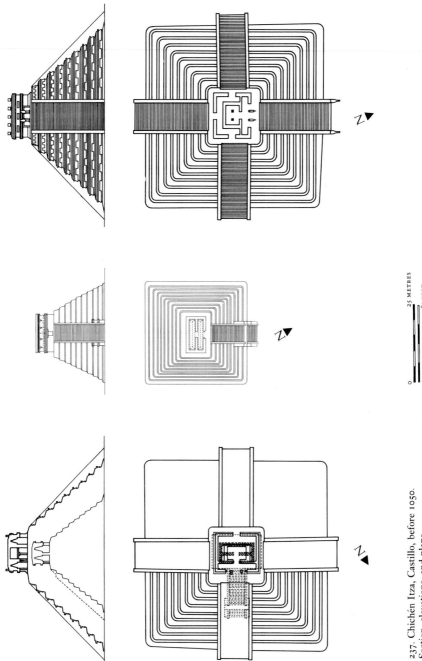

237. Chichén Itza, Castillo, before 1050.
Section, elevations, and plans

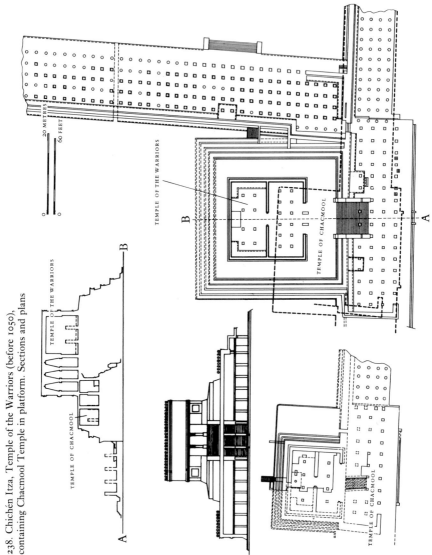

238. Chichén Itzá, Temple of the Warriors (before 1050), containing Chacmool Temple in platform. Sections and plans

ones are only about one-fifth the width of those at ground level. The effect of perspective diminution greatly enlarges our illusion of the size of the edifice.

The outer Castillo temple comprises four chambers, in an ingenious disposition comparable to the annular vaults of the Caracol. The doorway of the north entrance chamber is flanked by paired serpent-columns; behind it is the cella with two piers supporting three corbel-vaults; and surrounding the cella on three sides are continuous vaulted chambers, opening by centred doorways to east, west, and south. Both the temple and the pyramidal platform are more complicated designs than the Chacmool Temple and Pyramid. The forms of the two edifices are closely related – for example in the battered bases of the temple façades, and the panelled friezes and rounded corners of the platforms – but the Castillo appears in every way to be more advanced, more highly developed.[14] Perhaps fifty years separate the two designs; surely not more, and probably less, if one be guided by analogy concerning the rate of change in other architectural schemes of this magnitude (e.g. Gothic cathedrals).

The Chacmool Temple was eventually discarded, together with its platform, by being buried within the base of the Temple of the Warriors.[15] At that time, the platform was judged inadequate, and its profiles were replaced by an entirely different system (discussed below). The Chacmool Temple was two-chambered, with each chamber divided in two columnar ranges supporting twin corbel-vaults. This scheme was an improvement on the simple temple in the Castillo substructure, and it was later greatly enlarged, by double files of piers in each of the two chambers on top of the Temple of the Warriors [238]. These piers number twelve in the west chamber, and eight in the inner throne-room. The dense supports in the west chamber give it character as an ante-room or vestibule, and the wider intervals in the throne-room confirm it as a hall of audience and as a seat of authority.

In the Temple of the Warriors there is a remarkable change of style in the profiles of the platform. The four terraces no longer resemble Monte Alban; they are more like Teotihuacán, with a vertical framed panel in relief surmounting an inclined base. It is as if the architects of Chichén were searching for good historical models in an eclectic frame of mind, casting about among highland examples of five hundred to a thousand years earlier. The proportions of the platform stages of the Temple of the Warriors are nevertheless awkward. The relief panels ride like cornices upon disproportionately large sloping base planes [238]; the effect is papery rather than grandiose, and it is weakened by the effort to make inconsistent systems cohere. How much time elapsed between the building of the Chacmool and the enfolding Warriors? Probably not less than two generations, or fifty years, if we may be guided by other examples of the obsolescence of building fashions.

Vast vaulted colonnades form a pattern of enclosures along the eastern boundary of the Castillo court [235]. The range facing the eastern façade of the Castillo may be the oldest, antedating the platforms both of the Chacmool and the Warriors. Its northern end once projected westward into the Castillo court at the north-west corner of what is now the Warriors' Pyramid. This portion was replaced first by a demolished north-west colonnade associated with the Chacmool platform, and finally by the present colonnade, which forms a vaulted vestibule to the Warriors' Pyramid.[16] The southern end of this original west colonnade has not been excavated, but it was probably coeval with the substructure of the Castillo because of the exact parallelism between the orientation of the colonnade and the pyramid. In its pristine form, the west colonnade defined a wide, shallow court at the eastern foot of the Castillo. It was four rows deep, and its southern extension was vaulted with low, flat-angled corbel-vaults, with overhangs of a slope about 50–55 degrees. The columns were all cylindrical. In the Chacmool rebuilding of the colonnade, square piers were substituted, and these were repeated

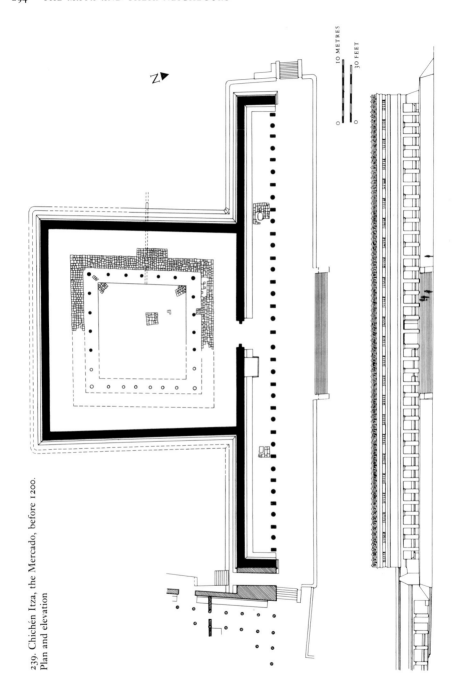

239. Chichén Itza, the Mercado, before 1200.
Plan and elevation

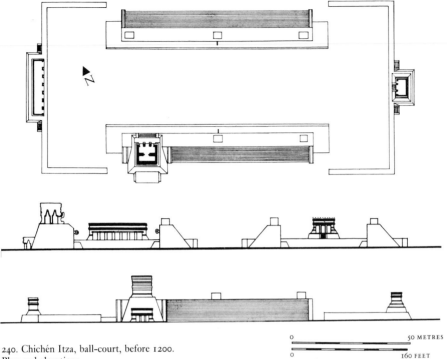

240. Chichén Itza, ball-court, before 1200.
Plan and elevations

in the final colonnade of the Warriors. The north colonnade post-dates the platform of the Warriors, and it has five rows of supports, of which the southern or outermost are square piers, and all the others are columns [251].[17]

The southernmost element of the colonnaded group is the edifice called the Mercado [239], of which other versions exist at Tula. The Mercado is given the same date as the Temple of the Jaguars because of spool ornaments in the upper façades and the wide, deep mouldings. The spools of the Mercado so closely resemble those of the Temple of the Jaguars that many were used in the restoration of the ball-court building. It is likely that the Court of the Thousand Columns was a market place with many little constructions like stalls and booths in north-south rows.[18] The Mercado may have been a tribunal, built after the market court had been paved with red-painted stucco. In the façade,

piers and columns alternate to vary the otherwise monotonous effect of the thirty-six intercolumniations. This gallery is like a stoa prefixed to a Roman atrium court.

The dating of the main ball-court group [240] is still uncertain. The gigantic dimensions (target-rings 20 feet above the floor, and a playing area 480 by 120 feet) make it less likely that humans were intended to use it than cosmic or mythological beings. Three smaller vertical-wall courts, grouped around the market place, may have preceded its construction. The court has an unusual profile with vertical playing-faces, like the Late Classic ball-court at Edzná in western Yucatán.[19] The north and south ends are closed by temple platforms, and the east mound has two temples upon upper [240, 242] and lower levels at the southern end. The profiles of these temples and their low relief carvings are the most sumptuous at Chichén.

Thompson, Lothrop, and Proskouriakoff believe the ball-court style to be early, coeval with the substructure of the Castillo, because the correlation they favour between Maya and Christian chronologies (Goodman–Thompson–Martinez) leaves no great gap between Classic Maya and Toltec Maya art. They regard the Toltec Maya, Puuc–Chenes, and Petén–Usumacinta styles as all roughly contemporaneous, falling in the opening generations of Toltec ascendancy at Chichén Itzá.[20] Lothrop and Proskouriakoff tend to bunch the styles together about the eleventh century; Spinden, Andrews, and now Parsons, Cohodas, and Ball spread out the Late Petén–Usumacinta, the Puuc–Chenes, and the Toltec Maya styles over a span of 600 years. The radiocarbon measurements of Late Classic and post-Toltec works support Spinden's correlation, allowing at least three centuries to separate Toltec ascendancy from the close of the Petén–Usumacinta Classic style. This, however, leaves the resemblance of many Toltec Maya forms to Classic Maya relief sculpture unexplained. Nothing like these forms appears in the Puuc–Chenes style, and Lothrop quite reasonably objects to Spinden's explanation as archaism. To this question we shall return when discussing the sculpture of Chichén Itzá.

If we confine our attention solely to architectural forms, it is obvious that the ball-court buildings [240] are later than the Court of the Thousand Columns, because their profiles most closely resemble those of the Mercado [239], which stands on top of the unbroken courtyard flooring. The date of this courtyard floor, in turn, is presumably earlier than that of the north colonnade, which post-dates the Temple of the Warriors. If this sequence is tenable, then the ball-court buildings post-date the Warriors group, and we are concerned with a renaissance rather than with coeval Classic and Toltec styles, as the archaeologists of the Carnegie Institution have supposed.

The actual chronological sequence of the main ball-court buildings is fairly clear.[21] Oldest is the lower Temple of the Jaguars, facing east [240]; then follow the parallel playing faces, the south and north temples, and finally the upper Temple of the Jaguars [242], which faces west. The façade of the lower Temple of the Jaguars (Maudslay's Temple E) resembles the substructure of the Castillo, and it probably antedates the present ball-court. The long east mound eventually incorporated this small, old-fashioned temple, which was modernized by the addition of sloping exterior wall-bases north and south and by the inside enrichment of narrative reliefs. This modernization occurred when the sloping benches were carved in the ball-court proper.

Excluding the lower temple shell, we may suppose that the entire campaign of building the ball-court occurred not long before the Toltec collapse and dispersal. Of the same general period is the Platform of the Eagles [241], a low edifice between the ball-court and the Castillo. It is related to the ball-court buildings by mouldings and relief-carvings. The *tzompantli* (skull-rack) rests upon the latest plaza floor,[22] so that it can be dated, like the Mercado, later than the construction of the colonnades, and together with the ball-court buildings, that is *c*. 1200.

All these edifices of the ball-court period have intricate profiles secured by compounding the traditional Maya *atadura* mouldings with foreign proportions and heavy members. The unified door-frames embrace several voids and display panelled exterior compartments in several planes of relief. The new silhouette is absent in the lower temple, but fully present in the upper Temple of the Jaguars [242]. Instead of the two horizontal façade zones of Maya tradition, there are four. An uppermost serpent frieze and a lower tiger frieze divide the upper façade. The lower bearing wall again is divided in two, with a sloping base beneath an upright wall-portion. This is panelled in several planes of relief recalling the salient receding portions of the Castillo terracing, although here the panelling is vertical rather than inclined. Almost identical is the profile of the gallery of the Mercado [239], with two sloping-base portions of different inclination, and a double division of the upper façade above impost level. Another

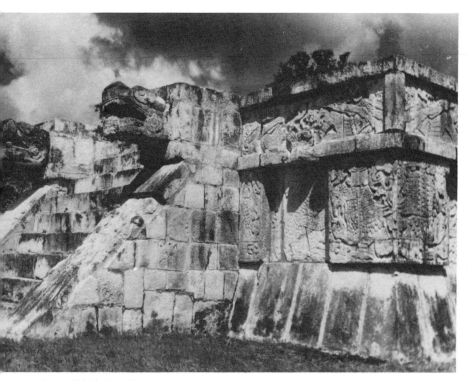

241 and 242. Chichén Itza, Platform of the Eagles (*above*),
and upper Temple of the Jaguars (*below*), before 1200

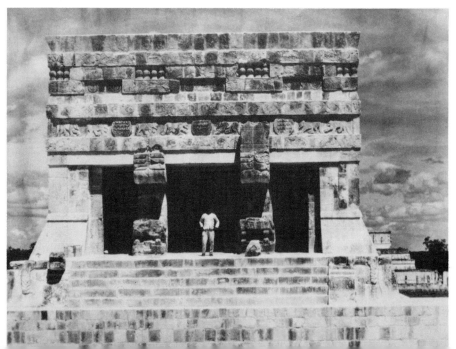

variant in the Platform of the Eagles, which Bishop Landa described in the sixteenth century as a 'theatre', exploits even more boldly the shadowed overhangs in the ascending sequence of inclined base, vertical in-and-out panels, and overhanging cornice [241].[23]

We have now examined the main sequence. Before 800, building at Chichén Itza expanded northward with the Caracol vaults, the substructure of the Castillo, and the west colonnade. Before 1050, we have supposed an eastern extension in the Court of the Thousand Columns, including the reconstruction of the Temple of the Warriors together with the slightly older 'fossil' temple within the Chacmool. In the twelfth century the main ballcourt marked a western extension, and the

243. Mayapán, Castillo, after 1250.
Elevation and plan

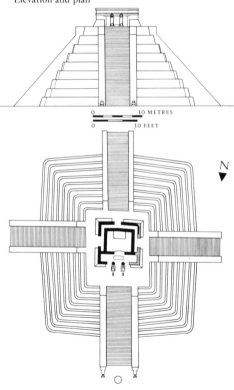

0 10 METRES
0 30 FEET

N
▼

Platform of the Cones arose in line with the paved road to the Well of Sacrifice at the northernmost boundary. It finally became a cruciform site with the north-south axis between the Nunnery and the northernmost *cenote*, and the east-west axis running from the main ball-court across the square of the Castillo and the Court of the Thousand Columns. The new elements were the colonnaded hall, with the vault overhangs carried upon wooden lintels, the peristyle atrium, as at the Mercado, and the covered stairways rising to temple level through the colonnade screening the platform base. With these innovations, the Maya architects of the Toltec period at Chichén achieved a new spatial order, initiating the possibilities of interior design upon a scale never available to their Classic predecessors.

Chichén Itza, like Uxmal three centuries earlier, abruptly ceased to be the artistic metropolis of Yucatán after about three centuries of intensive activity. Mayapán, 25 miles south of Mérida, became the new capital. The site has been systematically excavated.[24] Its position as the successor to Chichén Itza, in the period from *c.* 1200 to *c.* 1450, is now certain, although the interpretation of many jumbled bits of historical tradition, as preserved in Maya records, is still far from satisfactory. The excavations yield overwhelming proof that Mayapán sheltered a society in decline. It was a walled city enclosing about $1\frac{1}{2}$ square miles and contained over four thousand structures, most of which were dwellings. Only a few large edifices served ritual needs. The construction is shoddy and the plan disorderly, showing no sense of the ample spaces which characterized older Maya architecture. Innumerable small private shrines attest the disintegration of public worship and of the theocracy. The defensive city wall records a transformation in the concept of urban life, from the dispersed population of farmers who assembled periodically at a noble ritual centre, to a warren-like cluster of dwellings meanly crowded within walled defences. Its Castillo [243] is a literal copy of the one at Chichén, but of shrunken

size, about half as big, with the serpent heads of columns and balustrades executed in perishable stucco. The colonnaded halls were usually not vaulted, but roofed with beams and mortar.

The East Coast

The architecture of the East Coast of Yucatán, from Cape Catoche south to Espiritu Santo Bay, shows two main periods.[25] The older sites, represented by Cobá, are of the Classic Petén type. Early Classic Altun Ha in British Honduras may prefigure at Structure A–6B the double-range buildings at Uxmal [197, 187]. The later group hugs the coast, and there are buildings of the same period on the off-shore islands in the Caribbean Sea. Many coastal buildings have trapezoidal doorways and a silhouette with walls leaning outward in an exaggerated negative batter [244]. These traits probably derive from the Puuc, and from Uxmal in particular, where, as we have seen, architectural activity ceased at about the time of the rise of Toltec Chichén Itza. No negative batter has been observed at Toltec Chichén. Lothrop's supposition that the main part of Tulum was built early in the Toltec period[26] is therefore justified, although his dating in the thirteenth and fourteenth centuries is too late. The lack of post-Classic building activity in the Puuc proper suggested to Brainerd that the Toltecs forcibly expelled the Puuc inhabitants from their arid home.[27] If the Puuc people migrated to the East Coast, as the architectural habits of that region suggest, the stylistic sequence there would contain Classic, Puuc, Toltec, and Mayapán phases, with the Puuc intrusion occurring about the tenth century, the Toltec style in the twelfth and thirteenth centuries, and Mayapán traits appearing after the thirteenth century. Such a sequence corresponds to the chronology gained by excavation at Chichén and Mayapán.[28] Classic edifices are marked by thick walls in true plumb, with roof-combs and simple rectangular mouldings. Puuc-style buildings have marked negative batter without the sloping bases characteristic of Toltec

influence. Recessed lintels and columnar doorways are present in both the Puuc and the Toltec phases.[29] Of Toltec derivation are the serpent-columns of the Castillo at Tulum, as well as the sloping bases and the prolific use of over-door niches. The sculpture in stucco, finally, recalls the workmanship of Mayapán.

The complete sequence can be traced among the many re-buildings of an edifice like the Temple of the Frescoes at Tulum [244]. The initial Classic vaulted shrine (A) was encased in a larger building (B) with columnar façades and negative batter in the Puuc style. Finally this platform was augmented by a second-storey addition to the upper shrine. Its negative batter, as at Cancuén near by (Structure 4), is enriched by a sloping base of undercut profile. Without

244. Tulum, Temple of the Frescoes, Classic and later periods. Section and plan

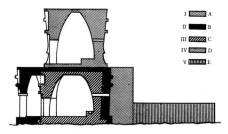

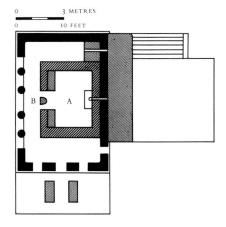

the undercutting, such bases are familiar at Chichén and Mayapán, permitting a date in Toltec Maya times or later. Beam-and-mortar roofs may have been in current use at all periods [160 G], and their popularity may account for the prevalence of compressed or contracted upper zones of façades, which are often only one-third as high, or less, than the bearing walls.[30] Well-preserved examples are the halls of the Castillo and Structure 25 at Tulum.

The Problem of Tula

The thesis of Toltec influence from Tula on the architecture of Yucatán weakens when we look for elements occurring solely at Tula prior to the Toltec intrusion at Chichén Itza. Among architectural forms round temples (Calixtlahuaca) [42] and sloping basal zones (Teotihuacán) [7, 8] emerge as possible Mexican contributions to Maya practice. Colonnaded doorways with Atlantean columns and effigy supports are commonly ascribed to Toltec influence, but there is much older Olmec precedent for them in sculpture (Potrero Nuevo). As to colonnaded interiors, the Late Classic example at Mitla [125] is probably more important than the colonnades at Tula, for which it is difficult to prove an early date. We have noted in the Toltec architecture of Chichén Itza strong resemblances to the panelled terracing of Monte Alban (Castillo) and Teotihuacán (Pyramid of the Warriors). Toltec Maya architecture now appears more cosmopolitan and eclectic than the traditional comparison with Tula alone would allow.

SCULPTURE

Toltec work is commonly regarded as inaugurating 'a new era in art ... primarily secular and dramatic ...', so closely allied to Tula that it is not usually considered part of the Maya development.[31] But we have seen in architecture that the Toltec intruders may have exported more from Yucatán than they brought into it, and when we assess the sculpture for proof of foreign influence, the balance again favours the Maya, with Chichén Itza clearly marked as the originating centre rather than as a receiving terminal. The Toltec Maya repertory at Chichén comprises many forms and techniques of which we have no trace at Tula, such as repoussé goldwork [260] and narrative sculpture in relief with the portrayal of landscape [256]. At Tula, on the other hand, the only sculptural forms with no exact equivalent at Chichén Itza are the colossal Atlantean supports [35, 36], which are perhaps only amplifications of very common smaller Atlantean figures at Chichén [246, 247].

As with the architecture, the impact of an alien ethnic group upon expression cannot be denied: the aggressive new expression, however, was articulated in traditional Maya elements of form, and it eventually returned, in its Yucatecan garb, to the Mexican highland. Thus the serpent-columns of Chichén Itza are prefigured not only at Teotihuacán but also in Late Classic Maya sculpture by effigy columns like those at Oxkintok.[32] The warrior figures of Toltec Chichén have many precedents in the Usumacinta region, and at Bonampak, Piedras Negras, and Yaxchilán. The reclining Chacmool figures are more numerous at Chichén than at Tula. Human sacrifice by heart removal is figured in reliefs at Piedras Negras, and possibly on the walls of Bonampak, so that Tula Toltec priority here too is doubtful.

The chronology of Toltec Chichén sculpture is as uncertain as that of architecture, because any seriation of the sculpture depends upon architectural chronology.[33] Our sequence places the substructure of the Castillo and the Caracol in the early phase; the Pyramid of the Warriors and the great colonnades in the middle phase; and the main ball-court in the final one, the three embracing over a century each, from before 800 to the thirteenth century.

By the orthodox correlation between Maya and Christian time (Goodman–Thompson–Martínez), these events at Chichén overlap with Late Classic art in other regions. In the chronology based on the C14 dates assembled by

Andrews, an ample Maya tradition of several centuries underlies many forms of the Toltec Maya style at Chichén. Its history contains a renaissance of Classic Maya art as well as an eclectic use of alien themes, such as the terrace profiles and pyramidal plans which echo many older Petén Maya, Monte Alban, and Teotihuacán forms. Toltec Chichén re-states entire traditions in Mesoamerican antiquity. Chichén is like Rome, but Tula is like a frontier garrison, on the very edge of the civilized world of town-dwellers, upon the *limes* where the barbarians roam, taking much of its art from the middle phase of the development at Chichén, and missing the late, splendid renaissance of the figural style.

We have seen that the extension of the corbel-vault on colonnaded ranges of supports gave its characteristic spaces to the architecture of Chichén Itza under Toltec domination. An analogous technical device allowed the Toltec Maya sculptors to enlarge their field and to achieve the ample narrative reliefs of the middle and late periods at Chichén. This device was the simple one of extending the compositional field beyond the limits of a single block of stone [252]. The Classic stela motif was almost invariably confined by the single block or slab of stone; at Chichén, however, the sculptural unit extends over several blocks of the masonry veneer. This practice must have been inherited from Late Classic architectural practice in western Yucatán. A few examples of sculpture over the masonry veneer are recorded from the Puuc district.[34] Two panels at Santa Rosa Xtampak have Classic motifs extending over many rectangular veneer blocks. At Xcalumkin there are door jambs like those of Chichén Itza, composed of several drums, and bearing Classic single-figure motifs of the most ancient Maya tradition. Proskouriakoff, with the aid of her trait graphs, dates both examples to about 731–51 (9.15.0.0.0–9.16.0.0.0). These panels of sculpture in pictorial extension require continuous planes rather than plastic masses, being pictures carved in two planes painted with brilliant tones of local colour.

Before we treat these reliefs in detail, the main types of free-standing sculpture require discussion.

Full-Round Figures

There are few full-round figures; the Maya peoples may have been indifferent to them. Their Olmec predecessors in southern Veracruz and their neighbours to the east and south all produced important free-standing works, but the Classic Maya themselves tended to convert plastic forms into scenes of shallow relief, under strong tectonic regulation in the flat planes of stelae, wall-panels, and lintels. In the Puuc and Toltec periods, stone seats carved to resemble jaguars were not uncommon: a celebrated example is the red throne inlaid with spots of jade, discovered in the chamber of the substructure of the Castillo [245]. This Toltec Maya version is chunky and awkward in its compromise between instrumental form as a legged seat, and

245. Chichén Itza, jaguar throne from the Castillo substructure, before 800(?). Painted stone inlaid with jade

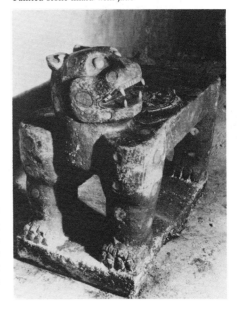

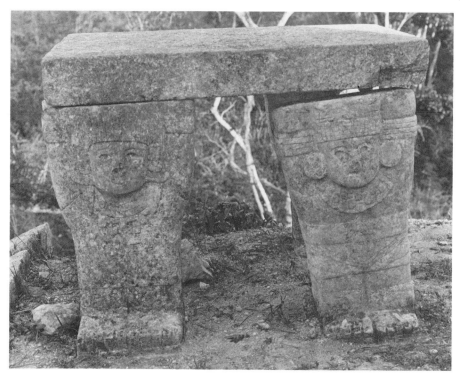

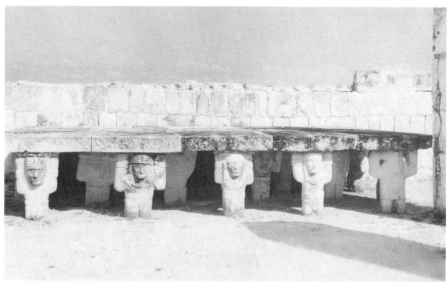

anatomical form in the curving head-planes and leg muscles. The type is itself of Classic origin. A two-headed jaguar seat was found at Uxmal; carved representations occur at Tikal, Piedras Negras, Palenque, and Xultún; and painted versions decorated the cella of the Chacmool Temple at Chichén.

The many small caryatid figures supporting tables or benches [246, 247] perhaps relate to older Maya traditions of sky-bearing personages represented in relief.[35] The oldest caryatids at Chichén Itza are probably in the Temple of the Tables adjoining the Pyramid of the Warriors on the north. This temple is coeval with the buried Chacmool Temple, which also has columnar reliefs and serpent-columns. Its caryatid table may be taken as part of the original design. The figures are like inverted cones, with features lightly carved in the frontal plane. In the neighbouring Temple of the Warriors, the stones are T-shaped, with more fully articulated arms and legs [246]. The best workmanship is seen in the Atlantean figures of the upper Temple of the Jaguars [247]. The conical shape seems old-fashioned, but the surfaces are articulated and differentiated in great detail, with images comparable to those of the cella doorway discussed below. In the south-east colonnade are kneeling caryatids (Room C). In Structure 3 C 6 the Atlantean columns of life-size male figures may be related to the colossal caryatids at Tula.

Probably outside the Maya tradition are the Chacmool figures at Chichén Itza, fourteen in all, varying from large simple forms [251] to small and fussy ones. These reclining male figures lie athwart an entrance axis and turn their heads out to the court or plaza, holding on the abdomen a plate or vessel clasped in both hands. The origin of the type is unknown, but it accompanies the Toltec dispersal [39], ap-

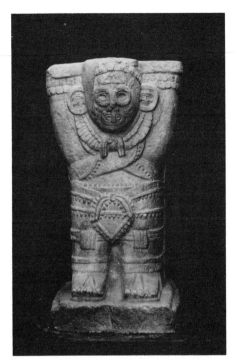

247. Atlantean figure of painted stone from Chichén Itza, upper Temple of the Jaguars, before 1200. *Mexico City, Museo Nacional de Antropología*

pearing in Michoacán and in Costa Rica and Veracruz, possibly in connexion with ritual drunkenness.[36] Crouching figures of stone, intended to hold standards or banners upright on the terrace edges, are also common at Chichén, and there is no Maya precedent for them.

The paired serpent-columns of the Castillo, the Temple of the Warriors [248], the High Priest's Grave, and the Temple of the Jaguars are like effigy columns of the Puuc period. The image of the fully feathered serpent is rare in Classic Maya art. It probably represents central Mexican highland traditions of rain and vegetation symbolism. Two architectural variants occur. In the older one (Castillo [237] and Chac-

246 (*opposite*). Chichén Itza, Atlantean figures of painted stone from the Temple of the Tables (*above*) and from the Temple of the Warriors (*below*) before 1050

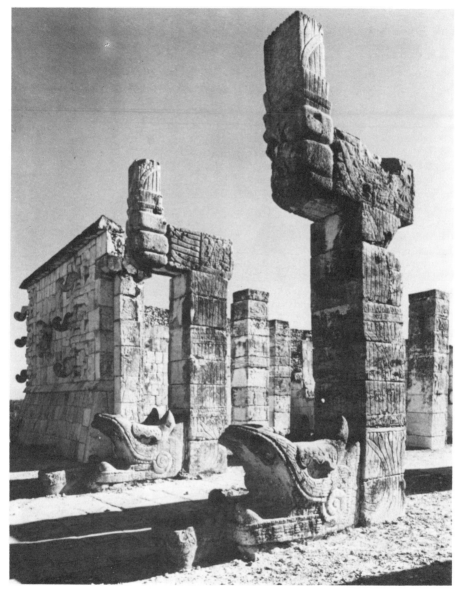

248. Chichén Itza, Temple of the Warriors, cella entrance, before 1050(?)

mool Temples), the serpent-head is the bottom drum of the round column. The others (Warriors [248] and High Priest) have square piers with the heads carved on separate adjoining blocks. The latter version is more practical and economical, and it is also less impressive. At the

High Priest's Grave, the pier drums were re-cut with feathers and scales, replacing older panelled figures like those of the piers in the Chacmool Temple or the Temple of the Tables.[37] The older cylindrical version re-appears in the doorway of the late Temple of the Jaguars [242], where other details confirm an impression that these columns, of which the heads are the largest single carved stones at Chichén, weighing $7\frac{1}{8}$ tons each, were re-used, after having been part of an older, now vanished structure.

The convergence of the serpent-column and a more conventional prototype is apparent in the vestigial capitals retained between support and lintel. These capital blocks provide the angular passage from shaft to cornice-block, with its rattlesnake's-tail motif. The oldest examples are the buried blocks with painting intact from the 'fossil' Chacmool Temple, and the closely similar capitals in the Castillo Temple. Both are carved with Atlantean reliefs of shell-, spider-, and turtleshell-men on three sides. The fourth side, facing the exterior, bears feathers. The Atlantean theme repeats in the membering of the supports in the cella interior. At the Temple of the Warriors, it is vestigial, appearing on only two sides of the topmost block [248]. In the Temple of the Jaguars, the theme disappeared altogether, in favour of a lintel drum carved with feathers and scales [242], making no pretence of conformity with the cella pilasters. The serpent-heads, finally, differ according to their context on piers or columns. Columnar heads are merely cubical, with jaws open less wide than the gaping mandibles of the heads joined to square piers. A difference of mythographic species appears in the horned heads at the entrance to the cella of the Temple of the Warriors [248].

Processional Reliefs

At Chichén Itza, all life obeyed processional arrangements. Moving among the ruins, one is surrounded by solemn images in profile, carved in shallow relief and shown striding towards the cardinal directions, each imprisoned upon a column or jamb face [257] or along the sloping dais benches [252], or upon the walls of the temple cellae [255]. It is as if all the stela figures of the southern Early Classic cities had convened, transformed into Toltec Maya priests, warriors, or god-impersonators, and even more rigidly governed by the architectural setting.

Three principal groups are evident – early, middle, and late – based upon our architectural sequence. The early reliefs (before 800) include the circular stone from the Caracol [249], which

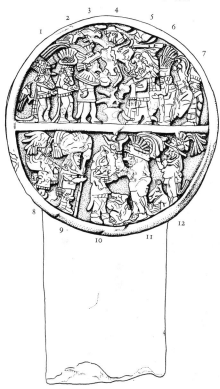

249. Chichén Itza, Caracol platform, processional disk relief with Maya and Toltec figures, before 800

Lothrop also regards as an Early Toltec work.[38] Upper and lower registers represent convergent files of figures, with proportions stunted at the

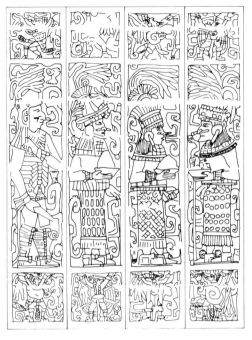

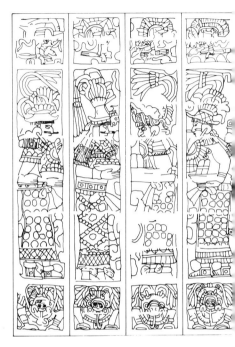

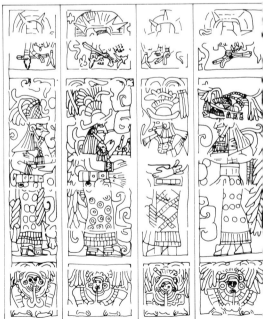

250. Chichén Itza, column reliefs,
before 1050. (A) Chacmool Temple (*above, left*);
(B) Temple of the Warriors (*above, right*);
(C) north colonnade (*right*)

ends of the semicircular fields. Both Maya and Toltec personages are present: the scenes may show the confrontations of four groups of Maya and Toltec allies.[39] Thus the figures here numbered as 1, 5, and 8 are surely Toltec, because of the nose-stick (No. 1), and the feathered-serpent coils (Nos 5, 8). Probably Maya by dress, towering head-gear, and lance are Nos 3, 6, 7, 9, and 11. The style of carving allows little space between figures, and the effect is crowded and awkward.

The reliefs of the middle period (800–1050) fall into two groups of columnar panels: an initial phase is represented by columns in the Chacmool Temple, which have human caryatids on the bases and capitals [250 A]; the second phase, in the colonnades and on the Temple of the Warriors, has bases with jaguar-bird-serpent masks framing human faces, and sun-disk deities in the capitals [250 B]. Jean Charlot has separated the different sculptors' hands, finding four masters in the north colon-

nade [250 C], and discovering changes between the reliefs of the Chacmool Temple and those of the Temple of the Warriors, such as increasing practicality, secularity, and stereotyping.[40] Also characteristic of sculpture of the middle period are the many stone benches in the temples and colonnades, with processions of figures in profile carved on their sloping faces. These benches recur at Tula, and much later, in more stereotyped forms, at Tenochtitlan.[41] The most elaborate example is in the north colonnade [251]. On each face, two files of figures converge upon a central sacrificial vessel beneath a cornice of undulant feathered serpents. Most of the processional figures are surrounded by the standing coils of serpents in S and Z forms. The coarse and spotty surface pattern was probably brought to harmony by the painted stucco coat; it recurs on the panel friezes of the terraces of the Pyramid of the Warriors, where eagles, tigers, and recumbent warriors symbolize the ritual of heart sacrifice.

251. Chichén Itza, north colonnade, reconstruction view of dais and Chacmool, c. 1200

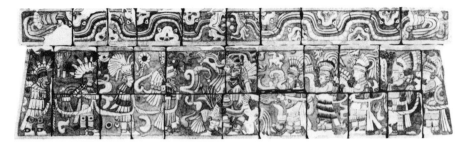

252. Chichén Itza, Mercado gallery, limestone processional relief on dais, *c.* 1200(?)

The twelfth-century reliefs of the late period cluster near the main ball-court, on its playing benches [254], in the lower Temple of the Jaguars [255], and on the platforms between the ball-court and the Castillo [241]. Rich costumes, animated movements, and a variety of curving passages from front to rear planes are the principal traits of this late relief style. The transition from the middle manner may be in the dais of the Mercado [252]. The files of prisoners, roped and named, converging upon a central figure beneath a feathered serpent cornice, are like those of the north colonnade, but the rhythmic organization and the variety in surface texture are far more intricate than in the earlier dais. The taste of a new generation of talented sculptors at the main ball-court is present,[42] and the Mercado dais may be one of its earliest expressions.

In the main ball-court, the order of erection, if we reconstruct it correctly, was the following: south temple, playing benches, lower Temple of the Jaguars, north temple, and finally upper Temple of the Jaguars. We place the south temple earliest because its piers resemble those of the Warriors, with jaguar-bird-serpent motifs in the bases [253]. The ball-court sculptor has obscured the unsightly median line separating the feathers from the paws, by extending the feathers in long curves that unify upper and lower halves of the panel. This kind of compositional improvement marks every production of the designers of the ball-court,[43] who gradually loosened postures and enriched

narrative accessories until they attained a completely pictorial manner. Eventually, in the mural decorations of the upper Temple of the Jaguars [264] and the cella of the Warriors, they dispensed altogether with relief sculpture.

This sequence is admittedly only an approximation on stylistic grounds, without adequate archaeological support. It is nevertheless possible when we concede the status of these craftsmen as members of a renaissance generation, rather than as a generation moving into artistic decadence. The thesis of progressive artistic degeneration has been the orthodox one,[44] i.e. that Maya sculptors close to Classic traditions progressively lost control and skill under Toltec domination. We have reversed the sequence, on the assumption that after the long figural vacuum during the Puuc period, architects and sculptors studied anew the traditions of Classic Maya sculpture, achieving mastery in the course of several generations, when Toltec Maya art came into being. The main ball-court reliefs are the finest monuments of this sequence.

The two ball-court benches are the largest processional reliefs at Chichén Itza, with scores of figures portrayed almost life-size upon a richly figured ground of Maya serpent and plant forms. The architectural setting, the armour, and the iconography of decapitation all recall Classic Veracruz sculpture of an earlier date (compare illustrations 254, 100, and 101). The six panels are nearly identical: in each, two processions converge upon a disk inscribed with

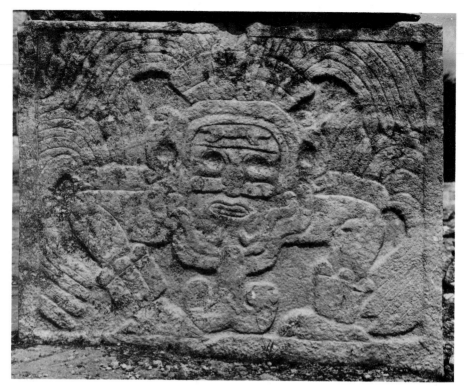

253. Chichén Itza, south temple, ball-court, limestone pier base with jaguar-serpent-bird relief, twelfth century(?)

a skull. Each panel has fourteen figures in ball-players' costume: the victorious team wear broad mosaic collars, and their leader has decapitated the opposing leader, from whose headless neck six serpents fan out,[45] as on the seven-serpent stelae from Aparicio in Veracruz.[46] The attitudes are monotonously regular, varying only in the springiness of the step. Decorative animation and movement appear in the plant and serpent scrolls which fill the ornate ground. The same scene re-appears in the six versions, with eighty-four figures, repeated three times on each bench. The four end panels have cornices of feathered serpents with cylindrical bodies. The west wall panels are more crowded, less well carved, and more shallow in relief, as if so many repetitions had made the carver careless. The most animated stances and the most open ground occur on the north-ernmost panel of the east wall: unfortunately, many blocks are missing. The south-east panel is more crowded with feathers and serpent scrolls; practically no open ground shows between the figures [254]. On the west wall, the central panel is the most crowded of all, and its relief is the most shallow. This poverty of invention and the limited thematic material suggest that the benches are the work of a generation still sympathetic to the art of the colonnades, yet moving towards a greater pictorial range, increased narrative variety, and more animated movements.

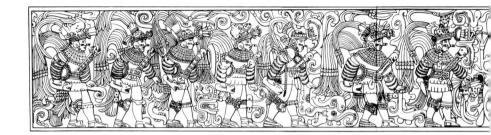

These new objectives are apparent in the multiplication of registers inside the lower Temple of the Jaguars [255]. Six registers, running without pause or interruption at the corners, circle the interior. In the base, five rinceau bands of plant, fish, and bird forms emerge symmetrically from four mask panels. Above, there are five registers. The lowest has a procession of twenty-four lance-bearing nobles in full-dress regalia. The next two registers, of equal width, are slightly narrower, and the top two in the vault overhang are again equal, but narrower than the pair just below. In all four upper registers are warriors armed with bundles of short spears and throwing-sticks (*atlatl*). In the centre of the top register is a sun-disk of Mexican type. It recurs on the wooden lintels and murals of the upper temple. An effort to interrupt the track-like sequence of the registers appears in the middle of the back wall, where a

gigantic feathered serpent breaks through the barrier between second and third registers, as a copula between parallel processional spaces. The quality of the carving is close to that of the benches, but the compositional scheme is more inventive and more animated. For example, the scrolls between figures are upright in the benches, but in the cella of the lower Jaguar Temple they inscribe vigorous curving diagonals as if to mark dance-like motions.

On the North Temple, finally, the band mouldings are suppressed, except to mark the vault overhang and the base. This base, like the one in the lower Temple of the Jaguars, has rinceau bands, with an unprecedented figure in the centre of the north wall: it is a recumbent corpse clothed in a tunic of hexagonal scales. From the abdomen rise two serpent bodies ending at feet and head in serpent jaws in profile.[47] Recumbent bodies also encircle the base of each

255. Chichén Itza, lower Temple of the Jaguars, processional reliefs on interior walls, before 1200

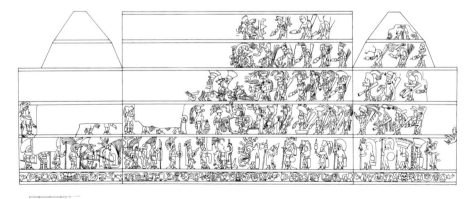

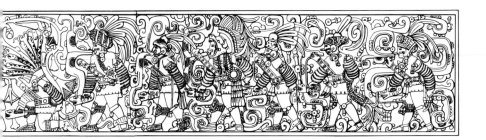

of the entrance columns beneath a trellis hung
with flowers and fruit. This theme of a vine or
tree of abundance re-appears upon the stairway
balustrades, rooted in a rain-god mask in
profile. On the three cella walls, five registers of
figures are shown [256], but they are separated
by band mouldings only on the vault overhang.

As in the cella of the lower Jaguar Temple,
the scenes in the North Temple turn corners
without interruption, in one continuous pic-
torial space embracing the three walls. The

254 (*above*). Chichén Itza, ball-court bench,
east face, processional relief, before 1200

256 (*below*). Processional reliefs and narrative
scenes from the ball-court of the North Temple,
Chichén Itza, before 1200

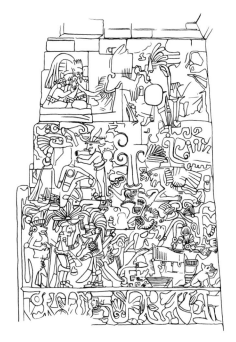

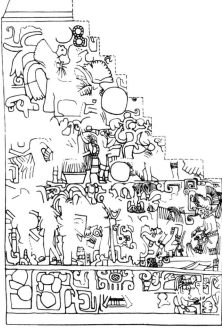

main group consists of three files, converging upon the centre. The lower figures bear arms of darts and throwing-sticks; the central row of seated figures – turbaned on the left, and wearing feather head-dresses on the right – listen to the central figure standing in open serpent jaws. Above, erect warriors converge upon the sun-disk. Speech-scrolls are the principal space-fillers: the whole group is like a three-storeyed dais procession. On the left and right are other scenes. Facing the west, and connecting with figures on the west wall, is a bird-dancer on ground level who dances to the sound of a seated drummer around the corner. The whole west wall is ruled by a seated figure in the upper corner presenting a smaller person to the others for homage. The scene on the east wall also includes groups on the adjoining north wall where two chiefs, seated in conversation inside a house, are meant to preside over the badly damaged scenes on the east. The clearest of these is the lower outer corner, where two upright persons examine a recumbent one.

The perspective throughout is ascending, in the sense that distant spaces are represented as high in the composition, with figures, trees, and scrolls all somewhat garbled and interfering with one another. The intention of the entire room is to portray actual events together with the indications of their symbolic meaning; probably it illustrates an historical account, not unlike the screenfold genealogies of the Mixteca. One scene in the vault overhang, showing a hunter with a blowpipe shooting at birds in a tree, exactly recalls a parallel image in the Bodley manuscript illustrating an event in the life of the Mixtec hero, Eight Deer (A.D. 1011–63)[134]. In these vault scenes the variety and the narrative detail suggest that the model might have been such a screenfold manuscript. Below the impost, the north wall shows an effort to break away from the conventional setting and to unify larger narrative spaces than the manuscript style permitted. To trace the further developments of this extended narrative space, we must later examine the mural paintings at Chichén Itza.

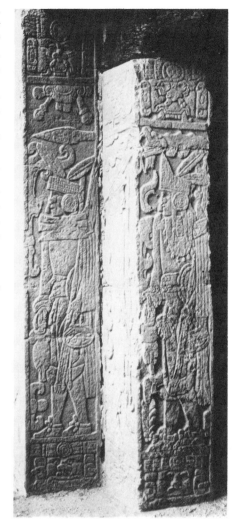

The pilasters framing the doorways of the upper Temple of the Jaguars [257] bear figures of warriors whose exposed genitals must have been an affront to the traditional modesty of the Maya natives of Yucatán. The quality of the carving, nevertheless, is the best at Chichén Itza, with rounded passages and portrait faces of an agreeable degree of finish requiring for appreciation neither stucco coating nor poly-

257 (*opposite*). Chichén Itza, upper Temple of the Jaguars, limestone reliefs of Toltec warriors on door-jambs, before 1200(?)

258 (*below*). Chichén Itza, skull-rack platform, thirteenth century(?). General view from the east

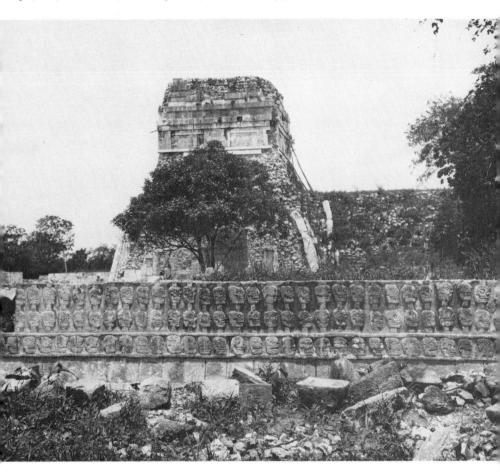

chromy. The expressive intention is clear: the alien masters are exalted, and native customs and conventions are ignored. This arrogant assertion of foreign manners recurs in the nearby platforms consecrated to the planet Venus, to the warrior society of the eagles [241], and to human sacrifice by decapitation at the *tzompantli*. These latter-day monuments are closest to Tula. The late date of the skull-rack [258], as

in the case of the Mercado, is suggested by construction over the uppermost plaster flooring of the plaza.

Other examples of Toltec Maya sculpture are the embossed gold disks dredged from the Well of Sacrifice.[48] They are coeval with the sculpture of the main ball-court, and they readily fall into three stylistic groups. Seven of the disks (A–E, I, J) resemble the processional friezes,

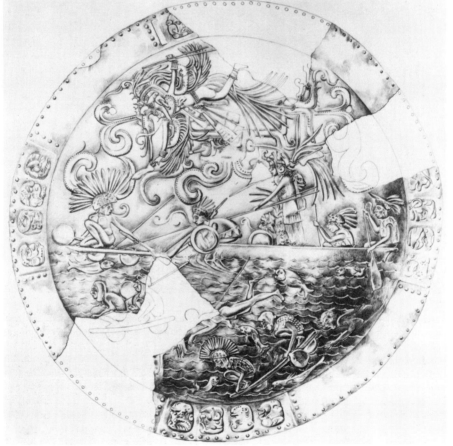

259–61 (*opposite*). Repoussé gold disk (D) with battle scene (*above, left*), repoussé gold disk (G) showing a battle at sea (*below*), repoussé gold disk (L) with eagle warrior (*above, right*), from the Well of Sacrifice, Chichén Itza, *c.* 1200. *Mexico City, Instituto Nacional de Antropologia e Historia*

with several figures of Toltec and Maya warriors occupying an unspecified space within the circular rim [259]; three (F, G, H) have clearly marked ground lines with some indication of pictorial environment and are closest in style to the murals at the Temple of the Warriors or the upper Temple of the Jaguars [260]; six others (K–P) are more heraldic in design [261] and can be connected with the jaguar and eagle friezes on the Platform of the Eagles [241].

In conformity with the orthodox position that Late Classic and Toltec Maya styles overlapped in time, Lothrop assigned F, G, H, and K–P to the early phase of Toltec Maya history in the tenth century.[49] The alternative hypothesis of a Toltec Maya period separated from the Classic period by at least three centuries requires another sequence, with the metalworkers im-

proving in draughtsmanship and in technique, until they regained mastery of the long-disused classical vocabulary. Our sequence of processional, pictorial, and heraldic styles may eventually require re-arrangement, but for the present we shall suppose that they spanned the twelfth and thirteenth centuries, on the strength of the parallels with architectural sculpture. Thus in D [259], the serpent motifs above and below the processional grouping are inexpert and uncertain. In G, the same theme receives an ample development in the space above the right-hand boat [260], and in L, this Classic Maya theme is replaced by a Mexican eagle warrior [261]. Certainly the marine battle of G is comparable, with its diagonal movements and receding plane of water, to the sea-coast mural in the Temple of the Warriors [262]. No hint of this illusion of deep space appears elsewhere in ancient American art: the fresco-painter and the goldsmith may have belonged to the same generation, and there is no evidence that their successors continued this promising line of investigating pictorial space.

262. Chichén Itza, Temple of the Warriors, wall painting of a sea-coast village, before 1050(?)

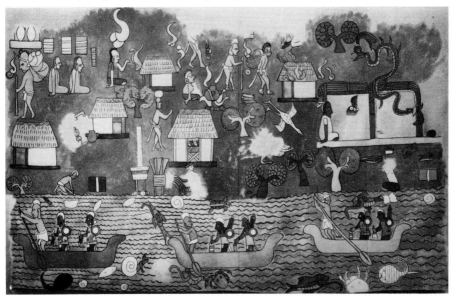

PAINTING

Murals

At Chichén Itza, narrative scenes covering large walls adorn the shrines of both the upper Temple of the Jaguars, which overlooks the ball-court, and the Temple of the Warriors. All are in extremely bad condition, and the paintings can be studied today only in reproductions. The ball-court frescoes are rhythmic and geometric arrangements of many small figures in dense clusters. The murals of the Warriors' Temple portray landscapes, a village and the seashore, in which scattered groups occupy a pictorial space much deeper than at the ball-court. By our hypothesis, Toltec Maya pictorial space was a gradual achievement. It broke with the schematic and geometric forms of the Puuc period and ended with the art represented by such gold repoussé disks as that of the sea-battle [260] and a human sacrifice by heart excision. In this developmental scheme the flatter and more geometric designs at the upper Temple of the Jaguars [264] antedate the pictures in the Temple of the Warriors [262], with their much greater depth in space. They are closer in spirit and in composition to the Bonampak frescoes [221–6]. The landscapes in the Temple of the Warriors bring to mind the strip-like arrangements and the cartographic designs of south Mexican manuscripts [135]. Since nothing like these small-figure murals was found in the 'fossil' Chacmool Temple,[50] buried within the platform of the Temple of the Warriors, their first appearance at the latter can be dated in the twelfth century, near the end of the architectural florescence of the Toltec Maya style at Chichén Itza.

Seven mural fragments decorate the inner chamber of the upper Temple of the Jaguars. Those on the north wall and in the north-eastern corner are completely destroyed, but fragments survive on the eastern, southern, and western walls [diagram, 263]. On the east wall (3, 4), two warriors and a landscape were interpreted by Seler as a terrestrial paradise.[51] Facing it and on the south walls are battle scenes, showing two armies under a volley of lances (south-west wall, 1); the siege of a town or temple (south wall, 2); and another siege scene (north-west wall, 7). As at Bonampak, many aggressors overcome very few defenders. Upon the stages of a pyramid (south wall, 2) less than ten men receive the violent attack of scores of spearmen and lancers. Over the doorway (8), above the lintel, is a recumbent figure, identical with the relief in the north ball-court temple, from whose belt rise serpents. On the vault overhang above this, a human sacrifice by heart excision[52] appears under another badly damaged battle scene. A base zone surrounds the room at floor level, with tendrils enfolding grotesque masks and reclining human beings, as in the lower temple reliefs.

The composition varies from wall to wall: in the best preserved fragment (south-west, 1), about 120 figures are grouped in eleven rows and eleven columns of shifting contours. They make a rhythmic panorama of spear-throwing warriors, whose attitudes in the lower left corner compose a sequence not unlike the frames of a cinematic or stroboscopic action exposure [263]. The same dense composition recurs on the south wall (2), where warriors mounted upon curious siege-towers made of timbers lashed together in three- and four-storey edifices attack a pyramidal platform [264].[53] A sun-disk deity presides in the upper right-hand corner. In both scenes the battlefield is confined at top and bottom by rows of houses with seated figures, probably the villages of the fighters.

On the east wall (3–5), the published fragments recall the deep space of the compositions of the Temple of the Warriors, especially in the depiction of trees and rolling terrain. A portion published by Willard as from the east wall[54] shows a score of warriors with shields and throwing-sticks advancing in two files behind the cover of hills to attack another army in the lower portion of the picture. The small-figure convention and the exaggerated contours of the landscape anticipate certain Mexican historical manuscripts, such as Codex Fernández Leal[55] or Codex Xolotl.

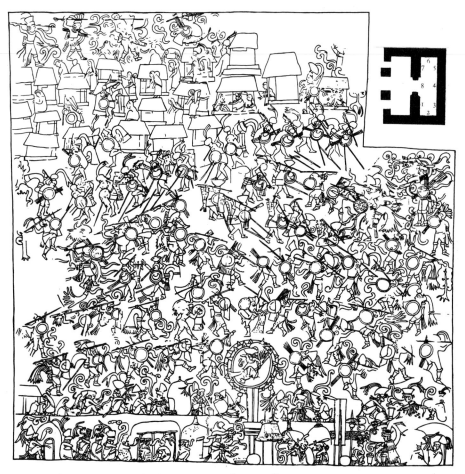

263. Chichén Itza, upper Temple of the Jaguars, south-west wall,
wall painting of a battle scene, twelfth century

The exterior surfaces of the Temple of the Warriors were also painted. The sloping basal zone received 131 coats of plaster: the twenty-second of the coats bore figures of men and animals in a processional order like that of the sculptured panels of the platform.[56] The cursive style with yellow, blue, white, and green figures on a red ground may belong to the time between the Chacmool murals and the interior murals of the cella of the Warriors' Temple. Neither of these paintings can be exactly dated, but the exterior murals at the Warriors stand half-way between the hieratic order of the Chacmool murals and the looser narrative manner of the cella frescoes.

Exterior murals also adorned the walls of a

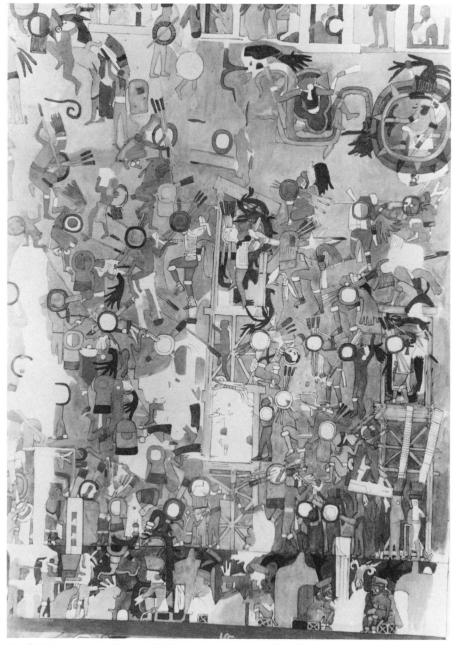

264. Chichén Itza, upper Temple of the Jaguars, inner room, south wall, painting of siege operations during a battle, before 1200(?)

platform at Santa Rita in British Honduras [265]. They are relevant here because they show Mexican connexions, as do the murals of Chichén Itza, but it is a different connexion, closer to Mixtec than to Toltec sources. If the usual late dating for Mixtec pictorial conventions is untenable in the light of the long Mixtec tradition revealed by Caso's studies of the genealogical manuscripts, the inception of Mixtec pictorial conventions may go back to Late Classic times. If a date corresponding to the

tions a few 'glazed sherds' found during excavation: if these were plumbate,[58] a Toltec Maya date would be in order. On the north wall, a doorway separated eastern and western processional files of figures roped together by the wrists, as in the processional reliefs on the dais in the Mercado. Extreme contortion of the bodies, angular panels of costume, rectilinear divisions of the form, high colour in seven tones, and enumerative composition by the addition of tassels, garlands, panaches, and jewellery [265]

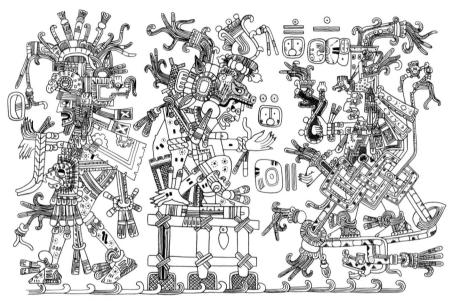

265. Santa Rita, British Honduras, wall painting with gods and calendar glyphs, tenth century(?)

Puuc period could be proved for the style of Santa Rita – but the proof is not now possible – the Santa Rita murals would be the oldest wall paintings betraying south Mexican influence in the Maya territory, rather than the most recent, as all published discussion suggests.[57]

The painted surfaces were most abundant on 35 feet of the north wall of a mound at Santa Rita. Three painted layers were noted before the paintings were destroyed. The portions copied by Gann were 4 feet 10 inches high. He men-

– these are the distinctive formal characteristics of the Santa Rita frescoes. Many reappear in Mixtec manuscripts of the type of Codex Borgia, and the murals at Mitla. The glyph-forms are Maya; the architectural profiles evoke Puuc Maya comparisons; the faces in profile, however, relate to the style of the Dresden manuscript [268], also in the rendering of eyes and hands.

Closely related to the Santa Rita frescoes are three gilded copper disks in punctated emboss-

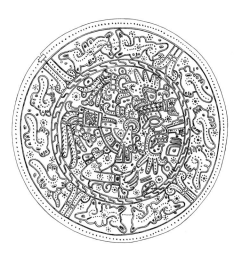

266. Deity with calendar glyphs in repoussé
gilded copper, from the Well of Sacrifice,
Chichén Itza, tenth-eleventh centuries(?).
*Mexico City, Instituto Nacional de Antropología
e Historia*

ing from the Well of Sacrifice at Chichén Itza
[266]. They combine Maya glyph-forms with
Mixtec manuscript figures and conventions.
Lothrop[59] favoured a sixteenth-century date,
but the evidence in no way precludes the Puuc
or Toltec periods. Lothrop believed that the
disks originated in southern Mexico, because
of the analysis of the metals, and that the em-
bossing was done in Yucatán.

Farther up the east coast at Tulum are sub-
stantial fragments of frescoed walls. The build-
ings, as we have seen, may well be of the Puuc
period. The frescoes are more integrally Maya
in content than those of Santa Rita. Lothrop
compares their style to Codex Peresianus [269]
and to certain painted potsherds from Chichén
Itza. He notes three stylistic groups, varying in
scale and amount of detail rather than in period.
An example is the figure of a woman grinding
corn upon a *metate*, taken from the cornice of
the Temple of the Frescoes, painted in blue and
black lines on a black ground [267]. Each struc-
tural part of the body and of the *metate* is sur-
rounded by a wiry outline, reminiscent of the

waxen filaments used in *cire perdue* metal cast-
ing. Upon the lower walls rectangular panels
framed by enlaced serpent-forms contain fig-
ures and ornaments of the same style, revealing
metallurgical connexions in the quality of the
line, and manuscript connexions in the division
of the wall by registers and compartments. The
twisted cord-like borders among them are iden-
tified by Arthur Miller with umbilical cords as
symbols of genealogical continuity, of an anti-
quity related to monumental reliefs at Izapa of
late pre-Classic date.[60]

Manuscripts

Three illustrated books of pre-Conquest Maya
manufacture survive. They are preserved in
Dresden, Madrid, and Paris.[61] All are painted
on paper made of the bark of the wild fig, sized
with fine lime coating, and pleated as screen-
folds with text on both sides. The leaves of the
Madrid and Paris manuscripts are respectively
22.6 and 22 cm. (about $8\frac{1}{2}$ inches) high; the
Dresden leaves are much smaller (18.5 cm.
high), but the Maya pages are of tall and narrow
proportions, unlike the square or rectangular
Mexican pages. Thompson regards Dresden as
the oldest of the three, because of the images of
'Toltec Maya' vessel forms. He places Paris
slightly later, and Madrid near the close of pre-
Conquest history.[62]

In all three manuscripts, extended written
statements are illustrated by panels containing
human figures, many with the attributes of
gods. The principal subject in the Dresden and
Madrid manuscripts is the augural calendar,
occupying usually one-third of a page, with
glyphs referring to the regents and auguries of
each division of the 260-day ritual calendar, as
well as naming the initial days and the durations
of the divisions [162]. Thus the writing frames
the illustration, which echoes or re-states the
gist of the writing in compact images.

These images were first classified in 1897 by
P. Schellhas,[63] who found only fifteen human
types among more than a thousand representa-
tions. Schellhas assigned a letter to each type;

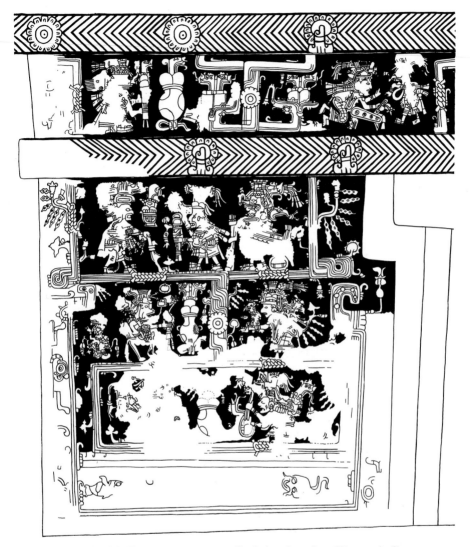

267. Tulum, Temple of the Frescoes, west passage, wall painting, eleventh-twelfth centuries(?)

with minor changes these identifications are still in use. The deities of the Maya religion are figured as patrons, regents, or prefigurations of the various time-periods. The most frequent is God B, a rain god with trunk-like nose, pendant fangs, and a knotted head-dress. He governed the second day, *ik*. The axe in his hand relates him to the head-glyph for six, where a hafted axe is set into the eye. His powers were those of germination and fruitfulness. God D, a toothless aquiline ancient, second in order of frequency, may stand for the supreme deity of the Maya gallery, Itzamna, although there is little agreement upon the definition of his powers.

God E, the youthful maize god wearing an ear of corn as a head-dress, symbolized the number eight and the fourth day, *kan*. He is third in frequency. God A, a death god, is the next frequent. He ruled the sixth day, *cimi*, and his attributes symbolize the number ten. His skeletal figure, hung with bells, was a sign of evil influence.

The manuscripts clearly belong to different regional styles and to different generations. The difficulty of dating them is further increased by

268. Dresden Codex: pages treating of the combination of 8 solar years with 5 Venus years in a cycle of 2920 days, after 1000(?). *Dresden, Sächsische Landesbibliotek*

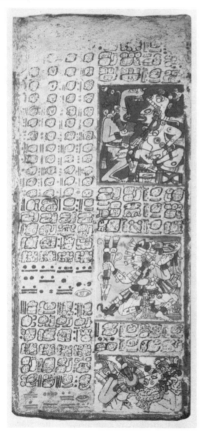

the likelihood that each is a late copy or recension of a variety of earlier material. The Dresden manuscript is closest in style to Classic Maya antecedents, although the iconography of certain portions betrays strong Mexican influences. For example, pages 46–50, treating of the cycle of 2920 days [268], relate to the combination of five Venus years with eight solar years ($5 \times 584 = 8 \times 365$). On each of the five pages a seated deity presides above a crouching warrior, and the lowest panel represents a wounded figure pierced by arrows, very much as in the south Mexican ritual manuscripts of the type of Codex Borgia.[64] Since the antecedents of that group are Mixtec, the *terminus post quem* for this iconography can be taken as about the eighth century. The absence of Toltec traits, other than the pottery forms mentioned above, strengthens a dating prior to the eleventh century. In short, the Late Classic period is probable, but the place of composition in the Maya area cannot be identified, although Thompson suggested Chichén Itzá.[65]

The Paris manuscript (known as Peresianus because of the name, *Perez*, written on it) is much damaged by the flaking of the plaster at the edges of each page [269]. The graphic style is crowded: two contrasting scales of large and small figures are surrounded by a mosaic of pebble-like glyph forms. The figures are more arbitrarily drawn than in the Dresden manuscript. There, a firm idea of the organic envelope of each figure guides the draughtsman's hand, but in the Paris pages, the huge heads, spindly limbs, and prolix attributes betray an enumerative approach from which the idea of any organic unity of the forms of bodies is very remote.

The Madrid manuscript has the coarsest and most cursive style of the three books, but it reports many details of the ritual life of its time and place in its scratchy pictures of deer-trapping [270], bee-keeping, farming, sacrifices, and warfare. Arthur Miller recently found mural paintings at Tancah on the East Coast related by style and iconography to the manuscript in Madrid.[66]

269 (*below, left*). Codex Peresianus: calendrical pages. After 1000(?). *Paris, Bibliothèque Nationale*

270 (*below, right*). Madrid (Tro-Cortes) Codex (p. 48): augural divisions of the 260-day ritual calendar, illustrated with figures of traps for deer and armadillo. *Madrid, Museo de América*

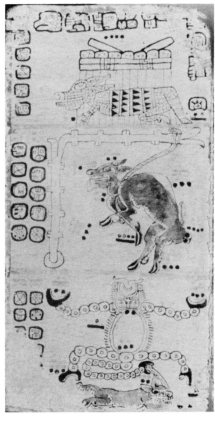

THE NEIGHBOURS OF THE MAYA

The Cordilleran highland region of Chiapas, Guatemala, and Salvador is a mountainous land bridge favouring east-west transit. Its volcanoes mark the southern boundaries of Classic Maya civilization. Repeated invasions of these highland valleys and Pacific plains from the Gulf Coast and from the mountains of Mexico occurred in all pre-Columbian periods, with the result that Maya culture was never dominant in the region, even if, from Chiapas to the Río Lempa, different dialects of the Maya language may always have been spoken.[1] The record of conquest and colonization from Mexico is apparent in the archaeology and place-names. At least four principal waves can be distinguished: an Olmec penetration of pre-Classic date; a Teotihuacán influence in Early Classic times; a Veracruz infiltration in mid and Late Classic times; and a Mexican highland conquest during the centuries after 1000.

Maya civilization, limited east and west by water, was bounded in the south by these Mexican peoples. The centripetal character of Maya history, with its displacements from the Petén to the river cities, and finally to the plains, may have an explanation in this combination of tribal and geographic limits. Maya stylistic elements, though present in the southern highland, always competed with other traditions in an uneasy coexistence.[2]

Certain essential Maya traits are recessive in southern highland art: for example, the corbelled vault appears only in underground tombs and never in free-standing buildings, where, instead, mortar beam-roofs were the rule. Initial-Series inscriptions are very rare, and monumental relief sculpture appears only sporadically. Large groups of sculpture are known at Izapa, in the Escuintla district, and at Kaminaljuyú. But on the principal sites, which can be roughly dated by relation to the main periods of Mexican and Maya archaeology, non-Maya traits predominate.

The oldest dated pyramidal platforms in Mesoamerica are in the highlands, at Kaminaljuyú, and at Ocós on the Pacific coast. At Kaminaljuyú, E III is a mound group at Finca Miraflores, in a suburb of Guatemala City. Radiocarbon dates from the excavation indicate early construction at E III 3 in the second millennium B.C., continuing until the Early Classic period in the opening centuries of the Christian era.[3] It appears that the mound was part of a long, narrow, rectangular plaza bordered by other mounds, all built of puddled and stamped clay (adobe). In the fourth stage of remodelling, dated about the twelfth century B.C., a sloping-apron moulding, with smoothed clay finish, was built,[4] which resembles the profiles of earliest lowland Maya terraces, such as those of E VII sub at Uaxactún (late pre-Classic).

Subsequent to Group E III at Kaminaljuyú are Mounds A and B, facing east and west across a plaza, at Finca La Esperanza [271]. In Early Classic times both pyramids were repeatedly enlarged, in the style of the principal pyramids of Teotihuacán, characterized by sloping talus walls and vertical tablero panels [6]. The tomb furniture likewise proves the direct influence of Teotihuacán, with cylindrical tripod vessels, many bearing stucco decoration in both Maya and Teotihuacán styles. As at Teotihuacán, the single-moulding cornice with cantilevered or counterweighted projections preceded the use of the full tablero.[5] The early stages of both pyramids were built of puddled clay. The final increments which show Teotihuacán forms are built of lumps of pumice laid in mud.[6] As early as A 2 the stairs are bordered by substantial

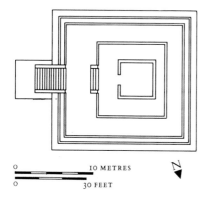

| 0 | 10 METRES |
| 0 | 30 FEET |

271. Kaminaljuyú, Mound A 7.
Reconstruction view and plan of appearance during Early Classic period, c. 300

balustrades; in A 5 an upper flight is separated from the lower one by a landing; and in B 4, an impressive fore-pyramid of two stages, surmounted by a temple on a landing [6 B], may reflect the model of the Pyramid of the Moon at Teotihuacán on a diminutive plan (28 m. or 92 feet wide, against 143 m. or 470 feet at Teotihuacán).

The most striking trait in the architectural style of all provinces of the Guatemalan highlands is the abundance of stairways, evident in Early Classic times, as during the Esperanza phase of Kaminaljuyú, and at Zaculeu in the western highlands. Balustrades of ample proportions, with an upper part of different slope ('battered balustrade'), appear at Zaculeu

in its earliest, Aztan phase,[7] which is coeval with the Esperanza phase of Kaminaljuyú. The form recurs at Nebaj in the Early Classic period, and it became a widely used type in the Guatemalan highlands by the end of the Classic era. In the lowlands at Altar de Sacrificios, where much traffic between the highlands and the Usumacinta converged, structure A II received six projecting stairways along its 110 m. façade in A.D. 711, as if to mark the trade relations of the site with the southern region by an architectural form, as at Kaminaljuyú in respect to Teotihuacán some centuries earlier.[8] When the tendency to move to hilltop sites, probably for military defence, became general, during the closing centuries of pre-Conquest history, the ornamental proliferation of many parallel and storeyed flights of stairs became the distinguishing feature of highland architecture, as at Cahyup and Chuitinamit in Baja Verapaz. Structure 2 at Cahyup [272, 273] is approached by no less than ten flights in the lower platforms, and the twin temples on its platforms have six each, totalling twenty-two distinct flights, combining with the terraced stages in an extraordinary effect of staccato rhythms and shadowed diagonals. These are the most variegated staircase compositions in ancient America: only those of Monte Alban approach their complication.

The monumental sculpture of the Guatemalan highlands betrays Mexican antecedents, both lowland and highland, in pre-Classic and Early Classic stages, yielding to Maya influences prior to a recrudescence of the Mexican style in the Toltec period.[9] These Mexican stimuli are of different sorts: Olmec, Monte Alban, Classic Veracruz, and Mixtec or Toltec strains can be defined in roughly that chronological order. Reminiscences of the Olmec style appear at Izapa in Chiapas, near the Guatemalan border, and at San Isidro Piedra Parada some 35 miles distant in south-eastern Quezaltenango. The Guatemalan example is the most unmistakably Olmec; the Izapa sculpture, though perhaps derived from the relief style of La Venta, is less obviously akin.

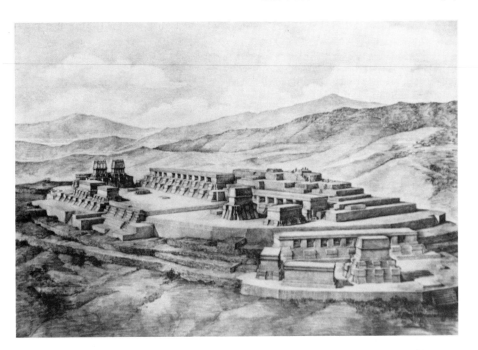

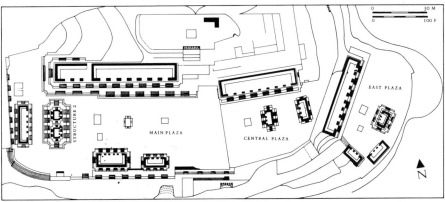

272 and 273. Cahyup, restoration view, after 1300, and general plan as in *c.* 1300

The Izapa sculptures may be divided into an indefinite number of groups, whose chronological positions are thought to occupy the period 500–A.D. 1.[10] Miles has connected Izapa sculpture with fourteen other sites, including Kaminaljuyú, Monte Alto, Abaj Takalik,[11] and Chocolá, in four divisions, of which (1) and (2) are pre-Olmec and Olmec, to 400 B.C.; (3) is a large-figure group, *c.* 350–100 B.C.; and (4) is a narrative style in the first century B.C. Divisions 1 and 2 include Stela 1 [274]; division 3 includes Stela B from Kaminaljuyú [275] and Stela 4

from Izapa. Division 4 (Izapa Stelae 5, 12, 18) has narrative and scenic reliefs evoking landscapes.[12] Stela 1 [274] has been compared to the reliefs at La Venta, as an example of late pre-Classic sculpture derived from Olmec centres of style. In addition, Proskouriakoff has suggested a connexion with Monte Alban,[13] which we would see reflected in the banded sky-symbols on the upper borders, but she was unwilling to attempt any correlation between the

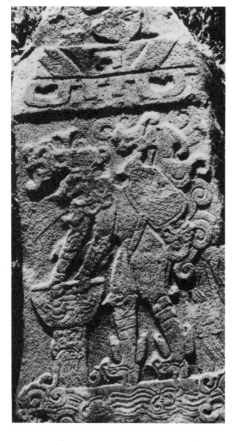

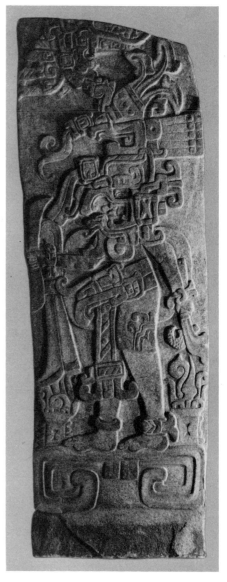

Izapa and Maya sequences beyond placing the interchange in Early Classic times. Possibly this Pacific coastal extension of the pre-Classic relief style enjoyed long regional esteem, continuing until a late date.

274 (*left*). Izapa, Stela 1, before 400 B.C.(?) Stone

275 (*above*). Stela B from Kaminaljuyú, second century B.C.(?). Stone. *Guatemala, Museo Nacional*

The next group of highland reliefs resembles not only the stelae of Monte Alban, but also the Early Classic style of central Veracruz, of which many elements occur at Cerro de las Mesas.[14] Closely similar are Stela 4 at Izapa, and Stela B at Kaminaljuyú [275]. Both have striding figures in profile, burdened by vast head-dresses, and standing upon glyph-like scrolls. These scrolls resemble the sky-symbols of certain stelae in Oaxaca [129] as well as of the tomb murals of Monte Alban [122]. A variant recurs in Teotihuacán painting: the form probably defines an Early Classic and non-Maya group. The Izapa stela relates as well to the group in the Olmec style on the same site, so that we may place it earlier than the Kaminaljuyú Stela B, of which many forms still suggest a tardy moment in Early Classic Maya art (e.g. costume elements and scroll forms), under Teotihuacán influence, e.g. stylized flames.[15]

Abundant looted examples of pottery in Teotihuacano shapes and iconography were noticed after 1970, coming from the Escuintla department between Tiquisate and the Pacific coast. Most frequent are incense burners and carved cylindrical tripods. The latter depict ball-players, executioners, temples, and deities, principally in the Teotihuacano mode, as well as occasional motifs of Oaxacan and Veracruzan derivation. Illustration 276 displays a ball-game executioner and pyre showing these inter-regional relations as analysed by N.

Hellmuth.[16] The ties with Teotihuacano designs and others indicate sixth- to eighth-century dates.

On the Pacific slopes of the central highlands many reliefs and full-round heads, used as architectural ornaments, occur in the department of Escuintla. They have long been associated with the historical Pipil tribe of Mexican origin. Thompson has placed this art no later than A.D. 900, and prior to the Toltec

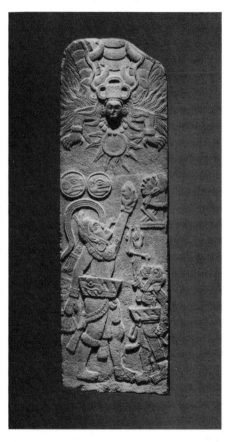

intrusions, because the Quetzalcoatl theme seems to be absent.[17] The reliefs from Santa Lucía Cotzumalhuapa [277] portray ball-game yokes in use, together with knee-guards and flagstone heads as ball paddles, as well as

276 (*above*). Cylindrical tripod vessel from Escuintla, eighth century

277 (*right*). Monument 3 from Bilbao, near Santa Lucía Cotzumalhuapa, *c.* 500–700(?). Basalt. *Berlin, Museum für Völkerkunde*

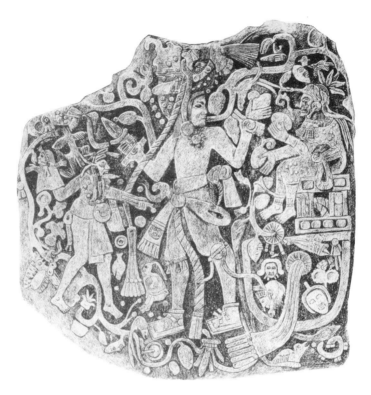

278. Monument 21 from Bilbao, near Santa Lucía Cotzumalhuapa, *c.* 500–700(?). Stone.
Berlin, Museum für Völkerkunde

showing a ritual of heart sacrifice [278]. Stone ball-game yokes and flat stone head-paddles frequently occur in the central highlands in forms like those shown in the reliefs. L. Parsons' excavations have led him to date the Cotzumalhuapa sculptures between A.D. 400 and 900, as manifestations of Teotihuacán intrusion. He divides the reliefs in two periods, the Narrative Group, corresponding to Teotihuacán III, produced in 500–700, and the Portrait Group, corresponding to Teotihuacán IV, produced in 700–900.[18]

The Cotzumalhuapa reliefs usually bear several figures spread over the surface in a regular pattern by registers, by radial pattern, or by simple left-and-right compositions lacking overlapping or other suggestions of depth. Animated motions are rendered with schematic and wooden clarity: one has the impression of unprofessional sculptors who remembered distant models without any present example to guide their work. The day-signs resemble those of the south Mexican calendar (e.g. Codex Laud) and the numeration by circles standing for units is also of south Mexican type. On the other hand, the tall, narrow panels, with a ballplayer below, raising his arm to the head of a deity above, recall the Maya codices and the formula of certain Piedras Negras stelae, which have priests in low relief on a lower level, beneath nearly full-round figures of deities in the niches above. As at Piedras Negras, the Cotzumalhuapa deities are frontally presented and nearly full-round. Underneath the deities, each of the ball-player figures stands in profile, wearing on one hand a mitten or glove which

ends in a flat stone head. Seven of these reliefs are known. The compositional formula remains identical, but the details of attributes and costume differ from one to another. Two groups are readily distinguished: those with and those without glyphs of Mexican derivation. One group, with glyphs [277], has greater figural mass, and a more decisive relation between figure and ground. The details of costume and attributes are also more clearly indicated (Monument 3). Circular Mexican glyphs characterize these reliefs, to which the flat panels of recumbent male figures also belong (Monuments 13 and 14), as well as two sacrificial scenes (Monuments 1, 11, 15, and El Baul, Monument 4). In the other group [278], the composition is carried by tendrils and streamers of an uncertain and inconclusive form (Monuments 5, 2, 4, and 6).

Among the Escuintla carvings, one group represents the heads of aged men, often with extruded eyeballs and sagging pouches set in deeply wrinkled faces. One large example resembles head-effigy vessels of plumbate ware;[19] another fragment evokes the stelae of Quiriguá, with the face in three-fourths relief against a ground of feathered parts of costume. The many horizontally tenoned stone heads can also be compared to those of Copán and Quiriguá.

The ceramic history of the Guatemalan highland contains many regional traditions. The best excavated sites are Kaminaljuyú, Chiapa de Corzo, Izapa, Iximché, Nebaj, and Zaculeu.[20] The main outlines of the sequence all confirm the interpretation of the cordillera as a land bridge between Mexico and Central America whose inhabitants were culturally separate from the lowland Maya peoples. Their most significant contributions to Maya art occurred in the Classic era. In the early phase, potters at Kaminaljuyú helped to mediate between the styles of Teotihuacán and Maya painting of the Tzakol period. Later on in the Tepeu I period, the painters of the Chixoy river in the Alta Verapaz produced the Chamá vases before 700. Finally, a pottery style of the Toltec era, called plumbate, probably originated in south-western

Guatemala or Chiapas, whence it spread over all Mexico and central America.

In the Esperanza tombs of Kaminaljuyú, the appearance of stuccoed cylindrical tripod jars of the same shape, but painted in the Maya styles of Teotihuacán and Tzakol, is recorded from the same tombs (Mounds B II and A VI) of Early Classic date. The pastes, like the fine volcanic ash temper, are identical, so that they are surely the product of the same school of potters, in highland Guatemala, just as the tall cylinder is peculiar to that region, never occurring at Teotihuacán. Kidder has also commented on the fact that these artists were capable of painting in the styles of two different civilizations, using quite different vocabularies of symbolic design, originating 600 miles apart.

Plumbate pottery has a grey, hard, and lustrous surface resembling vitreous glaze [279].[21] It is a slipware made from fine-textured

279. Pyriform vase, plumbate pottery, from the Campeche Coast, tenth century. *New Haven, Yale University Art Gallery, Olsen Collection*

clay of high iron content, fired in a reducing atmosphere at temperatures about 950° C. Its manufacture flourished between *c.* 900 and 1250. The ware marks a period of Toltec ascendancy, without being of Toltec manufacture, throughout Mexico and Central America. It is distributed from north-western Mexico to Nicaragua, and it is most frequent in western Guatemala at the Mexican border. This province, anciently known as Soconusco, may be the source of plumbate. The ware has been divided into three classes: San Juan, without effigy vessels, is the oldest; Robles, with moulded decoration, is intermediate in time and transitional in type; and Tohil comprises the elaborately decorated effigy vessels which are assigned to the twelfth and thirteenth centuries [280].[22] Only Tohil plumbate had a wide dif-

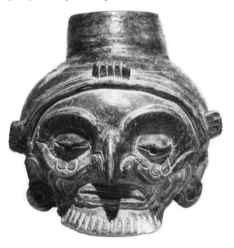

280. Head vessel, plumbate pottery, Tohil phase, before 1250. *New York, American Museum of Natural History*

fusion, and it can be recognized by elaborate form and effigy modelling, by distinctive paste and by scroll forms of decoration.

EASTERN CENTRAL AMERICA

As a geographical entity, Central America extends from Oaxaca to the northern Andes, in-

cluding both the Maya area and the non-Maya regions. The boundary between Maya and non-Maya at the Río Lempa in Salvador[23] and the Río Ulúa in Honduras is a cultural frontier. West of this line, Maya and Mexican archaeological types predominate. East of it another culture, best designated as Central American, appears with intrusions from Mexico and from the Andean region. The substructure of Central American culture is probably ancient, and it has a certain South American character, most apparent in the pottery and stonework of pre-Classic date, from Honduras to Panamá.[24] On the other hand, the principal stylistic groupings prized by collectors, such as Ulúa vases, Costa Rican highland stone sculpture, and objects of pottery and jade from the Nicoya peninsula, all betray Maya and Mexican contacts. Only the goldwork of Panamá and Costa Rica can be ascribed to Andean spheres of influence, and it reaffirms the South American connexions shown in the basic, pre-Classic manufactures of Central America. The exact composition of these shifting currents of pre-Columbian artistic influence is much less well understood in eastern Central America than in Mexico or the central Andes. South American forms were most important in early and in late times. The intervening period was under more or less direct Maya and Mexican artistic domination, probably for about a thousand years, and it was in this period that many of our examples, however insecurely dated, surely originated.

Long custom has enshrined two tribal terms in Central American archaeology: Chorotega, referring to groups along the Pacific coast of Nicaragua and Costa Rica; and Guetar, referring to the mainland regions with drainage into the Caribbean. Anterior to both the Chorotega and Guetar tribes were peoples bearing a distinctive and unified culture of Central American character. Neither term can surely be taken to describe events much older than the period of the Discovery, and it is preferable to speak of mainland and coastal regions.

What was the artistic character of this presumptive matrix of Central American cul-

ture? Certain classes of stone manufactures, and a group of ceramic traits are relevant.[25] Among stone carvings, the ornate three-legged and four-legged food-grinding tables (*metates*) are representative, and so are human figures raised upon pedestals or peg-like bases. In pottery, elaborate shapes encrusted with plastic additions recur throughout Central America as if in an early stratum. Spouted vessels, and shoe-form vessels; tall tripods or tetrapods, or pedestal bases are common; also effigy vessels with features in filleting, modelling, and incision. Animal and human forms predominate. The ornamental language, both in stone carving and in painted pottery, is a combination of bands and fields of braided, plaited, and recurving decoration possibly derived from textile techniques.

The Ulúa 'Marbles'

One instance among many of the penetration of these Central American forms into Maya territory is the case of the stone vessels found along the north coast of Honduras. They fall into two groups, eastern (prematurely identified with the historic Paya tribes) and western (centring upon the Ulúa Valley in the Maya country).[26] The eastern vessels are of porous volcanic stone [281]; the western ones are of travertine [282]. Both groups share their forms with Honduras. Vertical-walled vases with opposing handles of bird and animal shapes are the most common. The two regional varieties have different surface decorations: the Ulúa Valley 'marbles' are carved with overlapping scroll patterns, the 'Paya' vessels have only braided bands, or heavy corded decoration at the lip and base. Occasionally these braided interlaces appear in the Ulúa 'marbles'. Only the vertical-walled form, and the tripod feet of certain examples in both varieties, betray Maya and Mexican derivation. The tripod nubbin feet, which are Classic in form, usually coincide with the braided ornamental bands of Central American type. The date of the complex is Late Classic at the earliest.

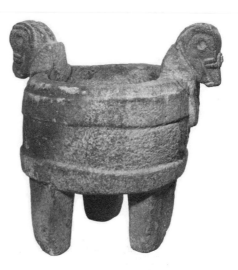

281. Stone vase from the Plantain river, ninth or tenth century. *Cambridge, Mass., Harvard University, Peabody Museum*

282. Travertine vase from the Ulúa Valley, ninth century(?). *Philadelphia, University Museum*

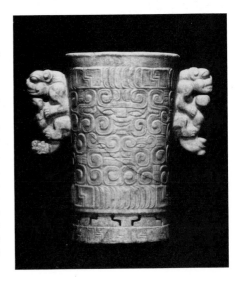

Costa Rican Mainland Sculpture

These north Honduran stone carvings can be considered together with those of the adjoining Mosquito Coast of Nicaragua, and the so-called 'Guetar' style of the Costa Rican highlands. Certainly the art of this entire Caribbean façade of eastern Central America seems connected by the production of stone vessels and instruments, carved with images of live forms and braided designs. In Costa Rica, the principal centre of these manufactures was probably around Mercedes, at the point where the highland joins the coastal plain. Statues, slab altars, and four-legged food-grinding tables in the shape of jaguars are the principal types [283].

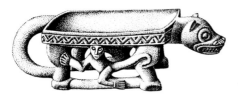

283. Food-grinding table from Mercedes, after 800

A sixteenth-century tribal name for the style has long been given as Guetar,[27] although the archaeological type-site, Mercedes, lies just outside the Guetar area. The style probably antedates by many centuries the appearance of the Guetar, a people of Chibcha language (hence of South American origin) who were in the region at the time of the Discovery. An early dating for the stone manufactures was confirmed by C14 evidence at Mount Irazú, where 'Guetar' associations occur about 1000.[28] While it is difficult to accept so vague an ethnic term as Guetar, it is also hard to discard so long-established a name. But much favours the adoption of a more descriptive geographic term, such as 'Mainland Costa Rican sculpture', distinguishing it from the art of the Pacific Coast of Nicaragua and the Nicoya Peninsula in north-western Costa Rica.

Among mainland Costa Rican sculpture, it is easier at first to see local variants than to affirm the existence of a coherent style. From south to north, at least three such local variants attract attention. At Palmar in southern Costa Rica, human figures are predominant, varying from columnar forms of igneous rock to slotted slab figures of sandstone, which often have three perforations to separate the arms and legs [284].

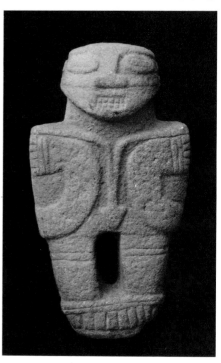

284. Stone slab figure, Diquis delta style, from southern Costa Rica, after 800.
Baltimore Museum of Art, Wurtzburger Collection

Farther north, the Mount Irazú sculpture of igneous rock from Las Pacayas is very different. Human figures still predominate, but they are carved in bloated, rotund forms with stubby limbs. The arms are curved ridges, and the legs appear as re-curved scrolls, without projections beyond the boulder-like envelope of the figure. These figures are perhaps a local variant of the

putative early style of columnar figures from Palmar. At Mercedes, farther north, in the lowland jungle at the edge of the highland meadows, lava figures of human beings and animals are abundant. The example here illustrated [285] is among the finest examples of sculptural articulation and organization in eastern Central America, with repeating rhythms of pendulous shapes and inflated limbs, which contrast with the fine cutting of the guilloche bands on the arms and flanks. The stance is free, asymmetrical, and open, with the feet connected by a stone septum to reduce the chances of breakage. Mason suggests that the columnar figures antedate the slabs, although he refrains from any closer seriation.[29] Certainly their general appearance is closer to the inception of a figural style than to an elaborate terminal phase.

Bars and connectors of stone appear again in the ornate stools and food-grinding tables excavated from the tombs of Mercedes, where their purposes is less to insure against breakage than to permit complicated sculptural variations, wherein small figures with free movements swing or balance upon the stretchers of stone or pottery. The most remarkable works are surely the tripod *metates* from the Reventazón valley north-east of San José [286].[30] The legs are enriched by acrobatic jaguars and spider monkeys balancing upon human heads. A panel in the sagittal plane is perforated with the outlines of a double-headed crocodile deity, standing upon a Mexican earth-monster, and holding a serpent in his mouth. Not the least singular trait of these *metates* is their orthogonal character as compositions in frontal plane and profile elevation, without any of the intermediary passages suggestive of rounded, continuous space. From western Panamá through Costa Rica to northern Honduras, sculptural invention and rhythmic ingenuity characterize the area.

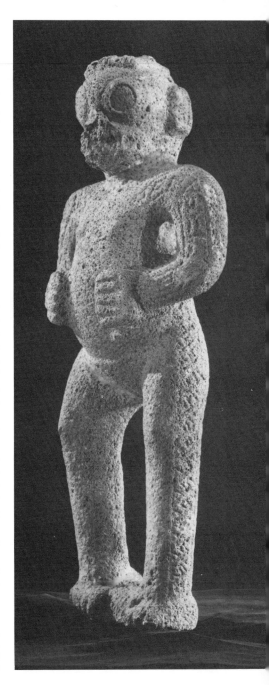

285. Monkey woman,
Las Mercedes style, after 800. Stone.
*New York, American Museum
of Natural History*

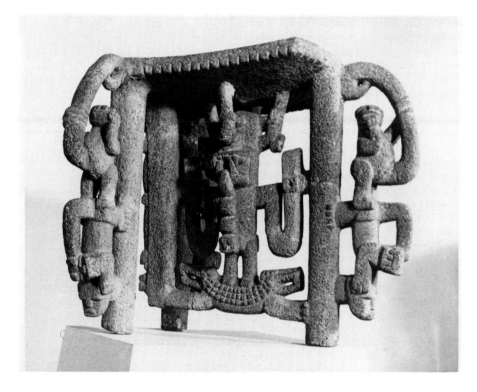

286. Stone food-grinding table
from San Isidro Guadalupe, eleventh century(?).
San José, Museo Nacional

The Pacific Coast

When we compare mainland sculpture with that
of the Nicoya Peninsula in Costa Rica, and
along the Pacific Coast of Nicaragua, the elusive
unity of the former, in respect of ingenious
sculptural complications, suddenly appears
clearly, in sharp contrast to the linear and
geometric propensities of the Nicoya sculptors.
The contrast obtains not alone for stone
manufactures, but for pottery too. On the main-
land, the predominantly monochrome vessels
are like clusters of sculptural increments, while
the Nicoya polychrome wares of north-western
Costa Rica are principally decorated with pain-
ted designs of Maya and Mexican derivation
[287]. This contrast between linear and plastic
tendencies reappears in the stone products of
Nicoya and the Costa Rican mainland. For in-
stance, the three-legged Nicoya *metates* (often

and without sufficient reason called by a tribal name as 'Chorotegan') are decorated with flat interlacing strapwork carved in basaltic lava.[31] The curved grinding surface rarely has a rim, as in the four-legged mainland types, and the occasional jaguar *metates* of Nicoya are composed of thin and elegant planes lacking the anatomical character of the 'Guetar' jaguars.[32]

The differences between the styles of the two regions may well reflect a chronological separation. The mainland monochrome pottery and figural stone-carvings are probably older than the Nicoyan types, whose date may be no earlier than the Late Classic associations indicated by Maya derivations in the painted forms and by the occurrence of Nicoya pottery in mid to Late Classic deposits at Copán.[33] That some Nicoya polychrome ware is coeval with the interlace *metates* is suggested by the occurrence of the same braided forms of ornament, identifiable as alligator-motives, in both.[34] In respect of design, a type portraying seated human beings in profile resembles south-eastern Maya pottery painting of mid-Classic date;[35] other groups (Papagayo on Culebra Bay), with a plaster-like slip and brilliant colours varnish-coated, resemble Mixtec pottery not only as to design, but also in shape and technique. Here the vexed question of Mixtec chronology arises once more, but the evidence for secure dating in Nicoya is no better than in western Oaxaca. In any event, one may bracket Nicoya polychrome ware between the ninth and thirteenth centuries, choosing the earlier date because of the tomb association at Copán, and the late one because of Mixtec affinities.

Jades. The distinctive blue-green jades of Costa Rica reflect the contrast of mainland and peninsular styles in divergent repertories of forms and techniques. The Nicoya jades are

287. Man-jaguar vessel, Nicoya polychrome pottery, after 800(?)

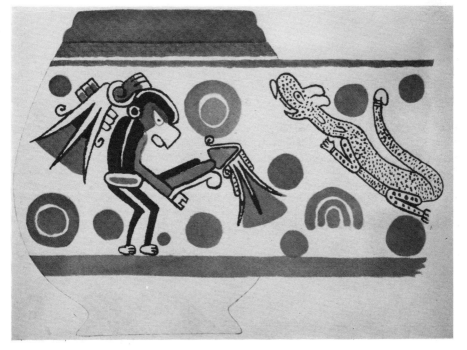

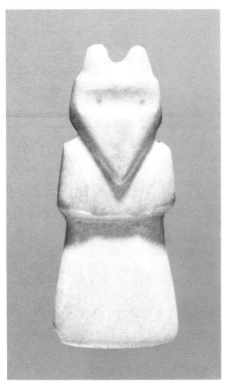

288. Jade bird celt from the Nicoya peninsula, before 500(?). *Washington, Dumbarton Oaks, Bliss Collection*

usually flat axe-blades cut to resemble human, animal, and bird forms [288]. In north-eastern Costa Rica, the region around Guápiles was another jade-working centre, where figures in profile with string-sawn, perforated inner silhouettes were the fashion.[36] The Nicoya axes are assumed to be typologically older than the Guápiles ornaments, which were probably meant to be worn only as parts of a costume, or as amulets. Their instrumental nature is much less evident than in the Nicoya axes, although a great variety of functional types can be noted in the Nicoya group. There are long and narrow blades like chisels, of differing sizes, as if for cutting different substances, and wide, spatulate blades as if for cutting meat. Some have cleft blades like those of Guerrero. Many blades have suspension drillings, so that they are often classed as amulets or pectorals, although the holes may only have served to pass a lanyard to the wrist of the user of the tool.

Monumental Sculpture. The Pacific Coast in Nicaragua is part of the same 'Chorotegan' area as the Nicoya Peninsula in Costa Rica. The pottery types are similar, although monumental sculpture is absent in Nicoya, and jades are uncommon in Nicaragua. The monumental sculpture is human statues on pedestals. Some bear animal figures on their heads and shoulders [289]. Opinion is divided on the origin of these burdened and enigmatic statues: some think they are archetypal Central American motifs; others ascribe them to South American sources. Whatever the origins, Mexican Toltec traits appear in certain figures.[37]

The statues are of two styles. One is of cylindrical shape with shallow carving and comes from the Chontales district east of Lake Nicaragua. The other is the *alter ego* or 'guardian-spirit' statues[38] from the islands and the shores of the Nicaraguan lakes. The Chontales statues distantly recall the central Andean sculpture from Huaraz, and the lake statues are faintly reminiscent of the San Agustín figures from Colombia. But Chontales figures can with equal reason be regarded as close relations of the Costa Rican mainland sculpture, and the lake figures can be regarded as South American parallels to Toltec Atlantean figures.

Distinct periods are probably present. The Chontales figures are primitive in respect of sculptural articulation. Their braided belts and guilloche bands mark them either as provincial imitations, or as archaic precursors, of the Mercedes style. The elaborate articulation and the powerful expressive character of the lake statues, however, correspond to an altogether different stylistic atmosphere of mature technical skill and of metropolitan demand.[39] The example here illustrated [289], from the north end of Zapatera Island in Lake Nicaragua, portrays a seated male. His head-dress resembles that of a Nicoya mace-head.[40] The meaning is

totally unknown, but the burdened expression of these figures crumpling beneath enormous animal charges is more than totemic or heraldic. The close connexion with burial grounds, more-

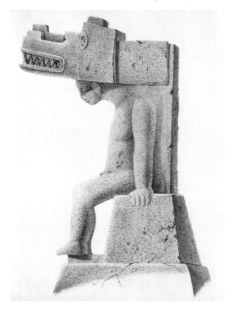

289. Zapatera Island, Lake Nicaragua, stone pedestal statue of a guardian spirit, before 1200(?)

over, is most unusual for ancient American sculpture.[41] The differences between Chontales and lake sculpture, in brief, are like the differences between mainland and coastal styles: possibly two different ethnic groups, separated by Lake Nicaragua, and by as much as several centuries, are involved.

The Styles of Panamá. The present republic of Panamá contains four main archaeological provinces. The easternmost, Darién, is artistically insignificant. The westernmost, Chiriquí, overlaps with mainland Costa Rica and with its eastern neighbour, Veraguas. Lifesize basalt pedestal figures carrying others are known as Barriles, as well as grinding tables, all prior to A.D. 500.[42] The central provinces of Veraguas

and Coclé require extended discussion, because of the separate aesthetic identity of their manufactures, and because of the exact knowledge about them provided by the admirable studies of S. K. Lothrop. Polychrome pottery, repoussé gold, and cast jewellery characterize the Coclé productions [290]. The province of Veraguas specialized in the manufacture of *metates* and open-back gold effigy pendants. Both the Coclé and Veraguas styles have strong South American resemblances and their influence, through trade, extended far to the west, into Yucatán, southern Mexico, and northern South America.

Veraguas. The volcanic stone *metates* resemble those of the Costa Rican mainland.[43] Some are three-legged, with sagittal panels of ornament under the grinding plane, and others are replicas of the 'Guetar' four-legged jaguar *metates*. Goldwork, however, was the most important manufacture in Veraguas. The effigy pendants, which influenced the Mixtec goldsmiths of Oaxaca, represent birds, jaguars, anteaters, monkeys, crocodiles, frogs, lobsters, fish, human beings, and monsters with jaguar, crocodile, or bird heads on human bodies [290]. The technique of all these pendants is *cire perdue* casting. The desired form was first built of threads and sheets of wax, then enclosed in a clay mould furnished with vents for the escape of the wax melted before the liquid gold was poured. Veraguas castings are usually flat and designed for wearing by suspension, and framed on two or more sides by rectangular flanges.

290. Effigy pendant from Sitio Conte, Coclé style, before 1000. *Cambridge, Mass., Harvard University, Peabody Museum*

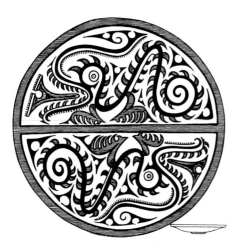
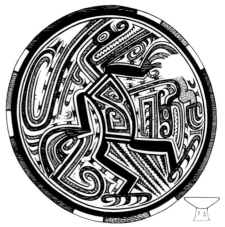

291. Polychrome pottery from Sitio Conte, Early and Late varieties (before 1000) of Coclé style.
Cambridge, Mass., Harvard University, Peabody Museum

The goldsmiths avoided the complications of full-round figures, preferring to leave the backs of the figures open. Their work gives the impression of production in series for an export market. It resembles certain South American types, especially in Colombia, both as to forms and techniques.

Coclé. All the evidence suggests that the prehistoric people of the province of Coclé were the most affluent and skilful artisans of the Isthmus.[44] The goldwork, of repoussé sheets and full-round castings, is less stereotyped, and technically more elaborate, than that of Veraguas. The polychrome pottery, painted in two or more colours on a light background, with scroll designs and animal forms of reversing-curve patterns, has a flamboyant ornateness instantly distinguishable from other American pottery. Although not without opposition, Lothrop suggested the Coclé style to have been of Amazonian origin, and affected by Central American traditions, because of the character of

the pottery design, recalling Marajó forms in the Amazon basin, and because of Colombian and Ecuadorean influences and trade relations in jewellery.

Two pottery styles can be discerned [291]: Lothrop, by grave associations and stylistic evidence, dated the earlier 1330–1420 and the later 1430–90, but radiocarbon and further excavation now place these styles between 500 and 1000.[45] He also assigned many vessels to individual artists. Early painters used a thin line and fewer colours than later ones. In the late style massive linear effects and bolder colours in balance became common. Early scrolls are generally circular; late ones are flattened or oval curves. The Coclé repertory of beasts and fish reflects hunting and fishing for subsistence. The potters and metal-smiths had a small vocabulary, but within it they enriched the images by stylistic devices which evoke North Andean art much more directly than any other sources [290].

THE ANDEAN CIVILIZATIONS

THE NORTHERN ANDES: COLOMBIA AND ECUADOR

The urban societies of the South American continent all flourished in the Andes, along a strip of mountainous coast less than a hundred miles wide, extending from the Caribbean façade of Venezuela and Colombia southward along the Pacific to northern Chile. Nomadic hunters of the southern Andes and plains and the tropical tribespeople of Amazonia, like the Indian tribes of North America, will not be treated here. In this part we deal only with those parts of the mountainous northern and western rim of the South American continent[1] where durable urban artistic traditions flourished.

The geographic conditions for civilization in the Andes are unlike those of Mesoamerica. Instead of the lakes and rivers of highland Mexico, spreading across the continent to the tropical Atlantic and the arid Pacific coasts, the Andean region is a narrow system of corridors between mountain ranges, rising abruptly from the coastal plains, and bounded on the east by oceans of tropical vegetation where the highlanders descended unwillingly. On the Pacific side major civilizations flourished in the river valleys separated by forbidding deserts. Conflict and interchange between the highlanders and the coastal peoples were continual: the Mexican parallel for the Andean situation is the relation between the coastal peoples and the central plateau dwellers. There is no South American analogy for Maya civilization, and there is no close Andean parallel for the sedentary farming peoples of western Mexico. Conversely Mexico

and Central America have no equivalent for the river-bank civilizations of the arid coast of Peru, nor have they any societies adapted to high altitudes like those of southern Peru and Bolivia.

These differences are clearly evident in the arts of Mesoamerica and the Andes. The anthropomorphic or humanist bent of all Mesoamerican expression is carried by innumerable representations of the human figure. In the Andes a humanistic style appears only intermittently, as in Colombia and Ecuador, or on the north coast of Peru; elsewhere the human figure is subjected to complex deformations tending either to the emergence of monster-like combinations or to the dissolution of the human form in geometric abstractions. Throughout the Andes a dominant concern for technological control over the hostile environment is apparent. It can be seen in great works of irrigation on the coast, or in stupendous agricultural terracing in the highlands. Andean metallurgy is at least fifteen hundred years older than that of Mexico and the Maya region. Another continuing preoccupation of the Andean peoples was to achieve political unity among widely scattered populations by religious or dynastic government. The repeated appearance of unified pan-Andean states is suggested in the archaeological record of Chavin, Tiahuanaco, and Inca art.

Favoured by this evidence of cultural unity in the relatively uniform environment of the Andes, archaeologists have been inclined since

1950 to systematize their findings in a developmental classification even more schematic than the Mesoamerican one.[2] This classification has more divisions than the Mexican and Maya schemes. For example, the term 'Classic' is not current in Andean archaeology, where its place was taken by 'Florescent', or 'Master Craftsmen', and more recently by 'Middle' or 'Regional Developmental'. On the other hand, the 'Cultist' and 'Experimenter' periods of some Andean chronologies have no counterparts in Mesoamerican terminology, where their places are still taken by ethnic terms of limited extension, such as 'Olmec' and 'Toltec'.

Some Andeanists prefer archaeological periods to cultural stages. Thus Lanning separates six pre-ceramic periods (before 9500–1500 B.C.) from six ceramic periods (1500 B.C.–A.D. 1534). His ceramic periods follow Rowe's framework of alternating Horizons and Periods (see table at foot of page) but his estimates of duration differ widely from Rowe's, especially in the Early Horizon.

There is no good reason for not extending the simpler terminology of Mesoamerica, based upon pre-Classic, Classic, and post-Classic periods, to the Andes. Some chronologies, like John Rowe's for the south coast of Peru, allow style-phases to be assigned to parts of a specific century. As such precision extends to chronologies elsewhere, it will perhaps become unnecessary to maintain the complicated and confusing developmental charts now in use for the different parts of ancient America. The scale of the present work justifies such a simplification, and the scheme has many precedents in Old World archaeology, although the transfer of the term 'Classic' from the Mediterranean world makes for confusion, especially where it refers, in Maya studies, solely to people who used Initial-Series and Period-ending dates, from the fourth to the tenth centuries A.D., as in Miss Proskouriakoff's *Classic Maya Sculpture*.

No such definition will serve for the preliterate Andean societies; but, for the sake of clarity, we shall apply the term 'Classic' to those civilizations (Mochica, Nazca, early Tiahuanaco) which existed in the same time-span as Classic Maya culture, and whose works of art occupied (as we shall see) a similar position in the history of form.

NORTHERN SOUTH AMERICA

In terms of human geography, South America is divided into the narrow Andean theatre of the urban societies, and the wide plains and rainforest of Argentina, Brazil, and the Guianas. The Andean region was densely settled, in contrast to the small and scattered population of diminutive migratory tribes in eastern South America. Northern South America reflects this division. Ecuador and the highlands of western Colombia extend the Andean cordillera. In Venezuela, a meeting of Caribbean, Mesoamerican, and Amazonian traditions occurs without spectacular objects or sites of great urban development. The system of these cultural connexions in antiquity has been compared to the letter H: the left upright connects Mesoamerica and the Andes via Central America; the right one connects the Caribbean islands and Amazonia; and the horizontal link between the uprights is Venezuela,[3] where elements of all areas intermingled. For the purposes of this book, only western Colombia and

	Rowe 1967	Lanning 1967
Initial Period	2100–1400 B.C.	1800/1500–900 B.C.
Early Horizon	1400–400 B.C.	900–200 B.C.
Early Intermediate Period	400 B.C.–A.D. 550	200 B.C.–A.D. 600
Middle Horizon	A.D. 550–900	A.D. 600–1000
Late Intermediate Period	A.D. 900–1476	A.D. 1000–1476
Late Horizon	A.D. 1476–1534	A.D. 1476–1534

Ecuador are relevant, with monumental sculpture and abundant metallurgical products, but there is little architecture, and the pottery has smaller expressive capacity than Central Andean types, being much older at Puerto Hormiga in northern Colombia (3100 B.C.) and southern Ecuador (2700 B.C.) than in Peru. Resemblances are claimed between Valdivia pottery in Ecuador and Middle Jōmon period wares in Japan: transpacific diffusion has been proposed, but opinion remains divided.[4]

COLOMBIA

Of twelve archaeological zones in Colombia only the Tierradentro zone between the upper valleys of the Magdalena and Cauca rivers has an imposing and durable architecture of rock-cut tombs [292]. The San Agustín zone farther south, near the headwaters of the Magdalena, contains an important style of monumental sculpture [293, 294]. The Calima river basin and the Chibcha, Quimbaya, and Sinú river provinces were all centres of different gold-working styles [295–302]. Tairona archaeology in the mountains of the north-eastern coast[5] shares features with both Venezuelan and Central American types.

The chronological sequence is still unsettled, although some students place San Agustín sculpture and Calima gold-work in an Early context, c. 500 B.C., possibly coeval with the Olmec and Chavín styles. The Tierradentro tombs are probably later and by a different people. Quimbaya gold-work has provisionally been fixed as of the last centuries B.C. in Colombian antiquity. Chibcha[6] and Tairona, which still existed in the sixteenth century, are classed as Late. Bennett pointed out that this arrangement, though better than none, is unsatisfactory because it provides nothing Early for some regions, and nothing Late for others.[7]

Architecture

The principal remains of ancient construction are stone streets and foundations in the province of Tairona, and the underground tombs of Tierradentro in the south. The Tierradentro tombs are oval, and the Tairona houses were circular. Bennett regards the Tairona villages as of Late construction. The Tierradentro tombs are generally accepted as of long duration. Pérez de Barradas divides them into three groups:[8] the initial group lacks niches; the intermediate tombs are painted; the last group are oval in plan, with painted walls, rock-cut piers, and stair-well chambers.

The elaborate tombs with slanting roof planes and radial niches are cut in the soft granodiorite bed-rock. The entrances are straight or circular stair shafts. The plastered walls have geometric and human figures in black, red, and orange paint. The pottery found in these tombs is unlike that of other Colombian styles. It has been compared to Amazonian types[9] (Marajó Island urns).

The tomb illustrated here [292] measures 8.35 m. (27½ feet) on the long oval axis, and 2.28 m. (7½ feet) in height. The niches are separated by pilasters adorned with geometric faces, carved in relief and painted.[10] Whether the tombs correspond, like Etruscan ones, to the domestic architecture of living people cannot be decided, in the absence of all traces of the dwellings above ground. The ovals with radial niches are superficially similar to European plans of the seventeenth century, but they bear a closer generic likeness to the organic architecture of earth and straw among West African tribes and in the South Seas. In actuality much evidence connects the Tierradentro tombs with Arawak origins in eastern South America. The shafted deep-level tombs and the geometric wall paintings, as well as the pottery types, may point in that direction.[11]

Sculpture

Adjoining Tierradentro on the south are the forested hills of a province surrounding the village of San Augustín near the headwaters of the Magdalena river. Scattered through the region [293, 294] are over three hundred and

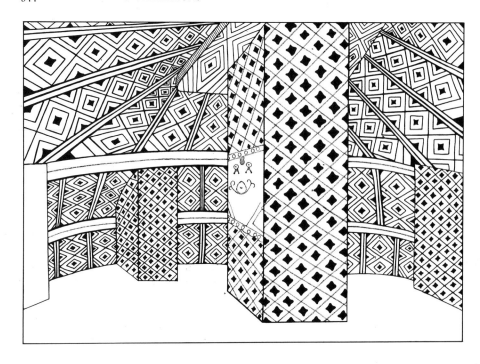

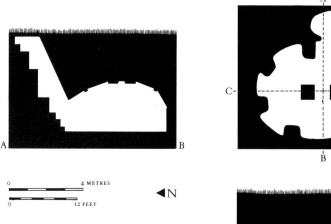

292. San Andrés, Tierradentro province, Colombia, Tomb 8, after 800(?). Perspective view, sections, and plan

twenty stone statues which served as grave markers, tomb covers, and shrine figures.[12] They represent men, animals, and monsters, in relief and full-round sculpture. The streambeds also are carved in channels and basins to form ornate biomorphic patterns of standing and running water. Because of a general resemblance to the art of Chavín in the north highlands of Peru, its date has been equated with the first millennium B.C. and with Olmec sculpture in eastern Mexico.

There is still no absolute measurement of the antiquity of these remains. The shrine sites have all been so thoroughly disturbed by treasure hunters that scientific excavation is no longer possible. Pérez de Barradas nevertheless claimed to have found stratigraphic evidence to warrant the division into initial, intermediate, and final stages of a historical development beginning long before 150 B.C., and closing about A.D. 700.[13]

As with the Tierradentro tombs, Pérez de Barradas tried a chronological sequence of sculpture based upon his classification by types. He noted three main categories: cylindrical figures; full-round figures carved in deep relief; and slab-like figures in low relief, and assumed that they appeared in this order. A standing human figure is almost invariably represented, often with the dentition of a puma. The proportions favour the head, which is a third or a quarter of the entire height, and the sculptural definition of the head is usually greater than that of the bodies.

The sculptors used three principal conventions to represent facial features. They are systems of combining the eyes and nose. One large group of figures always keeps the eyes and nose in a single flat plane, with a continuous curve outlining nose and eyes. This might be named the 'eyehook' curve [293, *above*]. The second group is more beetle-browed: the eyebrows make a continuous ridge across the forehead,

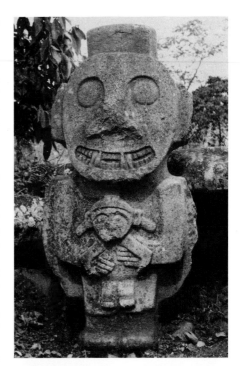

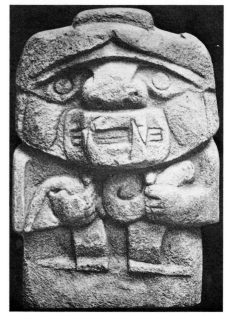

293. Stone shrine and tomb figures
from the San Agustín region in Colombia,
Mesita B, south barrow, before 700(?).
Eyehook type (*above*), and beetle-browed type

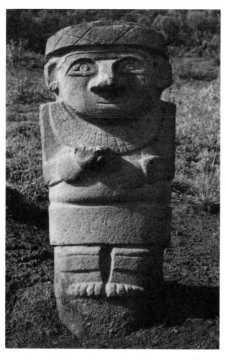

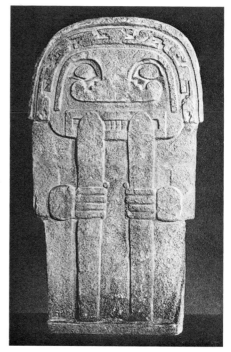

294. Stone shrine and tomb figures from the San Agustín region in Colombia, before 700(?).
(*Left*) Ox-yoke brow, Alto de los Idolos, female, and (*right*) nose-brow type, Mesita C

and from this ridge the nose is developed as an independent sculptural unit [293, *below*]. There are plain and ornate versions of the beetle-brow manner; the ornate version is like a double ox-yoke [294, *left*]. The third group reduces eyes and nose to flat relief in two planes: this device could be regarded as a variant of the eyehook style, save for the fact that the nose is so broad-nostrilled as to suggest a dish from which the eyebrows rise as opposing curves [294, *right*]. This third manner appears mainly on flat slabs.

It may be significant that each mode of treating the features occurs at a separate shrine in the region. These shrines are temple-like constructions, locally called *mesitas*, rectangular in plan (up to 10 by 15 feet), roofed by a single monolithic slab, and supported by walls, piers, or Atlantean figures. The principal statue stood near the centre of the shrine, and the whole

construction was covered with an earthen mound. The main mesitas near the town of San Agustín are three, A, B, and C. A has east and west mounds about 20 m. (65 feet) apart. B stands 180 m. (200 yards) to the north-west of A, with southern, northern, and north-western mounds. C lies 400 m. (450 yards) west of A.

The eyehook style occurs on scattered sites throughout the district, and at Mesita B more often than at Mesita A. The beetle-browed figures characteristically occur at Mesita B, the ox-yokes at Mesita A. The flat-relief (or nose-brow) faces, finally, occur more often at Mesita C. This distribution suggests the activity of different workshops of sculpture, spread out over generations, but it gives us no sure clue to the seriation of the figures.

Some are large: one in Mesita B at the north-west mound, called the Bishop because of its

mitre-like head-dress, stands 4·25 m. (14 feet) high. Their meaning is unknown. Some students have guessed that a very early lunar cult was displaced by solar worship, borne by an invading population which replaced the earlier moon-worshipping inhabitants.[14] By this supposition, the moon-people are identified with the Chavín period of Peruvian prehistory; the sun-people supposedly were the contemporaries of the builders of Tiahuanaco. Stylistic and iconographic parallels are made to support these comparisons. Colossal stone figures recur at Chavín and Tiahuanaco, and the monster with another creature in his mouth is also a central Andean theme. The *alter ego* figure or costume, as we have seen it in the lake sculptures of Nicaragua [289], occurs at San Agustín as well as in the pottery of the Peruvian coast and in stone figures from the Amazonian basin. It has also been supposed that the sculptures represent hallucinogenic visions of colossal jaguars.[15]

Metalwork

After the second century B.C., Colombian goldwork has a long history of uncertain duration.[16] Three technological stages are postulated. The earliest process was to cold-hammer and emboss the native gold found as dust and nuggets in streams and open rock faces. Colombian gold is argentiferous, but the ancient smiths never learned or cared to work silver separately. The second stage was to heat the metal until it melted: molten copper and open-mould casting were supposedly the principal achievements. In a third stage, smiths succeeded in alloying gold and copper. Called *tumbaga* or *guanin*, the alloy (ideally 82 per cent gold and 18 per cent copper) has a lower melting point than either metal in separation, and it can be hammered to hardnesses like those of bronze. This great invention has been ascribed to Colombian goldsmiths. A specimen of *tumbaga* was discovered at Copán beneath Stela H, dated A.D. 782 (9.17.12.0.0).[17] Other attainments of this stage were gilding and plating; *mise en couleur* by acids to remove the baser metal from the surface of an alloy; soldering; and lost-wax casting.

The arguments for greater antiquity than in the central Andes are weak. Silver, lead, and bronze were unknown in ancient Colombia, where the repertory is much smaller than in Peru or Mexico. Datable examples of stages 1 and 2 have never been identified. In stage 3, at least seven different regional styles have been provisionally established. The separation into regional styles and periods has been made difficult by many centuries of commercial grave-looting, and by the trading of objects throughout the Colombian Andes and into Central America. For instance, the region around Antioquia at the convergence of overland routes from the Caribbean to the Pacific was an important trading centre where Pacific salt was exchanged for highland products.[18] The shaft-graves of this region yield gold-work from nearly every province of Colombia.

Pérez de Barradas has provisionally arranged the geographic styles in two chronological groups.[19] The early one comprises the Calima, Darién, and Tolima styles; it precedes Quimbaya, Sinú, Tairona, and Chibcha. Pérez de Barradas admits that this grouping rests on 'suspicion' more than evidence. His 'early' group mainly includes embossing and the simpler castings, and the 'late' one has more complex castings and ornate filigree work. The 'late' group is supported by Lothrop's discovery of Sinú and Quimbaya gold objects in the Coclé area of Panamá, no older than 1300.[20]

The Calima Style.[21] The Calima river flows west towards the ocean, and its valley was a main thoroughfare for trade between the Cauca drainage and the Pacific Coast. Several hundred gold objects from the upper reaches of the river display a technique and style sufficiently uniform to justify a common designation, even though many different tribes during several centuries may have participated in their manufacture. Pectorals, diadems, nose ornaments, and pins are the principal items. *Tumbaga* alloys of varying ratios between gold and copper are the rule. The metal was hammered into sheets

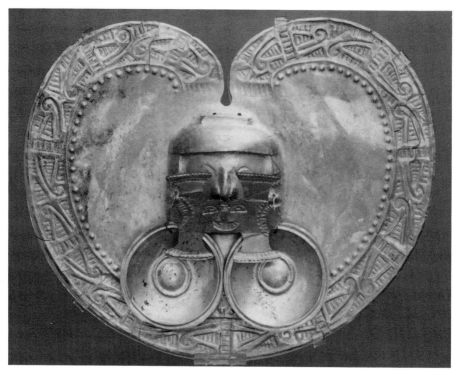

295. Gold pectoral from Colombia, Calima style, 100–500(?). *New York, Metropolitan Museum of Art*

of ornate profile, or cast by the lost-wax process into pins with minute figures on their heads. Pérez de Barradas suggests that the Calima style is the oldest in Colombia.[22] Among resemblances to the sculpture of San Agustín he noted two important facts: the San Agustín statues wear head-dresses and jewellery of Calima types; and many Calima pinheads are replicas of a San Agustín figure with rectangular mouth and eyes. The contemporaneity of the two styles seems assured, but their absolute date remains uncertain. Pérez de Barradas[23] fixes the high point of Calima production about 700, and its disappearance about 1000.

The meaning of Calima shapes is enigmatic. A typical form is the kidney-shaped pectoral [295]. A standard element in many graves, it usually has a face with closed eyes, hammered up from the sheet metal, wearing a head-dress like that of certain San Agustín statues, and adorned with large ear-rings and an H-shaped nose ornament. This nose ornament may represent the skin of a puma: at its centre a simple feline mask is embossed, often flanked or surrounded by clusters of dots like spotted fur. The closed eyes of the mask are often rendered by the beetle-browed convention resembling an ox-yoke [294, *left*], which we have seen in San Agustín statues. Calima smiths treated gold as if it were leather, as a pliable and impressionable substance, normally to be embossed over hard moulds of stone or wood, and repoussé with dies and punches.

The Calima pins with heads representing

men and animals are about 12 inches long. These *tumbaga* pieces are lost-wax castings with soldered additions of intricate detail on a minute scale, on figures about an inch high [296].

296. Cast gold pin-head showing a monkey eating a snake, from Colombia, Calima style, 100–500(?). *New York, Metropolitan Museum of Art*

Frequently shown is a masked figure wearing a domed face-cover with slotted apertures like a Hopi katchina. On his back a four-footed animal (a puma?) crouches in the posture of the representations of animal totems at San Agustín and in Nicaragua.

The Darién Style.[24] The Atrato river empties in a tropical flood plain on the Caribbean side of the base of the Isthmus of Panamá. *Tumbaga* casts of bat-headed human figures [297] are the only type now assigned to the region. They resemble a bat-figure occurring in Calima graves. The two hemispherical ornaments in the head-dress represent large bat's ears. The objects in the hands are rattle gourds, and the filigree scrolls flanking the head represent wings. The conversion of human forms into

planes and scrolls is a Darién characteristic. It also reflects a simpler casting process, possibly in an open stone mould, with extra planes added by soldering. Another example of this type was

297. Gold casting of a man with bat attributes, from Colombia, Darién style, after 1200. *New York, Metropolitan Museum of Art*

dredged from the Well of Sacrifice at Chichén Itzá. It is a knife rather than a pendant. Lothrop interpreted it as a 'flute-playing bird-god'.[25]

The Tolima Style. At the latitude of Cali, but on a western confluent of the Magdalena, lies the gold-working province of Tolima, near the headwaters of the Rio Saldaña. Metallic copper was abundant in the region, and it was exported to the Cauca basin – a region poor in copper – for use in *tumbaga* alloys.[26] The typical product is a flat casting of angular forms [298] based upon birds, reptiles, and animals. Heavy cast-filigree increments sometimes adorn the faces. The profiles of bodies recall ideographs and the abstractly expressive designs of contemporary painting. Pérez de Barradas notes that no Tolima pieces occur in Calima territory, but

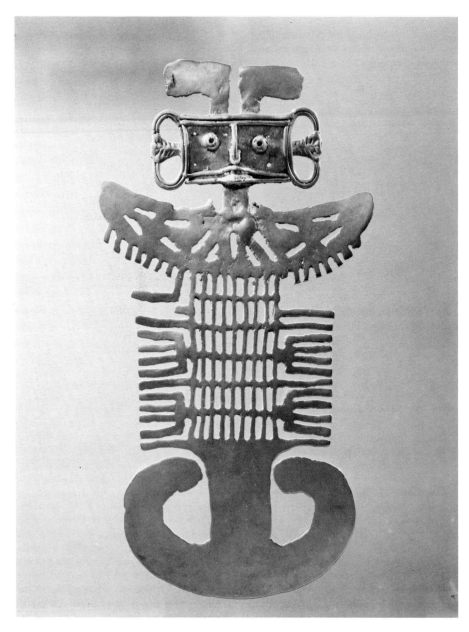

298. Zoomorphic knife from Colombia, Tolima style,
before 250(?). Cast gold with filigree additions.
Philadelphia, University Museum

that some of the finest examples of the Calima style appear on Tolima sites.[27] If the two styles are coeval, this distribution probably marks a one-way trade relation from metropolitan to provincial centres.

The Sinú Style. The valley of the Sinú river lies east of the Atrato. *Tumbaga* castings of pairs of birds with open backs like Veraguas forms are known, as well as flat filigree nose-bangles and pendants. These bangles may have been cast in moulds shaped on basket-work models.[28] The Sinú smiths also used carved stone reliefs for repoussé patterns.[29]

The Quimbaya Style. Long custom rather than a firm connexion between tribe and archaeology warrants the continued acceptance of this vague ethnic term. It is usually extended to include the makers of the celebrated cast-gold figures of seated and standing men and women, discovered at the end of the nineteenth century in the graves of the region between Cartago and Manizales. The Quimbayas were there when the Spaniards arrived, but the style appears throughout the middle Cauca valley to Antioquia, where other tribes lived. Quimbaya finds in Panamanian graves suggest a date before 1000 for the florescence of the style of the Coclé region.[30]

In Colombia nearly all non-Chibcha gold objects used to be assigned to Quimbaya smiths until Pérez de Barradas identified the Calima embossed style. The Quimbaya group is now limited mainly to heavy castings with smoothly rounded surfaces [299]. The helmets, bottles, and statuettes in the Museo de América at Madrid are typical instances.[31] Other Quimbaya manufactures are cleft nose-ornaments designed to clasp upon the septum, in crescent, triangle, scalloped, and elongated shapes. There are also pectorals, bells, bracelets, beads, and pins, masks, tweezers, and diadems.

The statuettes were cast by the lost-wax process in moulds of clay and charcoal,[32] with hands and feet cast separately and soldered to the body. The forms of the bodies have an inflated or bloated appearance. Indeed, the weightless and sinuous Quimbaya surfaces

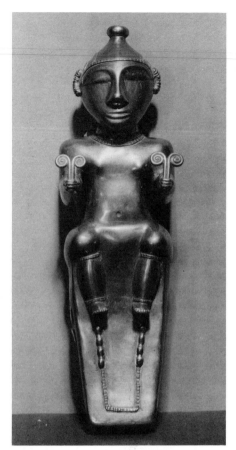

299. Seated figure from Colombia, Quimbaya style, before 1000. Cast gold. *Philadelphia, University Museum*

recall the undulant tubes of Hindu figural sculpture,[33] but the resemblance is merely technical, arising from the casting process rather than from contact between peoples. The nature of lost-wax casting required that the entire envelope be designed for pouring, and the molten gold had to find its way by gravity into all the crannies of the mould. The smooth portions of the bodies, the partly spherical joints, and the tube-like limbs all record these technical conditions for hollow casting under primitive circumstances.

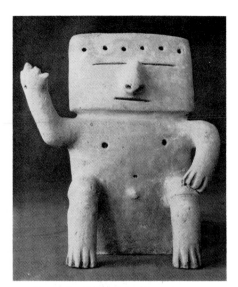

300. Pottery figure from Colombia, Quimbaya style,
before 1000. *Baltimore Museum of Art,
Wurtzburger Collection*

The stiffly symmetrical postures and the absence of any suggestion of movement can be connected with regional traditions of manufacturing pottery figurines,[34] such as the planiform seated images made by Quimbaya potters [300]. The hands and feet are diminutive; the surfaces have minimal variety; the contours are closed; and the expression is dead, as in the gold statuettes with closed slit-eyes and the posture of *rigor mortis.*

Among the Quimbaya statuettes, two types may be noted. One, a seated female of large-headed and sausage-limbed proportions, is represented in Philadelphia. The arms are diminutive, and the eye planes immense. The Madrid figures, of the second type, are more naturalistically proportioned: the limbs are longer, the expression approaches a smile, and the parts of the body are connected in anatomy as well as in the flow of molten metal into the mould. One figure of large-headed type (now in Berlin) reportedly comes from Manizales in the northern section of the Quimbaya territory. The

Madrid figures were all found near the village of Finlandia in the southern section. Possibly the two types correspond to different geographic schools of Quimbaya gold-work, and to different generations. If the latter is true, the first group may be the older one on the usual assumption of typological progression towards anatomical fidelity.[35]

The Quimbaya tribes probably came from the north, displacing an older population in the Cauca Valley.[36] Certain resemblances among Tairona, Darién, and Quimbaya pieces support the idea. For instance, a pendant in the Cleveland Museum has the double-knob head-dress of a bat figure in the Darién style [301], the spread-eagle and squatting posture of a Tairona pendant, and the facial features of Quimbaya work. Tairona gold-work, in the north-eastern corner of Colombia, in turn resembles Venezuelan productions. Both types are extremely rare, and it is more likely that Quimbaya, Tairona, and Venezuelan castings all belong to the same time-level as different styles, than

301. Amulet from Colombia, Quimbaya style,
before 1000. Cast gold. *Cleveland Museum of Art,
Norweb Collection*

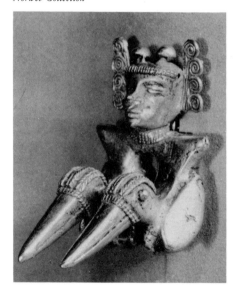

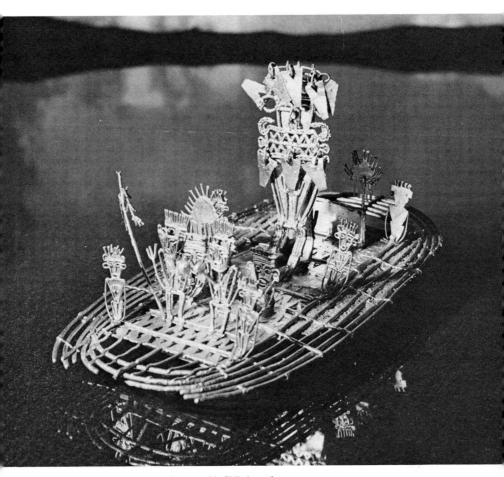

302. Dignitary and companions on raft, cast gold, Chibcha style,
after 1200. *Bogotá, Museo del Oro*

that the northern ones should be ancestral to
Quimbaya work. But in the absence of any firm
chronology, all remarks on sequence are guess-
work.

The Chibcha (also *Muisca*) *Style.* The *tum-
baga* castings from the region around Bogotá[37]
are the most planiform of all Colombian
productions. Typical forms are elongated
isosceles triangles of slab gold, with human
features and costumes rendered by lost-wax
casting upon moulds of waxen filaments. An

unusually complex example in Bogotá shows a
dignitary wearing a diadem, ear spools, and a
necklace, all indicated by cast filaments [302].
He is seated upon a litter or dais made of braided
filaments, in a raft with many attendants. These
figures, called *tunjos*, are traditionally believed
to represent certain Chibcha rulers, and to have
served as cult offerings. They were in manufac-
ture at the time of the Spanish Conquest among
people whose historical memory embraced only
about fifty years.

THE PACIFIC EQUATORIAL COAST

An immense artistic region extends along the Pacific coast between Tumaco in Colombia and Guayaquil in Ecuador. Its regional components in the provinces of Tumaco, Esmeraldas, Manabí, and Guayas are here treated together because of the occurrence of a distinct figural complex with striking Mesoamerican affinities. Indeed the Pacific equatorial coast is the southernmost frontier of the traditions of Mexican and Central American art with affinities also to the art of the central Andes.[38]

303. Solid pottery figurines from Valdivia (Ecuador), phase 4, after 2200 B.C. Frontal (*below*) and dorsal (*opposite*). *Washington, National Museum of Natural History*

Influences from the central Andean styles are late and few, indicated by such forms as divergent double spouts connected by strap handles, double vessels and house vessels, negative

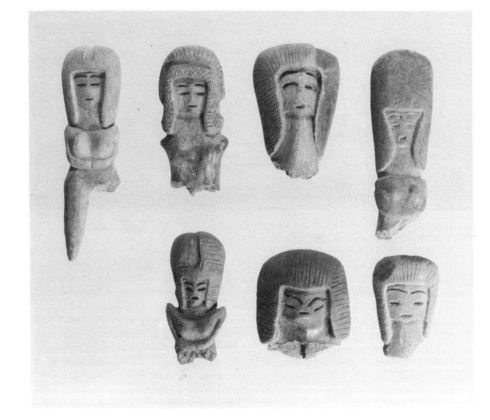

painting, the syrinx or Pan pipe, and the representation of pathological deformations and erotic scenes.[39] The latter, however, are also present in Late Classic Maya art. Other pottery forms relate to types prevailing north of the Isthmus of Panamá, such as flat stamps, cylinder seals, biomorphic figurines, and ocarinas. Certain themes, such as persons strapped to their beds, evoke west Mexico. The stone sculpture of Manabí includes seats borne upon the backs of crouching human beings, as well as Atlantean figures, to which the closest parallels are Central American and Toltec Maya.

The chronology of the Ecuadorean coast unfolds in five archaeological provinces with the usual early, middle, and late developmental periods.

On the Guayas coast at Valdivia, pottery dated about 3000 B.C., decorated by incised and punctated cuts, is accepted as among the oldest ceramic traditions in America.[40] There are equally old parallels at Puerto Hormiga in northern Colombia. Without accepting the thesis of Japanese Jōmon origins for the pottery, Gordon Willey suggests that this early tradition 'became the source for the development of pottery for most of the Americas'. Valdivia Phase pottery figurines after 2300 B.C. have punctated features on heads with large striated hairdresses [303]. These continue a prior stone tradition before 2300 B.C. of figurines shaped from pebbles and slabs, some with separated legs and incised faces, which bring to mind Mezcala blades from Guerrero in a later era (p. 190). In the other

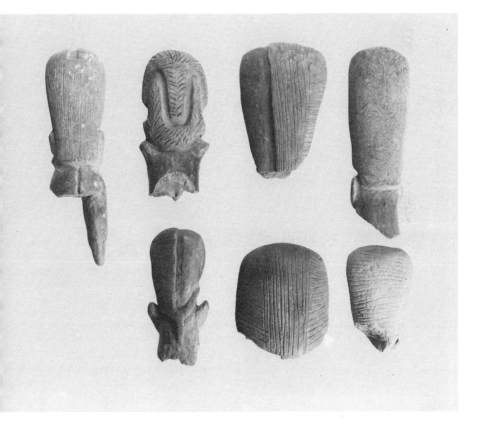

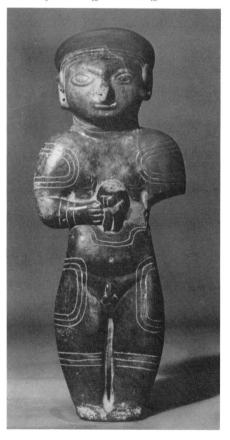

304. Red-ware whistle figurine from Guangala, Ecuador, before 500(?). *Cambridge University Museum of Archaeology and Ethnology*

direction to the south, the stirrup-spout bottle of Chavín and Mochica made its earliest appearance in southern Ecuador in the Machalilla phase between 2000 and 1500, together with pottery figurines having coffee-bean eyes. Chorrera pottery before 500 B.C. shows Mesoamerican contact in its figurines, iridescent painting, obsidian flakes, and other traits resembling those of the Ocós phases on the Pacific coast of Guatemala (see Note 38).

Guangala pottery, first identified by G. H. S. Bushnell, appears between 500 B.C. and A.D. 500. In the opinion of J. Jijón y Caamaño,[41] the Guangala corresponds to the Mochica style in Peru, and Manteño to Chimu. In effect, late Guangala objects display an advanced style of modelling, comparable to the mid-Classic Maya art of figurines, and to early Mochica attainments in Peru. Such figurines [304] are easily recognizable: they are usually whistles made of a dense and fine burnished red ware, scored by incised parallel lines in rectangular patterns near the joints of the body. Similar figurines have been found in Manabí and Esmeraldas,[42] but not in Tumaco. Mould-made figurines [305] are common, especially in Esmeraldas and Tumaco, where they are probably later than the hand-made Guangala examples, corresponding perhaps to the Manteño phase, from A.D. 500 to the Conquest.[43] The use of the mould transformed the craft, not only by extreme complication, but also by coarse production in series. The Guangala and Manteño types in Ecuador correspond roughly to the stages before and after the appearance of the moulding technique. The published collections of Manabí and Esmeraldas objects, however, contain numbers of figurines with 'coffee-bean' eyes. The type is common in Mesoamerica, and rare in the central Andes. Early figurines of Guangala type have these eyes.[44] Perhaps some Manabí and Tolita examples from Esmeraldas are pre-Guangala.

Among these types which may be pre-Guangala appear some of the finest productions of the art. A head in Paris from the Ostiones district in Esmeraldas can be ranked among the more expressive and harmonious of ancient

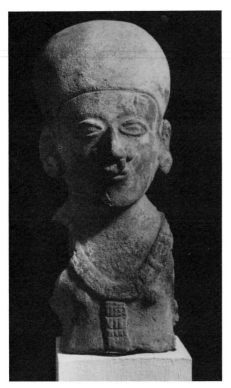

American figurines. The rear of the head shows a tabular deformation, associated with Guangala types and with examples having coffee-bean eyes. Shells cover the ears. The straight profile and the huge upper eyelids resemble Gulf Coast faces of the 'smiling' type. In expression this type [305] also recalls the withdrawn, remote Quimbaya statuettes of gold.

Stone sculpture of monumental character appears during this late period only in Manabí [306, 307]. Typical[45] slabs are carved with frontal human beings framed by borders of repeating textile-like patterns. Both these slabs and the simpler stone chairs may be pre-Manteño. The ornate stone chairs are presumed by Bushnell to belong to the Manteño period. The latter are deeply concave; the plain ones have shallow seats. A slab illustrated by Saville[46] shows a woman seated with splayed

305 (*left*). Pottery figurine from the Esmeraldas coast, Ecuador, after 1000(?). *Brooklyn Museum*

306 (*below*). Stone seat from Manabí, Ecuador, after 500(?). *New York, Museum of the American Indian*

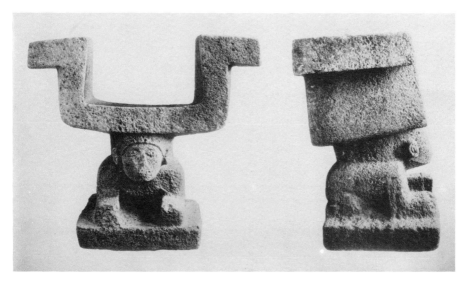

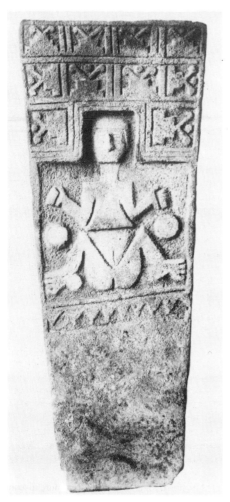

tral highlands a long stratigraphical sequence spans 3500 years (Early, to 500 B.C.; Middle, to A.D. 500; Late, to Spanish discovery in 1532).[47] As Donald Collier has put it, Ecuador forms with Colombia a north Andean unit, only slightly connected with the central Andes under Inca rule.[48]

307. Stone slab carved in low relief from Manabí, Ecuador, after 500(?). *New York, Museum of the American Indian*

legs upon a shallow throne, in an 'obstetrical' posture. Both slabs and chairs were found in enclosures marking the boundaries of dwelling compounds.

The highland of Ecuador is divided into northern, central, and southern groups, with Colombian affinities in the north, and Late Peruvian connexions in the south. For the cen-

THE CENTRAL ANDES: EARLY NORTHERN PERU

The Pacific Coast and the highlands of Peru, together with the Bolivian plateau, compose the central Andes. Cajamarca in northern Peru is isolated from southern Ecuador by several hundred miles of forested mountains and desert coast. On the east the tropical forests of the upper Amazon hem in the culture of the central Andes, and on the south the Atacama desert separates it from southern South America. From Ecuador to Chile, the central Andes extend for over 1000 miles, in a strip ranging from 50 to 250 miles wide. Here many interrelated civilizations all share a common historic tradition,[1] quite distinct from those of lowland South America and the northern Andes.

Central Andean life was predominantly urban, differing from Mesoamerica by the early importance of metallurgy and weaving. Building in the Andes lacks the spatial complexity of Maya and Mexican architecture. No system of writing, other than knotted string records, is known, unless Larco's hypothesis, that the marked beans of the north coast constituted writing, be accepted.[2]

For our needs the clearest division is by northern, middle, and southern regions. Northern Peru is separated from middle Peru along a line perpendicular to the coast at the Huarmey river. A similar line perpendicular to the coast just south of the Cañete river divides central Peru from the southern region, which includes parts of Bolivia. Northern Peru, like the rest of the central Andes, has a coastal desert interrupted by short rivers draining the western slopes of the maritime Cordillera. Beyond it are the Black and White Cordilleras, making three parallel chains with isolated highland basins scattered among them.

In the lower half of northern Peru, through the department of Ancash, the Santa river flows north between parallel mountain chains in a long valley and drains suddenly, at right angles to its upper course, into the Pacific. On the east, and parallel to the Santa, is the Marañón river, a tributary of the Amazon. The Santa river is the centre of a cluster of valleys where civilizations of the early period flourished. From its western mountain boundary, the Nepeña, Casma, and Huarmey rivers flow into the Pacific. Between the Santa and the Marañón stands Chavín de Huántar, the type-site for the most widely diffused Peruvian style of the early era, prior to the time of Christ. Its home territory coincides with the modern department of Ancash. Here are the most abundant and imposing traces of the Chavín style; north and south of Ancash, it is more scattered and sporadic.

The upper half of northern Peru, towards the Equator, contains the most important remains of two principal later stages of cultural development. Between the Santa and the Chicama rivers is the seat of the Mochica style, sometimes called Moche after the type-site near Trujillo. Mochica is coeval with Classic Maya art. Later on, and coeval with the Toltec rule in Mesoamerica, the Chimu dynasty established a powerful state in these same valleys. Its influence is apparent in the art of the northern valleys as far as Piura and Chira.

The north highlands were even more discontinuously settled than the coast, in basins about 200 miles apart, separated by mountain ranges and barren plateaus. Communication was difficult and infrequent, and the dwellers in each were more likely to go to the nearest coastal valley than to adjacent highland basins. The upper Santa river forms such a basin, called the Callejón de Huaylas. It is the least inaccessible. The others surround Cajamarca, Huamachuco, and Huánuco, which connect with Pacasmayo, Chicama, and Paramonga on the coast more readily than with one another.

In brief, the lower north coast harboured the oldest remains of monumental art in Ancash. The upper half was the home of the Mochica peoples in Classic times, and of the Chimu urban state after 1000. The question of the exact origin of the coastal styles is still unsolved.

Kotosh in the central highlands, on the eastern isotherms of the upper Huallaga between highland and rainforest, received the Chavín cult about 900 B.C., and Chavín itself is probably junior to Cerro Sechín on the central coast. But Kotosh itself has structures far older than anything at Chavín. The third rebuilding [308]

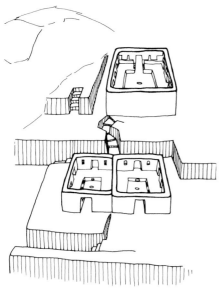

308. Kotosh, Templo de las Manos Cruzadas (*above*) and Templo Blanco (*below*), *c*. 1450 B.C.

is dated (c14) about 1450 B.C., and the oldest structure, with a relief in stucco showing crossed human forearms and hands, may date to about the appearance of pottery in the upper Huallaga *c*. 1500 B.C.[3] This is much later than the oldest known ceremonial architecture of the central coast at Chuquitanta (2000–1800 B.C., p. 411). Pottery in Peru, to present knowledge, is oldest (1800 B.C.) on the central coast and in

Ancash. It may reflect older origins in northern Colombia (3100 B.C.) and southern Ecuador (2700 B.C.), for it displays several traditions in its earliest Peruvian appearances. Much later the resemblances between the Olmec art of Tlatilco in the Valley of Mexico and the coastal Chavín style in Peru suggest but do not prove the thesis of connected traditions during the first millennium B.C.[4]

Huaca de los Reyes [309] in the Moche valley displays a symmetry of plan more rigorous than anything else in ancient America.[5] Only La Venta in Mesoamerica [66] is comparable. La Venta is far smaller and simpler, lacking the triple colonnaded propylaea, but having ground plans resembling geometrical jaguar masks. The radiocarbon dates span 1730 to 850 B.C., suggesting a pre-Chavín period for the architectural plan. The clay sculptures of large heads and standing figures resemble Punkurí, Moxeke, and Cerro Sechín more than Chavín de Huántar.

PRE-CHAVÍN REMAINS IN THE NORTH

Radiocarbon dating for the first appearance of the Chavín style in the Virú Valley places it in the ninth century B.C. at the latest.[6] It intruded upon the remains of an ancient fishing village near Guañape, where pottery had been made since about 1225 B.C. Before that, the radiocarbon dates for pre-ceramic coastal villages go back to 2700 B.C. at Huaca Prieta in the Chicama Valley. The beginning of agriculture in the region has been fixed at about 3000 B.C.

Huaca Prieta is a habitation midden 125 by 50 by 12 m. (400 by 150 by 40 feet) deep, made of refuse, laid down by fishing folk at the rate of 3 feet each century from 2500 B.C. until 1200 B.C. After 2000 B.C., they excavated their dwellings in the rubbish of previous generations. They lined the rough square or oval rooms with beach pebbles, and they roofed them with beams of wood and whalebone. These few hundred families made no pottery, but they grew cotton, beans, and peppers, and they made simple patterned-warp cloths of brown and white cotton, sometimes dyed blue and rubbed with red.

309. Huaca de los Reyes, Moche Valley, plan,
before 850 B.C.

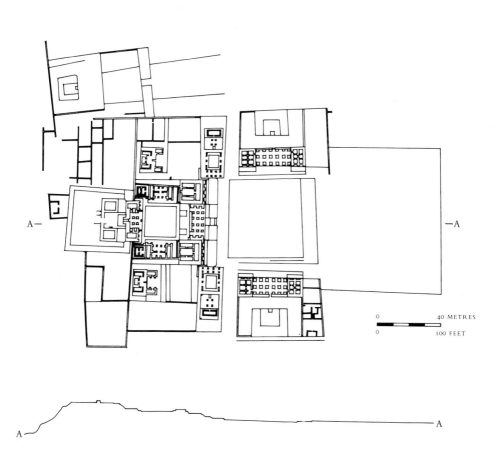

310. Near Huaca Prieta, Chicama Valley, excavations in house remains of *c*. 800 B.C., showing wall of conical adobes overlying one of cylindrical adobes

Similar middens of pre-ceramic date have been discovered in the Virú Valley and south of the Nazca Valley.[7]

In the Chicama Valley near Huaca Prieta are ruins of pre-Chavín date [310]. The pottery is like Early Guañape, but it occurs in houses with walls above ground, made of stacks of cylindrical and muffin-shaped adobes. The interstices between the upright cylinders were filled with mud. Large rectangular adobes laid on edge appear as early as the pre-ceramic levels at Guañape. Hence the cylindrical adobes, both tall and flat, may mark the transition from pre-ceramic villages to the corn-growing, pottery-producing society of about 1500 B.C. Later on, in the ninth century, conical adobes became standard on the coast.

EARLY ANCASH ART

The Chavín style is named after the type-site at Chavín de Huántar in Ancash, on a small tributary of the upper Marañón. The department of Ancash has important Andean buildings of pre-Classic date, some as old as 2000 B.C., like Las Haldas or Culebras in the lower Casma and Huarmey valleys, where maize was grown in the period 2500–1500 B.C., before pottery made its appearance.[8] Major monumental architecture, however, began in this region much later, in a group of sites restricted to the Casma and Nepeña Valleys. This architecture exhibits a style typified by Cerro Sechín, which is probably older than the other group, represented by Chavín de Huántar in the highland. It is here

assumed, for reasons set forth below, that Sechín preceded Chavín. The Chavín style in turn falls into early and late phases, spanning an extremely long period, so that the sequence of Early Ancash styles, for our purposes, may be summarized Sechín, Early Chavín, Late Chavín. In current use, however, Sechín and Chavín are not separated chronologically. The term Chavín has always been over-extended. Since 1919 it has come to mean less and less in an ever-widening circle: a style of art, a period of time, a 'horizon' or archaeological marker, a 'culture', and even an 'empire'.[9] G. Willey has criticized these extensions. He restricts Chavín to a stylistic definition and to an iconographic tradition, both related to a religious system of early date in the central Andes.[10] This religion centres upon the worship of feline and other monsters symbolic of natural forces, among villagers possessing maize agriculture, carved and incised pottery, weaving, and early metallurgy. The style, the iconography, and the functional setting are roughly analogous to those of Olmec art in Mesoamerica.[11]

Some dated material comes from the Chicama Valley, where a roof timber associated with Chavín-style pottery and corn agriculture gave a radiocarbon date of 848 B.C., \pm 167 years.[12] A terminal date can also be offered. Fragments of the style and the iconographic tradition persisted in Mochica art, until at least about A.D. 500. At Chavín proper, furthermore, the ornamental style shows relations with the Nazca region which can now be ascribed to the sixth century.[13] Thus Chavín art is a north Peruvian phenomenon, with occasional manifestations in central and southern Peru, as at Ancón and Paracas.[14] It endured at least thirteen centuries as a recognizable constellation of form and meaning.

The architectural forms are grandiose terraced platforms. The sculptural repertory includes full-round and relief carvings, based upon a few ideographic ciphers drawn from feline, reptile, fish, bird, and human figures. These are compounded in monstrous hybrids such as a bird's wing with tiger's teeth at the base of each feather [319]. Embossed gold objects bearing Chavín forms are possibly the earliest metal products in the New World.[15] The principal remains of the Chavín style in Ancash are at Cerro Blanco in the Nepeña Valley, and Chavín de Huántar.

Another style, more closely bound to visual images and more generous in sculptural expression, appears at Cerro Sechín in the Casma Valley, and at Moxeke and Punkurí in the Nepeña Valley. Its date is still uncertain. All students agree that the Nepeña Valley contains Chavín manifestations, but Larco regards it as the most ancient of Chavín territories, while Tello considered both Nepeña and Casma as provincial manifestations of an earlier highland style visible at Chavín de Huántar.[16] Strong and Evans support Larco's opinion, giving priority to the coastal appearances of the Chavín style, and Lanning concurs in believing Sechín to be the most likely ancestor of the Chavín cult.[17] In either case two main phases of Ancash art can be defined. One includes Cerro Sechín [311, 312], Moxeke, and Punkurí. It has powerful sculptural forms, close to natural appearances. The other stage is represented both at Cerro Blanco in the Nepeña Valley [323] and at Chavín de Huántar, by linear designs in dense symbolic compounds. Many centuries probably separate the two eras.

Cerro Sechín

Cerro Sechín is a granitic hill dominating the lower Casma Valley at the confluence of the Sechín and Moxeke rivers.[18] It was fortified in antiquity with numerous walled enclosures surrounding the dwellings and temple platforms. Near each enclosure is a cemetery. The several settlements, connected by paths, were furnished with water from reservoirs and aqueducts. Tello considered them the dwelling compounds of the various lords of the valley fields. They lived on these barren slopes not only for security from abrupt floods and from invasion, but also to reserve the precious arable flood plain of the valley for agriculture. The largest compound

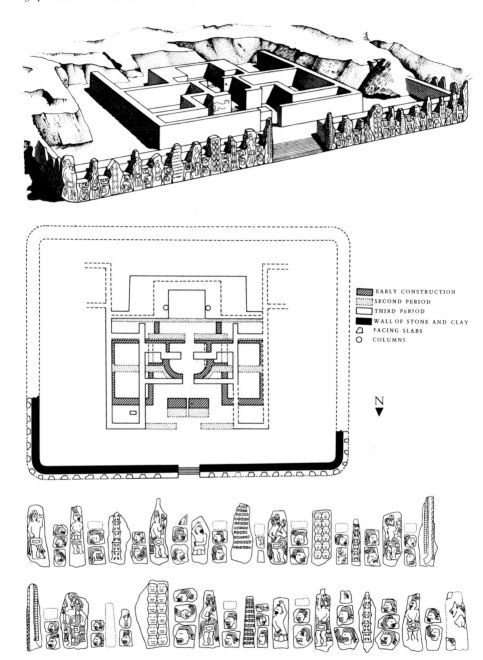

311 and 312. Cerro Sechín, temple platform, before 900 B.C.(?).
Perspective section and plan and orthostatic reliefs re-used in the revetment

lies on the north side of the hill, with the temple platform [311] at the foot of a bowl-like slope. The platform was faced with dressed and carved granite slabs [312], brought from an older construction farther down the slope, which was covered by alluvium during an ancient flood before the end of the Chavín style.

The slabs may well be the oldest known monumental sculpture in the central Andes. They were arranged in a post-and-infill system, of narrow upright reliefs alternating with wall sections of smaller squarish stones between the tall uprights. The effect is like that of fence-post construction. On the upright slabs, ranging in height between 1.60 and 4.40 m. ($5\frac{1}{4}$ and $14\frac{1}{2}$ feet), are incised human figures in profile, ideogrammatic representations of implements, severed trophy heads, and spinal columns. The standing, armed warriors on the posts [313] seem to display the grisly trophies shown on the smaller panels, as they move in symmetrical files leading from the west and east walls round the corners towards a recessed central staircase on the north façade. The carving shows two types of incision. The outer contours of the bodies are given by bevelled cuts: a sloping side marks the outside and the vertical side marks the inside of the form. Interior outlines such as lips or eyelids are given by simple, shallow incisions without a bevelled side. In technique and in processional composition, these reliefs are like some of the Danzantes at Monte Alban [116], though no direct historical connexion can be supposed.

The platform itself rose perhaps a dozen steps, with the upper portions of the processional reliefs forming a wall to surround the platform terrace. The temple proper was built of conical adobes on a rectangular plan enclosing chambers symmetrically arranged to open out from the central entrance axis. Tello reported three phases of construction. The regular bilateral symmetry of the edifices was enhanced by affronted red jaguars painted on the walls flanking the outer entrance.

Conical adobes laid point to point, with the circular bases forming a pattern of roundels on the wall faces, are characteristic of the Chavín style along the coastal valleys where stone was

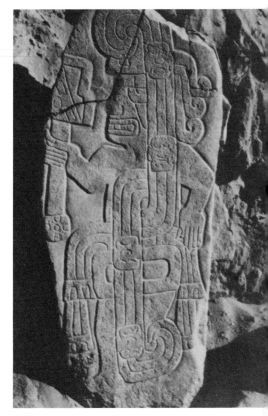

313. Sculptured stone panel LIX, revetment, from Cerro Sechín, before 900 B.C.(?). *Lima, Museo Nacional*

scarce. Their use has been assumed to mark a period of Chavín ascendancy on the coast.[19] They form part of a sequence, however, which began with cylindrical and muffin adobes long before the appearance of the Chavín style. Conical adobes probably continued through the changing modes of coastal architecture until the general acceptance of parallelipipedal adobe bricks in the early centuries of Mochica domination.

Illustration 314 shows methods of wall-building with conical adobes. Point-to-point position allows equal volumes of brick and amorphous clay, and it permits regularly patterned wall surfaces of agreeable appearance. The

314. Diagrams for wall construction
using conical adobes, first millennium B.C.

second method shows bonded corners, which are rare in America, with facing bricks like deeply tenoned masonry surrounding a core of interlocking conical bricks. The third method requires the closest interlocking of brick with brick at all points, and it uses the least amount of clay mortar. These techniques were probably contemporaneous, serving different structural or functional requirements. Gabled roofs of timber and straw rested on the massive walls. Their appearance is recorded by pottery vessels in the Chavín style, of which the manufacture was limited to the coast. Nothing of the Sechín roofs survives today, after many generations of plunder by treasure-hunters. The conical adobes are the firmest assurance of a date close to the early Chavín style, but when we examine the correspondences between Sechín and Chavín forms, their contemporaneity is not at all apparent. As we might expect, adobe brick shapes were less sensitive to secular change than figural forms. Conical adobes may have preceded and outlasted the Chavín style.

Stylistic resemblances between the Sechín and Chavín styles are very faint. The Sechín sculptors show simplified ideogrammatic schemes close to visible reality. They report the facts of warfare and head-hunting directly,

unlike the makers of the Chavín reliefs, whose monstrous combinations of various forms of life lead the mind into an associative labyrinth of ritual symbols, organized more like metaphorical allusions than direct expository statements.

There are no monsters in the known Sechín repertory. Entirely absent are the feline dentitions, the animal-headed joints, and the reduplications or substitutions of the Chavín style. Only by an occasional trait can a connexion be established; the fence-post order of the stone wall facings, the facial stripe curving from eye to ear, and the elongated thumbnails shown in profile are the strongest evidence we have. The two styles seem divergent yet connected: they may be early and late expressions, or tribal variants of the same tradition. In either case, the Sechín style appears to be the earlier of the two. A soapstone cup in the Dumbarton Oaks Collection bridges the gap between Sechín and Chavín. On its base is a head in profile with a curving Sechín stripe from eye to ear, and the feline dentition typical of the Chavín style. On the cylindrical wall, in low relief, a two-headed, eight-legged animal appears, with Chavín toenails and feline facial traits. There is another stone vessel with this form in the Larco Collection now at Lima. Both pieces are of unknown provenance.[20]

Moxeke

Moxeke lies about two miles south-east of Sechín. It is a pyramidal platform of eight terraces, rising a hundred feet above the level flood-plain, near an L-shaped intersection of two axial files of rectangular plazas. The pyramidal platform built of conical adobes [315] stands a little apart from these plazas, which may be of later date. It is much larger (165 by 170 m.; 540 by 560 feet) than the Sechín pyramid, and it has carved clay reliefs instead of stone sculpture. A free-standing stair protrudes beyond the north-east face, rising by six steps to a portico on the first terrace. The second flight, of five steps, cuts through the second terrace face to a wide landing. From it the third and

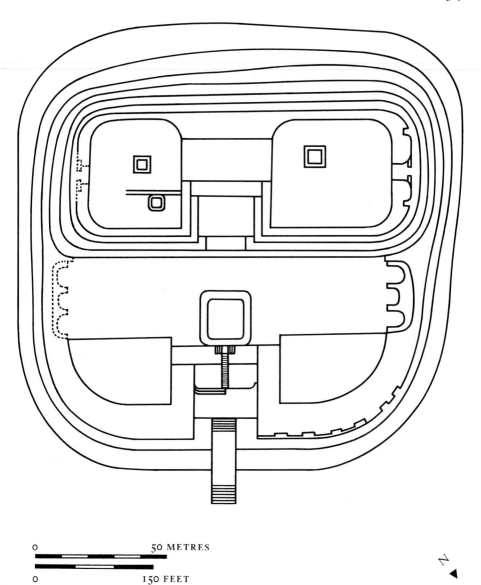

0 50 METRES

0 150 FEET

315. Moxeke, platform-temple,
ninth century B.C.(?). Plan

316. Moxeke, modelled stucco figures I, IV, and V on third stage riser, ninth century B.C.(?)

longest flight rises, and it splits at the head into two small opposing flights. The fourth terrace is divided into four quadrants.[21] The level of the southern pair is higher than that of the northern. In each quadrant, a platform rises. The northern pair is smaller in plan than the twin southern ones, so that the highest points are on top of the larger southern platforms. All terraces have rounded corners.

The north corner of the third terrace on the principal platform is adorned by six deep niches containing carved and painted clay figures of colossal dimensions [316]. Only the lower portions survive, painted red, black, blue, and white. They are of smoothed clay over cores of conical adobes. Each niche is nearly 4 m. (13 feet) wide, and 1.7 m. (5½ feet) deep. Between the niches are salient faces 4.45 m. (14½ feet) wide, also adorned with polychrome relief carvings on clay. Facing north at the rounded corner are two smaller niches, with colossal heads 2.4 m. (8 feet) wide by .90 m. (3 feet) deep, painted green, white, red, and black.

These figures all resemble those of Cerro Sechín more closely than those of Chavín. The fluted skirts of the niche-figures (I–IV) are identical with the ones of severed torsos on the Sechín slabs. The salient panels between the niches bear serpentine convolutions like those of the standing warriors at Sechín. The colossal head in Niche V, finally, wears curved stripes of red face-paint, as do the standing Sechín warriors.[22] The only trait connecting Moxeke directly with the art of Chavín appears in Niche IV, where four serpents painted red and blue dangle from the arms of the human torso.

Punkurí

Punkurí in the Nepeña Valley is a terraced platform facing north-north-west. It is split by a stair of two flights separated by a landing. Near the bottom of the upper flight is a painted jaguar modelled of clay over a stone core [317]. On a

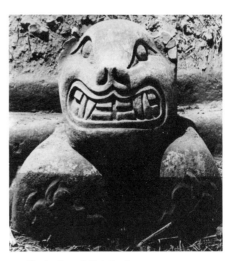

317. Punkurí, modelled clay jaguar on stairway landing, eighth century B.C.(?)

wall of the chamber behind this stair are incised wall decorations in the Classic Chavín style. Thus Punkurí, alone among the coastal sites, contains both styles: the full-rounded and veristic Sechín manner (Punkurí jaguar), as well as the schematic linear design of the Chavín wall decoration.[23]

Chavín

Unlike the sculptors of Sechín, the Chavín artists lacked the means of marking individuality, or of telling a story. A few highly stylized signs convey the entire content of this art. Linear designs, of an extreme degree of abstraction, compounded of parts of bodies, are common to several sites in the highland and at sea-level. On the coast the designs are carved in smoothed clay [323] and pottery; in the highland they are incised upon architectural facing slabs [319], cornices, and pottery. The highland centre is far larger and richer in variety than the coastal site at Cerro Blanco. Both differ from other coastal sites in Ancash, such as Punkurí, Moxeke, and Cerro Sechín, principally in the method of composition, which is the substitution and repetition of the motifs of parts of human bodies. In the Chavín style, heads in profile are doubled to read as frontal representations. Certain frontal heads, when seen upside down, still present right-side-up images [322]. Such double-profile figures and anatropic (reversible) images appear sporadically in pottery and metalwork throughout the central Andes, but the monumental examples occur only at Chavín and in the Nepeña Valley.

Chavín de Huántar. The steeply walled platforms, honeycombed with stone-lined passages and surrounding a sunken plaza, are unique among temple groups in pre-Columbian America. Maxcanú in Yucatán,[24] or Mitla in Oaxaca can be compared with Chavín. The Maxcanú platform is much smaller, and the Mitla palaces were residences, quite unlike the labyrinthine recesses in the platforms at Chavín. The relation of the masses to enclosed volumes is like that of a mountain range, where geological formations enfold caves and vents of bewildering complexity. The entire visible group extends some 200 yards along the west bank of the Mosna river, with platforms grouped around a sunken plaza 48 m. (160 feet) square. Like Chuquitanta a millennium earlier, Chavín began as a main shrine (containing the Great Image or *lanzón*) flanked by wings [318].

After three enlargements on the flanks, a new façade arose facing east, as a portal overlooking a larger court flanked by new north and south wings. The portal itself, framed by cylindrical columns, and faced with white granite blocks on the south and black limestone on the north, gave access to opposing interior stair ramps.[25]

The principal edifice looks east across the plaza. Called the Castillo, it is faced with cut stone blocks in courses of varying widths. These walls rose about 50 feet, above a great pedestal of cyclopean blocks, uncovered by Tello along the western front of the Castillo. Inside the core are at least three irregular storeys of stone-lined galleries, chambers, and ventilating shafts. On each level, these were built, like the facings, before the infill was packed in.

At the south-west corner the outer masonry of the Castillo is adorned with grotesque heads tenoned into the facing, beneath an overhanging cornice incised on edge and soffit with profile jaguar and serpent bodies. A north-east corner likewise bore incised reliefs of stylized condors [319]. Within the original stone-lined shrine a stone prism, 4.5 m. (15 feet) tall and incised with feline grotesques, marked the centre like a lance-point (*lanzón*) thrust through the platform down into the chamber [320]. In the sunken plaza a slab of regular form (the Raimondi Monolith) perhaps stood upright in the centre, incised with reversible designs of animistic symbols compounded in the Late Chavín style [322].

The rough chronological sequence of these sculptural elements is suggested by their positions. The *lanzón*, deep in the interior, may be among the most ancient. The cornice slabs of the outer facing are more recent. The Tello Obelisk [321] and the Raimondi Monolith are undated. The original emplacement of the Raimondi Monolith is uncertain. According to reports collected by Bennett from local people, it stood on the west terrace near the sunken plaza, until its removal to Lima by Antonio Raimondi, the geographer, in 1874. Its intricate metaphorical decoration suggests a terminal phase of the Chavín style.[26] Three periods are

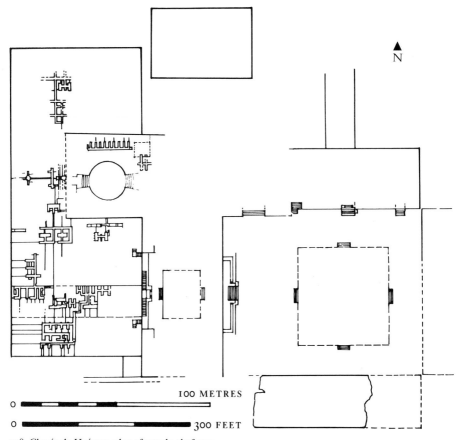

318. Chavín de Huántar, plan of temple platforms,
as in 700 B.C.

now named for building periods, correlated
with the principal monuments of sculpture:

BUILDING	ROWE PHASE	SCULPTURE
early temple	A, B, C	lanzón, Tello obelisk
first enlargement	D	falcon cornice
new temple	E, F	Raimondi stela

The chronological span has been increased to
include from 1400 until 500 B.C. Two main
periods at Chavín de Huántar therefore are
indicated: an early one, including the Castillo
sculpture [319], and a late one, represented by

the Tello Obelisk and the Raimondi Monolith
[321, 322].

The early ('normal') style is characterized by
intact silhouettes of men, jaguars, and condors,
containing intrusions and substitutions from
other orders of life in the parts of the body
and at the joints. The lanzón, for example,
represents a standing human being with feline
teeth and serpent hair [320]. The cornice slabs
of the Castillo represent jaguars in profile and
condors in spread-wing dorsal view. The

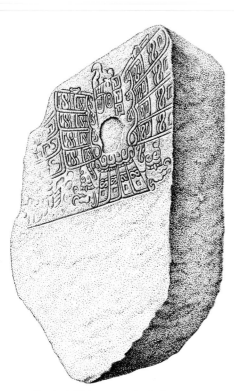

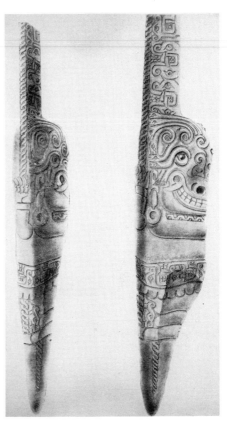

319. Chavín de Huántar, temple platform, north-east corner, cornice soffit with incised slabs showing condors, before 700 B.C.

320. Chavín de Huántar, carved monolith (*lanzón*) in interior gallery of the pyramidal platform, after 900 B.C.(?)

jaguars' tails, however, are feathered, and the condors' wings have jaguar masks in profile at the base of each feather [319]. But these substitutions are internal and they do not break up the silhouette.

The Tello Obelisk and the Raimondi Monolith both show an ornamental prolixity that spills out beyond the organic silhouette. The obelisk is difficult to read: the elongations, substitutions, and peripheral complications are so dense that it is impossible at one glance to

determine the relationships of all these parts. By long study, and by adding the parts together in the mind, one arrives at a synthetic version of the two rampant felines incised in profile upon the quadrilateral prism. Each stands on its tail, with front and rear paws pointing up and down respectively. Every body area contains substitutions: thus the spinal column is treated as a long row of feline teeth. The two felines in profile are probably meant to represent one animal: left and right, back and belly have been

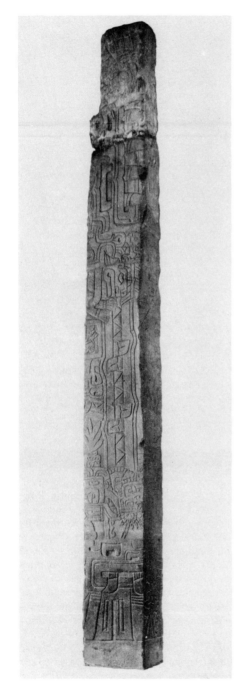

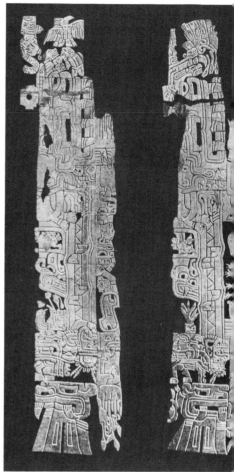

321. Tello Obelisk from Chavín de Huántar, showing diagrams of incised relief panels, c. 500 B.C.(?). Stone. *New York, American Museum of Natural History*

re-arranged as a prismatic sleeve of incised shapes so that the creature has four legs and two sides [321].

The Raimondi Monolith is of diorite. Its rectangular frame (1.95 by .74 m.; 6½ by 2½ feet) determines the general rectilinearity of all the parts. The human body fills only one-third the length of the slab [322]. This square figure can

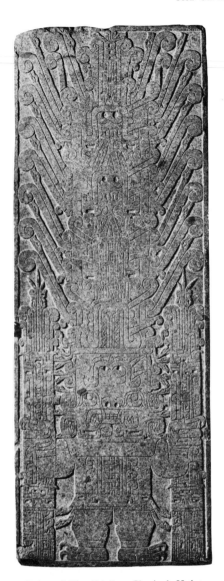

322. Raimondi Monolith from Chavín de Huántar, before 200 B.C.(?). Incised diorite slab.
Lima, Museo Nacional

be read either as a standing staff-bearer, or as a human being in descending flight. In the first position the top of the slab consists of head-dress elements in repeating series; in reverse position, this series becomes a tongue-like pendant. Perhaps the slab was once used as an overhead roof-panel, for its design requires viewing from both ends, in the anatropic scheme that also characterizes Paracas textiles (*c.* third century A.D.).

Inside the underground galleries of the Castillo, pottery vessels paralleling these early and late styles have been identified. The Rocas galleries yielded early types, resembling grey or black stone. The Ofrendas galleries contained various forms related by their decoration to the style of the Tello Obelisk.[27]

Cerro Blanco in the Nepeña Valley has never been adequately published.[28] It is a platform with stone walls covered by carved and painted clay reliefs in the zoomorphic system of the early Chavín style, as on the cornice slabs of the Castillo at Chavín de Huántar. It represents a bird with out-spread wings [323]. The head is a low platform, with the body, wings, and tail formed by low-walled terraces at the sides and rear. These platforms were later covered by another construction of small conical adobes. Tello believed that the blanket edifice was built specially to hide the carved clay walls underneath, painted in red, white, blue, and green. The scale is much larger than anything at Chavín proper, and the colours also differ from those of the highland site, but the compositional device, of two bird-profiles forming a frontal jaguar-mask, is of Chavín type.

In summary, the natural subject matter of Chavín art comprises few motifs, all subordinated to rigid conventional formulas. Rowe describes these metaphorical substitutions as 'kennings' by analogy with the literary device used in Norse saga, and he names the figures as the 'Smiling God' (on the *lanzón*), the 'Staff God' (Raimondi Slab), or the 'cayman deity' (Tello Obelisk).[29] An entire natural shape, such as a jaguar or a condor, is recognizable only by general contour: within the form, interchangeable parts of bodies and multiple points of view complicate the iconography. We may guess that the clustering of the attributes of jaguar, falcon, fish, snail, shell, condor, and serpent was meant to personify and codify various forces of nature.

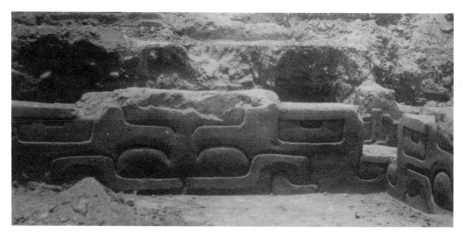

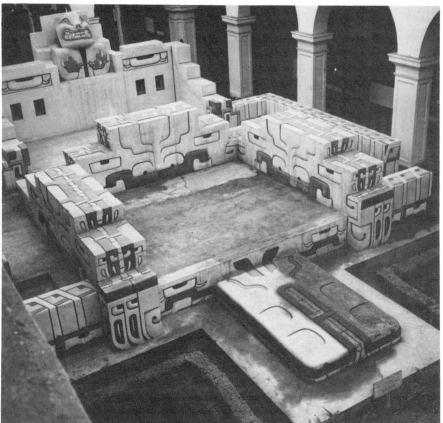

323. Cerro Blanco (Nepeña Valley), carved clay platform, eighth century B.C.(?),
with reconstruction at *Lima, Museo Nacional*

LATER ANCASH ART

The Callejón de Huaylas

Early pottery fragments found in the ruins of Sechín and Chavín are similar: monochrome with incised, carved, and modelled decoration. About 700–500 B.C., experiments with painting began to appear in the coastal valleys. Here the potters used white-paint decoration on a red ground. Other experiments leading to pottery painting appear elsewhere in Peru as well, always in an early context, and prior to the great florescence of Middle times. As Willey suggested, the technical innovation of white on natural red-slip ground colour arose when potters changed from reduction-firing in closed ovens to open-kiln firing. The former mode produced black ware, while open-kiln firing gave the reddish and brown tones that characterize Middle period pottery. White-on-red pottery is now generally recognized as belonging to a technological horizon which marks the passage from Early to Middle times, following the period of monochrome pottery, and preceding that of negative painting. At Chavín in Ancash, white-on-red pottery is well established as 'post-Chavín'.[30]

Negatively painted pottery is made by applying the design in strips of wax or clay. When dipped in dye, only the bare ground takes colour. The original vessel colour emerges intact after the strips of wax or clay, called 'resist elements', are removed. If the figural parts are resist-covered, they emerge in a light colour on a dark ground, with the effect of making the ground visually more active than when the figure appears in dark upon light. The antecedents of resist-painting are still unknown, although Willey and Kroeber have suggested origins in the north Andean highland.[31] Its earliest Peruvian appearance on the coast in the Chicama Valley has been dated by radiocarbon as about 500 B.C.

The most elaborate examples of negative painting come from the upper Santa Valley, where the technique appears upon elaborately modelled vessels, belonging to what is known as the Recuay style [324, 325], whose influence is apparent in the north coast valleys as well.[32] Certain shapes and themes of the Recuay style recur in Mochica art until its closing centuries. The Recuay tradition endured less long than that of Chavín, and its spread was less extensive, but its presence throughout Middle time has been obscured by the tendency to mark off Peruvian archaeological history by neat boxes in rigid succession.

The shapes of Recuay vessels are extremely variegated. The simplest ones recall gourds and squashes; there are also cups, head-shaped goblets, tripod vessels, handled dippers, and a great variety of modelled shapes representing people, animals, and buildings, both singly and in groups. The colour combinations also are numerous, triple combinations of black, white, and red being most common. The painted designs show jaguars, birds, fishes, and serpents rendered in linear ciphers, more like the wall paintings of the tombs in Colombia[33] [292] than anything in Peru. These ciphers owe much of their form to the strips and fillets of wax or clay used as resist elements. The most common cipher develops from a circular eye to show a crested jaguar, with radiating filaments of varying widths to indicate comb-like teeth, semicircular body, claws, crest, and tail.

Unprecedented in earlier Peruvian pottery are the Recuay vessels representing houses with inhabitants, chiefs or deities encircled by their followers, and human beings accompanied by birds or animals. Such narrative propensities may have entered the Recuay style from Middle period coastal sources in Mochica art, but the abstract modelling, the absence of individuality, and the stratigraphic evidence all suggest that such contact occurred nearer the beginning than the end of the Mochica style. The vessel shapes, the negative painting, and the figural ornaments also relate to Quimbaya pottery forms [300]. Notable among examples of these north Andean relationships with the Recuay style are ring-shaped vessels surmounted by a sausage-like stirrup-spout. Another example from the Quimbaya territory in the Cauca river basin is

a vessel decorated with negative painting and surmounted by figurines.[34] The date of these parallels with Quimbaya pottery has been tentatively fixed as of the centuries after 1000 A.D., but such sequences were all established before radiocarbon chronology, and new absolute datings are not yet available.

Tello divided the pottery of Recuay into two groups: phytomorphic (plant-shaped) pieces, and pieces modelled to show single figures or groups of people. Kroeber divided the pottery of Recuay into two styles, A and B. Recuay A includes gourd-shapes, as well as globular vessels with short horizontal spouts and jar mouths with disk-like lips, bearing several modelled figurines above a zone of negative painting [324]. Recuay B contains vessels modelled as whole figures and as groups, such as men leading animals, with three- and four-

colour painting [325]. It has long been supposed that A preceded B,[35] but final stratigraphic proof has not been discovered. An argument in support of Kroeber's sequence is the treatment of the eyes: coffee-bean and slit eyes appear only on the plainer examples of group A,[36] and on examples most closely resembling the Quimbaya parallels from Colombia.

Recuay pottery was deposited probably as grave furniture in stone-lined subterranean chambers or galleries. The gallery walls were faced with large slabs surrounded by smaller spalls and chips, and roofed with flat slabs. The entire Macedo Collection in Berlin came from such subterranean galleries and chambers at Katak near Recuay. Other more elaborate pyramidal platforms and above-ground houses in the Callejón de Huaylas[37] were probably built in later periods.

324. Resist-painted pottery vessel, Recuay Style A, after 200 B.C.
Lima, Museo Nacional

325. Painted pottery effigy vessel, Recuay Style B, before 300(?).
Lima, Museo Nacional

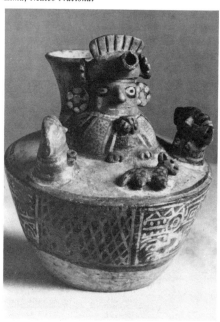

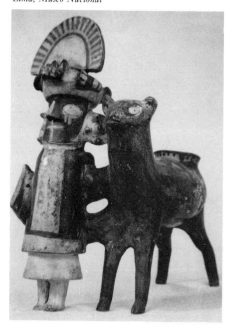

Definitely belonging to the Recuay period are many stone statues. One group from Aija, near the upper Huarmey river, represents warriors [326] and women. The warriors resemble shapes found in Recuay B ceramics, bearing the square shields that were probably characteristic of the Ancash tribes.[38] In the Huaraz Museum many other statues have been brought together from the entire Callejón. Schaedel's study proposes three tentative developmental stages, changing from curvilinear incisions (1) to relief carving in faint (2) and bold (3) phases. He suggests that phase 1 may correspond to the white-on-red period; phase 2 to Recuay A; and phase 3 to Recuay B.[39]

The later stages of the archaeological history of the Callejón are poorly known. There is a stratum of sherds of a type called Viñaque in the Huari-Tiahuanaco style, found at Wilkawaín by Bennett. The usual traces of Inca occupation also appear, and the native language today is a dialect of the Quechua tongue of the Inca conquerors. It is mixed with remnants of an older, unidentified language manifested in many place-names.

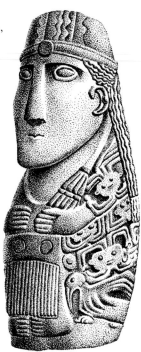

326. Aija, stone figure, before 200

THE UPPER NORTH: MOCHICA AND CHIMU

The modern Peruvian departments of La Libertad and Lambayeque, which extend nearly 250 miles along the Pacific Coast north of Ancash, contain the principal remains of the Middle and Late periods of central Andean archaeological history. Two civilizations dominated the region: Mochica, which flourished from about 250 B.C. until after A.D. 700, and Chimu, governed by a dynasty enduring from about 1370 until the Inca conquest of the north coast valleys before 1470.[1] The six centuries between Mochica and Chimu civilizations are poorly explained. Strong traces appear of an art called Tiahuanaco-Huari, and identified with the southern coast and highlands. Radiocarbon dating for the end of Mochica is far from complete and the historic evidence sifted by Rowe refers only to dynastic and not to stylistic events. Eventually the six-century gap between Mochica and Chimu will surely be narrowed by extending the duration of Mochica,[2] and by recovering the early stylistic phases of Chimu. For the present, Tiahuanaco intrusions on the north coast are generally accepted as of before 1000.

The geographical distribution of Mochica and Chimu was roughly similar, with different patterns of expansion. Mochica influences appear to have worked south, while Chimu expansion affected the more northerly valleys. It is therefore justifiable to speak of inner and outer zones in northern Peru. The inner zone centred upon the Moche river valley, but the outer zone for Mochica peoples was in the valleys southward to Nepeña or beyond. For Chimu history, the outer zone was northward, to the deserts of Sechura and Piura and beyond.

PRE-MOCHICA STYLES

The remarkable discoveries by Junius Bird at Huaca Prieta in the Chicama Valley included the earliest dated ceramics on the north coast. The pots are very plain, but there are incised gourds of a complicated design, belonging to the pre-ceramic levels, which are among the earliest dated examples of graphic art in America [327].

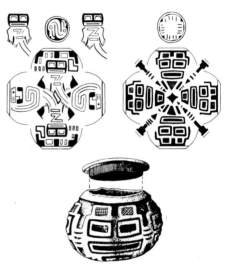

327. Huaca Prieta, incised gourds, before 1950 B.C.

They are related by Lanning to origins in southern Ecuadorean drawings of before 2000 B.C. The radial figures with squarish heads and eyes rise from base to rim. Diagonal curving lines on one give an effect of swirling or rotating forms; on the right-hand specimen the symmetry is complete on a bi-axial scheme. Both vessels have lids, and one bears a two-headed Z-curved condor shape, which anticipated the dated Chavín designs with interchangeable body parts by several centuries.[3]

Cupisnique refers to a dry ravine approached from the north side of the Chicama Valley, and emptying into the Jequetepeque drainage. On

its arid floor R. Larco Hoyle in 1934 found large quantities of sherds in the Chavín style, mostly black-fired pottery of a stony appearance, decorated with incisions. He also found incised red sherds, cream-on-red with incised outlines, red and brown, and solid red as well as solid cream-coloured pottery. On the site near the Cupisnique called Pampa de los Fósiles, there are foundations of rough stone building as well, but no graves, and no entire pots.[4]

The intact examples have in common only certain types of incised and modelled surface treatment, representing figures related to the Chavín system of interchangeable feline, bird, fish, and reptile parts. But the vessel shapes range from coarse pre-Mochica forms to the most intricately harmonious Mochica contours of the terminal periods, so that, as in the case of Chavín sculpture in Ancash, we are here forced again to recognize an indefinite duration of a style, ranging from the ninth century B.C. to the still-undetermined end of Mochica times. Larco separates Initial (pre-Cupisnique), Middle (Cupisnique), and Terminal stages on the basis of iconographic traits,[5] while the Mochica seriation (discussed below) rests mainly upon traits of shape. Larco's nucleus of 'pure Cupisnique' vessels does not come from that site but from many valleys, and its forms include both Early shapes (heavy stirrup spouts) and the most delicately shaped vessels of Classic Mochica type. Furthermore the finds in the Cupisnique style in the graves opened in the Chicama Valley (Barbacoa site) include red-and-black, orange, and red-on-cream wares of Mochica type.[6]

The dilemma is like that of the Olmec style in Mesoamerica, where coastal and highland versions of an art unified by certain icono-graphic themes persisted through an indefinite duration of American prehistory. Larco's single horizon of brief duration before 500 B.C. divides 'Cupisnique' pottery into four stylistic groups [337, 338], recognizing differences of shape, but insisting upon their pre-Mochica date.[7] Style A has sausage-stirrups and lipped spouts; B has slender rounded stirrups; C has low stirrups; D has high trapezoidal stirrups. Examples of

monochrome brown occur in groups A and D; red-ware appears in groups A, B, and D.

Recent excavations by Lumbreras in the galleries at Chavín produced pottery in the shapes and with the ornament of Cupisnique, showing their identity as highland and coastal versions of the same art. Thus Cupisnique A resembles Rocas-period pottery at Chavín, but B, C, and D shapes and figures parallel the Ofrendas types at Chavín itself, while continuing to appear as late as Mochica III. Rowe interprets these vessels of Mochica III date and later as archaisms and as 'persistent conventions'.[8] Other terms of description could be revival, renascence, Renaissance, or tradition, but until the magnitude of the phenomenon is known, a choice is difficult. The principal difference is that coastal Chavín pottery is usually mono-chrome, and Mochica III usually bichrome. The coastal Chavín style may have had its home high in the constricted drainage of each coastal river, while the Mochica style flourished nearer to the sea on the open flood-plains.

The coastal Chavín repertory of forms is much poorer than that of the Mochica style. The linear designs are simple and powerful, but they tend to extreme abstraction, and to harmonious ciphers incised upon the curved surfaces without any enlargement of the descriptive programme such as we have seen in the high-land Chavín art of Ancash. Figural paintings, such as pictures of actual life, are entirely lacking. Yet the effigy vessels depict a mother nursing her child, a gabled house, various heads, monkeys, crustaceans, molluscs, and birds always singly and without the portrayal of action which characterizes Mochica art.

The Salinar style is another discovery made in the upper Chicama Valley by R. Larco Hoyle.[9] This red-ware pottery was baked in open kilns. Its surfaces are thus different from the much darker Chavín surfaces, which were fired in closed kilns. The vessel forms include new bottle-shapes, and handled vessels. The stirrup spouts most closely resemble Larco's Cupisnique B. The effigy forms are far cruder, with filament limbs, coffee-bean eyes, and fired

white paint. Salinar is a local style. Its stratigraphic position is above Cupisnique and below the Mochica graves. It is possible and likely that early white-on-red experiments in the Callejón de Huaylas, together with the mature sculptural tradition of the coastal Chavín style (Cupisnique A), facilitated the invention of the Salinar style in the Chicama Valley, with its great freedom in figural modelling, and its clear red firing. Salinar in turn may be taken as an initial or preparatory stage in the emergence of modelled and bichrome Mochica pottery. The possibility of long duration for the Salinar style should not be excluded. Certain of its forms, such as effigy groups (one example shows a healer massaging a recumbent patient), suggest contact with fully developed Mochica schemes of representation. Similar red-ware forms with archaic modelling, however, appear in many other regions on pre-Mochica levels. Strong and Evans have discussed all the occurrences and parallels of white-on-red throughout the Andes.[10]

A distinctive feature of the Salinar style is the representation of houses in pottery [328]. One bottle form has an entire house carefully portrayed on the container at the junction of the handled spout. A vertical wooden support, probably a tree-trunk, bears a cross-member on which the roof panel rests. Perforated wall-panels enclose the sides and rear. Painted lines mark the walls guarding the access to the enclosure. This roofing by ventilating planes and sunshade panels is our earliest record of the ancient Peruvian coastal tradition of shelter from sun, wind, and heat rather than from damp and cold, on these arid valley floors where rain scarcely ever falls. Another Salinar pot shows a cylindrical edifice with perforated walls. It probably represents a temple, and has terraced slots and a guilloche band decorating the round envelope.

328. Pottery house vessels from the Virú Valley, Salinar style, fourth century B.C.(?).
Lima, Museo Nacional

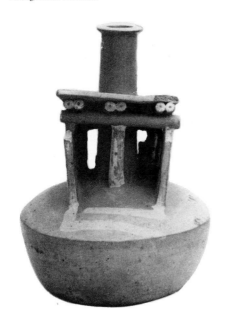
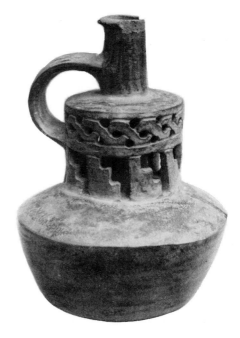

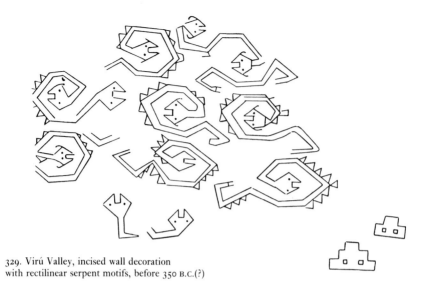

329. Virú Valley, incised wall decoration with rectilinear serpent motifs, before 350 B.C.(?)

Still another period of coastal pottery is identified with pre-Mochica times. The Gallinazo groups of honeycomb dwellings in the Virú Valley[11] were built from 150 B.C. to about A.D. 100 with puddled adobe (*tapia*) walls as well as ball and rectangular adobes. Bricks made in cane moulds and bearing their marks are characteristic of Gallinazo wall construction. Resist-negative painting on the pottery from this area suggests a connexion with highland Recuay. Certain buildings coated with yellow clay are decorated with incised serpent forms [329] of textile derivation which also recall the themes of Recuay resist-painting. Bennett showed that only the terminal period of this style, Gallinazo III, overlapped with Early Mochica art. But, on the evidence of radiocarbon and stylistic parallels, Recuay A, Salinar, Gallinazo, and Early Mochica, together with Cupisnique B and Chavín-Castillo art, all seem to cluster in the centuries immediately around 500 B.C. The possibility of putting them in more open seriation becomes questionable as the radiocarbon dates accumulate. The case may be one of parallel local developments, rather than of seriated events. Thus Vicús pottery from shaft-tomb cemeteries near Ecuador resembled both

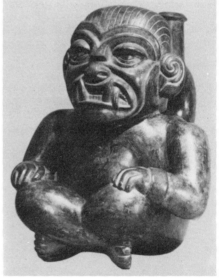

330. Pottery vessel from Vicús, Mochica I style, first century. *Piura, Domingo Seminario Urrutia*

Cupisnique [330] and Mochica classes before affecting or being affected by Salinar and Gallinazo techniques of resist-painting, cream and red slips, and geometrized modelling. This

case again suggests parallel events rather than seriated ones[12] (like the contemporaneity of Recuay, Vicús, and Mochica traditions), and thousand-year local durations rather than brief secular ones.

THE CLASSIC MOCHICA PEOPLES

The hearth of Mochica civilization was in the valleys of Chicama and Trujillo. The ancient name is unknown, and Mochica is a modern term.[13] A bellicose people, the Mochicas eventually extended their dominion to the area between Casma in Ancash and Pacasmayo in the north, along some 200 miles of the Pacific coast. More than any other cultural group of ancient Peru, they recorded their behaviour in a pictorial art of much detail and great animation. Their immense pyramidal platforms [331, 332] and country estates [335] differ sharply from the scattered villages of immediately preceding periods. Mochica civilization was based upon an agriculture irrigated from aqueducts, reservoirs, and canals built on a gigantic scale. The valley areas anciently under cultivation greatly exceeded those in modern use.[14] In the Virú Valley, for example, the Mochica canals supplied an area 40 per cent larger than the present cultivated area, and the land supported 25,000 people, where today there are only 8000.[15]

The beginning and the end of Mochica history are roughly fixed. The earliest stages of the society overlap archaeologically with Gallinazo sites (after 300 B.C.). The latest occurrences of Mochica objects, in layered guano deposits on the Chincha Islands, attest the great spread and the survival of the style until about the ninth century A.D. The terminal events have long been connected with an invasion by the bearers of a southern pottery style called Huari-Tiahuanaco, which elsewhere on the Peruvian coast can be dated by radiocarbon measurements to about the sixth to tenth centuries A.D.[16]

Rafael Larco Hoyle, the foremost collector and student of Mochica art, has tried to re-construct Mochica chronology, as well as to deduce something of the society from its art.[17] For Larco, the civilization originated in the Chicama Valley and spread to the Trujillo Valley (also called Santa Catalina, Moche, or Chimor) during the early centuries of a long ceramic development. The earliest pottery, which he called Chicama-Virú, resembles Bennett's Gallinazo style. Larco's sequence will be followed here, with certain modifications. Because adjacent stages are not clearly separable, we shall group them as Early (I and II); Middle (III and IV); and Late (Larco V). Rowe and Sawyer assign different spans to the Larco periods:

Rowe 1968		Sawyer 1968
I	c. 0–150	250–50
II	c. 150–250	50–0
III	c. 250–400	0–200
IV	c. 400–550	200–500
V	c. 550–650	500–700

Sawyer's dates agree better with the assumptions of this chapter, as stated on pp. 379–80.

Architecture

The ceramic sequence from the excavations in the Virú Valley permits certain inferences about Mochica architecture. The groups of dwellings, like those of the Gallinazo period, were clusters of adjoining chambers built of rectangular adobe bricks, in both irregular and symmetrical arrangements. Reed-marked adobes made in moulds of cane are probably pre-Mochica, smoothed bricks are of Mochica date.[18] Temple or palace platforms of rectangular form first appeared long before the Mochica development proper, during the period of the earliest red-on-white pottery decoration (named the Puerto Moorin Period in the Virú Valley). New Mochica forms are suggested by the foundations of large rooms, courts, and corridors on these platforms. They contrast with the earlier clusters of tiny rooms [310] built one over the other by successive generations as a filled-in honeycomb of abandoned habitations.

The Castillo of Huancaco in the Virú Valley is such a terraced platform, built along the lower slopes of a hill which dominated the fields of the lower Virú Valley bottom.[19] The steep pyramidal terraces are built of small mould-made adobes without stone foundations, assembled in adjacent but unbonded columns and sections of wall. The sherd collections from the Huancaco site indicate construction during the Gallinazo period, and enlargement with a great pyramidal platform during the Mochica period. Thus Mochica architecture was a continuation of earlier practices, on a larger scale and with more stately effects. The Pyramid of the Moon at Moche in the neighbouring valley of Trujillo is similar, projecting in terraced adobe platforms from a stony hillside. The pottery associations, however, are much later, belonging to fully developed Middle Mochica types (300–550).[20]

331 and 332. Moche, Pyramid of the Sun, c. 100–600(?). South half of the east side, and south side seen from ground level, 1899

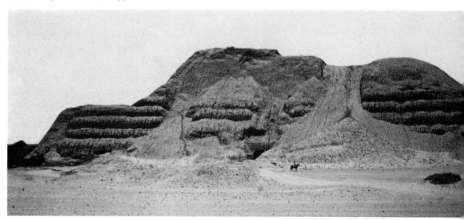

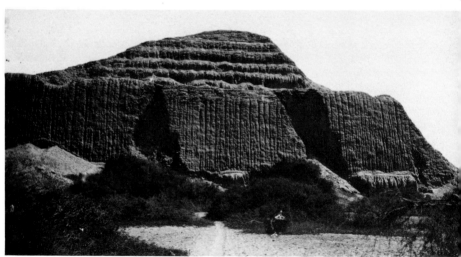

The great buildings at Moche are exceptional because they still show the original form of the Mochica pyramid-cluster. Elsewhere the early platforms were covered with additions by later builders, as at the Brujo pyramid in the Chicama Valley or at Pacatnamú in the Pacasmayo valley. On this last site, Chimu settlers enlarged the older buildings and connected them with a grid of courtyards and ranges of dwellings.[21]

ash lens were fragments of Early Mochica pottery belonging to Period I (first century A.D.?).[22] Upon the southern terrace separating the base from the crowning pyramid, Uhle found intrusive graves with pottery in the coastal Huari-Tiahuanaco style. The construction can therefore be assigned to the Middle and Late Mochica periods, although a hypothetical nucleus, long since wasted away, may have been older.

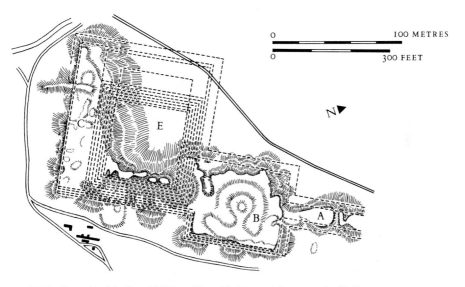

333. Moche, Pyramid of the Sun, Middle and Late Mochica periods, c. 100–600(?). Plan

The Pyramid of the Sun at Moche [331, 332] stands at the river's edge some 550 yards west of the Pyramid of the Moon (both names are modern). The river has carried away nearly half of the vast adobe brick construction, but even today in its diminished state it is the largest ancient construction of its type in South America, rising 41 m. (135 feet) above the valley floor. Like the other platforms described above, it is an aggregate of unbonded walls and columns. At building level beneath the highest portion, the river has exposed a lens of ashes, probably from a dwelling site antedating the construction of the pyramid. Embedded in that

The overall dimensions including the ramp are 136 by 228 m. (440 by 250 feet) [333]. The southern platform (C), nearly square, has five stages, surmounted by a smaller square platform (E) of seven more stages. Broad terraces separated the primary and secondary platforms on the southern and western exposures. A long ramp (A) gave access to the lower northern platform (B). Every detail confirms an impression of work by unskilled labourers, who laid the bricks in stints as contributions to the collective place of worship. The Moon Pyramid was probably a palace-platform, and the Sun Pyramid was a temple.[23]

On the evidence of vase-paintings, Mochica society was probably a theocratic organization, governed by priestly persons. The farming population lived in clusters of dwellings at the valley edges. The nobles and their servants occupied walled and terraced hillocks, of which the form is recorded in many pottery vessels. An example from the Virú Valley in the Lima Museum[24] has pyramidal terraces indicated by bands of red and cream colour [334, 335]. A walled chicane corridor protected the entrance, and ramps led from level to level. The wide lower terraces were for servants, and the withdrawn upper courts, surrounded by gabled houses of ventilator planes and sun-shades, housed the masters. The model has a lipped spout characteristic of the Early Mochica style.

The transition to these class-structured dispositions under Mochica rule was therefore of early date, probably connected after 400 B.C. with a regime of artificial irrigation by man-made canals on a large scale. Such a regime gave mastery of the entire society to a few persons controlling the upper valley necks. In the Chicama Valley, the Cumbre Canal is still in use over about 113 km. (70 miles). The Ascope aqueduct carried water on a dike 1400 m. (1530 yards) long across the embayment of a small lateral valley north of the Chicama river, saving many miles of contour-line ditching by its straight embankment 15 m. (50 feet) high.[25]

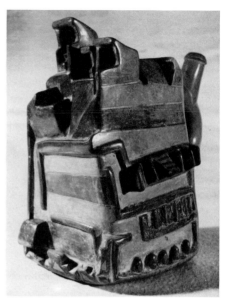

334. Pottery house vessel from the Virú Valley, Mochica I style, 250–50 B.C.(?).
Lima, Museo Nacional

Such gigantic enterprises required rigorous organization and the subordination of other concerns to public works.

The utilitarian and collective bias of the Mochica culture is most evident in the amassing of enormous dikes and platforms. It appears as

335. Mochica house group of the first century B.C.(?). Reconstruction drawing based on illustration 334

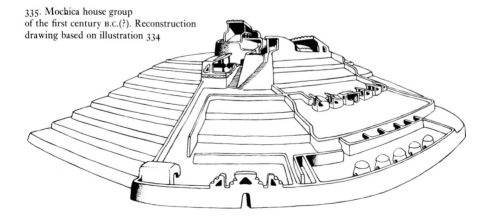

well in a structural experiment (or accident) approximating to true arch construction. One Chicama Valley tomb reported by Larco has a curved roof of adobe bricks resembling a European tunnel vault. A model of this tomb was available at the Chiclin Museum. W. Bennett believed it to be a variant of the standard Mochica box-tomb, built with longitudinal sticks supporting a surface layer of adobe bricks. The sticks disintegrated, and the bricks were locked by gravity into position as an accidental vault.[26] Intentional or accidental, the resemblance to a tunnel vault is striking. Larco also mentions arched doorways in Mochica temple and tomb construction, but his illustrations show only corbelled, rather than true, arches.

Sculpture

The sculptural impulses of the Mochica people were channelled into modelled pottery and small objects of metal, bone, and shell. Carved clay decoration[27] and large stone statues are extremely rare on the ancient coast. The predominance of small sculptured objects may perhaps be related to the prime importance of large irrigation works, which required the principal energies of the people for their construction and maintenance. Another hypothesis is that the Mochica people were exceptionally endowed with tactile faculties, preferring sculptural expression to chromatic variety, and adopting clay sculpture in preference to other means of recording their preternaturally sensitive perceptions of spatial order. The large number of erotic subjects in Mochica pottery has been connected with this hypothesis of congenital tactile sensitivity.[28] Others have noted the emphasis placed by the Mochica people upon pottery made especially for burial rites. These ornate vessels of fine quality are so distinct from the utilitarian wares found in refuse deposits that their manufacture has been attributed to a special group of priest-potters who were identified with the ruling class, and who supplied such mortuary pottery to the people in return for services.[29] The grave specimens rarely show signs of use; sometimes bundles of small leaves (coca?) are stuffed into the necks. Identical replicas of certain portrait-vessels and moulded figures in the tombs of widely separated sites, as at Chimbote and in the Chicama Valley, prove the unity of Mochica culture, and indicate the use of figural pottery to increase social cohesion in the absence of writing. The many replicas of certain portrait-types [339, 340], with commanding facial expressions, surely reflect a cult addressed to governing persons.

The generic resemblance to west Mexican pottery in Colima and Nayarit is striking in the portraits and scenes of daily life modelled on pottery made for graves. The chief difference is a fundamental one: the Andean potters rarely endowed the entire figure with studied sculptural form. The container form rigidly framed the anatomical design. Mochica modelling is an art of lavishly detailed parts connected by schematic passages.

About 10 per cent of the pottery collected by Uhle from the Mochica tombs at the pyramids of Moche bears figural decoration of sculptural character, in effigy and in relief scenes. There are painted designs on 34 per cent, and all the rest, 66 per cent, are undecorated vessels.[30] Of this collection, 90 per cent have red-and-white colour, of an effect described as 'piebald', which is distinctly graphic in intention rather than colouristic.

The vessel shapes are elaborate and varied, both in function and in plastic variety for its own sake. Spherical jars with flaring conical mouths, of a form used probably for the storage of food, are very common (35 per cent). The most numerous (42 per cent) are stirrup-mouth vessels designed for the storage of liquids. These containers are vented by two curved branches joining at a tubular mouth. The handle-like stirrup lets the vessel be carried on a belt or sash. Its mouth is contrived to reduce losses by evaporation and spilling, and pouring is eased by the branching tubes, of which one admits air. More than any other form, the stirrup spout registers the passage of Mochica time

336. Stirrup spout profiles, Mochica I–V,
250 B.C.-after A.D. 800(?)
(A) House-vessel. *Formerly v. Schoeler Collection*
(B) Tiger-vessel. *Formerly v. Schoeler Collection*
(C) Painted vessel. *Lima, Museo Nacional*
(D) Painted vessel. *Berlin, Museum für Völkerkunde*
(E) Painted vessel. *Chicago, Art Institute,
Cummings Collection*

A

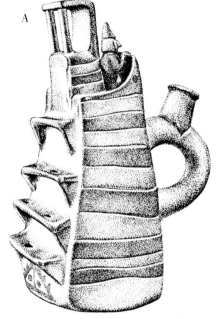

B

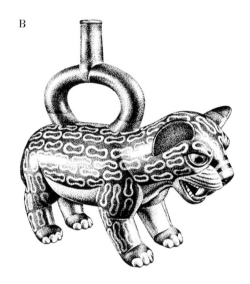

C

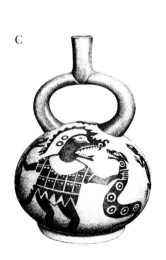

D

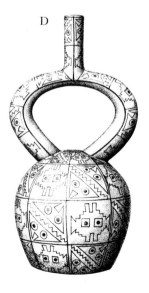

E

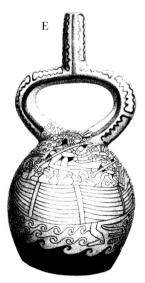

[336]. Larco's chronology is based mainly upon changes in its proportions, articulation, and construction.[31]

Mochica I vessels have short spouts with rimmed mouths. The curving stirrup straddles the container with wide-set insertions, and the vessel itself is globular, lacking a distinct pedestal. Mochica II stirrups are more like closed loops, with the ends drawn closer together at the insertion. The spouts are longer, with almost imperceptible rim reinforcements. Mochica III, corresponding to the Middle Period, has stirrups of varying curvature, nearly flat in the horizontal upper portion, and rapidly curving to meet the wide-set insertions on the container. The spouts are often concavely profiled, widening gradually to the mouth. Mochica IV stirrups are tall and angular. The spouts are straight-sided, and the lip is bevelled inside. The insertions on the container are widely separated, and the container profile is more like a hat than a sphere. The flat bottom, luted to the upper portion, simplified the process of shaping the container. Mochica V stirrups are approximately triangular in profile, with conical spouts. They are sometimes taller than the container. The insertions are nearly contiguous, drawing the loop of the stirrup into a triangular shape with an apex on the container. Mochica V potters also explored the continuous combination of both profiles, on the container and in the stirrup. The curve of the inner stirrup profile gently reverses the container silhouette, so that a figure of eight emerges, with the lower loop formed by a solid outside profile and the upper loop by an inside (i.e. void) profile of remarkable grace.[32]

Regional and ethnic differences modify this evolution. For instance, the stirrup spout, which rides on top of the container, may mark either an axis from front to rear or a plane from side to side [337–40]. On Cupisnique vessels the

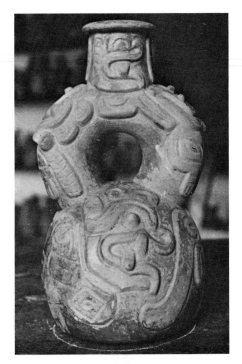

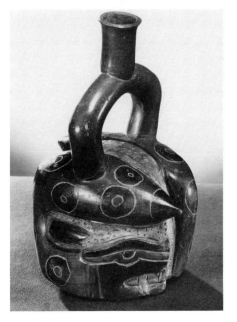

337. Vessel forms of coastal Chavín ('Cupisnique') style, 900–200 B.C. A type (*above*), *University of Trujillo, Museum*, and B–C type (*below*), *Lima, Museo Nacional*

stirrup plane goes from side to side, and it marks a frontal aspect. The same position of the stirrup, spanning the front view with its bridge-like silhouette, characterizes the other pre-Mochica styles, called Salinar and Gallinazo. But the Mochica stirrups all mark the sagittal or axial plane. In a portrait vessel, for example, the face occupies one plane, but the beautifully proportioned stirrup requires us to turn the vessel. The stirrup establishes the profile, and the container establishes the front. The two views more urgently require the observer to rotate the vessel than do the pre-Mochica examples. The portrait vessels also show a progressive refinement of axial composition. In Mochica IV, the head tilts back from the base, with an upward lift of the facial plane. Face and stirrup spout compose a curved diagonal axis in profile, and this com-

manding expression conveys high moral stature and purpose [340, *right*].

We have already seen that the early stages of the art of anatomical modelling were gradually worked out by Salinar, Recuay, and Gallinazo potters. In general the fundamentals of Mochica sculpture were all defined long before the emergence of Larco's Mochica I, not only for the human face and figure, but also in the modelling of animal, plant, and monster forms. We shall again retain Larco's phase numbers, grouping them as Early, Middle [339, 340], and Late stages (see p. 383).

Early, to A.D. 0 (Larco I and II). The heads are stereotyped spheres, lacking the pronounced individuality of the heads of the Middle stage. The burnished surfaces are much finer in texture than the coarse and gritty moulded wares

338. Pottery vessel, coastal Chavín style, before 200 B.C., D type. *R. Larco Hoyle Collection*

339. Portrait vessel, Mochica style, Periods I–II, 250 B.C.–A.D. 0. *Lima, Museo Nacional*

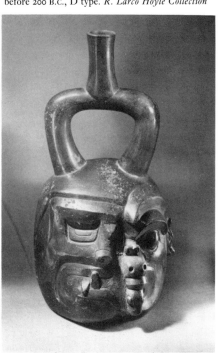

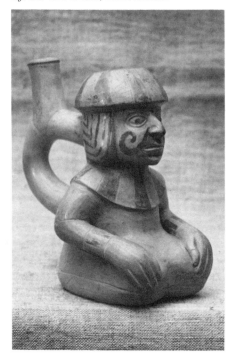

of late date. The eyelids are strongly ridged, in an almond-shaped figure. The eyeball is correctly indicated as a sphere set into the head. The nose prolongs the arch of the eyebrow, but the union of the nose and cheeks is still arbitrary. The mouth is a V-shaped cut, faintly modelled to mark the contour of the lips.

Middle, to 500 (Larco III and IV). The muscular structure of the facial planes, lacking in the Early stage, is given by powerful, simple detail, indicating the unique individuality of the person represented, in a system of surfaces ridged and furrowed by the play of muscles. The eyelids are profiled in reversing curves. Tiny folds of muscle appear under the bony arch of the eyebrow. The precise muscular set of the mouth is shown by furrows. Wrinkles indicate the age and temper of the subject.

Another common theme in this period is the scene of a mountain sacrifice, showing a number of people among mountain peaks in the presence of a jaguar god of human aspect, engaged in the sacrifice of one or more of their numbers. An example of Mochica III or IV, from the Warrior-Priest's Grave in the Virú Valley, shows five mountain peaks. Six human figures and a lizard are present at the sacrifice. Another such mountain-vessel, associated with Mochica IV specimens, comes from Cerro Sorcape in the Chicama Valley [341]. It has seven peaks. The human being to be sacrificed is again spread face-down upon the central peak. There are also eight celebrants, a recumbent person, and the bust of a tusked god. All these figures are moulded in relief, and painted[33] in the usual red-and-white technique.

340. Portrait vessels, Mochica style, Period III, before 200, *Chicago, Art Institute, Cummings Collection*; Period IV, 200–500, *Chicago, Art Institute, Buckingham Fund*

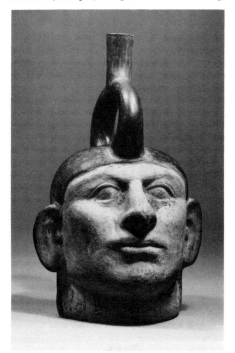 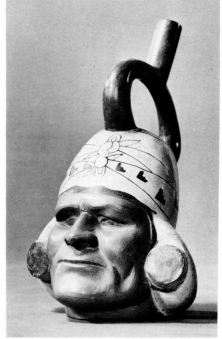

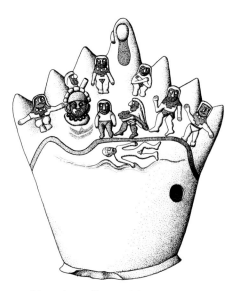

341. Mountain sacrifice vessel from a grave at Sorcape in the Chicama Valley, Mochica V style, after 500

Mochica carving in wood, bone, and shell has never been studied systematically. Wooden staffs with figural heads occur in the Warrior-Priest Grave of Mochica III–IV date in the Virú Valley, as well as among very late deposits in the guano beds of the Chincha Islands.[34]

Mochica metallurgy, like woodcarving, is stylistically coherent with the pottery forms. If, however, large portions of the Chavín repertory be correlated with Mochica developments as proposed here on p. 380, then a puzzling discrepancy vanishes. Lothrop observed an extremely wide range of Chavín metals and processes, of which many 'disappeared' until Mochica times.[35] When Late Chavín and Mochica are considered as overlapping, the history of metallurgy in northern Peru no longer requires a hypothesis of 'disappearing' techniques.[36]

Painting

The topic of Mochica painting has received intense iconographic analysis, but systematic studies of its morphology and expressive resources are still to come. Mochica painters[37] renounced colour and became expert in the delineation of movement. The line was brushed or penned, without variations in width, in red-brown or brown-black line on cream or beige slip, and in cream or beige line on dark brown-red slip. Figures in profile predominate, and there is little attempt to suggest depth by perspective devices other than the simplest overlapping of forms.

The Mochica draughtsman's main concern was to achieve effects of movement. Every resource at his disposal was used to increase the agitation and restlessness of his work. The painted spherical containers, with their scenes of ritual and battle, are themselves suggestive of motion, as the eye slips over their rounded surfaces, or as the hand turns them over. The painted men run furiously: pumas attack suppliant victims; the waves curl on the waterline of a boat; the tassels of the ears in a field of corn are tossed by the wind; a flight of birds rises in all directions from a clump of cane. Even the space surrounding the figures is alive with agitation, conveyed by spots and rosettes as in Corinthian orientalizing pottery of the sixth century B.C. Such space-fillers are frequently occupied by other fillers, which in turn bear tertiary fillers. Consistent with this technique is the lively inversion of line and field, whereby the shape and its ground exchange their roles.

This description, however, is synthetic and non-historical, true only for the cumulative result of many centuries of development. Sharply defined stages can be isolated, and here, as in preceding sections of this book, we may rely upon Larco's tentative and unproved, but inherently probable, chronology. An independent linear mode of figural description upon flat or curving planes first arose during Mochica II, as we may deduce from its absence in I, and its fully developed presence in III. During

Mochica I [339], face paint, body markings, and costume details, as well as bands of geometric ornament, were the only subjects entrusted to linear description. In Mochica II pottery we first encounter figures of human beings and animals in low relief,[38] probably shaped in moulds, and painted with colour in patches and lines to describe costume and expression. Space-fillers were not yet used, and figures in solid colour tended to carry the design, as in Attic black-figure vase-painting before 500 B.C.

During the Middle Mochica centuries (Larco III, IV), painters abandoned figures in solid colour for wiry and active outlines, giving the illusion of total movement [343]. Narrative and processional scenes of many figures replaced the single and double figure panels of the early period. The scenes often occupy two or more registers. Spiralling processional scenes required hair-fine brushwork upon a tiny scale. These tendencies towards figural complication probably characterize Mochica IV.[39] The shift from figures in solid colour to outlined figures with much interior detail recalls the Greek shift from black-figure to red-figure vase-painting after 500 B.C.

The murals at the Moon Pyramid at Moche are of Middle Mochica date, painted on a dado about 3 feet high, in seven colours upon a white ground. The figures represent a battle between human beings and animated implements, with the victory going to the implements. The linear outlines look like freehand incisions. The colour was hastily applied. Other Mochica murals at Pañamarca, near Chimbote, portray a robing scene and a battle with life-size figures in seven tones: black, white, grey, red, yellow, brown, and blue.[40]

Late Mochica (Larco IV) pottery painting is the most restless [345]. Violent animation possesses the figures. The backgrounds swarm with space-fillers of agitated contours. The figures and their settings often lose distinctness, for the pattern becomes so dense that the eye cannot easily separate the figure from the ground.

The pictorial description of the Mochica environment by pottery painters therefore dates from the Middle Period, and passes into ornate complication at the end of the sequence during a span of several centuries before 700. Instead of exploring the imagery of deep perspective, the Mochica painter, in his quest for effects of movement, chose to indicate the setting by linear devices as agitated as his forms in motion. Thus a desert landscape is shown by cactus and tillandsia plants rooted in a sinuous ground line: the area above it is vacant, but tortuous enough to hold the eye without giving a sense of uncomfortable voids [342]. In another example many running human legs seem to churn the ground into hillocks, and the ground line becomes an ornamental figure, undulating more because of the action portrayed than because of the nature of the ground [344].

342. Desert landscape with foxes, Mochica III style, after 200(?). Berlin, Museum für Völkerkunde

In a hunting scene the agitation of the moment is increased by the undulant ground line, but neither the hunter nor his prey touches it [343]. Both are shown as if instantaneously

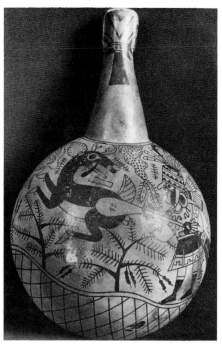

343. Shallow-handled pottery dipper with painted deer-hunting scene, from the north coast, Mochica III style, before 200(?). *Lima, Museo Nacional*

arrested during the kill. The huntsman plunges his lance into the flank of an exhausted deer. The hunter's feet leave the ground and the painted deer throws his head back in pain as his fragile legs crumple under him. Another such scene of arrested motion occurs on many vessels. In one example, a huge jaguar with bared claws and fangs leaps upon a seated warrior. The man waits in breathless fear, with clasped hands, closed eyes, and open mouth. Every line conveys violence, motion, or suspense. All the schematic conventions of Mochica figure drawing combine to express the terror and violence of the moment. Nothing is left uncertain; nothing

is unclear; all parts of the design accurately describe the motion of beings in action.

The representation of distant planes is also subjected to a rule of maximum animation. In a racing scene [344], the runners fly, barely touching the ground-line. Above their heads another ground-line with tillandsia hanging upside down indicates a plane behind and far away, registering distance by inversion. Indoor scenes are shown by simple cross-sections through the beamed structure of the gabled houses [345]. Pyramids, platforms, and furniture appear as orthogonal projections showing the most significant and active profiles.[41]

Iconography. The uncanny Mochica facility for isolating and representing significant moments of behaviour also took form in portraiture and humorous characterization. Many vessels are unmistakable records of specific persons at determinable ages and in identifiable moods and attitudes [339, 340]. In one class these portraits show men of noble bearing at the peak of maturity, with the firm expressions of those who bear great responsibilities. The portraits exist in many replicas, probably honouring dynastic chiefs or important officers. In another class, individual peculiarities are common, as well as mutilations and lesions. In all these cases the unique and special aspects of individuality were isolated, like the climactic moments of action in the narrative scenes. The portrait and the action scene are like instantaneous exposures, taken from the vast range of appearances.

Thus Mochica iconographic types are both traditional and disruptive of tradition. The stylized, tusked human beings of Chavín origins continue in modelled and painted Mochica vessels, together with the metaphoric clusters of animal attributes that characterize the Nazca style. Alongside these traditional types, the Mochica artist introduced new, special forms of great veracity and instantaneous vivacity. An abrupt enlargement of perception is apparent. The Chavín artist channelled all experience into a few arbitrary signs. The Nazca painter codified experience by pictorial metaphors drawn from an animistic conception of the world. The Mochica artist, however, turned his

344 and 345. Runners wearing animal attributes, Mochica III style, after 200(?), and house and occupants, centipede, and jaguar-fang deity, Mochica IV style, before 500. *Berlin, Museum für Völkerkunde*

gaze outward from ceremonial custom and from magical properties, to examine in great detail the world before him. Hence the Mochica monsters consist of animal attributes related by visually plausible organic connexions [345]. In the tusked human faces, the muscular structure is accommodated to the great dentures. Owl-man, fox-man, crab-man, and many others are all plausibly compounded.

One most remarkable innovation of the Mochica artists was their style of landscape painting. One example shows a cornfield, with the entire environment skilfully portrayed: the nodes of the stalks are depicted, the ears and their tassels burden the stalk, and the tassels nod in many directions, as in a cornfield tossed by a choppy breeze. On another painted vessel we see a watery marsh. Here small water-birds feed upon the cane, a heron feeds upon the fish, and water-grasses and snails fill the composition. There are no human beings and no monsters. Natural landscape appears with an evocative vigour unparalleled in ancient America.

Erotic behaviour and sexual organs are shown on about two per cent of all Mochica pottery. The scenes are usually anthropomorphic. Since they appear among tomb furnishings, a serious intention may be supposed. Coitus, masturbation, and sodomy may have conveyed concepts of divine inspiration, afflatus, and possession.

346. Dancing deer, relief scene on Mochica III–IV pottery vessel from the north coast, before 500(?). *Berlin, Museum für Völkerkunde*

Another prominent trait of Mochica sensibility is humour – the awareness of discrepancies between ideal and real behaviour. Humour depends upon detached observation of reality and the self, in a revelation of some part of truth by ridicule. Mochica pots often provoke laughter by skilful and sympathetic exaggerations. Many erotic scenes are funny: a woman wards off the embraces of a gross lover, or a nursing infant rages at its mother's amorous distraction. Humorous descriptions of animal behaviour are common: there are scenes of monkeys embracing or chasing one another's tails, and dances of upright deer holding hands with their young does and bucks [346]. In another vein there are chain dances performed by human skeletons, like the late medieval *danses macabres* of western Europe.[42]

The iconographical treatment of Mochica art remains at the level of description and preliminary identification. A knife-like accessory worn by many figures has been explained both as a metal bell and as a weapon. One writer claims to have identified a supreme deity named Ai Apaec; another has proposed four classes of nature-demons ruled by Si, a moon god who navigated the skies in a crescent-shaped boat. Where one interpreter sees messengers bearing dispatches written on marked beans, another proposes fertility races to stimulate the crops [344]. There is no archaeological evidence for the use of hallucinogens in Mochica life, as noted by E. Benson, who distinguishes stimulants, such as coca and chicha, from drugs.[43] We have encountered similar difficulties in the determination of conventional meanings

elsewhere in ancient America, and, as before, one must be content with approximating the intrinsic meaning.

Mochica art differs radically from the rest of American Indian art, save for the parallels to west Mexican pottery styles. With few exceptions, it is an art directly connected with sensation, based upon instantaneous perceptions of the changing appearances of reality. Mochica pictorial habits betray an interest in particular situations at the instant of happening. These attitudes most closely resemble the empirical and pragmatical modes in modern behavioural classification, and they suggest to us that the incidence of these modes of behaviour is not necessarily contingent upon economic conditions.

THE END OF MOCHICA ART

A most important connexion in the central Andean archaeological sequence appeared in 1899 with Max Uhle's discovery of intrusive graves, containing pottery in the Tiahuanaco style, on the south terrace of the main platform of the Sun Pyramid at Moche.[44] Uhle rightly understood these graves as related to the end of the Mochica style, and to its replacement by traces of a different culture.

All subsequent discoveries have reinforced Uhle's conception of the sequence of Mochica, Tiahuanaco, and Chimu on the north coast. As we shall see, the Huari-Tiahuanaco style at Moche (called 'Epigonal' by Uhle) was a weak reflection of more resplendent achievements on central and southern coastal sites, yet the cul-

tural change which these sherds attest seems to have been of the same order of magnitude as the displacement of Christian by Islamic art in Spain at about the same time, near the end of the first millennium A.D. On the north coast, only the Mochica territory was affected, in Ancash and La Libertad. No evidence of pottery intrusions in the Huari-Tiahuanaco style has come to light north of the Chicama Valley, although murals in a style compounding Mochica and Huari forms are reported at Huaca Facho north of Chiclayo, with single-figure rectangular panels facing a central axis, in a manner similar to the 'textile' arrangement of the Sungate at Tiahuanaco.[45] The Tiahuanaco sherds are painted in black and white on a red slip. They come from flaring-sided goblets, cups, double-spout vessels, and face-collar jars. The painted designs show geometrically simple puma and condor figures, as well as oblong fields and panelled divisions which all have affinities with the rectilinear structure of textile designs, such as the tapestry fragments in the Tiahuanaco style found at Moche.

Other pottery types associated with the intrusive Huari-Tiahuanaco style are moulded and have reduced-fired surfaces as black as heavily oxidized silver. Still others favour geometric designs painted in black, white, and red, as well as cursive designs painted on tripod vessels and modelled pottery. The older differentiation of grave wares and utilitarian types ceased.[46]

The systematic excavation of settlements in the Virú Valley confirms the thesis of an abrupt and profound cultural replacement. The building of great pyramids ceased, including palace-pyramids of the type of the Moon Pyramid at Moche, and the fortified hill-top enclosures which characterized Mochica architecture. Instead, huge compounds were built, as large as 130 m. (430 feet) square, surrounded by *tapia* adobe walls, and containing symmetrical files or ranges of rooms, corridors, and courtyards, disposed around small earthen platforms. Willey connects these reticulated compounds with the appearance of the Huari-Tiahuanaco style in figural art. They stand near the coastal roads built at this time to connect the valleys. Such roads probably formed a new system of communications, linking the coastal centres to one another rather than to their own valley necks and highland basins.[47]

THE LAMBAYEQUE DYNASTY

Far to the north, in the valley of the Leche river, the site called El Purgatorio [347] displays monuments of both the Mochica and Tiahuanaco eras. In its south-western quadrant are numbers of solid pyramidal platforms without enclosures, believed to be of Mochica date. At the northern rim of the site are files and courts of rooms upon an immense primary platform nearly 450 yards long: Schaedel attributed them to the period between the Mochica and Chimu states, and explained them as palaces housing families of the ruling class with their servants and artisans.[48]

An ornate example of a roadside mound within a walled rectangular enclosure of 55 by 59 m. (180 by 193 feet), internally surrounded with regular files of cells, is the Huaca Dragón, just east of Chanchan in the Trujillo Valley [348].[49] The outer wall of moulded and painted clay is divided into repeating panels of identical motifs several tiers high. The recurrent theme is an arched and two-headed serpentine body outlined by wave-scrolls, with each head devouring a small human figure. Within this outer wall are rows of cubicles like temple workshops, where artisans made shell incrustations for wooden statues. They left great quantities of discarded shell in all stages of manufacture. The inner pyramid was two stages high with a steep ramp adorned with moulded friezes. The entire edifice has been assigned to about A.D. 1100. Similar moulded adobe friezes of a coarser execution, with arched, two-headed figures, appear in the Lambayeque Valley at the Huaca Chotuna.[50]

These edifices in the valleys of the Moche, Lambayeque, and Leche rivers and elsewhere have been ascribed on archaeological evidence

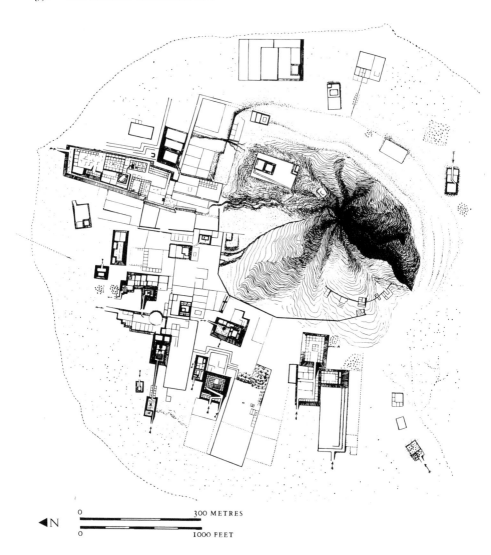

◄N

0 300 METRES

0 1000 FEET

347. El Purgatorio, Leche Valley,
thirteenth-fourteenth centuries.
General plan

alone to a period before the Chimu conquest in the fourteenth century, and after Mochica domination on the north coast. In addition we have two distinct historical traditions bearing upon the region, conveyed by reliable colonial authors. Here, for the first time in our survey of Andean prehistory, we can match archaeological and textual evidence. Miguel Cabello Balboa, writing in 1586, reported a dynastic history for the region now called Lambayeque.[51] The dynasty was founded by a seaborne colonizer named Naymlap, who came with his retinue in boats. He settled at Chot (probably Chotuna).

348. Huaca Dragón, near Chanchan, carved adobe wall decoration, c. 1100

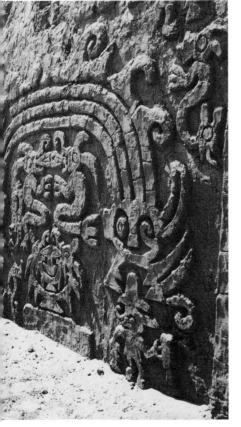

A succession of twelve rulers governed the region until its conquest about 1420 by the Chimu dynasty from the Trujillo Valley. Hence the inauguration of the Naymlap lineage goes back to the twelfth century, on the assumption that each ruler equals one generation of about 20–30 years' duration.

The description of the court of Naymlap mentions many functionaries who belonged to an aristocratic class, and gave personal services to the ruler. The sons of Naymlap settled other valleys in the Lambayeque basin; both the sons and the courtiers established dynastic lineages which continued for centuries as genealogical lines through the colonial era.[52] Cabello reported an interregnum of unknown duration between the last ruler (named Fempellec) of the Naymlap dynasty in Lambayeque and the Chimu conquest of 1420. If the interregnum was brief, then the Naymlap account fits in with the archaeological evidence as a historical record.[53] It reports the same kind of feudal and aristocratic lineage, replacing the previous theocracies, which we encountered in the Mixtec and Toltec dynasties of Mesoamerica at about the same epoch.

In 1936–7, three large golden knives bearing winged human figures were found in the Lambayeque Valley. One of them was inset with turquoises and bore red paint on the cheeks [349]. Luis Valcárcel at once suggested that these were dynastic images of Naymlap himself who, when he died, took wings and flew to the sky.[54] On closer study it appeared that this winged human figure, associated with a knife and wearing a semicircular diadem, is the most common simple theme of the coastal archaeology of the late periods. It appears in pottery, and on textiles and metal objects from the north and central coast. R. Carrión Cachot related the figure to a lunar deity with marine associations, and she regards it as a Chimu rather than a pre-Chimu form.[55] The representations all have almond-shaped eyes, with rising scrolls at their outer corners. A mural at the Huaca Pintada in the Lambayeque Valley records the same personage, flanked by bird-headed acolytes who

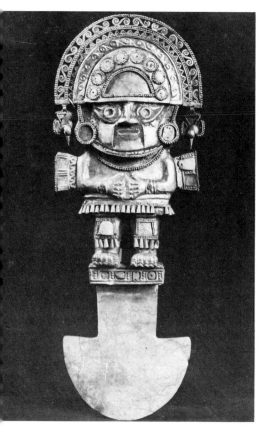

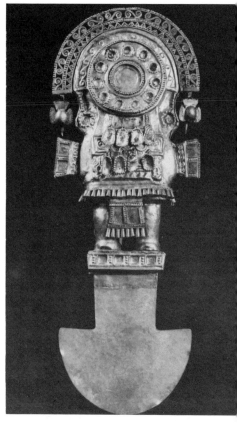

sacrifice two recumbent human beings. The theme of a wave-bordered, semicircular curve reappears in the moulded clay friezes at Huaca Chotuna in the Lambayeque Valley, as well as at the Huaca Dragón near Chanchan [348]. It also recurs in textiles from Pachacamac, where the diademed and winged figure is connected with the taking of trophy heads. It is most common in black-ware from the Lambayeque Valley, on double-spouted vessels and on taper-spouted vessels with loop handles, assigned by both Kroeber and Bennett to pre-Chimu times.[56]

The finest examples of north coast art in this period after Mochica and before Chimu

domination unquestionably come from the Lambayeque Valley. There the metal-smiths attained great virtuosity in the use of curved and plane wafers of soldered and welded metal [350]. The pottery forms likewise manifest a distinct style, more linear and more ideographic than the waxy shapes of Chimu origin in the Trujillo Valley.

THE CHIMU PERIOD

A Spanish chronicle written in 1604 furnishes our only record of the dynastic history of the land of Chimor or Chimu.[57] The founder, Tay-canamo, came like Naymlap by sea to Chimor

349 (*opposite*). Ceremonial knife with figure of Naymlap(?) from Illimo (Lambayeque Valley), twelfth century(?). Gold inlaid with turquoise. *Lima, Museo Nacional*

350 (*below*). Openwork ear-plugs of gold from the north coast, Lambayeque period, twelfth century. *Lima, Museo Nacional*

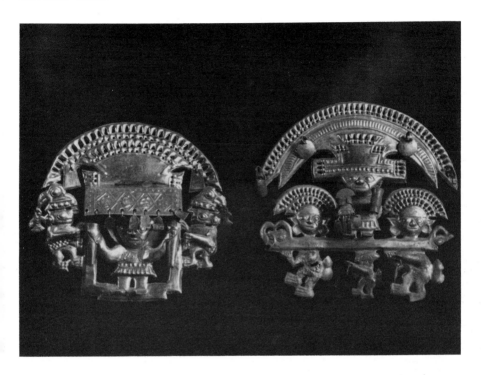

Architecture

early in the fourteenth century. Twelve generations of his descendants succeeded him in the kingship. About 1370, Taycanamo's grandson, Nançen-pinco, extended Chimu rule by conquest from the Santa river to Pacasmayo, and the ninth ruler, Minchançaman, brought all coastal valleys from Carbaillo near Lima to Tumbez under Chimu domination. This took place about 1460. The 'fortress' at Paramonga, built of adobe bricks, probably corresponds to this period. Minchançaman's career was interrupted before 1470 by Inca armies under Tupac Yupanqui, overrunning the Chimu Kingdom, looting the cities, and reducing the dynasty to vassal status.

Even with these indications, we are not clear about the beginnings of the Chimu state. The principal city, called Chanchan and situated near Trujillo [351], is now a vast ruin. The ancient name was probably Chimor. It has only recently become the object of systematic excavation, although a commercial company was formed in the sixteenth century to mine the huge treasure of its burials,[58] and illegal excavation of ruins has continued ever since. We do not know when they ceased to be inhabited. The finds of pottery strongly suggest that Chanchan was not in existence during the Mochica era and

that its earliest history does not antedate the twelfth or thirteenth centuries.

The ruins, which today cover about 11 square miles [352], probably represent a gradual accumulation during not longer than 300–400 years. The remains of ten or eleven walled enclosures, surrounded by adobe brick walls rising as high as 50–60 feet, still stand out clearly.[59] Most of the enclosures are regular rectangles. Two of the best preserved compounds, named Rivero and Tschudi, consist of two adjacent rectangles, one large and one smaller, combined in L-shaped angles [353].

The most palatial compound, named after Max Uhle [354], contains a quadrangle with thirty-three gable-ended terrace houses in ranges two to five units long, all arranged symmetrically on a low platform around a rectangular courtyard. The terrace houses never turn corners, and the interior courtyards are all open-corner quadrangles. This remarkable scheme was walled off from the adjoining units by double walls breached only on the north. Its symmetrical regularity and its relatively good preservation allow us to date it near the end of Chimu history. Older construction is plentifully evident throughout Chanchan.

Between the better-preserved enclosures are the faint traces of many smaller compounds, each defined by double parallel walls with blocks of terrace housing within. These smaller and less distinct outlines can be discerned only in aerial photographs taken under favourable lighting conditions. From the air they give the effect of a palimpsest, as if the traces of an older architectural grid were faintly visible among the bold outlines of the principal enclosures. That early and late edifices are involved seems certain, but the absence of scientific excavation makes it impossible to verify the detailed sequence of construction. Some of the low walls may of course define ephemeral or inferior construction, reflecting differentiation between palaces and proletarian housing, but such differences were probably less notable in adobe brick building than they would have been in more durable materials.

The wide variety in degrees of erosion is therefore indicative of the age of the buildings. The highest and least eroded walls are probably the most recent. Air photos [351] show clearly that three stages of construction can be inferred: at the lower right corner of the Rivero group is a small quadrangle containing many small

351. Chanchan and environs, thirteenth-fifteenth centuries. Air view

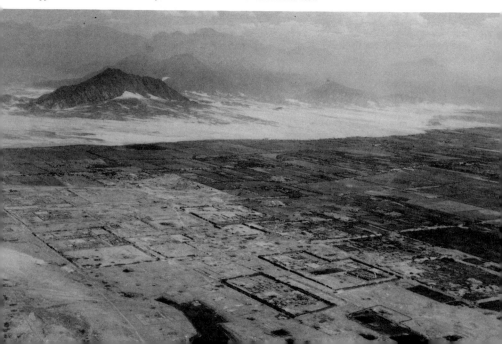

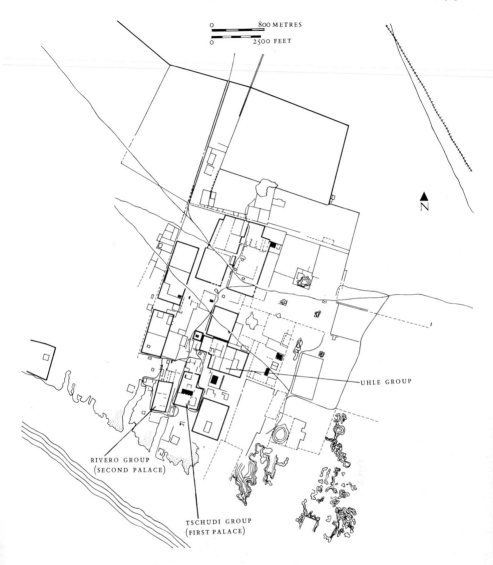

352. Chanchan. General plan, thirteenth-fifteenth centuries

courts, and its upper left margin is overlaid by the great double wall of a much larger quadrangle, which in turn is overlaid by the nearly intact double wall of the Rivero quadrangle [352]. Because large parts of Chanchan were thus abandoned to decay during the active life of the city, we may revise the estimate of the population. The traditional guess of 200,000, on the assumption that all quadrangles were simultaneously occupied, is far too high, and it does not seem unwarranted to reduce this figure by two-thirds. One may suggest that the builders of the city often changed the circumvallation, to enlarge the enclosure, or to make it more

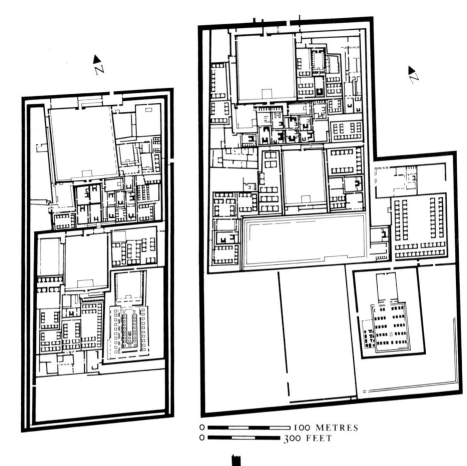

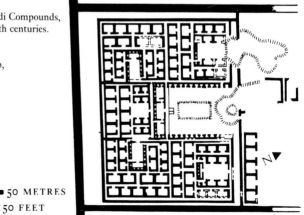

0 ▬▬▬▬▬▬▬ 100 METRES
0 ▬▬▬▬▬▬▬ 300 FEET

353. Chanchan, Rivero and Tschudi Compounds,
main enclosures, thirteenth-fifteenth centuries.
Plans

354 (*right*). Chanchan, Uhle Group,
thirteenth-fifteenth centuries. Plan

0 ▬▬▬▬▬▬ 50 METRES
0 ▬▬▬▬▬▬ 150 FEET

regular, for as we examine the plans of two of the best preserved enclosures, in relation to their eroded extramural neighbours, we receive the impression that some buildings inside a new wall are possibly as old as the eroded ruins outside the wall and immediately adjoining. The wall may mark a boundary between abandoned buildings and buildings that were kept in repair. In this event, the wall is the new construction rather than the buildings it separates. It is also notable that no compound opens to the north; that the highest walls shelter the compound from the prevailing south-westerly on-shore winds of the coast; and that most house-blocks face away from the southern exposures on courts opening to the north [352]. In these latitudes, of course, the northern exposure receives the most sun, in a climate where fog during many months makes every sunny day a welcome event. Thus certain peculiarities of the plan of Chanchan can be explained by the need for shelter from the ocean winds and for favourable exposure to the sun. Other traits of Chimu architecture require a sociological explanation.

The number and the size of the surrounding compound walls are astounding. In some places three parallel dikes define two clear streets, and usually one such street surrounds an entire rectangle, breached only by a single door [353, 354]. In which sense were these walls restrictive? Were they to keep the residents in, or to protect them from outsiders? Were the rectangular enclosures palaces, or were they factories? The two enclosures nearest the ocean, named after Rivero and Tschudi [353], contain a random assembly of dwelling blocks which can most easily be explained as industrial settlements.[60] On the other hand, the inland enclosure named after Uhle has a plan of spacious symmetry, like a carefully planned residence for privileged persons [354]. Rivero and Tschudi look like gradual accumulations, arbitrarily set in order by a vast enclosure, but the Uhle compound seems to have been designed all at one stroke, and probably at a late moment in the history of the city.

Rowe has shown that many features of Inca polity were borrowed from the Chimu state: one was the custom of governing by means of the local nobility; other traits are rectangular town plans, mass production methods, and craft practices in metal-working, textiles, and luxury goods such as feathered cloths.[61] After the Inca conquest of the land of Chimor about 1470, Minchançaman, the deposed Chimu king, was kept in exile at Cuzco as an honoured vassal, and with him went a colony of Chimu craftsmen. The Inca treatment of conquered subjects probably repeats earlier Chimu customs, and these may explain the urban form of Chanchan. By this hypothesis, resident vassals, together with their colonies of craftsmen, lived in productive exile at the Chimu capital, each colony in its compound, with more spacious quarters for the upper classes. The argument is supported by the close resemblances between the compounds of Chanchan and those of other sites, such as the one at the mouth of the Jequetepeque river, called Pacatnamú after the Chimu general who conquered the territory probably about 1370.[62]

Striking differences distinguish Chanchan from the northern cities. They are smaller and more provincial, and they are older, while Chanchan is the metropolis and the new city. The difference in age is evident in the small number of pyramidal platforms at Chanchan. Pacatnamú has about sixty pyramids, one with a core of Mochica date, and only one great compound. Chanchan, which has many compounds, boasts only a few pyramids of modest size. The site of Chanchan, however, is riddled with deep rectangular pits called *pozos* (wells) or *mahamaes*, which are like the negative impressions of pyramids [351]. They were probably produced to supplement canal irrigation. The excavated clays and gravels may have been used to build walls and platforms. Many compounds contain such *pozos*, and there are others in the unwalled areas between compounds.[63]

Sculpture

The dwellings of the upper classes in the palace compounds of Chanchan and other buildings of the Chimu period on the Peruvian coast are enriched with carved clay decoration of bold

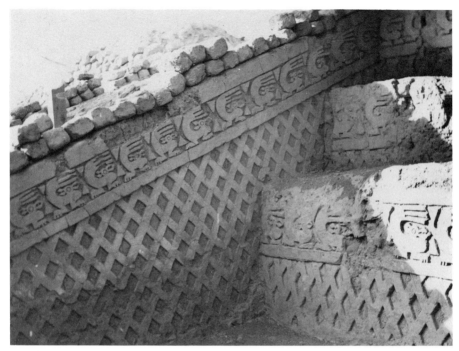

355. Chanchan, Huaca La Esmeralda, moulded and carved clay wall decoration at ramp, after 1300(?)

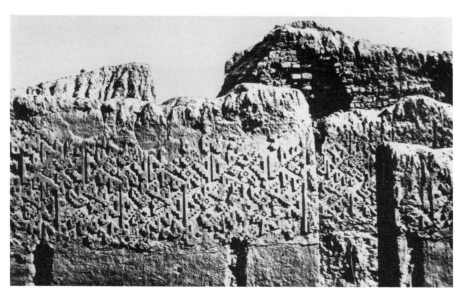

356. Chanchan, wall with moulded and carved clay decoration, c. 1400(?)

sculptural quality, arranged in panels and bands of repetitious figures [355, 356]. These carved clay arabesques usually adorn chambers, terrace-faces, and ramps. They differ from pre-Chimu clay decoration of the type of the Huaca Dragón [348] by the absence of rounded passages of moulding. The imaginative variety and the complicated ritual traditions of Mochica art disappeared and were replaced by secular themes, compressed into ornamental bands and patterns. At Chanchan, the relief is in two planes sharply separated by vertical cuts. A few incised lines are the only modifications of the plane surface. Many of the same motifs recur on repoussé metal objects and in Chimu textile decoration. A recent study of a late carved frieze shows that the clay was applied in two layers, of which the outermost, c. 2 cm. thick, was carved while drying. This frieze of fish, bird, crustacean, and human figures has been dated as of the Inca Conquest and occupation, before 1470.[64]

The predilection for a few ornamental figures in stereotyped repetition is a fundamental trait of Chimu art. It is related to enormous construction of the simplest, most rapid, and most effective sort. It is usually assumed that textiles were the sources of these repetitious schemes. Many wall patterns, however, suggest figured twill weaves, which are not abundant in Peruvian cloths. Twill construction would more commonly have been used in basketry and mats.[65] Hence we may suppose that some carved clay wall decoration of the Chimu cities perpetuates an ancient habit of hanging the interiors with matting in figured basket-weaves [356]. Other pictorial conventions of the Chimu people were so limited in the repetition of a few themes in meander and fret motifs that their origin need not be sought in any special craft.

Although Chanchan has long had the reputation of an important metalworking centre, very few objects can be ascribed with certainty to its furnaces. In the Baessler Collection of Peruvian metal objects in Berlin, of 570 items, only one, a semicircular knife-blade, is of Chanchan origin, and only twenty-five come from 'Tru-

jillo'.[66] We may suppose that the sacking of the graves of Chanchan began about 1470, when the Inca conquerors of the city removed its treasure to Cuzco. A few museums, however, have metal objects from Chanchan, and they are always small ornaments. The castings are of fluid plastic form, and secular in theme. The repoussé sheet metal cups and ornaments in the Chimu style exploit the brilliance of gold and silver by a variety of reflecting planes, often achieved with hinged bangles and filaments.

Chimu sherds at Chanchan are plain household red-ware; in the cemeteries black-ware is predominant. Stirrup-spout vessels, as well as effigy vessels, re-appeared here in common use after a lapse perhaps several centuries long. The phenomenon suggests a revival or a renaissance of Mochica forms, but without the pictorial style of Mochica draughtsmanship.[67] The Chimu potters revived from their Mochica predecessors' repertory only the monochrome wares. The black burnished surfaces resemble oxidized silver, and the polished red-ware resembles copper. Both black-ware and red-ware modelling have passages suggestive of repoussé or hammering more than of sculpture in clay.[68] The concept of a revival, involving certain Mochica forms stressing metallic effects, helps to define the character of Chimu pottery as a craft overshadowed by metalworking techniques. Unfortunately the principal products were destroyed by Inca and Spanish invaders.

Chimu textiles, like other crafts in the Late Period, show repetitive and geometric stylizations, governed by rectangular compartments or frames, with colour sequences which favour a diagonal movement of the eye across the whole pattern.[69] The north coast examples are far less abundant than those of the region from Lima to the Nazca Valley in the central area, and their quality is less impressive.

When the artistic attainments of the late north coast peoples are placed in perspective against those of their contemporaries in the south, they appear less intense and less complex. On the other hand the political attainments of

the Chimu dynasty, exemplified in the creation of enormous cities, far outstripped those of their predecessors and rivals. The Chimu tradition of imperial rule, maintained by aggressive expansion and by economic regulation, must surely have become the heritage of the Inca dynasty in the fifteenth century. One of the prices paid for this imperial political organization seems to have been the progressive loss of aesthetic vigour and inventiveness.

THE HIGHLAND BASINS

To each of the three main clusters of north coast valleys there corresponds a highland centre situated just beyond the continental divide on the Atlantic side. Chavín de Huántar, as we have seen, communicated most easily with the coastal valleys of the department of Ancash. Huamachuco was the highland intermediary at the nexus of the headwaters feeding into the Marañón basin as well as into the Chicama and Trujillo Valleys. Cajamarca, finally, connected the Lambayeque and Jequetepeque systems with the Marañón basin. All three were highland citadels, capable of guarding (or threatening) the headwaters of the Pacific streams, as well as of controlling the approaches to the Pacific Coast from the Amazonian rain-forests, via the Marañón river. Any interchanges between coastal and Amazonian peoples, such as the trade in tropical feathers and highland wool, must have been negotiated at such centres. The Inca war-lords, before attacking the rich coastal valleys, secured possession of Cajamarca with its surrounding domains, gaining a secure military base from which to conquer the land of Chimor in the 1460s.

The archaeology of Cajamarca is known with a completeness that would be desirable for every region of Peru.[70] In Cajamarca the sequence resolves itself into passive and active stages, in an area spread between the Hualgayoc and the Crisnejas rivers. After an initial period of incised monochrome pottery, distantly similar to that of the Chavín style, the region slowly evolved a distinctive ceramic decoration based on cursive brushwork in black and red or orange on tan, cream, or white slip (Cajamarca I–III). This evolution occurred independently, without influences from the coast. It endured until the close of the Mochica sequence, about the ninth century A.D., when Cajamarca was invaded by the same intrusive art from the south (Huari-Tiahuanaco) of which we have already seen the effects on the coast at the close of the Mochica series. Subsequent relations between Cajamarca and the coastal peoples are shown by the occurrence in the coastal valleys of Cajamarca IV vessels together with pre- and early Chimu styles. These sherds differ from the 'classic cursive' (spiral brush-strokes) and 'floral cursive' of Cajamarca III by the addition of bold geometric fields derived from the Huari-Tiahuanaco style.

In 1532 the Spaniards routed the Inca army and took the ruler, Atahualpa, prisoner at Cajamarca.[71] The chroniclers describe various edifices, forming an impressive group, of which little survives. Whether these were Inca constructions or re-used buildings of older date is not known. In a walled plaza stood three 'pabellones' containing eight rooms. One of these chambers still stands in the present Hospital de Belén, and an old tradition makes it the room where Atahualpa's ransom was brought together. These buildings were probably 'galleries' like those of Huamachuco, described below. A rectangular pyramidal platform stood east of the walled square. Systematic study of the architecture of Cajamarca, to parallel Reichlen's ceramic sequence, is still lacking.

Some idea of the architectural tradition of the north highlands can be gained, however, from the buildings of Huamachuco,[72] about 40 miles distant from Cajamarca as the crow flies. The earliest people lived in hilltop villages of stone houses with rectangular rooms, arranged in casual order around open courts. Much later, the populace built a high-walled fortress called Marca Huamachuco. It was possibly contemporary with the later stages of Mochica history, to judge from the stone heads and reliefs collected by Uhle. The heads[73] wear helmets close to those of the Mochica styles. The reliefs show geometric reductions of organic forms recalling

Tiahuanaco sculpture. The houses were long and narrow galleries, two or three storeys high, with the floors carried on corbels. The floorings have all vanished, and the walls themselves are ruined. The absence of doors and windows at ground level in some 'galleries' suggests that the entrances were on the upper floors, reached by ladders, which could be withdrawn in case of attack. These people used a style of cursive pottery painting on ring-base pots similar to

that of Cajamarca III, as well as negative painting like that of the region around Recuay in the Ancash highland.[74] No trace of negative painting appears at Cajamarca, however, so that Huamachuco may be taken as a boundary between the highland traditions of Ancash and Cajamarca in pottery decoration.

About $2\frac{1}{2}$ miles north of Huamachuco are the ruins of Viracochapampa [357], a grid-city laid out upon a square of about 580 by 565 m. (635

357. Viracochapampa.
General plan *c.* 750–800

by 620 yards), with the sides facing the cardinal points. A road cuts straight through the city from north to south, and a central plaza, bordered by smaller courtyards, is the nucleus of the city. The rest of the city consists of courts surrounded on three sides by narrow gallery houses. The plan resembles the compounds at Chanchan. Plan and buildings resemble the garrison city called Pikillaqta [400], 20 miles south-east of Cuzco. Both usually pass as Inca settlements of the early sixteenth century, designed to concentrate the rural populations of the area under one central control. A case has been made for a date during the Huari domination, manifested by Viñaque pottery before 900.[75]

CENTRAL PERU

Before the appearance of pottery in Peru, the central coast valleys were the scene of the earliest large ceremonial architecture now known in ancient America, built between 2000 and 1800 B.C. At Chuquitanta in the lower Chillón Valley, clay walls with stone facings formed a temple upon a mound, flanked by long wings, capable of housing a thousand persons.[1] In later periods, originality in the repertory of expressive forms is rare throughout the region between the Paramonga and Cañete Valleys. Whether on the coast or in the highlands, buildings and crafts resemble those of other regions, as if central Peru had been a receptacle for styles originating elsewhere. Thus examples both of the Paracas style and of a style related to Chavín occur at Playa Grande near Ancón in the same approximate stratum at the beginning of the sequence of the fine wares.[2] This intermediate position between powerful artistic radiations from north and south makes it difficult to identify a specific regional expression: perhaps central Peru became the natural meeting place for northern and southern traditions, constituting a limitrophic province rather than an autonomous artistic region. The exact boundary between northern and southern archaeological traditions was tentatively fixed by Stumer between the Rimac and Chillón Valleys just north of Lima.[3]

In any event, central Peruvian sites are important and large enough to warrant treatment in a separate chapter. Thus Pachacamac was a metropolitan centre, much like Lima during colonial and republican periods, although depending far less upon seaborne commerce than the viceregal capital. North of Lima the stylistic connexions of the coastal valleys point to Ancash and beyond. South of Lima, connexions are more common with the Tiahuanaco and Inca styles, that is, with the southern highlands.

FROM LIMA NORTH

The group of the northern valleys, from the Rimac to Huarmey, embraces about 160 miles of the Pacific Coast. Close to the beach, at Ancón and at Supe, 80 miles farther north, are large cemeteries and middens containing objects worked in the coastal Chavín style.[4] On both sites the early pottery is red or black, with the characteristic incised surfaces of Chavín art. There are stirrup spouts, and at Ancón and Supe the images include serpents, felines, and birds in the Chavín style. The aridity of these coastal cemeteries has preserved from decay some specimens of textiles [358] and wood-

358. Tapestry fragment representing a condor-feline figure, from Supe, Chavín style, before 400 B.C.(?)

carving in this style. The buildings were simple dwellings with stone foundations, and no public edifices have been identified among these fishing folk[5] whose burial artifacts so closely reflect the early ceremonial customs of Ancash and Libertad much farther north.

An elaborate public architecture first appears in the fourth century at Cerro Culebra near the mouth of the Chillón river. The original plan of this platform-pyramid was covered over with later constructions, but parts of the primitive

painted facing have been exposed, to show 26 m. (85 feet) of fresco decoration in seven colours on a yellow clay ground, representing geometrized figures surrounded by serpent attributes and fish motifs. Two distinct grades of workmanship are evident. The style of the wall decoration resembles the pottery painting of Recuay in the Callejón de Huaylas, some 150 miles to the north-east,[6] and the ceramic associations also place Cerro Culebra in this same period, prior to A.D. 500.

Coeval with Cerro Culebra is the style designated as Lima. The type-site is Maranga, a great cluster of pyramidal platforms and graves lining the highway from Lima to Callao.[7] It is a ceremonial centre of Classic date, built before the intrusion of the Huari style. The stepped platforms are built of hand-made and mould-made rectangular adobe bricks, like the principal edifice at Moche on the north coast, with which the architecture of Maranga is probably contemporary.[8] Five phases have been identified in the history of Maranga. The earliest antedates the platforms, with many small adjoining rows of foundations. The second (coeval with the painted walls of Cerro Culebra) comprises early terrace constructions; the third has new construction separated from the earlier stages by a layer of ashes, and containing ceramic designs of interlocking positive and negative forms. These interlocking shapes relate both to the Recuay and the Nazca styles, allowing a date prior to A.D. 500. The fourth and fifth stages included many new buildings. Sherds of the Mochica as well as of Late Nazca style appear among the ruins of the fourth period.

In the fourth period, however, Maranga yielded place after 600 to a new urban centre in the Rimac Valley at Cajamarquilla,[9] 18 km. (11 miles) east of Lima. Here uncounted foundations of rooms and small courts have been found, enough to house thousands of families. They date from after 500. The pottery shows Nazca, Mochica, and Huari traits. The site as a whole belongs without question to the group defined by R. Schaedel as 'Urban Elite Centers'. An earlier portion is built of hand-made

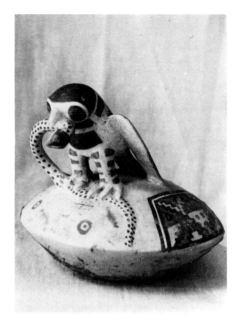

359. Polychrome pottery showing bird and serpent, from Cajamarquilla, Lima style, after 500. *Lima, Museo Nacional*

adobes mixed with *tapia* walling; the later constructions under Inca domination have *tapia* walling mixed with moulded bricks.

The characteristic pottery of the earlier levels at Cajamarquilla, like that at Maranga, is also called Lima. It is often of fine orange paste decorated in six colours (white, grey, black, brown, red-violet, and yellow), and enriched with full-round sculptural forms. This combination of painted and sculptural shapes confers upon the best Lima pottery its singular quality [359]. The products are more polychrome than those of the Mochica style, and more sculptural than those of the Nazca style. The vessel shapes derive from both traditions, but the standard forms are blurred, tending more to the rounded shapes and bases characteristic of south coast pottery. The long tapering spouts have a fragility and elongation that distinguish products of the Rimac Valley from all

others. In general the affinities of this pottery are with south coast styles, as in the high frequency of pottery pan-pipes. Certain traits are decidedly foreign, like tripod or tetrapod vessels, which are Ecuadorean and Meso-american, but not typically Peruvian, unless in the northern highlands around Cajamarca (p. 408).

That peculiar mixture of an independent artistic tradition with provincial derivations, and folk-art slovenliness, which characterizes the art of the valleys to the near north of Lima, is most clearly evident in late pottery from Chancay on the lower Pasamayo river, adjoining the Chillón river. At a period immediately before the Inca conquest, these Chancay potters ignored the moulded techniques of their Chimu contemporaries. They used globular shapes, with coarsely modelled sculptural increments at the neck, and low-slung carrying-loops [360].

The painted decoration varies by combining black, white, and red according to the white or red ground clays and slips.[10] The effect of casual workmanship arises in the production of easily recognizable types in large numbers, and recalls that of the modern pottery workshops in places like Pucará or Quinoa, where tens of thousands of pieces are produced each year for the market-places.

The upper valleys of the Chillón and Pasamayo rivers belong to Los Atabillos (or Cantamarca province), whence Pizarro took the title of his marquesate. The region is remarkable for walled cities of stone dwellings. They resemble the stone burial towers in the province of Collao near the shore of Lake Titicaca. Like the Aymara *chullpas* of the southern highlands, these *kullpi* houses are built of dry-laid boulders, with simple corbel-vaulted roofs [361]. They differ from the southern examples

360. Polychrome pottery vessel from Chancay, Pasamayo river, *c.* 1500. *Lima, Museo Nacional*

361. Corbel-roofed stone houses in Cantamarca province, after 1000(?). Sections

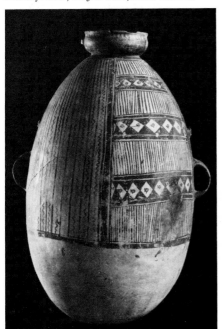

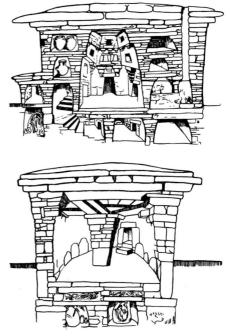

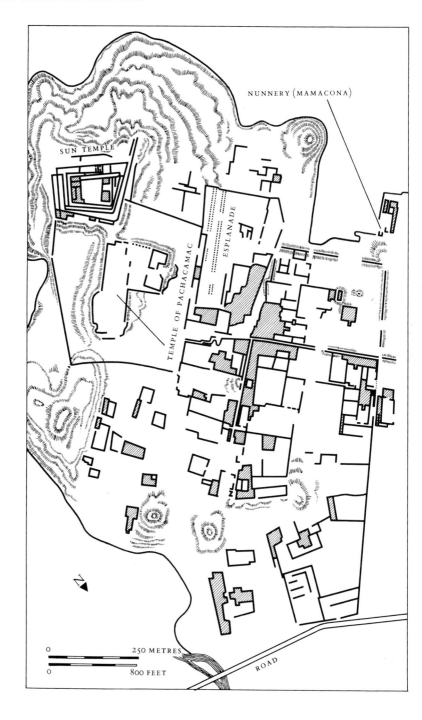

in being genuine dwellings. There are two types.[11] Square and round towers with central columns supporting the vaults occur around Canta in the upper Chillón Valley. Farther north, in the Pasamayo Valley, 2800 m. (8900 feet) above sea level, at Chiprak and Añay, are larger dwellings with central corbel-vaulted halls surrounded by massive walls, honeycombed with storage chambers and small rooms. These houses resemble those of the Callejón de Huaylas, e.g. at Wilkawaín near Huaraz, where Bennett excavated gallery houses and a temple of storeyed construction, associated respectively with the ceramics of Recuay and Tiahuanaco.[12] The towers at Canta have no particular façades, and the central columns are designed to support the corbelled roof, over plans as wide as 6.5 m. (21 feet). At Chiprak, however, the flat façades have a striking rhythmic decoration by narrow trapezoidal niches rising from ground to cornice level. These niches evoke the Inca habit of breaking the wall by trapezoidal recesses. They may correspond to a later date of construction than the Canta towers.

SOUTH OF LIMA

The Lurín Valley empties into the Pacific among low hills about 20 miles south of Lima. Pachacamac stands on the north bank, covering an area of about 4 by 2 miles,[13] between the highway and the ocean. The principal buildings and streets obey a roughly regular plan which quarters the cardinal points [362]. The south-western quadrant is a hill sheltering the city from the prevailing on-shore winds. It is crowned by an earthen platform traditionally called the Sun Temple. In the south-eastern quadrant another high hill rises, and the saddle between the hills is occupied by an older temple platform identified by Uhle as pertaining to the cult of the local deity, Pachacamac [363]. Its oldest parts are coeval with the Mochica and

362 (*opposite*). Pachacamac, mostly after 700. General plan

363 (*below*). Pachacamac, Inca platform, before 1500 (*left*), and platform of the Tiahuanaco period, 600–1000 (*right*)

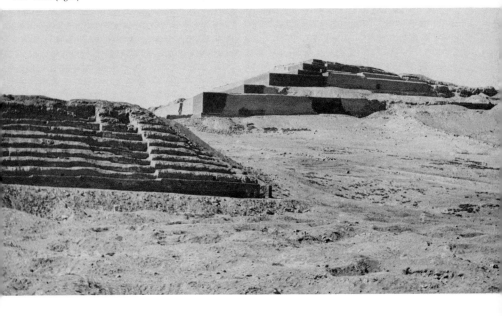

Nazca civilizations.[14] The north-eastern quarter contains the oldest dwellings, and the north-west quadrant is dominated by a building of Inca date called the Nunnery (Mamacona), facing the Sun Temple across a colonnaded esplanade. The esplanade, unique in Peru, extends for about 330 yards on an axis from south-west to north-east. The combination of temple platforms with residential terraces and courts corresponds to the type of Chanchan.

Though smaller than the great 'urban elite centres' of the north coast, Pachacamac is the largest pre-Conquest city in central or southern Peru, and its architecture represents the southernmost occurrence of large assemblies of pyramidal platforms. Several colonial texts describe the buildings in some detail, and according to them the Inca Temple of the Sun was the one nearest the sea, and the highest one, painted red, and built of *tapia* in six stages. The Jesuit Bernabé Cobo,[15] writing before 1636, describes the building in great detail. His measurements coincide closely with those of Max Uhle,[16] and he saw the buildings in much better repair. The top terrace accommodated two parallel buildings, each 170 feet long by 75 feet wide, and 24 feet high, with deep niches on the north-west and south-east faces overlooking the surrounding prospects. They contained shrines and priests' dwellings, painted in various colours with figures of animals. Other buildings occupied the wide terraces on the second, third, and fourth stages. Some were recessed like caves into the high terrace risers.[17]

The south-western exposure was the principal façade, overlooking the ocean. Spanning the two uppermost buildings and facing the water was a colonnade on the penultimate terrace. Its roof was an extension of the topmost terrace floor. The main stairs, on the opposite or north-eastern face, with ten or twelve ramps of about twenty broad steps each, rose within the terrace faces. Strong's excavations established most of these details,[18] although he and his associates do not quote either Cobo's description or a manuscript plan by Josef Juan in the British Museum (Add. Ms. 17671), dated 1793,

and showing substantially the arrangements described by Cobo. Strong also confirmed the Inca date of the entire outer construction. Underneath the north-eastern face, however, Strong uncovered burials of a much older period, containing pottery of the interlocking style and of the same approximate date as Recuay (p. 375) and Paracas. Similar sherds were found by Uhle at the other, lower platform structure associated with the cult of Pachacamac.

The temple of Pachacamac is a platform of many terraces covering a large rectangular area, much less high than the Sun Temple on the hilltop above it. Eight of these terraces, each no more than 3 feet high, rise on the northern face, painted with plants and animals in rose, yellow, blue-green, and blue-grey earth colours.[19] The ground colours were applied with large swabs of cotton cloth, and the figural designs were then brushed on. Small cotton bags containing the pigments, and brushes of reeds and human hair were found near the terraces in 1938. The black contour lines surrounding the figures were not the guiding sketch lines, but served to strengthen and define the figures in a final retouching, much as in Nazca pottery. The paintings were frequently redone, with as many as sixteen coats showing in certain spots. The top of the platform, like that of the Sun Temple, bore buildings surrounding a courtyard. As at the Sun Temple, the spatial arrangements included dwellings and temples in a loose and functional order.

Farther north is a stystem of large forecourts. Three parallel and double rows of supports show in the air photographs: at one time these colonnades must have supported simple roofs of matting for the shelter of pilgrims and merchants. At the extreme north-western boundary of the site stands the imposing *tapia* building called the Nunnery. Its foundations, of many courses of beautifully regular pink masonry in the Cuzco style, have each stone fitted by friction to its neighbours. The general plan of these heavily restored chambers comprises a terraced courtyard opening to the south with a view of

the temples and the sea. It recalls the Inca nunnery building on the island of Coati in Lake Titicaca.

The colonnaded platforms and esplanades are elements of striking originality. The importance of Pachacamac as a holy centre is attested by many early Spanish sources. Calancha speaks of shrines maintained by other groups at Pachacamac; burial near the temples was a privilege eagerly sought by members of the cult of Pachacamac, and pilgrims came to the shrines from all parts of Peru. But the textiles, woodcarvings, metal objects, and pottery in the tombs, though abundant and belonging to many periods in a history of two thousand years, lack the impress of any long-term patterning which we can identify as peculiar to this site.

Designs in cloth and on pottery, based on eagles stylized as at Tiahuanaco, became important during the eighth century on the central coast,[20] and are identified as the 'Pachacamac style'.

THE SOUTH COAST VALLEYS

Polychrome ceramics and bright-hued textiles characterize the southern regions of the central Andes as decisively as bichrome pottery and large urban groupings do the ancient civilizations of northern Peru. Such many-coloured vessels, and the textiles, were traditional products as early as the fifth century B.C. These southern regions extend from the Cañete Valley on the Pacific Coast of Peru, east and south to Bolivia, the north-west Argentine, and northern Chile. As in the rest of Peru, the important centres of artistic activity were either in the coastal valleys or in widely separated highland basins. In the south, too, the coastal peoples were under the rule of highland masters late in pre-Columbian history, much as in the north, so that the same division by coast and highland regions, and by early, middle, and late periods, is practical.

PARACAS AND NAZCA

Two river valleys sheltered the early civilizations of southern Peru (1400 B.C.–A.D. 540). The Ica river, which flows south to the coast through desert plateau country, is lined by the oldest known settlements on the south coast. Many remnants of these earliest urban societies were buried in graves on the distant wastes of the Paracas peninsula, isolated by deserts from both the Pisco and Ica river valleys. The other river is the Río Grande de Nazca, emptying into the Pacific some 20 miles south-east of the Ica estuary. Its upper course receives many confluents, separated by barren pampas and mountain ranges. Each of these upper valleys was settled by groups of people sharing the same culture, and flourishing much later than the earliest settlements in the Ica Valley. Students of the archaeology of this region are now agreed upon naming the older Ica culture after its great

burial ground on the Paracas Peninsula, and the more recent one after its main habitat in the upper Nazca valley.

The whole chronological question is exceptionally complex because of the disparity between absolute dates given by radiocarbon measurements, and the different relative datings based upon typology alone. Andean C14 measurements made before 1960 dated an event like the coastal appearance of pottery seven centuries later than measurements made after 1960 in other laboratories. This 'long scale' is now in general use, but the chronologies themselves still are based more on stratigraphy and stylistic seriation than on radiocarbon.[1] The tendency, as in northern Peru, is to put in series a number of events which were actually contemporary, thereby turning regional variants into historical sequences.

On the Paracas peninsula, Tello recognized two periods, represented by the Cavernas burials and by the Necropolis burials [366, 367]. The latter occupied refuse layers of older Cavernas dates. Cavernas and Necropolis therefore form a true sequence.[2] Absolute Paracas dates are more problematic. Early (Cavernas) and Late (Necropolis) stages perhaps overlapped. Tello's Paracas chronology has been displaced by one based on Paracas pottery style as found in the Ica Valley, yielding ten phases, each lasting one century (long-scale, 1400–400 B.C.). Phases 1–8 correlate with Chavín sculpture, and the tenth (fifth century B.C.) overlaps with Early Nazca pottery, but it includes a fine unpainted white ware called Topará, which remained dominant during Early Nazca [367]. Embroidered Necropolis textiles appear as late as the Early Nazca period,[3] in grave-areas at Cahuachi on the middle reach of the Río Grande de Nazca.[4] Thus Necropolis embroideries and Early Nazca pottery were coeval.

Another example of coeval groups is Strong's 'Middle Nazca' (336 ± 100 to 525 ± 80 by C14), which practically coincides with his 'Proto-Nazca' (325 ± 80 to 495 ± 80), when his seriation is related to short-scale radiocarbon dates.[5] The most recent paper to refine the stylistic sequence of Nazca art, by L. E. Dawson, proposes nine phases.[6] A seriation still in use is the original one proposed by Gayton and Kroeber in 1927.[7] They classed a large collection from the Nazca region on the assumption that simple shapes and designs (A), followed by a transition (X), preceded more elaborate ones (B), which in turn preceded (Y), a 'slovenly breakdown'. Their correlation of vessel shapes and painted designs [368, 369] led them to propose a seriation of A, X, B, and Y styles. They at first divided the last of these into three phases, Y1, Y2, and Y3, and in a later revision of the method Kroeber reaffirmed the sequence of A, B, and Y, with Tiahuanaco traits appearing in Y2. He abandoned Y3, whose components were reassigned to Nazca A, and he questioned the validity of a transitional X.

Carbon 14 dates, whether short- or long-scale, confirm the sequence of A and B, and they serve as chronological centres for the early and late phases of the Nazca style.[8] We are therefore given two stylistic groupings, called Paracas and Nazca, each with early and late stages. The late stage of Paracas (Necropolis) and the early stage of Nazca (A) overlap enough to justify considering the entire duration as a unit with early, middle, and late phases, of which the dominant expressions were pottery and textiles.[9]

Architecture

Before discussing these sculptural and pictorial systems, we must consider the architectural production of the peoples of the south coast valleys. There is no evidence that the Paracas peninsula was inhabited by the wealthy people who were buried there. Poor fishermen made a living on the beaches, but the rich burials were brought to this desolate site, perhaps from the Ica Valley, 55 miles away, and from the Chincha

and Pisco Valleys, 20–25 miles distant. The Cavernas tombs adjoin the Necropolis. They are bottle-shaped excavations in a yellow slate-like rock. The nearby Necropolis tombs are chambered and rectangular constructions, built among the remnants and refuse of an earlier occupation of Cavernas type [364].

Of Late Paracas (Necropolis) dates are certain mounds in the Ica and Nazca Valleys.[10]

364. Paracas peninsula, underground burial structures of Cavernas and Necropolis types, *c.* 200 B.C.

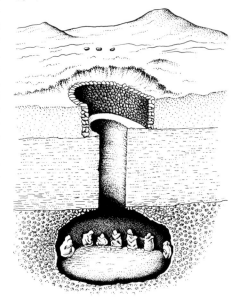

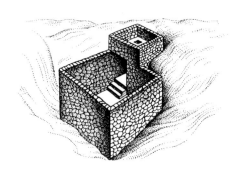

One at Ocucaje in the Ica Valley is built of bundled reeds and rectangular adobe bricks in a mammiform shape 50 m. (165 feet) in diameter and 4 m. (13 feet) high. Other remains of connected dwellings on rectangular plans at Cahuachi show post and wattle construction daubed with clay.

The most extensive Early Nazca ruins are at Cahuachi on the middle stretch of the Nazca river, where a pyramidal platform of wedge-shaped adobes 65 feet high, overlooking several clusters of rectangular rooms, rises upon a steep hillside. Other terraced platforms rise north and east, some with conical, grooved adobes. None approaches the grandeur of north coast architectural remains. There is a peculiar wooden assembly at La Estaquería, near Cahuachi, of very late date (short-scale 1055 ± 70 by C14), connected with Late Nazca and Early Tiahuanaco remains in the region. It consists of twelve rows of twenty upright tree-trunks, forked at the top and spaced 2 m. (6 feet) apart. The purpose of the monument is unknown. The arrangement resembles the regularly spaced stone piles in the deserts between the upper valleys of the Nazca drainage.[11] These in turn are part of an immense network of lines, stripes, spirals, and effigies, all executed on a colossal scale upon the barren table-lands above the Palpa and Ingenio rivers, in an area about 60 miles long and several miles wide [365]. The weather-worn surface of small stones is dark, but the sand and gravel just underneath are much lighter in colour. The lines and stripes were formed by piling the dark surface stones along the sides of the exposure. Many straight lines strike across the plateau and rise without lateral deflection up precipitous slopes to vanish inexplicably, going between points of no particular distinction without any pretence of serving as paths or roads. Certain modular measurements recur: lengths of 26 m. and 182 m. (7 times 26) have been ascertained. Miss Maria Reiche, who has patiently plotted and computed the plans and their possible use as astronomical sighting-lines, finds that some mark solstitial and equinoctial points upon the horizon. Others may point to the rising and setting of certain stars, such as one in the constellation of Ursa Major, which coincided with the annual flood season in November at the beginning of the agricultural cycle. The stripes of expanding width may record intervals in the observations taken upon a given star.[12]

We can only guess at the methods used to plot these giant figures with such remarkable geometric regularity. Some scheme of enlarging the parts of a model design by fixed proportions has been supposed for the rectilinear portions. The large curved figures of plants and animals may have been constructed with the help of radial guide-lines, of which faint traces remain here and there [370].

The function of the effigies is unknown, but their style is close to that of Early Nazca drawings. They represent a fish hooked upon a line, a spider, a bird in flight, a branching tree, all drawn at colossal size in continuous lines the width of a footpath. They may be images symbolic of the constellations. One may also imagine that their outlines served as processional paths for celebrants in rites of imitative or compulsive magic. Surely their 'drafting' required many generations of work, because the interlacing of successive lines and designs in some areas shows many layers in a dense grid of overlapping intersections that betray a constantly shifting design.

It is perhaps unexpected, but it is not improper, to call these lines, bands, and effigies a kind of architecture. They are clearly monumental, serving as an immovable reminder that here an important activity once occurred. They inscribe a human meaning upon the hostile wastes of nature, in a graphic record of a forgotten but once important ritual. They are an architecture of two-dimensional space, consecrated to human actions rather than to shelter, and recording a correspondence between the earth and the universe, like Teotihuacán or Moche, but without their gigantic masses. They are an architecture of diagram and relation, with the substance reduced to a minimum.[13]

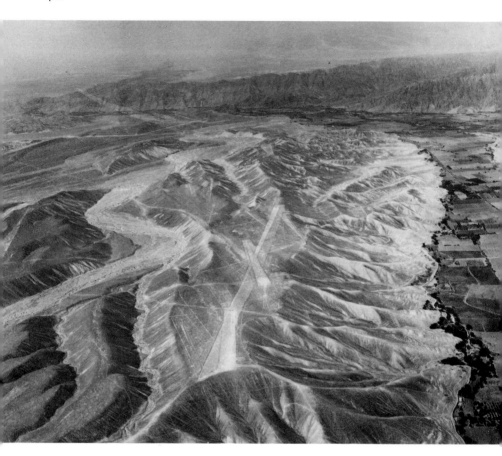

365. Markings on the pampa above the Palpa river,
first millennium B.C.(?)

Pottery

The south-coast peoples lacked writing in any form. Pottery painting and textile decoration therefore carried the burden of recorded communication. The climate, even more arid than on the north coast, and the elaborate burial customs are responsible for the extraordinary state of preservation of huge quantities of pottery and textiles recovered from Paracas and Nazca tombs. The pottery shapes all have rounded bases [368, 369], quite unlike the ring bases and the flat basal planes of north-coast pottery. These globular bases indicate a domestic architecture with loosely packed, sandy floors, in which the rounded vessels easily stood upright. The shapes are much more variegated than in the Mochica culture. From the earliest period, the polychrome decoration stresses conceptual abstractions and combinations more than pictorial descriptions of the environment. The representation of action shared by several figures is totally lacking. There are no conven-

tions for showing landscape or housing. The preference for complex colour relations also required a bold patterning by areas, precluding the refinements of draughtsmanship to which the Mochica potters were dedicated. In brief, the Mochica painters attained animation at the expense of colour, unlike their south-coast contemporaries, who secured polychromy at the expense of pictorial range. The principal topics for a discussion of south-coast pottery are shape, colour, design, composition, and iconography, which are of course the customary divisions required by the consideration of the art of painting.

The shapes of Paracas phases 1–8 afforded smoothly curved surfaces for incised and painted designs [366]. The effigies of heads, as of seated or standing persons, have slowly curving pear-shaped contours to permit clear linear incision of the principal details, as in the art of Chavín, where linear articulation of the design was also predominant. Necropolis or Late Paracas (Topará) shapes are more sculptural in

366. 'Crust-painted' pottery from the Cavernas site, Paracas peninsula, after 500 B.C.(?).
New York, American Museum of Natural History, Gift of John Wise

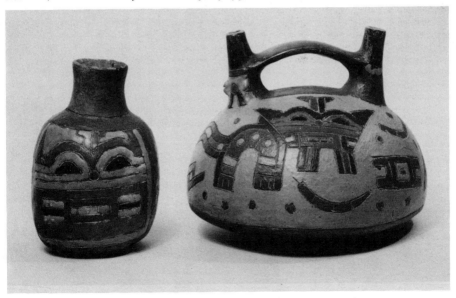

abandoning linear and painted decoration and in the use of sharply angled contours and ribbed panels reproducing the shapes of gourds and squashes [367]. Early Nazca shapes once again

367. White-slipped pottery from the Necropolis site, Paracas peninsula, before 200 B.C.(?).
Lima, Museo Nacional

favour the painter in avoiding vessel forms of extreme contour, and in providing large curved surfaces for the development of repeating or encircling figures [368]. Later Nazca shapes

[369] run to kettle forms as well as elongated vases and goblets of flaring or undulating contour. Modelling of human or animal features appears, and the decoration includes many bands and zones corresponding to the increased complexity of the vessel shape.

The history of the Nazca colouristic achievement can be reconstructed in part.[14] The earliest pottery prefiguring Nazca multi-coloured firing is the style of Cavernas on the Paracas peninsula. A variant is known from Ocucaje and Juan Pablo in the Ica Valley. The vessel forms are bowls, jars, and spouted containers. They are decorated with patches of a powdery pigment of bright, high-key earth colours applied after firing [366]. This method of colouring the incised designs is called 'crusting'; it appears only on sites belonging to the Paracas style, sometimes in conjunction with resist (or 'negative') painting, such as we have seen in the Ancash series. Occasionally the incised and coloured designs resemble Chavín forms, but these connexions with the north are infrequent. They suggest a date equivalent to Salinar in the

368 and 369. Polychrome pottery vessels from the south coast, Early Nazca style, before 100(?), and Late Nazca style, after 300. *Chicago, Art Institute*

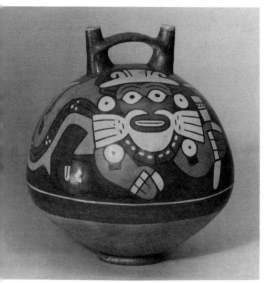
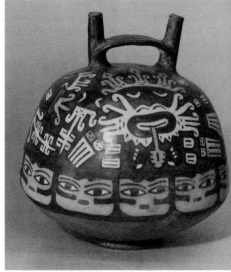

Chicama Valley, because of their association with vessels of a globular form surmounted by a pottery handle connecting the tubular spout with a modelled head.[15]

From the earliest phases of the Paracas pottery, post-firing or 'crusting' continued intermittently, but with more colours, of a heavy resinous consistency, in large patches separated by incisions cut deeply into the polished clay. Resist-painting appears alone, no longer joined with crusting on the same vessels. Another Late Paracas type is rare – a white or orange, slipped, and polished pottery of gourd and vegetable shapes, associated with the Topará Valley, but most common in the Chincha and Pisco Valleys [367]. It occurs in diminishing quantities farther south, at Ocucaje in Ica, and Cahuachi in the Nazca Valley. Upon white or solid-colour grounds, the Nazca potters gradually learned to fire the paint in as many as twelve colours, attaining polychrome effects more varied and more brilliant than those of all other ancient American vessels.[16] Like the painting of other pre-Columbian peoples, however, Nazca colour rarely imitates appearances, being restricted to symbolic conventions for abstract ideas by means of solid and ungraded tones. Shadows or modelling are therefore absent from Nazca practice.

The stages of the development have been seriated by Strong.[17] As we have seen, the radiocarbon dates still do not allow a sharp chronological separation of Strong's Proto-Nazca, Early Nazca, and Middle Nazca 'periods', which may be regional variants of the same experimental tendency towards fired colouring of wide variety. They are readily treated together as the components of the Nazca A style [368]. In Strong's Proto-Nazca collections from Cahuachi, fired colours up to six in number are painted over incised outlines. The attainment of brushed colour without incised boundaries characterizes Strong's Early Nazca. His Middle Nazca has cream-white or red backgrounds bearing fine-line brushed designs which surround boldly contrasted areas of local colour. The ground and the design are clearly

separate, and roughly equivalent in area. 'Early Nazca' is cruder than either Proto-Nazca or Middle Nazca, which may well be coeval. Middle Nazca in any case is the climactic achievement, with large and eloquent forms from nature curving round the vessels as integral shapes in simple, clear outline, painted in many colours of fired slip and burnished to a high polish. In museums this polish is often enhanced by modern waxing, which simulates the original brilliance lost during many centuries of interment beneath alkaline sands. Late Nazca colour is even more variegated, with the surfaces broken into many small areas of repeating forms, usually in a high key and in several registers [369]. White grounds are more common than before, and the number of six-colour designs is greater.[18]

Effigy vessels and figurines representing men and women form an important part of the Late Nazca style. Only the main contours of head, torso, and legs are modelled: all other features are painted in a conventional manner precluding all individuality. The main variations appear in proportions and in the painted symbols on the bodies.[19]

Paracas and Nazca designers from the beginning relied upon line, whether incised or painted, more to separate areas of colours than to circumscribe them. Unlike Mochica line, which is cursive and mobile, Nazca line is passive because it merely surrounds other modes of describing, without itself having active properties, such as variable thickness, or conventions of foreshortening in curving and tapering contours. Nazca colour relations probably came first in the designer's mind. He executed them with slip clays in several tints. Thus a vessel with adjacent and overlying areas of magenta, rust, white, grey, and red would be finished in black outlines separating the adjoining areas. In this technique, the line is merely cosmetic, serving to define the principal colour relations, and contributing little to their fundamental order. Early Paracas potters incised these separating boundaries; Nazca potters painted them with some sort of stylus, perhaps a thorn or a quill,

avoiding any variation of thickness in the same contour. Early Nazca vessels rely less upon linear definition than Late Nazca, where the broken and active forms required a more energetic line than the large, closed shapes of the earlier manner [368, 369].

Composition is the orderly arrangement of images and signs. Special problems arise in composing the curved surfaces of pottery, because optical space must be adapted to the surfaces of spherical and cylindrical containers. Repetitious order approaches decoration. Heterogeneous order approaches pictorial form in the case of images, and writing in the case of signs standing for ideas. Whether a composition be repetitious or heterogeneous, its frame on a pottery vessel is never so completely defined as on flat surfaces. A repeating order re-enters itself, and a heterogeneous order has no lateral boundaries, because of the geometry of vessels, which consists of globes, cylinders, cones, and combinations of curved surfaces.

The oldest south-coast vessels from the Paracas burials, however, escape these conditions because their makers were more interested in sculptural representations than in painted ones. Some vessels have repeating geometric designs, and a few others have repeating compositions based upon forms seen in nature, but many Cavernas vessels are effigies, or bear natural forms, which combine sculptural representation of the heads with painted and incised representations of the bodies. These are split in two to decorate front and rear faces of the same vessel. This sculptural propensity continued in Necropolis wares, with modelled representations of fruit and squashes, of birds and frogs, without any painted modifications whatever.[20]

Hence the emergence of a painted style in Nazca pottery shows a complete transformation in compositional habits, from geometric designs and sculptural increments to schemes of repeating images and pictorial compounds. In the Early Nazca style, the images tend to be repeated, with a few large reiterations of almost ideographic forms, stylized to the point of generic images without individual characteristics [368]. Later on, a single form such as the 'jagged-staff demon'[21] is enlarged by annexes, extensions, reduplications, and other proliferations all contained within a single organic outline, and occupying the entire surface [369]. Repetitious order of course continued, but in themes became smaller and more cursive, with details omitted in the interest of lively surface patterns. Moving figures, such as running human beings, are represented. The number of sculptural forms increased, with effigy vessels and modelled increments returning to fashion. These considerations of compositional technique bring us directly to the question of the meaning of the images on Nazca pottery, that is the problem of iconography.

The principal motifs are anthropomorphic. The most common image represents an elaborately dressed human being, burdened with animal attributes [375]. Symbols of feline origin predominate, such as a whiskered mouth. Examples of beaten gold appear in the mummy bundles. Other attributes of feline character are spotted fur, and rings on the paws and tail. The Nazca representations of felines differ from those in Cavernas pottery of Chavín style: there the tusk-like incisor teeth were the principal mark of feline nature, but in Nazca iconography the whiskered mouth is its main symbol.[22]

Other important themes [370, 371, 378, 379] are representations of the killer-whale (Orca gladiator) and of predatory birds, such as the falcon (Pandion haliaetus). Severed trophy heads and many plants and weapons enrich the repertory. Female figures are common in the middle and late style both in full-figure effigies and in painted representations of faces alone.

There are no texts to aid the interpretation of these motifs. All modern efforts to explain them proceed from the classification of the themes, and from analogies with unrelated cultures where ethnographical explanations have been collected. Thus E. Seler, who first listed the motifs, identified them as demons; the feline figure was a divine provider of food; the cat-demon with human or bird attributes represen-

370. Ground drawings, possibly processional paths, outlining a bird and a monkey,
Early Nazca Style(?), Nazca river drainage, after 200 B.C.(?)

ted the souls of the dead; and other figures were
'vegetation-demons' or 'jagged-staff demons' of
uncertain powers, composed of cactus-like
branches and spines.[23] In the absence of written
sources, however, the conventional meanings of
these forms cannot be certainly known, and all
that we can hope to do is to establish their
intrinsic meaning.

It is probable that the compositions convey
relationships among ideas rather than among
things. Unlike the Mochica painter, who de-
lineated the lively image of a running man as the
eye sees him, the Nazca artist painted the idea
of swiftness by joining the images of arrows and
killer-whale fins [371A, B]. As in the art of
Chavín, many of these forms and their abbrevia-
tions were interchangeable. The eye-markings
of certain falcon species are used to adorn
human eyes. The serrated mouth and the dorsal
fin of the killer-whale likewise enter a variety of
contexts [371]. In principle, any part of an
animal form may be invaded by images of parts

drawn from other species. A falcon's body has
human trophy heads on the neck, on the back,
and on the tail. Each feather is a simplified
trophy head, with eyes and mouth shown as dots
on the rounded feather tips. In the cat's whisker
motif, each hair is likewise a trophy head. In
illustration 371A the back outline of the falcon
has pointed serrations, a repetitious shorthand
for the dorsal fin of the killer-whale.

Such processes of composition are more ver-
bal than visual: they resemble the metaphor.
The killer-whale is swift, and so is the falcon.
Since both are swift, parts of either may stand
for the idea of swiftness. The killer-whale
therefore has a dorsal fin like a feather [371].
Elsewhere arrows are substituted for feathers:
the idea of sharpness also permits knives to
stand for arrows, or for fins. Both felines and
hunters are predators, and may therefore wear
trophy heads and whiskers.

These metaphoric associations suggest an
intricate ritual of sympathetic and imitative

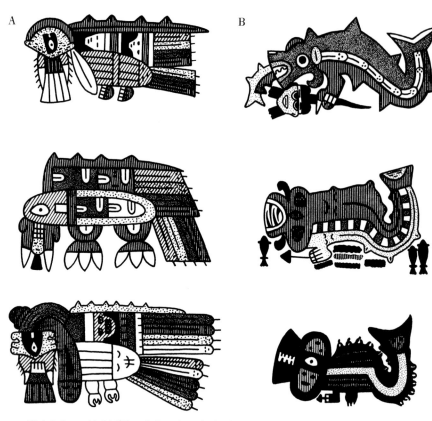

371. Bird designs with (A) killer-whale and trophy head substitutions, and (B) killer-whale design with feathers and trophy head substitutions, Late Nazca style, 200–500(?). *Lima, Museo Nacional*

magic. The human being assumes the special faculties of admired animals by wearing their attributes. His vision will be as sharp as the falcon's if his eyes are painted with the falcon's markings. His success as a fisherman will increase if he wears killer-whale attributes. In addition, the puma, the falcon, and the killer-whale were all surely deities, worshipped by impersonators wearing the divine markings.

Individual beings and individual events are never represented. The paintings show actions outside the time of real happening with its infinite number of accidents. The repertory is more various than in the art of Chavín, and it is less specific than in Mochica painting.

Textiles

The south-coast weaves of Peru have few parallels anywhere in the world for fineness and intricacy. Not only is the preservation remarkable, owing to the extreme aridity of the climate, but some Peruvian cloth is older than 3000 B.C. in the coastal valleys. In the Chicama Valley, at Huaca Prieta, Junius Bird excavated twined cotton fabrics with geometric designs of interlocked birds, animals, and humans, dated by radiocarbon as of about 2000 B.C.[24] Analogous embroidered textiles in the distinctive rectilinear and curvilinear style of Paracas-Nazca design occur in the Cavernas, Necropolis, and

Early Nazca periods, spanning perhaps a thousand years, from 1000 B.C. The complete range of Late Nazca textile decoration has so far not been identified. Its chronological range spans 600 B.C.–200 B.C., changing towards increased clarity of representation and symbolic enrichment.[25]

Certain formal and technical conditions of textile art need to be mentioned before we discuss the history of Paracas and Nazca fabrics. Because the woven support for the design is flexible, meant to be worn as clothing in unforeseen folds and overlappings, textile designers are always reluctant to cover the surface with large pictorial compositions which are visible only when stretched out, as could be done in tapestries. Far more appropriate for clothing are small-figure designs of geometric character, spaced in repeating patterns so that one visible portion suggests and recalls all the portions concealed by the folds of the cloth. The technical requirements of the loom further restrict the designer: large curvilinear forms are generally restricted to embroidery. The weaver must resolve all curves into the rectangular co-ordinates of warp and weft. An escape from the requirements of the loom is given only by additive techniques imposed upon the finished cloth, such as embroidery and certain brocades.

The chronology is incomplete, but it parallels the ceramic history of the region, in the sequence of Cavernas and Necropolis–Nazca A. No earlier stages are known, and the Cavernas weavers already possessed a fully developed knowledge of spinning both cotton and wool, as well as of dyeing and all the principal loom techniques.[26] The use of wool wefts in the earliest period proves commerce with the highlands, because the wool-bearing animals of Peru (llama, alpaca, and vicuña) cannot survive in the coastal climate. The loom (known before 1500 B.C.) was of simple backstrap construction with heddles to lift the warp threads. The weight of the weaver against the backstrap controlled the tension of the warps. With this simple equipment the weavers produced cloths of extraordinary sizes. A plain-weave cotton cloth found by Strong at Cahuachi measured 7 m. (23 feet) in width and 50–60 m. (160–200 feet) in length, all apparently one single piece.[27]

The construction of these textiles shows distinct historical changes relating to taste more than to invention. Plain cotton weaves, some with interlocking warps and wefts, characterized the Paracas cloths on both Cavernas and Necropolis sites. Embroidered decoration in stem stitch on a plain cloth base was the technique preferred by the makers of Necropolis and Early Nazca textiles. Tapestry technique (more weft than warp, and weft completely concealing the warp) is rare. Twills are known from Ocucaje. Double cloths (reversible fabric woven on two sets of warp) occur in the Cavernas tombs. Floating warp patterns, which require expert control, and gauzes (weft passed through twisted warps) are further evidence of the maturity of weaving in the earliest known south-coast period.

Cavernas colours number only about ten or twelve clustering around brown, red, yellow-orange, blue-green,[28] and the natural whites of wool and cotton. Grey was achieved by spinning brown and cream fibres together. The total effect was far less brilliant than in Necropolis and Nazca embroideries, where some 190 hues were used, with the dark colours numbering about two-thirds of the total. They were used in variations of local tone on repeating figures of identical contour and varying direction. These regular chromatic sequences were saved from monotony by frequent inversions and changes of rhythm[29] in the hue, intensity, and value of the repeating fields of colour. A mantle, for instance, displays perhaps a hundred repeating figures, divided into several distinct sections of surface pattern carried by colour alone [373]. The patterned colour sequence in each section may follow straight or broken courses. Sometimes the sequence reverses in a given course, or an expected sequence is invaded by a rhythm from another sequence in a separate section. These variations of shape, direction, and colour are comparable to the phrasings of a musical composition.

To grasp so many variations simultaneously is impossible: our eyes can hold the sequence of only two or three at once, although the weavers and the users of these fabrics were probably accustomed to retain many more in a process not unlike our habituation to polyphonic music. Paracas embroideries cannot properly be called pictures, because pictorial composition implies the arrangement of diverse images upon a field in an order manifesting some unity. In Paracas embroidery, repeating shapes compose not a picture, but a decoration approaching musical form.

372. Double cloth from the Cavernas site, Paracas peninsula, before 200 B.C.(?).
Lima, Museo Nacional

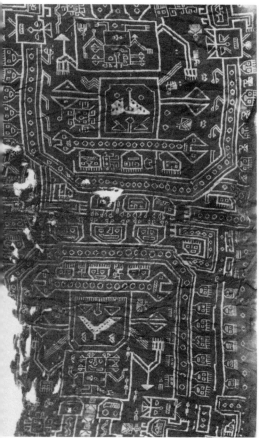

Most knowledge about Paracas embroideries comes from the collection excavated by J. C. Tello at Cerro Colorado on the sandy peninsula in 1925, some 11 miles south of Pisco Harbour. Tello transferred 429 mummy bundles from the 'Necropolis' burials to the Archaeological Museum in Lima. A few have been opened and studied.[30] From the published accounts it is clear that at least four stylistic groups can be isolated.

Rectilinear only [372]:
1. Plectogenic shapes, woven, embroidered, or painted, Cavernas and Ocucaje.

Dimorphic (both rectilinear and curvilinear):
2. Static anthropomorphic and animal figures of simple contour. Bundles 217 [373], 421, and sampler, Museum of Primitive Art, New York.
3. Animated figures rendered by overlapping planes [376]. Bundles 157, 382.

Curvilinear only:
4. Contorted figures; indented contours; prominent attributes in costume and on tentacles [377–9]. Bundles 290, 378, 318, 319, 451.

Group 1, earliest by type, is a plectogenic style as old as Huaca Prieta (2500–1500 B.C.), imitating the structural limitations of loom technique in embroidery and in painted cloths [372]. The textiles of the Cavernas period all bear plectogenic decoration. It consists of straight portions of horizontal, vertical, and diagonal lines, without curved portions of any sort. This totally rectilinear manner continued into the Necropolis period, where it coexisted with the simpler styles of embroidered curvilinear ornament.[31] It may have disappeared in the more ornate textile assemblages of later date.

The rectilinear mode is categorically different from the freehand curvilinear style. It has different objectives; it forms a separate tradition, and attains effects impossible in the curvilinear style. The curved-line style is pictorial. It represents opaque bodies in an effort to reproduce retinal images, by overlapping planes and monotone forms of solid colour

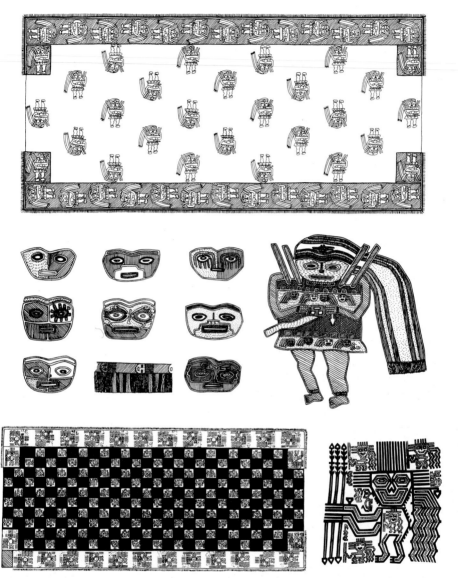

373 and 374. Embroidered Paracas mantles, one with details of recurrent design,
the other with enlargement of rectilinear motif, Mummy 217, from Necropolis, before 200 B.C.
Lima, Museo Nacional

[373]. It derives from pottery painting and from painting on cloth. The plectogenic style is ideographic rather than pictorial. Its forms occupy all the available space with networks of parallel contour lines. Inside and around itself, the main theme repeats on a smaller scale. The bodies are like transparent containers to admit these echoing recalls [374].

375. Personages in animal costumes on painted cotton cloth, from the Necropolis site, Paracas peninsula, Nazca style, before *c.* 200 B.C.(?). *Cleveland Museum of Art, Norweb Collection*

The loom-determined limitation to rectilinear portions of line originally required a numerical formulation of the weaving process, with the operator trained to follow or memorize a complex series of motions in sequence. The transfer of plectogenic forms to embroidery and painting gave the designer greater freedom to improvise, but he retained the rectilinear mode probably because of its ideographic tradition, which permitted kinds of statement impossible with a pictorial system based upon visual effect.[32]

In groups 2 and 3, both modes of design were in use. Bundle 217 contained a cloth with rectilinear and curvilinear styles. The sources of the freehand pictorial style are preserved in a few painted cloths,[33] of which one in Cleveland (27 by 8 inches) portrays five humans dressed in animal skins and brandishing knives and trophy heads [375]. The details are rendered with a firm, descriptive line of which the embroideries give us a distant reflection.

Yacovleff and Muelle thought that the embroiderers failed to comprehend or to reproduce faithfully the designs of the Nazca ceramic repertory. Such paintings as the Norweb cloth make it evident that even the potters owed their craft to this art of painting on cloth, of which the rare fragments give us only a tantalizing glimpse. Actually, the border of the Cleveland mantle fits best with our group 4, because of the enormous tentacle-like tails, tongues, and antennae, which compose an undulating rhythm. The early embroiderers usually portrayed only one theme per cloth, in many repeats, without variation in contour [373, 374].[34]

On the embroidered garments in group 2 [373] each figure is clearly and simply presented, with the legs in profile and the head and torso in frontal view. The colour fields are few. The poses are stiff and awkward, like the heraldic faces in a pack of cards, stating their message boldly and unequivocally.

Our group 3 displays more animated contours. A variety of overlapping planes establishes the bodies in visual space [376]. At the

376. Detail of Paracas embroidery with overlapping planes, Necropolis style, before 200 B.C. *Lima, Museo Nacional*

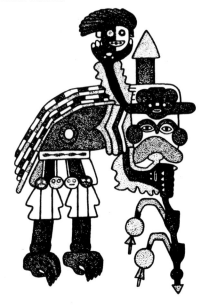

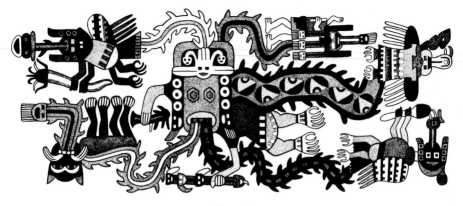

377. Details of Paracas embroideries with tentacled extensions,
Necropolis style, before 200 B.C. *Lima, Museo Nacional*

same time, the attributes are more numerous, and their interaction with the organic figures destroys its plausibility.

Group 4 differs from the simpler modes in deeply indented figural outlines, with the appendages treated as tentacles, to which the figure itself is an accessory [377]. The multiplication and compounding of attributes becomes ideographic and ambiguous. Thus the eyes of a human being serve simultaneously as the eyes of the killer-whale in two head-dress decorations [378, 379]. These killer-whale forms also allow the figure to be read as a diving personage when it is seen upside down. Other attributes repeat and multiply with organic connexions in every cranny and division of the design. Both the inverting figures and the self-extending designs strongly recall the tautologous compositional devices of a late stage in the art of Chavín, as in the Raimondi Monolith [322].

The Paracas and Early Nazca embroiderers[35] had less thematic variety, and less consistency in the rules of combination, than their pottery-painting contemporaries. Attributes and figural types are more freely compounded in the embroideries, so that elements which do not concur in pottery (e.g. killer-whale and bird forms) appear on the same figure in certain embroideries. The Paracas embroidery designer usually departed farther from the visual image

in his search for rhythmic variation by colour, and he represented fewer themes. Most of the varieties of fish and marine birds, as well as the shrimp, toad, lizard, fox, and rodent and the

378. Personage wearing killer-whale attributes, cotton embroidery, from the Necropolis site, Paracas peninsula, before *c.* 200 B.C.(?).
Lima, Museo Nacional

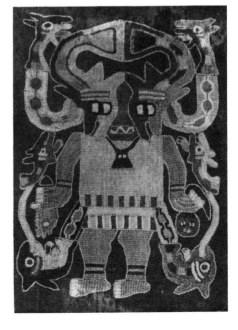

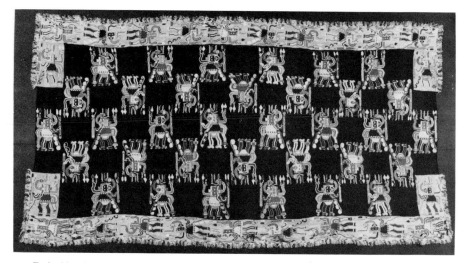

379. Embroidered Paracas mantle, black ground, from Necropolis, before *c.* 200 B.C.(?).
Providence, Rhode Island, Museum of Art

partridges and swifts of Nazca pottery, are absent in the embroideries. As Yacovleff and Muelle observed in their brilliant essay on Paracas art,[36] the potters held the lead, and the embroiderers were derivative in the creation and exploration of the south-coast pictorial tradition.

THE END OF NAZCA ART

The Middle Horizon (c. 600–1000)

The replacement of the Nazca style by a style of highland origin, based upon a few angular and ideographic figures, was as abrupt and decisive in the south-coast valleys as in central or northern Peru.[37] The place of origin and the nature of the diffusion of this remarkable pictorial art, which is more like a language than like a style bound to time and place, are still obscure. Most authorities view the art as originating at Tiahuanaco in Bolivia, and as an expression of a religious cult with high attractive power. Others regard Huari in the Mantaro basin as more central, and they ascribe the diffusion to military expansion by highland tribes. The initial appearance was abrupt at every place con-

cerned, followed by a slow degradation of the highland forms towards more schematic and cursive ciphers.

The earliest intrusion of the Huari style upon the disintegrating Nazca tradition of the coastal valleys was on the Pacheco site near the city of Nazca. Here Tello in 1927 found nearly three tons of polychrome sherds, which could be restored to make entire vessels. There were twenty gigantic tubs or *tinajones* of various shapes, and a hundred vases with full-scale human faces modelled on the constricted necks, as well as three large llama-figure vessels. Several of the largest tubs are inverted bell shapes, containing 120 litres (26 gallons), and measuring 64 cm. (25 inches) in height and 75 cm. (30 inches) across the top, with walls nearly 5 cm. (2 inches) thick [380]. Others are flaring cylinders of the Classic Tiahuanaco *kero* (cup) shape, 50 cm. (20 inches) across the top, 35 cm. (14 inches) at the base, and about 60 cm. (2 feet) in height, with a capacity of 50 litres (11 gallons). The bottoms are all flat, unlike those of the vessels of the Nazca tradition. It is likely that this immense deposit of pottery was for ceremonial use, and that it was all smashed intentionally in some episode of unrest.

The painted forms are of two kinds, uniting the Nazca and Tiahuanaco traditions: plants of curving outline in a free descriptive intention, and geometric human figures with rectilinear outlines and ideographic features.[38] The pictures of plants, shown in light tones on a dark ground, represent highland species of vegetables, tubers, and cereals. Each plant appears complete with roots or tubers, blossoms, leaves, and edible portions depicted as clearly as in an early European botanical woodcut. The style, however, is Nazca in the exaggeration of distinctive traits.[39]

The ideographic figures have square faces from which tentacles radiate [380], bearing heads of fishes, birds, and pumas, as well as stylized fruit and flowers. Their close resemblance to the central sun-gate relief at Tiahuanaco makes it likely that both representations signify the same thing. No text exists to allow an identification. Both belong to the same figural tradition, which probably originated in textile design, and which also may have spread by commerce in textiles. The net effect of the Pacheco *tinajones* suggests a message of religious and agricultural content, as

380. Large polychrome pottery tub (heavily restored) from the Pacheco site, Nazca Valley, coastal Tiahuanaco style, after 600. *Lima, Museo Nacional*

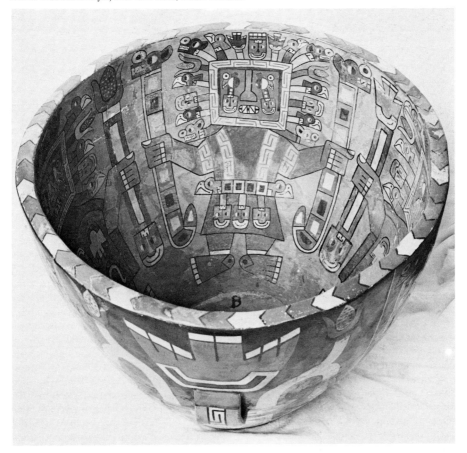

if to connect the worship of the square-faced Tiahuanaco deity with certain highland food plants.

The modelled faces on the necks of the large jars [381] are among the most commanding

which some are found in museums, often with provenances pointing to south coast valleys [382]. Their forms are those of Classic highland Tiahuanaco art in stone and in pottery, frequently subjected to extreme geometric

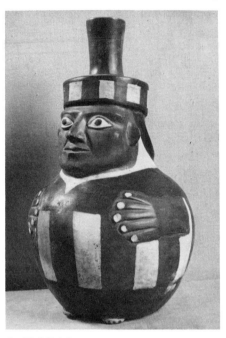

381. Modelled-face pottery vase from the Pacheco site, Nazca Valley, coastal Tiahuanaco style, after 600. *Lima, Museo Nacional*

382. Face-and-scroll theme, cotton-and-wool tapestry, from the south coast, coastal Tiahuanaco style, after 600. *Washington, Dumbarton Oaks*

examples of ancient Andean sculpture, resembling archaic Greek heads in the geometrically governed regularity of their proportions. On the surfaces a network of polychrome slip in geometric figures reinforces the impression that some mathematical order underlies this art, which Menzel connects with the style of Chakipampa near Huari. Other vessels are double containers, with an effigy connected by a short tube to a cylindrical cup. Large single effigies of standing or seated llamas again indicate the highland origin of the whole style. Certainly contemporary with the Pacheco style are the fine tapestries in the Tiahuanaco style of

deformation, especially by lengthening the design in one direction but not in the other.

Menzel estimates this first period of the 'Middle Horizon' as lasting only about fifty years. Local derivations and adaptations (e.g., Viñaque style of Huari appearing in Atarco style in the Nazca Valley) followed in the seventh and eighth centuries, with the centre shifting from Nazca to the Ica Valley. These derivations became progressively coarser. The Nazca style components disappeared completely as the shapes and colours became more and more debased. The Pacheco style probably heralded the cultural subordination of the south-coast

valleys to highland masters: thereafter, provincial slovenliness spread until the emergence of a new local style in the Ica Valley.[40]

In the Ica style, after the tenth century, rounded vessel vases returned to fashion. The painted decoration consists of textile imitations or transfers, depicting birds or fish in black, white, and red dots and bars as if in woven technique

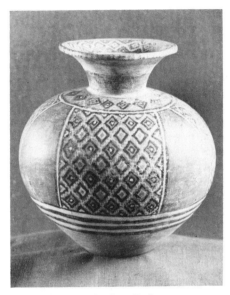

383. Painted pottery bowl, textile themes, from the Chincha Valley, Ica style, after 1000. *Lima, Museo Nacional*

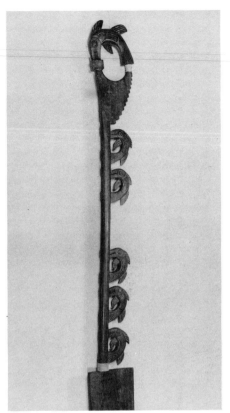

384. Wooden implement from the Ica Valley, after 1000. *Cleveland Museum of Art, Norweb Collection*

[383]. Some curvilinear feline and bird shapes retain a distant connexion with antecedents at Huari and Pachacamac. Carved and painted wooden agricultural tools of ceremonial form are another characteristic Ica Valley product during these centuries. The outlines are carved with rows of men or birds, and a panel of pierced work in geometric rows, like those of the pottery, usually forms the head [384].[41] The Ica style preceded the Inca conquest of the south coast, and it probably corresponds to a period up to the fifteenth century, when the valleys of Cañete, Chincha, and Pisco each had independent tribal rule, and engaged in hostilities against each other without much knowledge of conditions elsewhere in Peru.[42]

Under Inca rule in the fifteenth and sixteenth centuries, the Nazca and Ica Valleys were relegated to an even lower provincial rank than in the preceding period. The centre of regional administration shifted to the Pisco, Chincha, and Cañete Valleys, where the most imposing buildings of the late period were built. Other than these edifices, there are few works of art to consider here. The Chincha Valley was perhaps the centre of government in the region: the Pisco Valley probably afforded an avenue of communication with the Mantaro basin and the

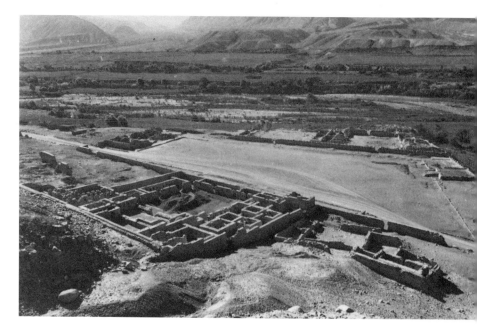

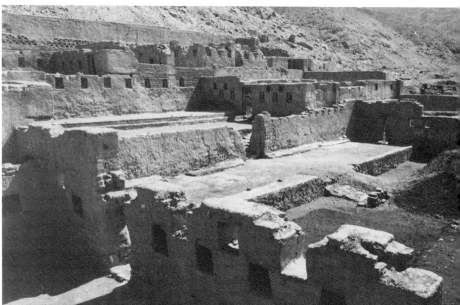

385. Tambo Colorado, Pisco Valley, after 1400

provinces surrounding Ayacucho; and the Cañete Valley was the coastal link to the central coast settlements.

The buildings are massive piles of adobe clay in brick or *tapia* construction. Certain groups of early date, like the Huaca de Alvarado in the Chincha Valley, are built of ball adobes of Paracas date. La Centinela in the Chincha Valley has a terraced platform of *tapia* rising 100 feet above the valley floor, and built in the late pre-Inca style. A palace at its south-western corner drops away in several terraces to the plain, with courts and halls as well as galleries and esplanades, all of Inca date, and built of rectangular adobes.[43] In the Pisco Valley, Tambo Colorado is the best-preserved adobe building of Inca date in existence [385]. The main compound has a courtyard with buildings of large flat adobe bricks on terraced levels around it. The walls have storage niches painted red, yellow, and white. It was probably an inn, with storehouses, barracks, and administrative quarters. This architectural tradition of buildings with closed-corner courtyards, in massive adobe construction and with niched walls, probably originated on the central coast, where the oldest buildings of this type are of Middle Horizon date, before the tenth century, combining highland requirements with coastal materials and construction habits in a prefiguration of Inca state control under Huari domination.

THE SOUTH HIGHLANDS

The principal urban centres in the southern highlands occupy three major basins: the region called the *altiplano*, surrounding Lake Titicaca at the boundary between Peru and Bolivia; the region from Ayacucho to Jauja in the Mantaro river valley basin; and the Cuzco region near the headwaters of the Urubamba river. The basin of Lake Titicaca supported early civilizations at Pucará and at Tiahuanaco from about 500 B.C. until after A.D. 500. Thereafter the style of Tiahuanaco spread to the Mantaro Valley and to the Cuzco region. A style like that of the Mantaro phase eventually appeared in the south coastal valleys beginning, as we have seen, about A.D. 600 in the Pacheco ceramics of the Nazca Valley. The terminal stage of pre-Columbian history in the Andes was dominated in the fifteenth century by the territorial expansion of the Inca dynasty from Cuzco through the entire central Andes and into Chile, north-western Argentina, and Ecuador.

THE EARLY ALTIPLANO

The plateau round Lake Titicaca (3812 m.; 12,500 feet) very early provided a subsistence for hunting folk and for pastoral peoples. Some pottery at Chiripa was being made before 1300 B.C. The vicuña, llama, and alpaca supplied wool for textiles. The llama was probably domesticated here as the only native American beast of burden. Certain food plants such as potatoes, quinoa, and oca were also probably first domesticated here. The lake itself provided reeds for mats and boats, and fish for food. The surrounding mountains contain immense deposits of free metallic gold and copper, as well as silver, tin, and mercury ores for use by early metalworkers. An acclimatized people could easily achieve many fundamentals of civilization in this cold, treeless, and tundra-like country, but its limitations would eventually require the *altiplano* dwellers to expand to warmer climates either by commerce or by conquest.

Bennett demonstrated the lack of cultural unity in the basin when he divided it on archaeological evidence into six distinct provinces.[1] Under Inca domination the region was united politically, but even then four groups speaking different dialects of Aymara still occupied the basin. During antiquity, before A.D. 500, distinct northern and southern Titicaca styles are apparent, centred respectively at Pucará and at Tiahuanaco. It was long believed that the two styles were contemporaneous, until radiocarbon datings showed that the Pucará style flourished from after 500 to the first century B.C., or several centuries before the Tiahuanaco style and before Huari.[2]

The Pucará site has monumental architecture of which only the foundations of red sandstone slabs survive. They form a C-shaped enclosure of irregular radial chambers entered from within the curve, each containing one or two altar slabs. A sunken square court in the centre had a tomb chamber built of stone slabs in the middle of each face.[3] Above the dressed stone foundations, the now-vanished walls were of adobe clay, bearing thatched roofs. The stones of the wall bases are smoothly dressed, but they lack the channels for metal cramps and the other complicated stone joints that characterize the Tiahuanaco masonry of a later period.

The figural art of the Pucará region is distinctive, but uneven in quality and variegated in technique. It is easily recognized by rounded body forms [386], unlike the cubical shapes of Tiahuanaco style, by stylized figures of edible freshwater fish called *suche*,[4] and by panelled flat reliefs of symmetrical volutes and zigzag lines carved in shallow relief on standing slabs like stelae. Some figures found at Pucará clearly

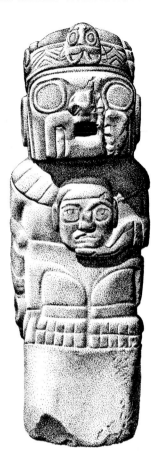

386. Pucará, stone pedestal figure
holding trophy head, first century B.C.(?)

Pucará, and around Sicuani, halfway to Cuzco.[5] It is contemporary with the earliest pottery from Chiripa near the southern shore of Lake Titicaca, where stone houses surrounding a sunken court, as at Pucará, also occur.[6]

The fully developed Pucará style of ceramic decoration [387] is of the first century B.C. by radiocarbon dating, and it is related to Pucará

387. Incised polychrome pottery vessels
from Pucará, first century B.C.
Lima, Museo Nacional

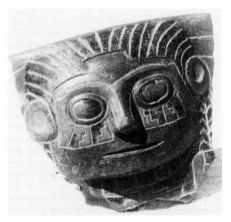

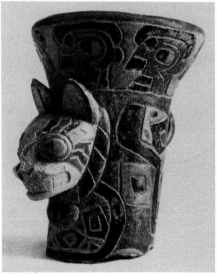

belong to a later Tiahuanaco style, and others at nearby Caluyu may well represent an early stage in the history of the style.

The ceramic sequence for the northern half of the Titicaca basin, though still incomplete, shows Pucará preceding Tiahuanaco, and overlying an early ceramic style found at Caluyu. A radiocarbon date of 500 B.C. for the Caluyu pottery found near Pucará established its position. This pottery, decorated either by incision or in painted geometric designs of red or brown on cream, recurs near Ayaviri, upstream from

sculpture in the forms of representation. Modelled feline and human heads decorate a variety of vessels, further adorned by incised designs painted in black and yellow on a polished red slip. Only sherds are preserved, but the vessel shapes, the technique, and the designs stand to the Tiahuanaco style in much the same relation as Cavernas to Nazca pottery, displaying the same kind of progression from modelled and incised polychromy to a style dependent upon painted effects alone. It is true that Pucará depictions [386] are curvilinear on rounded planes,[7] while those of Tiahuanaco are prismatic and rectilinear [395], but the range of representations is nevertheless similar – so much so as to warrant their treatment as a stylistic unit, as in the case of Greek art, where Hellenic and Hellenistic sculpture offer a succession of stylistically related expressions.

Thus the art of Pucará may be regarded as an early stage of an *altiplano* style characteristic of the northern Titicaca basin. By the same token, Tiahuanaco is the late stage flourishing in the southern surroundings of the lake. Indeed, the Pucará sculptural styles seem to be the most ancient in the southern region. Both Bennett and Posnansky agreed in considering certain figures in the Pucará style at Tiahuanaco to be among the oldest sculpture in the district. These are the colossal kneeling figures flanking the churchyard entrance in the colonial village of Tiahuanaco.[8] Others from Pokotia and Wancani, south of Tiahuanaco, are clearly related to Pucará. Two statues from near the village of Pokotia [388] also represent kneeling figures: one, with the face damaged, is of a greenish volcanic rock, and the other is of whitish sandstone.[9] Both wear serpent-turbans with massive braids falling symmetrically over each shoulder to end on the back in animal heads. The bared upper bodies show the ribs and navel, and the ponderous heads with protruding lips, high cheekbones, distended eyes, and aquiline noses resemble the modern Aymara Indians of the region. From Wancani,[10] not far distant, come three prismatic stela-like stones, 4–5 m. (13–16 feet) long, carved with low-relief

figures in several registers, representing *suche*-fish forms, human beings, and felines, in postures of much animation, but treated more as glyph-like elements than as coherent pictorial scenes. These stones also represent standing human beings, with proportional divisions like those of the statues at Tiahuanaco. But the surface reliefs recall Pucará sculpture more than the fine-line, small-scale incisions of Tiahuanaco, so that perhaps we have in these southern basin sites a style intermediate between Pucará and Tiahuanaco. We can add to the southern group the monoliths of Mocachi and Santiago de Guata: they also represent standing human beings compounded with reliefs of *suche*-fish and felines.[11] Bennett found one stela of this style at Tiahuanaco, together with many other sculptures from various periods,[12] all brought together in an edifice of Late Tiahuanaco date.

To sum up, sunken courts surrounded by adjoining houses of rectangular plan, and statues with anatomically descriptive planes, bearing relief decorations of felines and freshwater fish, characterize an early stage in the history of *altiplano* art. It endured until the first centuries after Christ, and it has been identified with Pucará, north of the lake. That site, however, may display only an important regional variant of a major style extending from Sicuani and Chumbivilcas in the north to the southern sites and eastward into the Bolivian lowlands. The division of the *altiplano* into northern and southern styles is perhaps less accurate than a chronological division by early and late phases of the *altiplano* style, corresponding to the type-sites of Pucará and Tiahuanaco.

TIAHUANACO

Architecture

The archaeological zone called Tiahuanaco[13] or Taypicala includes several platforms, enclosures, and buildings, thinly spread over an area of about 1500 by 1300 yards and built of earth revetted with large fitted stones. It con-

444

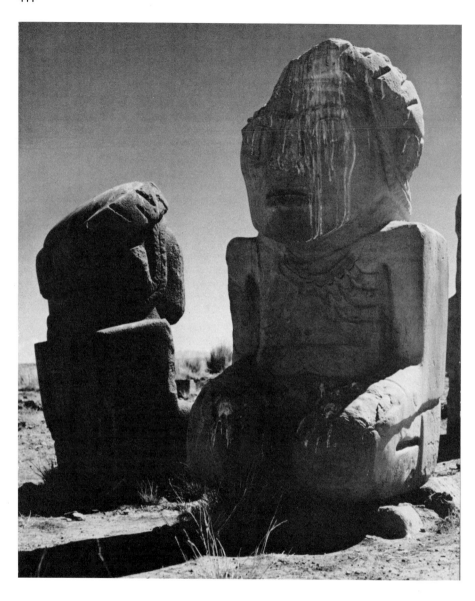

388. Pokotia, stone statues,
first or second century(?)

tained a ceremonial centre, like Moche or Tikal or Teotihuacán, though far smaller, with buildings approximately orientated upon the cardinal points [389]. Like Teotihuacán, it was no doubt a station for observations of the solar year, and as such it was the centre of the cosmos, as suggested by its Aymara name, Taypicala, signifying 'the stone at the centre'.

The site has been sacked by every generation for five centuries. Each year of casual plunder has added to the disorder, so that the disintegrated array of stones and earthworks today allows us to form only a ghostly idea of the original appearance, now far beyond recall. Even with the most generous intentions, modern attempts to reconstitute Tiahuanaco yield only a loose group of edifices falling far short of the scale and importance of the greater Mexican and Maya centres, as well as of the principal coastal Andean sites. Tiahuanaco is comparable in magnitude and complexity to Chavín de Huántar or Cerro Sechín. Its foundation probably happened before 400, and it may have flourished under a variety of masters until the Spanish Conquest. The sculpture and the pottery for which Tiahuanaco is celebrated were produced during a period of which the 'Classic' phase can be given a radiocarbon date after A.D. 300. The later phases of Tiahuanaco history are unknown, although the coastal importance of the Huari style after the sixth century suggests that the highland site continued long as a functioning religious centre.

The ancient site stands at an altitude of 3825 m. (12,520 feet), south of the river, in a wide valley of well-watered pastures which today support some 20,000 inhabitants on a cultivable area of about 600 km. (232 miles). The main group of buildings, dominated by an earthen platform, consisted of several structures surrounded by a moat or ditch, 50 m. (165 feet) wide, designed to catch surface water and to connect various springs [389]. The moat drained northward into the Tiahuanaco river, using the bed of one of its small affluents on the eastern side of the enclosure. Half a mile to the south-west is another edifice, called Puma

Puncu, which today consists of a mound and many large stones strewn in disorder, near a terraced bastion overlooking the basin of a small stream called the Huaricoma, which joins the Tiahuanaco river. Recent studies suggest that both groups of edifices once formed a single ritual centre connected by roadways intersecting at right angles. This is shown in dotted lines on our plan, which has been adapted from Ruben and Ibarra Grosso.[14]

Great uncertainties surround the question of the original form of these buildings. The principal units are a possibly late earthen platform, called Akapana (210 by 210 by 15 m.; 690 by 690 by 50 feet); a platform-enclosure called Calasasaya; and the other platform group called, as we have seen, Puma Puncu [390]. Ibarra, Mesa, and Gisbert extracted from sixteenth-century texts a reconstruction that shows the Akapana as a pyramidal platform with a narrow chambered building facing west; the Calasasaya as a U-shaped platform facing east (135 by 130 m.; 430 by 445 feet); and Puma Puncu as a repetition of the same two forms, both facing east. They also adduce the Kantataita stone, a large monolith carved with diminutive stairways and a sunken court, weighing 900 kgs. (18 cwt.), as a kind of model for the Calasasaya. Of the chambered buildings mentioned in the texts only scattered stones remain, and the earth of the platforms has been so completely disturbed by treasure-hunters that only the stone foundations of the revetments now mark out the original plans, and these are interrupted by many gaps. Ibarra, Mesa, and Gisbert believe the buildings were once revetted with cut and fitted stone; certainly the amount of fine masonry taken from the ruins to nearby towns for colonial building supports their view. Only the largest stones or the deeply-buried ones have been left at Tiahuanaco.

Three distinct methods of wall assembly point the way to a possible chronological division at Tiahuanaco. The excavations at the Calasasaya enclosure show a possibly early method. Prismatic uprights of lava stand like fence-posts at intervals, with a filling or curtain-

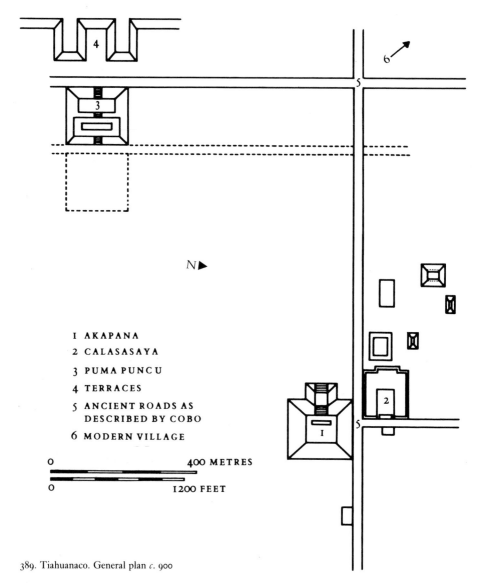

1 AKAPANA

2 CALASASAYA

3 PUMA PUNCU

4 TERRACES

5 ANCIENT ROADS AS
 DESCRIBED BY COBO

6 MODERN VILLAGE

389. Tiahuanaco. General plan *c*. 900

wall of smaller fitted lava elements arranged in dry courses between the uprights. This unbonded post-and-infill system resembles the very early one at Cerro Sechín (p. 365), and it continued in use at Tiahuanaco until a late period in the history of the site, in the construction of the small, nearly square edifice just east of the Calasasaya, where Bennett excavated sculpture of many periods in 1932.[15] The masonry between the posts included carved heads in several styles. The entire enclosure may consist of re-used elements.

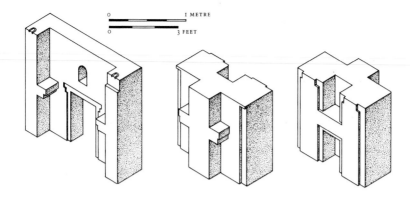

0 1 METRE

0 3 FEET

390. Tiahuanaco. Dressed stones at Puma Puncu, after 400. (A) Doorway block;
(B) and (C) opposite faces of a wall block carved with niches

A second method recalls the bonding used in Greek temples: the stones are linked by shallow matching T-shaped channels in which molten copper was poured to form H-shaped cramps. This is the earliest American use of metal for structural purposes. On some stones there are small holes for pegs or dowels, presumably to affix sheets or borders of gold. Another, more complicated method of bonding stones was by grooves, slots, and mortise-tenon cuts, allowing the units to be joined like woodwork. Puma Puncu [390] is littered with immense dressed slabs, too heavy to plunder, which may originally all have matched in a construction held together by tongues, tenons, and channels cut with extreme precision, as in Japanese wooden temple architecture.

The people who cut these stones must have possessed metal tools, probably of cold-hardened copper.[16] Radical differences distinguish this phase of the Tiahuanaco style from all other ancient American stone sculpture. Angular cuts, rectilinear designs, and minutely detailed ornaments are its characteristics. A rough chronology can perhaps be based upon the appearance of these shapes which required new tools. Thus the Calasasaya post-and-infill technique can be regarded as dependent upon stone tools alone, for abrasion, chipping, or flaking with stone mauls were sufficient to shape

these elements. By hypothesis, a second stage of stone-tool technique is evident in the neat, box-like assemblies of blocks and flat slabs uncovered west of the Calasasaya in 1903 [391].

391. Tiahuanaco, underground stone chamber west of Calasasaya enclosure, after 400

Similar block-and-slab crypts are known at Huari near Ayacucho in the Mantaro basin [398].[17] Again, nothing about these slabs and blocks requires us to suppose the use of metal tools; they could all have been shaped by abrasion alone. The transition to cuts made by metal tools appears most clearly in the elaborately compartmented stones at Puma Puncu, worked at the edges into grooves, tongues, mortises, tenons, and slots [390]. On

the faces there are ornamental geometric figures in many terraced planes of relief, or minutely detailed and textile-like bands of decoration, as on the standing statues and on the celebrated Sun Door [394]. These ornaments recall textile designs in mathematically regular order, requiring foresight and accuracy in execution.

Of course these stages of stone-cutting technique did not each displace the foregoing one. We may assume only that examples of the third stage would not precede those of stages one and two. The latter probably coexisted with the more elaborate third stage late in the history of the site. Hence the hypothesis allows one only to suppose that stone cutting by metal tools came later at Tiahuanaco than stone shaped by stone tools, and that the earlier modes were not displaced by the later one. The study of the figural sculpture confirms these impressions.

Sculpture

Students of the ruins have long agreed, despite other differences, upon dividing the sculpture of Tiahuanaco[18] into two principal phases: an early style of curved surfaces, contours, and lines; and a later style of prismatic figures bounded by planes incised with small rectilinear figures based upon textile forms. No detailed chronology has been proposed. The correlation between prismatic figures and painted pottery in the 'Classic' style has not been securely proved.

Thus the 'Early' sculpture at Tiahuanaco, which resembles the work at Pokotia, Mocachi, and Pucará (see p. 441), can be equated with the pre-Classic style. It consists of statues and reliefs carved with the thickly rounded forms that are produced by chipping and flaking with stone mauls and axes. To this class belongs the small stela found at La Paz together with the great prism-figure that bears Bennett's name. This stela is clearly the stylistic ancestor of the colossal figure with which it was buried, perhaps in an ancient effort to preserve the arcana during a crisis in the history of the site.

Intermediate between it and the columnar Bennett Statue of the Classic period is another flat, stela-like slab of sandstone on which the elements of human form, such as the hands clasping the abdomen, are reduced to rectilinear elements of minimum expression. The ventral band bears yoked fish and eagle forms gathered into square knots; the legs are incised with fishes, the eyes are scaly square plates, and on the headband are two bearded faces in symmetrical opposition [392]. All the elements

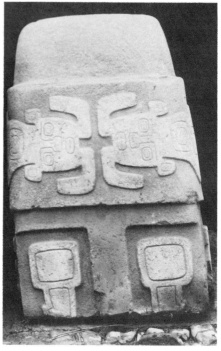

392. Tiahuanaco, flat stone idol, before 300(?)

are unmistakably in the Tiahuanaco style, but their relationship and scale suggest an experimental moment of rude clarity.

The sculpture of the 'Classic' or middle period includes the principal statues and reliefs. The statue called 'El Fraile', a colossal head at La Paz, and the curious double figures which Posnansky called 'anticephalic' reliefs [393] seem to belong together, judging by the large

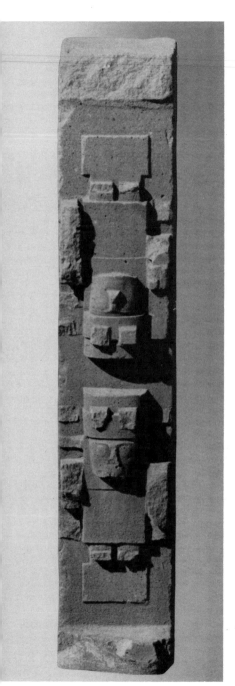

393. Stone slab with two figures
from Tiahuanaco, after 300(?).
La Paz, Museo al Aire Libre

scale and simple detail of the incised decoration.
The eyes are protruding, plate-like carvings on
both the Fraile and the colossal heads, and the
mouths are like rectangular grilles. The head-
band reliefs of the colossal head still show the
large scale and the many separate fields of the
body which may be taken as characteristic of
earlier rather than of late work in this period.
The geometric simplification of the masses and
the fine-line web of surface incisions are clues to
the use of metal tools. In the double reliefs of
standing and inverted figures [393], the use of
metal tools is even more evident in the deep
vertical relief and the rectangular cutting. These
reliefs may have served as roofing slabs. One
bears thin-line incisions of various animals in
the large, cloisonné convention peculiar to this
group. All these figures originally carried staffs
in both hands, projecting into the full-round,
but they have been smashed, and only the
broken background supports are visible today.

A second phase of Classic work can be iden-
tified by its morphological traits. It comprises
the most celebrated pieces, the Sun Gate and
the Bennett Statue. In these the scale of the
incised decoration is adjusted and refined to
allow a delicate intricacy, as of jeweller's work.
On the Sun Gate[19] the reliefs thus hold the
attention both from a great distance and at close
quarters [394]. The artistic problem has been
realized and resolved: it required the establish-
ment of forms that would command the eye by
the bold masses, and at the same time by the
delicate web of the incisions. In older work the
incisions were too large to satisfy the closer
viewer, probably because of technical obstacles
in the early manipulation of copper tools. On
the Bennett Statue, the main proportional divi-
sions of the figure are stressed in shadows cast
by prominent overhangs at the hat-band, the
chin, the forearms, and the waist-band. This
division by shadow asserts the long-distance
authority of the colossal figure. The incised Sun

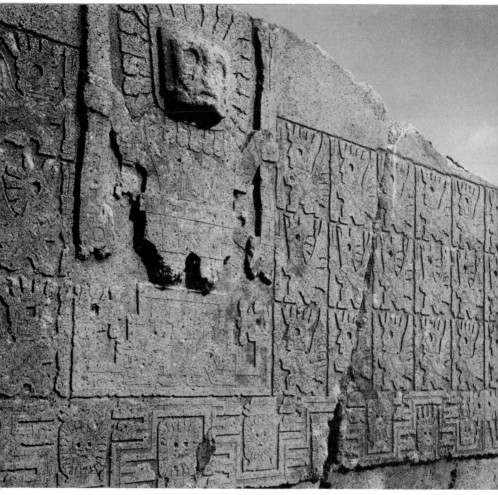

394. Tiahuanaco, monolithic portal, detail of centre and frieze, after 600(?)

Gate themes on the jacket and headband not only recall the textile origin of the ornament, but also satisfy the requirements of the person standing close by.

Again on stylistic grounds, it is reasonable to regard certain other figures as terminal in the sequence. Among them is the statue discovered in 1903 by Courty [395], and called 'Kochamama' by Posnansky, as well as a group of stones[20] with relief sunk into the stone in-stead of projecting from it. The waist-band of the Kochamama figure is carved in this manner, allowing the ground of the design to prevail over the figure itself, in a scheme requiring exact angular cuts. The network of the incisions on the rest of the figure is dry and repetitious, as if the inventive vigour of the earlier craftsmen had frozen into set conventions. The sunk relief brings the shadows into play in an active com-positional scheme, as in Egyptian reliefs of the

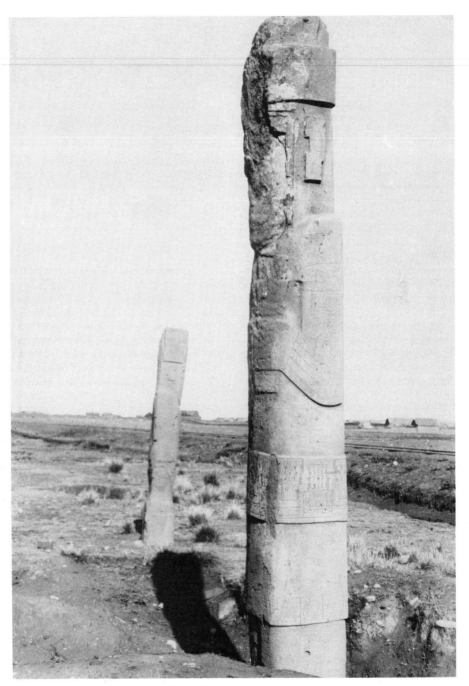

395. Tiahuanaco, monolithic figures, after 600(?)

New Kingdom. This kind of visual device does not occur at the beginning of a stylistic sequence in sculptural form; it generally appears late in the history of a style, as the conclusion to a series of investigations based upon the more obvious properties of solid form, and it is related to studies of illusion in the painter's vocabulary.

Painting

Architectural elements were painted white, red, and green. Traces of these colours still remained on the parts excavated in 1903.[21] The statues and reliefs were also polychrome; the human heads used as wall decorations and found by Courty were painted with an ochreous red. A feline head found by the same excavator was painted ultramarine in the eye cavities, and red in the ears and mouth. Certain friezes and cornices, in addition, were sheathed with metal plates, presumably of gold, fastened to the stone by nails.[22]

Of figure painting, only the polychrome pottery survives [396, 397]. Bennett's excavations in 1932–4 yielded a stratigraphic sequence in the southern Titicaca basin comprising Early (or Qeya), Classic, and 'Decadent' phases, all

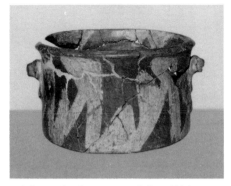

396. Pottery bowl, cream on red, from Chiripa, before 200 B.C.(?). *New York, American Museum of Natural History*

preceded by a phase called Chiripa which distantly resembles the Caluyu phase of the Pucará style, having yellow paint on red slip, with incised outlines and coarse appliqué reliefs of modelled cat figures. The rare pieces of early Tiahuanaco pottery are painted in four and five colours on a buff clay, or on a black background. The vessel shapes include cylinders with wavy rims and puma-head spouts, long-necked bottles, bowls, and plates. On one group of

397. Pottery bowls from Tiahuanaco, Early or Qeya, before 600 (*left*), Classic (*centre*), and Late Tiahuanaco styles, after 600. *New York, American Museum of Natural History*

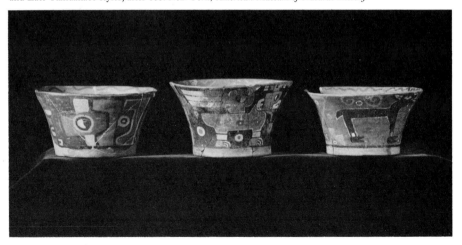

spittoon-shaped vessels, the exteriors bear geometric designs, as well as representations of stylized fish and puma forms painted on the inner rims.

The Classic Tiahuanaco painted wares comprise handsome cups of concavely flaring profile, as well as libation bowls which are squat, wide versions of the cups. Both are painted in as many as five colours on a red slip with heavy black outlines surrounding the areas of local colour. The figures of pumas, human beings, and condors in profile are clearly delineated and easy to recognize. One group of burial cups found throughout the southern lake basin[23] is adorned with a face-design resembling the central figure of the Sun Gate at Tiahuanaco: otherwise the Classic wares do not repeat the forms used by the sculptors. In the late period, which Bennett called Decadent, new shapes appeared. The decoration was painted in black and white on an orange slip, showing parts of human, puma, and condor shapes re-combined in powerful and expressive forms of great vigour, approaching the stability of ideographic signs. The exact correlation of these ceramic types with the architectural and sculptural history of Tiahuanaco is still uncertain, but there is little doubt that the Classic and 'Decadent' ceramics were made at about the same time as the Sun Gate and related monuments. As we shall soon see, a serious problem in chronology arises in regard to late events in the history of Tiahuanaco.

Iconography

The style of Tiahuanaco and Huari belongs to the Andean tradition of conventional signs ordered more by semantic needs than by mimetic relationships. It conveys information about ideas rather than pictures of things, and in this it resembles the art of Chavín, although major differences separate the two styles. Chavín objects are curvilinear and asymmetrical; those of Tiahuanaco are rectilinear and balanced. Chavín carving recalls woodworking and hammered metal; Tiahuanaco art evokes textile and basketry techniques. The art of Chavín includes few motifs; the art of Tiahuanaco embraces a wide range of stylized human and animal forms.

These motifs are as rigid and schematic as if drawn by compass and ruler. The human figure, reduced to the simplest geometric components, serves as the armature for a decoration of small-scale animal appendages and inserts, including male and female condor heads, pumas, fish, snails, and perhaps others. Their parts are interchangeable, combining and re-combining in patterns probably governed by colour changes like those of Paracas textiles. The conventional meanings of these figures are unknown. Some students have unsuccessfully sought to prove ideographic writing and calendrical records. Others have supposed a pantheon of moon, sun, lake, and fish gods. One writer imagines mystic brotherhoods keeping vigil over the 'inviolable orthogonal' of the Tiahuanaco religion.[24] Although the conventional meanings are inaccessible, because of the total lack of texts, the intrinsic meaning is plainly evident. This society, in which the endless variety of real experience could be conveyed and summarized by a few rigid ciphers, was probably governed, like Islam, by religious prohibitions discounting the impermanent, changeable, and fugitive aspects of existence. Pure geometric order expressed the desired stability, unity, and eternity of the society better than the protean forms of Mochica or Nazca art. A priestly law of negation and sanctions conditioned these severe images, which suggest frugality, discipline, and ethical dynamism.[25]

THE MANTARO BASIN

Although the Mantaro Valley was always a principal thoroughfare between the south Peruvian highlands and the central coast, its archaeology is much less well understood than that of other regions in Peru, partly because there are few imposing buildings or statues, and partly because the pottery was prematurely identified with the Tiahuanaco style, so that the region seemed to lack an artistic identity.[26]

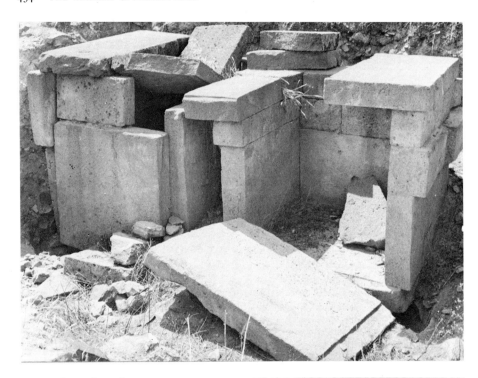

398. Huari, near Ayacucho,
slab-masonry chambers, after 700

399 (*right*). Polychrome pottery effigy vessel
from Anja, Department of Jauja, Mantaro Valley,
Viñaque style(?), *c.* 600. *Whereabouts unknown*

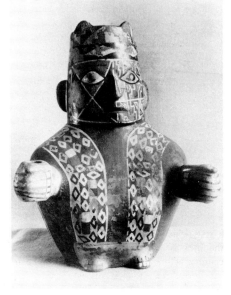

Huari near Ayacucho has attracted most attention. The site was densely inhabited before the Inca occupation. Fine chambers of slab-masonry like prison cells [398], and some stone statues are the only monumental remains. Many sherds of painted polychrome pottery were excavated by Bennett, but their quality is inferior, compared to the Chakipampa or Conchopata sherds from Ayacucho [399],[27] and to the fine pottery found near Huancayo a hundred miles farther up the Mantaro river. The big vessels from the Pacheco site in the Nazca Valley [380, 381] surpass all other Mantaro products in size and finish.

The architectural, sculptural, and ceramic remains at Huari all seem provincial in comparison with work from other Mantaro centres. The subterranean chambers of fitted slab-masonry resemble those of Tiahuanaco [391]. The standing statues, of squat proportions and heavy, inexpressive features, lack both the geometric clarity and the double viewing distance of Tiahuanaco sculpture. The ceramic decorations are related to the Tiahuanaco style only by the presence of certain motifs, executed in geometric conventions recalling the stone carvings at Tiahuanaco without necessarily belonging to the same period.[28]

The dating of the Mantaro phase of the Tiahuanaco now places Huari as contemporary with Tiahuanaco in Bolivia after A.D. 400. The Pacheco pieces from the Nazca Valley [380, 381] which most closely resemble the Mantaro vessels are dated after the sixth century (pp. 434–5). Andeanists today speak of two 'empires' in the Middle Horizon. One was centred near Huari, in control at Ica and Nazca Valleys after 600. Huari itself, as suggested by the spread of its Viñaque pottery style [399], then dominated northward to Chicama and Cajamarca and south to the *altiplano* during the eighth century. The other empire was Tiahuanaco, which gave Huari its style and dominated southward as far as Atacama, Cochabamba, and north-west Argentina. Possibly the Mantaro style extended Tiahuanaco influence in Peru proper.[29] Certainly the forms of the Mantaro painters escape from the rigid rectilinearity of Tiahuanaco art: the contours are curved, the expressions are vivid, and the variety of shapes is greater than in the Bolivian style [399].

THE VALLEY OF CUZCO

Montaigne's unforgettable phrase, 'l'espouventable magnificence de Cuzco',[30] described a city which rose to imperial power under the Inca dynasty only after 1440, less than a century before the Spanish Conquest. To be sure, primitive settlement in the valley was at least two thousand years older. The strategic and economic importance of this ancient glacial lake bed, lying at the nexus of a whole system of natural lines of communication to the Amazonian lowlands, the *altiplano*, and the main inter-Andean basins, was not exploited until the last moments of pre-Columbian history, and the importance of Cuzco endured only about three generations. Nevertheless its brief century of imperial authority produced monuments of which mankind will always remember the frightening splendour.

Chanapata, the principal pre-Inca settlement of Cuzco,[31] is of about the same age as Pucará, Chiripa, or Chavín de Huántar, but its material remains are far simpler than those of any of these early sites. There is no monumental architecture, no stone sculpture, and no metal. The typical pottery is polished and painted or incised in a manner distantly recalling the forms of the Chavín style. The Tiahuanaco period passed lightly over Cuzco, leaving no major remains in or near the city, although substantial traces of Tiahuanaco pottery have been uncovered at Batan 'Urqo near Urcos[32] and in the neighbourhood of Lucre, 20 miles from Cuzco.

The presence of Huari-Tiahuanaco pottery at many points in this southern end of the immediate valley of Cuzco led Rowe and Lanning to suppose that the ruined city of Pikillaqta [400] is of that date. Actually, refuse of any kind in the city is so rare that the date has been settled on architectural associations[33] alone. The layout of the city closely resembles that of Viracochapampa near Huamachuco in the northern highlands [357]. The two can almost surely be ascribed, like sixteenth-century Spanish colonial towns, to the same governing class and to approximately the same period. It covers an area of 2 km. by 1 km. (just over a half by one and a quarter miles) with about 160 square blocks, separated by narrow streets. As at Viracochapampa, the square courts are surrounded by long, narrow gallery houses, usually without ground-level doors or windows. The walls are of irregular, sharp-edged rough stone, laid in an ample bedding of clay mortar and faced with a thick coating of

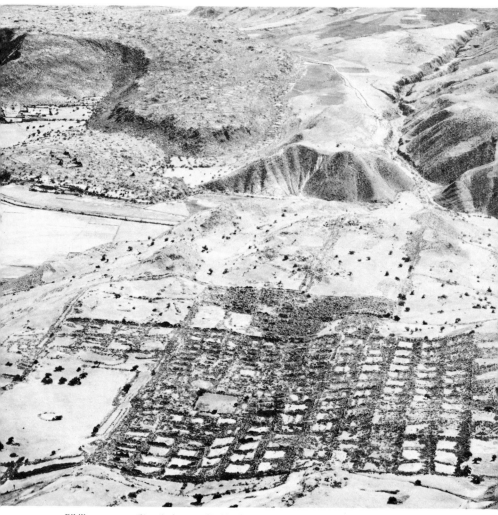

400. Pikillaqta, c. 1500(?) or before 900(?). Air view

clay. Access to the interiors was probably by upper-level entrances reached by ladders. Today the plan of circulation is difficult to reconstruct, because the streets and doorways have been walled off by the modern occupants to prevent the wandering of their animals.

If the urban knowledge and skill of the builders of the Huari period was sufficiently developed to produce both Pikillaqta and Viracochapampa, and their placement before 900 is indeed correct, then the earliest important towns in Peru are these, and they show a grid-plan[34] antedating the great compounds of Chanchan [351] by some centuries at least. On present evidence it is still possible that they are both Inca garrison towns, perhaps built during

the Spanish Conquest, and never occupied long enough for great refuse deposits to form.

In 1927 forty figurines of turquoise, all carved with different costumes,[35] were found under the floor of one of the rooms at Pikillaqta. Other similar sets appeared at Oropesa near by, and in the Ica Valley, as well as in the vicinity of Ayacucho. The Pikillaqta find was associated with a bronze implement, which favours an Inca dating for the objects. Possibly the figurines portraying many types of regional dress helped officials to verify the origin of travellers on the Inca road. On the other hand, Rowe and Wallace found unspecified resemblances to the sculpture of Huari, which, taken together with impressions of likeness in construction,[36] seemed to confirm the Huari-Tiahuanaco dating. Our treating Pikillaqta here, rather than as material of clear Inca style, expresses the present uncertainty.

Inca Architecture

Because the dynasty and the city were intimately connected,[37] the building history of Cuzco fixes the range and span of Inca architectural practice. There were twelve or thirteen rulers whose dates can be fixed from about 1200 until the Spanish Conquest in 1533. The original core of the city surrounded the present Dominican church on a ridge dominating the lower city, between the Huatanay and Tullumayo rivers, where the foundations of the Inca Temple of the Sun still stand [401]. In the fourteenth century, during the reign of the sixth ruler, Inca Roca, this early settlement began to expand rapidly. Henceforth each Inca constructed his own palace instead of occupying the traditional domicile of the earlier family. The form of the city in 1533 was eventually dominated by these great walled enclosures, each consecrated to the memory of a dead Inca, and inhabited by his descendants and their families and servants.

Soon after 1400 the early raids by the Incas upon neighbouring tribes became a systematic campaign of conquests followed by administrative consolidation. Under Pachacuti, the ninth Inca, during the second third of the fifteenth century, the highland basins and valleys from Lake Titicaca to Lake Junin came under Inca control, and by 1500 the entire Andean region from Quito to lower Chile constituted the Empire. It was the largest state ever brought together under single rule in pre-Columbian America.

During the middle years of the fifteenth century, Pachacuti enlarged the city by laying out a new centre north of the old nucleus. This region, once a swamp, was drained to accommodate a huge ceremonial square and many new courtyards, of which portions survive now as wall fragments lining the colonial streets. Pachacuti also began the fortress called Sacsahuamán [402], which dominates the northern approaches to Cuzco, and he rebuilt the Temple of the Sun [403] at the old centre on the southern ridge.

In this courtyard group on the site of the present Dominican monastery, a few Inca walls survive in the ground-floor chambers of the east and west ranges surrounding the main cloister. A curved wall supports the sanctuary of the church, and it is among the most celebrated of Inca fragments, rising about 20 feet in a curved inclination like the entasis of the Doric order [403]. Its original use and designation are unknown, but the presence of a large niche on the inner face (excavated in 1951) suggests that the area was once roofed over.[38]

Thus two eminences, the fortress and the temple, rose over the city, which was an open concourse surrounded by a network of walled courtyards, divided by the highways connecting the capital to the four quarters of the empire. The city itself between the rivers was a sacred thing, and it was likened to a puma, with the tail at the confluence of the rivers, the head at the fortress, and the body at the main plaza, surrounded by courtyard dwellings.[39] Priests, officials, nobles, and their servants lived in Cuzco supported by the labour of the farmers and artisans who existed as subjects and tributaries in many surrounding villages. Between the Augustan reforms of Pachacuti and the Spanish

401. Cuzco. General plan *c.* 1951, showing Inca wall remnants

Z

CATHEDRAL

SACSAHUAMÁN

TEMPLE OF THE SUN
(SANTO DOMINGO)

300 METRES

1000 FEET

INCA
WALLS

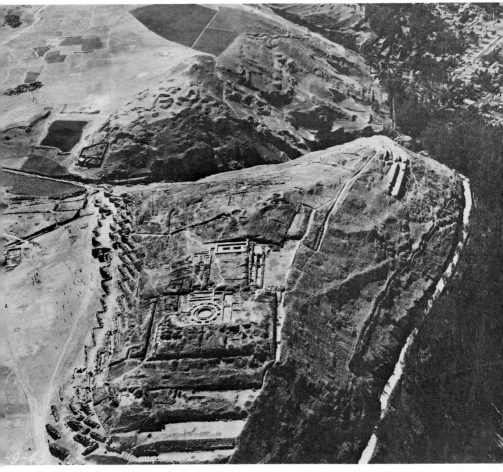

402. Cuzco, terraces of Sacsahuamán, mid fifteenth century. Air view

Conquest, barely ninety years embrace the entire history of imperial Inca architecture.

It is not now possible to distinguish between Inca buildings erected before and after Pachacuti's time in Cuzco, but it is likely that most of the earlier edifices were of sod and clay rather than of stone. The chroniclers give the names of four architects, all Inca nobles, who designed the buildings and fortifications of Sacsahuamán; Huallpa Rimachi, Maricanchi, Acahuana, and Calla Cunchui. Their work began under Pachacuti's successor, for Pachacuti only prepared the site and assembled the building materials. The main design is simple. Three terraced stone walls, laid out in zigzag angles like saw-blades, defend the northern approach to a hill whose abrupt southern rise commands the city [402]. Each terrace face has about forty straight portions, angled to keep invaders under crossfire. Three narrow doorways, one for each wall, were the only points of access. Within the fortress, stone buildings

housed the stores, the garrison, and the water supply.[40]

Much of the colonial city was later built with stones taken from Sacsahuamán, and eventually the ruins were covered with earth to prevent their use by rebel groups during the civil wars of the early colonial period. When the earthen mantle was removed in 1934, only the foundations of the buildings were left, and the eastern ends of the triple bastion were seen to have been destroyed long ago. This early colonial custom of filling in the Inca ruins with earth holds also in the city proper, where certain bits of courtyard wall of the fifteenth century now function as retaining walls for sixteenth- and seventeenth-century infill, to support the colonial platform mounds upon which the Spanish churches, convents, and town houses stand.[41]

The difficulty of identifying pre-Conquest walls is increased by the fact that Inca methods of building walls continued in Cuzco for a long time under colonial government. Many portions of wall commonly identified as pre-Conquest are actually of colonial date. An example is the three-storeyed façade of the Casa de los Pumas, with Inca coursing in the doorways on two levels. The colonial doorways, however, have perpendicular jambs, in contrast to the trapezoidal profiles of pre-Conquest entrances. The purpose of the Inca builders in having the jambs incline towards one another was obviously to shorten the span of the lintel, and to economize in the manipulation of large stones. Throughout the city, colonial and pre-Conquest walls and doorways are so mingled that it is now impossible to define the limits of the Inca city, or to tell precisely where the colonial streets and buildings begin. A few trapezoidal doorways and a few walls with niches mark the presence of Inca fragments, but their original position in the courtyard system remains uncertain.

The most important walls, such as those at Sacsahuamán and in the Temple of the Sun, display a pre-Conquest technique of shaping the individual stones which may well have continued in use until the sixteenth century. Three principal masonry types are evident: 'polygonal' walls, with large irregular stone blocks carefully fitted; rectangular blocks of stone or adobe laid in approximately regular courses; and *pirca*, or rough boulders laid in clay mortar.[42] The walls of Sacsahuamán belong to the first type, the walls of the Temple of the Sun are of the second type. *Pirca* served mainly for simple boundaries, and for plain housing. Polygonal masonry probably arose from the *pirca* tradition, and it was used only for retaining walls and major enclosure walls requiring massive dimensions. Rectangular block masonry, on the other hand, arose from the tradition of square-cut blocks of sod, and it was used mainly for free-standing, two-faced walls.[43]

Both methods of wall assembly show extreme precision in the fitting of the stones. The polygonal walls at Sacsahuamán have peculiarities which suggest the manner of attaining this precision. Many stones, especially the largest ones, retain the stubs of tenons left on the outer faces. Furthermore all stones fit upon concavely curved depressions ground into the stones immediately below them. In polygonal masonry, no stone is seated upon a level surface. Every stone is cupped by its support, although the curve of the cup may be almost imperceptible. The combination of sockets or tenons with these curved seating planes immediately suggests the manner of shaping the stones to their close fit.[44] After rough shaping with stone or bronze tools, each stone was ground against its bed in a swinging motion, suspended from a wooden gantry by rope slings catching the tenons. A few men could then abrade the swinging stone to a close fit with its neighbours by simple friction in a pendulum motion.

In coursed masonry like that of the Temple of the Sun [403], the technique was less complicated but more laborious. The concave seating planes are not evident. The fit of stone upon stone was secured by push-and-pull abrasion in the flat plane, as we see in the bed between courses now exposed on top of the curved wall. The weight of the stones in both polygonal and

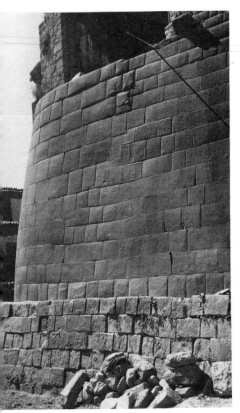

Huaraz possess a number of stone slabs carved with a network of polygonal cells. Two of the cells are usually higher than the others, rising above the remainder of the network [404]. P. A. Means interpreted them as counting-boards for arithmetical operations, but their resemblance to the plan of Cuzco, with the temple and the fortress rising high above the rest of the

403. Cuzco, carved wall of Coricancha, below west end of church of Santo Domingo, fifteenth century

404. Cellular stone slab, possibly architectural model, from Cabana or Urcon, province of Pallasca (Ancash), fifteenth century(?). *Paris, Musée de l'Homme*

coursed masonry diminished with increasing height. A layer of fine reddish clay was the only substance introduced between the stones. There is no trace of metal cramps like those used by the builders of Tiahuanaco. The upper walls of the Temple of the Sun were adorned with a frieze of gold plates nailed to the stone, known only from confused verbal accounts by soldiers and chroniclers.

Throughout the provinces of the Empire, Cuzco was venerated as a holy place, and knowledge of its physical form was brought to the subject peoples by means of topographic models.[45] The museums at Lima, Cuzco, and

city, should not be entirely discounted. Cuzco itself is notably irregular, showing many traits of organic growth rather than planned expansion. The exact form of Cuzco, therefore, could not easily be followed in the widely divergent geographical and cultural situations of Inca military expansion. In each region, the local tradition was adapted to Inca use, and certainly the superior local features were perpetuated by the conquerors. Thus the large rectangular enclosures of Chanchan may have stimulated the Inca custom of housing each family of the ruler and each subject ruler in a separate compound.[46]

A

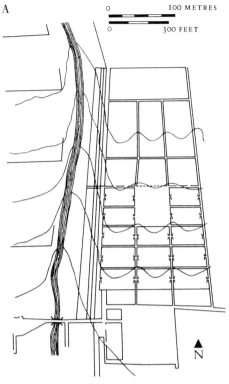

0 100 METRES

0 300 FEET

N

Ollantaytambo, in the Urubamba River Valley, is an example of late-fifteenth-century Inca town-planning [405]. Its history was closely connected with Cuzco, only 30 miles away as the crow flies. The fortress, built high on a mountain shoulder above the confluence of two rivers, commanded important passes. Downstream for nearly 40 miles are the terraced towns of the Vilcabamba region,[47] of which Machu Picchu is the most celebrated. Ollantaytambo was in all probability the provincial capital of the entire chain of Urubamba Valley frontier posts reaching towards the tropical rain-forest dwellers, whose products were important to the highlanders' economy. Below the fortress, on a wide bench of flat land, is the late-fifteenth-century city of Ollantaytambo, laid out upon a grid-plan of eighteen rectangular blocks separated by rectilinear streets, and surrounding a central plaza. Every block is a double compound enclosing two unconnected courtyards which are placed back to back. Each court is surrounded by four stone-built rooms with niched interior walls. Small corner courts fill the angles between the

405. Ollantaytambo. (A) General plan c. 1500;
(B) detail of dwelling block

B

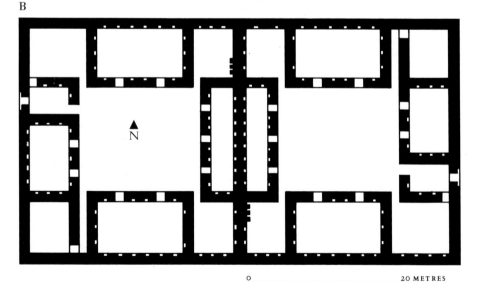

N

0 20 METRES

0 60 FEET

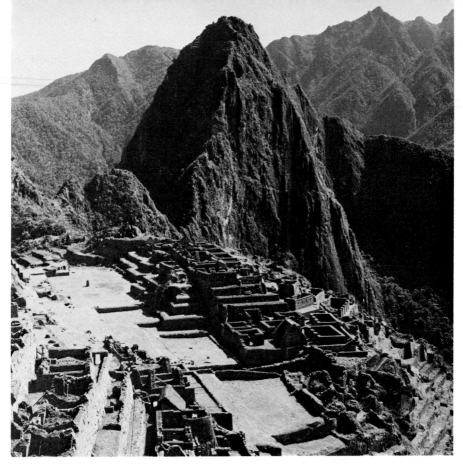

406. Machu Picchu, *c.* 1500. View from the north

rooms. The buildings are still inhabited, and they may be the oldest continuously-occupied dwellings in South America.

High above the valley, as well as at the level of the Urubamba river, are many smaller settlements from Pisac to Machu Picchu, all set among very elaborate terraced platforms, sometimes, as at Inty Pata, rising many hundreds of feet. There are few novel architectural forms in the region. The sites are distinguished more for their scenic grandeur and for the bold use of complex topography. But at Runcu Raccay an interesting circular house[48] surrounds a round court 11 m. (36 feet) in diameter. The three long rooms are curved parts of a ring, opening by doorways upon the sheltered court. It is an annular version of the standard rectangular compound.

Machu Picchu is the most elaborate of these mountainside settlements, with many terraced ranges of gabled stone buildings marking out the southern and eastern boundaries of an oblong plaza [406]. This is the only level place among the ruins,[49] and its quiet, ample enclosure gives needed relief from the vertiginous terraced slopes falling to the river or rising to the summits on either side. Wild strawberries and raspberries today grow upon the abandoned agricultural terraces, from which at almost any point one looks down 2000 feet into the river valley. The mild climate, with its theatrical fogs, sunsets, and milky distances, affords one of the

most picturesque archaeological settings in the world. The buildings, untouched during four centuries, still give a valid and detailed impression of the character of highland Inca town existence, as an austere cycle of agricultural ceremonies and religious duties enmeshing life at every point and moment.

South of Cuzco, in the *altiplano* of Lake Titicaca, Inca architecture manifests a strikingly different regional quality, although sharing with the river-valley sites the same predilection for magnificent siting and for noble prospects. Two important examples of the Inca style of the province of Collao are on neighbouring islands in Lake Titicaca, separated by about six miles of open water.[50] One ruin on Titicaca Island, called Pilco Kayma, was originally a two-storey dwelling block [407] overlooking the lake towards Coati Island, where a two-storeyed edifice with a court, traditionally called the

407. Titicaca Island, Palace, late fifteenth century. (A) Condition in 1870; (B) plan of ground floor; (C) plan of upper storey

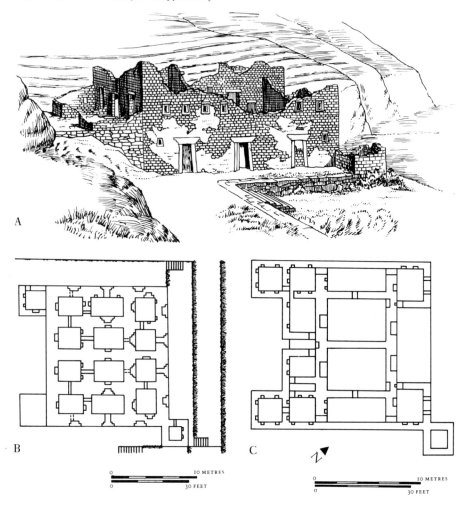

A

B

C

0 ⊢—————————⊣ 10 METRES
0 ⊢—————————⊣ 30 FEET

0 ⊢—————————⊣ 10 METRES
0 ⊢—————————⊣ 30 FEET

'Palace of the Virgins of the Sun' [408], faced it. Tradition also gives their construction to the reign of Topa Inca in the last quarter of the fifteenth century. The 'palace' is remarkable for its symmetrical envelope and the ingenious fitting of six apartments on two floors to make the best use of the site and of the prospect, with an open esplanade on the second floor overlooking the lake [407]. The arrangement recalls the regular envelopes of Italian Renaissance buildings. The compulsion to symmetry is so strong that blind doorways flank the genuine entrances in each façade of the block.

The 'Nunnery' building forms a three-sided court opening north, and its elevations are enriched by many recessed planes making a geometric decoration of light and shade which recalls the stonework of Tiahuanaco [408]. It belongs to an entirely different category of architectural design, as divergent from the block-like palace as Italian Renaissance block design is divergent from Islamic courtyard façades. Two quite distinct architectural traditions are probably present here, reflecting an Inca vernacular of trapezoidal doorways, niched walls, and terraced approaches (the 'Palace') and the persistence of a Tiahuanaco style, with chiaroscuro effects in geometric planes (the 'Nunnery').

On the coast, Inca architectural complexes survive in many valleys: examples are at

408. Coati Island, 'Nunnery', late fifteenth century. Elevation and plan

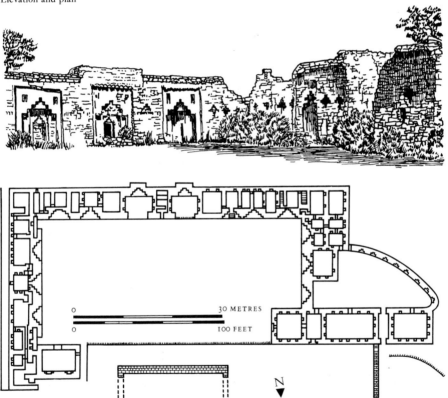

30 METRES

100 FEET

N

Pachacamac (Sun Temple and Nunnery [362]) and at Tambo Colorado [385], of which the terraced courts correspond to the chroniclers' descriptions of Inca highway inns and granges.

Another celebrated ruin on the road to the Collao stands at Cacha [409] in the upper Urubamba drainage, about 130 km. south-east of

gonal stones, surmounted by adobe brick rising to a gabled roof over a four-naved space divided into possibly three storeys. Adjoining this vast barn-like structure were at least six small courtyards, each surrounded by gabled buildings of rectangular plan, perhaps for the lodging of pilgrims or priests. Separated from these buildings

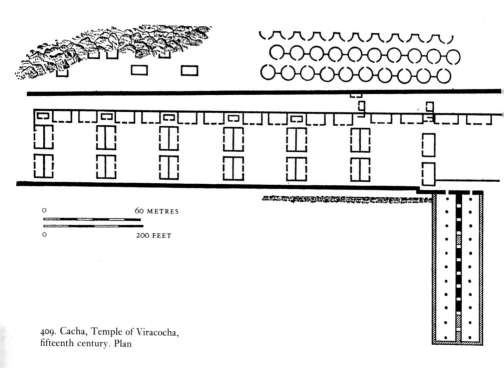

409. Cacha, Temple of Viracocha, fifteenth century. Plan

Cuzco. It is traditionally called the Temple of the god Viracocha. Garcilaso de la Vega described the edifice in detail as a storeyed temple, entered from the east, with the sanctuary on an upper floor.[51] It was a huge building, of which Squier's plan gives the approximate size, with a central pier-wall 15 m. (50 feet) high and 90 m. (300 feet) long, symmetrically flanked by columns. Both the pier-wall and the columns have masonry bases 2 m. (6 feet) high, of fitted poly-

by a wall are more houses, all circular in plan, in ten parallel rows of twelve each, built of *pirca* masonry.[52]

This type of circular dwelling is common throughout the central Andes, but the date of the innumerable examples is difficult to establish. Throughout the *altiplano*, burial towers called *chullpas* reflect this tradition of domestic architecture. Some are built of carefully fitted stone like Inca coursed masonry, as at Sillustani

410. Sillustani, burial tower,
fourteenth-fifteenth centuries(?)

north-west of Puno on Lake Titicaca [410];
others are of square plan and small size. M. H.
Tschopik, who studied the entire Collao group,
believes all *chullpas* to be of Inca or immediately

pre-Inca date, rather than of the Tiahuanaco
period, on the basis of the ceramic associations
she was able to study.[53]

Sculpture and Painting

The urban impulse to commemorate important
experiences by monumental sculpture was satis-
fied in Inca society by intricate non-figural
carvings on the surfaces of caves and boulders.
Such work was common throughout the south-
ern highlands under the Inca regime.[54] It con-
sists mainly of terraced seats, stepped incisions,
angular or undulant channels, and, in general,
of laborious modifications of the striking geo-
logical features of the landscape. They mark the
presence of man without representing him in
images or statues.

According to the notices gathered by colonial
chroniclers, some rocks were simply sacred
places (*huacas*) where supernatural forces
resided; some were regarded as petrified
remains of the ancient races of man; and others
were the places where the principal events of
mythology occurred. The rocky outcrops on the
heights above Cuzco were especially venerated
in these various ways. Certain clusters of fis-
sured rocks, like those of the amphitheatre
called Kenko [411], consist of intricate passages

411. Cuzco, shrine at Kenko, fifteenth century

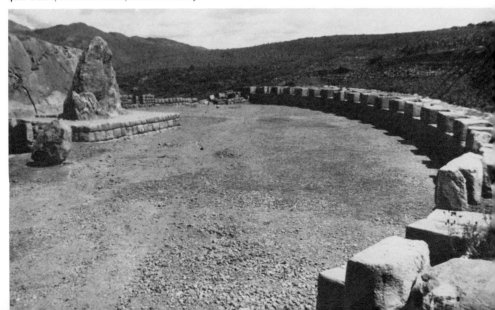

with elaborate exterior carvings. Kenko was probably the burial place of the Inca Pachacuti, where elaborate annual commemoration festivals occurred including the worship of the mummified remains of the monarch, displayed upon the rock, with libations of *chicha* (maize-beer).[55] The whole compound was probably regarded as an earth-entrance and as a gate to the underworld of the dead.

Because they were destroyed by European missionaries, large statues in the Inca style are practically non-existent, although texts of the sixteenth century mention cult figures, like the statue of Viracocha at Cacha. In 1930 a large stone head which has been thought to represent the Inca Viracocha was excavated at a depth of 8 m. (25 feet) below the pavement of the Jesuit church in Cuzco.[56] This fragment is unique, and it may have been re-cut in the colonial period, with a timid effort to represent the features of a middle-aged man by incisions representing wrinkles.

Miniature objects of metal and stone figuring human beings and animals are extremely common. They may reflect a vanished monumental sculpture. Tiny llamas of gold, nude standing figures of men and women with ungainly bodies and stiff gestures, diminutive heads encrusted with gold and turquoise, and small terracotta models of buildings and compounds are the most intimate expressions of Inca art. A heavy gold and silver drinking vessel preserved in the Archaeological Museum of Cuzco is typical of this more intimate and luxurious side of Inca art. It is formed of welded inner and outer shells of silver. The outer wall is inlaid with golden relief figures, and the shell has a filling spout shaped as a miniature vessel perched upon the rim. When the liquid rises to the rim of the shell, it is higher than the figures standing in the shallow bowl, and one of the little men most surprisingly urinates into the miniature vessel at his feet [412].[57]

Conspicuously absent are the monsters and composite animals of the other styles of Andean art. Inca representations are limited to the generalized statement of normal appearances, and they are applied to instruments and objects

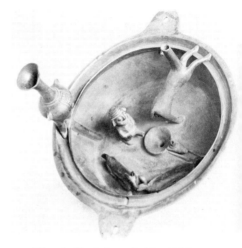

412. Silver double-shell vessel with gold inlay, from Cuzco, c. 1500. Cuzco, Museo Arqueológico

of utilitarian character. The schematic figural designs are composed with restraint, and used economically. Detailed surfaces are avoided in favour of extreme geometric clarity of form. The representation of individuals is sacrificed to generic likenesses. For example, small stone figures of llamas are very common, carved as essential characterizations of the species, always drilled with a cylindrical depression in the back for votive offerings of fat [413]. The image is

413. Stone figure of llama used for votive offerings, from the South Highlands, c. 1500. Lima, Museo Nacional

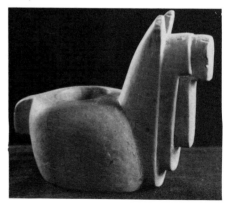

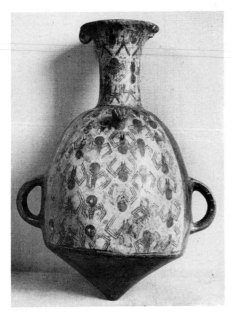

414. Inca polychrome pottery vessel, 'aryballos' form, after 1450.
Lima, Museo Nacional

inexact analogy with the Greek form. Cuzco wares are technically excellent, if stereotyped in form, with simple geometric painted decorations which seem, in Rowe's phrase, 'machine-printed' with almost mechanical poverty of invention.

Although colonial writers mention painted images of Inca deities,[59] no pre-Conquest examples survive. The people adored any strange or peculiar form of nature, such as multiple birth, large trees, oddly shaped fruit and vegetables, springs, rivers and lakes, mountains, rocks and peaks of all shapes, wild animals, metals, and coloured stones. It is probable that painted images were not abundant, and that an image could receive many different and inconsistent meanings, so that Inca images in general tended to undifferentiated stereotypes.

The intrinsic meaning of Inca art reinforces the general impression of an oppressive state. It is as if, with the military expansion of the empire, all expressive faculties, both individual and collective, had been depressed by utilitarian aims to lower and lower levels of achievement.

It is significant that our only exhaustive pictorial description of Inca culture was composed about 1615. Not until the pictorial resources of European civilization became available could the history, rites, and customs of the Inca peoples be thus illustrated. The book is by an itinerant mestizo of Quechua language, Felipe Guaman Poma de Ayala,[60] who used sixteenth-century European book illustrations as his models. The subject matter alone is Incaic, and this subject matter was probably never before portrayed in such detail, because of the lack of a living native pictorial tradition among the Inca peoples. The painted wooden cups called *keros*, which bear figural scenes, are all likewise colonial adaptations of European pictorial methods to native subject matter. The rare pre-Conquest examples are decorated with geometric fields and conventional animal forms.[61]

generic and it is instrumental. Many stone bowls and dishes likewise show this regard for generic form, reduced to geometric essentials in the representations of animals and plants, and subordinated to the instrumental purpose of the vessel.

Inca pottery is divided into two types: an early type called Killke, and a late type of superior quality called Cuzco polychrome.[58] The Killke types point to connexions with the Collao by their geometric designs in black and red on buff clay, but their execution is careless. Rowe calls them Provincial Inca, assigning them to the period 1200–c. 1438. The Cuzco series is identified with the Empire from the mid fifteenth century on. The most common shapes are handled plates, and jars with pointed bases and long necks, called *aryballoi* [414] by

LIST OF THE PRINCIPAL ABBREVIATIONS

A.A.	*American Anthropologist*
A.C.H.	W. C. Bennett and J. Bird, *Andean Culture History*, New York, 1949
A.I.I.E.	*Anales del Instituto de Investigaciones Estéticas*, Mexico
A.I.N.A.H.	*Anales del Instituto Nacional de Antropología e Historia*, Mexico
Am.A.	*American Antiquity*
A.M.N.A.H.E.	*Anales del Museo Nacional de Arqueología, Historia y Etnografía*, Mexico
A.M.N.H.	American Museum of Natural History
A.M.N.H.A.P.	*Anthropological Papers of the American Museum of Natural History*
B.-A.	*Baessler-Archiv*
B.B.A.E.	*Bulletin of the Bureau of American Ethnology*
B.E.O.	*Boletín de Estudios Oaxaqueños*
C.A.	*Cuadernos Americanos*
C.A.A.	*Contributions to American Archaeology*, Carnegie Institution of Washington
C.A.A.H.	*Contributions to American Archaeology and History*, Carnegie Institution of Washington
C.S.A.E.	*Columbia Studies in Archaeology and Ethnology*, Columbia University
D.O.S.	*Dumbarton Oaks Studies in Pre-Columbian Art and Archaeology*
E.C.M.	*Estudios de Cultura Maya*
F.M.N.H.A.M.	*Field Museum of Natural History, Anthroplogical Memoirs*
F.M.N.H.A.S.	*Field Museum of Natural History, Anthropological Series*
G.A.	E. Seler, *Gesammelte Abhandlungen*, 5 vols, Berlin, 1902–23
G.B.A.	*Gazette des Beaux-Arts*
H.M.A.I.	*Handbook of Middle American Indians*
H.S.A.I.	Ed. J. H. Steward, *Handbook of South American Indians* (*Bureau of American Ethnology, Bulletin* CXLIII), 6 vols, Washington, 1946–50
I.C.A.	*International Congress of Americanists*
I.N.A.H.	Instituto Nacional de Antroplogía e Historia; *Bol* = *Boletin; Invest.* = *Investigaciones*
I.N.M.	*Indian Notes and Monographs*, Museum of the American Indian, Heye Foundation, New York
J.S.A.	*Journal de la Société des Américanistes de Paris*
M.A.	*El México Antiguo*
M.A.R.P.	*Middle American Research Publications*
Marquina	I. Marquina, *Arquitectura prehispánica*, Mexico, 1951
M.A.R.S.	*Middle American Research Studies*, Tulane University, New Orleans
M.R.P.	*Mesa Redonda de Palenque*
M.S.S.A.	*Memoirs of the Society for American Archaeology*
Nat. Geo. Soc.	National Geographic Society
N.M.A.A.E.	*Notes on Middle American Archaeology and Ethnology*, Carnegie Institution of Washington
Ñ.P.	*Ñawpa Pacha*
P.M.M.	*Memoirs of the Peabody Museum of Archaeology and Ethnology*, Harvard University
P.M.P.	*Papers of the Peabody Museum of American Archaeology and Ethnology*
Proskouriakoff	T. Proskouriakoff, *A Study of Classic Maya Sculpture*, Washington, 1950
R.M.E.A.	*Revista Mexicana de Estudios Antropológicos*
R.M.E.H.	*Revista Mexicana de Estudios Históricos*
R.M.N.A.A.	*Revista del Museo Nacional de Antropología y Arquelogía*, Lima
R.M.N.L.	*Revista del Museo Nacional de Lima*
S.M.A.M.R.	*Sociedad Mexicana de Antropología, Mesa Redonda*
U.C.A.R.F.	*University of California Archaeological Research Facility, Contributions*

U.C.P.A. *University of California Publications in Anthropology*
U.C.P.A.A.E. *University of California, Publicatiions in American Ethnology and Archaeology*
V.F.P.A. *Viking Fund, Publications in Anthropology*

NOTES

CHAPTER I

27. 1. Paul Rivet, in A. Meillet and M. Cohen, *Les langues du monde* (Paris, 1924), 599–602, and K. Sapper, 'Die Zahl und Volksdichte der indianischen Bevölkerung in Amerika vor der Conquista und in der Gegenwart', *I.C.A.*, XXI (1924), 95–104. Dissenting estimates on Central Mexico propose about 25 million in 1492 (W. Borah and S.F. Cook, 'The Aboriginal Population of Central Mexico on the Eve of the Spanish Conquest', *Iberoamericana*, XLV, 1963) based on early colonial records. Although widely accepted at first, this revision has continually been under criticism among scholars unwilling to accept such a reversal of world-wide population densities before 1600.
28. 2. See D. W. Lathrap, 'Relationships between Mesoamerica and the Andean Areas'. *H.M.A.I.*, IV (1966), 265–75.
3. W. D. Strong, 'Cultural Resemblances in Nuclear America: Parallelism or Diffusion', *I.C.A.*, XXIX (1951), 271–9.
4. Wendell Bennett and Junius Bird first summarized several years' work upon a simplified developmental classification of the prehistory of western South America, under the title *Andean Culture History* (New York, 1949).
30. 5. P. Armillas, 'The Arid Frontier of Mexican Civilization', *Transactions, New York Academy of Sciences*, XXXI (1969), 699.
6. L. Parsons, 'Peripheral Coastal Lowlands', *Middle Classic Mesoamerica* (New York, 1978), 26.
31. 7. K. Lehmann-Hartleben, 'Thomas Jefferson, Archaeologist', *American Journal of Archaeology*, XLVII (1943), 161–3. G. Kubler, 'Period, Style and Meaning', *New Literary History*, I (1970) 127–44.
8. W. F. Libby, *Radiocarbon Dating* (Chicago, 1951). A revision of the half-life of Carbon 14 from 5568 to 5730 years adds 1.03% to the age of all specimens measured previously. Irregular variations in the amount of Carbon 14 also affect datings. See C. Renfrew, *Scientific American*, CCXXV (1971), 68.
32. 9. G. Holton, 'The Roots of Complementarity', *Daedalus*, XCIX (1970), 1018, 1045.
10. E. R. Wolf (ed.) *The Valley of Mexico* (Albuquerque, 1976), 3–4; E. Pasztory (ed.), *Middle Classic Mesoamerica, A.D. 400–700* (New York, 1978), 108–42, and 'Artistic Traditions', *ibid.* R. Sharp,

'Architecture as Inter-elite Communication', *ibid.*, 158–71, analyses step-frets (figure 27) in Oaxaca, Veracruz, and Yucatán as Middle Classic ornament, speaking among different ruling groups of shared worship and calendar.
33. 11. For Diego de Landa, the best edition is by A. M. Tozzer, *Relación de las cosas de Yucatán*, *P.M.P.*, XVIII (1941). The best edition of Sahagún is by A. J. O. Anderson and C. E. Dibble, *Florentine Codex* (Santa Fé, 1950–69).
12. For the central Andes, the article by J. H. Rowe, 'Inca Culture at the Time of the Conquest', *H.S.A.I.*, II, 183–330, refers to nearly all significant sources.
13. G. Kubler, 'The Quechua in the Colonial World', *H.S.A.I.*, II, 331–410. For Mexico, several reports on seventeenth-century idolatry appeared in *A.M.N.A.H.E.*, VI (1892–9).
14. F. J. Clavigero, *Historia antigua de México* (Mexico, 1945).
35. 15. The most complete presentation of such schemes is the book by Gordon Willey and Philip Phillips, *Method and Theory in American Archaeology* (Chicago, 1958).
16. S. G. Morley complained that the native chronicles of Yucatán suffered from 'a frequent telescoping of the time scale to make successive events contemporaneous' (*Ancient Maya*, Stanford, 1947, 87). The same tendency appears in the long defence of the Goodman-Martínez-Thompson correlation for Maya dates, by the Carnegie Institution of Washington, whose workers thereby joined an ancient tradition on Maya chronology; see p. 204. See also C. Coggins, 'The Art Historian and New Archeology', *I.C.A.*, XLII (1976), vol. VII (1979), 291–9.
17. *Historia general de las cosas de Nueva España*, ed. M. Acosta Saignes, II (Mexico, 1946), 276, 315.
18. See the complementary colloquy between G. Willey, 'Mesoamerican Art and Iconography and the Integrity of the Mesoamerican Ideological System', and G. Kubler, 'Science and Humanism among Americanists', both in *Iconography of Middle American Sculpture* (New York, 1973), 153–62, and 163–7.
19. Gregorio Garcia, *Origen de los indios en el nuevo mundo* (Madrid, 1729).
20. Franz Kugler, *Handbuch der Kunstgeschichte* (Stuttgart, 1842), and J. L. Stephens, *Incidents of Travel in Central America* (New York, 1841).

36. 21. I have shown elsewhere, 'On the Colonial Extinction of the Motifs of Precolumbian Art', *Essays ... S. K. Lothrop* (Cambridge, 1961), that utilitarian traits survive or travel more easily than symbolic systems, which are much more perishable. In this context, the diffusionists have yet to explain the translation of Asiatic symbolic forms to America, where matters of mere utility failed to 'survive'.

22. The most complete statement of the new diffusionist arguments is the group of essays entitled *Asia and North America. Transpacific Contacts*, in *M.S.A.A.*, IX (1953). For the argument based upon motifs appearing in art, see the essay by Gordon Ekholm entitled 'A Possible Focus of Asiatic Influence in the Late Classic Cultures of Mesoamerica', *ibid.*, 72–89. To be added to his bibliography are the major works by C. Hentze, *Rituels, croyances ... de la Chine antique et de l' Amérique* (Antwerp, 1936); Miguel Covarrubias, *The Eagle, The Jaguar and the Serpent* (New York, 1934); Harold S. Gladwin, *Excavations at Snaketown* (Globe, 1937). The most complete diffusionist statement by a modern art historian is the essay by R. Wittkower, 'Eagle and Serpent. A Study in the Migration of Symbols', *Journal of the Warburg and Courtauld Institutes*, II (1938–9), 293–325. Also three articles by R. Heine-Geldern on Asiatic tigers, 'Chinese influences' on the Tajín style, and 'Chinese influences' in ancient American pottery, in *I.C.A.*, XXXIII (1959), tomo I, San José, Costa Rica.

The symposium volume edited by Carroll J. Riley, *Man across the Sea* (Austin, 1971), brings together two dozen articles by authors who re-evaluate these problems, coming to no resolution of the questions of diffusion, but assembling different lines of evidence. The question begs to be left open.

37. 23. *Op. cit.* (Note 20).

24. E. Viollet-le-Duc, in D. Charnay, *Cités et ruines américaines* (Paris, 1863).

38. 25. R. Goldwater, *Primitivism in Modern Painting* (New York, 1938).

26. *Geschichte der Kunst aller Zeiten und Völker*, I (Leipzig and Vienna, 1900–11), 81–97.

27. *A Study of Maya Art, P.M.M.*, VI (1913).

28. P. Kelemen, *Medieval American Art* (New York, 1943, 1956, and 1969), and José Pijoan, *Historia del arte precolombino* (*Summa Artis*, X) (Barcelona, 1952), embrace the entire hemisphere. Salvador Toscano, Miguel Covarrubias, Paul Westheim, and Paul Gendrop have written histories of Mesoamerican art alone.

39. 29. Terrace-profiles rather than columnar orders differentiate the regional varieties of Mesoamerican architecture (Kubler, 'Iconographic Aspects', *op. cit.* (Note 18), 24–39.

30. On the role of the individual, see the essays by

R. Trebbi del Trevigiano in *Critica d' Arte*, especially 'Premesse per una storia dell'arte pre-colombiana', XIX (1957), 22–31.

31. E. Panofsky, *Studies in Iconology* (London, 1939), 3. For Mesoamericanists' conceptions of iconographic study, H. B. Nicholson (ed.), *Origins* (Los Angeles, 1976).

40. 32. G. Kubler, 'La evidencia intrínseca y la analogía', *S.M.A.M.R.*, XIII (1972), 1–24.

33. This assumption underlies the remarkable stylistic seriation of Nazca pottery by A. Kroeber and A. H. Gayton in *U.C.P.A.A.E.*, XXIV (1927), a seriation later confirmed by excavations; see W. D. Strong, *M.S.A.A.*, XIII (1957).

41. G. von Sydow, *Die Kunst der Naturvölker und der Vorzeit* (Berlin, 1923), 11.

35. A. L. Kroeber, *Anthropology* (1948), 60–1, 390–1. Materialist interpretations: C. Klein, 'Central Deity', *Art Bulletin*, LVIII (1976); J. Broda, 'Ideology and Human Sacrifice', *Center and Periphery* (n.d.). Other materialists (M. Harner, M. Harris) have sought to explain sacrificial cannibalism as nutritional necessity under protein insufficiency, but J. Broda, B. Price, and M. Sahlins have objected (Broda, *op. cit.*, 34–5) as materialists.

36. A. Vierkandt, 'Prinzipienfragen der ethnologischen Kunstforschung', *Zeitschrift für Ästhetik*, XIX (1925), 338 f. E. Pasztory has recently written about what 'is now almost never mentioned in serious company: the question of artistic quality' (in Aztec sculpture): 'Masterpieces', *I.C.A.*, XLII (1976), vol. VI (1979), 377–90.

42. 37. A. L. Kroeber, *Style and Civilizations* (Ithaca, 1957).

38. B. Petermann, *Gestalt Theory* (London, 1932).

39. During the 1970s much was written about ritual use of hallucinogens in Ancient America (P. Furst, *Flesh of the Gods*, New York, 1972). The hypothesis accounts better for the slow-down than for an acceleration of cultural change, but in either case, firm proofs appear only in sporadic local situations.

40. The earliest accepted dates for early man in America, by tools and faunal remains, now begin 70,000 ± 30,000 before present in North America (F. S. MacNeish, 'Early Man', *American Scientist*, LXIV, 1976, no. 3, 316–27).

41. H. de Terra, 'Preliminary Note', *Am.A.*, XIII (1947), 40–4. Critique by A. D. Krieger, *Am.A.*, XV (1950), 343–9.

42. It measures 13.2 by 19.3 cm. (5 by 7½ ins.). M. Barcena and A. C. del Castillo, *A.M.N.M.*, II (1882), 439–44; L. Aveleyra Arroyo de Anda, 'The Pleistocene Carved Bone from Tequixquiac', *Am.A.*, XXX (1965), 261–77.

44. 43. M. J. Becker ('Priests, Peasants, and Ceremonial Centers', *Maya Archaeology and*

Ethnohistory, Austin, 1979, 3–20) reviews these theories of Maya social class structure in relation to the ideologies of the archaeologists.

44. Hosler and others conclude that the growth of 'artisan' groups could have been the root cause of the collapse of Classic Maya civilization, in a 'maladaptive settlement pattern', with concentrations on non-food-producers, and decreases in food per capita, leading to 'precarious man-nature balance' and 'vulnerability to external pressures' ('Simulation Model', *Social Process*, London, 1977, 582; see also R. Sharer, 'Maya Collapse Revisted', *ibid.*, 531–49).

45. 45. P. Kirchhoff, 'Civilizing the Chichimecs', *Latin American Studies*, v (1948), 80–5. M. C. Webb ('Epiclassic', in Browman, *Cultural Continuity in Mesoamerica*, The Hague, 1978, 155–78) discusses archaeological evidence in Mesoamerica during the eighth to tenth centuries A.D. as composing an 'Epiclassic period' 750–950, following W. Jiménez-Moreno and J. Paddock (*Ancient Oaxaca*, Stanford, 1966), and using 'architectural, sculptural and ceramic intercontact' leading to commercial wars.

CHAPTER 2

47. 1. P. Armillas, 'Cronología y periodifición de la historia de la América precolombina', *Journal of World History*, III (1956), 463–503. Still valid is the clarification of pre-Classic chronology by Román Piña Chan, *Las culturas preclásicas de la Cuenca de México* (Mexico 1955), 104. His sequence, based on C14 dates, reads:

Lower pre-Classic, 1350–850 B.C.
Middle pre-Classic, 850–450 B.C.
Upper pre-Classic, 450–150 B.C.

2. R. d'Harcourt, 'Archéologie de la province d'Esmeraldas', *J.S.A.*, XXXIV (1942–7), 61–201.

3. Review of the Carbon 14 dating in B. Spranz, *Totimehuacán* (Wiesbaden, 1970), 9–10. The eruption of Xitle is now dated about the first century B.C., and the beginning of the pyramid-building phases is placed about the fifth century B.C., relating it to Late Ticomán. R. Heizer and J. Bennyhoff, 'Cuicuilco', *Science*, CXXVII, no. 3292, 232–3.

4. W. du Solier, 'Estudio arquitectónico de los edificios Huaxtecas', *A.I.N.A.H.*, I (1945); G. Ekholm, 'Excavations at Tampico and Panuco in the Huasteca', *A.M.N.H.A.P.*, XXXVIII (1944), no. 5.

5. H. E. D. Pollock, *Round Structures* (Washington, 1936).

48. 6. G. Vaillant, *A.M.N.H.A.P.*, XXXII (1930), 143–51. Cf. W. du Solier, *La plástica arcaica* (Mexico, 1950), and R. Piña Chan, *Las culturas preclásicas de la Cuenca de México* (Mexico, 1955).

7. P. Drucker, *B.B.A.E.*, CXL (1943), 77–8. During Teotihuacán III (p. 36) moulds were used and

hand-made figurines ceased in central Mexico [19].

8. G. Vaillant, 'Early Cultures of the Valley of Mexico', *A.M.N.H.A.P.*, XXXV (1935), 300.

9. M. N. Porter, *Tlatilco and the Pre-Classic Cultures of the New World* (New York, 1953); *idem* and L. I. Paradis, 'Early and Middle Pre-Classic Culture in the Basin of Mexico', *Science*, CLXVII (1970), 344–51.

10. *Ancient Civilizations of Mexico and Central America* (New York, 1928); G. Willey, in *The Florida Indian and his Neighbors*, ed. J. B. Griffin (Winter Park, 1949), 101–16; K. V. Flannery (ed.), *The Early Mesoamerican Village* (New York, 1976).

11. M. Covarrubias, 'Tlatilco', *C.A.*, IX (1950), no. 3, 149–62; M. Coe, *The Jaguar's Children* (New York, 1965).

12. G. Vaillant, *op. cit.* (Note 8), 297–300. A later study of Vaillant's evidence confirmed his findings as to typology and sequence (P. Tolstoy, 'Surface Survey …', *Transactions of the American Philosophical Society*, XLVIII, 1958, part 5, 64–5).

49. 13. E. Noguera, *M.A.*, III (1935), no. 3, 17–18. P. Drucker, *B.B.A.E.*, CXL (1943), 118, 120, has collated other coeval ceramic styles elsewhere in Mexico.

14. Until the rediscovery of the archaeological site of Tula in Hidalgo in 1940, many writers took Teotihuacán for Tula and designated it as the Toltec capital. The name is Aztec, and roughly 600 years removed from the real (lost) name. The names of the pyramids (Sun, Moon, and Ciudadela) are of sixteenth-century origin. Texts discussed by P. Armillas, 'Teotihuacán, Tula y los Toltecas', *Runa*, III (1950), 37–70. L. Sejourné, *Burning Water* (London, 1956), unsuccessfully attempted to return to the pre-1940 conception identifying Tula as Teotihuacán, and designating Teotihuacán as Toltec.

15. A. V. Kidder, J. D. Jennings, and E. M. Shook, *Kaminaljuyu* (Washington, 1946).

51. 16. The basic studies are by Manuel Gamio, *La población del valle de Teotihuacán*, II (Mexico, 1922), and P. Armillas, *Runa*, III (1950). On Teotihuacán I (pre-pyramid), see C. S. Leonard, *Boletín del centro de investigaciones antropológicas de México*, IV (1957), 3–9.

The contribution to the question by R. Millon, 'The Beginnings of Teotihuacán, *Am.A.*, XXVI (1960), 1–10, put the building of the Sun and Moon Pyramids in the first century B.C. or earlier on the strength of new finds to the north-west at nearby Oztoyahualco. A radiocarbon date for the Tzacualli finds at this site, submitted by Carmen Cook de Leonard, and measured at Yale Geochronometric Laboratory (specimen Y-644), reads 1930 ± 80 before present, confirming the position suggested here, as about the beginning of our era. I am indebted

to René Millon for the information used on the insert to the map of Mexico in this volume. His article 'A Long Architectural Sequence at Teotihaucán', *Am.A.*, XXVI (1961), 516–23 reported finds at Oztoyahualco 'spanning the Preclassic, Classic, and Postclassic periods'.

In 1972 Millon revised his chronology as follows:

	Patlachique	150–0 B.C.
I	Tzacualli, Early	0–
IA	Tzacualli, Late	–150
II	Miccaotli	150–200
IIA	Tlamimilolpa, Early	200–
IIA-III	Tlamimilolpa, Late	–450
III	Xolalpan, Early	450–
IIIA	Xolalpan, Late	–650
IV	Metepec	650–750

(after Millon 1972, in E. R. Wolf, *Valley of Mexico*, Albuquerque, 1976, 25). The abandonment has recently been attributed to the collapse of food supplies from other areas (H. Prem, *Lateinamerika Studien*, III, 1977). Prem calculates a peak population at the pyramids not exceeding 90,000, in contrast to Sanders' estimate of over 160,000 (Sanders and others, *Teotihuacán Valley Project*, I, 1970, 442).

See also J. Quirarte, 'Izapan and Maya Traits in Teotihuacan III Pottery', *U.C.A.R.F.*, XVIII (1973), 11–29.

17. D. Heyden, 'Un Chicomoztoc en Teotihuacán?', *Bol. I.N.A.H.*, II (1972), no. 6, 3–18 (English version in *Am.A.*, XL, 1975, 131–47).

E. Rattray, 'Early Sequence', *I.C.A.*, XLI (1975), I, 364–8, has established that the lower tunnel contains Early Tzacualli sherds. The upper tunnel, made by R. E. Smith in 1962, contained Miccaotli sherds.

18. I. Marquina in *La pirámide de Tenayuca* (Mexico, 1935).

53. 19. S. Linné, *Archaeological Researches at Teotihuacan* (Stockholm, 1934); P. Armillas, *C.A.*, III (1944), no. 4, 121–36.

20. The usual designation as the pyramid of Quetzalcoatl may be questioned, for, as Armillas has shown, the feathered serpents carved in relief upon its terraces refer to water gods and deities of plant growth in pre-Toltec symbolism; *C.A.*, VI (1947), no. 1, 177.

21. A. Caso, 'El paraíso terrenal en Teotihuacán', *C.A.*, I (1942), no. 6, 127–36.

54. 22. S. G. Morley, *The Ancient Maya* (Stanford, 1947), 350, describes the wasteful process in detail. In Yucatán today, about one cord of wood is burned to produce a cubic metre of lime powder; E. Morris, in *Temple of the Warriors*, I (Washington, 1931), 225.

23. P. B. Sears, 'Pollen Profiles and Culture Horizons in the Basin of Mexico', *I.C.A.*, XXIX (1951), 57–61, notes that pollen deposits suggest unfavourable moisture conditions during the Classic era.

J. C. Olivé N. and Beatriz Barba A., 'Sobre la desintegración de las culturas clásicas', *A.I.N.A.H.*, IX (1957), 57–71, blame a social revolution. Sanders, Parsons, and Logan (E. R. Wolf, ed., *Valley of Mexico*, Austin, 1978, 178) add that Teotihuacanos showed little interest in the possibility of lake-borne transportation and commerce.

24. On top of the south pyramid ('Quetzalcoatl') a layer of human bones beneath a layer of seashells was discovered. It suggests rites of secondary burial.

25. On modern survivals of such 'concourse centres' or 'vacant towns', see S. Tax, *A.A.*, XXIX (1937); R. Linton, in *The Maya and Their Neighbors* (New York, 1940), 39–40; and G. McBride, *Geographical Review*, XXXII (1942), 252 ff. Contrast W. T. Sanders, *V.F.P.A.*, XXIII (1956), 114–27.

26. See the maps comparing Maya and Mexican sites, drawn to the same scale, in Marquina, *Arquitectura prehispánica* (Mexico, 1951), plates 276–9. The definitive mapping by R. Millon, B. Drewitt, and G. Cowgill appeared in 2 vols., *Urbanization at Teotihuacán* (Austin, 1973).

27. W. T. Sanders, *op. cit.*, 123–5, writes of 'at least 50,000 inhabitants' living in 'luxurious residential palaces aligned along a wide boulevard ... surrounded ... by ... almost continuous clusters of rooms separated by small patios and narrow, winding alleys'. For Teotihuacán proper this assumes too much, in the absence of corresponding house foundations, refuse heaps, or burials.

55. 28. The three groups of four secondary platforms surrounding the main pyramid in the principal court recall the calendrical division of the Middle American cycle of fifty-two years into four parts of thirteen years each.

56. 29. Atetelco: P. Armillas, 'Exploraciones recientes en Teotihuacán', *C.A.*, III (1944), no. 4, 121–36. Closed court: J. R. Acosta, *El Palacio del Quetzalpapálotl* (Mexico, 1964). Carbon 14 measurements surprisingly range between A.D. 50 and 250 (p. 53), perhaps registering re-used timbers?

On 'Quetzalpapálotl' as a misnomer, see M. Chomel, 'Lechuza en Teotihuacan', *I.C.A.*, XLI (1976), vol. II, 325.

30. O. Apenes, 'The "Tlateles" of Lake Texcoco', *Am.A.*, IX (1943), 29–32; R. C. West and P. Armillas, 'Las Chinampas de México', *C.A.*, V (1950), no. 2, 165–82, especially 169–70. D. Puleston ('Hydraulic Agriculture', *Social Process*, London, 1977, 449–65) has enlarged the topic by studying the Maya 'raised' fields, dated in Belize as 1800 B.C. by Carbon 14, and relating their use to Maya calendar and mythology, through crocodile representations, as on Altar T at Copán, of the earth monster Itzam Cab Ain. The earth monster in Codex Borgia, and the Tello Obelisk of Chavín culture in the Andes

[321] are also brought into consideration (pp. 464–5).

57. 31. E.g. Kaminaljuyú (Guatemala City), Tikal, and Aké (Yucatán), where it reflects Maya contact with the Valley of Mexico; C. Coggins, 'Teotihuacan at Tikal', *I.C.A.*, XLIII (1976), vol. VIII (1979), 251–69. On Aké, see L. Roys and E. Shook, 'Ruins of Aké', *M.S.A.A.*, XX (1966), figure 48 (talus and panel at Structure 15, primary, of Early Classic date). Also J. W. Ball, 'Southeastern Campeche and the Mexican Plateau', *I.C.A.*, XLIII (1976), vol. VIII (1979), 271–80.

58. 32. I. Marquina, *Proyecto Cholula* (1970), 31–45.

60. 33. Only 11,000,000 (minimum) to 33,000,000 (maximum) New World inhabitants are estimated as of the Discovery. A. L. Kroeber, 'Cultural and Natural Areas of Native North America', *U.C.P.A.A.E.*, XXXVIII (1939).

34. Small animal effigies on wheeled platforms of clay have appeared in the Valley of Mexico, at Tres Zapotes, in Oaxaca, and perhaps Panamá, in post-Classic periods, after A.D. 1000. See the article of composite authorship (A. Caso, M. Stirling, S. K. Lothrop, J. E. S. Thompson, J. García Payón, G. Ekholm), 'Conocieron la rueda los indígenas mesoamericanas?', *C.A.*, V (1946), no. 1, 193–207.

35. W. H. Holmes, *B.B.A.E.*, LX (1919).

36. Fray Juan de Mendieta, writing at the end of the sixteenth century, described another colossal stone figure, too large to move, recumbent (*tendido*) on top of the largest pyramid (the Sun). *Historia ecclesiástica indiana*, ed. Icazbalceta (Mexico, 1870).

37. Illustrated in Marquina, 105.

38. S. Toscano, *Arte precolombino* (Mexico, 1944), 211. W. Krickeberg, *Felsplastik*, I (1949), 199–206, assigns the 23-foot-high unfinished statue of andesite from Coatlichan to the same period.

39. R. García Granados, 'Reminiscencias idolátricas en monumentos coloniales', *Anales del Instituto de Investigaciones estéticas*, II (1940), no. 5, 54–6.

40. G. Kubler, *The Arensberg Collection* (Philadelphia, 1954), plate 2.

62. 41. Aztec mummy bundles wearing similar masks are figured in a sixteenth-century pictorial history of early colonial date; *Codex Magliabecchi*, ed. Duc de Loubat (Rome, 1901).

42. S. Linné, *Archaeological Researches* (Göteborg, 1934), 171–5. E. Seler, *G.A.*, V, 533 and plate LI, discusses two pottery braziers in which such masks were used. Smaller ring-eyed masks are portrayed in clay as pectorals of dead warriors worn by mould-made figurines of the period A.D. 550–750 (H. von Winning, 'Human-Mask Pectorals', *Masterkey*, LII, 1978, no. 1, 11–16).

63. 43. The conventional designation as 'portrait type' is a misnomer. 'Stereotype' would be better.

64. 44. It covers an earlier structure discovered in 1939 by D. F. Rubín de la Borbolla, *A.I.N.A.H.*, II (1941–6), 61–72.

45. The square plan and the width of the terraces allow the calculation that 366 such heads (including stair balustrades) adorned the platform. The number suggests calendrical symbolism bearing on the solar year.

46. Various discoveries are reported by A. Villagra in *A.I.N.A.H.*, V (1952), 67–74; VI (1955), 67–80.

65. 47. T. Proskouriakoff, 'Classic Vera Cruz Sculpture', *C.A.A.H.*, XII (1954), no. 58. The platform is illustrated in Marquina, plate 27. E. Seler, *G.A.*, V, 519, Abb. 170 illustrates a carved cylindrical tripod vessel from Teotihuacán with these forms.

48. The technique is called 'fresco' decoration because of the high key and matt finish of the pigment. The processional figures are more common on the later slab-footed tripods than on the somewhat earlier plug-footed vessels; P. Armillas, *C.A.*, III (1944), no. 4, 131, plates 1–11.

66. 49. A repertory of all known fire-signs at Teotihuacán is by H. von Winning, 'The Old Fire God and his Symbolism at Teotihuacán', *Indiana*, IV (1977), 7–62. See also 'New Fire', *ibid.*, V (1978), 15–43.

50. *C.A.*, I (1942), no. 6, 127–36. Aztec texts are as far removed from Teotihuacán murals as St Isidore of Seville is from the Roman mosaics of Italica. The mural now (1980) dated in the seventh-century Metepec phase (E. Rattray, cited by E. Pasztory, *Murals of Tepantitla*, New York, 1976, preface). E. Taladoire (*S.M.A.M.S.*, XIV, 1976, 25–31) notes resemblances between the stick-ball game portrayed in illustration 24 (upper right) and one surviving in Guerrero.

51. S. Linné, 'Teotihuacan Symbols', *Ethnos*, VI (1941), 174–86; H. Neys and H. v. Winning, 'The Treble Scroll', *N.M.A.E.E.*, III (1946–8), 81–9; H. v. Winning, *M.A.*, VI (1947), 333–4; VII (1944), 126–53, and *N.M.A.A.E.*, III (1946–8), 170–7; *I.C.A.*, XLII (1967), vol. VII (1979), 425–37; R. L. Rands, 'Some Manifestations of Water in Mesoamerican Art', *B.B.A.E.*, CLVII (1955), 265–303. L. Sejourné, *Burning Water* (London, 1956), finds hearts and other 'Náhuatl' symbols in the figural work, without proper evidence.

68. 52. A. Caso, *M.A.*, IV (1937), 131–43; H. Beyer, *ibid.*, I (1921), 211. Their use as a visual code of signs organized as a linguistic system (Kubler, *Iconography*, *D.O.S.*, IV, 1967) has been contested by E. Pasztory, who prefers a 'synthetic' approach allowing her to continue using Aztec deity names ('The Gods of Teotihuacan', *I.C.A.*, XL 1972, vol. I, 1973, 147–59), despite the frequent presence of clusters of signs having no Aztec cognates. H. von Win-

478 · NOTES

ning, 'Cloth and Warriors', *Masterkey*, LIV (1980), no. 1, 17–23, analyses warrior images in murals at Tepantitla and Atetelco (late Xolalpan, after 650?). Ritual cloths in these images are related by him to those of Palenque.

53. E. Rattray, 'Contactos Teotihuacán-Maya', *Anales de Antropología*, XV (1978), 35–52, discusses Maya pottery at Teotihuacán from 550 to 750 A.D.

54. P. Armillas, 'Los dioses de Teotihuacán', *Anales del Instituto de Etnología americana* (Mendoza, Univ. de Cuyo), VI (1945); E. Pasztory, 'Iconography of the Teotihuacán Tlaloc', *D.O.S.*, XV (1974); C. Millon, 'Painting, Writing and Polity', *Am.A.*, XXXVIII (1973), 294–314.

55. Proskouriakoff, 119. L. Parsons (*Bilbao*, II, Milwaukee, 1969, 170–1) regards Xochicalco as bridging the Late Classic gap between Teotihuacán and Tula. On its rivalry with Teotihuacán, J. Litvak King, 'Xochicalco en la caída del clásico', *Anales de Antropología*, VII (1970), 131–44, and 'Las relaciones externas', *ibid.*, IX (1972), 53–76.

56. E. Noguera, *C.A.*, IV (1945), no. 1, 119–57, and *R.M.E.A.*, X (1948–9), 115–19; C. Sáenz, 'Exploraciones en Xochicalco', *Bol. I.N.A.H.* (1966), no. 26, 24–34.

57. Contrast with W. T. Sanders, *V.F.P.A.*, XXIII (1956), 125.

70. 58. Marquina, 924, makes the sculptured platform coeval with Late Classic Maya art. The excavations have failed to give a sequence for the building history of the site. E. Noguera excavated the sweatbath of Maya type (*R.M.E.A.*, X, 1948–9, 115–19). For other traces of Maya influence in Guerrero see *El occidente de México* (*S.M.A.M.R.*, IV, 1948), especially H. Moedano, 'Oztotitlan', pp. 105–6, reporting Maya corbelled vaults of 4.5 m. (14¾-foot) span.

59. E. Noguera, *C.A.*, IV (1945), no. 1, 119–57. Analogous ball-courts at Toluquilla and Ranas in the north-eastern part of the state of Querétaro recall the style of Xochicalco and of Tajín on the Gulf Coast. They are probably of the same pre-Toltec period as Xochicalco; Marquina, 241. On the antiquity of the game, see S. Borhegyi, 'The Pre-Columbian Ballgame', *I.C.A.*, XXVIII (1968), I, 499–515.

60. K. Ruppert, *Chichen Itza* (Washington, 1952), 82–3; L. Satterthwaite, Jr, *Piedras Negras Archaeology: Architecture*, Part V (Philadelphia, 1952).

61. Restored by L. Batres in 1910 to its present shape. J. O. Outwater, *Am.A.*, XXII (1957), 261, believes the carving was done at the quarry.

62. Marquina compares this cornice to Maya mouldings (p. 138). Tajín cornices (p. 920) seem more closely related.

73. 63. Marquina, 138.

64. A. Caso, 'Calendario y escritura en Xochicalco', *R.M.E.A.*, XVIII (1962), 49–79; H. Prem,

'Überlegungen', *Ethnologische Zeitschrift*, I (1974), 351–64.

74. 65. M. Foncerrada de Molina ('La pintura mural de Cacaxtla', *I.C.A.*, XLII, 1967, vol. VII, 1979; 'The Cacaxtla Murals', *Ibero-Amerikanisches Archiv*, IV, 1978, 141–60) is reluctant to accept direct cultural contact with Maya, but accepts Thompson's Putún-Maya trader theory. The absence of Maya glyphs leads her to treat the murals as a regional expression in an eclectic situation.

CHAPTER 3

77. 1. The chronicled date for the fall of Tula was first corrected from A.D. 1116 to 1168 by W. Jiménez Moreno, 'Tula y los Toltecas segun las fuentes históricas', *R.M.E.A.*, V (1940). The fall and abandonment may also be placed *c.* 1260, on the assumption that the great 'inconsistencies' among the chronicles reflect the coeval functioning of many distinct local calendars which can all be correlated (P. Kirchhoff, 'Calendarios Tenochca, Tlatelolca y otros', *R.M.E.A.*, XIV, 1954–5, 257–67). L. Matos, in E. Pasztory (ed.), *Middle Classic Mesoamerica* (New York, 1978), 172–7, reports continuity from the Metepec phase (650–750) at Tula Chico mixed with Coyotlatelco incised pottery. Tula Chico is identified as the 'initial nucleus' at the end of the Classic period (Metepec phase).

2. Jorge Acosta, *R.M.E.A.*, XIV (1956–7), 75–110; R. Chadwick, 'Post-Classic Pottery of the Central Valleys', *H.M.A.I.*, X (1971), 228–57; E. Matos, *Tula*, 2 vols. (Mexico, 1976); J. Yadeún, *El caso de Tula* (Mexico, 1975).

3. J. E. S. Thompson, *The Rise and Fall of Maya Civilization* (London, 1956).

4. Critical bibliography in S. Toscano, *Arte precolombino* (Mexico, 1944), 57–64. R. Blanton ('Texcoco', *Am.A.*, XL, 1975, 227–30) agrees with Parsons that the early Toltec era was a 'Balkanization' of the Valley of Mexico until the expansion of the Toltec state.

81. 5. W. T. Sanders, 'Settlement Patterns in Central Mexico', *H.M.A.I.*, X (1971), 3–44; D. Charnay, *The Ancient Cities of the New World* (London, 1887); R. A. Diehl and R. A. Benfer, 'Tollan', *Archaeology*, XXVIII (1975), 112–24; F. Meraz, 'Hallazgo de Gran Urbe Tolteca', *Excelsior* (10 June 1980), 11A (newspaper report on new discoveries extending the spread of the site).

6. E.g. Walter Lehmann, *Aus den Pyramidenstädten in Alt-Mexiko* (Berlin, 1933).

7. P. Armillas, 'Fortalezas mexicanas', *C.A.*, VII (1948), no. 5. Contrast A. Palerm, 'Notas sobre las construciones militares y la guerra en Mesoamérica', *A.I.N.A.H.*, VIII (1956), 123–34.

8. A. Ruz Lhuillier, *Guía arqueológica de Tula* (Mexico, 1945).

9. Rémy Bastien, 'New Frescoes in the City of the Gods', *Modern Mexico*, xx (1948), 21, compares Atetelco and Tula.

83. 10. The west chamber, with twenty-six columns, contained stacks of neatly sorted Mazapan pottery, smashed when the roof fell in the destruction of Tula. Building 3 (*A.I.N.A.H.*, ix, 1957, figure 4) has two impluvium patios surrounded by double rows of wooden supports faced with stucco.

11. A. Caso, 'El mapa de Teozacualco', *C.A.*, viii (1949), no. 5, 145–81. The blue-and-yellow meander at Tula has a parallel among Mixtec place-names, but its meaning is still unidentified.

12. Illustrated in E. Seler, *G.A.*, v 433. The Tula crenellations are like the conch sections on the bodies of the feathered serpents of Xochicalco [26].

13. H. Moedano, cited by W. Krickeberg, *Alt-mexikanische Kulturen* (Berlin, 1956), 323, regards the Atlantean supports as images of the planet Venus (Tlahuizcalpantecuhtli) in the form of the hunting god named Mixcoatl, because of traces of red-and-white striped body paint on the statues.

86. 14. Discussion in Tozzer, 'Chichen Itza', *P.M.M.*, xi (1957), 71–2,. 100 (illustrated by S. Toscano, *Arte precolombino*, 139).

15. P. Armillas, 'La serpiente emplumada, Quetzal-coatl y Tlaloc', *C.A.*, vi (1947), no. i, 161–78.

16. C. Lizardi Ramos, 'El Chacmool mexicano', *C.A.*, iv (1944), no. 2, 137–48, analyses the types and their significance. See also J. Corona Núñez, *Tlatoani*, i (1952), nos. 5–6, 57–62. H. von Winning, *I.C.A.*, xl (1973), 123–31, discusses West Mexican, Valley of Mexico, South Central Veracruz, Oaxacan, and Maya types and variants, as representations of 'ritual inebriation'.

87. 17. These remarkable achievements of primitive astronomical observation and calculation surely came to the Toltecs from Maya sources, where calendrical computations had reached great complexity during the Late Classic era.

88. 18. H. Moedano, 'El Friso de los caciques', *A.I.N.A.H.*, ii (1941–6), 113–36, and H. Beyer, 'La procesión de los señores', *M.A.*, viii (1955), 1–65.

19. In Mixtec and Aztec society, a heraldic name and a calendar name (determined by the birth day) were customary for every person of consequence. C. Navarrete and A. M. Crespo, 'Cerro de la Malinche', *E.C.N.*, ix (1971), 11–15, have reassigned this relief carving to Mexican sculptors rather than Toltec. Recent discoveries by R. Abascal of I.N.A.H. (*Excelsior*, 10 June 1980, 11A) extend Tula from 11 square kilometres to 16 square kilometres and suggest growth during Mexican history to 30,000 inhabitants. A stone

image of Coyolxauhqui may antedate Mexican rule in the Valley of Mexico.

20. P. Armillas, *C.A.*, vi (1947), no. 1, 161–78; A. López Austin *El hombre-dios, Quetzalcoatl* (Mexico, 1972). G. Willey, 'Mesoamerican Civilization and the Idea of Transcendence', *Antiquity*, l (1976), 205–15, relates the historical ruler, Topiltzin Quetzalcoatl, founder of Tula *c.* 900, to a transcendental ideology of ecumenical stability, which he associates with a rising merchant class.

21. It must surely have been climatic changes that occasioned these cyclical movements of peoples. Soil profile studies in the Teotlalpan district show alternating periods of drought and moisture which relate clearly to the archaeological and textual evidence of the succession of cultures; S. F. Cook, 'The Historical Demography and Ecology of the Teotlalpan', *Ibero-Americana*, xxxiii (1949).

22. P. Kirchhoff, 'Civilizing the Chichimecs', *Latin-American Studies*, v (1948).

23. The Toltec saga as related by sixteenth-century sources often includes a first golden age of peaceful arts, which may reflect the theocracy of Teotihuacán; e.g. *Die Geschichte der Königreiche von Colhuacan und Mexiko*, ed. W. Lehmann (Stuttgart, 1938).

24. W. Krickeberg, *Altmexikanische Kulturen*, 308, seeks to restrict the term to the Valley of Mexico, excluding the adjoining plateaus of Toluca and Puebla. This distinction rests more upon textual sources than upon the archaeology of the period. The excavations show a uniform style of artifacts to which a name as generic as 'Chichimec' is not inappropriate.

89. 25. E. Boban, *Documents pour servir à l'histoire du Mexique*, 2 vols. and atlas (Paris, 1891), i, 134, 147; C. Dibble, *Códice Xolotl* (Mexico, 1951). The study of these manuscripts as examples of painting belongs to a later section, as they are examples of Aztec pictorial conventions, although of post-Conquest date.

26. P. Radin, 'The Sources and Authenticity of the History of the Ancient Mexicans', *U.C.P.A.A.E.*, xvii (1920), 1–150; R. Carrasco, 'The Peoples of Central Mexico and their Historical Traditions', *H.M.A.I.*, xi (1971), 459–73; also R. Chadwick, 'Native Pre-Aztec History of Central Mexico', *ibid.*, 474–504.

27. F. de A. Ixtlilxochitl, *Obras históricas*, ed. Chavero (Mexico, 1891–2).

28. The Tepanecs were probably related to the Matlatzinca tribe of the valley of Toluca. Tezozomoc, *Crónica mexicana* (Mexico, 1878).

29. E. J. Palacios and others, *Tenayuca* (Mexico, 1935).

30. T. D. Sullivan, 'Tlaloc', *I.C.A.*, xl, vol. 2 (1974), 213–17, supplies a linguistic interpretation of the name as 'He Who is Made of Earth', whose rain function may have been a later development.

31. J. García Payón, *Zona arqueológica de Tecaxic-Calixtlahuaca* (Mexico, 1936); H. E. D. Pollock, *Round Structures* (Washington, 1936).

91. 32. A tribal fetish of solar nature, meaning 'Humming-bird of the left' (i.e. south), consulted as an oracle and given the cult of a war god.

33. P. Kirchhoff revised the traditional date of the founding (*c* 1325) to *c*. 1370 on the basis of calendar studies correlating the numerous municipal systems of recording dates; *Transactions of the New York Academy of Sciences*, XII (1950).

34. The genealogical line is fully reported in *Códice Xolotl*, ed. C. Dibble.

35. R. H. Barlow, 'The Extent of the Empire of the Culhua Mexica', *Ibero-Americana*, XXVIII (1949), based upon the tribute lists of the Codex Mendoza, a sixteenth-century compilation by Indian informants, ordered for Viceroy Mendoza as a guide for Spanish colonial taxation in the same area (*Codex Mendoza*, ed. and transl. J. C. Clark, 3 vols., London, 1938).

92. 36. B. de Sahagún, *Historia general*, is the most complete source: preferred edition: *Florentine Codex*, transl. A. J. O. Anderson and C. E. Dibble (Santa Fé, 1950–69). Excision of the heart (Toltec origin), flaying (south Mexico), and gladiatorial combat and arrow sacrifice (east coast) were the commonest forms of immolation. For a survey of the annual calendrical sacrifices, see G. Kubler and C. Gibson, *The Tovar Calendar* (New Haven, 1951). H. B. Nicholson, 'Religion', *H.M.A.I.*, X (1971), 431 f.

37. A. Caso, *The Aztecs* (Norman, 1958), 12–13. Recent literature on Aztec civilization is summarized by W. Bray, 'Civilizing the Aztecs', in *The Evolution of Social Systems*.

38. G. Kubler, 'The Cycle of Life and Death in Metropolitan Aztec Sculpture', *G.B.A.*, XXIII (1943), 257–68. Carmen Aguilera, *Arte tenochca, significación social* (Mexico 1977), analyses the cultural and historical contexts, as well as the functions of official, courtly art within these conditions.

39. L. Schultze, *Indiana*, II (Jena, 1933–8).

40. M. Toussaint, J. Fernández, E. O'Gorman, *Planos de la ciudad de Mexico* (Mexico, 1938); I. Alcocer, *Apuntes sobre la antigua México-Tenochtitlán* (Mexico, 1935); Hernando Cortés, *Letters*, ed. F. A. MacNutt (New York, 1908); B. Díaz del Castillo, *True History*, ed. A. P. Maudslay (London, 1908–16); B. de Sahagún, *Historia*, Book XII; Diego Durán, *Historia*. Overview by Sanders, *H.M.A.I.*, X (1971), 24–9.

41. J. W. Schottelius, *Ibero-amerikanisches Archiv*, VIII (1934).

42. 'Tlatelolco a través de los tiempos', *Memorias de la Academia de Historia*, III-IV (1944–8).

93. 43. D. Robertson suggests that the basic paper drawing, apart from the pasted-over colonial additions, may well be of pre-Conquest manufacture, and that its grid corresponds to a suburban fringe of new growth along the western fringe of Tenochtitlan; *Mexican Manuscript Painting of the Early Colonial Period* (New Haven, 1959). Contrast Toussaint, Fernández, and O'Gorman, *Planos*. D. Stanislawski, 'Origin and Spread of the Grid-Pattern Town', *Geographical Review*, XXXVI (1946), 105, and XXXVII (1947), 97, denies the existence of grid plans in pre-Conquest town planning. E. E. Calnek, *Am.A.*, XXXVIII (1973), 190–4, locates the map as a suburban island near Atzcapotzalco. Calnek (*I.C.A.*, XL, vol. IV, 97) differs from Wittfogel, Sanders, Palerm, and Price on reclaimed *chinampa* lands, in favour of Mexican dependence on trade and marketing after the floods of 1382–5.

95. 44. T. de Benavente Motolinia, *Historia de los Indios de la Nueva España* (Barcelona, 1914); English translation by F. B. Steck, O.F.M., entitled *Motolinia's History of the Indians of New Spain* (Washington, 1951).

45. Marquina, 220. Teopanzolco has been trenched to reveal the outlines of an older interior platform.

46. E. Seler, *G.A.*, III, 487–513. The alleged month-glyphs on the cella bench are discussed by G. Kubler and C. Gibson, *The Tovar Calendar* (New Haven, 1951), 62–3.

47. J. García Payon, *R.M.E.A.*, VIII (1946). The rock is a volcanic ash containing clay, which is soft when wet; hard when dry. J. O. Outwater, 'Precolumbian Stonecutting Techniques of the Mexican Plateau', *Am.A.*, XXII (1957), 258.

96. 48. W. Krickeberg, 'Das mittelamerikanische Ballspiel und seine religiöse Symbolik', *Paideuma*, III (1948).

97. 49. G. C. Vaillant, *The Aztecs of Mexico* (New York, 1941, and Harmondsworth, 1950).

50. J. García Payón, *La Zona arqueológica de Tecaxic-Calixtlahuaca* (Mexico, 1936).

51. Tizatlán: E. Noguera, *R.M.E.H.*, II (1928); Comalcalco: F. Blom and C. Lafarge, *Tribes and Temples*, I (New Orleans, 1926), 113; Corozal: T. Gann, *B.B.A.E.*, LXVI (1918), 82; Zacualpa: R. Wauchope, *Excavations at Zacualpa* (New Orleans, 1948), 66–7.

52. W. Jiménez Moreno, 'El enigma de los Olmecas', *C.A.*, V (1942). To the Aztecs, the Olmecs were a real and redoubtable tribal entity, whose territory yielded important revenues. On merchants and markets, B. Bittmann and T. D. Sullivan, 'The Pochteca', *I.C.A.*, XL (1976), vol. IV, 203–12.

99. 53. Discussed by H. Moedano, 'El friso de los caciques', *A.I.N.A.H.*, II (1947).

54. On kingship, see Manuel M. Moreno, *La organización política y social de los Aztecas* (Mexico 1931).

55. A cast gold figure of Tizoc is discussed by M. Saville, *The Goldsmith's Art in Ancient Mexico* (New York, 1920). D. Easby and F. J. Dockstader, 'Requiem for Tizoc', *Archaeology*, XVII (1964), 85–90, prove that it is a modern work.

56. The frontal portraits of the dynastic rulers of Tenochtitlan, garbed as Xipe Totec and carved upon the rock face of Chapultepec, are mutilated beyond recognition. H. B. Nicholson, 'The Chapultepec Cliff Sculpture', *M.A.*, IX (1959), 379–444.

100. 57. H. Beyer, *El llamado 'calendario Azteca'* (Mexico, 1921). E. Umberger, *I.C.A.*, XLIII (1979), Abstracts AI31, reinterprets the dates as recording 1428, the overthrow of the Tepanecs, as the 'birth' of the empire. On this group of major sculptures see R. Townsend, 'State and Cosmos', *D.O.S.*, XX (1979).

58. A. Caso, *El Teocalli de la guerra sagrada* (Mexico, 1927).

103. 59. E. Seler, *G.A.*, II, 704–16.

60. M. Saville, *The Woodcarver's Art in Ancient Mexico* (New York, 1925). Also E. Noguera, *Tallas prehispánicas en madera* (Mexico, 1958). The copper knives occasionally found in Mexico lacked the hardness and temper for stonework and wood carving. Bronze cutting-implements were common only in the Andean region. P. Rivet, *La métallugie en Amérique précolombienne* (Paris, 1946); M. Saville, 'Votive Axes from Ancient Mexico', *I.N.M.*, VI (1929); H. B. Nicholson, 'Religion', *H.M.A.I.*, X (1971), 422–4.

61. G. Kubler and C. Gibson, *The Tovar Calendar* (New Haven, 1951). E. Pasztory (lecture, Columbia University, 26 January 1979) suggested that the two stone 'masks' of Xipe in the British Museum are of mid-nineteenth-century date. She also doubts the antiquity of the parturition figure [57]. Her opinions will appear in a forthcoming conference volume at Dumbarton Oaks on 'fakes'.

62. Illustrated by the discoverer, G. Vaillant, in *Aztecs of Mexico*. Another example of the same hollow fired clay image has been found in Costa Rica. A Zapotec Xipe figure is illustrated by A. Caso and I. Bernal, *Urnas de Oaxaca* (Mexico, 1951), figure 396. See also H. B. Nicholson, 'Xipe Totec', *S.M.A.M.R.*, XII (1972), 213–18.

105. 63. J. E. S. Thompson, 'The Moon Goddess in Middle America', *C.A.A.H.*, V (1939), 121–73; W. Krickeberg, *Altmexikanische Kulturen* (Berlin, 1956), 181–216. Many forms of the earth goddess as death goddess are pictured in *Codex Magliabecchi*, facs. ed. Duc de Loubat (Rome, 1901). B. Spranz, *Göttergestalten* (Wiesbaden, 1964); A. Hvidtfeldt, *Teotl and Ixiplath* (Copenhagen, 1958); F. A. Robiczek, *A Study in Maya Art and History: The Mat Symbol* (New York, 1975).

64. M. Acosta Saignes, *Los Pochteca (Acta Anthropologica*, 1) (Mexico, 1945). This work analyses the history of the clan monopolizing the foreign trade activities of the Aztec state. It functioned as a priestly corporation, under the aegis of a god, Yacatecutli, with special rites and privileges. Its members enjoyed the status of hereditary nobles and warriors. They were both instruments and strategists of Aztec economic and political expansion.

65. The literature of the Coatlicue figure, written since its discovery in 1790, is the subject of the illuminating book by Justino Fernández, *Coatlicue* (Mexico, 1954). The Yolotlicue figure was discovered in the foundations dug for the Supreme Court building. Both are 2.52 m. (8¼ feet) high. The surfaces of the Yolotlicue figure are damaged.

66. S. K. Lothrop, *Pre-Columbian Art* (Bliss Collection) (New York, 1957), 240–1. The material is wernerite.

67. H. B. Nicholson, 'The Birth of the Smoking Mirror', *Archaeology*, VII (1954), 164–70, has gathered other representations of birth scenes.

107. 68. These excavations have been in progress since 1978. See E. Matos, *Boletín I.N.A.H.*, no. 24 (1978), 3–17; C. Aguilera, 'Significado de Coyolxauhqui', *ibid.*, 81–92.

110. 69. S. Ball, 'The Mining of Gems and Ornamental Stones by American Indians', *B.B.A.E.*, CXXVIII (1941), 20, 27, 28.

70. E. Seler, *Einige Kapitel aus dem Geschichtswerk des Fray Bernardino de Sahagun* (Stuttgart, 1927), 376–7.

71. Illustrated in *Ancient American Art* (Cambridge, Mass., 1940). C. Aguilera, *I.C.A.*, XLIII (1979), Abstracts A2, found no reference in the sources to Coyolxauhqui as the moon, but often in association with Cihuacóatl.

72. M. Saville, 'The Goldsmith's Art in Ancient America', *I.N.M.* (1920); D. T. Easby, jr, 'Sahagún y los orfebres precolombinos de México', *A.I.N.A.H.*, IX (1957), 85–117.

73. The '*Plano en papel de maguey*' (see Note 43) is an administrative map rather than a work of art.

74. John Glass, *Catálogo de la colección de códices* (Mexico, 1964). Donald Robertson, *Mexican Manuscript Painting* (New Haven, 1959), analyses these documents in the light of the replacement of native conventions by European ones.

75. I. J. Gelb, *A Study of Writing* (London, 1952), 51–9, characterizes 'Aztec and Maya' signs as 'limited systems' to be counted among the forerunners of writing, and not as full writing. They are semasiography rather than phonography; based upon pictures, and not upon syllabic signs representing language instead of nature.

111. 76. W. v. Hoerschelmann, 'Flächendarstellun-

gen in altmexikanischen Bilderschriften', *Festschrift Eduard Seler* (Stuttgart, 1922), 187–204.

77. Tlaxcala, though regarding Tenochtitlan as the hereditary enemy, belonged to the Aztec culture, much as Sparta belonged to Greek civilization.

112. 78. Marquina, 212.

79. E. Noguera, 'Los altares de sacrificio de Tizat-lán', *Publicaciones de la Secretaría de Educación Pública*, XV (1927), no. 11, 23–62. Fired bricks, extremely rare in Mexico, were used in the stairs, the bench, and the altar-tables. The bricks measure 56 by 30 by 6 cm. (22 by 12 by 2½ ins.). See also A. Caso, *R.M.E.H.*, I (1927).

113. 80. Its colonial date is indicated by the deep pictorial space of certain month festivals, particularly in the scene showing dancers winding around a pole; *Codex Borbonicus*, facs. ed. E.-T. Hamy (Paris, 1899).

81. C. E. Dibble, *Códice en Cruz* (Mexico, 1942).

82. *Codex Telleriano-Remensis*, facs. ed. E.-T. Hamy (Paris, 1899).

83. *Codex Mendoza*, ed. and transl. J. C. Clark, 3 vols. (London, 1938).

114. 84. E.g. *Codex Magliabecchiano*, facs. ed. Duc de Loubat (Rome, 1904), illustrates many Aztec textile patterns in sixteenth-century drawings prepared on European paper.

85. E. Seler, *Einige Kapitel aus dem Geschichtswerk des Fray Bernardino de Sahagún* (Stuttgart, 1927), 378 f., and M. Acosta Saignes, *Los Pochteca*. Also E. Seler, *G.A.*, II, 641–63.

116. 86. F. Heger, *Annalen des K. K. Hofmuseums*, VII (1892), and F. v. Hochstetter, *Über mexikanische Reliquien aus der Zeit Montezumas in der K. K. Ambraser Sammlung* (Vienna, 1884).

87. R. Chadwick, 'Postclassic Pottery of the Central Valleys', *H.M.A.I.*, X (1971), 248–56.

CHAPTER 4

117. 1. M. Swadesh, 'The Language of the Archaeologic Huastecs', *N.M.A.A.E.*, IV (1949–53), no. 114, 223–7.

2. W. Jiménez Moreno 'El enigma de los Olmecas', *C.A.*, V (1942), 113–45.

3. Tres Zapotes: P. Drucker, *B.B.A.E.*, CXL (1943); La Venta: P. Drucker, *B.B.A.E.*, CLIII (1952), and P. Drucker, R. F. Heizer, and R. J. Squier, *B.B.A.E.*, CLXX (1959); R. F. Heizer and P. Drucker, 'The La Venta Flute Pyramid', *Antiquity*, XLII (1968), 52–6; San Lorenzo: M. Coe, 'San Lorenzo and the Olmec Civilization', *Dumbarton Oaks Conference on the Olmec* (Washington, 1968), 41–78; general: M. Covarrubias, *Indian Art* (New York, 1957).

4. F. J. Bove, 'Laguna de los Cerros', *Journal of New World Archaeology*, II (1978), no. 3, 1–56, publishes a plan and a ceramic sequence which, together with 'central place' theories, indicate its possible importance.

118. 5. I. Bernal, *The Olmec World* (Berkeley, 1969), 106–17; P. Tolstoy and L. Paradis, *U.C.A.R.F.*, XI (1971), 7–28. On the paw-wing, M. Coe, *Jaguar's Children* (New York, 1965).

Examining only 'major sculptural groups', S. Milbrath (*D.O.S.*, XXIII, 1979, 48) proposes four periods: I, 1250–1150 B.C., full-round, mainly La Venta and San Lorenzo; II, 1150–900 B.C., full round, fewer San Lorenzo; III–IV, 900–400 B.C., dominant relief, mainly La Venta. The colossal heads are not discussed. The method seeks ceramic ties for dating Group II. Other studies: C. W. Clewlow, Jr, 'A Stylistic Study', *U.C.A.R.F.*, XIX (1974); and B. de la Fuente, *Escultura monumental olmeca* (Mexico, 1973); also *Hombres de piedra* (Mexico, 1977). M. Coe and R. Diehl, *In the Land of the Olmec*, 2 vols. (Austin, 1980) was not published when these revisions were written (May–July 1980).

6. On the 'fluted' platform, J. Graham and M. Johnson, 'Great Mound of La Venta', *U.C.A.R.F.*, XLI (1979), 1–6, suggest its resemblance to radial-stairway pyramids as at Uaxactún, Tikal, and Chichén.

119. 7. L. W. Wyshak and R. Berger, 'Possible Ball Court at La Venta', *Nature*, CCXXXII (1971), 650.

8. E. Benson, *An Olmec Figure* (1971), describes a jade figurine with complex ideographic incisions, recalling both Monument 44 at La Venta and the Idolo de San Martín Pajapan.

9. J. Scott, 'Post-Olmec Art', *I.C.A.*, XLI (1976), vol. II, 380–6.

120. 10. M. N. Porter, *Tlatilco* (New York, 1953), plate 6G, H. This site of pre-Classic (Middle Zacatenco) date received Olmec influence from some unidentified centre.

11. M. Stirling, *An Initial Series from Tres Zapotes* (Washington, 1940). Contrast J. E. S. Thompson, *Dating of Certain Inscriptions of Non-Maya Origin* (Washington, 1941). Confirmation of Stirling's position is by M. D. Coe, 'Cycle 7 Monuments in Middle America: A Reconsideration', *A.A.*, LIX (1957), 597–611. M. Tellenbach, 'Algunas Consideraciones', *Indiana*, IV (1977), 63–7, claims credit for seeing the connexion between the fragments in 1971, and connects its glyphs with Stela 13 at Monte Alban and Stela 10 at Kaminaljuyú.

12. Enumerated by M. Covarrubias, *Mexico South*, 50–83. R. Grennes-Ravitz and G. H. Colman, 'Highland Olmec', *Am.A.*, XLI (1976), 196–206, argue that the highland centres were dominant and coastal

sites 'pilgrimage centres' only. See the critique by P. Tolstoy, *Am.A.*, XLIV (1979), no. 2, 333–7.

Recent archaeological discoveries: in the Usumacinta-Maya region, L. Ochva and M. Ivón Hernández, 'Olmecas del Usumacinta', *Anales de Antropología*, XIV (1977), 77–90; in the central Guatemalan highlands, C. Navarrete, 'Iconografía post-Olmeca', *ibid.*, 91–108.

13. E. Shook and A. V. Kidder, *Nebaj* (Washington, 1951), 32–43.

14. P. Drucker, *B.B.A.E.*, CLIII (1952), plate 56; I. Bernal, *The Olmec World* (Berkeley, 1969), 80. See C. W. Clewlow a.o., 'Colossal Heads', *U.C.A.R.F.*, IV (1967), and C. Wicke, *Olmec* (Tucson, 1971), on the problem of seriation. On proportions, J. Fernández, *Arte olmeca* (Mexico, 1968). Also C. W. Clewlow, *U.C.A.R.F.*, XIX (1974).

121. 15. P. D. Joralemon, *A Study of Olmec Iconography* (Washington, 1971), proposes ten gods, by developing the suggestions of M. Coe (*America's First Civilization*, New York, 1968, 111–15).

16. The jade 'canoe' from Cerro de las Mesas, with jaguar-masks engraved at both ends, seems to represent such an art; P. Drucker, *B.B.A.E.*, CLVII (1955), 47–9. The slit-eyed mask in the American Museum of Natural History (from a cave in Cañon de la Mano south of Taxco in Guerrero) is by style an Olmec wooden object. See G. Ekholm, *Ancient Mexico and Central America* (New York, 1970), 38.

122. 17. Mutilation is as difficult to define archaeologically as sacrilege. See A. Pohorilenko, 'Ceremonial Markings', *S.M.A.M.R.*, XIII (1975), vol. 1, 265–81. The markings (striations, cup-marks, nipple-markings) are attributed to both Olmec and post-Olmec peoples.

18. B. de la Fuente ('Cobata', *I.C.A.*, XLI, 1976, vol. 11, 348–57) believes it the latest, by its stylistic relationship to the heads from Tres Zapotes and Cerro Nestepe. She has classified it as 'non-Olmec of late date'. Only its reburial in post-Classic time has been attested (by R. and P. Krotser, correspondence).

126. 19. This rests only upon analogy with similar changes elsewhere, as in Greek pediment sculpture of *c.* 550–450 B.C., or early Gothic portal figures in northern France of *c.* 1140–1250. B. de la Fuente, 'Escultura monumental olmeca', *I.C.A.*, XLII (1976), vol. VII (1979), 338, finds √2 proportional relationships in free-standing figures and colossal heads. The recent estimate based on radiocarbon fixes the end of the period of the heads as prior to the epoch of the relief sculptures. It does not accord with the sculptural evidence. The parallels with Maya sculpture still leave it possible to assume a terminal date *c.* A.D. 300 for La Venta carvings. Contrast P. Drucker, R. F. Heizer, and R. J. Squier, 'Excavations

at La Venta, 1955', *B.B.A.E.*, CLXX (1959). Also R. F. Heizer, 'Agriculture and the Theocratic State in Lowland Southeastern Mexico', *Am.A.*, XXVI (1960), 215–22.

20. According to M. D. Coe ('San Lorenzo', *Dumbarton Oaks Conference*, Washington, 1968, 63) the end of the colossal-head sequence was marked by their mutilation *c.* 900 B.C. He now seriates the heads as beginning with San Lorenzo and ending with La Venta (differing from his own earlier estimate).

C. Wicke (*Olmec, an Early Art Style of Precolumbian Mexico*, Tucson, 1971, 113–27) at first supported the seriation LV-TZ-SL with Guttmann scalograms, but he later agreed with Coe's ordering. The question of seriation cannot now be resolved without additional evidence. The extent to which the heads may be intrusive in relation to their immediate surroundings is still unknown. C. W. Clewlow, R. A. Cowan, J. F. O'Connell, C. Benemann ('Colossal Heads of the Olmec Culture', *U.C.A.R.F.*, IV, 1967, 61) have examined and measured the heads, concluding that they may all be 'relatively contemporaneous'. See also C. W. Clewlow, Jr, 'A Stylistic and Chronological Study of Olmec Monumental Sculpture', *U.C.A.R.F.*, XIX (1974). A recent computer mapping of the statistical distances among the heads by Takashi Miyawaki using data provided by G. Kubler ('The Styles of the Olmec Colossal Heads', *New Mexico Studies in the Fine Arts*, I, 1976, 5–9) was made using Kubler's traits and weighting. These maps distinguish the sites from one another in the non-weighted distances. With the same data weighted, resemblances of style appeared clearly between heads at different sites. The data did not permit a seriation.

J. Brüggemann and M. A. Hers (*I.N.A.H.*, *Boletín*, XXXIX, 1970, 18–26), reporting their stratigraphic excavation at San Lorenzo, note that the 'round' Head 9 was found undamaged at 4 m. depth in a pit penetrating 2 m. below undisturbed base level. Head 7, a 'long' head, occurred in the humus at a depth of only 50 cm. Heads 7 and 9 belong to different kinds of andesite (*ibid.*, 26–9).

21. Proskouriakoff, figure 7 and p. 19.

127. 22. Proskouriakoff, 28–9. 'Altar' is probably a misnomer; such stones were surely used more as seats or platforms than as sacrificial tables.

23. D. Grove and J. Angulo established a pottery chronology marking Middle pre-Classic occupation (900–800 B.C.): 'Chalcatzingo', *Bol. I.N.A.H.*, 11 (1973), no. 4, 21–6.

24. R. Heizer, 'Analysis of Two Low Relief Sculptures from La Venta', *U.C.A.R.F.*, III (1967), 25–55.

129. 25. M. Stirling, *B.B.A.E.*, CXXXIX (1943), plates 17–18 and pp. 18–21 (Monument C).

130. 26. *B.B.A.E.*, CLIII (1952), 133. The formative stages of this process have not been discovered.
27. Illustrated in *B.B.A.E.*, CLIII (1952), plates 31–6; CXXXIX (1943), plates 32–6. R. Piña Chan and L. Covarrubias, *El Pueblo del Jaguar* (Mexico, 1964).
28. This composition existed in monumental basalt sculpture at La Venta; see *B.B.A.E.*, CLIII (1952), plate 59 (Monument 8).
132. 29. Such a 'replica' of a La Venta jade is the seated figurine of Tlatilco, discussed by M. N. Porter, *Tlatilco*, plate 4B and p. 23. Many helmeted figurines of clay can be seen among the purchase specimens illustrated by Weiant in *B.B.A.E.*, CXXXIX (1943). R. Piña Chan, *Culturas preclásicas* (Mexico, 1956), 14, has suggested an analogous division by 'rural' (Valley of Mexico) and 'semi-urban' (Gulf Coast) groups.
133. 30. M. Covarrubias, 'El arte "Olmeca" o de la Venta', *C.A.*, v (1946), no. 4, 153–79, and *The Eagle, the Jaguar and the Serpent* (New York, 1957).
134. 31. M. Covarrubias, *Mexico South*, 77–8.
32. The theses of Covarrubias are maintained by M. Coe in *The Jaguar's Children: Pre-Classic Central Mexico* (New York, 1965) and *America's First Civilization* (New York, 1968).
33. M. N. Porter, *Tlatilco*, 71–9, enumerated the similarities between Olmec and Chavín styles.
34. An economic view is advanced by K. Flannery. 'The Olmec and the Valley of Oaxaca', *Dumbarton Oaks Conference on the Olmec* (Washington, 1968), 79–108, who regards the style as a reflection of trade relations.
35. D. C. Grove, 'Los murales de la Cueva de Oxtotitlan', *Invest. I.N.A.H.*, XXIII (1970), and 'The Olmec Paintings of Oxtotitlan Cave', *D.O.S.*, VI (1970). C. Gay, 'Oldest Paintings of the New World', *Natural History*, LXXVI (1967), 28–35. H. von Winning, 'Bedeutung einer Jaguarskulptur', *Zeitschrift für Ethnologie*, C (1975), 224–37, presents another version of the Olmec origin myth.
135. 36. W. Davis, 'Copulation Scenes', *Am.A.*, XLIII (1978), no. 3, 453–6, questions the interpretation, preferring an 'aggressive, ritual, or allegorical meaning'.
137. 37. W. Krickeberg, 'Die Totonaken', *B.A.*, VII (1918–22), 1–55; IX (1925), 1–75.
38. See the comparisons drawn to uniform scale in Marquina, láms. 276–82.
39. J. García Payón, 'Archaeology of Central Veracruz', *H.M.A.I.*, XI (1971), 527, table 1.
139. 40. J. García Payón, *Exploraciones en el Tajín (Informes I.N.A.H.*, no. 2) (Mexico, 1955); also *A.I.N.A.H.*, v (1952), 75–8.
141. 41. Marquina, 450–2.
42. J. García Payón, 'Arqueología de Zempoala',

Uni-Ver, I (1949), 11–19; 134–9; 449–76; 534–48; 581–95; 636–56.
43. H. Strebel, *Alt-Mexiko*, 2 vols. (Hamburg-Leipzig, 1885–9).
44. P. Agrinier, *The Carved Human Femurs from Tomb 1, Chiapa de Corzo* (Orinda, 1960); E. Shook and A. V. Kidder, *C.A.A.H.*, XI (1952), 117. See Proskouriakoff, *H.M.A.I.*, XI (1971), 559.
45. M. Stirling, *B.B.A.E.*, CXXXVIII (1943), 31–48. The earth platforms of the site were covered with stucco painted red.
46. Proskouriakoff, 172–4.
142. 47. Compare Stela 11, Monte Alban; A. Caso, *Estelas zapotecas* (Mexico, 1928).
48. T. Proskouriakoff, 'Varieties of Classic Central Veracruz Sculpture', *C.A.A.H.*, no. 58 (1954), 63–94. M. E. Kampen, *The Sculptures of El Tajín* (Gainesville, 1972), 83–5, places the Pyramid Sculptures 4–6 and Pyramid Panel 3 as early in a sequence occupying six centuries (A.D. 300–900). T. Proskouriakoff, 'Classic Art', *H.M.A.I.*, XI (1971), 570, regards the entire style as 'terminal classic', and as lacking Toltec traits.
49. Tres Zapotes (Weiant, *B.B.A.E.*, CXXXIX, 1943, plate 7) and Cerro de las Mesas (Drucker, *B.B.A.E.*, CXLI, 1943, plate 58): yoke and *hacha* with Lower II (Late Classic) associations.
143. 50. Illustrated in Proskouriakoff, figure 9g. Cf. M. E. Kampen, *op. cit.*, 24–6.
144. 51. J. García Payón, *A.I.N.A.H.*, II (1947), 73–111. The *palmas* are dated here as of the sixth century, although their wide diffusion into Central America (García Payón, 'Archaeology of Central Veracruz', *H.M.A.I.*, XI, 1971, 505–42) justifies a longer duration.
52. G. Ekholm, *A.A*, XLVIII (1946), 593–606, and *Am.A.*, XV (1949), 1–9. S. J. K. Wilkerson, 'Un yugo in situ de la región del Tajín', *Bol. I.N.A.H.*, XLI (1970), 41–4. The large literature on the ballcourt and the equipment of the players was recently summarized by M. F. Kemrer, Jun., 'A Reexamination of the Ball-game in Mesoamerica', *Cerámica de Cultura Maya et al.*, no. 5 (1968), 1–25, and L. H. Ritman, 'The Rubber Ball-Game', *ibid.*, 27–57.
53. C. W. Weiant, *B.B.A.E.*, CXLI (1943), plate 58.
54. E. J. Palacios, *Los yugos y su simbolismo* (Mexico, 1943), illustrates many yokes which are not relevant to the analysis by T. Proskouriakoff. M. Krutt, 'Un yugo in situ', *I.N.A.H.*, *Boletín*, XXXVI (1969), 16–19, enumerates five burials containing yokes, and refutes the idea that plain stone yokes were marginal imitations of the ornate examples in Veracruz.
145. 55. A stela found at Aparicio in Veracruz shows the elongated *palma* in place upon a player; J. García

Payón, *R.M.E.A.*, x (1948–9), 121–4. The relief may be compared to the figure with seven snakes entwined at the head shown at Chichén Itzá in the ball-court reliefs [254].

146. 56. All the reliefs of the main court are illustrated by M. Kampen, *op. cit.* N. Hellmuth, 'Precolumbian Ballgame', *Progress Reports, Foundation for Latin American Anthropological Research*, I (1975), no. 1, 1–31, finds that Maya ball-game dress and playing rules differ categorically from the Veracruz and Toltec game.

57. The cacao tree relief (M. Kampen, figure 5a) belongs to this heavily outlined style of patterned background.

147. 58. E.g. Type IX figurines, Cerro de las Mesas (Drucker, *B.B.A.E.*, CXLI, 1943, plate 43).

59. H. D. Tuggle, 'The Structure of Tajín World-View', *Anthropos*, LXVII (1972), 435–48; 'The Columns of El Tajín', *Ethnos*, XXXIII (1968), 40–70. See also J. García Payón, 'Ensayo de interpretación', *M.A.*, IX (1959), 445–60, and L. Knauth, 'El juego de pelota', *E.C.M.*, I (1961), 183–99. J. Quirarte, 'El jugo de pelota', *E.C.M.*, 83–96, analyses the design of most known courts. Also S. Borhegyi, *Ballgames* (Milwaukee, 1980). M. Kampen notes the importance of bat, vulture, and rabbit in ball-court iconography ('Classic Veracruz Grotesques', *Man*, XIII, 1978, no. 1, 116–26).

148. 60. H. W. McBride, in *Ancient Art of Vera Cruz*, ed. O. Hammer (Los Angeles, 1971), 23–30.

61. S. C. Belt, *ibid.*, 41.

62. H. Strebel, *op. cit.* The important pre-Classic finds at Remojadas in central Veracruz are still incompletely published. See A. Medellín Zenil, *Cerámicas del Totonacapan* (Xalapa, 1960), 176–84; also A. Medellín Zenil and F. A. Peterson, 'A Smiling Head Complex from Central Veracruz, Mexico', *Am.A.*, XX (1954), no. 2, 162–9.

63. P. Drucker, *B.B.A.E.*, CXLI (1943), 86.

149. 64. V. Rosado Ojeda, 'Las mascaras rientes totonacas', *R.M.E.A.*, V (1941), 53–63. Moulded figurines of Cuicuilco-Ticoman date are reported from Remojadas; F. A. Peterson, *Tlatoani*, I (1952), 63–7. At the Cerros site near Tierra Blanca in Veracruz a heap of rejects was found. Medellín and Peterson, *op. cit.*, 166; A. Medellín Zenil, *Cerámicas del Totonacapan* (Xalapa, 1960), 78–84. García Payón, *H.M.A.I.*, XI (1971), 532, dates the laughing figurines as of 500–800.

65. See M. Torres *et al.*, 'Zapotal', *S.M.A.M.R.*, XIII (1975), vol. 1, 323–30.

66. G. Ekholm, *A.M.N.H.A.P.*, XXXVIII (1944), 499, notes that burnt clay floors can be identified as of the Pánuco period II (pre-Classic) in the Huasteca. El Ebano is discussed by Marquina, 407.

67. W. Du Solier, 'Primer fresco mural huasteca', *C.A.*, V (1946), no. 6, 151–9.

68. H. E. D. Pollock, *Round Structures* (Washington, 1936).

151. 69. H. Beyer, 'Shell Ornament Sets', *M.A.R.S.*, V (1934), 153–215.

70. C. Seler-Sachs, *Auf alten Wegen in Mexiko und Guatemala* (Berlin, 1900).

152. 71. E. Seler, *G.A.*, III, 514–21.

153. 72. H. Spinden, 'Huastec Sculptures and the Cult of the Apotheosis', *Brooklyn Museum Quarterly*, XXIV (1937), 179–88. G. Stresser-Péan, 'Ancient Sources on the Huasteca', *H.M.A.I.*, XI (1971), 582–602.

CHAPTER 5

155. 1. I. Bernal, 'Archaeological Synthesis of Oaxaca', *H.M.A.I.*, III (1965), 788–813. See also A. Caso, *Exploraciones en Oaxaca ... 1934–35* (Mexico, 1935); *idem.* *1936–37* (Instituto panamericano de geografia e historia, Pubs. 17 and 34) (Mexico, 1938). I. Bernal, *Exploraciones en Cuilapan* (Mexico, 1958), 66, supposes that Monte Alban was already in disuse during IIIb, when Cuilapan, at the south foot of Monte Alban, was flourishing.

2. A. Caso, 'El mapa de Teozacualco', *C.A.*, VIII (1949), no. 5, 145–81.

3. John Paddock, *Ancient Oaxaca* (Stanford, 1966), 176–200; *idem*, 'More Ñuiñe Materials', *B.E.O.*, no. 28 (1970). C. Moser (*Ñuiñe Writing*, Nashville, 1977) has made a list of 142 motifs and symbols, and a catalogue of 76 sculptures in stone and pottery. Paddock's thesis is supported by L. Parsons, *Bilbao*, II (Milwaukee, 1969), 171. The supposition that Mitla is Mixtec was strengthened by the discovery of Yagul, a site near Mitla, much like Mitla, and clearly Mixtec by ceramic evidence; *Mesoamerican Notes*, IV (1955), and V (1957). See P. Dark, *B.E.O.*, no. 10 (1958), with supplementary note by John Paddock.

156. 4. The south platform includes re-used materials of Monte Alban I and II (Caso, *Exploraciones* (1938), 5–7).

5. The most recent architectural chronology by R. Blanton (*Monte Alban*, New York, 1978, 107–9) is supported by archaeological and radiocarbon evidence:

500 B.C.	Foundation as a 'disembedded capital'
late I	Main plaza begun 300+ stone
300–200	monuments erected (*Danzantes*)
II	Defensive work on north, north-
before	west, and west edges of plaza; irriga-
A.D. 200	tion canals on east; plaza attained present shape

IIIa, IIIb 200–600	Massive construction in main plaza; all terraces occupied by over 2,000 house groups in fourteen *barrio* clusters. Tombs on north, houses on east slopes. North platform becomes palace; south platform a temple
IV 600–950	No new construction; abandonment
V 950–1500	Population moves to base of hill, leaving summit deserted

Mound J in the south central portion of the plaza belongs by ceramic and sculptural evidence to Monte Alban II (Caso, *Exploraciones* (1938), 11, 62). The peaked vault of slabs leaning upon one another also characterizes the underground tombs of Period II.

157. 6. Caso, *Exploraciones* (1935), 13–15; Marquina, lám. 93 and figure 143. Another two-chambered cella with columns *in antis* is the temple on Mound H, at the centre of the main plaza. Columnar plans characterize the buildings of Monte Negro in the Mixteca, ascribed to the period of Monte Alban I (plan in Marquina, lám. 104).

159. 7. A fragment of another such model is illustrated in Caso, *Exploraciones* (1938), figure 56. More models are illustrated by H. Hartung, 'Notes on the Oaxaca Tablero', *B.E.O.*, no. 27 (1970), 5.

160. 8. If the temple is the dramatic centre of the space, it is permissible to speak of its stairway and terraces as the proscenium to stress the ritual unity of the temple and its staired approach.

9. General discussion in A. Caso, *Las estelas zapotecas* (Mexico, 1928), and 'Sculpture and Mural Painting in Oaxaca', *H.M.A.I.*, III (1965), 849–70. I. Bernal, 'The Ball Players of Dainzú', *Archaeology*, XXI (1968), 246–51. The relief from Tilantongo, showing 'Five Death', is illustrated by P. Kelemen, *Medieval American Art* (New York, 1943), plate 58A.

161. 10. A. Villagra, 'Los Danzantes', *I.C.A.*, XXVII (1939), II, 143–58. J. Scott, 'Danzantes', *D.O.S.*, XIX (1978), defines seventeen stylistic groups, beginning about 200 B.C., continuing until about A.D. 250, and spanning Monte Alban periods I–II in part. Joyce Marcus ('Zapotec Writing', *Scientific American*, 1980, 52–3), like Blanton, interprets these carvings as a now-dispersed museum or archive of conquests formed during Monte Alban I.

11. Cf. A. Caso, *Calendarios y escrituras de las antiguas culturas de Monte Albán* (Mexico, 1947).

163. 12. J. Marcus, *op. cit.*, 56, relates the Bazán slab to other inscriptions at the corners of the south pyramid (*estela lisa*, Stela 1, and Stela 7) as referring to embassies from Teotihuacán, dressed in tasselled headgear (C. Millon, *Am.A.*, XXXVIII, 1973, 294–314). The left figure on the Bazán relief itself is seen as a Teotihuacano, following Caso (*H.M.A.I.*,

III, 1965, 'Sculpture and Mural Painting of Oaxaca', 849–70).

13. A. Caso, I. Bernal, J. R. Acosta, *La cerámica de Monte Alban* (Mexico, 1947). The collections in Berlin, assembled by Eduard Seler, have been catalogued by I. von Schuler-Schömig, *Figurengefässe aus Oaxaca* (Mexico, 1952); S. Linné, *Zapotecan Antiquities* (Stockholm, 1938); J. A. Mason, *Museum Journal*, XX, no. 2 (1929); C. G. Rickards, *J. S.A.*, X (1913), 47–57.

14. E.g. the 'rain-god (Cocijo) complex', a 'maize-god complex', and calendrical deities such as 'Five Flower', 'Thirteen Serpent', 'Eleven Death', or 'Two Tiger'. The same classing appears in F. Boos, *Corpus antiquitatum americanensium*, 2 vols. (Mexico, 1964–6).

15. Emily Rabin, 'The Lambityeco Friezes, Notes on Their Content, with an Appendix on C14 Dates', *B.E.O.*, no. 33 (1970). S. D. Scott, *Am.A.*, XXXIV (1969), 352, gives as 'most probable date' for offerings in the last rebuilding of the pyramid, A.D. 700 ± 95. D. Potter, *Mexikon*, II (1980), no. 1, 8–10, is concerned to define 'decadence' at this site.

167. 16. Tomb 104 being of Period IIIa and Tomb 105 of IIIb? Caso, *H.M.A.I.*, III, 866.

168. 17. By A. Caso's interpretation ('Teozacualco', *C.A.*, XLVII, 1949, no. 5, 145–81) the genealogies began *c.* 692, but recent studies by E. Rabin (in press) make his position untenable (N. Troike, 'Interpretations', *Am.A.*, XLIII, 1978, no. 4, 553–68) by starting the genealogies about three centuries later. (E. Rabin's articles are cited by Troike, p. 567.)

18. A. Caso, *Exploraciones* (1938), 47f.: B. Dahlgren de Jordan, *La Mixteca* (Mexico, 1954), 341. Monte Negro is of Monte Alban I date; Tomb I at Yucuñudahui is of Monte Alban III date.

19. The stucco figures of Tomb I at Zaachila (excavated by R. Gallegos, 'Zaachila', *Archaeology*, XVI, 1963, 229–31) are discussed by A. Caso, 'The Lords of Yanhuitlan', in J. Paddock, ed., *Ancient Oaxaca* (Stanford, 1966), 319–30. Paddock ('Mixtec Ethnohistory', *ibid.*, 377) cites the sixteenth-century *relaciones* on the thirteenth-century arrival of Mixtecs at Zaachila and Cuilapan. I. Bernal ('The Mixtecs in Valley Archaeology', *ibid.*, 365) admits that 'the first Mixtec phase in the Valley – which we might then call Monte Alban Va – may have to be extended back to the middle of the thirteenth century'. Compare R. Chadwick, 'Pre-Aztec History', *H.M.A.I.*, XI, 487–8. A. Caso, *Exploraciones* (1932), 32, first identified the Tomb 7 burial as Mixtec of the fifteenth or early sixteenth century, by parallels with Aztec works of art.

169. 20. A. Caso, *Exploraciones en Mitla, 1934–35* (Mexico, 1936); John Paddock, 'Excavations at

Yagul', *Mesoamerican Notes*, IV (1955), 80–90; 'Relación de Tlacolula y Mitla', *Papeles de la Nueva España*, ed. F. del Paso y Troncoso, IV (Madrid, 1905), 144–54; English version in *Mesoamerican Notes*, IV (1955), 13–24.

21. M. Saville, 'The Cruciform Structures of Mitla and Vicinity', *Putnam Anniversary Volume* (New York, 1909), 151–90.

22. A. Caso and D. F. Rubín de la Borbolla, *Exploraciones en Mitla* (1936), 11–12.

171. 23. *Mesoamerican Notes*, IV (1955), and V (1957). Reviewed by H. B. Nicholson, *Am.A.*, XXIII (1957), 195, warning against the equation of *style* and *ethnic group*. See also I. Bernal and L. Gamio, *Yagul: el palacio de seis patios* (Mexico, 1974).

173. 24. G. B. Gordon, 'Prehistoric Ruins of Copán', *P.M.M.*, I (1896); G. Strómsvik, 'Substela Caches and Stela Foundations at Copán and Quiriguá', *C.A.A.H.*, VII (1942), 63–96.

175. 25. J. P. Oliver has grouped the mosaics by rectilinear and curved elements in archaic, classic, and baroque phases, separated by transitions (*Mesoamerican Notes*, IV, 1955, 57–62). He proposes curved forms as posterior to rectilinear ones. Oliver's types are based upon the listing by N. León, *Lyobaa ò Mictlan* (Mexico, 1901), without much regrouping. If we eliminate obvious repetitions and duplications, the repertory can be simplified as follows (see illustration 128):

Oliver-León		
1–2	tilted *5* key-fret	I
3–6	stepped key-fret (*xicalcoliuhqui*)	II
7–9, 14	key rinceau	III
10	serrated key	IV
11–12	diamond pattern	V
13, 16, 17, 18, 21, 22	spiral fret	VI
	spiral meander	VIa
15, 19	key meander	VII
20	key and diamond	VIII

Key forms are rectilinear; spirals are curved. R. Sharp (*Middle Classic Mesoamerica*, New York, 1978, 158–71) analyses step fret occurrences chronologically, as originating in Monte Alban II (p. 159) on pottery, and serving as a sacred symbol of ruling-class values until its secularization in Late Classic time (*ibid.*, 169).

26. A. Caso, 'El mapa de Teozacualco', *C.A.*, VIII (1949), no. 5, 145–81. Only the place-glyphs for Tilantongo and Teozacualco are known with certainty. About sixty place-names appear in Codex Bodley; seventy-five in Codex Selden.

27. The Dominican chronicler Fray Francisco de Burgoa (*Geográfica descripción* ..., Mexico, 1674) regarded Mitla as a pagan Vatican: the pontiff resided in the Group of the Columns. Burgoa, a native of Oaxaca, recorded colonial folklore rather than pre-Conquest tradition.

28. Seven of these reliefs are illustrated by A. Caso, *Estelas Zapotecas* (Mexico, 1928), figures 80, 81, 82, 83, 84, 93, 94. Caso, 'Sculpture and Mural Painting of Oaxaca', *H.M.A.I.*, III (1965), 857, assigns Zaachila relief no. 1 to period IIIa, and the tomb slab found between Zaachila and Cuilapan to periods IIIb–IV (*ibid.*, 942). J. Marcus calls them Zapotec 'genealogical registers', recorded in boustrophedon order. She describes illustration 129 here as from Noriega, and showing a newborn heir in the middle register.

176. 29. E. Seler, 'The Wall Paintings of Mitla', *B.B.A.E.*, XXVIII (1904), 243–324.

177. 30. W. Lehmann, 'Les Peintures Mixteco-Zapotèques', *J.S.A.*, II (1905), 241–80. The Zapotec, Cuicatec, Mazatec, Chinantec, Mije, and Popoloca variants are not fundamentally distinct. Recent problems in these studies are reported by N. Troike, *I.C.A.*, XLII (1976), vol. VII (1979), 143–6.

31. The term 'codex' signifies the European book, and it consists of pages hinged or sewn at one side. Mexican usage has long confused *codex* with *manuscript*.

32. F. Burgoa, *Palestra historial* (Mexico, 1670).

178. 33. A. Dibble, *Códice Xolotl* (Mexico, 1951). On the Tlailotlacs, see B. Dahlgren de Jordan, *La Mixteca*, 58. R. Parmenter, *I.C.A.*, XLIII (1979), Abstracts A97, takes up this topic from the point of view of Coixtlahuaca. M. Jansen, *ibid.*, A78, adds further evidence relating to the Mixteca-Popoloca in the Valley of Puebla.

34. *C.A.*, VIII (1949), no. 5, 165 ff. Other dynastic lists are known: Teozacualco, Coixtlahuaca, and another (Codex Selden, Oxford) for an unidentified place represented by the sign of a spitting mountain. These lists display divisions and durations similar to those of Tilantongo. Cf. B. Dahlgren de Jordan, *La Mixteca*, chapter V, and P. Dark, *Mixtec Ethnohistory* (Oxford, 1958). A. Caso, in *Ancient Oaxaca*, ed. J. Paddock (Stanford, 1966), 313–35, gives genealogies for Yanhuitlán and probably for Cuilapan. E. Rabin's studies cast doubt on Caso's early generations, in suggesting that the reconstruction was possibly three centuries too long: E. Rabin, 'Some Problems of Chronology, I', *I.C.A.*, XLI (1974); II (1976).

35. J. Furst, *Codex Vindobonensis I* (Albany, 1978).

179. 36. A. Caso, 'Base para la sincronología Mixteca y cristiana', *Memoria de el Colegio Nacional*, VI (1951), 49–66, calls it 'spitting-mountain'.

37. *Lienzo de Zacatepeque*, ed. A. Peñafiel (Mexico, 1900); C. G. Rickards, 'Notes on the "Codex Rickards" ', *J.S.A.*, X (1913), 47–57.

181. 38. J. Cooper Clark, *The Story of Eight Deer* (London, 1912). S. Garza, *Códices genealógicos* (Mexico, 1978), analyses architectural imagery in great detail and with knowledge of current archaeological work.

39. Facsimile reproductions: Colombino in A. Chavero, *Antigüedades mexicanas* (Mexico, 1892); A. Caso and M. E. Smith, *Códice Colombino* (Mexico, 1966); Becker in H. de Saussure, *Le manuscrit du cacique* (Geneva, 1892); K. A. Nowotny, *Codices Becker I/II* (Graz, 1961). On Mixtec manuscripts in general, see M. E. Smith, *Picture Writing from Ancient Southern Mexico: Mixtec Place Signs and Maps* (Norman, 1973).

40. E. Seler, 'Der Codex Borgia und die verwandten aztekischen Bilderschriften', *G.A.*, I, 133–44; W. Lehmann, *J.S.A.*, II (1905), 251. Seler's study enumerates the parallel passages. See K. A. Nowotny, *Tlacuilolli: Die mexikanischen Bilderhandschriften, Stil und Inhalt, mit einem Katalog der Codex-Borgia-Gruppe* (Berlin, 1961); also B. Spranz, *Göttergestalten in den mexikanischen Bilderhandschriften der Codex Borgia-Gruppe* (Wiesbaden, 1964).

41. A deerhide sheet in Paris (Bibl. Nat. MS. Mex. n. 20, repr. in E. Boban, *Manuscrits mexicains*, Paris, 1891, plate 21) shows the nexus between the Borgia group and the Mixtec genealogies.

42. G. Vaillant connected Oaxaca and southern Puebla as one archaeological province with the conception of a 'Mixteca-Puebla' area; *Aztecs of Mexico* (Harmondsworth, 1950), 41–2. His estimate of its importance is best set forth in 'Patterns of Middle American Archaeology', *The Maya and their Neighbors* (New York, 1940), 295–305.

43. E. Seler, *Codex Féjérváry-Mayer* (Berlin-London, 1902), 210.

44. The twenty weeks of thirteen days appear in Borgia, Vaticanus B, Borbonicus, the Aubin *tonalamatl*, Vaticanus A, and Telleriano-Remensis, sufficiently alike to come all from a common source.

45. The earliest if inexact facsimiles are those gathered by Lord Kingsborough in *Antiquities of Mexico* (London, 1831). Féjérváry-Mayer, Borgia, Cospi, Vaticanus B, Laud, Bodley, Selden, Vienna, Zouche-Nuttall, and Colombino-Becker have all been reproduced in more or less modern facsimiles, the first four at the expense of the Duc de Loubat in exact colour photography; the Vienna manuscript likewise (by W. Lehmann and O. Smital, in 1929). The Zouche-Nuttall and Colombino-Becker manuscripts exist in tracings reproduced lithographically in colour: *Codex Nuttall* (Cambridge, Mass., 1902); H. de Saussure, *Le manuscrit du cacique* (Geneva, 1892), and A. Chavero, *Antigüedades mexicanas* (Mexico, 1892) (vol. of plates). See J. Glass, *Catálogo de los códices*

(Mexico, 1964), and J. B. Nicholson, 'The Mesoamerican Pictorial Manuscripts', *I.C.A.*, XXXIV (1962), 199–215, as well as the list of coloured facsimiles published by the Akademische Druck und Verlagsanstalt in Graz as the series called *Codices selecti* (Handschriften fremder Kulturen).

183. 46. J. Soustelle, *La pensée cosmologique des anciens Mexicains* (Paris, 1940), 57. B. Spranz, *Göttergestalten* (Wiesbaden, 1964), has analysed the costumes of the deities, showing that fixed identities are less evident than changing assemblages of attributes.

47. E. Seler, 'Venus Period in the Picture Writings of the Borgian Codex Group', *B.B.A.E.*, XXVIII (1904), 355–91.

184. 48. Ñuiñe style: *Ancient Oaxaca*, ed. J. Paddock (Stanford, 1966), 175–200. Yagul: C. C. Meigs, *Mesoamerican Notes*, IV (1955), 72–9.

49. E. Noguera, *El Horizonte Tolteca-Chichimeca* (Mexico, 1950); S. K. Lothrop, *The Pottery of Costa Rica and Nicaragua* (New York, 1926); G. Ekholm, 'Excavations at Guasave, Sinoloa', *A.M.N.H.A.P.*, XXXVIII (1942).

50. I. Bernal, 'Excavaciones en Coixtlahuaca', *R.M.E.A.*, X (1949), 5–76.

51. E. Noguera, *La cerámica arqueológica de Cholula* (Mexico, 1954), 120–42.

185. 52. A. Caso, *Exploraciones* (1932), and *Natural History*, XXXV (1932), no. 5, discusses the contents of Tomb 7 at Monte Alban. See also M. H. Saville, *The Wood-carver's Art in Ancient Mexico* (New York, 1925); *Turquoise Mosaic Art in Ancient Mexico* (New York, 1922); and *The Goldsmith's Art in Ancient Mexico* (New York, 1920).

53. Turquoise chips appeared in the early village site of El Arbolillo in the Valley of Mexico, probably imported from the north. Vaillant, *A.M.N.H.A.P.*, XXXV (1935), 245.

54. E. Morris, J. Charlot, and A. Morris, *Temple of the Warriors*, I (Washington, 1931), 189 f.

55. M. Saville, *Turquoise Mosaic*, plates V, VI, VII, VIII, XIX, XXI are Toltec; the Mixtec cave finds are discussed on pp. 47 and 63.

56. E. Seler, 'Über szenische Darstellungen auf altmexikanischen Mosaiken', *G.A.*, IV, 362–83.

57. D. Pendergast, 'Tumbaga at Altun Ha', *Science*, CLXVIII (1970), no. 3927, 116–18; S. K. Lothrop, 'Metals from the Cenote of Sacrifice', *P.M.M.*, X (1952), 22–6.

186. 58. A. Caso, *El tesoro de Monte Albán* (Mexico, 1969). On Zaachila, see Note 19.

59. S. K. Lothrop, 'Archaeology of Southern Veraguas, Panama', *P.M.M.*, IX (1950).

CHAPTER 6

189. 1. On a shifting boundary between western Mexico and Mesoamerica (1200–900 B.C.), see P. Tolstoy and I. Paradis, *U.C.A.R.F.*, XI (1971), 25–6. Also C. T. E. Gay, *Xochipala, the Beginnings of Olmec Art* (Princeton, 1972), and G. Griffin, 'Xochipala, the Earliest Great Art Style in Mexico', *Proceedings, American Philosophical Society*, CXVI (1972), 301–9. For all periods see B. Bell (ed.), *Archaeology of West Mexico* (Ajijic, 1974). See also P. Schmidt on Maya vaults, Fine Orange pottery, and stelae in Guerrero ('Maya en Guerrero', *Anales de Antropología*, XIV, 1977, 63–73) after A.D. 750.

2. M. Covarrubias, *Mezcala, Ancient Mexican Sculpture* (New York, 1956); also 'Tipología de la industria de piedra tallada y pulida de la Cuenca del Río Mezcala', *El occidente de México* (*S.M.A.M.R.*, IV) (Mexico, 1948), 86–90; and *Indian Art of Mexico and Central America* (New York, 1957), 104–14. The material is classified and provisionally dated by C. Gay, *Mezcala Stone Sculpture; the Human Figure* (New York, 1967).

190. 3. M. Covarrubias has discussed the class as 'puramente local', without great antiquity, and as derivative from the Olmec axes; *El occidente de México* (*S.M.A.M.R.*, IV), 88.

191. 4. Guerrero sculpture is also illustrated by G. Médioni and M. T. Pinto, *Art in Ancient Mexico* (New York, 1941), figures 4–32, and G. Kubler, *The Arensberg Collection* (Philadelphia, 1954). See R. H. Lister, 'Archaeological Synthesis of Guerrero', *H.M.A.I.*, XI (1971), 619–31.

5. In western Guerrero, at Placeres de Oro (now called Vistahermosa), slabs with feline figures in incised relief distantly resembling the Chavín style were reported by H. J. Spinden (*A.A.*, XIII, 1911, 29–55). I. Kelly has related the site to middle period finds at Apatzingan (*El occidente de México*, *S.M.A.M.R.*, IV, table opposite p. 76).

6. I. Kelly, in *S.M.A.M.R.*, IV (1948) (North Mexico), 55. Also *S.MA.M.R.*, III (West Mexico), 1943. Also *Research Reports for 1969*, Nat. Geo. Soc. (1978), 307–11: Capacha pottery from Colima is the earliest phase, including stirrup-spouted vessels dated 1450 B.C. by C14, and resembling Opeño finds in Michoacán of the same age, as well as Valdivia (Ecuador) and Tlatilco (Valley of Mexico). In 'Seven Colima Tombs', *U.C.A.R.F.*, XXXVI (1978), 1–7, Kelly shows that tombs were re-used for further deposits during a period spanning Late Pre-Classic to Middle Classic (Ortices, Comala, Colima phases).

7. J. Corona Núñez, 'Tumba de el Arenal, Etzatlán, Jal.', *Informes I.N.A.H.*, III (Mexico, 1955). For Nayarit, see J. Corona Núñez, 'Diferentes tipos de tumbas prehispánicas in Nayarit', *Yan*, III (1954), 46–50; B. Bell, 'Archaeology of Nayarit, Jalisco and Colima', *H.M.A.I.*, XI (1971), 694–753.

8. H. D. Disselhoff excavated several intact tombs at sites south-east of the town of Colima, finding associated lots of figurines with coffee-bean eyes and slab figurines, as well as slit-eye figures in other tombs; *Revista del Instituto de Etnología de la Universidad Nacional de Tucumán*, II (1932), 525–37. The Ortices phase equates in Colima by C14 with 160 B.C.; I. Kelly, *Research Reports for 1969*, Nat. Geo. Soc. (1978), 307–11.

192. 9. Without advancing a chronology, P. Kirchhoff, *Arte precolombino del occidente de México* (Mexico, 1946), set forth a classification by costume, distinguishing nude, breech-clout, and painted-garment folk, whom he provisionally identified with distinct ethnic groups in western Mexico.

10. H. von Winning and O. Hammer, *Anecdotal Sculpture of Ancient West Mexico* (Los Angeles, 1972); H. von Winning, *Shaft Tomb Figures* (Los Angeles, 1974); C. Meighan and others, 'Amapa, Nayarit', *Monumenta archaeologica*, II (Los Angeles, 1976).

11. M. Kan, C. W. Meighan, and H. B. Nicholson, *Sculpture of Ancient West Mexico* (Los Angeles, 1970).

193. 12. This grouping of 'early' and 'late' is based upon the figure of a mother and child in the Diego Rivera Collection (*Arte precolombino*, 51). The two styles appear together: the mother is of 'late' Ameca workmanship, and the suckling infant shows the retention of 'earlier', less articulated habits of modelling. It can of course be argued from this evidence that both manners are coeval. The linking of both types as of Ameca Valley origin remains valid.

13. H. von Winning, 'Keramische Hausmodelle aus Nayarit', *B.A.*, XIX (1971), no. 2, 343–77. On Nayarit ballgame-court models, E. Taladoire, 'Ball-Game Scenes in West Mexico', *Indiana*, V (1978), 33–43, is unaware of H. von Winning's book on shaft-tomb figures (1974) and their dating before A.D. 550.

194. 14. E. W. Gifford, 'Surface Archaeology of Ixtlán del Río, Nayarit', *U.C.P.A.A.E.*, XLIII (1950), 183–302. All three of our types, and others, are represented in collections from the area about Ixtlán. On 'Chinesca' figures see B. Bell, *op. cit.*, *H.M.A.I.*, XI (1971), 717–19. Pole-scenes: H. von Winning, *Anecdotal Sculpture* (1972), 23–4.

15. In *Arte precolombino*, 31.

195. 16. J. Corona Núñez, 'Relaciones arqueológicas entre las Huastecas y las regiones al Poniete', *R.M.E.A.*, XIII (1952–3), 479–83, ascribes the differences of the Nayarit style to Huasteca origins, and he regards Nayarit as the centre of diffusion to Jalisco and Colima. A circular platform at Ixtlán has been

rebuilt with profiles like those of Tajín (*op. cit.*, figures 66–70); it would correspond to the period of the large tomb figures with fully modelled eyes.

17. Only by analogy with central Mexican religion, as reported by Motolinia in the sixteenth century. S. Toscano, in *Arte precolombino*, 24.

18. P. Furst, 'West Mexican Tomb Sculpture as Evidence for Shamanism in prehispanic Mesoamerica', *Antropológica*, xv (1965), 29–81; 'West Mexican Art: Secular or Sacred?', in *Iconography of Middle American Sculpture* (New York, 1973), 98–133. Cf. G. Kubler, 'Evidencia intrínseca', *S.M.A.M.R.*, xiii (1972).

196. 19. R. Chadwick, 'Archaeological Synthesis of Michoacan', *H.M.A.I.*, xi (1971), 657–93; E. Noguera, 'Exploraciones en El Opeño, Michoacán', *I.C.A.*, xxvii (1943), 574–86; M. N. Porter, 'Excavations at Chupícuaro', *Transactions of the American Philosophical Society*, xlvi (1956), part 5, 515–637.

20. E. Noguera, 'Exploraciones en Jiquilpan', *Anales del museo michoacano*, iii (1944), 37–52. The parallel platforms, identified by Noguera as a ballcourt, are about 30 yards apart, much too wide for the ascribed purpose. The name of the site itself is El Opeño, west of the city of Jiquilpan.

197. 21. M. Covarrubias, *Indian Art of Mexico and Central America*, 95, charts the occurrences of the inlaid-paint technique from Arizona to Peru. Detailed discussion of west Mexican examples in G. Ekholm, *A.M.N.H.A.P.*, xxxviii (1942), 91–6. Ekholm regarded Teotihuacán 'frescoed' pottery as an imitation of western lacquer (p. 95) rather than as deteriorated lacquer (as Covarrubias suggests).

22. D. Rubín de la Borbolla, 'Arqueología tarasca', *Occidente de México S.M.A.M.R.*, iv (1948), 30–5; W. Jimenez Moreno, *ibid.*, 146–57. H. P. Pollard, 'Prehispanic Tzintzuntzan', *Proceedings, American Philosophical Society*, cxxi (1977), no. 1, 46–69, presents the city as an administrative centre.

23. The *Relación de Michoacán* (1541), ed. Tudela (Madrid, 1956), is the most important historical source, richly illustrated with drawings of the period. **198.** 24. D. Rubín de la Borbolla, 'La orfebrería tarasca', *C.A.*, iii (1944), no. 3.

25. G. Ekholm, 'Excavations at Guasave', *A.M.N.H.A.P.*, xxxviii (1942). The term 'Aztatlán' originally meant post-Classic, red-on-buff pottery on the west coast of Mexico. I. Kelly, *Ibero-Americana*, xiv (1938), 19. 'Aztatlán' now refers to a pre-Aztec and post-Classic archaeological period in Culiacán and Sinaloa. See also H. von Winning, 'Escenas rituales de Nayarit', *I.C.A.*, xli (1976), vol. ii, 387–400: Cholula-style polychrome pottery, with ritual scenes resembling Codex Borgia, from Amapa-

Peñitas in Nayarit (twelfth-thirteenth centuries). 26. I. Kelly, *Ibero-Americana*, xxv (1945). J. C. Kelley and H. D. Winters ('A Revision of the Archaeological Sequence in Sinaloa', *Am.A.*, xxv, 1960, 547–61) have expanded this span with phase names, spreading from A.D.250 (Chametla horizon) to Guasave phase, *c.* 1150–1350. Cf. C. W. Meighan, 'Archaeology of Sinaloa', *H.M.A.I.*, xii (1971), 754–67.

27. J. M. Reyes, 'Breve reseña …', *Boletín de la Sociedad de Geografía y Estadística*, v (1881), 385 ff. **200.** 28. P. Armillas, 'Fortalezas mexicanas', *C.A.*, vii (1948), no. 41, 143–63.

29. E. Noguera, *Ruinas arqueológicas del norte de México* (Mexico, 1930); E. Guillemin Tarayre, *Exploration minéralogique des régions mexicaines* (Paris, 1869); M. Gamio, *Los monumentos arqueológicos de las immediaciones de Chalchihuites* (Zacatecas, 1910); A. Hrdlička, 'The Region of the Ancient Chichimecs', *A.A.*, v (1903), 384–440.

30. J. C. Kelley, 'Archaeology of the Northern Frontier', *H.M.A.I.*, xi (1971), 776. Unpublished radiocarbon dates for La Quemada show a tenth-century concentration.

CHAPTER 7

201. 1. S. G. Morley, *Inscriptions of Peten*, iv (1938), 313. Epigraphers refer to part of the Classic era of Maya history as the 'Initial Series period'.

2. Only some Classic Maya sites display all the diagnostic traits. At Holmul in the Petén only the vaulted architecture survives; at Pusilhá we have only the stelae and glyphs; at El Paraiso there are only stelae.

3. R. L. Roys, 'The Engineering Knowledge of the Maya', *C.A.A.*, ii (1934), 27–105; H. Hohmann, 'Gewölbekonstruktionen', *Mexikon*, i (1979), no. 3, 33–6.

4. A. L. Smith, 'The Corbelled Arch in the New World', *The Maya and their Neighbors* (New York, 1940), 202–21.

203. 5. R. Wauchope, *Modern Maya Houses* (Washington, 1938), and 'House Mounds of Uaxactun', *C.A.A.*, ii (1934), 107–71.

6. J. E. S. Thompson, *Maya Hieroglyphic Writing* (Washington, 1950); also T. S. Barthel, 'Die gegenwärtige Situation in der Erforschung der Maya-Schrift', *J.S.A.*, xlv (1956), 219–27. D. Kelley, *Deciphering the Maya Script* (Austin, 1976), and H. Berlin, *Signos y significados en las inscripciones mayas* (Guatemala, 1977), are reference works for advanced students, as well as for beginners.

7. In addition to J. E. S. Thompson's *Commentary on the Dresden Codex* (Philadelphia, 1972), the most convenient edition of the Madrid, Paris, and Dresden

manuscripts is by C. and J. A. Villacorta, *Los códices Mayas* (Guatemala, 1930). The inscriptions are best studied in S. G. Morley, *The Inscriptions of Peten*, 5 vols. (Washington, 1937–8). A complete corpus of the inscriptions is planned by Ian Graham at Peabody Museum in Cambridge, Mass., as Director of the Maya Hieroglyptic Inscription Study. See *The Art of Maya Hieroglyphic Writing* (New York, 1971).

8. The main publications expounding the historical approach are the following: H. Berlin, 'El glifo "emblema" en las inscripciones Mayas', *J.S.A.*, XLVII (1958), 111–19; T. Proskouriakoff, 'Historical Implications of a Pattern of Dates at Piedras Negras', *Am.A.*, XXV (1960), 454–75; 'Historical Data in the Inscriptions of Yaxchilan', *E.C.M.*, III (1963), 149–67, and IV (1964), 177–202; D. H. Kelley, 'Glyphic Evidence for a Dynastic Sequence at Quirigua', *Am.A.*, XXVII (1962), 323–35; T. Barthel, 'Historisches in den klassichen Mayainschriften', *Zeitschrift für Ethnologie*, XCIII (1968), 119–56; G. Kubler, *Studies in Classic Maya Iconography* (New Haven, 1969). D. Dütting, 'Great Goddess', *Z.E.*, CI (1976), 41–146, interprets the dynastic evidence differently, as relating to a divine couple (female deity and consort) who establish royal lineages. See also J. Marcus, *Emblem and State* (Washington, 1976).

205. 9. The best account of Maya hieroglyphs and calendar mechanisms, written for beginners, is still that by S. G. Morley, 'An Introduction to the Study of the Maya Hieroglyphs', *B.B.A.E.*, LVII (1915). J. E. S. Thompson's *Maya Hieroglyphs Without Tears* (London, 1972) should be used to supplement Morley, but Thompson's primer is mainly concerned with rules of decipherment and exercises. It omits discussion of the historical content of the inscriptions. See Note 3 to Chapter 8. Also E. Benson (ed.), *Mesoamerican Writing Systems* (Washington, 1973).

260 days are the interval between zenith passages of the sun in the latitude of Copán and Izapa (V. H. Malmstrom, 'Origin', *Science*, CLXXXI, 1973, no. 4103, 939–41).

10. H. J. Spinden, *Ancient Civilizations of Mexico and Central America*, first published in New York in 1917. The scheme persisted as late as S. G. Morley's *Ancient Maya* (Stanford University, 1947).

11. Described in detail by S. G. Morley, *The Ancient Maya*, 141–8.

12. Basic is the introduction to O. G. and E. B. Ricketson, *Uaxactun, Guatemala. Group E. 1926–1931* (Washington, 1937). See P. Harrison, 'Rise of the *bajos*', *Social Process* (London, 1977), 469–508, for an enriched and confirming reinterpretation of the Ricketson argument. J. Marcus, 'Territorial Organization of the Lowland Classic Maya',

Science, CLXXX (1973), 911–16, finds references to four political centres in the inscriptions, shifting through time, and organized in five tiers within each state.

13. A. V. Kidder, *N.M.A.A.E.*, III (1946–8), 128. On survivals in the vacant towns and concourse centres of modern Guatemala, see Sol Tax, *A.A.*, XXXIX (1937). On the agricultural necessity for the division of ritual and dwelling centres, R. Linton, 'Crops, Soils, and Cultures in America', *The Maya and their Neighbors* (New York, 1940), 39–40. On Maya domestic buildings of Classic date, R. Wauchope, 'House Mounds of Uaxactun', *C.A.A.*, II (1934), 107–71. On parallels with the Khmer cities of the Angkor period (A.D. 802–1431), M. D. Coe, *Am.A.*, XXII (1957), 409–10.

14. Estimate based upon the house mound count at Uaxactún. Ricketson and Ricketson, *Uaxactun*, 15, 23. Total Maya population in the Classic era is estimated upon these samples as between eight and thirteen million.

206. 15. C. W. Cooke, 'Why the Mayan Cities of the Peten District, Guatemala, were abandoned', *Journal of the Washington Academy of Sciences*, XXI (1931), 283–7. U. Cowgill and G. E. Hutchinson, *I.C.A.*, XXXV (1964), vol. 1, 603–13, find that the *bajo* east of Tikal was never a lake. See also T. P. Culbert (ed.), *The Classic Maya Collapse* (Albuquerque, 1973).

16. Epigraphic: S. G. Morley, *Inscriptions of the Peten*, table IV, 358–79; R. L. Roys, 'The Maya Katun Prophecies of the Books of Chilam Balam', *C.A.A.H.*, XII (1954), no. 57; ceramic: R. E. Smith, *Ceramic Sequence at Uaxactun* (New Orleans, 1955).

17. Radiocarbon: W. F. Libby, *Radiocarbon Dating* (Chicago, 1955), L. Satterthwaite, *Am.A.*, XXI (1956), 416, and E. K. Ralph, *Am.A.*, XXVI (1960), 165–84. S. G. Morley, 'The Correlation of Maya and Christian Chronology', *American Journal of Archaeology*, XIV (1910), 193–204, and H. J. Spinden, 'The Reduction of Maya Dates', *P.M.P.*, VI (1924), no. 4. For other correlations, J. E. S. Thompson, *C.A.A.*, III (1935), no. 14.

On Carbon 14 fluctuations, C. Renfrew, 'Carbon 14 and the Prehistory of Europe', *Scientific American*, CCXXV (71), 63–72.

On recent correlations, L. Satterthwaite, 'An Appraisal of a New Maya-Christian Correlation', *E.C.M.*, II (1962), 251–75.

On continuing archaeological support for the Spinden correlation, see E. W. Andrews IV, 'Progress Report', *M.A.R.P.*, XXXI (1965). On 'Andrews' Dilemma', see Kubler, 'Mythological Dates at Palenque and the Ring Numbers in the Dresden Codex', *M.R.P.*, III (1976), 225–30.

18. M. P. Closs, 'New Information', *Am.A.*, XLI

(1976), no. 2, 192–5. Ponce de León's discovery of Yucatán on 8 July 1513 is recorded in the Book of Chilam Balam as occurring in Tun 13 of Katun Lahan. The Morley–Spinden correlation fails, but the Goodman–Martínez–Thompson passes this test.

207. 19. Full publication of the recent excavations at Mayapán in *Current Reports* (Carnegie Institution of Washington, Division of Historical Research). E. W. Andrews ('Archaeology and Prehistory in the Northern Maya Lowlands', *H.M.A.I.*, II, 1965, 289 and 318–19) retains the Spinden correlation as a viable possibility, and rejects the term 'Classic', preferring to articulate the periods in his area as *Formative* until the first century B.C.; *Early* (first A.D.–650 'Spinden'/900 'Thompson'); *Flores-cent* (650/900–1200); and *Decadent* (A.D. 1200–1450). His refusal of 'Classic' denies this confusion of geography with history, and of outside influences with local developments in the northern lowlands. His retention of the Spinden correlation revives an old idea of different starting-points for the northern and southern day counts.

20. Petén is a Maya term used for a lake or island interchangeably, and in general it means 'any geographical body surrounded by a different body'. G. Lowe, 'Civilizational Consequences of Varying Degrees of Agricultural and Ceramic Dependence within the Basic Ecosystems of Mesoamerica', *U.C.A.R.F.*, XI (1971), 212–48, discusses the principal environmental conditions (riverine and tropical forest) in the Maya lowlands. N. Hammond, 'Distribution', *Mesoamerican Archaeology* (Austin, 1974), 313–34, discusses central place theory, Thiessen polygons, nearest-neighbour contouring, and economic matrices in explanation of the rise of Maya culture.

21. J. E. Thompson, H. E. D. Pollock, and J. Charlot, *A Preliminary Study of the Ruins of Cobá* (Washington, 1932), 198; A. Barrera, 'Cobá', *I.N.A.H., Boletín*, II (1976), no. 16, 9–14.

22. W. Coe, *Tikal: A Handbook of the Ancient Maya Ruins* (Philadelphia, 1967). Peculiar to Tikal, and newly discovered at Yaxhá by N. Hellmuth, are the assemblages called 'twin pyramid complexes', erected every twenty years, and consisting of 'a court with a single stela and altar set in an enclosure on the north side, facing a vaulted building directly opposite on the south side. Identical pyramids are on the east and west sides. These are flat-topped and have a stairway on each of their four sides'. Further details in *Tikal Reports*, nos. 1–4 (1958), 9–10. The later survey of Tikal (*Tikal Reports*, no. 11, 1961) contains accurate maps.

209. 23. On radial-stair platforms: O. G. and E. Ricketson, *Uaxactun, Group E* (Washington, 1937).

Another example in central Yucatán is La Muñeca, Structure XIII; K. Ruppert and J. H. Denison, Jr, *Archaeological Reconnaissance in Campeche, Quintana Roo, and Peten* (Washington, 1943). See also Acanceh, in Marquina, 800–5. On twin-pyramid complexes: C. Jones, 'The Twin Pyramid Group Pattern', doctoral thesis MS., University of Pennsylvania, 1969. N. Hellmuth, 'Yaxhá', *Katunob*, VII (1972), no. 4, 23–49; 92–7.

210. 24. Gnomon groups are listed by Morley, *Inscriptions of Peten*, III (1938), 107. Also O. G. and E. Ricketson, *op. cit.*, 107; K. Ruppert and J. H. Denison, Jr. *op. cit.*, 5–6; G. Kubler, 'The Design of Space in Maya Architecture', *Miscellanea Paul Rivet*, I (Mexico, 1958), 515–31. H. Hartung, *Zeremonialzentren der Maya* (Graz, 1971), describes recurrent principles of grouping in the main sites. G. Guillemin, 'Tikal Ceremonial Center', *Ethnos*, XXXIII (1968), 5–39, discusses directional aspects of Maya plans. W. Rathje, 'Classic Maya E-Group Complex', *I.C.A.*, XL (1976), vol. IV, 223–35, argues that these groupings are restricted to the Petén and neighbouring sites of his 'core area', and served 'long-distance trading activities' based in that region.

25. A. M. Tozzer, 'Nakum', *P.M.M.*, V (1913), no. 3.

26. T. Maler, 'Tikal', *P.M.M.*, V (1911), no. 1, 3–135.

27. T. Proskouriakoff, *An Album of Maya Architecture* (Washington, 1946), plates 28–36.

212. 28. S. G. Morley, *Inscriptions of Peten*, IV, 4. Markers at Cancuen, Lubaantun, Chinkultic, Laguna Perdida. F. Blom, *M.A.R.S.*, IV (1932), 487, analyses texts and typology. For Tikal, E. M. Shook, *University Museum Bulletin*, XXI (1957), 37–52. A ball-court at Calakmul may also be added to the Petén family. M. Cohodas, 'Architectural Styles and the Ball Game Cult', *Middle Classic Mesoamerica* (New York, 1978), 105–6, presents his thesis that Puuc and Chichén Toltec were coeval styles (following Parsons, *Bilbao*, II, 179) from 600 to 900 in relation to ballcourts (see Note 5 to Chapter 9). Parsons assumes that the traces of an early structure under the Nunnery (Bolles, *Monjas*, Norman, 1979, 44) must be of Toltec style.

29. R. L. Roys, *op. cit.* (Note 3); H. E. D. Pollock, 'Architecutre of the Maya Lowlands', *H.M.A.I.*, II (1965), 378–440.

214. 30. G. Kramer, *Maya Research*, II (1935), 106–18. G. Griffin, 'Cresterías of Palenque', *M.R.P.*, IV (1979), 139–46, examines the iconography of the roof-combs in relation to other parts of Mesoamerica.

215. 31. Copán: F. Robiczek (Note 32).

Quiriguá: S. G. Morley (Note 34).

Altar de Sacrificios: G. Willey, *P.M.P.*,

LXIV (1973), no. 3.
Seibal: G. Willey, 'Excavations', *P.M.M.*,
XIII (1975), nos. 1, 2.
Yaxchilán: R. Garcia Moll, *Bol. I.N.A.H.*,
XII (1975), no. 2, 3–12.
Piedras Negras: L. Satterthwaite (Note 35).
Palenque: A. Ruz Lhuillier, *M.R.P.*
(1973).
Comalcalco: see Note 43.

217. 32. G. Stromsvik, *Copan* (Washington, 1947).
Copán has always been more easily accessible than any
other Classic Maya site. Accounts of its architecture
may be found in J. L. Stephens, *Incidents of Travel in
Central America* (New York, 1841); A. P. Maudslay,
Biologia Centrali-Americana (London, 1889-1902);
J. M. Longyear III, 'A Historical Interpretation of
Copan Archaeology', *I.C.A.*, XXIX (1951), 86–92.
219. 33. A. S. Trik, 'Structure XXII, Copan',
C.A.A.H., VI (1939), 87–106; G. B. Gordon, 'The
Hieroglyphic Stairway', *P.M.M.*, I (1902); F. Robic-
sek, *Copan* (New York, 1972), plate 147.

34. S. G. Morley, *Guide Book to the Ruins of Quiri-
gua* (Washington, 1935).

35. L. Satterthwaite, *Piedras Negras*, part V (1952),
25, questions Morley's identification as sweat-baths.

36. The best early accounts are by W. H. Holmes,
*Archaeological Studies among the Ancient Cities of
Mexico*, II (Chicago, 1897), and A. P. Maudslay,
Biologia Centrali-Americana, text volume IV. There
is an account of Palenque chronology by R. L. Rands,
'A Chronological Framework for Palenque', *M.R.P.*,
I (1974), 35–8. The pottery sequence is limited
between A.D. 300 and 800, confirmed by the
epigraphic period of dated sculptural production and
vice versa.

Five volumes of *M.R.P.* are concentrated on Palen-
que and contain the main studies by North American
and European specialists since 1974. As necropolis: A.
Miller, 'West and East in Maya Thought: Death and
Rebirth at Palenque and Tulum', *M.R.P.*, II
(1974), 45–9. As port of trade: A. Chapman, 'Port of
Trade Enclaves', in K. Polanyi *et al.* (eds.), *Trade and
Market in the Early Empires* (Glencoe, 1957), 135–41.
See also B. de la Fuente, *La escultura de Palenque*
(Mexico, 1965).

37. A. Ruz Lhuillier, 'Exploraciones en Palenque:
1951', *A.I.N.A.H.*, V (1951), 65 f., and 'Presencia
atlántica en Palenque', *R.M.E.A.*, XIII (1952–3),
455–62. On excavations 1967–73, J. Acosta, in *Social
Process* (London, 1977), 265–85.

38. H. Berlin, *The Tablet of the 96 Glyphs* (New
Orleans, 1968), 145, holds that 'any great temple
building activity ceased at Palenque around 9.13.0.0.0
[A.D. 692], and architecture became less solid ...'.
L. Schele, 'Observations', *M.R.P.*, I (1974), 41–61,

uses the iconography to relate buildings dynastically.
The Temple of Inscriptions commemorates Sun
Shield (Pacal), and the Tablets of the Temples of the
Cross, Foliated Cross, and Sun record the accession
of the next ruler, Snake Jaguar (Chan Bahlum). These
names of rulers are known only by approximation
from their name-glyphs. Modern ethnic patriotism is
reflected in the use of translations into Chol Maya,
although Pacal is not a Chol equivalent of shield. D.
Dütting, 'Birth, Inauguration and Death', *M.R.P.*,
IV (1979), 210, suggests that 'sacred language' was
'closer related to Yucatec and the Quichéan languages
than to the Cholan language group'.

The known ruler list of thirteen names appears in
Robertson, Scandizzo, and Scandizzo, 'Ruling
Lineage', *M.R.P.*, III (1976), 83. L. Schele, 'The
Figure Panels', *M.R.P.*, IV (1979), 58–61, adds
another (Xoc), and still more names may be expected
as genealogical study proceeds.
221. 39. A. Ruz Lhuillier, 'Exploraciones',
A.I.N.A.H., IV (1949–50), 49–60. M. D. Coe, 'The
Funerary Temple among the Classic Maya', *South-
western Journal of Archaeology*, XII (1956), 387–94,
has proposed the Palace as used more for ceremonies
than for residence.

40. A. Ruz Lhuillier, 'Exploraciones en Palenque:
1950', *A.I.N.A.H.*, V (1951), 25–46. J. Carlson has
carefully measured the possible astronomical align-
ments at Palenque, finding no 'explicit or convincing
indication of deliberate sighting lines', but urging
further exploration ('Astronomical Investigations',
M.R.P., III, 1976, 115).

H. Hartung, 'Espacio exterior', *M.R.P.*, III
(1976), 123–35, analyses open-volume composition at
Palenque in detail. A. Aveni and H. Hartung ('Ar-
rangement of Buildings', *M.R.P.*, IV, 1979, 176)
determined that Temple XIV and the Temple of the
Sun both face winter solstice sunrise.
223. 41. A. Ruz Lhuillier, 'Estudio de la cripta del
templo de las inscripciones en Palenque', *Tlatoani*, I
(1952), nos 5–6, 2–28; *El Templo de las Inscripciones*
(Mexico, 1973).

42. M. Cohodas, 'Iconography', *M.R.P.*, III
(1976), 175; also 'Aspects of Cross Symbolism',
M.R.P., IV (1979), 215–30. L. Schele, 'Accession
Iconography', *M.R.P.*, III (1976), 12–13, believes
that the short, muffled figure on the tablets is the dead
Pacal rather than the highland emissary proposed by
Kubler ('Paired Attendants', *S.M.A.M.R.*, XII,
1972, 317–28), but she has recently shifted the Pacal
identification ('Tri-Figure Panels', *M.R.P.*, VI,
1979, 41–3) to other undisclosed arguments. In any
case, his short stature is due to the fact that he is dead,
in Schele's belief.

43. F. Blom and O. Lafarge, *Tribes and Temples*

(New Orleans, 1926), I, 104–36. Photographs, G. F. Andrews a.o., *Edzná* (Eugene, 1969). E. W. Andrews V, 'Dzibilchaltun and Palenque', *M.R.P.*, I (1974), 137–47, notes similarities as to inset corners, window openings, masonry, interior space, and stuccoed facades.

44. E. R. Littmann, *Am.A.*, XXIII (1957), 135–40. Fired bricks of pebble-tempered clay are reported from Corozal in British Honduras; T. Gann, *B.B.A.E.*, LXIV (1918), 82.

45. T. Maler, *P.M.M.*, II (1903), 104 ff., called them the Lesser (western) and the Greater (eastern) Acropolis groups.

227. 46. L. Satterthwaite, Jr, *Piedras Negras Preliminary Papers*, Philadelphia, and *Piedras Negras Archaeology: Architecture*, I-VI (1943–54). T. Maler first reported in detail on the site: *P.M.M.*, II (1901).

47. L. Satterthwaite, Jr, 'A Stratified Sequence of Maya Temples', *Journal of the Society of Architectural Historians*, V (1946–7), 15–20, and 'Some Central Peten Maya Architectural Traits at Piedras Negras', *Los Mayas antiguos* (Mexico, 1941), 183–210. A platform at Kohunlich (Quintana Roo) has balustrade masks in an arrangement recalling K5 (V. Segovia, *I.N.A.H., Boletín*, XXXVII, 1969, 1–7).

228. 48. L. Satterthwaite, Jr, *Piedras Negras Archaeology: Architecture*, Part V, *Sweathouses* (Philadelphia, 1952).

49. C. L. Lundell, 'Preliminary Sketch of the Phytogeography of the Yucatan Peninsula', *C.A.A.*, II (1934), 274–5; K. Ruppert and J. H. Denison, Jr, *Archaeological Reconnaissance in Campeche, Quintana Roo and Peten* (Washington, 1943). W. Haberland designates this area as the Río Candelaria district (*Die regionale Verteilung von Schmuckelementen im Bereiche der klassischen Maya-Kultur*, Hamburg, 1953), although the course of this river is in doubt. A useful account of Campeche is by A. Ruz Lhuillier, *Campeche en la arqueología Maya* (*Acta Anthropologica*, I: 2–3, Mexico, 1945). A 'data-oriented framework' is by R. E. W. Adams, 'Rio Bec Archaeology', *Origins* (Albuquerque, 1977), 77, bearing on Becán, Chicama, and Xpuhil. The stage sequence of pottery periods is: I, Acachen 600–300; 2, Pakluum 300–A.D. 250; 3, Chacsik and Sabucan 250–600; Bejuco 600–730; Chintok 730–830, which is the 'florescence' discussed here as Late Classic; 4, Xcocom, 830–1050, was 'post-collapse', without known new buildings. (Pottery phases based on Becán.) At Becán, defensive earthworks began *c.* 250 (D. Webster, 'Warfare', *Origins*, *op. cit.*, 337). Adams regards the Maya élite as accounting for 'probably 95 percent' of monumental architecture, as well as the stela cult.

50. D. L. Webster, *Earthworks at Becan* (New Or-

leans, 1976), 86–7; *Archaeological Ceramics of Becan* (New Orleans, 1977), 186–7. The radiocarbon dates appear to confirm the range between sixth and eighth centuries A.D. in the Goodman-Thompson-Martínez correlation (about 260 years earlier in the 12.9.0.0.0 or Spinden correlation)

230. 51. *Radiocarbon*, XIV (1972), 135. I-4286 top floor, room 9, 720±95; I-4287, room 8, 655±95.

232. 52. A systematic description of the subdivisions of the architecture of Campeche is by A. Ruz Lhuillier, *op. cit.* (Note 49). H. E. D. Pollock ('Architectural Notes on some Chenes Ruins', *P.M.P.*, LXI, 1970, 1–87) finds the architecture of the region more distinctive than its sculpture, but still of uncertain spread.

53. S. G. Morley, *The Ancient Maya*, 77, 80.

54. R. de Robina, *Estudio preliminar de las ruinas de Hochob* (Mexico, 1956), 94, regards the main building at Hochob as coeval with Temples 11 and 22 at Copán (before 9.17.0.0.0 or A.D. 770) and the doorway of the Magician at Uxmal, on stylistic resemblances among the doorway mask-panels. Culucbalom: K. Ruppert and J. H. Denison, *Archaeological Reconnaissance* (Note 49), figure 112.

55. Puuc-style buildings occur in Chenes territory. Dzibiltun is an example.

56. T. Proskouriakoff, *An Album of Maya Architecture* (Washington, 1946); R. E. Merwin and G. C. Vaillant, 'The Ruins of Holmul', *P.M.M.*, III (1932).

233. 57. R. de Robina, *op. cit.* R. L. Roys distinguishes this 'northern block masonry' from the block masonry of Copán in terms of the superior northern cement and concrete; 'The Engineering Knowledge of the Maya', *C.A.A.*, II (1934), 67–8.

58. S. G. Morley and G. W. Brainerd, *The Ancient Maya* (Stanford, 1956), 264. Excellent summary of Puuc archaeology in J. E. S. Thompson, 'El area maya norte', *Yan*, III (1954), 8–13.

59. The main periods defined by Pollock, *Puuc* (Cambridge, Mass., 1980), 587, are tentative:

Early Oxkintok	*c.* 475–600
Proto-Puuc	600–700
Early Puuc	700–800
Late or Classic Puuc	800–1000

Also E. W. Andrews V, 'Puuc Architecture', in L. Mills (ed.), *The Puuc* (Pella, 1979), 1–17, and D. Potter, *Central Yucatan* (dissertation, 1973), 298–310, who considers Puuc as a 'horizon style' more than as a regional one, and following the central Yucatán style (Río Bec-Chenes).

60. Based on the 11.9.0.0.0 correlation and represented in all the archaeological publications of the Carnegie Institution of Washington.

61. Proskouriakoff, *Classic Maya Sculpture* (Washington, 1950), 167.

234. 62. E. W. Andrews, *Dzibilchaltun* (New Orleans, 1965), table 5.

63. J. W. Ball, 'Summary View', in L. Mills (ed.), *The Puuc* (*op. cit.*), 47, citing E. W. Andrews V in corroboration of this view.

64. A. Ruz Lhuillier, *Campeche en la arqueología Maya*, 42, calls the western group the Camino Real, along the railway line from Campeche to Mérida.

65. The best rapid survey is by A. Ruz Lhuillier, *op. cit.*, 52–61.

66. See R. E. Smith and J. C. Gifford, 'Pottery of the Maya Lowlands', *H.M.A.I.*, II (1965), 503 (Cehpech phase).

67. E. Kurjack and others, 'Settlement Patterns', in L. Mills (ed.), *The Puuc* (*op. cit.*), 41.

68. Examples of *atadura* capitals in buildings of the Río Bec are Channa, Structure I (Ruppert and Denison, *op. cit.*, Note 49, figures 77–9), and Culucbalom (*ibid.*, figure 112).

69. Columns are rare at Uxmal: local peculiarity or chronological clue? Pollock, *H.M.A.I.*, II (1965), 405. Note the combination of *atadura* mouldings at Bonampak as in about A.D. 800 with columns reported from the Lacanha district.

236. 70. The outer ranges, according to A. Ruz, *op. cit.*, 55, are later additions. G. F. Andrews, *Edzná* (Eugene, 1969), has excellent maps, plans, and descriptive sections. Dates on the stelae span 672–810 in the Late Classic era.

71. Other chambered pyramids are that at Santa Rosa Xtampak and the Akabtzib at Chichén Itza. On Xtampak, see T. Maler, 'Yukatekische Forschungen', *Globus*, LXXXII (1902), Abb. 19, 226. It has early traits related to the Río Bec-Chenes style.

72. Marquina, 768. On recent work at Uxmal, see A. Ruz Lhuillier, *A.I.N.A.H.*, VI (1952), 49–67, suggesting that no building post-dates the thirteenth century, and C. Sáenz, *I.N.A.H. Bol.*, XXXVI (1969), 5–13. Sherds found during excavation and restoration support a dating from the sixth to the tenth centuries.

238. 73. E. Seler, 'Die Ruinen von Uxmal', *Abhandlungen der königlich preussischen Akademie der Wissenschaften (Phil.-hist. Kl.)* (1917), no. 3, 20. C. A. Sáenz, 'Gran Piramide', *Bol. I.N.A.H.*, XII (1975), no. 2, 39–44, reports on excavation and repair at the Great Pyramid which is of Chenes style. W. Lamb finds planetary references by counting mosaic elements, doors, steps and colonnettes at the Nunnery (*Am.A.*, XLV, 1980, no. 1, 79–86), and prefers Venus to Chac symbolism at Uxmal.

241. 74. M. Foncerrada, *La escultura arquitectónica de Uxmal* (1965), 153–63. E. S. Deevey a.o., *Radiocarbon*, I (1959), 165, date from ground-floor room (Y. 627) A.D. 560 ± 50. Andrews, *Dzibilchaltun* (New Orleans, 1965), 63, reports this date as being from the earliest stage of the 'Magician'. Cf. Pollock, *P.M.M.*, LXI (1970), 66–80, on Chenes-period structures west of the Governor's House.

75. F. Blom, 'The "Negative Batter" at Uxmal', *Middle American Papers, New Orleans*, IV (1932), 559–66, supposes that the outward lean served only to stress the cast shadows in the friezes.

76. E. Seler, *op. cit.*, figure 44, illustrates this older, plainer edifice, encased within the present structure, of which the trapezoidal doorways appear within the later frames.

77. For discussion of wall-span ratios in relation to age, L. Satterthwaite, *Piedras Negras Preliminary Papers*, III (1935), 56–9. Foncerrada, *op. cit.*, 167–8 regards the Nunnery as coeval with the Governor, accepting 653 ± 100 for the north range Carbon 14 lintel date, rather than the previous measurement of 885 ± 100 (see Chapter 8, Note 49), which conforms to 12.9.0.0.0 correlation.

243. 78. According to A. Ruz, *A.I.N.A.H.*, VI (1952), 59–60, colonnaded aedicules, probably later additions, masked these archway designs. See his figure 4.

79. D. M. Pendergast, *Altun Ha*, I (Toronto, 1980), 182. The dating is only 'a rough indication of possible time of inception and completion'. L. Roys and E. Shook, 'Ruins of Aké', *M.S.A.A.*, XX (1966), 52, relate such 'multiple-door building fronts' to those of Piedras Negras and Palenque.

CHAPTER 8

248. 1. T. Proskouriakoff, *Classic Maya Sculpture* (Washington, 1950); W. Haberland, 'Die regionale Verteilung von Schmuckelementen in Bereiche der klassichen Maya-Kultur', *Beiträge für mittelamerikanische Völkerkunde*, II (1953); M. Greene, R. L. Rands, and J. A. Graham, *Maya Sculpture* (Berkeley, 1972) (illustrated with rubbings by M. Greene); G. Ekholm, *A Maya Sculpture in Wood* (New York, 1964). Cf. W. Coe, *Tikal: A Handbook* (Philadelphia, 1967).

2. This point, first made here, is amplified by F. Claney, 'Pedestal Stones', *New Mexico Studies in the Fine Arts*, I (1976), 101–9.

3. J. E. S. Thompson, *Maya Hieroglyphic Writing* (Washington, 1950), especially chapters 8 and 9. His views are closer to Morley's than to Proskouriakoff's. See Notes 8 and 9 to Chapter 7. M. Davoust, 'Les Chefs Mayas de Copan', *I.C.A.*, XLII (1976), vol. VII (1979), 221–37, unfortunately uses Yucatec names instead of transcriptions from the nominal

glyphs into visual approximations easily translated into any modern language. Davoust (*I.C.A.*, XLIII, 1979, Abstracts A31) also claims to have identified ten rulers at Chichén Itza, of whom most bore Chol names, and the first came perhaps from Bonampak. A full version appears in *Mexicon*, 11 (1980), no. 2, 25–9, as 'Les premiers chefs Mayas de Chichén Itzá'.

4. The evidence is collected in W. Taylor, 'The Ceremonial Bar and Associated Features of Maya Ornamental Art', *Am.A.*, VII (1941), 41–63; J. E. S. Thompson, 'Sky Bearers, Colors and Directions in Maya and Mexican Religion', *C.A.A.*, 11 (1934), 209–42, and Proskouriakoff, *Classic Maya Sculpture* (Washington, 1950), figure 31. Also J. Marcus, 'Iconography of Power', *World Archaeology* [London], VI (1974), no. 1, 83–94.

5. Kubler, *Studies* (New Haven, 1969), 33–46; M. G. Robertson, 'The Quadripartite Badge', *M.R.P.*, I (1974), 77–93. D. Joralemon, 'Ritual Blood-Sacrifice', *M.R.P.*, 11 (1974), 59–76, prefers to interpret the leaf as a stingray spine penis perforator.

6. Kubler, *Studies* (New Haven, 1969), and 'Aspects of Maya Rulership', *D.O.S.*, XVIII (1977).

7. Proskouriakoff distinguishes only Early and Late Classic; her 'Late' is my Middle; and my 'Late' Classic is her post-Classic in architecture. But her Late Classic and my Late Classic in figural sculpture coincide. Here Puuc architecture and Late Classic sculpture are separated, where others have driven them together.

8. S. G. Morley, *The Inscriptions of Peten*, 5 vols. (Washington, 1937–8). Also his *Inscriptions at Copán* (Washington, 1920), and B. Riese, *Grundlagen* (Hamburg, 1971).

250. 9. K. Ruppert, J. E. S. Thompson, T. Proskouriakoff, *Bonampak* (Washington, 1955).

10. S. G. Morley, *Quirigua* (Washington, 1935), 76–87.

251. 11. M. A. Fernández, 'Los Dinteles de Zapote', *I.C.A.*, XXVII (1939), 1, 601; W. R. Coe, E. Shook, and L. Satterthwaite, 'The Carved Wooden Lintels of Tikal', *Tikal Reports*, no. 6 (1961), 15–112. C. Jones, *Am.A.*, XLII (1977), 28–60, convincingly identifies three rulers of Tikal at A.D. 682, 734, and 768 as being of the same family.

252. 12. *Maya Art and Civilization* (Indian Hills, 1957), figure 212 (first published in 1913).

253. 13. This sequence is based upon the stylistic analysis by T. Proskouriakoff, *op. cit.*, which resolves many problems left open by S. G. Morley's epigraphic results (*Inscriptions of Peten*, 11, 434). Morley interpreted Palenque as the initiator of Usumacinta sculptural traditions. On Seibal, see G. R. Willey and others, 'Excavations at Seibal', *P.M.M.*, XIII-XIV (1975–8). F. J. Sanders, 'Twin

Stelae of Seibal', *Am.A.*, XLII (1977), no. 1, 78–86, argues use of patterns or templates, which may be relevant for the murals at Cacaxtla.

14. E.g. Piedras Negras, Stelae 26, 8, 4, 1, ranging from about 9.10.0.0.0 to about 9.13.0.0.0; T. Maler, *P.M.M.*, 11 (1901). The feet of Stela 7 (9.14.10.0.0, or about A.D. 460) open more naturally, at an angle of 120–130 degrees.

15. Detailed colour notes in S. G. Morley, *Inscriptions of Peten*, 111. Flesh parts were red.

254. 16. Illustrated in S. G. Morley and G. W. Brainerd, *The Ancient Maya* (Stanford, 1957), plate 70 and figure 39. Full account in L. Satterthwaite, Jr, *Piedras Negras Preliminary Papers*, 111 (1935).

17. The Initial Series date is 9.18.5.0.0 (c A.D. 795), corrected on stylistic grounds by Miss Proskouriakoff to 9.17.0.0.0 2 (A.D. 771 ± 40).

18. Proskouriakoff, *Classic Maya Sculpture* (1950), 119–20, notes a resemblance to the sculpture of Xochicalco, and suggests that Piedras Negras may early have been part of a south Mexican complex. Compare E. Seler, *G.A.*, 11 128–67, especially figures 10, 33, 61, 64.

19. Imitations or derivatives of the seated figure in a niche occur at Quiriguá, Stela I, back (Morley, *Inscriptions of Peten*, IV, plate 172d) and Xochicalco (Seler, *op. cit.*, figure 61, p. 155). The Quiriguá figure is dated on style 9.17.0.0.0 ± 2 katuns (A.D. 771 ± 40). See the Teapa (Tabasco) urn, discussed by Carmen Leonard in *Yan*, 111 (1954), 83–95. Cf. pp. 329–31 below on the sculpture of Santa Lucía Cotzumalhuapa in the central highlands of Guatemala.

255. 20. Other grain-scattering scenes in the Petén and Motagua regions are enumerated by Morley, *Inscriptions of Peten*, 111, 241. R. L. Rands, *B.A.E. Bull.*, CLVII (1955), interprets the action as scattering water.

258. 21. The later sculpture of Bonampak is clearly related to Yaxchilán, and it is fully discussed in the monograph by K. Ruppert, J. E. S. Thompson, and T. Proskouriakoff, *op. cit.* (Note 9).

22. Even earlier is Lintel 46 (Maler, *P.M.M.*, 11 (1903), plate LXVIII), dated about 692 (9.13.0.0.0).

23. M. Cohodas reaffirms this point (*I.C.A.*, XLII, 1976, vol. VII, 1979, 311) in a table separating 'narrative', 'symbolic', and 'both school' works at Yaxchilán.

24. P. Furst, 'Ritual Blood-Letting', *M.R.P.*, 111 (1976), 192, bases his argument on that of Joralemon, 'Ritual Blood-Sacrifice', *M.R.P.*, 11 (1974), 59–76, although Proskouriakoff, 'Yaxchilan', *E.C.M.*, 111 (1963), 149–67, had suggested only an 'invocation' to a spirit of a dead person in an apotheosis 'symbolized by the serpent and the mask' (*ibid.*, 156).

261. 25. Cf. 'stelae' at Tonina (F. Blom and O.

LaFarge, *Tribes and Temples*, ii, New Orleans, 1926, figures 212–56) and Tajín. The Tonina statues were carved about the middle of the fifth century A.D. (9.11.0.0.0–9.15.0.0.0, Proskouriakoff, 121). Occasional statues of seated figures are known at Yaxchilán and Copán, but the form is rare, and bound to architectural emplacements.

26. M. G. Robertson, 'Painting Practices', *Social Process* (London, 1979), 297–326, studies many technical details at the Palace. Also Beatriz de la Fuente, *La escultura de Palenque* (Mexico, 1965). Older descriptions by A. P. Maudslay, *Biologia Centrali-Americana*, and E. Seler, 'Beobachtungen und Studien', *Abhandlungen der preussichen Akademie der Wissenschaften, Phil.-Hist. Klasse* (1915), no. 5. R. Trebbi del Trevigiano, *Critica d'arte*, XXVIII (1958), 246–85, boldly attempted a grouping of Palenque sculpture by personal style. The effort is worth while, but it overlooks many monuments and it disregards Miss Proskouriakoff's fundamental work on Classic Maya sculpture. He identifies a 'Maestro della Croce' and the works of his pupils as well as a 'Maestro dei Volti' (stucco facade masks), and a 'Maestro dei Rilievi Tardi' and his school, spanning the sixth to mid eighth centuries. G. Kubler has interpreted the temple tablets ('The Paired Attendants', *S.M.A.M.R.*, XII, 1972) as referring to historical persons of the period 642–92.

27. G. Griffin, 'Portraiture in Palenque', *M.R.P.*, III (1976), 137–48; P. Mathews and L. Schele, 'Lords of Palenque', *M.R.P.*, I (1974), 63–76. Their views on the age of Lord Pacal as eighty at death are contested by A. Ruz Lhuillier, 'Gerontocracy', *Social Process* (London, 1977), 287–95, on osteological evidence, and in 'Nueva interpretación', *M.R.P.*, III (1976), 87–94, on epigraphic readings. F. G. Lounsbury, 'Inscription of the Sarcophagus', *M.R.P.*, II (1974), 5–20, supports Mathews and Schele with a reading identical to an independent one (unpublished) by H. Berlin. Neither author knew of the other's results.

28. Kubler, 'Aspects of Classic Maya Rulership', *D.O.S.*, XVIII (1977) (written 1974), and L. Schele, 'Tri-Figure Panels', *M.R.P.*, VI (1979), 64–7.

29. General study by K. Helfrich, *Menschenopfer* (Berlin, 1973); in vase painting, M. Foncerrada de Molina, 'Sacrificio por decapitación', *M.R.P.*, III (1967), 177–80.

30. Tablet of the Slaves: H. Berlin (*Tablet of the 96 Glyphs*, New Orleans, 1968, 146) accepts a dating in the eighth century. Cf. Fuente, *op. cit.* (Note 26), 169; A. Ruz Lhuillier, 'Exploraciones en Palenque, 1950', *A.I.N.A.H.*, v (1952), 35–8. Throne-back: see E. Easby and J. Scott, *Before Cortés. Sculpture of Middle America* (New York, 1970), no. 174.

262. 31. D. Robertson, *M.R.P.*, II (1974), 105–7,

regards these slabs as an assemblage or museum of works by different sculptors in differing materials. C. Baudez and P. Mathews reaffirm Robertson and analyse the relevant inscriptions. Three other tablets at Palenque (the Scribe, the Orator, and Temple XXI) are reinterpreted as illustrating the 'capture and sacrifice complex' on the evidence of inscriptions ('Capture and Sacrifice, *M.R.P.*, VI, 1979, 36–7).

32. L. Schele, 'Observations', *M.R.P.*, I (1974), figure 9. Schele believes the tablets portray rites of accession to power (see also Schele, 'Accession', *M.R.P.*, III, 1976, 9–34, in which Pacal appears also as 'Pyramid' after death). M. Cohodas reads the same tablets at Palenque as a 'narrative sequence which is concerned with agricultural fertility' ('Iconography', *M.R.P.*, I, 1974, 96) to describe 'the cycles of the sun and the maize with the attendant ceremonies', and human figures who impersonate sun and moon, as well as being historic rulers and their attendants.

33. Kubler, 'Mythological Ancestries', *M.R.P.*, II (1974), 24–44. On the same subject, see also Kubler, 'Mythological Dates', *M.R.P.*, III (1976), 225–30, and Lounsbury, 'Rationale', *ibid.*, 211–24.

264. 34. A. V. Kidder, E. M. Shook, and J. D. Jennings, *Excavations at Kaminaljuyu* (Washington, 1946), 104–24; A. L. Smith and A. V. Kidder, *Excavations at Nebaj* (Washington, 1951), 32–42. Also W. F. Foshag, in *Pre-Columbian Art* (R. W. Bliss Collection) (New York, 1957), 45–7. A jade mine near Guatemala City is reported in *Archaeology*, VII (1954), 120. Survey article: R. L. Rands, 'Jades of the Maya Lowlands', *H.M.A.I.*, III (1965), 561–80.

35. Cf. S. G. and F. Morley, 'The Age and Provenance of the Leyden Plate', *C.A.A.H.*, v (1939), 1–17, who ascribe the carving to Tikal. The piece was found near the Motagua river delta (now in the Rijksmuseum voor Volkenkunde, Leyden, Holland).

265. 36. On carved wares, R. E. Merwin and G. C. Vaillant, 'The Ruins of Holmul', *P.M.M.*, III (1932), 79–80; Mary Butler, 'A Pottery Sequence from Guatemala', *The Maya and their Neighbors* (New York, 1940), 261–4; R. E. Smith, *Ceramic Sequence at Uaxactun* (New Orleans, 1955), 42–4. On pre-Classic shape, see Vaillant's remarks on the Q-complex in *Maya Research*, I (1934), 87–100; J. E. S. Thompson's on vessel shapes in *Excavations at San José* (Washington, 1939), 230, 246. On carved 'Fine Orange' ware, R. E. Smith, *Am.A.*, XXIV (1958), 151–60.

37. M. H. Saville, *A Sculptured Vase from Guatemala* (New York, 1919). Authenticity questioned by J. E. S. Thompson, *Am.A.*, IX (1943), 116.

38. J. E. S. Thompson, *San José*, 156; R. E. Smith,

Uaxactun, 100; J. M. Longyear, *The Ceramics of Copan* (Washington, 1952), 104; G. Willey, 'Artifacts of Altar de Sacrificios', *P.M.P.*, LXIV (1972), 7–76. In R. L. and B.C. Rands, 'Pottery Figurines of the Maya Lowlands', *H.M.A.I.*, 11 (1965), 535–60, eight 'sub-areas' are considered: Puuc, Jaina, Jonuta, Palenque, Usumacinta, Nebaj, Petén, Lubaantun.

266. 39. A. Ruz Lhuillier, *Campeche* (Mexico, 1945), 71–2. A systematic survey of the iconography is by C. Corson, *U.C.A.R.F.*, XVIII (1973), 51–75; also M. E. Miller, *Jaina Figurines* (Princeton, 1975). See also H. Moedano Koer, 'Jaina: un cementerio Maya', *R.M.E.A.*, VIII (1946), 217–42, and A. Delgado, 'El Arte de Jaina', *Artes de México*, XII (1965), no. 60, 11–18.

40. H. J. Spinden, *A Study of Maya Art*, *P.M.M.*, VI (1913); *Pre-Columbian Art* (Bliss Collection) (New York, 1957), plates LXXVI–LXXVII; P. Kelemen, *Medieval American Art*, 11 (New York, 1943), plates 133–4.

41. Illustrated in Morley and Brainerd, *The Ancient Maya*, plate 82, bottom corners, and *Pre-Columbian Art* (New York, 1957), plate LXIX.

267. 42. Another focus of moulded production was the Alta Verapaz region of the Guatemalan highlands, along the upper Chixoy drainage. These wares are best illustrated in E. P. Dieseldorff, *Kunst und Religion der Mayavölker* (Berlin, 1926), figures 5–49. Also Mary Butler in *The Maya and their Neighbors* (New York, 1940), 261–4. R. E. Smith, 'Pottery from Chipoc', *C.A.A.H.*, XI (1952), 215–34, connects Chipoc mould-made figurines with Tepeu 1–2. Neutron activation studies (M. M. Goldstein, 'Maya Figurine Trade in Coastal Campeche', *I.C.A.*, XLIII, Abstracts A49) show that Comalcalco, Tierra Nueva, and other sites manufactured the Jaina figurines (but not Palenque or Jonuta). The styles are Maya and Mexican mixtures. The article is extracted from her unpublished doctoral dissertation at Columbia University (1979).

43. The initial analysis of serpent-mask panels is by H. J. Spinden, *P.M.M.*, VI (1913), 118–27, reissued in Part 1 of *Maya Art and Civilization* (Indian Hills, 1957). M. Foncerrada, *Uxmal*, 144–5, holds that serpent images are lacking in Puuc art, and that the serpents at Uxmal of realistic aspect (Monjas, west and north) are Toltec forms. Her inventory of Puuc ornamental forms (96) includes masks, step-frets, lattices, columns, house-models, serpents, owls, feathers, jaguars, and humans.

44. R. E. Merwin and G. C. Vaillant, *P.M.M.*, III (1932), no. 2, 18–20.

268. 45. A. S. Trik, 'Temple XXII at Copan', *C.A.A.H.*, V (1939), 87–103. Its platform shows a tablero profile of Teotihuacán style.

46. K. Ruppert and J. H. Denison, *Archaeological Reconnaissance* (Washington, 1943), figures 45, 96, 111. Pollock, 'Chenes Ruins', *P.M.P.*, LXI (1970) 73, notes that a curvilinear panel of Chenes style on Building 1 at Uxmal is buried beneath the Governor's platform, proving its priority there.

47. Ruppert and Denison, *op. cit.*, plates 35–6.

269. 48. The best photographs of the Chenes facades are in E. Seler, 'Die Quetzalcouatl-Fassaden Yukatekischer Bauten', *Abhandlungen der preussischen Akademie der Wissenschaften, Phil.-Hist. Kl.* (1916). J. E. S. Thompson, 'Las llamadas fachadas de Quetzalcoatl', *I.C.A.*, XXVII (1939), 391–400, withdraws the iconographic identification. The accounts of Puuc architecture are by T. Maler in *Globus*, LXVIII (1895), LXXXII (1902). H. E. D. Pollock, 'Architectural Notes on Some Chenes Ruins', *P.M.P.*, LXI (1970), 1–88, surveys the present state of the question. See also J. W. Ball, *Am.A.*, XXXIX (1974), 85–93.

49. A radiocarbon date from the north building of the Nunnery at Uxmal yields A.D. 893 ± 100; De Vries, *Science*, CXXVII (1958), 136. Andrews, *Dzibilchaltun* (1965), 63, reports this as GRO-613, 885 ± 100; Foncerrada, *Uxmal* (1965), 57, gives it as 653 ± 100. This difference between Carbon 14 interpretations reflects the continuing uncertainty between Spinden and Thompson correlations. Foncerrada (*op. cit.*, 58–60) has disagreed with my sequence because the earliest structure at the Magician, dated by Carbon 14 in the sixth century, has Puuc-style ornament, while the later east chamber at the head of the stairs displays a Chenes-style doorway [218]. Its crude workmanship, however, suggests that it was built of discarded or re-used elements in phase 4 of the building history of the Magician, leaving the date of the Chenes style unfixed. See Note 46.

50. E. Viollet-le-Duc, 'Antiquités américaines', in D. Charnay, *Cités et ruines américaines* (Paris, 1863), 1–104; R. Wauchope, *Modern Maya Houses* (Washington, 1938).

51. Channa, St 1, Room 2, has engaged cylindrical columns at the door jambs with *atadura* capitals; Ruppert and Denison, *op. cit.*, figure 79. Also Culuc-balom, St 1 (*ibid.*, figure 112).

52. K. Ruppert, J. E. S. Thompson, T. Proskouriakoff, *Bonampak*, 28.

53. Described by S. G. Morley, *C.I.W. Yearbook*, XLI (1941–2), 251. Portions of the Puuc-style sculpture of this core are illustrated by E. Seler, *Abhandlungen der preussischen Akademie* (1917), 27 f.

270. 54. The actual facades of the north Nunnery building envelop an older construction from which the tiered masks may have been salvaged.

271. 55. Full excavation details in A. L. Smith, *Uaxactun 1931–1937* (Washington, 1950), 54–6 and

figure 46. The Tzakol dating depends upon ceramic, architectural, and epigraphic evidence. Another painted stucco fragment of Tzakol date was excavated at Nebaj in the Alta Verapaz. See A. L. Smith and A. V. Kidder, *Excavations at Nebaj* (Washington, 1951), frontispiece and p. 57.

56. Cf. Proskouriakoff, figure 9.

272. 57. K. Ruppert, J. E. S. Thompson, T. Proskouriakoff, *op. cit.* A crust of opaque calcareous deposits required that the walls be soaked with kerosene until the murals were visible enough for copying in watercolours. Two such copies were made, one by A. Tejeda for the Carnegie Institution and another by A. Villagra for the Mexican government. The first is blonder, and the ruined portions are more legible than in the second. See A. Villagra, 'Las pinturas de Bonampak', *C.A.*, VI (1947), 151–68.

58. E. R. Littmann, 'Maya Blue', *Am.A.*, XLV (1980), no. 1, 87–100, proposes that indigo and attapulgite have the observed properties of the ancient pigment, which is, however, more complex, but used from the Basin of Mexico to Monte Alban, Kaminaljuyú, and Cozumel.

276. 59. This seriation of the rooms is only approximate. It would be more precise to classify the walls as follows: register walls, 1–4, 9; unified single wall, 5; triptych walls, 6–8, 10–12.

60. Thompson, *op. cit.*, 54, regards the prince as drawing blood from his tongue, although no red colour or thorny cord, as at Yaxchilán, supports this view.

277. 61. Is the body headless? If so, does the severed head on the steps in Room 2 belong to this body?

62. E.g. Chinkultic, Cancuen, Copán.

279. 63. E. H. Thompson, *P.M.M.*, III (1904), plate VIII.

64. S. G. Morley, *The Ancient Maya*, 402; A. O. Shepard in J. Thompson, *San José*, 251–77; R. E. Smith, *Ceramic Sequence at Uaxactun* (New Orleans, 1955); R. L. and B. C. Rands, 'The Ceramic Position of Palenque', *Am.A.*, XXIII (1957), 140–50.

65. Summarized by R. E. Smith, *op. cit.* (Ia), 53–9. Techniques described by A. Kidder, E. M. Shook, and J. D. Jennings. *Kaminaljuyu* (Washington, 1946), 218–38. The decorative use of stucco on pottery is as old as the Miraflores phase at Kaminaljuyú (pre-Classic). A. Kidder and A. Shepard, *N.M.A.A.E.*, II (1944), no. 35, 22–9.

66. J. Quirarte, 'Maya and Teotihuacán Traits', in D. L. Browman (ed.), *Cultural Continuity in Mesoamerica* (The Hague, 1978), 289–302, suggests that Maya painters at Kaminaljuyú executed the Teotihuacano figures on the burial vessels found in Mound A.

See Kidder, Jennings, and Shook, *Kaminaljuyu*

(1946), figure 29, and Cheek, 'Teotihuacan Influence', 443; Kidder, Jennings, and Shook, *op. cit.*, figure 209 f. Illustration 231: Quirarte, 'Representation' (1979), 107, and Joralemon (n.d.) compare this black-ground vase to illustration 228 (sarcophagus lid, Palenque).

The theme of human or animal figures seated on dragon masks of the type known as Cauac monsters is related to rain and caves in an ancient association portrayed by Olmec sculptors at Chalcacingo [80]. See D. Taylor, 'The Cauac Monster', *M.R.P.*, IV (1979), 79–89. Ethnographic and archaeological evidence on Maya caves in B. MacLeod and D. Puleston, 'Pathways into Darkness', *ibid.*, 71–7.

280. 67. J. Quirarte, 'Actual and Implied Visual Space in Maya Vase Painting', *U.C.A.R.F.*, XXXVI (1978), 27–38, studies double images and two-headed compound creatures in this context.

68. Mary Butler, 'A Pottery Sequence from the Alta Verapaz', *The Maya and their Neighbors* (New York, 1940), 250–71. Also E. P. Dieseldorff, *Kunst und Religion der Mayavölker*, 2 vols. (Berlin, 1926–31), illustrating many examples. On dating for Chamá 3 style as Tepeu 1 (seventh century) see R. and B. Rands, 'Pottery of the Guatemalan Highlands', *H.M.A.I.*, II (1965), 131. Many examples of Classic Maya pottery painting in M. Coe, *Maya Scribe* (New York, 1973); *Lords of the Underworld* (Princeton, 1978); 'Supernatural Patrons of Maya Scribes and Artists', *Social Process* (London, 1977), 327–47; *Classic Maya Pottery at Dumbarton Oaks* (Washington, 1975).

281. 69. University Museum, Philadelphia, illustrated by Gordon and Mason, *op. cit.*, plate LII (rabbit); plates I–II (Ratinlixul).

70. 'Representation of Place, Location, and Direction', *M.R.P.*, IV (1979), 99–110. Quirarte assumes an 'Underworld' place, at its western corner (black), at the time of the dead ruler's becoming sun god. If the style of drawing derives from the lid of the Palenque sarcophagus carving, an early Tepeu 2 date about 730 seems possible.

71. R. E. W. Adams, 'The Ceramics of Altar de Sacrificios', *P.M.P.*, LXIII (1971), 68–78. Adams argues ('Comments', *Social Process*, London, 1977, 418) that the scene portrays the funeral of the woman in the burial. The dancing figure [230] would portray Bird-Jaguar III, ruler of Yaxchilán, as among the guests. The pottery was imported from the Alta Verapaz (and painted at Altar?). See also D. M. Pendergast, *Actun Balam* (Toronto, 1969), 41–52.

72. Gordon and Mason, *op. cit.*, plates XXIX–XXX.

73. C. C. Leonard, 'El vaso de Tabasco', *Yan*, III (1954), 96–102, interprets the scene as concerning deities and their rituals.

74. A. L. Smith, 'Two Recent Ceramic Finds at Uaxactun', *C.A.A.*, II (1934), 1–25; G. E. Merwin and G. C. Vaillant, *P.M.M.*, III (1932), plates 29 and 30; T. W. F. Gann, *B.B.A.E.*, LXIV (1918). M. Foncerrada de Molina, 'Ritual Maya', *I.C.A.*, XLI (1976), vol. II, 334–47, ascribes a palace scene (on a vessel said to be from Uaxactún) as the work of a Maya artist of bourgeois rather than courtly associations, in the Tepeu 3 phase. The murals of room 3 at Bonampak may also be part of this anecdotal component in Maya painting.

284. 75. J. M. Longyear, *Copan Ceramics* (Washington, 1952), 30–1, 60–3, figure 118; and W. D. Strong, A. Kidder II, and A. J. D. Paul, *Smithsonian Institution, Miscellaneous Collections*, XCVII (1938), no. 1. C. Baudez and P. Becquelin, *Los Naranjos* (Mexico, 1973), have established four archaeological phases at this extended site on the north shore of Lake Yojoa: 1, Jaral, 800–400 B.C. (monochrome pottery, defensive moat); 2, Eden, 400 B.C.–A.D. 550 (bichrome pottery); 3, Yojoa, 550–950 (polychrome pottery); 4, Río Blanco, 950–1250 (ball-game sites). Also J. M. Longyear, 'Archaeological Investigations in El Salvador', *P.M.M.*, IX (1944), no. 2. The Summary in J. W. Ball, 'Archaeological Pottery of the Yucatan-Campeche Coast', *M.A.R.P.*, XLVI (New Orleans, 1978), 69–146, gives exemplary maps of ceramic and population movement by nine phases spanning 300 B.C.–A.D. 1550, showing events on land and at sea by spheres of activity in the major periods.

76. T. S. Barthel, 'Gedanken zu einer bemalten Schale aus Uaxactum', *Baessler-Archiv*, XIII (1965), first proposed the underworld interpretation, when discussing a figured plate from Uaxactún. Michael Coe, *The Maya Scribe and his World* (New York, 1973), has extended and generalized Barthel's views. See also M. Coe, 'Supernatural Patrons', *Social Process* (London, 1979), 327–47, offering technical and iconographic observations on books and monkeys. Other studies of Maya vase painting are by M. Foncerrada de Molina, 'Reflexiones sobre la decoración de un vaso Maya', *A.I.I.E.*, XXXIX (1970), 79–86, and R. E. W. Adams, 'The Ceramics of Altar de Sacrificios', *P.M.P.*, LXIII, no. 1 (1971). M. Foncerrada, 'Vaso Rietberg', *Anales, Instituto de Investigaciones Esteticas*, XII (1974), no. 43, 37–47, analyses a vase portraying everyday life. Also A. Paul, *Archaeology*, XXIX (1976), no. 2, 118–26, on a sacrificial event at court. G. Kubler, 'Aspects of Maya Rulership', *D.O.S.*, XVIII (1977), 15–23, has restudied the Initial Series vase from Uaxactún, redating it from A.D. 672 to A.D. 759, and relating the scene to a commemoration of events about 248 B.C. (concerned with the inauguration of the Long Count?). M. Foncerrada has also added merchants to

the repertory of Late Classic vase painters ('El comerciante', in *Del Arte*, Mexico, 1977, 45–52).

285. 77. M. S. Edmonson, *The Book of Counsel: the Popol Vuh of the Quiche Maya of Guatemala* (New Orleans, 1971), 38, note 1003; 235, note 7843.

78. Coe's 'Primary Standard Text' appears on thirty-two of the eighty-one vessels illustrated. There is no doubt about its identification as a textual type, but only about its interpretation exclusively from the Popol Vuh.

79. L. Schele, who is among the most active students of glyphic art at Palenque, notes that iconographers and epigraphers cannot work in isolation, and that visual study is vital to identification of graphemes ('The Palenque Triad', *I.C.A.*, XLII, 1976, vol. VII, 1979, 422).

CHAPTER 9

287. 1. The most complete earlier account of the history, archaeology, and ethnology is by A. M. Tozzer, 'Chichen Itza and its Cenote of Sacrifice', *P.M.M.*, XI–XII (1957). Contrast L. Parsons, *Bilbao*, II (Milwaukee, 1969), 172–84. On Teotihuacán forms at Dzibilchaltun and Acanceh, E. W. Andrews, 'Northern Maya Lowlands', *H.M.A.I.*, II (1965), 296–305; 475. Also E. W. Andrews V, 'Early Central Mexican Architectural Traits at Dzibilchaltun', I.C.A., XLII, vol. VIII (1969), 237–49.

The late Howard Cline's manuscript on calendars (unpublished) presents a revision of Tula chronology (migrations *c.* 660; Tula founded *c.* 770; expansion *c.* 970; fall of Tula 1168). J. E. S. Thompson, *Maya History and Religion* (Norman, 1970), 3–47, has enriched the problem with his thesis of a Chontal Maya group in the Putun district of the Tabasco lowlands, who were sea traders, affected by Mexican neighbours. During the ninth and tenth centuries these Putun Maya traders expanded their influence into the Usumacinta drainage. In eastern Yucatán and at Chichén in 918 a branch of the Putun Maya settled as the Itza. This first wave of Mexicanization prepared the way for the highland groups from Tula *c.* 987.

J. W. Ball, 'Northern Maya Prehistory: A.D. 700–1200', *Am.A.*, XXXIX (1974), 85–93, proposes this sequence at Chichén:

1. *c.* 780–900: Founding of Chichén by the Chontal or Putún Itza; building of old Chichén. Itza occupy Seibal after 830, remaining in the Pasión area until the end of the tenth century.

2. *c.* 987–1160+: Itza return under Tula-Toltec leaders. Rebuilding of Chichén surrounding Castillo until after the fall of Tula *c.* 1160.

2. A. Barrera Vásquez and S. G. Morley, 'The Maya Chronicles', *C.A.A.H.*, x (1949). Rigorous reviews of all literary evidence in M. Wells Jakeman, *The Origins and History of the Mayas* (Los Angeles, 1945). M. Davoust, 'Chefs Mayas de Chichen Itza', *Mexikon*, II (1980), 25–9, finds in the inscriptions the names of ten rulers.

3. S. G. Morley and G. W. Brainerd, *The Ancient Maya* (Stanford, 1956), 79–99. Parsons, *loc. cit.*, seeks to establish a pre-Puuc period of 'Teotihuacanoid' influence. See W. Bullard, 'Topoxté', *P.M.P.*, LXI (1970), 301–5, on Itza presence in the Petén in the fifteenth century.

288. 4. The best guide to all the ruins is by K. Ruppert, *Chichen Itza, Architectural Notes and Plans* (Washington, 1952), containing a map (1:3000) with five-foot contours. J. Bolles, *La Iglesia* (San Francisco, 1963), 6, reports radiocarbon dates 600 ± 60 and 780 ± 70 for the Iglesia, and 610 ± 60 at the Casa Colorada (Chicchanchob). These seventh-century dates correspond to the middle of the early period of old Chichén: the Iglesia was preceded by the east wing of the Nunnery, and it preceded the south-east annex. The three structures 'were probably built between A.D. 500 and 700' (11).

J. Thompson, in Bolles, *Las Monjas* (Norman, 1977), 266, reads the date on Lintel 6 as corresponding to A.D. 880, 6 February (GTM correlation), and supposes that the second storey of the Nunnery was therefore dedicated in 889, about a century later than the Iglesia.

5. A. M. Tozzer, *op. cit.* (Note 1), 1, 33–50. His sequence:

Chichén Itza I (Yucatán Maya), 600–1000
Chichén Itza II (Toltec Maya A), *c.* 948–*c.* 1145
Chichén Itza III (Toltec Maya B), *c.* 1150–1260
Chichén Itza IV (Dissolution), 1280–1450
Chichén Itza V (Abandonment), 1460–1542

Tozzer ascribes to Period II the main ball-court and the gold disks; here they are set in III. Tozzer puts the Warrior group in III; here it is made older in II. Tozzer's analysis is ethnographical and archaeological, without special concern for the stylistic factors, on which we base our seriation. Tozzer was unable (e.g. p. 42) to separate conclusively the constructions of Periods II and III.

L. Parsons (*Bilbao*, II, 198) also rearranges the periods:

I ('Teotihuacanoid') *c.* 500–750
II (Chichén-Puuc) *c.* 700–950
III (Tula-Toltec) ?900–1263
VI 1263–

He sees Teotihuacán influence at Chichén Itza in the sixth century at the inner Castillo and in the seventh at the Great Ball-Court, the Mercado, and the Chacmool Temple. The outer Castillo and the Caracol

substructure are assigned to 700–750 as transitional between 'Teotihuacanoid' and 'Chichén-Puuc'. The tenth century is a transition from 'Chichén-Puuc' to 'Tula-Toltec' (Temple of the Warriors, upper Temple of the Jaguars). The eleventh and twelfth centuries are 'Tula-Toltec' (High Priest's Grave, Temple of Wall Panels, Court of the 1000 Columns). This parallels the chronology of the chronicles.

M. Cohodas, *The Great Ball Court* (New York, 1974), 151–2, divides five styles in three phases:

1 styles I, I-II, 630–720
2 styles II-IV, 720–900
3 style V, 900–1000

(also articulated as *Regionalism* (seventh century); *Regional Interaction* (late seventh-early eighth century); *Full Late Classic* (eighth-ninth century))

The underlying assumption (p. 199), following Parsons, *Bilbao*, II, 198–9, is that Chichén-Toltec and Chichén Maya styles co-existed during the seventh century, in an alliance between Chontal or Putún Maya and Yucatec Maya. The author stresses the fact that 'there exists no shred of concrete evidence for the dating of any structure at Chichén Itzá'. His periodization is mostly by stylistic comparisons.

The groups I propose here (1980) still follow Andrews' chronology in *Dzibilchaltun* (New Orleans, 1965), 62. The argument that the Monjas ball-court predates that structure, as defended by Parsons, *Bilbao*, II (1969), 179, needs further excavation to prove that Toltec remains underlie those of the Puuc period.

6. F. Morris, J. Charlot, and A. Morris, *Temple of the Warriors*, 1 (Washington, 1931), figure 53.

7. A. Tozzer, *I.C.A.*, XXIII (1928), 164, and J. Charlot, in Morris, *Temple of the Warriors*, 1, 342, regard the ball-court as earlier than the Temple of Warriors because of the coarsening of the sculpture of the Warriors reliefs. Against this argument see p. 308.

8. D. Charnay, *The Ancient Cities of the New World* (London, 1887). Charnay's observations were given more systematic form by A. Tozzer, 'Maya and Toltec Figures at Chichén Itza', *I.C.A.*, XXIII (1930), 155–64. The Mexican excavations are reported by Jorge Acosta in *R.M.E.A.* (see pp. 46–7).

9. K. Ruppert, 'The Temple of the Wall Panels', *C.A.A.*, 1 (1931), 139–40, follows H. J. Spinden's 'Study of Maya Art', *P.M.M.*, VI (1913), 205, in this enumeration.

10. Most amply represented in the monumental study by A. M. Tozzer, published posthumously as 'Chichen Itza and its Cenote of Sacrifice' (Note 1).

290. 11. H. E. D. Pollock, *Round Structures of Aboriginal Middle America* (Washington, 1936).

12. K. Ruppert, *The Caracol* (Washington, 1935), 274–5, suggests that it also served as a watch tower.

H. Hartung, *Zeremonialzentren der Maya* (Graz, 1971), 78–9, has observed that four sighting lines in the Caracol point at the various ball-courts. H. Hartung and A. Aveni ('Circular Tower', *Ibero-Amerikanisches Archiv*, V, 1979, 1–18) favour a Quetzalcoatl symbolism for the tower near Xpuhil dated by E. W. Andrews V after A.D. 830.

13. Ruppert, *op. cit.*, 273, admits the possibility that the vaulted portions preceded the building of the secondary platform. The C14 date was published in *American Journal of Science, Radiocarbon Supplement*, 1 (1959).

293. 14. A lintel from the outer Castillo temple is dated A.D. 810 ± 100 (Y-626b) (E. W. Andrews, *Dzibilchaltun*, New Orleans, 1965, 63). Much smaller, although nearly an exact replica of the Castillo, is the High Priest's Grave, also called the Osario (E. H. Thompson, 'The High Priest's Grave', *F.M.N.H.A.S.*, XXVII, 1938). Like the Temple of the Inscriptions at Palenque, this covered a burial. J. E. S. Thompson, in this publication (p. 59), regarded the edifice as transitional between the Castillo and the Warriors 'and as also later than the Chacmool Temple'.

15. Surely coeval were the Chacmool Temple and the adjoining Temple of the Tables immediately north. The column reliefs and the serpent columns support the comparison.

16. This sequence is based upon the floor-levels discovered and reported by Earl Morris, *op. cit.*, I, 172–6.

295. 17. On the north-east colonnade, see E. B. Ricketson, 'Sixteen carved Panels from Chichen Itza', *Art and Archaeology*, XXIII (1927), 11–15.

18. K. Ruppert, *Chichen Itza*, 72–4.

19. A. Ruz Lhuillier, *Campeche en la Arqueología Maya* (Mexico, 1945), 82. On ball-court typology, see J. Quirarte, 'El juego de pelota en Mesoamerica', *E.C.M.*, VIII (1970), 83–96. On ball-rings, F. Solis, 'Anillos', *I.C.A.*, XLI (1975), vol. I, 252–61.

296. 20. Proskouriakoff, 171: 'It seems an inescapable conclusion that some contact, however tenuous, must have existed between the Toltec and the classic people in the last phase of the latter's history'. Also Lothrop, 'Metals from the Cenote of Sacrifice', *P.M.M.*, X (1952), 111–12.

21. As set forth by Lothrop, *op. cit.*, 69.

22. O. Ponciano Salazar, 'El Tzompantli', *Tlatoani*, I (1952), 37–41; J. Acosta, 'Exploraciones', *A.I.N.A.H.*, VI (1952), 39–41.

298. 23. The edifice is repeated near the Nunnery in the southern, Puuc-period part of Chichén (Structure 3C 17; Ruppert, *Chichen Itza*, 57). Reconstruction drawing in Proskouriakoff, *Album* (Washington, 1946), 22.

24. H. E. D. Pollock, R. L. Roys, T. Proskouriakoff, and A. L. Smith, *Mayapan* (Washington, 1962), and R. E. Smith, 'Pottery of Mayapan', *P.M.P.*, LXVI (1971), 2 vols.

299. 25. J. E. Thompson, H. E. D. Pollock, and J. Charlot, *Cobá* (Washington, 1932), and S. K. Lothrop, *Tulum* (Washington, 1924). Also A. Escalona Ramos, *Boletín de la Sociedad mexicana de Geografía y Estadística*, LXI (1946), 513–628, and M. A. Fernández, *A.M.N.H.A.E.*, III (1945).

26. *Op. cit.*, 172. Tulum was walled about, like Mayapán later, or Aké, Becán, and Muna in north-western Yucatán earlier; E. B. Kurjack and E. W. Andrews V, 'Early Boundary Maintenance', *Am.A.*, XLI (1976), 317–25. On Aké, L. Roys and E. M. Shook, *M.S.A.A.*, XX (1966); Becán, D. L. Webster, *M.A.R.P.*, XXXI (1974); Mayapán, H. E. D. Pollock et al., *Mayapán* (Washington, 1962).

27. In S. G. Morley, *The Ancient Maya*, 77.

28. Lothrop's sequence of four groups at Tulum is based on roofing habits, number of doorways, and moulding types. His earliest group lacks buildings with negative batter, but Lothrop did not then know of the Puuc associations of this trait. D. Webster, 'Lowland Maya Fortifications', *American Philosophical Society, Proceedings*, CXX (1976), 361–71, assembles other evidence, from 500 B.C., in the Maya lowlands.

29. The recessed lintels, and the negative batter itself, recall Mitla in Oaxaca.

300. 30. E.g. Temple no. 5, Tulum, a corbel-vaulted shrine. M. A. Fernández, in *Los Mayas antiguos* (Mexico, 1941), 157–80, dates this negative-batter building in the period between 1000 and 1200.

31. Proskouriakoff, 170; also Morley and Brainerd, *The Ancient Maya*, 83–5. The view here (formulated in 1958), that the art of Tula was generated at Chichén, received a balanced appraisal from A. Ruz Lhuillier ('Chichén Itzá y Tula: Comentarios a un ensayo', *E.C.M.*, II, 1962, 205–20), and it was supported by Proskouriakoff, *H.M.A.I.*, II (1965), 491. Since then the arguments advanced by E. W. Andrews (*Dzibilchaltun*, New Orleans, 1965) and L. Parsons (*Bilbao*, Milwaukee, 1969, 174) bring new support to the idea. The question it raises remains open until the chronology becomes clearer. J. W. Fox, 'Lowland to Highland', *Am.A.*, XLV (1980), no. 1, 43–54, examines an 'Epiclassic (ca A.D. 800–1000) Mexican-influenced archaeological pattern' as to 'Toltec linkage' in the Río Negro-Río Motagua basins.

32. Illustrated in Proskouriakoff, 96–7.

33. E. W. Andrews, *Dzibilchaltun* (1965), 60–6.

301. 34. Illustrated in Proskouriakoff, figure 94 and pp. 167–8. Older examples are the serpent-mask

facades of Chenes and even of Petén-Maya date (see p. 247); they lead rather to the mosaic facade of the Puuc period than to the extended reliefs here under discussion.

303. 35. J. E. S. Thompson, 'Skybearers', *C.A.A.*, 11 (1934), 234–5.

36. Ruz, *op. cit.* (Note 31), 209, finds Maya antecedents on the sarcophagus lid at Palenque and the glyph of 'God II' there (Thompson, *Catalog of Maya Hieroglyphs*, Norman, 1962, 1030 f.). The Maya phrase means red claw, and it is a fanciful appellation given by A. Leplongeon (1876), On distribution, E. Seler, *G.A.*, 1, 677; v, 267. Also Lothrop, *Pottery of Costa Rica and Nicaragua* (New York, 1926), 286. On the possible meaning as a god of drunkenness, C. Lizardi Ramos, *C.A.*, iv (1944), no. 2, 137–48; as a messenger bearing blood-gifts to the gods, J. Corona Núñez, *Tlatoani*, 1 (1952), 57–62.

305. 37. The re-cutting is visible in E. H. Thompson, 'The High Priest's Grave', *F.M.N.H.A.P.*, xxvii (1938), 6.

38. Lothrop, *op. cit.* (Note 20), 57.

307. 39. For a discussion of the differences between Maya and Toltec costumes, see D. E. Wray, *Am.A.*, xi (1945–6), 25–7.

40. Jean Charlot, in Morris, Charlot, and Morris, *Temple of the Warriors*, 1, 231–343.

41. H. Moedano Koer, 'El friso de los caciques', *A.I.N.A.H.*, 11 (1941–6), 113–36, and H. Beyer, 'La procesión de los señores', *M.A.*, viii (1955), 1–65. The Tizoc Stone in the Mexican National Museum [48] pertains by composition to this family.

308. 42. K. Ruppert, *C.A.A.H.*, viii (1943), 245, noted its superiority over other dais, commenting on its 'depth and clarity of definition', and comparing it to the main ball-court reliefs. The dais is far in advance of the slovenly and retrograde pilaster figures at the doorway, which recall the Chacmool Temple pilasters in the cella doorway, by the use of frontal masks in bases and capitals.

43. Other examples, possibly earlier, are the façade panels flanking the serpent-column entrance of the cella of the Temple of the Warriors, which may, however, be a later remodelling, because the pier bases inside follow the older style with the median division.

44. As in A. M. Tozzer, *op. cit.*, and D. E. Wray, *Am.A.*, xi (1945–6), 25–7.

309. 45. E. J. Palacios, *Enciclopedia Yucatanense*, 11 (Mexico, 1945), 526, supposes that the disk is the earth, protigated as a god of fertility by the blood rite.

46. Illustrated by M. Covarrubias, *Indian Art of Mexico and Central America* (New York, 1957), figure 81. They are of Classic Veracruz style.

310. 47. The best account of the North Temple is by Adela Breton, *I.C.A.*, xix (1917), 187–94. The

building is also called the Temple of the Bearded Man, in honour of the recumbent figure. The Breton drawing shows the twin serpents arising behind the corpse; another rendering by M. A. Fernández records the serpents as a belt worn by the corpse.

313. 48. S. K. Lothrop, *op. cit.* (Note 20). Disks are worn as pectorals by several figures in the reliefs of the lower Temple of the Jaguars: they may represent gold examples. See also T. Proskouriakoff, 'Jades', *P.M.M.*, x (1974).

315. 49. S. K. Lothrop, *op. cit.*, 62.

316. 50. The Chacmool frescoes are best illustrated in Morris, Charlot, and Morris, *Temple of the Warriors*, 11, plates 132–8. They represent seated figures like those of Classic stelae, painted in rich, deep tones. The types are Toltec, the forms are Maya.

51. Before A. G. Miller's study of the copies by Adela Breton in 1901–2 ('Captains of the Itzá', *Social Process*, London, 1977, 197–225), the most complete discussion of these murals was by E. Seler, *G.A.*, v, 324–57. Useful reproductions have appeared in Maudslay, *Biologia*, iii; T. A. Willard, *City of the Sacred Well* (London, n.d.), opp. 221; and G. O. Totten, *Maya Architecture* (Washington, 1926). Excellent drawings of the south-west wall in Jean Charlot, 'A XII Century Mayan Mural', *Magazine of Art*, xxxi (1938), no. 11, 624–9 and 670. Further drawings of the east wall by W. Lehmann in 1925–6 in G. Kutscher, 'Wandmalereien des vorkolumbischen Mexico', *Preussischer Kulturbesitz*, ix (1971), 71–120, esp. figures 29, 33; south wall, figure 16.

A. G. Miller (*op. cit.*) numbers the walls inversely to the sequence discussed here in illustration 263. He reads the scenes as showing the battles of a protagonist ('Captain Serpent') and an antagonist ('Captain Sun-Disk') confronting each other at the centre of the east wall. Their campaigns fill the walls. The north group is assumed to portray an attack on a village 'possibly in Oaxaca'. The south group presumably portrays a rain-forest environment, 'possibly the Peten'. Both battles are dated by Miller in the 'Terminal Classic Period', and related to Seibal as being possibly the Chakanputun of the Maya Chronicles. 'Captain Sun-Disk' is also identified with the personage portrayed at Seibal on Stelae 10, 11 before A.D. 900. Also discussed by Miller are the murals in the Temple of the Warriors, as portraying Putún military actions on the East Coast during the Terminal Classic period ('The Little Descent', *I.C.A.*, xlii, 1976, vol. viii, 1979, 221–36).

52. A similar scene of sacrifice by heart excision appeared near the cella doorway of the Temple of the Warriors. Morris, Charlot, and Morris, *Temple of the Warriors*, 11, plate 145.

53. Another such battle of warriors attacking an

island village with flaming spears adorns the Nunnery at Chichén. Willard, *op. cit.*, opp. 253.

54. Willard, *op. cit.*, 221, probably based upon one of Teobert Maler's drawings.

55. *Pacific Art Review*, 11 (1942), nos. 1–2.

317. 56. Morris, Charlot, and Morris, *op. cit.*, 11, plate 164.

319. 57. Thomas Gann, 'Mounds in Northern Honduras', *19th Annual Report, Bureau of American Ethnology* (Washington, 1900), 655–92. Gann dated the frescoes in the late fourteenth or early fifteenth centuries (676). J. Quirarte, 'The Santa Rita Murals: A Review' (unpublished), analyses them as a composite of 'Maya, Mixtec, Mixteca-Puebla, and possibly Aztec sources' with the 'controlling visual and thematic language' being Mixtec and Mixteca-Puebla. Their dating is still uncertain. Quirarte believes the painters were 'Maya, Maya-Toltec or Putun (Chontal) Maya'.

58. On the character and significance of plumbate pottery, see A. O. Shepard, *Plumbate* (Washington, 1948).

320. 59. Lothrop, *op. cit.* (Note 20), 74–7. W. Bray, 'Maya Metalwork', *Social Process* (London, 1977), 365–403, offers a complete list of known metal finds and their forms, techniques, and dates, including Mexican and Isthmian connexions.

60. S. K. Lothrop, *Tulum* (Washington, 1924), 50–61. Also M. A. Fernández, 'El templo no. 5 de Tulum', *Los Mayas antiguos* (Mexico, 1941), 157–82. A. Miller is preparing new drawings and field studies on East Coast murals, as well as the drawings of Chichén Itza murals by Adela Breton, now in Bristol, England ('Mural Painting', *I.C.A.*, XL (1972), 465–71). D. Robertson, 'Tulum Murals', *I.C.A.*, XXXVIII (1968), vol. 2, 77–88, suggests an 'international' post-Classic style.

61. On the possibility that painted flakes of plaster, found in an Early Classic tomb at Uaxactún, are the remnants of a book, see R. E. Smith, *C.A.A.H.*, IV (1937), 216.

62. J. E. S. Thompson, *Maya Hieroglyphic Writing* (Washington, 1950), 23–6. For study of the content, the most accessible edition of the four manuscripts is the outline facsimile of J. A. Villacorta C., *Los Códices Mayas* (Guatemala, 1930). Study of draughtsmanship and technique is best made with the photographic facsimiles: E. Förstemann, *Die Maya-Handschrift der königlichen Bibliotek zu Dresden* (Leipzig, 1892); *Códice Maya denominado Cortesiano*, ed. J. de la Rada y Delgado and J. López de Ayala (Madrid, 1892); *Manuscrit Troano*, ed. C. E. Brasseur de Bourbourg (Paris, 1869–70); *Codex Peresianus*, ed. L. de Rosny (Paris, 1887). An indispensable aid is the collection of papers by E. Förstemann, P. Schellhas, and

A. M. Tozzer, published in *P.M.P.* IV (1904–10).

63. P. Schellhas, 'Representation of Deities of the Maya Manuscripts,' *P.M.P.*, IV (1904–10), 1–47; cf. Thompson, *Maya Hieroglyphic Writing* (Washington, 1950). G. Zimmerman, *Die Hieroglyphen der Maya-Handschriften* (Hamburg, 1956), 161–8, separates deities of favourable and unfavourable aspect. On Maya gods, J.E.S. Thompson, *Maya History and Religion* (Norman, 1970), 197–329.

Much disagreement surrounds these figures, whose meaning varies according to technical mode, region, and period. Robiczek, 'Mythological Identity of God K', *M.R.P.*, IV (1969), 127, warns against 'creating mythology instead of interpreting it', and detects seven distinct sub-groups among the known representations of 'God K'. See also M. Greene Robertson, '*Inscriptions* Piers of Palenque', *M.R.P.*, IV (1979), 129–38, where 'God K' is taken to stand for blood lines and 'divine rulership rights'.

322. 64. E. Seler, 'Venus Period in the Picture Writings of the Borgia Codex Group', *B.B.A.E.*, XXVIII (1904), 355–91.

65. Twenty-seven Initial Series dates are recorded in the Dresden manuscript, ranging between 8.6.16.12.0 on p. 70 and 10.19.6.1.8 (A.D. 1216) on p. 51. The date of manufacture may well be this latest one, although others, e.g. C. F. Bowditch, preferred 9.9.16.0.0 (A.D. 629) as the date of composition. Spinden specified western Yucatán, south of Uxmal or in Tabasco, pointing to similarities with south Mexican manuscripts; 'A Study of Maya Art', *P.M.M.*, VI (1913), 153. J. E. S. Thompson, in his *Commentary on the Dresden Codex* (1972), 15, prefers a date between 1200 and 1250.

66. A. Miller, 'Tancah and Tulum', in E. Benson (ed.), *The Sea in the Pre-Columbian World* (Washington, 1977); *idem*, 'Mural Painting', *I.C.A.*, XL (Genoa, 1972), 465–71. The Grolier Codex (Coe, *The Maya Scribe*, New York, 1973, 150–1), although made of an amate paper radiocarbon-dated as between 1100 and 1360, was shown by Thompson (*U.C.A.R.F.*, XXVII, 1975, 1–9) to be of modern drawing by chemical analysis of the inks and pigments.

CHAPTER 10

325. 1. S. de Borhegyi, 'Guatemalan Highlands', *H.M.A.I.*, 11 (1965), 3–58, and S. W. Miles, 'Sculpture of the Guatemala-Chiapas Highlands', *ibid.*, 237–75; P. Becquelin, *Nebaj* (Paris, 1969). Review of the later archaeological evidence by C. Navarrete, 'Algunas influencias mexicanas en el area maya meridional durante el posclásico tardió', *Estudios de Cultura Náhuatl*, XII (1976), 345–82.

2. A. L. Smith, *Archaeological Reconnaissance in Central Guatemala* (Washington, 1955), 75.

3. W. Libby, *Science*, CXX (1954), 720. Structure 4 measured 3142 (1188 B.C.) ± 240; Structure 5 measured 2490 (536 B.C.) ± 300. Opinion is still divided on the interpretation of these and other radiocarbon datings: see M. Coe, 'La Victoria', *P.M.P.*, LIII (1961), 128, and Borhegyi, *op. cit.*, 7, note 2. On the earliest pyramids, see B. Spranz, *Totimehuacán* (Wiesbaden, 1970), 39–44.

4. E. M. Shook and A. V. Kidder, 'Mound E-III-3, Kaminaljuyu', *C.A.A.H.*, XI (1952), 33–128, and figure 16b.

5. Cf. Marquina, lám. 21.

6. A 7–8 and B 4–5 were built of pumice and mud. Kidder, Shook, and Jennings (*op. cit.*, 95) have placed A 6 and B 3; A 7 and B 4 as coeval. A 8 precedes B 5 by a small interval. They suppose that 'no more than a century, perhaps even as little as fifty years, would cover the entire life of the two mounds'. Lacking at Kaminaljuyú is the figurine production of Teotihuacán; lacking at Teotihuacán are the sumptuous burials of Kaminaljuyú. Further work is recorded by J. W. Michels and W. T. Sanders (eds.), *Kaminaljuyu Project* (1973).

326. 7. R. B. Woodbury and A. S. Trik, *The Ruins of Zaculeu*, I (Richmond, 1953), 284.

8. A. L. Smith, *op. cit.*, 76, and 'Altar de Sacrificios', *P.M.P.*, LXII, no. 2, 51 and figure 16.

9. M. W. Stirling, 'Stone Monuments of Southern Mexico', *B.B.A.E.*, CXXXVIII (1943), 60–74. S. Miles, 'Sculpture', *H.M.A.I.*, II (1965), 237 f., distinguishes in the region from Tonala to Tazumal four 'divisions': (1) pre-Olmec; (2) coastal Olmec; (3) pre-Classic Kaminaljuyú-Izapa; (4) Izapa narrative style during 'transition' to Early Classic. There follow four 'Pipil' periods from Early to Post-Classic: (1) Early Classic (Esperanza); (2) Late Classic (Cotzumalhuapa); (3) Early Post-Classic (San Juan plumbate); (4) Mexican Pipil.

327. 10. S. W. Miles, 'Sculpture of the Guatemala-Chiapas Highlands and Pacific Slopes', *H.M.A.I.*, II (1965), and S. Ekholm-Miller, 'Mound 30, Izapa', *Papers of the New World Archaeological Foundation*, no. 25 (Provo, 1969). J. Quirarte, *Izapan-Style Art* (Washington, 1973), defines the traits of this style during the late pre-Classic period. He returns to the theme, in order to contrast Izapa, Maya, and Olmec traditions, in 'Early Art Styles', *Origins* (Albuquerque, 1977), 249–83.

11. J. Graham, R. F. Heizer, and E. M. Shook, 'Abaj Takalik', *U.C.A.R.F.*, XXXVI (1978), 85–114, report Maya dates older than any others known (Stela 2, first century B.C., and Stela 5, A.D. 126). See also J. Graham, 'Discoveries', *Archaeology*, XXX

(1977), no. 3, 197, and 'Maya, Olmecs and Izapans', *I.C.A.*, XLII (1976), vol. VIII (1979), 179–88.

328. 12. These groupings are still fluid and inconsistent: Izapa, Stelae 3 and 11 appear in Divisions 1, 2, and 3 (Miles, *op. cit.*, 242–57).

13. *Classic Maya Sculpture*, 177. Also K. A. Dixon, 'Two Masterpieces of Middle American Bone Sculpture', *Am.A.*, XXIV (1958), 53–62. Mino Badner ('A Possible Focus of Andean Artistic Influence in Mesoamerica', *Studies in Pre-Columbian Art and Archaeology*, no. 9, Washington, Dumbarton Oaks, 1972) proposes iconographic parallels between Izapa and Chavín. J. Quirarte, 'Narrative Frames', *M.R.P.*, I (1974), 129–36, seeks to relate Izapa and Palenque by means of symbolic frames which he sees as common to both.

329. 14. M. W. Stirling, *op. cit.*, 31, 48.

15. On the sculpture of Kaminaljuyú, see Lothrop, *Indian Notes and Monographs*, III (1926), 147–71. The silhouetted reliefs figured by A. V. Kidder, E. M. Shook, and J. D. Jennings, *Excavations at Kaminaljuyu* (Washington, 1926), figure 141, probably belong to this group and period, although their exact provenance is unknown.

L. Bardawil, 'Principal Bird Deity in Maya Art', *M.R.P.*, III (1976), 195–209, seeks to identify Maya bird forms with those of Izapan art, using the 'long-lipped' profile of illustration 275 as a trait of continuity, and assuming that it is an 'avian manifestation of Itzamna' and therefore Principal Bird Deity in Maya art.

16. In E. Pasztory (ed.), *Middle Classic Mesoamerica* (New York, 1978), 79–81.

17. Thompson, *C.A.A.H.*, IX (1948), 51. Barbara Braun assembles evidence on ball-game iconography documenting the conduct of the ritual in the Cotzumalhuapa culture *c.* A.D. 400–900.

330. 18. L. Parsons, *Bilbao*, II (Milwaukee, 1969), 138. These dates do not consider the possibility that the reliefs were produced by a later people who installed their work on platforms of much older construction. This is again the problem, as at La Venta (p. 126), of dating the sculpture in a museum by the architecture of the museum.

331. 19. A. O. Shepard, *Plumbate* (Washington, 1948), figure 18.

20. Kidder, Shook, and Jennings, *op. cit.*, 229–32; G. Lowe and P. Agrinier, 'Excavations at Chiapa de Corzo', *Papers of the New World Archaeological Foundation*, no. 8 (1960); A. Trik and R. Woodbury, *Zaculeu* (Richmond, 1953); G. Guillemin, 'Urbanism and Hierarchy at Iximche', *Social Process* (London, 1977), 227–64; P. Becquelin, *Nebaj* (Paris, 1969).

21. A. O. Shepard, *Plumbate*. Also 'Studies in Ancient Soconusco', *Archaeology*, XI (1958), 48–54.

The term is misleading but traditional. No lead salts are present. Only the colour seems leaden.

332. 22. R. E. Smith, 'Tohil Plumbate and Classic Maya Polychrome Vessels in the Marquez Collection', *N.M.A.A.E.*, no. 129, V (1954–7), 117–30.

23. R. J. Sharer *et al.*, *Chalchuapa*, 3 vols. (Philadelphia, 1978), give a full account of excavations in western Salvador showing the 2600-year pendulum of east-west external influences in this frontier area between dominant Olmec-Maya-Mexican ascendancies and weaker Central American ones.

24. C. F. Baudez, *Amérique Centrale* (Geneva, 1970), and volume IV of the *Handbook of South American Indians*, edited by Julian Steward and entitled 'The Circum-Caribbean Tribes', *B.B.A.E.*, CXLIII (1948). Baudez distinguishes the Mesoamerican zone as a Pacific coast area including Salvador, western Honduras and Nicaragua, and north-west Costa Rica. The South American zone is Caribbean, lying eastward in those countries and including all of Panamá.

333. 25. Doris Stone, *Pre-Columbian Man Finds Central America* (Cambridge, Mass., 1972). Also F. B. Richardson, 'Non-Maya Monumental Sculpture of Central America', *The Maya and their Neighbors*, 395–416, and Doris Stone, *Introduction to the Archaeology of Costa Rica* (San José, 1958). For Salvador archaeology, see J. M. Longyear III, *H.M.A.I.*, IV (1966), 132–55; western Honduras, J. B. Glass, *ibid.*, 157–79; lower Central America, S. K. Lothrop, *ibid.*, 180–207.

For north-eastern Honduras, P. Healy, 'Selin Farm', *Vinculos*, IV (1978), 60, reports five radio-carbon dates (A.D. 375–745) in the Selin period (A.D. 300–1000). Commerce with Mesoamerica is present but contact with lower Central America 'nonexistent'. R. Reyes, 'Influencias epi-Teotihuacanas', *Vinculos*, III (1977), 47–65, analyses rock-carvings from southern Guatemala, Salvador, and Honduras in relation to arts of Teotihuacan and Ñuiñe origin.

26. H. J. Spinden, 'The Chorotegan Culture Area', *I.C.A.*, XXI (1924), 529–45, believed the eastern types were derived from the Ulúa vessels, but Doris Stone, 'Masters in Marble', *M.A.R.S.*, Publ. 8, holds the opposite. See also Doris Stone, 'Archaeology of the North Coast of the Honduras', *P.M.M.*, IX (1941); S. Borhegyi, 'Travertine Vase in the Guatemala National Museum', *Am.A.*, XVII (1952), 254–6; J. Glass, *op. cit.*, 173; D. Stone, *Pre-Columbian Man* (1972), 140–1.

334. 27. On the meagre history of the extinct Guetar people, see S. K. Lothrop, *Pottery of Costa Rica and Nicaragua*, I (New York, 1926), 15–16.

28. *Science*, CXXVII (1958), no. 3290, 136. Sculp-

ture from Las Pacayas on Mount Irazú is figured by J. A. Mason, *Costa Rican Stonework* (*A.M.N.H.A.P.*, XXXIX) (New York, 1945).

335. 29. J. A. Mason, *Costa Rican Stonework*, 293–301.

30. Jorge A. Lines, *Los altares de Toyopan* (San José, 1935).

337. 31. C. V. Hartman, 'Archaeological Researches on the Pacific Coast of Costa Rica', *Memoirs of the Carnegie Museum*, III (1907), 1–188.

32. The mainland jaguar *metates* extend into western Panama. See S. K. Lothrop, 'Archaeology of Southern Veraguas, Panama', *P.M.M.*, IX (1950), 27–31.

33. Lothrop, *Pottery*, 116, 173–7, and plate LXVIIIb.

34. C. Baudez, *Amérique Centrale* (Geneva, 1970), 108, fixes the period as 800–1200. R. Accola, 'Revisión de tipos de cerámica en Guanacaste', *Vinculos*, IV (1978), no. 2, 80–105, shifts from a typological (Ford) to a 'modal' classification (Rouse), retaining the Baudez chronology.

35. E.g. Lothrop, *Pottery*, plate XXVI.

338. 36. Guápiles jades are described by S. K. Lothrop, *Pre-Columbian Art* (New York, 1957), 30–1, and 'Jade and String Sawing in Northeastern Costa Rica', *Am.A.*, XXI (1955), 43–51. C. V. Hartman, *op. cit.*, plates XXXII–XLV, illustrates many jades from the cemeteries at Las Guacas and other sites of the Peninsula. Baudez, *op. cit.*, 69, assigns the jades to his period II (300 B.C.–A.D.500) by their association with pottery of Linear Decorated phase. E. Easby, *Pre-Columbian Jades from Costa Rica* (New York, 1968).

37. Doris Stone, *H.S.A.I.*, IV, 190, favours the Central American thesis; F. B. Richardson, in *The Maya and their Neighbors*, 415, favours South American origins. H. J. Spinden, *Maya Art and Civilization* (Indian Hills, 1957), 341–4, enumerates the Mexican antecedents of the 'Chorotegan' people; also Lothrop, *Pottery*, 91–4.

38. On *alter ego* figures; E. Nordenskiöld, *Origin of the Indian Civilizations of South America* (Göteborg, 1931).

39. Chontales figures are discussed by F. B. Richardson, *op. cit.*, 412–16. The late statues are reproduced by E. G. Squier, *Nicaragua* (New York, 1852), and by Carl Bovallius, *Nicaraguan Antiquities* (Stockholm 1886). Good photographs in C. Baudez, *op. cit.*, figures 84–9.

40. Carl Bovallius, who discovered the statue, described it as a crocodile.

Nicoya mace-heads are illustrated by C. V. Hartman, *op. cit.*, plates XXV–XXXI. Both *alter ego* figures and stone mace-heads have South American

antecedents. A. Kidder II, 'South American Penetrations in Middle America', *The Maya and Their Neighbors*, 431–41.

339. 41. F. Boyle, 'The Ancient Tombs of Nicaragua', *Archaeological Journal*, XXIII (1866), 41–50; J. F. Bransford, Archaeological Researches in Nicaragua', *Smithsonian Contributions to Knowledge*, XXV (1881). Stone grave-markers like these occur near San Agustin in Colombia (see pp. 343–5).

42. Concise review by S. K. Lothrop, 'The Archaeology of Panama', *H.S.A.I.*, IV (1948), 143–67. In more detail, G.G. MacCurdy, 'A Study of Chiriquian Antiquities', *Memoirs of the Connecticut Academy of Arts and Sciences*, III (1911). On Barriles, C. Baudez, *op. cit.*, 159–60. Valuable overview by O. Linares, 'Ancient Panama', *D.O.S.*, XVII (1977).

43. S. K. Lothrop, 'Archaeology of Southern Veraguas', *P.M.M.*, IX (1950), 27–30.

340. 44. S. K. Lothrop, 'Coclé', *P.M.M.*, VII (1937), VIII (1942); A. Emmerich, *Sweat of the Sun and Tears of the Moon* (New York, 1965).

45. G. Willey, *Introduction*, II (1971), 358, note 209.

CHAPTER II

341. 1. An older introduction to the archaeology is by W. C. Bennett and J. Bird, *Andean Culture History* (New York, 1949). Also fundamental is the exhibition catalogue by W. C. Bennett, *Ancient Arts of the Andes* (New York, 1954), describing the display at the Museum of Modern Art. A synthesis of recent archaeology appears in E. P. Lanning, *Peru before the Incas* (Englewood, N. J., 1967), who presents 'a theory explaining the growth of prehistoric Peruvian civilization', without dependence on 'developmental stages'. See J. Rowe, 'Stages and Periods', in J. Rowe and D. Menzel, *Peruvian Archaeology, Selected Readings* (Palo Alto, 1967), 1–15.

342. 2. Bennett and Bird, *A.C.H.*, 95–244. The most recent exposition of this system is by G. Willey and P. Phillips, *Method and Theory in American Archaeology* (Chicago, 1958). Contrast Lanning, *op. cit.*, 24–5 and table 2.

3. C. Osgood and G. D. Howard, *An Archaeological Survey of Venezuela* (New Haven, 1943).

343. 4. B. Meggers, C. Evans, E. Estrada, *Early Formative Period of Coastal Ecuador* (Washington, 1965). G. Willey, *Introduction*, II, 275–6 and 350 reviews the state of opinion.

5. J. Alden Mason, 'Archaeology of Santa Marta, Colombia. The Tairona Culture', *F.M.N.H.A.S.*, XX (1931–9); G. Reichel-Dolmatoff, *Colombia* (New York, 1965), 142 f.

6. The 'Chibcha' tribes near Bogotá are sometimes called Muisca, to avoid confusing the tribe with the linguistic stock. J. Pérez de Barradas, *Colombia de Norte a Sur* (Madrid, 1943).

7. W. C. Bennett, 'Archaeology of Colombia', *H.S.A.I.*, II (1946), 830; also *Archaeological Regions of Colombia: A Ceramic Survey* (New Haven, 1944), 109–13.

8. J. Pérez de Barradas, *Arqueología y antropología precolombinas de Tierra Dentro* (Bogotá, 1937). Presented as a chronological sequence spanning the ninth to twelfth centuries A.D., this arrangement is merely typological, without conclusive evidence as to time. G. Willey, *Introduction*, II, 316, now dates the chambers as earlier than those of San Agustín.

9. Gregorio Hernández de Alba, 'The Archeology of San Agustín and Tierradentro, Colombia', *H.S.A.I.*, II, 851–9.

10. Extended description in G. Hernández de Alba, *Revista de las Indias*, II (1938), no. 9, 10.

11. W. Krickeberg, *Felsplastik und Felsbilder bei den Kulturvölkern Altamerikas* (Berlin, 1949), 38–9.

345. 12. K. T. Preuss, *Monumentale vorgeschichtliche Kunst* (Göttingen, 1929); J. Pérez de Barradas, *Arqueología agustiniana* (Bogotá, 1943). G. Reichel-Dolmatoff, *San Agustín* (London, 1972), 55–6, describes the whole culture, and defines six categories of free-standing sculpture (columnar, flat, full-round, shaft, peg, and isolated heads). These he separates (69) into 'archaic', 'expressionistic', and 'abstract' styles. Many figures show a 'jaguar-monster' (see Reichel-Dolmatoff, 'The Feline Motif', *Cult of the Feline*, Washington, 1972, 51–68) which he relates to modern shamanism in Colombian ethnology.

13. Reichel-Dolmatoff, *San Agustín*, 127, reports a Carbon 14 dating for a tomb (Alto de Lavapatas) as 550 B.C. In 1970 (*Cult of the Feline*, 67) he mentioned pottery evidence for dating the sculpture 1500–1000 B.C. Various other chronological schemes are summarized by G. Willey, *Introduction*, II (1971), 356, note 150. According to Reichel-Dolmatoff, *Colombia* (1965), 94, L. Duque Gómez proposes an early period (555 B.C.–A.D. 425) of shaft graves and wooden carvings; middle (A.D. 425–1180) stone sarcophagi and statuary; and late (after 1100) 'realistic' stone sculpture.

347. 14. Pérez de Barradas, *op. cit.*

15. Extended discussion of *alter ego* in Preuss, *op. cit.*, 108–16. Hallucinogenic art: G. Reichel-Dolmatoff, 'The Feline Motif in Prehistoric San Agustin Sculpture', in *Cult of the Feline*, ed. E. Benson (Washington, 1972), 61–2.

16. The best technical discussion is by W. C. Root, *H.S.A.I.*, V, 205–25, placing Colombian work in relation to the rest of America. For Colombia proper J.

Pérez de Barradas, *La orfebrería prehispánica de Colombia*, 6 vols. (Madrid, 1954–66). P. Rivet and H. Arsandaux, *La métallurgie en Amérique précolombienne* (Paris, 1946), 176, supposed that Colombian techniques came from lowland South America, on linguistic rather than archaeological evidence. G. Willey, *Introduction*, 11, 277; A. Emmerich, *Sweat of the Sun* (Seattle, 1965), 66, assigns Calima goldwork to a period from before 100 B.C. until perhaps the fourth century A.D. A. Dussan de Reichel, 'Goldwork of Colombia', in E. Benson (ed.), *Pre-Columbian Metallurgy of South America* (Washington, 1979), 41–52, regards the formal analysis as lacking meaning, and the chronological speculations as highly doubtful.

17. Legs of a figurine in *tumbaga* of Veraguas type. Illustrated by G. Stromsvik, *C.A.A.H.*, VII (1942), no. 37, figure 14. D. Pendergast, *Science*, CLXVIII, no. 3927 (3 April 1970), 116–18, reports another *tumbaga* find as of *c.* A.D. 500, perhaps from Coclé, found at Altun Ha.

18. H. Trimborn, *Señorío y barbarie en el valle del Cauca* (Madrid, 1949), 174 f.

19. *Orfebrería prehispánica de Colombia*, 301. See also Enzo Carli, *Pre-Columbian Goldsmiths' Work of Colombia* (London, 1957).

20. S. K. Lothrop, *H.S.A.I.*, IV, 159.

21. S. K. Lothrop, *Pre-Columbian Art* (New York, 1957), 271, calls it Conto style, from the earlier name of the town near which the graves occur. Today the town is called Restrepo.

348. 22. The magnificent volumes of text and plates by J. Pérez de Barradas, *op. cit.*, illustrate the entire subject. Barradas inclines to the view that Oceanic *tiki* figures played a part in the formation of Calima style (pp. 319–20).

23. *Op. cit.*, 321.

349. 24. G. Hernández de Alba, *Colombia, Compendio arqueológico* (Bogotá, 1938), 51–3, wrote of the style of the left bank of the Atrato as 'Chiriquí' and of the right bank as Darién. The confusion with eastern Central America is obvious. 'Atrato style' would be preferable. The term 'Chiriquí' was first used by V. Restrepo (*Los Chibchas antes de la Conquista*, Bogotá, 1895).

25. Lothrop, 'Metals from the Cenote of Sacrifice', *P.M.M.*, X (1952), no. 2, figure 88, p. 95.

26. P. Rivet and H. Arsandaux, *op. cit.*, 25.

351. 27. *Orfebrería*, 298.

28. G. Hernández de Alba, *El Museo del oro* (Bogotá, 1948), lámina 89.

29. W. C. Root, *H.S.A.I.*, V, 211.

30. Lothrop, 'Coclé', *P.M.M.*, VII (1937), 204. G. Willey, *Introduction*, II (1971), 328–33, now dates Coclé from 500 to 1000.

31. Illustrated by H. Lavachéry, *Les arts anciens d'Amérique au Musée archéologique de Madrid* (Antwerp, 1929), 78–99.

32. The process has been reconstructed in detail by Dudley T. Easby, Jr, *University Museum Bulletin*, XX (1956), no. 3, 3–16.

33. A. Basler and E. Brummer, *L'art précolombien* (Paris, 1928), 39.

352. 34. Illustrated in W. C. Bennett, *Archaeological Regions of Colombia: A Ceramic Survey* (New Haven, 1944), especially plate 10 F. See also K. Bruhns, 'Stylistic Affinities', *Ñ.P.*, VII–VIII (1969–70), 65–84; and '*Cire perdue* Casting Moulds', *Man*, VII (1972), no. 2, 308–11, dated as of A.D. 900–1200.

35. I. Large-headed statuettes.
1. University Museum, Philadelphia (SA2752). Seated aged woman.
2. University Museum, Philadelphia (SA2751). Seated woman.
3. Museum für Völkerkunde, Berlin. Seated man.
4. Museum für Völkerkunde, Berlin. Standing man.
5. Museum für Völkerkunde, Berlin. Seated figure, bearing horizontal staff in both hands, from Manizales.
II. Small-headed statuettes.
1. Museo Arqueológico, Madrid. Seated fat woman.
2. Museo Arqueológico, Madrid. Seated man on stool.
3. Museo Arqueológico, Madrid. Seated woman bearing double scrolls.
4. Museo Arqueológico, Madrid. Standing man clasping double scrolls.
5. Museo Arqueológico, Madrid. Standing, empty-handed man.
6. Bogotá, Museo del Oro. Standing man (fragment), from Zamarraya in the Choco region.
The Berlin figures are illustrated by W. Krickeberg, *Atlantis* (1931), and the Madrid ones by H. Lavachéry, *op. cit.* The Philadelphia pieces are both illustrated in D. T. Easby, Jr, *op. cit.*

36. E. Restrepo Tirado, *Los Quimbayas* (Bogotá, 1912), 12–15.

353. 37. Comprehensive review of the history of the tribes by A. L. Kroeber, 'The Chibcha', *H.S.A.I.*, II, 887–910. A copper figurine, of carbon date A.D. 1055 ± 59, from the Muisca area, was made by lost-wax casting over a core of clay and charcoal. The face was formed over a stone matrix (W. Bray, *Gold Bulletin*, XI, 1978, 139).

354. 38. Pottery figurines of Mesoamerican types from Tumaco Island and shore are dated by Reichel-Dolmatoff (*Colombia*, 1965, III) *c.* 500 B.C.,

although the iconographic types are similar to those of Teotihuacán at the earliest (e.g. body with head in abdomen). J. C. Cubillos, *Tumaco* (Bogotá, 1955), describes the Colombian sector. See also H. Nacht-igall, *B.A.*, N.F. III (1955), 97–121. J. H. Rowe, *Archaeology*, 11 (1949), 31–4, labels the region Atacames in order to include Esmeraldas and Tumaco. The pottery from the tropical Esmeraldas coast is best studied in R. d'Harcourt, *J.S.A.*, XXXIV (1942–7), 61–200. M. H. Saville, *Antiquities of Manabí* (New York, 1907–10), treats the forested coast south of the Equator. G. H. S. Bushnell, *Archaeology of the Santa Elena Peninsula* (Cambridge, 1951), has excavated the arid country west of Guayaquil. R. d'Harcourt, *J.S.A.*, XXXVII (1948), 323, first asserted the unity of the stylistic area between Tumaco and Guayas. M. D. Coe's excavations in Guatemala confirm Spinden's 1917 thesis of early diffusion between Middle and South America; 'Archaeological Linkages with North and South America at La Victoria, Guatemala', *A.A.*, LXII (1960), 363–93. These are enumerated by B. Meggers, *Ecuador* (New York, 1966). See also C. Evans and B. Meggers, 'Mesoamerica and Ecuador', *H.M.A.I.*, IV (1966).

On Formative, pre-Classic, or pre-ceramic periods and typologies, see the handbook by J. A. Ford, *Comparison of Formative Cultures in the Americas* (Washington, 1969). Ford accepted transpacific diffusion from Japan for Valdivia.

355. 39. J. M. Corbett, 'Some Unusual Ceramics from Esmeraldas', *Am.A.*, XIX (1953–4), 145–52; H. Lehmann, 'Le personnage couché sur le dos', *I.C.A.*, XXIX (1951), 291–8 (in vol. entitled 'The Civilizations of Ancient America'). Also *Am.A.*, XIX (1953–4), 78–80.

40. H. Bischof, 'The Origins of Pottery in South America', *I.C.A.*, XL (1973), vol. I, 270–83, reports pre-ceramic layers under Valdivia, and earlier radiocarbon dates for Puerto Hormiga pottery than at Valdivia.

G. F. McEwan and D. B. Dickson, 'Nautical Problems', *Am.A.*, XLIII (1978), 362–71, find the transpacific thesis 'highly improbable'. Also counter to it: B. D. Hill, 'New Chronology', *Ñ.P.*, X–XII (1972–4), 1–32, proposing eight Valdivia phases (c. 3200–1900 B.C.).

356. 41. 'Las civilizaciones del sur de Centro América y el noroeste de Sud América', *I.C.A.*, XXIX (1952), 165–72 ('The Civilizations of Ancient America'). On Guangala and Manteño spindle whorls with decorations, J. Wilbert, *The Thread of Life* (Washington, 1974).

42. Saville, *Antiquities*, I, plate LI, 4; II, plates LXXXV, LXXXVIII, 3/4; LXXXIX, 4, 5; CX, 6, 9. R.

d'Harcourt, *J.S.A.*, XXXIV (1942–7), plate XIX, 2, 4.

43. J. C. Cubillos, in *Tumaco*, dates them in the same epoch as Upper Tres Zapotes. On Formative Period pottery in coastal Ecuador, see C. Evans and B. J. Meggers, *Am.A.*, XXII (1951), 235–47; B. Meggers, C. Evans, and E. Estrada, *Early Formative Period of Coastal Ecuador* (Washington, 1965); G. Willey, *Introduction*, II (1971), 275.

44. Illustrated by Saville, *Antiquities*, I, plate LI, 4. C. Evans and B. J. Meggers have found figurines of 2500–2000 B.C. near Guayaquil; 'Valdivia', *Archaeology*, XI (1958), 175–82. See also D. W. Lathrap, *Ancient Ecuador* (Chicago, 1975).

357. 45. G. H. S. Bushnell, 'The Stone Carvings of Manabí', *I.C.A.*, XXX (1952), 58–9.

46. *Antiquities*, II, figure 17, p. 147.

358. 47. J. Jijón y Caamaño, *Puruhá* (Quito, 1927). D. Collier, *H.S.A.I.*, II, 783, believes this chronology needs contraction. Our dates are from B. Meggers, *Ecuador* (1966), 25.

48. 'Peruvian Stylistic Influences in Ecuador', *M.S.A.A.*, IV (1948), 80–2.

CHAPTER 12

359. 1 W. C. Bennett, 'The Peruvian Co-Tradition', *M.S.A.A.*, IV (1948), 1–7. The admirable catalogues of the collections of the Museum für Völkerkunde in Berlin, by D. Eisleb (*Altperuanische Kulturen*, 2 vols., Berlin, 1975–7), discuss Chavín, Paracas, Virú, Vicús, and Nazca pottery, stone, metal, and textile objects in the Macedo, Baessler, Seler, Gretzer, and other deposits.

2. R. Larco Hoyle, 'La escritura peruana pre-incana', *M.A.*, VI (1944), 219–38.

360. 3. S. Izumi and S. Toshihiko, *Excavations at Kotosh* (Tokyo, 1963), 46, plate 15 and figure 26; E. Lanning, *Peru before the Incas* (Englewood, 1967), 83; also S. Izumi in *Dumbarton Oaks Conference on Chavín* (1971), 49–72. C. Kano, *D.O.S.*, XXII (1979), 7, believes the sequence of pottery types began in the Wairajirca phase of the Huallaga river basin, continuing through the Kotosh phase, and at peak in the Chavín period. He based the sequence on excavations at Shillacoto (Huánuco), as follows:

Shillacoto-Mito 2000–1800
Shillacoto-Wairajirca 1800–1500
Shillacoto-Kotosh 1500–200
Shillacoto Higueras 200–0
(Kano, 'Shillacoto', *I.C.A.*, XXXIX, vol. III, 1971, 52–62.) See also T. Matsuzawa, 'Las Haldas', *Am.A.*, XLIII, no. 4, 652.

4. M. N. Porter, *Tlatilco* (New York, 1953). J. C. Tello, *Antiguo Perú* (Lima, 1929), championed the

thesis of highland priority. On earliest Peruvian appearances of pottery, Lanning, *op. cit.*, 82–8.

5. T. Pozorski, 'Huaca de los Reyes', *Am.A.*, XLV (1980), 100–10.

6. J. Bird, 'South American Radiocarbon Dates', *M.S.A.A.*, VIII (1951), 37–49.

362. 7. G. Willey, 'Prehistoric Settlement Patterns in the Virú Valley', *B.B.A.E.*, CLV (1953), 38–42; W. D. Strong, *M.S.A.A.*, XIII (1957), 10.

8. Lanning, *Peru*, 65–8. Excavations by T. Grieder, *Ñ.P.*, XIII (1975), 99–112, span Carbon 14 dates 780 ± 70 B.C. to 410 ± 90 B.C. for the third, terminal occupation. Building began before 1650 B.C. Also A. Bueno and L. Samaniego, 'Sechin', *Amaru*, XI (1969), on more recent excavations.

363. 9. The most elaborate example is by R. Carrión Cachot, 'La cultura Chavín', *R.M.N.A.A.*, II (1948).

10. 'The Chavín Problem: A Review and Critique', *Southwestern Journal of Anthropology*, VII (1951), 103–44.

11. M. N. Porter, *Tlatilco*, 71–9. M. Badner, *A Possible Focus of Andean Artistic Influence in Mesoamerica* (Washington, 1972), prefers to compare Izapa with Chavín.

12. J. Bird, *M.S.A.A.*, VIII (1951), 40–1.

13. First stated by A. L. Kroeber in 1926; restated *V.F.P.A.*, IV (1944), 86, and independently reworked by J. C. Muelle, *B.A.*, XXVIII (1955), 89–96, who also made an earlier analysis of Nazca traits in relation to Chavín sculpture (*R.M.N.L.*, VI (1937), 135–50).

14. R. Carrión Cachot, *op. cit.*, 65–74 (Ancón); A. L. Kroeber, 'Paracas Cavernas and Chavin', *U.C.P.A.A.E.*, XL (1953), 313–48.

15. S. K. Lothrop, 'Gold Artifacts of Chavin Style', *Am.A.*, XVI (1950–1), 226–40.

16. R. Larco Hoyle, *Los Mochicas*, I (Lima, 1938), 36; *idem*, *Los Cupisniques* (Lima, 1941), 8. Contrast J. C. Tello, *Arqueología del valle de Casma* (Lima, 1956), 14–20.

17. W. D. Strong and C. Evans, Jr, *Cultural Stratigraphy in the Virú Valley* (New York, 1952), 231. G. Willey, in his review of the problem (*Southwestern Journal of Anthropology*, VII (1951), 131), also favoured this interpretation, while rejecting the Chavín affinities of Sechín sculpture. Cf. Lanning, *Peru* (1967), 93, and D. Collier, 'Casma Valley', *I.C.A.*, XXXIV (1960), 411–17 [publ. 1962].

18. J. C. Tello, *op. cit.* A. Bueno Mendoza and L. Samaniego, 'Sechin', *Amaru*, XI (1970), 31–8, have reported inconclusive finds of non-Chavín pottery and more reliefs.

365. 19. Discussion in R. Larco, *Los Cupisniques*, 116–23. Also A. L. Kroeber, *Peruvian Archeology in 1942*, *V.F.P.A.*, IV (1944), 139–40.

366. 20. *Pre-Colombian Art*, plate CXX, no. 297, and Tello, *Antiguo Perú*, figure 112. Another such bridge is the carved conch shell from Chiclayo, illustrated by Larco, *Los Cupisniques*, figure 174: among interlaced serpents and feline profiles a standing man blows a conch-shell trumpet, wearing a curved-stripe eye decoration. (Also Tello, *El strombus en el arte Chavín*, Lima, 1937.)

368. 21. Tello's plan (our illustration 315) is only approximate. It does not correspond to his descriptions, because of the chaotic state of the upper portions.

22. Tello describes Head V as a 'dios felinomorfo', but his illustrations convey nothing of this description.

23. Best illustrations (plan and sections) in R. Larco Hoyle, *Los Mochicas*, figures 18–23: the Chavín-style painting is figured by Tello, *Sobre el descubrimiento de la cultura Chavín* (Lima, 1944), plate III.

369. 24. Maxcanú in Yucatán was described by J. L. Stephens, *Incidents of Travel in Yucatan*, I (New York, 1848), 214.

25. Description and rough sketch plan by W. C. Bennett, 'The North Highlands of Peru. Excavations in the Callejón de Huaylas and at Chavín de Huántar', *A.M.N.H.A.P.*, XXXIX (1944), 71–92. For excavations of 1955–6 and plan of successive building campaigns, see J. Rowe, *Chavin Art* (New York, 1962), 7–12. L. G. Lumbreras, 'Towards a Re-evaluation of Chavín', *Conference on Chavin* (Washington, 1971), 3–8, gives a plan of courts and galleries.

26. J. Rowe, *Chavin Art* (New York, 1962), 12–13, proposes a seriation related to building sequence, and lasting from *c.* 700 to 200 B.C. It opens with an archaic phase A B (to and including the *lanzón*). The Tello Obelisk defines phase C. Phase D is based on the sculptured columns of the portal, and correlated with Phases 4 and 5 of the Paracas sequence at Ica. Phase EF includes the Raimondi slab. A. I. Kroeber, 'Ancient Pottery from Trujillo', *F.M.N.H.A.M.*, II (1926), no. 1, 36–7, divided sculpture at Chavín into M and N phases. N refers to Nazca affinities, and M to Maya. Kroeber later proposed five stylistic groups (*Peruvian Archeology in 1942*, 88–9) of incised slabs, without pressing any chronological sequence, and omitting references to Maya sculpture. The Nazca connexions of the Raimondi Monolith were restated by J. C. Muelle, 'Del estilo Chavín', *B.A.*, N.F. III (1957), 89–96.

373. 27. J. C. Muelle, 'Filogenía de la estela Raimondi', *R.M.N.L.*, VI (1937), 135–50, connected this relief with the late Nazca style. L. G. Lumbreras and H. Amat Olozabal, 'Galerías interiores de Chavín', *R.M.N.L.*, XXXIV (1965–6), 143–97.

28. The best descriptions are by Tello, 'Discovery

of the Chavín Culture in Peru', *Am.A.*, IX (1941-2), 136-7, and *Origen y desarrollo de las civilizaciones prehistóricas andinas (I.C.A.*, XXVII, Lima) (Lima, 1942), 114-16. R. Larco Hoyle proposed the Nepeña Valley as the origin of all Chavín manifestations. He placed Punkurí coeval with Sechín, and prior to Cerro Blanco, which, with Chavín de Huántar, he regarded as contemporary with fully developed Mochica style (*Los Cupisniques*, 8-9).

29. Rowe (*Chavín Art*, 1962, 14-17) also speaks of 'modular width' (crediting L. Dawson), or banded designs with repeating features like eyes and fangs. See also Note 30 to Chapter 2 on crocodile earth-monsters in relation to artificial 'raised fields' in Mesoamerica.

375. 30. G. Willey, 'A Functional Analysis of "Horizon Styles" in Peruvian Archaeology', *M.S.A.A.*, IV (1948), 8-15; Bennett, *A.M.N.H.A.P.*, XXXIX (1944), 98-9.

31. Willey, *op. cit.*, 11.

32. The best account of Recuay archaeology is by W. C. Bennett, 'The North Highlands of Peru', *A.M.N.H.A.P.*, XXXIX (1944), 99-106. An important excavation in 1971 by T. Grieder at Pashash yielded nine Carbon 14 measurements (300-600) dating both the pottery and stone sculpture of Recuay affinities in a temple cache; 'Pashash', in M. E. King and I. R. Taylor (eds.), *Art and Environment in Native America* (Lubbock, 1974).

33. Cf. illustrations 324 and 325 in this volume with a Recuay vessel in Berlin, published by E. Seler in *Peruanische Alterthümer* (Berlin, 1893), plate 44, centre row, right end. On supposed parallels with Nicoya pottery from Costa Rica, W. Krickeberg, *Festschrift Schmidt* (Vienna, 1928), 381. He proposes a common origin in Colombia for both Nicoya and Recuay styles.

376. 34. Bennett, *Ancient Arts of the Andes* (New York, 1953), 141, and figure 159-60.

35. Kroeber, *F.M.N.H.A.M.*, 11 (1926), no. 1, 36.

36. Seler, *op. cit.*, plate 43, bottom row; plate 44, centre right.

37. Tello, *Antiguo Perú*, 36-46. The Macedo Collection is illustrated in Max Schmidt, *Kunst und Kultur von Peru* (Berlin, 1929), 231-42.

377. 38. H. Disselhoff discusses a Mochica vessel painted with battle-scenes between Mochica warriors and foreigners whom he identifies as Recuay tribesmen by their slings, shields, and head-dresses decorated with hands; 'Hand und Kopftrophäen in plastischen Darstellungen der Recuay-Keramik', *B.A.*, N.F. IV (1955), 25-32.

39. R. Schaedel, 'Stone Sculpture in the Callejón de Huaylas', *M.S.A.A.*, IV (1948), 66-79.

CHAPTER 13

379. 1. The most recent major work on Mochica and pre-Mochica archaeology is by W. D. Strong and Clifford Evans, Jr, 'Cultural Stratigraphy in the Virú Valley, Northern Peru, The Formative and Florescent Epochs', *C.S.A.E.*, IV (1952). For Chimu dynastic history, J. H. Rowe, 'The Kingdom of Chimor', *Acta Americana*, VI (1948), 26-59.

2. My estimate, based upon stratified guano accumulations in the Chincha Islands, extended Mochica duration into the ninth century A.D. (Kubler, 'Towards Absolute Time: Guano Archaeology', *M.S.A.A.*, IV, 1948, 29-50).

3. J. B. Bird, 'Pre-Ceramic Art from Huaca Prieta', *Ñ.P.*, 1 (1963), 29-34; Lanning, *Peru* (1967), 66.

380. 4. R. Larco Hoyle, *Los Mochicas* (Lima, 1938), 1, 20, and map between pp. 56-7, and *Cronología arqueológica del norte del Perú* (Buenos Aires-Chiclin, 1948), 15-24. The best account is by W. Bennett, in *A.M.N.H.A.P.*, XXXVII (1941), 90-3. The only intact graves were in the Chicama Valley near Sausal; Larco, *Los Cupisniques* (Lima, 1941), 177-242.

5. *Cronología*, 15-24. To counter Tello's hypotheses of eastern Andean origins for the Chavín style, Larco proposed that the coastal pottery of heavy form with incised or modelled decoration on monochrome surfaces was archetypal, and that it be called Cupisnique. But the intact examples answering this description come from many valleys other than Cupisnique. Very few were excavated under proper control, and most of the vessels appeared in commerce as the results of illegal digging under destructive conditions.

6. H. Ubbelohde-Doering, 'Ceramic Comparisons of Two North Coast Peruvian Valleys', *I.C.A.*, XXIX (1951) ('Civilizations of Ancient America'), 224-31, encountered comparable juxtapositions in the graves of the Jequetepeque Valley. His 'Chavín' examples look more Mochica than Chavín.

7. *Los Cupisniques*, 34.

8. J. Rowe, 'Influence of Chavín Art on Later Styles', *Conference on Chavin* (Washington, 1971), 101. Larco's classification in 1948 (*Cronología*, 15-20) alters these groups: his 'early Cupisnique' includes A and D vessels; 'Transitorio' has B and C shapes; 'Santa Ana' has B and D. On these vessel-types in the underground galleries of Chavín de Huántar, see L. G. Lumbreras, 'Re-evaluation', *Conference on Chavin* (Washington, 1971), 1-27. H. Lechtman and others, 'Gold Jaguars', *D.O.S.* XVII (1975), show such persistences between Chavín and Mochica in metallurgy.

9. R. Larco Hoyle, *Cultura Salinar* (Buenos Aires, 1944). Detailed discussion of other coastal occur-

rences of Salinar style in Strong and Evans, *C.S.A.E.*, IV (1952), 237–9.

381. 10. Strong and Evans, *op. cit.*, 237–40.

382. 11. W. C. Bennett, *The Gallinazo Group, Virú Valley, Peru* (New Haven, 1950); Strong and Evans, *loc cit.*, and figures 57–60.

383. 12. J. A. Bennyhoff, 'The Virú Valley Sequence: A Critical Review', *Am.A.*, XVII (1952), 231–49, criticizes the authors of the Virú project for interpreting sequence where coexistence is equally tenable. On Vicús, see A. Sawyer, *Ancient Peruvian Ceramics* (New York, 1966), 19–20, and *Master-craftsmen of Ancient Peru* (New York, 1968), 24–35: the older Chavinoid phase (fourth century B.C.) preceded an Early Mochica climax (300 B.C.-A.D. 100), which yielded to resist-painted wares lasting until A.D. 700. Also R. Larco Hoyle, *La cerámica de Vicús*, 2 vols. (Lima, 1965–7). R. Matos Mendieta, 'Estilo de Vicús', *R.M.N.L.*, XXXIV (1965–6), 89–130, discusses its connexions with Ecuador and Colombia before A.D. 500. H. D. Disselhoff, *Vicus* (Berlin, 1971) (radiocarbon dates in the fifth century A.D.).

13. Mochica refers to a language once spoken in the Chicama Valley; in Trujillo, the Quingnam dialect was spoken. Some prefer to call the civilization Moche, after its principal ceremonial centre in the Trujillo Valley; J. H. Rowe, *op. cit.* (Note 1). Other recent names for the civilization, now disused, are Early Chimú and Proto-Chimú.

14. P. Kosok, 'The Role of Irrigation in Ancient Peru', *Proceedings of the Eighth American Scientific Congress* (Washington, 1940), II, 169–78, and *Life, Land and Water in Ancient Peru* (New York, 1965); D. Collier, in *Irrigation Civilizations: A Comprehensive Study* (*Social Science Monographs*, I) (Washington, Pan-American Union, 1955), 19–27.

15. G. Willey, 'Prehistoric Settlement Patterns', *B.B.A.E.*, CLV (1953), 394–5.

16. W. D. Strong, 'Paracas, Nazca, and Tiahuanacoid Cultural Relationships in South Coastal Peru', *M.S.A.A.*, XIII (1957).

17. *Los Mochicas*, 2 vols. (Lima, 1939), and *Cronología arqueológica* (Buenos Aires-Chiclin, 1948). In 1946 Larco considered that the last half of Mochica history witnessed an expansion north and south from the ancestral home of the style in the Chicama and Trujillo Valleys. J. H. Rowe verified Larco's I-V sequence in the Uhle Collection from Moche (*Handbook of Latin American Studies*, XVI, 1950, 29) and found it acceptable. It is also acceptable in principle, although 'too finely drawn', to W. D. Strong and C. Evans, *C.S.A.E.*, IV (1952).

18. Strong and Evans, *op. cit.*, 220. Contrast H. Ubbelohde-Doering, 'Untersuchungen zur Baukunst

der nordperuanischen Küstentäler', *B.-A.*, XXVI (1952), 23–47, who proposed reed-marked bricks as Mochica and smooth bricks as post-Mochica. This paper was written in 1938 and published without revision. E. Benson, *Mochica* (London, 1972), 95, notes the geographical differences.

384. 19. G. Willey, 'Prehistoric Settlement Patterns', *B.B.A.E.*, CLV (1953), 205–10.

20. M. Uhle, 'Die Ruinen von Moche', *J.S.A.*, X (1913), 108–9; A. L. Kroeber, 'The Uhle Pottery Collections from Moche', *U.C.P.A.A.E.*, XXI (1925), 191–234.

385. 21. On Pacatnamú, H. Ubbelohde-Doering, *Auf den Königsstrassen der Inka* (Berlin, 1941), 50–6; El Brujo, *ibid.*, plate 325, p. 49.

22. J. Bird, 'South American Radiocarbon Dates', *M.S.A.A.*, VIII (1951), 41–2.

23. A. de la Calancha, *Coronica moralizada* (Barcelona, 1658), 485, reported a tradition that the Sun Pyramid was built in less than three days by 200,000 workers. Its ruin dates from the seventeenth century. Other pyramid clusters of Mochica date are described by R. Schaedel, 'Major Ceremonial and Population Centers in Northern Peru', *I.C.A.*, XXIX (1951), 232–43.

386. 24. *R.M.N.L.*, V (1936), 192, and E. Langlois, *La Géographie*, LXV (1936), 203–11.

25. J. A. Mason, *The Ancient Civilizations of Peru* (London, 1957), 69. Illustrations in Kroeber, *Peruvian Archaeology in 1942* (*V.F.P.A.*, IV) (1944), plate 30.

387. 26. Illustrated in R. Larco Hoyle, *Los Mochicas*, 33. Cf. Larco, *H.S.A.I.*, II, 164 n.

27. Walls carved in two places, showing rectilinear sting-rays painted in four colours, adorn the Mochica terrace facing at El Brujo in the Chicama Valley. Ubbelohde-Doering, *op. cit.*, plate 325, p. 49.

28. J. C. Muelle, 'Lo táctil como carácter fundamental en la cerámica muchik', *R.M.N.L.*, II (1933), 67–72; R. Larco Hoyle, *Checán* (Geneva, 1965); E. Benson, *Mochica* (London, 1972), 138–54.

29. J. A. Ford and G. Willey, *A.M.N.H.A.P.*, XLIII (1949), 66.

30. Kroeber, *U.C.P.A.A.E.*, XXI (1925), 200–2. In the Virú Valley the large number of three-colour vessels (red, white, and black) has been taken to mark a later period in Mochica history than the red-and-white lots at Moche. Strong and Evans, *C.S.A.E.*, IV (1952), 176.

389. 31. *Cronología arqueológica*, 28–36. Cf. Note 17. The earliest known stirrup-spouted bowls occur in the Machalilla phase on the south coast of Ecuador c. 2000 B.C. B. Meggers, *Ecuador* (1966), 48 and figure 11.

32. A. Sawyer, *Ancient Peruvian Ceramics* (New

York, 1965), 24–34. Also C. B. Donnan, 'Moche Ceramic Technology', *Ñ.P.*, III (1965), 123–4.

391. 33. Virú: Strong and Evans, *op. cit.*, 165; Sorcape: H. Disselhoff, 'Zur Frage eines Mittelchimu-Stiles', *Zeitschrift für Ethnologie*, LXXI (1939), 129–38. Other examples of the mountain sacrifice are illustrated by A. Baessler, *Ancient Peruvian Art*, I (Berlin, 1902), plates 92–6. Two carved black-ware examples of Mochica III date are illustrated by Tello, *Inca*, II (1938), 280. K. Bruhns, 'Moon Animal, *Ñ.P.*, XIV (1976), 21–40, assigns this theme to Mochica III-IV as a 'complete entity' derived from Recuay antecedents.

392. 34. Strong and Ford, *C.S.A.E.*, IV (1952), 153–5, and Kubler, *M.S.A.A.*, IV (1948), 46–9.

35. Lothrop, 'Gold Artifacts of Chavin Style', *Am.A.*, XVI (1951), 226–40.

36. J. Jones, 'Mochica Works of Art in Metal', in E. Benson (ed.), *Pre-Columbian Metallurgy of South America* (Washington, 1979), 66, alludes to this problem.

37. G. Kutscher, *Nordperuanische Keramik (Monumenta americana*, I) (Berlin, 1954), contains line-drawings originally prepared for a book by E. Seler in 1904. Kutscher distinguishes only a 'linear style' on spherical vessels, and a 'silhouette style' on flattened spheroids with concavely curved spouts. The doctoral dissertation (unpublished) by C. I. Calkin, *Moche Figure-Painted Pottery* (Univ. of California, Berkeley, 1953), treats the stylistic development of the human figure. D. Lavallée, *Représentations Mochica* (Paris, 1970), 21: 'Les Mochica ignoraient la céramique polychrome'. She distinguishes early solid area drawing (*à-plat*) from middle and late Mochica line-drawing (*au trait*).

393. 38. E. Benson, 'A Man and a Feline', *D.O.S.*, XIV (1974).

39. I. Schuler-Schömig, *B.-A.*, XXVII (1979), 186, departing from a venerable and generally accepted interpretation by A. Voss (1876) of Mochica battle-scenes portraying bloody conflict, prefers to read them as ritual and mythical ceremonies of calendrical or divine re-enactment.

40. A. L. Kroeber, *F.M.N.H.A.M.*, II (1930), no. 2, 71–2; R. Schaedel, 'Mochica Murals at Pañamarca', *Archaeology*, IV (1951), no. 3, 145–54. James Ford discovered similar wall-paintings in niches at the Huaca Fecho on Hacienda Batán Grande in the Lambayeque Valley (verbal communication).

394. 41. Mochica textiles are extremely rare. The most important fragment, from Pacatnamú, represents a house in cross-section, as in illustration 345, and subject to the rectilinear deformations of textile technique. Reproduced by H. Ubbelohde-Doering, *Vom Reich der Inka*, 345.

396. 42. E. Benson, 'Death-associated Figures on Mochica Pottery', *Death and the Afterlife* (Washington, 1975), 105–44; C. L. Moser, 'Ritual Decapitation', *Archaeology*, XXVII (1974), 30–7; A. Sawyer, *I.C.A.*, XLIII (1979), Abstracts AII4–15 ('The Living Dead').

43. J. C. Muelle, 'Chalchalaca', *R.M.N.L.*, V (1936), 65–88. Contrast Kutscher, *op. cit.*, 61–2. For Ai Apaec, see Larco, *H.S.A.I.*, II, 171–3. On the god Si, Kutscher, *I.C.A.*, XXVII (1948), 621–31. Bean-writing: Larco, *Revista geográfica americana*, XI (1943), 122–3. Fertility races: Kutscher, *I.C.A.*, XXIX (1951), 244–51. General: Kutscher, 'Iconographic Studies as an Aid in the Reconstruction of Early Chimu Civilization', *Transactions of the New York Academy of Sciences*, N.S. XXII (1950), 194–203. E. Benson (*Mochica*, London, 1972, 27–30) discusses the supreme deity, a jaguar-god (Ai Apaec), and a 'radiant god' and their companions and messengers. Warriors, animal impersonators, rituals, and symbolism are described. E. Benson has also discussed symbolic meanings of Mochica costume by contextual analysis as to deities, priests, prisoners, occupations, and social rank ('Garments', *I.C.A.*, XLII, 1976, vol. VII, 1979, 291–9). D. Lavallée, *Représentations animales dans la céramique mochica* (Paris, 1970), offers a complete systematic analysis. C. B. Donnan adopts the 'thematic approach', based on more than 7,000 examples divided as ninety categories, in *Moche Art and Iconography* (Los Angeles, 1976) (reissued and expanded as an exhibition catalogue in 1978, entitled *Moche Art of Peru*). Donnan's method is contextual and linguistic, preferable to the random Mesoamericanist mixtures of early and late cultural patterns in search of explanatory clues. E. Benson, 'Man and Feline', *D.O.S.*, XIV (1974), is concerned with tracing continuities, as from Chavín through Inca representations of the same theme, without assuming identities of meaning.

44. J. H. Rowe, 'Max Uhle, 1856–1944', *U.C.P.A.A.E.*, XLVI (1957), 7–8. The Tiahuanaco-style sherds and figured cloths are illustrated by Max Uhle in 'Die Ruinen von Moche', *J.S.A.*, X (1913), figure 16, and by A. L. Kroeber, *U.C.P.A.A.E.*, XXI (1925), plate 63. R. Larco, *Cronología arqueológica*, 37–49, identifies this style as radiating from Huari near Ayacucho, with upper (A) and lower (B) north coast phases, which he regards as a chronological sequence, complicated by other local (Lambayeque) and intrusive (Cajamarca) pottery styles. See L. M. Stumer, 'Coastal Tiahuanacoid Styles', *Am.A.*, XXII (1956), 62.

397. 45. Bennett, *H.S.A.I.*, II, 122–3, gives a census of coastal Tiahuanaco finds, enumerating only the Virú, Moche, and Chicama Valleys on the north

coast. D. Menzel, 'Style and Time in the Middle Horizon', *Ñ.P.*, II (1964), 70, fixes the end of the Huari 'empire' and its northernmost appearance in Chicama about A.D. 700 (MH-2B). Lanning, *Peru*, 134, detects Viñaque traits in southern Ecuador. In C. B. Donnan, 'Moche-Huari Murals', *Archaeology*, XXV (1972), 85–95, the 'fall' of the Moche 'kingdom' is dated about A.D. 850. See also R. P. Schaedel, 'Illimo', *Archaeology*, XXXI (1978), 27–37.

46. Ford and Willey, 'Surface Survey of the Viru Valley', *A.M.N.H.A.P.*, XLIII (1949), 66–9. The cursive style probably reflects north highland influences (Recuay and Cajamarca).

47. G. Willey, 'Prehistoric Settlement Patterns in the Virú Valley', *B.B.A.E.*, CLV (1953), 353–4. P. Kosok, 'Transport in Peru', *I.C.A.*, XXX (1952), 65–71, believes the inter-valley roads were built under Mochica rule.

48. R. P. Schaedel, 'The Lost Cities of Peru', *Scientific American*, CLXXXV (1951), no. 2, 18–23; *idem*, 'Major Ceremonial and Population Centers in Northern Peru', *I.C.A.*, XXIX (1951), 232–43; A. L. Kroeber, *F.M.N.H.A.M.*, II (1930), no. 2, 94. Schaedel's dating is typological rather than stratigraphic.

49. R. P. Schaedel, 'Huaca El Dragón', *J.S.A.*, LV (1966), 458, suggests that the Naymlap dynasty was related to the founder of the Chimu dynasty, and that the structure was related to commerce with the guano islands. The 'dragon' reliefs are called 'centipede' by H. Horkheimer, *Vistas arqueológicas* (Trujillo, 1944), 70. The figures also resemble killer-whale stylizations (see pp. 427–8).

50. H. Horkheimer, *op. cit.*, 41.

399. 51. The texts are also evaluated by J. Rowe, 'The Kingdom of Chimor', *Acta Americana*, VI (1948), 37–9. Rowe believes that the Naymlap story is 'pure legend' and of 'late origin', in spite of an independent and confirmatory version written in 1718 by J. M. Rubiños y Andrade; *Revista histórica*, X (1936).

52. R. Vargas Ugarte, 'Los Mochicas y el Cacicazgo de Lambayeque', *I.C.A.*, XXVII (1942), II, 475–82.

53. P. A. Means, *Ancient Civilizations of the Andes* (New York, 1931), 51–5, assuming a long interval after Fempellec, related the Naymlap story to Mochica culture.

54. Luis Valcárcel, *The Latest Archaeological Discoveries in Peru* (Lima, 1948), 27–31, and *R.M.N.L.*, VI (1937), 164. The example we illustrate is 43.5 cm (17⅛ ins.) high. According to Cabello, the name Lambayeque means 'image of Naymlap'. G. Antze, 'Metallarbeiten aus dem nördlichen Peru', *Mitteilungen aus dem Museum für Völkerkunde in Hamburg*, XV (1930), illustrates the Brüning Collection, now in Hamburg, all from the same region in Lambayeque as the knives discussed above (Batán Grande near Illimo).

55. R. Carrión Cachot, 'La luna y su personificación ornitomorfa en el arte Chimu', *I.C.A.*, XXVII (1942), I, 571–87.

400. 56. Kroeber, *F.M.N.H.A.M.*, II (1926), 28; Bennett, *A.M.N.H.A.P.*, XXXVII (1939), 101. Examples from Ancón to Piura are reported. R. Schaedel, 'Illimo', *Archaeology*, XXXI (1978), 27–37, reconstructs and illustrates several murals thought by him to relate to North Coast reverence for the 'deities of marine ecosystems' rather than the sun-worshipping religion which was introduced by the Inca highlanders.

57. Text in R. Vargas Ugarte, 'La fecha de la fundación de Trujillo', *Revista historica*, X (1936), 229–39, and J. Rowe, *op. cit.* (Note 51), 28–30 (English translation).

401. 58. A. de la Calancha, *Coronica moralizada* (Barcelona, 1658), 550. The best narrative account of Chanchan is still that by E. G. Squier, *Peru* (New York, 1877), chapters VI-VII. See also Otto Holstein, 'Chan-Chan: Capital of the Great Chimu', *Geographical Review*, XVII (1927), 36–61. On the mapping and excavation by Harvard University anthropologists, see M. West, 'Community Settlement Patterns at Chan Chan', *Am.A.*, XXXV (1970), 74–86, estimating population between 68,000 and 100,000 +.

402. 59. A plan by Emilio González García, published in *Chimor*, I (1953), 26, and reproduced here as illustration 352, should be consulted together with the plan drawn before 1790 for Bishop Martínez de Compañón (*Trujillo del Perú*, ed. J. Domínguez Bordona, Madrid, 1936, plate LXXXI). In the plan the compounds are recognized as palaces, and the intervening areas are marked as covered with houses. The most recent plans are by M. E. Moseley and C. J. Mackey, *Chan-Chan* (Cambridge, Mass., 1974). See also Moseley, *Science*, CLXXXVII (1975), 219–25.

405. 60. The Tschudi enclosure measures 1600 by 1100 feet (Squier's measurements). All students of Chanchan have reported the presence of many slag-spattered portions of the ruins where metallurgical furnaces probably functioned (e.g. Squier, *Peru*, 164).

61. *Acta Americana*, VI (1948), 45–6. H. Lechtman and M. E. Moseley, 'Scoria', *Ñ.P.*, X-XII (1972–4), 129–34, conclude that the areas thought to have been metal-working were only burned over in blazes lasting from sixteen to forty hours (Gran Chimú, Velarde, Central, and Tschudi scoria).

62. Willey, 'Prehistoric Settlement Patterns',

B.B.A.E., CLV (1953), 416–17. H. Ubbelohde-Doering, *op. cit.* (Note 21), renamed the ruin called La Barranca (Kroeber, *F.M.N.H.A.M.*, 11 (1930), 88–9) as Pacatnamú, the city which Calancha (*Coronica moralizada*, 547) called a Chimu colony. Another such Chimu colony may be the Purgatorio ruin on the Leche river near Tucume (Kroeber, *op. cit.*, 93–4). Schaedel, *I.C.A.*, XXIX (1951), 238–9, identified Apurle (Motupe R.) and Farfán (Jequetepeque) as other 'urban elite' centres of main importance in the Chimu state.

63. M. E. Moseley, 'Assessing *mahamaes*', *Am.A.*, XXXIV (1969), 485–7, and J. Rowe, 'Sunken Gardens', *ibid.*, 320–5.

407. 64. M. Hoyt and M. Moseley, 'The Burr Frieze', *Ñ.P.*, VII-VIII (1969–70), 41–57.

65. Bird, in Strong and Evans, *C.S.A.E.*, IV (1952), 359, reported that twills first appeared in the Gallinazo period, and became more common (28.4 per cent, Huancaco period) in Mochica times.

66. A. Baessler, *Altperuanische Metallgeräte* (Berlin, 1906). An excellent cross-section of Peruvian metalwork is reproduced in Max Schmidt, *Kunst und Kultur von Peru* (Berlin, 1929), plates 367–409. J. C. Tello once remarked in a newspaper article (*El Comercio*, Lima, 29 January 1937, 5) that 75 per cent of all known Peruvian pre-Conquest gold in the museums of the world comes from the vicinity of Tucume (Leche river), rather than from Trujillo or Chicama.

67. R. Burger, 'Archaism in Chimu Ceramics', *Ñ.P.*, XIV (1976), 95–104, studies the topic of 'Mochica archaisms', using specific motifs of fishing, crab-catching, and geometric design.

68. J. C. Muelle, 'Concerning the Middle Chimu Style', *U.C.P.A.A.E.*, XXXIX (1941), 203–22; H. Scheele and T. C. Patterson, 'A Preliminary Seriation of the Chimu Pottery Style', *Ñ.P.*, IV (1966), 15–30.

69. L. M. O'Neale and A. L. Kroeber, 'Textile Periods in Ancient Peru', *U.C.P.A.A.E.*, XXVIII (1930–1), 23–56.

408. 70. H. and P. Reichlen, 'Recherches archéologiques dans les Andes de Cajamarca', *J.S.A.*, XXXVIII (1949), 137–74.

71. H. H. Urteaga, *El fin de un imperio* (Lima, 1933). Also J. C. Tello, 'La ciudad inkaica de Cajamarca', *Chaski*, I (1941), no. 3, 2–7.

72. T. D. McCown, 'Pre-Incaic Huamachuco', *U.C.P.A.A.E.*, XXXIX (1945), no. 4.

73. A. L. Kroeber, 'A Local Style of Lifelike Sculptured Stone Heads in Ancient Peru', *Festschrift R. Thurnwald* (Berlin, 1950), 195–8.

409. 74. McCown, *op. cit.*, 341.

410. 75. Rowe, *Am.A.*, XXII (1956), 149. Lanning, *Peru*, sees it as the work of a Huari garrison and as a storehouse site built during pacification.

CHAPTER 14

411. 1. F. Engel, 'El Paraiso', *J.S.A.*, LV (1966), 43–96; E. Lanning, *Peru before the Incas* (1967), 71, 78. Other sites, Río Seco (Chancay), Tank (Ancón), Chira (Rimac), have house compounds at this time. Lanning deduces collaborative communal organization under stratified social structure, and prior to irrigation farming.

2. E. E. Tabío, *Excavaciones en Playa Grande* (Lima, 1955), 33.

3. T. C. Patterson, *Pattern and Process* (Berkeley, 1966), 117, sees the region as important for pilgrimages and cults from 400 to 800. His nine phases for Lima pottery span *c.* A.D. 100–600. L. M. Stumer, 'The Chillón Valley of Peru', *Archaeology*, VII (1954), 172; R. d'Harcourt, 'La céramique de Cajamarquilla-Nievería', *J.S.A.*, XIV (1922), 107–18.

4. Ancón: R. Carrión Cachot, 'La cultura Chavin', *R.M.N.A.A.*, II (1948), 97–172; Supe: G. Willey and J. M. Corbett, 'Early Ancon and Early Supe Culture', *C.S.A.E.*, III (1954). Also G. Willey, 'The Chavin Problem', *Southwestern Journal of Anthropology*, VII (1951), 119–21. A. Cordy-Collins, 'Cotton and the Staff-God', *J. B. Bird Textile Conference* (Washington, 1979), 51–60, relates coastal Chavín painted textiles to a cult of cotton plants associated with the jaguar-faced human frontal figure.

5. The main burial ground at Ancón is much later (W. Reiss and A. Stübel, *The Necropolis of Ancon*, 3 vols., Berlin, 1880–7), and finds from it fill the museums of Europe and America. W. Conklin, 'Weaving Inventions', *Ñ.P.*, XVI (1978), 1–12, analyses the 'revolution' in Chavín textiles of central coastal origin (and 'floating' date).

412. 6. L. M. Stumer, *op. cit.*, 171–8, 220–8; also *Scientific American*, CXCII (1955), 98–104.

7. J. Jijón y Caamaño, *Maranga* (Quito, 1949); A. L. Kroeber, 'Proto-Lima', *Fieldiana: Anthropology*, XLIV (1955); T. C. Patterson, *Pattern and Process in the Early Intermediate Period Pottery of the Central Coast of Peru* (Berkeley, 1966).

8. L. M. Stumer, 'Population Centers of the Rimac Valley of Peru', *Am.A.*, XX (1954), 130–48.

9. A. H. Gayton, 'The Uhle Collections from Nievería', *U.C.P.A.A.E.*, XXI (1924), 305–29; also R. d'Harcourt, *J.S.A.*, XIV (1922). The site is described in detail by P. E. Villar Córdova, *Las culturas prehispánicas del departamento de Lima* (Lima, 1935).

413. 10. S. K. Lothrop and Joy Mahler, 'A Chancay-Style Grave at Zapallan, Peru', *P.M.P.*, L (1957), discovered that several varieties of Chancay pottery, originally listed as a chronological sequence

by Kroeber (*U.C.P.A.A.E.*, XXI (1926), 265–304), are actually contemporaneous. See also L. de Usera, 'Chrónica del valle de Huára', *Revista española de arqueologia americana*, VII (1972), no. 2, 191–234 (occupation *c.* A.D. 900–1470).

415. 11. P. E. Villar Córdova, 'Las ruinas de la provincia de Canta', *Inca*, I (1923), 1–23; *I.C.A.*, XXIII (1928), 351–82; and *Culturas prehispánicas del departamento de Lima*, 289–332. See also A. Rossel Castro, *Chaski*, I (1941), no. 3, 59–63; A. L. Smith, 'The Corbelled Arch', *The Maya and their Neighbors* (New York, 1940), 202–21.

12. W. C. Bennett, *A.M.N.H.A.P.*, XXXIX (1944), 14–53.

13. M. Uhle, *Pachacamac* (Philadelphia, 1903); W. D. Strong, G. Willey, and J. M. Corbett, *Archaeological Studies in Peru, 1941–1942, C.S.A.E.*, I (1943).

416. 14. Tello reported Chavín-style sherds at the Nunnery of Pachacamac, without further details of place or association; *Chaski*, I (1940), no. 2, 1.

15. *Historia del Nuevo Mundo*, ed. M. Jiménez de la Espada, IV (Seville, 1893), 47–54.

16. Cobo mentions six stages, and Uhle only five, but Cobo included a low basal platform which Uhle did not rank as a stage.

17. This arrangement was also described by Jerónimo de Román y Zamora, writing before 1575 (*Republicas del Mundo*, 2nd ed., Salamanca, 1595).

18. *C.S.A.E.*, I (1943), 37.

19. J. C. Muelle and J. R. Wells, 'Las pinturas del templo de Pachacamac', *R.M.N.L.*, VIII (1939), 265–82. D. Bonavia, *Murales prehispánicas* (Lima, 1974), gives an account of all murals in the Central Andes.

417. 20. Max Schmidt's *Kunst und Kultur des alten Peru* (Berlin, 1929) is illustrated principally with the finds from Pachacamac, like A. Baessler's *Altperuanische Metallgeräte* (Berlin, 1906). Willey, *Introduction*, 11, regards the Pachacamac style as a product of Huari influence on Lima or Nievería style. Lanning, *Peru*, 135, regards it as 'Tiahuanacoid style related to Viñaque (Huari) and Atarco (Nazca) expressions', following Menzel ('Style and Time in the Middle Horizon', *Ñ.P.*, II [1963], 70, 71).

CHAPTER 15

419. 1. J. Rowe, 'Radiocarbon Measurements', in *Peruvian Archaeology*, ed. J. Rowe and D. Menzel (Palo Alto, 1971), 16–30; G. Willey, *An Introduction to American Archaeology. South America*, II (New York, 1971), 127 and note 166.

2. J. C. Tello, *Antiguo Perú* (Lima, 1929), 113–49.

3. D. Menzel, J. Rowe, and L. E. Dawson, *Paracas Pottery* (Berkeley, 1964). With a five-period scheme,

Alan Sawyer retains the older terms (*Ancient Peruvian Ceramics*, New York, 1966, 71):

pre-Cavernas:	Formative Paracas	I	(900–700)
	Early Paracas	II	(700–400)
Cavernas:	Middle Paracas	III	(400–250)
Necropolis:	Late Paracas	IV	(250–100)
	Proto-Nazca	V	(100–0)

4. L. M. O'Neale, 'Textiles of the Early Nazca Period', *F.M.N.H.A.M.*, 11 (1937), plates lvi–lix.

420. 5. W. D. Strong, 'Paracas, Nazca, and Tiahuanacoid Cultural Relationships in South Coastal Peru', *M.S.A.A.*, XIII (1957), 44, 46.

6. J. H. Rowe, 'Explorations in Southern Peru', *Am.A.*, XXII (1956), 147. Dawson's paper has not yet been published; see digest by G. Willey, *Introduction*, 11, 144–7. Alan Sawyer, *op. cit.*, adheres to Kroeber's AXBY terminology, and uses the short-scale Carbon 14 dating for the earliest Chavín-influenced Paracas pottery, as beginning *c.* 900 B.C. (long-scale is *c.* 1400).

7. A. H. Gayton and A. L. Kroeber, 'The Uhle Pottery Collections from Nazca', *U.C.P.A.A.E.*, XXIV (1927), 1–46, and A. L. Kroeber, 'Toward Definition of the Nazca Style', *U.C.P.A.A.E.*, XLIII (1956), 327–432.

8. *Science*, 1 November 1957, and S. K. Lothrop and J. Mahler, 'Late Nazca Burials in Chaviña', *P.M.P.*, L (1957). J. Rowe, 'Radiocarbon Measurements', in J. Rowe and D. Menzel (eds.), *Peruvian Archaeology* (Palo Alto, 1967).

9. As in A. Sawyer, 'Paracas and Nazca Iconography', *Essays S. K. Lothrop* (Cambridge, 1961), 269–98. The problem of differences between Ica and Nazca Valley styles is discussed by D. Proulx, 'Local Differences and Time Differences in Nasca Pottery', *U.C.P.A.*, V (1968). He considers Nazca 3 and 4 in Ica and Nazca Valleys. Minor shapes and themes differ: Nazca Valley was dominant in phase 3 (175–55 B.C.), and declined during phase 4 (55 B.C.–A.D. 65).

10. W. D. Strong, *M.S.A.A.*, XIII (1957).

421. 11. La Estaquería: best description by A. L. Kroeber, *Peruvian Archaeology in 1942, V.F.P.A.*, IV (1944), 26–7. C14 date, Strong, *op. cit.*, 34, 46. For the stone piles and pampa-figures, Maria Reiche, *Los dibujos gigantescos en el suelo de las pampas de Nasca y Palpa* (Lima, [1949]); P. Kosok and M. Reiche, 'Ancient Drawings on the Desert of Peru', *Archaeology*, 11 (1949), 206–15; P. Kosok, *Life, Land and Water* (New York, 1965), 49–62. Large, regular grids of stone piles also occur near Salta in Argentina, at Pucará de Lerma (G. de Créqui-Montfort, *I.C.A.*, XIV, 1904, part 11, figures 21–3).

12. Maria Reiche, *op. cit.*, 20–5. The thesis of astronomical sighting-lines was first proposed by Paul

Kosok, 'The Mysterious Markings of Nazca', *Natural History*, LVI (1947), 200. A short-scale radiocarbon date reported by Strong, *M.S.A.A.*, XIII (1957), 46, gave A.D. 525 ± 80, measured on a wooden post from the intersection of two lines.

13. The celebrated earthwork design in the sand on the seaward hill flank of Paracas peninsula, called Tres Cruces, may belong to the same class. It represents a geometrical tree-shape 128 m. (140 yards) long and 74 m. (81 yards) wide (M. Uhle, 'Explorations at Chincha', *U.C.P.A.A.E.*, XXI, 1924, 92–4), and its forms are comparable to those of Late Nazca pottery. E. Harth-Terré, 'El boto', *Bulletin d'Études Andines*, III (1974), 33–48, adds a 'ludic' or ritual interpretation to the gigantic linear figure of the killer-whale.

424. 14. Mainly through Strong's preliminary publication of his reconnaissance and excavations; *M.S.A.A.*, XIII (1957).

425. 15. A. L. Kroeber, 'Paracas Cavernas and Chavin', *U.C.P.A.A.E.*, XL (1953), 313–48. On Paracas chronology, based upon ceramic typology, J. H. Rowe, 'La seriación cronológica de la cerámica de Paracas elaborada por Lawrence E. Dawson', *Revista del Museo Regional de Ica*, IX (1958), 9–21. Compare A. Sawyer, *Ancient Peruvian Ceramics*, 79–95, who distinguishes local Ica-Paracas styles at Ocucaje, Juan Pablo, and Callango, as to animal motifs, shapes, and phases. Dawson's phases: 1–4 (Nazca A) monumental; 5 (Nazca X) transition; 6–7 (Nazca B) proliferous; 8–9 (Nazca Y) disjunctive and Tiahuanaco-Huari.

16. A. Sawyer, *Ancient Peruvian Ceramics*, 89, regards cream-slip Topará pottery as a local variant of Cavernas culture. Lothrop and Mahler, 'Late Nazca Burials in Chaviña', *P.M.P.*, L (1957), 9, ascribe the first appearance of multiple slipping in various colours to Cavernas times. The whites are kaolin clay; black is soot or ground slate; red is an iron oxide. Yellow comes from ferruginous clays, and the greens and blues were made of copper-bearing minerals, such as malachite. S. Linné, *The Technique of South American Ceramics* (Göteborg, 1925), 134. For information on cream-slipped pottery I am indebted to John Rowe.

17. Strong, *M.S.A.A.*, XIII (1957). A. Sawyer follows Strong, *Ancient Peruvian Ceramics*, 122–32; Dawson's division in nine phases is summarized by Rowe (see Note 15).

18. Gayton and Kroeber, *U.C.P.A.A.E.*, XXIV (1927), 13. See also P. Roark, 'From Monumental to Proliferous in Nasca Pottery', *Ñ.P.*, III (1965), 1–93.

19. Lothrop and Mahler, *op. cit.*, 24–5, discuss the Nazca effigies. Three were excavated at Chaviña (G. Willey, *Introduction*, II, figures 3–78).

426. 20. A useful table of outline drawings of the principal Cavernas and Necropolis vessels was published by R. Carrión Cachot, *Paracas Cultural Elements* (Lima, 1949), plate XVIII.

21. Lothrop and Mahler, *op. cit.*, 10, call the characteristic form a 'cactus-spine demon' in their analysis of B-style motifs. Roark, *op. cit.*, 16, calls these elements 'quartet rays' and 'jagged rays'. Roark's study is about the transition (Phase 5, second century A.D.) or Kroeber's X and Sawyer's Middle, between Early and Late.

22. L. Valcárcel, 'El gato de agua', *R.M.N.L.*, I (1932), 3–27, identified these whiskers as belonging to the sea-otter. Contrast E. Yacovleff, 'La deidad primitiva de los Nazca', *R.M.N.L.*, I (1932), 102–61, and E. Seler, 'Die buntbemalten Gefässe von Nazca', *G.A.*, IV (1923), 172–338. A. Sawyer, *Ancient Peruvian Ceramics*, 124, notes that 'up-swept' whiskers may indicate sea-otter nature.

427. 23. Seler, *loc. cit.* For H. Ubbelohde-Doering, whose interpretations are more fanciful, the concentric-square theme represents the tomb, and the 'jagged-staff' figures refer to a tabu on menstruating women, by analogy with nineteenth-century beliefs in New Zealand; *J.S.A.*, XXIII (1931), 177–88, and XXV (1933), 1–8.

428. 24. J. Bird, in *M.S.A.A.*, VIII (1951), and (with Louisa Bellinger) *Paracas Fabrics and Nazca Needlework* (Washington, 1954), 2.

429. 25. J. H. Rowe, 'Radiocarbon Measurements from Peru', *Peruvian Archaeology: Selected Readings* (Palo Alto, 1967), 16–30; J. P. Dwyer, 'Chronology and Iconography of Paracas-Style Textiles', *J. B. Bird Textile Conference* (Washington, 1979), 105–28; A. R. Sawyer, 'Painted Nasca Textiles', *ibid.*, 129–50.

26. L. M. O'Neale, 'Textile Periods in Ancient Peru, II: Paracas Cavernas and the Grand Necropolis', *U.C.P.A.A.E.*, XXXIX (1945), 143–202.

27. Strong, *M.S.A.A.*, XIII (1957), 16. On wide weaves, see also Anni Albers, *On Designing* (New Haven, 1959).

28. G. A. Fester and J. Cruellas, 'Colorantes de Paracas', *R.M.N.L.*, III (1934), 154–6. Indigo dye on brown or yellow fibre produced the characteristic Paracas greens. M. E. King, 'Paracas Textile Techniques', *I.C.A.*, XXXVIII (1969), vol. I, 369–77.

29. C. E. Stafford, *Paracas Embroidery* (New York, 1941).

430. 30. General account by J. C. Tello, *Antiguo Perú*, 126–49. Cavernas tombs: E. Yacovleff and J. C. Muelle, 'Una exploración en Cerro Colorado', *R.M.N.L.*, I (1932), 31–59 and 81–9. Survey of the wrapping and clothing types by R. Carrión Cachot, 'La indumentaria en la antigua cultura de Paracas', *Wira*

Kocha, I (1931). Detailed account of the unwrapping of bundle no. 217 by Yacovleff and J. C. Muelle, 'Un fardo funerario de Paracas', *R.M.N.L.*, III (1934), 63–153. My main source for reconstructing the other mummy-bundle associations has been the article by R. Carrión Cachot. Julio C. Tello, *Paracas, Primera Parte* (Lima, 1959), written in 1942, presents Tello's views on sequence as at that date. The illustrations add to the range published by Carrión. A. Paul, *Paracas Textiles* (Göteborg, 1979), follows the chronology of E. and J. Dwyer, *Paracas Cemeteries* (Washington, 1973), dividing the cloths into early 'linear' and late 'block' phases, but recognizing that both may appear in the same mummy bundle. The Göteborg textiles are identified as of Necropolis origin.

31. Yacovleff and Muelle, *op. cit.*, in their fundamental analysis of Paracas style, described the co-existence of rectilinear and curvilinear styles as a 'dimorphism'. Bundle 217, however, on which their observations were based, belongs by style to an early group. Bundle 290 (Tello, *Paracas*, plates LXVIII–LXXVIII) contained one rectilinear piece among many approaching the ornate manner of our Group 4. J. Bird, 'Samplers', *Essays ... S. K. Lothrop* (Cambridge, 1961), 299–316. Ascribed by Dawson to Nazca 1 and 2, this embroidery shows coeval plectogenic and curvilinear designs.

432. 32. The best account of the Cavernas tomb finds is the article by E. Yacovleff and J. C. Muelle quoted in Note 30 (*R.M.N.L.*, I). See also M. E. King, 'Textiles from Ocucaje', *I.C.A.*, XL (1974), vol. II, 521–9, on a collection dated as of the sixth century B.C. (phase 9, p. 23, this volume) and as having mythological content.

33. Another painted cloth, from Trancas in the Nazca Valley, portrays birds bearing twigs in their beaks. Reproduced in L. M. O'Neale, 'Textiles of the Early Nazca Period', *F.M.N.H.A.M.*, II (1937), 135. It is closer to groups 2 and 3 in style than the Cleveland cloth, which by style should be several generations later. See also Tello, *Paracas*, plates LXVIII–LXXVIII (mummy 290), for a painted cloth belonging to our group 4.

34. An exception in the Peabody Museum, Harvard, has cats on the field and birds in the border of a group 2 mantle. Bennett, *Ancient Arts of the Andes* (New York, 1953).

433. 35. On the differences between Nazca and Necropolis embroideries, see L. M. O'Neale and T. W. Whitaker, 'Embroideries of the Early Nazca Period and the Crop Plants Depicted on Them', *Southwestern Journal of Anthropology*, III (1947), 294–321. Paracas details vary less in drawing, and more in colour. The best reproductions in colour are

in the album of plates with text by Itoji Muto and Kunisuke Akashi, *Textiles of Pre-Inca* (Tokyo, 1956).

434. 36. *R.M.N.L.*, III (1934), 63–153.

37. Dorothy Menzel, 'Style and Time in the Middle Horizon', *Ñ.P.*, II (1964), 1–106; J. H. Rowe, 'Archaeological Explorations in Southern Peru', *Am.A.*, XXII (1956), 147–50. Other key sites for the Tiahuanaco expansion are in the Ayacucho region (p. 447) and at Pachacamac (pp. 416–17).

435. 38. E. Yacovleff, 'Las falconidas en el arte y las creencias de los antiguos peruanos', *R.M.N.L.*, I (1932), 110–11. The Olson excavations at the same site in 1930 are summarized in the article by D. Manzel, *op. cit.*, 23–31. The plant forms on the giant tubs are reproduced with identifications by E. Yacovleff and F. L. Herrera, 'El mundo vegetal de los antiguos peruanos', *R.M.N.L.*, III (1934), 243–322, and IV (1935), 31–102.

39. The same conventions appear in Nazca embroideries of the early period; L. M. O'Neale and T. W. Whitaker, *op. cit.*

437. 40. Kroeber and Strong, 'The Uhle Pottery Collections from Ica', *U.C.P.A.A.E.*, XXI (1924), 95–133. P. Lyon, 'Origins of Ica Pottery Style', *Ñ.P.*, IV (1966), 31–62, analyses the archaizing revival of Huari traits in Ica 1 after A.D. 900. See also D. Menzel, *Pottery Style* (Berkeley, 1976) (Ica Valley, 1350–1570).

41. Twenty Ica carved boards are illustrated by M. Schmidt, *Kunst und Kultur des alten Peru* (Berlin, 1929), 426–33.

42. H. Trimborn, *Quellen zur Kulturgeschichte des präkolumbischen Amerika* (Stuttgart, 1936), 236. This report of 1558, written by C. de Castro and D. de Ortega Morejón, named the rulers of the three valley tribes at the time of the Inca conquest, given as having lived early in the fifteenth century. ('Relaçion y declaraçion del ... valle de Chincha', ed. W. Petersen.) E. Harth-Terré, 'Incahuasi. Ruinas incaicas del valle de Lunahuaná', *R.M.N.L.*, II (1933), 99–126, gives plans and restored views of various dwelling compounds in the Cañete Valley, corresponding to the period of this text.

439. 43. For these details on Chincha Valley architecture I am indebted to John H. Rowe, whose advice on this chapter has been most valuable. For plans and views, see G. Gasparini and L. Margolies, *Arquitectura inka* (Caracas, 1977), 130–3.

CHAPTER 16

441. 1. 'Cultural Unity and Disunity in the Titicaca Basin', *Am.A.*, XVI (1950), 89–98.

2. Dr Alfred Kidder kindly communicated his dates before publication from his 1955 excavations. He had

earlier suggested the priority of Pucará on stratigraphic arguments (*M.S.A.A.*, IV (1948), 87–9), relating to the position of Bennett's Chiripa site as pre-Tiahuanaco rather than late (*ibid.*, 90–2). Lanning, *Peru*, 84, mentions early pottery (1300 B.C.) at Chiripa.

3. A. Kidder, II, 'Some Early Sites in the Northern Lake Titicaca Basin', *P.M.P.*, XXVII (1943), 5–6. *Ñ.P.*, XIII (1975), 1–44, contains papers on Pucará topics by J. Rowe, S. Chávez, M. Hoyt, M. Donahue, and K. Chávez.

4. L. Valcárcel, 'Litoesculturas y cerámicas de Pukara', *R.M.N.L.*, IV (1935), 25–8, illustrates eight pieces, of which three from Caluyu are typologically simpler, and possibly earlier.

442. 5. J. H. Rowe, 'Archaeological Explorations in Southern Peru', *Am.A.*, XXII (1956), 144.

6. Bennett, *A.M.N.H.A.P.*, XXXV (1935), 413–46, and *M.S.A.A.*, IV (1948), 90–2.

443. 7. J. Rowe, 'Two Pucara Statues', *Archaeology*, XI (1958), 255–61; 'Papers on Early Sculpture', *Ñ.P.*, XIII (1975), 1–2.

8. Nos 30 and 31 in the Bennett catalogue of Tiahuanaco stone sculpture; *A.M.N.H.A.P.*, XXXIV (1934), 462–3.

9. Posnansky, *Tihuanacu* (New York, 1945), 170–2, and figures 91–6. A figure closely resembling the Pokotia statues has been traced to Chumbivilcas province, 100 miles north-west of Pucará. Another statuette in Berne, acquired at Tiahuanaco, is also of the Pokotia type, with serpent-braids looping over the shoulders; Rowe, *Archaeology*, XI (1958), 255–61.

10. S. Rydén, *Archaeological Researches in the Highlands of Bolivia* (Göteborg, 1947), 90–7, regards Wancani as a Late Tiahuanaco site because of its ceramic types.

11. E. Casanova, 'Investigaciones arqueológicas en el altiplano boliviano', *Relaciones de la sociedad argentina de antropología*, I (1937), 167–72. W. Ruben, *Tiahuanaco, Atacama und Araukaner* (Leipzig, 1952). 50–5, gives a concise survey of the entire *altiplano* question, grouping all Pucará-style sites.

12. Bennett, *A.M.N.H.A.P.*, XXXIV (1934), 441 and 462 (no. 24).

13. A. Stübel and Max Uhle, *Die Ruinenstaette von Tiahuanaco* (Leipzig, 1892); W. Bennett, 'Excavations at Tiahuanaco', *A.M.N.H.A.P.*, XXXIV (1934), 359–494; D. E. Ibarra Grosso, J. de Mesa, and T. Gisbert, 'Reconstrucción de Taypicala (Tiahuanaco)', *C.A.*, XIV (1955), 149–75. The essay by R. Trebbi del Trevigiano, *Critica d'arte*, XXIII (1957), 404–19, asserts the 'centripetal' character of Tiahuanaco as a receiving centre, on stylistic grounds. His chronological and cultural connexions, however, are weak.

445. 14. The best modern discussions of the site as a whole are by W. Ruben, *op. cit.*, and Ibarra Grosso, Mesa, and Gisbert, *op. cit.* Three objections to the reconstructions by the latter are necessary: their simplification of the plan of the Akapana is not supported by air photographs, which show re-entrant corners as on the Posnansky plan; their thesis of intersecting roadways takes no account of the water barrier at the moat; and the reconstruction of the Akapana as a solid platform is less probable than a U-shaped secondary platform, as indicated by the present contours and by the drainage conduit uncovered by G. Courty in 1903 (*I.C.A.*, XIV (1904), part 2, figure 2, and 533).

446. 15. Bennett, *A.M.N.H.A.P.*, XXXIV (1934), 387.

447. 16. Bronze objects of indubitable Tiahuanaco style are not known from the *altiplano*; P. Rivet and H. Arsandaux, *La métallurgie en Amérique précolombienne* (Paris, 1946), 27–8. W. C. Root, *H.S.A.I.*, V, 222, points out that cold-worked copper is harder than unworked cast bronze. Stübel and Uhle, *op. cit.*, 44–5, first observed that the perfect rectangularity on a small scale is explainable only by sharp, hard tools, which we must now suppose to have been of copper. The rough quarrying probably depended upon fire, water, and ice. See H. Lechtman, 'Issues in Andean Metallurgy', in E. Benson (ed.), *Pre-Columbian Metallurgy of South America* (Washington, 1979), 1–40, on arsenical bronzes for tools in the Moche Valley after A.D. 1000.

17. G. de Créqui-Montfort, *op. cit.*; Bennett, *A.M.N.H.A.P.* XXXV (1935), figure 37; and Bennett, *Excavations at Wari* (New Haven, 1953).

448. 18. The catalogue by Bennett (*A.M.N.H.A.P.*, XXXIV (1934), 460–3) lists the principal pieces with bibliography. His chronological succession (478) agrees in the main outlines with the one proposed here, although his 'Decadent' pieces fit better with our 'Early' group.

451. 19. The name is modern; nothing is known of the intended meaning of the reliefs (Yacovleff, *R.M.N.L.*, I (1932), 84–6), save that they represent costumed humans, some of them masked. M. Uhle, *Wesen und Ordnung der altperuanischen Kulturen* (Berlin, 1959), 57–77, gives a plausible interpretation based upon two colonial myths. Uhle identifies the figures as sun-symbols surrounded by heralds or messengers.

20. Illustrated in Posnansky, *Tihuanacu*, figures 141, 143–4, 150.

452. 21. The painted portions are described by Créqui-Montfort, *op. cit.*, 536, 541.

22. The nail holes surrounding certain reliefs are illustrated by Posnansky, *op. cit.*, figures 56–8.

453. 23. C. Ponce Sanginés, *Cerámica Tiwanacota. Vasos con decoración prosopomorfa* (Buenos Aires,

1948), assigns polychrome examples to the Classic phase, and black-ware pieces to a later time.

24. F. Buch, *El Calendario Maya en la cultura de Tiahuanacu* (La Paz, 1937). J. C. Tello, 'Wirakocha', *Inca*, I (1923), 93–320, 583–606; F. Cossio del Pomar, *Arte del Perú precolombino* (Mexico–Buenos Aires, 1949). The most recent addition to the literature of these monuments is by F. Hochleitner, 'Die Vase von Pacheco', *Zeitschrift für Ethnologie*, LXXXV (1960), 259–68.

25. Bennett, *A.M.N.H.A.P.*, XXXV (1936), 331–412; S. Rydén, *op. cit.*, and W. Ruben, *op. cit.*, have studied the provincial diffusion of the Tiahuanaco style eastward into the Bolivian lowlands and south towards Chile. A. Sawyer analyses the design modes in coastal tapestries ('Tiahuanaco Tapestry Design', *Textile Museum Journal*, I (1963), 27–38), assuming that design complication corresponded to official rank in government or religion.

26. Rowe, 'Archaeological Explorations in Southern Peru', *Am.A.*, XXII (1956), 150; Bennett, *Excavations at Wari*, 114–18. Larco Hoyle, *Cronologia arqueológica* (Lima, 1948), 37 f., was the first to propose the Mantaro basin as the centre of this diffusion.

Rowe, *Am.A.*, XXII (1956), 144, suggested Huari as the originating metropolitan centre for all the regional variants of Tiahuanaco style in Peru and Bolivia. Bennett believed that Tiahuanaco in Bolivia had the better claim. Also L. G. Lumbreras, 'La Cultura Wari', *Etnología y Arqueología*, I (1960), 130–227.

454. 27. Bennett, *Wari*, 85. Mantaro pottery has never been properly published. The best collection belonging to the Gálvez-Durán family in Huancayo, was dispersed about thirty years ago. W. H. Isbell and K. J. Schreiber, 'Was Huari a State?', *Am. A.*, XLIII (1978), no. 3, 372–89, conclude that a state government is supported but not confirmed. The stylistic evidence seems contrary to their view, if statehood determines centre and periphery. See R. Shady and A. Ruiz, 'Interregional Relationship', *Am.A.*, XLIV (1979), 676–84.

455. 28. Rowe, *Am.A.*, XXII (1956), 149, defined a stylistic frontier between Peruvian and Bolivian versions of Tiahuanaco ceramic style in the vicinity of Sicuani, between Cuzco and Lake Titicaca.

29. E. Lanning, *Peru* (1967), chapter 9, 127–40. P. A. Means, *Ancient Civilizations of the Andes* (New York, 1931), 111–13 and 136–46, proposed two older eras at Tiahuanaco, labelled I and II (third to tenth centuries A.D.), followed by 'Decadent' coastal or 'Epigonal' forms in the rest of Peru (A.D.900–1400). Based upon Uhle's excavations and upon the colonial chronicle by F. Montesinos, the Means sequence no longer holds among professional Andeanists. See

L. M. Stumer, 'Development of Peruvian Coastal Tiahuanacoid Styles', *Am.A.*, XXII (1956), 59–69.

30. *Essais*, ed. Motheau and Jouaust, VI (Paris, 1888), 60.

31. J. H. Rowe, 'An Introduction to the Archaeology of Cuzco', *P.M.P.*, XXVII (1944), no. 2.

32. H. Reichlen, *J.S.A.*, XLIII (1954), 221–3. Slab masonry shaft tombs recall the Huari constructions. Over Chanapata sherds near by lay a thick deposit of Tiahuanaco-style sherds. Also Rowe, *Am.A.*, XXII (1956), 142, who sees a resemblance between Huari and Pikillaqta.

33. Rowe, 'Urban Settlements', *Ñ.P.*, I (1963), 14–15. L. Valcárcel, *R.M.N.L.*, III (1934), 184, found enough Inca sherd material at that time to be convinced of its Inca date. S. Astete Chocano, *Revista del Instituto Arqueológico del Cuzco*, III (1938), 53–8, assigns the construction to the Pinawa tribe who dominated the area. Luis Pardo, *Revista Universitaria del Cuzco*, XXII (1933), 139–47, gives the legendary history of the site. It can be traced as far as 1834, when the story related by Pardo was recorded by the French traveller E. G. E. de Sartiges, *Dos viajeros franceses en el Perú republicano*, ed. R. Porras (Lima, 1947). It treats the building of the aqueduct as a love-test imposed by a princess.

456. 34. On the thesis that all grid-plan towns are of Old World origin, and on the absence of chequerboard plans in ancient American planning, D. Stanislawski, *Geographical Review*, XXXVI (1946), 105; XXXVII (1947), 94–105.

457. 35. L. Valcárcel, 'Esculturas de Pikillajta', *R.M.N.L.*, II (1933), 19–48, treats them as Inca symbols of the submission of other Andean peoples.

36. Huari lacks any semblance of grid-planning, in the only map of the site, made by Bennett, *Wari*, 19, figure 2.

37. J. Rowe, 'An Introduction to the Archaeology of Cuzco', *P.M.P.*, XXVII (1944), no. 2, and 'Absolute Chronology in the Andean Area', *Am.A.*, III (1945), 265–85. See now G. Gasparini and L. Margolies, *Arquitectura inka* (Caracas, 1977); E. Moorehead, 'Inca Adobe', *Ñ.P.*, XVI (1978), 65–94.

38. The fullest treatment of the fragments is by J. Rowe, *P.M.P.*, XXVII (1944), 26–41. G. Kubler, *Cuzco* (Paris, 1952), 8, figure 2, on excavation at the curved wall.

39. Cf. J. Rowe, 'What Kind of a Settlement was Inca Cuzco', *Ñ.P.*, V (1967), 60, to prove the use of Cuzco as a ceremonial centre; also R. T. Zuidema, *The Ceque System of Cuzco* (Leiden, 1964), who relates its layout to social organization; in *I.C.A.*, XLIII (1979), Abstracts A140, Zuidema treats the metaphor as such. See also Gasparini and Margolies, *op. cit.*, 50–1. J. Rowe, 'Shrines of Cuzco', *Ñ.P.*,

XVII (1979), 1–80, analyses Cobo's account written before 1571, without mention of Zuidema's work.
460. 40. P. Cieza de Léon records Tupac Yupanqui's organization of the labour force: 20,000 labourers were brought from the provinces, including 4,000 quarrymen and 6,000 transport workers. The remainder were masons and carpenters, under professional foremen. All workers were lodged in their own geographic camps (*Travels 1532–1550*, London, 1864). The chroniclers' descriptions, written in the sixteenth and seventeenth centuries, are reprinted in the excavation account by L. Valcárcel, *R.M.N.L.*, III (1934), 14–24. The excavations were fully reported in *R.M.N.L.*, III (1934), 3–36, 211–23; IV (1935), 1–24, 161–203; and in *H.S.A.I.*, II, 177–82. The Swedish ethnographer E. Nordenskiöld held that saw-tooth defences were imitated in Europe, where they first appeared about 1550, from American examples like Sacsahuamán; 'Fortifications in Ancient Peru and Europe', *Ethnos*, VII (1942).

41. The more recent building history of Cuzco is recapitulated by G. Kubler, *Cuzco, Reconstruction of the Town and Restoration of its Monuments* (Paris, Unesco, 1952).

42. Bennett's seven types (*H.S.A.I.*, II, 145–6) are inadequately differentiated. 'Megalithic', 'polygonal', and 'modified polygonal' are all nearly identical, like his 'square blocks' and 'dressed-stone blocks'. *Pirca* and adobe brick are the remaining two categories in Bennett's listing.

43. This functional explanation was first proposed by John Rowe (*P.M.P.*, XXVII, 1944, 24–5).

44. M. K. Jessup, 'Inca Masonry at Cuzco', *A.A.*, XXXVI (1934), 239–41.

461. 45. Luis Pardo, 'Maquetas arquitectónicas en el antiguo Perú', *Revista del Instituto Arqueológico del Cuzco*, I (1936), 6–17, has studied the small terracotta models of buildings in the Cuzco Archaeological Museum, but there is no clear proof that these were projects for buildings. They were perhaps souvenirs or mementos of important monuments. On cellular slabs, P. A. Means, *Ancient Civilizations of the Andes*, and L. Baudin, *L'empire socialiste des Inka* (Paris 1928), 126, n. 1. See also J. W. Smith, Jr, 'Recuay Gaming Boards', *Indiana*, IV (1977), 111–38. An example from Pashash is dated as late Recuay, A.D. 550 (figure 6), and twelve examples are interpreted as pertaining to a hypothetical game.

46. As suggested by Rowe, *H.S.A.I.*, II, 229.

462. 47. P. Fejos, 'Archeological Explorations in the Cordillera Vilcabamba, Southeastern Peru', *Yale University Publications in Anthropology*, III (1944).

463. 48. Fejos, *op. cit.* figure 15 and pp. 52–3.

49. The best account of the city is by Hiram Bingham, *Machu Picchu, A Citadel of the Incas* (New Haven, 1930). Bingham's views concerning the historical position of the site are recapitulated in *Lost City of the Incas* (New York, 1948), but his uncritical use of the chronicler F. Montesinos makes these works unreliable. See G. Kubler, 'Machu Picchu', *Perspecta*, VI (1960), 48–55.

464. 50. Both edifices are best known by E. G. Squier's descriptions and schematic drawings, *Peru* (New York, 1877), 343–6 and 359–66. A. F. Bandelier, *The Islands of Titicaca and Koati* (New York, 1910), presents more accurately measured plans and elevations.

466. 51. Garcilaso de la Vega, *Comentarios reales* (Madrid, 1723). Gasparini and Margolies, *op. cit.*, 243–63, prefer a one-storey elevation gabled at the ends.

52. Squier, *op. cit.*, 402–13.

467. 53. M. H. Tschopik, 'Some Notes on the Archaeology of the Department of Puno, Peru', *P.M.P.*, XXVII (1946), 52–3. A. Ruiz Estrada, *Sillustani* (Lima, 1976), reports finds of gold and 'turquoise' associated with Collao pottery (late fifteenth century?) in the Lagarto *chullpa*.

54. Systematic description in W. Krickeberg, *Felsplastik* (Berlin, 1949), 1–24. Photographs, H. Ubbelohde-Doering, *Auf den Königsstrassen der Inka* (Berlin, 1941).

468. 55. L. Valcárcel, *H.S.A.I.*, II, 177–82, and *R.M.N.L.*, IV (1935), 223–33.

56. *Arte peruano* (Madrid, 1935), plates LXXIV–LXXV, and p. 15. Also *Art des Incas* (Paris, 1933), plate XVII (Collection of Juan Larrea). Two seated life-size figures of pumas from Cuzco are the only other examples we possess of large Inca figure sculpture.

57. Such devious drinking-vessels of carved and painted wood (*pacchas*) are common: T. A. Joyce, 'Pakcha', *Inca*, I (1923), 761–78. Lothrop, 'Peruvian Pacchas and Keros', *Am.A.*, XXI (1956), 240, ascribes their invention to Chimu culture.

469. 58. Rowe, *op. cit.* (Note 37), 60–3; *H.S.A.I.*, II, 243, 287.

59. Especially B. Cobo, writing about 1653, *Historia del nuevo mundo*, III (Seville, 1892), 323–46. Also R. Lehmann-Nitsche, *Revista del Museo de La Plata*, XXXI (1928), 1–260.

60. *Nueva coronica y buen gøbierno* (Paris 1936), and R. Porras, *El cronista indio Felipe Guaman Poma de Ayala* (Lima, 1948).

61. On colonial *keros*, Mary Schaedel, *Magazine of Art*, XLII (1949), 17–19. Pre-Conquest examples, L. Valcárcel, 'Vasos de madera del Cuzco', *R.M.N.L.*, I (1932), 11–18. J. Rowe, 'The Chronology of Inca Wooden Cups', *Essays . . . S. K. Lothrop* (Cambridge, 1961), 317–41.

Adobe. Clay from which sun-dried bricks are made; unburnt bricks.

Adorno. Any modelled clay attachment to a vessel wall or rim.

Atadura. Literally, a binding. Maya façade moulding at impost level, usually consisting of three members.

Atlatl. Wooden throwing-board for javelins, serving to lengthen the user's radius of reach.

Avant-corps. Projecting portion, suggesting a wing or pavilion, which interrupts the continuity of the plane of a façade.

Batter. In a wall of tapered section, the sloping face. A wall with inverted taper, thicker at the top than at the bottom, has negative batter.

Cella. A temple chamber.

Cenote. Natural well in a collapsed portion of the surface limestone of Yucatán.

Chacmool. A fanciful yet standard term designating the stone figures of recumbent human males shown holding basins or platters on the abdomen (Mexico and Yucatán).

Chamfer. A horizontal moulding of intaglio effect recessed within the wall of a Maya temple or pyramidal platform.

Chapopote. Shiny pigment of resin, asphalt, and soot used in Veracruz pottery painting.

Chinampa. A small artificial island made for gardening in the lakes of the Valley of Mexico.

Chullpa. In the Central Andes, a stone tower used for burials.

Cire perdue. The lost-wax method of casting metal objects by displacing a waxen model with molten metal.

Classic. A developmental stage in Mesoamerican archaeology, referring to the period of the rise of high civilizations in many independent centres.

Codex. The European book, consisting of leaves or folds of rectangular pages sewn together at one side, adopted by American peoples only after the Spanish Conquest.

Collao. A district of the Andean highlands around Lake Titicaca.

Concrete. A mixture of cement, sand, and water with any aggregate, capable of setting to the hardness of stone.

Fine orange. Untempered pinkish-orange pottery of dense paste.

Fin wall. Masonry membranes compartmenting the loose infilling in pyramid facings.

Flying façade. Ornamental vertical extension in the plane of the façade of a Maya building.

Glyph. Each pebble-shaped unit of Maya writing.

Greenstone. Those American minerals, e.g. nephrite, serpentine, wernerite, possessing colours similar to oriental jades.

Hacha. Thin stone blades with profiles of human heads.

Header. Of bricks or stones, those laid in the wall with the smallest face exposed.

Horizon style. A complex of traits having a known position in time, useful to date new finds and to correlate regions in time.

Huaca. Quechua term in the central Andean region for any buried or ruined structure of putative religious use: more generally, any sacred thing or creature.

Initial Series. A Classic Maya method (also called Long Count) for dating events by the day-count from a starting point. Identified by its initial position in longer inscriptions. Each digit is vigesimal rather than decimal: in a date transcribed 9.3.10.10.5, the first digit states that 9 cycles of 400 years (each having 20 periods of 20 years) have elapsed, followed by 3 twenty-year periods or *katuns*, 10 *tuns* or years of 360 days each, 10 *uinals* or months of 20 days each, and 5 *kins* or days. The total enumerates the days which have elapsed since the starting-point.

Lienzo. A Mexican pictorial chart drawn or painted on a sheet of cloth.

Lost wax. See Cire perdue.

Mapa. A Mexican chart or pictorial table displaying geographical and historical relationships.

Mesoamerica. The parts of pre-Columbian Mexico and Central America occupied by peoples of advanced urban traditions.

Metate. Náhuatl term for a portable stone surface for grinding food.

Middle America. The area from Panama to the Río Grande, including the Antilles.

Milpa. In Central America, a small burned clearing planted and abandoned after a few seasons.

Mise en couleur. A colouring process for gold–copper alloys by immersion in an acid pickle to dissolve the oxides, leaving a coating of pure gold.

Negative painting. Before firing, a vessel surface partly covered with wax is immersed in slip. Firing fixes the coloured slip but clears the waxed portions, so that the figure and its ground are reversed.

Palma. Tall, fan-shaped stones with concavely curved bases.

Palmate stone. See Palma.

Pastillage. Sculpture built of pellets of plaster shaped over a rough stone core.

Pirca. Andean wall construction using dry-laid, un-shaped stones.

Plectogenic. Textile ornament of rectilinear composition determined by loom stringing in warps and wefts.

Plumbate. Monochrome pottery of a hard, grey, vitrified surface found throughout pre-Columbian Mesoamerica.

Post-fired painting. Addition of stucco or paint to pottery surfaces after firing.

Quetzal. A Central American bird of brilliant plumage.

Radiocarbon dating. Natural carbon 14 produced by cosmic rays enters the carbon dioxide life cycle at a constant rate. Upon the death of the organism the amount of c_{14} will decay according to the known half-life of 5730 ± 30 years. The measured residue of c_{14} in organic samples allows relatively precise age determinations

Resist-painting (see Negative painting). A batik process, in which waxed parts of a cloth remain undyed.

Roof-comb. Ornamental vertical extension rising above the rear wall or over the centre of Maya temple roofs.

Slip. A wash or dip of clay applied before the final firing of pottery objects, serving as ground for painted designs.

Spall. A large splinter or chip of stone, used to adjust the seat of larger stones in the coursing of the wall.

Stirrup spout. In Mochica pottery, a pouring vent consisting of two tubular branches united at the spout.

Stretcher. A brick or stone laid in the wall with its longer face showing.

Tablero. Literally, an apron. On the stages of a pyramidal platform, these portions rise vertically above each of the diagonal portions of the silhouette.

Talus. The slope of the face of a building, like the rock debris at the foot of a cliff: *see Batter.*

Tapia. A wall built by successive layers of puddled clay, i.e., worked when wet to be impervious to water.

Teotihuacano. Related to Teotihuacán in an adjectival sense (as Hispanic, or Italianate, or Parisian).

Tepetate. In Mexico, a lava flow of pumice-stone.

Teponaztli. Horizontal cylindrical drum slotted to form two tongues of different pitch.

Terraced meander. A band pattern of stepped rectilinear segments.

Tezontle. A light and porous volcanic stone, usually red, grey, or black, common in the Valley of Mexico.

Tlachtli. Náhuatl term for the I-shaped ball-court used throughout Middle America.

Tumbaga. An alloy of gold with copper.

BIBLIOGRAPHY

More detailed references to special subjects are abundant in the Notes. The books and articles cited here are general, and have been selected from a longer master bibliography, which can all be found in the Notes.

I. COMPREHENSIVE WORKS

American Sources of Modern Art. New York (Museum of Modern Art), 1933.

ARMILLAS, P. 'Cronología y periodificación de la historia de la América precolombina', *Journal of World History*, III (1956).

ASHTON, D. *Abstract Art before Columbus*. New York, André Emmerich Gallery, 1957.

BALL, S. 'The Mining of Gems and Ornamental Stones by American Indians', *B.B.A.E.*, CXXVIII (1941), 20, 27, 28.

BASLER, A., and BRUMMER, E. *L'art précolombien*. Paris, 1928.

BENSON, E.P. *The Cult of the Feline*. Washington, 1972.

BIRD, J. *Pre-Columbian Gold Sculpture*. New York, 1958.

BORHEGYI, S. 'The Pre-Columbian Ballgame', *I.C.A.*, XXVIII (1968).

CASO, A., STIRLING, M., LOTHROP, S. K., THOMPSON, J. E. S., GARCÍA PAYÓN, J., and EKHOLM, G. 'Conocieron la rueda los indígenas mesoamericanas?', *C.A.*, v (1946), no. I.

EMMERICH, A. *Sweat of the Sun and Tears of the Moon*. Seattle, 1965.

An Exhibition of Pre-Columbian Art. Cambridge, Mass., 1940.

FORD, J. A. *Comparison of Formative Cultures in the Americas*. Washington, 1969.

JIJÓN Y CAAMAÑO, J. 'Las civilizaciones del sur de Centro América y el noroeste de Sud América', *I.C.A.*, XXIX (1952).

KELEMEN, P. *Medieval American Art*. New York, 1943; new ed. 1956.

KIDDER II, A. 'South American Penetrations in Middle America', *The Maya and their Neighbors*. New York, 1940.

KRICKEBERG, W. *Felsplastik und Felsbilder bei den Kulturvölkern Altamerikas*. Berlin, 1949.

KROEBER, A. L. 'Cultural and Natural Areas of Native North America', *U.C.P.A.A.E.*, XXXVIII (1939).

KUBLER, G. *The Arensberg Collection*. Philadelphia, 1954.

LAVACHÉRY, H. *Les arts anciens d'Amérique au Musée archéologique de Madrid*. Antwerp, 1929.

LIBBY, W. F. *Radiocarbon Dating*. Chicago, 1955.

LINTON, R. 'Crops, Soils, and Cultures in America', *The Maya and their Neighbors*. New York, 1940.

LOTHROP, S. K. *Pre-Columbian Art* (Bliss Collection). New York, 1957.

OLIVÉ N., J. C., and BARBA A., B. 'Sobre la desintegración de las culturas clásicas', *A.I.N.A.H.*, IX (1957).

PIJOAN, J. *Historia del arte precolombino* (*Summa Artis*, x). Barcelona, 1952.

RIVET, P., and ARSANDAUX, H. *La métallurgie en Amérique précolombienne.* Paris, 1946.

ROOT, W. C. 'Metallurgy', *H.S.A.I.,* V (1949).

SELER, E. *Gesammelte Abhandlungen zur amerikanischen Sprach- und Altertumskunde.* 5 vols and index. Berlin, 1902–23.

SMITH, A. L. 'The Corbelled Arch in the New World', *The Maya and their Neighbors.* New York, 1940.

STANISLAWSKI, D. 'Origin and Spread of the Grid-Pattern Town', *Geographical Review,* XXXVI (1946).

TAYLOR, R. E., and MEIGHAN, C. W. *Chronologies in New World Archaeology.* New York, 1978.

TREBBI DEL TREVIGIANO, R. 'Premesse per una storia dell'arte precolombiana', *Critica d'arte,* XIX (1957), 22–31.

TRIMBORN, H. *Quellen zur Kulturgeschichte des präkolumbischen Amerika.* Stuttgart, 1936.

WILBERT, J. *The Thread of Life: Symbolism of Miniature Art from Ecuador.* Washington, 1974.

WILLEY, G. 'Prehistoric Settlement Patterns', *B.B.A.E.,* CLV (1953).

WILLEY, G., and PHILLIPS, P. *Method and Theory in American Archaelogy.* Chicago, 1958.

WILLEY, G. *An Introduction to American Archaeology. North and Middle America,* I. New York, 1966.

II. MESOAMERICA

ACOSTA SAIGNES, M. *Los Pochteca (Acta Anthropologica,* I). Mexico, 1945.

ARMILLAS, P. 'Fortalezas mexicanas', *C.A.,* VII (1948), no. 5.

BARLOW, R. H. 'The Extent of the Empire of the Culhua Mexica', *Ibero-Americana,* XXVIII (1949).

CHARNAY, D., and VIOLLET-LE-DUC, E. *Cités et ruines américaines.* Paris, 1863.

CLARK, J. C. (ed. and trans.). *Codex Mendoza.* 3 vols. London, 1938.

CORONA NÚÑEZ, J. 'Cual es el verdadero significado del Chac Mool?', *Tlatoani,* I (1952), nos. 5–6.

CORTÉS, HERNANDO. *Letters* (ed. F. A. MacNutt). New York, 1908.

COVARRUBIAS, M. *Indian Art of Mexico and Central America.* New York, 1957.

DÍAZ DEL CASTILLO, B. *True History of the Conquest of New Spain* (trans. and ed. A. P. Maudslay). 5 vols. London, 1908–16.

DURÁN, D. *Historia de las Indias de Nueva España.* 2 vols and atlas. Mexico, 1867–80.

EASBY, E., and SCOTT, J. *Before Cortés. Sculpture of Middle America.* New York, 1970.

GENDROP, P. *Arte prehispánico en Mesoamérica.* Mexico, 1970.

HEYDEN, D., and GENDROP, P. *Pre-Columbian Architecture of Mesoamerica.* New York, 1975.

HOERSCHELMANN, W. VON. 'Flächendarstellungen in alt-mexikanischen Bilderschriften', *Festschrift Eduard Seler.* Stuttgart, 1922.

HOLMES, W. H. *Archaeological Studies among the Ancient Cities of Mexico.* 2 vols. Chicago, 1895–7.

KEMRER, M. F., Jr. 'A Re-examination of the Ball-game in Mesoamerica', *Cerámica de Cultura Maya et al.,* no. 5 (1968).

KINGSBOROUGH, E. *Antiquities of Mexico.* London, 1831.

LIZARDI RAMOS, C. 'El Chacmool mexicano', *C.A.,* IV (1944), no. 2.

LOWE, G. 'Civilizational Consequences of Varying Degrees of Agricultural and Ceramic Dependence within the Basic Ecosystems of Mesoamerica', *U.C.A.R.F.,* XI (1971).

MARQUINA, I. *Arquitectura prehispánica.* Mexico, 1951.

MOTOLINIA, T. DE B. *Historia de los Indios de la Nueva España.* Barcelona, 1914. English translation by F. B. Steck, entitled *Motolinia's History of the Indians of New Spain,* Washington, 1951.

NICHOLSON, H. B. 'The Birth of the Smoking Mirror', *Archaeology,* VII (1954).

NOGUERA, E. *Tallas prehispánicas en madera.* Mexico, 1958.

NOWOTNY, K. A. *Tlacuilolli.* Berlin, 1961.

PALERM, A. 'Notas sobre las construcciones militares y la guerra en Mesoamérica', *A.I.N.A.H.,* VIII (1956).

POLLOCK, H. E. D. *Round Structures of Aboriginal Middle America.* Washington, 1936.

QUIRARTE, J. 'El juego de pelota en Mesoamérica', *E.C.M.,* VIII (1970).

RANDS, R. L. 'Some Manifestations of Water in Mesoamerican Art', *B.B.A.E.,* CLVII (1955).

RITMAN, L. H. 'The Rubber Ball-Game', *Cerámica de Cultura Maya et al.,* no. 5 (1968).

SAVILLE, M. *The Goldsmith's Art in Ancient Mexico.* New York, 1920.

SAVILLE, M. *Turquoise Mosaic Art in Ancient Mexico.* New York, 1920.

SAVILLE, M. *The Woodcarver's Art in Ancient Mexico.* New York, 1925.

SCHULTZE, L. *Indiana,* II. Jena, 1933–8.

SELER-SACHS, C. *Auf alten Wegen in Mexiko und Guatemala.* Berlin, 1900.

SHEPARD, A. O. *Plumbate.* Washington, 1948.

DU SOLIER, W. *La plástica arcaica.* Mexico, 1950.

SOUSTELLE, J. *La pensée cosmologique des anciens mexicains.* Paris, 1940.

SPINDEN, H. J. *Ancient Civilizations of Mexico and Central America*. New York, 1928.

THOMPSON, J. E. S. 'Sky Bearers, Colors and Directions in Maya and Mexican Religion', *C.A.A.*, II (1934).

THOMPSON, J. E. S. 'The Moon Goddess in Middle America', *C.A.A.H.*, V (1939).

THOMPSON, J. E. S. *Dating of Certain Inscriptions of Non-Maya Origin*. Washington, 1941.

TOSCANO, S. *Arte precolombino*. Mexico, 1944.

WEBB, M. C. 'The Significance of the Epiclassic Period in Mesoamerican Prehistory', in D. I. BROWMAN (ed.), *Cultural Continuity in Mesoamerica*, 155–78. The Hague, 1978.

WILLEY, G. 'Mesoamerican Civilization and the Idea of Transcendence', *Antiquity*, L (1976), 205–15.

III. ANCIENT MEXICO

A. GENERAL

Art mexicain du précolombien à nos jours. Paris, 1952.

BOBAN, E. *Documents pour servir à l'histoire du Mexique*. 2 vols and atlas. Mexico, 1891.

BORAH, W., and COOK, S. F. 'The Aboriginal Population of Central Mexico on the Eve of the Spanish Conquest', *Iberoamericana*, XLV (1963).

BORHEGYI, S. 'The Pre-Columbian Ballgame', *I.C.A.*, XXVIII (1968).

CHARNAY, D. *Cités et ruines américaines*. Paris, 1863.

CHAVERO, A. *Antigüedades mexicanas*. Mexico, 1892.

CLARK, J. C. (ed. and trans.). *Codex Mendoza*. 3 vols. London, 1938.

EKHOLM, G. *Ancient Mexico and Central America*. New York, 1970.

Kunst der Mexikaner. Zürich, 1959.

LÓPEZ AUSTIN, A. *El hombre-dios, Quetzalcoatl*. Mexico, 1972.

MÉDIONI, G., and PINTO, M. T. *Art in Ancient Mexico*. New York, 1941.

PIÑA CHAN, R. *Historia, arqueología y arte prehispánico*. Mexico, 1972.

ROBERTSON, D. *Mexican Manuscript Painting of the Early Colonial Period*. New Haven.

SAHAGÚN, B. DE. *Historia general de las cosas de Nueva España*. 5 vols. Mexico, 1938.

SAHAGÚN, B. DE. *Florentine Codex* (trans. A. J. O. Anderson and C. E. Dibble). Santa Fé, 1950– .

SAVILLE, M. 'Votive Axes from Ancient Mexico', *I.N.M.*, VI (1929).

SELER, E. *Einige Kapitel aus dem Geschichtswerk des Fray Bernardino de Sahagun*. Stuttgart, 1927.

Twenty Centuries of Mexican Art. New York (Museum of Modern Art), 1940.

WESTHEIM, P. *Arte antiguo de México*. Mexico, 1950.

WINNING, H. VON. 'Mexican Figurines attached to Pallets and Cradles', *I.C.A.*, XL (1973), vol. I, 123–31.

B. CENTRAL MEXICO

ACOSTA, J. 'Exploraciones en Tula', *R.M.E.A.*, IV (1940); 'Últimos descubrimientos en Tula', V (1941); 'La ciudad de Quetzalcóatl', VI (1942); 'La cuarta y quinta temporadas de exploraciones arqueológicas en Tula', VII (1943–4).

AGUILERA, C. *El arte oficial tenochca. Su significación social*. Mexico, 1977.

APENES, O. 'The "Tlateles" of Lake Texcoco', *Am.A.*, IX (1943).

ARMILLAS, P. 'Exploraciones recientes en Teotihuacán', *C.A.*, III (1944), no. 4.

ARMILLAS, P. 'Los dioses de Teotihuacán', *Anales del Instituto de Etnología americana*, VI (1945).

ARMILLAS, P. 'La serpiente emplumada, Quetzalcóatl y Tlaloc', *C.A.*, VI (1947), no. 1.

ARMILLAS, P. 'Teotihuacán, Tula y los Toltecas', *Runa*, III (1950).

AVELEYRA ARROYO DE ANDA, L. 'The Pleistocene Carved Bone from Texquixquiac', *Am.A.*, XXX (1965).

BASTIEN, R. 'New Frescoes in the City of the Gods', *Modern Mexico*, XX (1948), 21.

BEYER, H. *El llamado 'calendario Azteca'*. Mexico, 1921.

BEYER, H. 'La procesión de los Señores', *M.A.*, VIII (1955).

BRENNER, A. 'The Influence of Technique on the Decorative Style in the Domestic Pottery of Culhuacan', *Columbia University Contributions to Anthropology*, XIII (1931).

CALNEK, E. E. 'Localization of the Sixteenth-Century Map, called the Maguey Plan', *Am.A.*, XXXVIII (1957).

CARRASCO, P. 'The Peoples of Central Mexico and their Historical Traditions', *H.M.A.I.*, XI (1972).

CASO, A. 'Las ruinas de Tizatlán', *R.M.E.H.*, I (1927).

CASO, A. *El Teocalli de la guerra sagrada*. Mexico, 1927.

CASO, A. 'Tenían los Teotihuacanos conocimiento del tonalpohualli?', *M.A.*, IV (1937).

CASO, A. 'El paraíso terrenal en Teotihuacán', *C.A.*, I (1942), no. 6.

CASO, A. *The Aztecs*. Norman, 1958.

CASO, A. 'Calendario y escritura en Xochicalco', *R.M.E.A.*, XVIII (1962).

CHADWICK, R. 'Post-Classic Pottery of the Central Valleys', *H.M.A.I.*, X (1971).

CHADWICK, R. 'Native Pre-Aztec History of Central Mexico', *H.M.A.I.*, XI (1972).

COE, M. *The Jaguar's Children: Pre-Classic Central Mexico*. New York, 1965.

COVARRUBIAS, M. 'Tlatilco', *C.A.*, IX (1950), no. 3.

COVARRUBIAS, M. *The Eagle, the Jaguar and the Serpent*. New York, 1957.

DIBBLE, C. E. *Códice en Cruz*. Mexico, 1942.

DIBBLE, C. E. *Códice Xolotl*. Mexico, 1951.

EASBY, D. T., Jr. 'Sahagún y los orfebres precolombinos de México', *A.I.N.A.H.*, IX (1957).

EASBY, D., and DOCKSTADER, F. J. 'Requiem for Tizoc', *Archaeology*, XVII (1964).

FERNÁNDEZ, J. *Coatlicue*. Mexico, 1954.

FONCERRADA DE MOLINA, M. 'The Cacaxtla Murals: An Example of Cultural Contact?', *Ibero-Amerikanisches Archiv*, IV (1978), no. 2, 141–60.

GAMIO, M. *La población del valle de Teotihuacán*. 3 vols. Mexico, 1922.

GARCÍA PAYÓN, J. *Zona arqueológica de Tecaxic-Calixtlahuaca*. Mexico, 1936.

GLASS, J. *Catálogo de la colección de códices*. Mexico, 1964.

HAMY, E. T. (ed.). *Codex Borbonicus*. Facsimile ed. Paris, 1899.

HAMY, E. T. (ed.). *Codex Telleriano-Remensis*. Facsimile ed. Paris, 1899.

HEIZER, R., and BENNYHOFF, J. 'Cuicuilco', *Science*, CXXVII, no. 3292.

HEYDEN, D. 'An Interpretation of the Cave underneath the Pyramid of the Sun in Teotihuacán, Mexico', *Am. A.*, XL (1975), 131–47.

HOCHSTETTER, F. VON. *Über mexikanische Reliquien aus der Zeit Montezumas in der K. K. Ambraser Sammlung*. Vienna, 1884.

HOLMES, W. H. 'Handbook of Aboriginal American Antiquities', *B.B.A.E.*, LX (1919).

HVIDTFELDT, A. *Teotl and Ixiptlatli*. Copenhagen, 1958.

IXTLILXOCHITL, F. DE A. *Obras históricas* (ed. Chavero). Mexico, 1891–2.

JIMÉNEZ MORENO, W. 'Tula y los Toltecas segun las fuentes históricas', *R.M.E.A.*, V (1940).

KIRCHHOFF, P. 'Civilizing the Chichimecs', *Latin-American Studies*, V (1948).

KIRCHHOFF, P. 'The Mexican Calendar and the Founding of Tenochtitlan-Tlatelolco', *Transactions of the New York Academy of Sciences*, XII (1950).

KIRCHHOFF, P. 'Calendarios Tenochca, Tlatelolca y otros', *R.M.E.A.*, XIV (1954–5).

KRICKEBERG, W. 'Das mittelamerikanische Ballspiel und seine religiöse Symbolik', *Paideuma*, III (1948).

KUBLER, G. 'The Cycle of Life and Death in Metropolitan Aztec Sculpture', *G.B.A.*, XXIII (1943).

KUBLER, G., and GIBSON, C. *The Tovar Calendar*. New Haven, 1951.

LEHMANN, W. *Aus den Pyramidenstädten in Alt-Mexiko*. Berlin, 1933.

LEHMANN, W. (ed.). *Die Geschichte der Königreiche von Colhuacan und Mexiko*. Stuttgart, 1938.

LEONARD, C. C. 'Excavaciones en Ostoyohualco, Teotihuacán', *Boletín del centro de investigaciones antropológicas de México*, IV (1957).

LINNÉ, S. *Archaeological Researches at Teotihuacan*. Stockholm, 1934.

LINNÉ, S. 'Teotihuacan Symbols', *Ethnos*, VI (1941).

LOPEZ AUSTIN, A. 'Iconografía mexica. El monolito verde del templo mayor', *Anales de Antropología*, XVI (1979), 133-53.

LOUBAT, DUC DE (ed.). *Codex Magliabecchi*. Rome, 1901.

MARQUINA, I., and others. *La pirámide de Tenayuca*. Mexico, 1935.

MARTÍNEZ DEL RÍO, P., and others. 'Tlatelolco a través de los tiempos', *Memorias de la Academia de Historia*, III–IV (1944–8).

MATOS MOCTEZUMA, E. 'The Tula Chronology: A Revision', in E. PASZTORY (ed.), *Middle Classic Mesoamerica*, 172–7. New York, 1978.

MATOS MOCTEZUMA, E. 'El proyecto templo mayor', *Boletín I.N.A.H.*, época III, no. 24 (1978) (*Antropología e Historia*), 3–17.

MENDIETA, FRAY JUAN DE. *Historia ecclesiástica indiana* (ed. J. García Icazbalceta). Mexico, 1870.

MILLER, A. G. *The Mural Painting of Teotihuacan*. Washington, 1973.

MILLON, R. 'The Beginnings of Teotihuacán', *Am.A.*, XXVI (1960), 1–10.

MOEDANO, H. 'El friso de los caciques', *A.I.N.A.H.*, II (1947).

MOEDANO, H. 'Oztotitlan', *El occidente de México* (*S.M.A.M.R.*, IV). Mexico, 1948.

MORENO, M. M. *La organización política y social de los Aztecas*. Mexico, 1931.

NEYS, H., and WINNING, H. VON. 'The Treble Scroll', *N.M.A.A.E.*, III (1946–8).

NICHOLSON, H. B. 'The Chapultepec Cliff Sculpture', *M.A.*, IX (1969).

NICHOLSON, H. B. 'Religion', *H.M.A.I.*, X (1971).

NOGUERA, E. 'El ladrillo como material de construcción entre los nahuas', *R.M.E.H.*, II (1928).

NOGUERA, E., in *M.A.*, III (1935), no. 3.

NOGUERA, E. 'Exploraciones en Xochicalco', *C.A.*, IV (1945), no. I.

NOGUERA, E. 'Nuevos rasgos característicos encontrados en Xochicalco', *R.M.E.A.*, X (1948–9).

NOGUERA, E. *El horizonte Tolteca-Chichimeca*. Mexico, 1950.

NOGUERA, E. *La cerámica arqueológica de Cholula*. Mexico, 1954.

OUTWATER, J. O. 'Precolumbian Stonecutting Techniques of the Mexican Plateau', *Am.A.*, XXII (1957), 258.

PIÑA CHAN, R. *Chalcatzingo, Morelos (Informes I.N.A.H.*, no. 4). Mexico, 1955.

PIÑA CHAN, R. *Las culturas preclásicas de la Cuenca de México*. Mexico, 1955.

PORTER, M. N. *Tlatilco and the Pre-Classic Cultures of the New World*. New York, 1953.

RADIN, P. 'The Sources and Authenticity of the History of the Ancient Mexicans', *U.C.P.A.A.E.*, XVII (1920).

RATTRAY, E. 'Los contactos Teotihuacan-Maya vistos desde el centro de México', *Anales de Antropología*, XV (1978), 33–52.

RUBÍN DE LA BORBOLLA, D. F. 'Teotihuacán: Ofrendas de los templos de Quetzalcóatl', *A.I.N.A.H.*, II (1941–6).

RUZ LHUILLIER, A. *Guía arqueológica de Tula*. Mexico, 1945.

SÁENZ, C. 'Exploraciones en Xochicalco', *Bol. I.N.A.H.* (1966), no. 26.

SANDERS, W. T. 'Settlement Patterns in Central Mexico', *H.M.A.I.*, X (1971).

SCHOTTELIUS, J. W. 'Wieviel Dämme verbanden die Inselstadt Mexico-Tenochtitlán mit dem Festland', *Ibero-amerikanisches Archiv*, VIII (1934).

SEARS, P. B. 'Pollen Profiles and Culture Horizons in the Basin of Mexico', *I.C.A.*, XXXIX (1951).

SÉJOURNÉ, L. *Burning Water*. London, 1956.

SPRANZ, B. *Göttergestalten in den mexikanischen Bilderhandschriften des Codex Borgia-Gruppe*. Wiesbaden, 1964.

SPRANZ, B. *Totimehuacán*. Wiesbaden, 1970.

TEZOZOMOC, H. *Crónica mexicana* (ed. Orozco y Berra). Mexico, 1878; reissued 1944.

TOLSTOY, P. 'Surface Survey of the Northern Valley of Mexico', *Transactions of the American Philosophical Society*, XLVIII (1958), part V.

TOLSTOY, P., and PARADIS, L. 'Early and Middle Pre-Classic Culture in the Basin of Mexico', *U.C.A.R.F.*, XI (1971).

TOUSSAINT, M., FERNÁNDEZ, J., and O'GORMAN, E. *Planos de la ciudad de México*. Mexico, 1938.

VAILLANT, G. 'Excavations at Zacatenco', *A.M.N.H.A.P.*, XXXII (1930), part I.

VAILLANT, G. 'Early Cultures of the Valley of Mexico', *A.M.N.H.A.P.*, XXV (1935).

VAILLANT, G. *The Aztecs of Mexico*. Harmondsworth, 1950.

WEST, R. C., and ARMILLAS, P. 'Las chinampas de México', *C.A.*, V (1950), no. 2.

WINNING, H. VON. 'Representations of Temple Buildings', *N.M.A.A.E.*, III (1946–8), no. 83.

WINNING, H. VON. 'A Symbol for Dripping Water', *M.A.*, VI (1947); 'Shell Designs on Teotihuacan Pottery', VII (1949).

WINNING, H. VON. 'Teotihuacan Symbols: The Fire God Complex', *I.C.A.*, XLII (1976), vol. VII (1979), 425–37.

WINNING, H. VON. 'The Old Fire God and his Symbolism at Teotihuacan', *Indiana*, IV (1977), 7–62.

WINNING, H. VON. 'The "Binding of the Years" and the "New Fire" in Teotihuacan', *Indiana*, V (1978), 15–32.

WINNING, H. VON. 'Human-Mask Pectorals on Teotihuacan Figurines', *Masterkey*, LII (1978), no. 1, 11–16.

WOLF, E. R. (ed.) *The Valley of Mexico*. Albuquerque, 1976.

YADEÚN ANGULO, J. *El estado y la ciudad: el caso de Tula; Proyecto Tula*. Mexico, 1975.

C. EASTERN MEXICO

BERNAL, I. *The Olmec World*. Berkeley, 1969.

BEYER, H. 'Shell Ornament Sets', *M.A.R.S.*, V (1934).

BOVE, F. J. 'Laguna de los Cerros: An Olmec Central Place', *Journal of New World Archaeology*, II (1978), no. 3, 1–56.

BRÜGGEMANN, J., and HERS, M. A. 'Exploraciones arqueológicas en San Lorenzo', *Bol. I.N.A.H.*, XXXIX (1970).

CLEWLOW, C. W., a.o. 'Colossal Heads', *U.C.A.R.F.*, IV (1967).

CLEWLOW, C. W. 'A Stylistic and Chronological Study of Olmec Monumental Sculpture', *U.C.A.R.F.*, XIX (1974).

COE, M. *The Jaguar's Children: Pre-Classic Central Mexico*. New York, 1965.

COE, M. *America's First Civilization*. New York, 1968.

COE, M. 'San Lorenzo and the Olmec Civilization', *Dumbarton Oaks Conference on the Olmec*. Washington, 1968.

CORONA NÚÑEZ, J. 'Relaciones arqueológicas entre las Huastecas y las regiones al Poniente', *R.M.E.A.*, XIII (1952–3).

COVARRUBIAS, M. 'El arte "Olmeca" o de La Venta', *C.A.*, V (1946), no. 4.

COVARRUBIAS, M. *Mexico South*. New York, 1946.

DRUCKER, P. 'Ceramic Sequences at Tres Zapotes', *B.B.A.E.*, CXL (1943).

DRUCKER, P. 'La Venta, Tabasco: A Study of Olmec Ceramics and Art', *B.B.A.E.*, CLIII (1952).

DRUCKER, P., HEIZER, R.F., and SQUIER, R. F. 'Excavations at La Venta, 1955', *B.B.A.E.*, CLXX (1959).

DU SOLIER, W. 'La cerámica arqueológica de El Tajín', *A.M.N.A.H.E.*, 5 ép., III (1936-8) (1945).

DU SOLIER, W. 'Estudio arquitectónico de los edificios Huaxtecas', *A.I.N.A.H.*, I (1945).

DU SOLIER, W. 'Primer fresco mural huasteca', *C.A.*, V (1946), no. 6.

EKHOLM, G. 'Excavations at Tampico and Panuco in the Huasteca', *A.M.N.H.A.P.*, XXXVIII (1944), no. 5.

EKHOLM, G. 'The Probable Use of Mexican Stone Yokes', *A.A.*, XLVIII (1946).

EKHOLM, G. 'Palmate Stones and Thin Stone Heads', *Am.A.*, XV (1949).

FERNÁNDEZ, J. *Arte olmeca*. Mexico, 1968.

FLANNERY, K. 'The Olmec and the Valley of Oaxaca', *Dumbarton Oaks Conference on the Olmec*. Washington, 1968.

FUENTE, B. DE LA. *Escultura monumental olmeca*. Mexico, 1973.

GARCÍA PAYÓN, J. 'Una "palma" in situ', *R.M.E.A.*, X (1948-9).

GARCÍA PAYÓN, J. 'Arqueología de Zempoala', *Uni-Ver*, I (1949).

GARCÍA PAYÓN, J. *Exploraciones en El Tajín* (*Informes I.N.A.H.*, no. 2). Mexico, 1955.

GARCÍA PAYÓN, J. 'Ensayo de interpretación', *M.A.*, IX (1959).

HEIZER, R. F. 'Excavations at La Venta, 1955', *Bulletin of the Texas Archaeological Society*, XXVIII (1957), 98-110.

HEIZER, R. 'Analysis of Two Low Relief Sculptures from La Venta', *U.C.A.R.F.*, III (1967).

HEIZER, R. F., and DRUCKER, P. 'The La Venta Flute Pyramid', *Antiquity*, XLII (1968).

JIMÉNEZ MORENO, W. 'El enigma de los Olmecas', *C.A.*, V (1942).

JORALEMON, P.D. *A Study of Olmec Iconography*. Washington, 1971.

KAMPEN, M. E. *The Sculptures of El Tajín*. Gainesville, 1972.

KAMPEN, M. E. 'Classic Veracruz Grotesques and Sacrificial Iconography', *Man*, XIII (1978), 116-26.

KNAUTH, L. 'El juego de pelota', *E.C.M.*, I (1961).

KRICKEBERG, W. 'Die Totonaken', *B.A.*, VII (1918-22); IX (1925).

KRUTT, M. 'Un yugo in situ', *Bol. I.N.A.H.*, XXXVI (1969).

MCBRIDE, H. W., in O. HAMMER (ed.). *Ancient Art of Vera Cruz*, 23-30. Los Angeles, 1971.

MEDELLÍN ZENIL, A., and PETERSON, F. A. 'A Smiling Head Complex from Central Veracruz, Mexico', *Am.A.*, XX (1954), no. 2.

MEDELLÍN ZENIL, A. *Exploraciones en la Isla de Sacrificios*. Jalapa, 1955.

MEDELLÍN ZENIL, A. *Cerámicas del Totonacapan*. Xalapa, 1960.

MIYAWAKI, T. 'Multidimensional Scaling and the Seriation of the Twelve Olmec Colossal Heads'. Manuscript, 1970.

PALACIOS, E.J. *Los yugos y su simbolismo*. Mexico, 1943.

PASO Y TRONCOSO, F. DEL, and GALINDO Y VILLA, J. 'Las ruinas de Cempoala y del templo del Tajín', *A.M.N.A.H.E.*, III (1912), apen.

PIÑA CHAN, R., and COVARRUBIAS, L. *El Pueblo del Jaguar*. Mexico, 1964.

POHORILENKO, A. 'New Elements of Olmec Iconography: Ceremonial Markings', *S.M.A.M.R.*, XIII (1975), vol. I, 265-81.

PROSKOURIAKOFF, T. 'Classic Veracruz Sculpture', *C.A.A.H.*, XII (1954), no. 58.

ROSADO OJEDA, V. 'Las mascaras rientes totonacas', *R.M.E.A.*, V (1941).

SPINDEN, E. 'The Place of Tajin in Totonac Archaeology,' *A.A.*, XLVIII (1933).

SPINDEN, H. 'Huastec Sculptures and the Cult of the Apotheosis', *Brooklyn Museum Quarterly*, XXIV (1937).

STIRLING, M. *An Initial Series from Tres Zapotes*. Washington, 1940.

STIRLING, M. 'The Cerro de las Mesas Offering of Jade and Other Materials', *B.B.A.E.*, CLVII (1955).

STREBEL, H. *Alt-Mexiko*. 2 vols. Hamburg-Leipzig, 1885-9.

STRESSER-PÉAN, G. 'Ancient Sources on the Huasteca', *H.M.A.I.*, XI (1971).

SWADESH, M. 'The Language of the Archaeologic Huastecs', *N.M.A.A.E.*, IV (1949-53), no. 114.

TORRES GUZMÁN, M., REYES, M. A., and ORTEGA, J. 'Proyecto Zapotal', *S.M.A.M.R.*, XIII (1975), vol. I, 323-30.

TUGGLE, H. D. 'The Structure of Tajín World-View', *Anthropos*, LXVII (1972), 435-48.

TUGGLE, H. D. 'The Columns of El Tajín', *Ethnos*, XXXIII (1968).

WICKE, C. *Olmec*. Tucson, 1971.

WILKERSON, S. J. K. 'Un yugo in situ de la región del Tajín', *Bol. I.N.A.H.* XLI (1970).

WINNING, H. VON. 'Die mythologische Bedeutung eines olmekischen Jaguarskulptur', *Z.E.*, C (1975), 224-37.

WYSHAK, L. W., and BERGER, R. 'Possible Ball Court at La Venta', *Nature*, CCXXXII (1971).

D. SOUTHERN MEXICO

AGRINIER, L. *The Carved Human Femurs from Tomb 1, Chiapa de Corzo*. Orinda, 1960.

BERNAL, I. 'Excavaciones en Coixtlahuaca', *R.M.E.A.*, X (1949).

BERNAL, I. *Exploraciones en Cuilapan*. Mexico, 1958.

BERNAL, I. 'The Mixtecs in Valley Archaeology', in J. PADDOCK (ed.), *Ancient Oaxaca*. Stanford, 1966.

BERNAL, I. 'The Ball Players of Dainzú', *Archaeology*, XXI (1968).

BOOS, F. *Corpus antiquitatum americanensium*. 2 vols. Mexico, 1964–6.

BURGOA, F. *Geográfica descripción* ... (written *c.* 1666–71). Mexico, 1934.

BURGOA, F. *Palestra historial*. Mexico, 1934.

CASO, A. *Estelas Zapotecas*. Mexico, 1928.

CASO, A. *Exploraciones en Oaxaca ... 1934–35* (Instituto panamericano de geografía e historia, Pub. 17), Mexico, 1935; *idem, 1936–37* (Pub. 34), Mexico, 1938.

CASO, A. *Exploraciones en Mitla, 1934–35*. Mexico, 1936.

CASO, A. *Calendarios y escrituras de las antiguas culturas de Monte Alban*. Mexico, 1947.

CASO, A. 'El mapa de Teozacualco', *C.A.*, VIII (1949), no. 5.

CASO, A. 'Base para la sincronología Mixteca y cristiana', *Memoria de el Colegio Nacional*, VI (1951).

CASO, A. *Codex Bodley 2858*. Mexico, 1960.

CASO, A. 'Sculpture and Mural Painting of Oaxaca', *H.M.A.I.*, III (1965).

CASO, A. 'The Lords of Yanhuitlan', in J. PADDOCK (ed.), *Ancient Oaxaca*. Stanford, 1966.

CASO, A. *El tesoro de Monte Albán*. Mexico, 1969.

CASO, A. *Reyes y reinos de la Mixteca*. Mexico, 1977.

CASO, A., a.o. *La cerámica de Monte Albán*. Mexico, 1947.

CASO, A., and BERNAL, I. *Urnas de Oaxaca*. Mexico, 1952.

DAHLGREN DE JORDAN, B. *La Mixteca*. Mexico, 1954.

DARK, P. (with supplementary note by John Paddock). 'Speculations on the Course of Mixtec History', *B.E.O.*, no. 10 (1958).

DARK, P. *Mixtec Ethnohistory. A Method of Analysis of the Codical Art*. Oxford, 1958.

GALLEGOS, R. 'Zaachila', *Archaeology*, XVI (1963).

HARTUNG, H. 'Notes on the Oaxaca Tablero', *B.E.O.*, no. 27 (1970).

LEHMANN, W. 'Lés peintures Mixtéco-Zapotèques', *J.S.A.*, II (1905).

LEHMANN, W., and SMITAL, O. (eds.). *Codex Vindobonensis Mexic. 1*. Facsimile ed. Vienna, 1929.

LEÓN, N. *Lyobaa ò Mictlan*. Mexico, 1901.

LINNÉ, S. *Zapotecan Antiquities*. Stockholm, 1938.

PADDOCK, J. 'Excavations at Yagul', *Mesoamerican Notes*, IV (1955).

PADDOCK, J. 'Mixtec Ethnohistory', *Ancient Oaxaca*. Stanford, 1966.

PADDOCK, J. 'More Ñuiñe Materials', *B.E.O.*, no. 28 (1970).

PASO Y TRONCOSO, F. DEL (ed.). 'Relación de Tlacolula y Mitla', *Papeles de la Nueva España*, IV. Madrid, 1905. English version in *Mesoamerican Notes*, IV (1955).

PEÑAFIEL, A. (ed.). *Lienzo de Zacatepeque*. Mexico, 1900.

PROSKOURIAKOFF, T. 'Classic Art of Central Veracruz', *H.M.A.I.*, XI (1971).

RABIN, E. 'The Lambityeco Friezes', *B.E.O.*, no. 33 (1970).

SAUSSURE, H. DE. *Le manuscrit du cacique*. Geneva, 1892.

SAVILLE, M. 'The Cruciform Structures of Mitla and Vicinity', *Putnam Anniversary Volume*. New York, 1909.

SCHULER-SCHÖMIG, I. VON. *Figurengefässe aus Oaxaca*. Berlin, 1970.

SELER, E. (ed.). *Codex Féjerváry-Mayer*. Berlin–London, 1902.

SELER, E. 'Der Codex Borgia und die verwandten aztekischen Bilderschriften', *G.A.*, I (1902).

SELER, E. 'Venus Period in the Picture Writings of the Borgian Codex Group', *B.B.A.E.*, XXVIII (1904).

SELER, E. 'The Wall Paintings of Mitla', *B.B.A.E.*, XXVIII (1904).

SHARP, R. 'Early Architectural Grecas in the Valley of Oaxaca', *B.E.O.*, no. 32 (1970).

SHOOK, E., and KIDDER, A. V. 'Mound E-III-3, Kaminaljuyu', *C.A.A.H.*, XI (1952).

SPRANZ, B. *Göttergestalten in den mexikanischen Bilderhandschriften der Codex Borgia-Gruppe*. Wiesbaden, 1964.

TOMPKINS, J. B. 'Codex Fernandez Leal', *Pacific Art Review*, II (1942).

VILLAGRA, A. 'Los Danzantes', *I.C.A.*, XXVII (1939), II.

E. WESTERN MEXICO

BELL, B. 'Archaeology of Nayarit, Jalisco and Colima', *H.M.A.I.*, XI (1971).

CHADWICK, R. 'Archaeological Synthesis of Michoacan', *H.M.A.I.*, XI (1971).

CORONA NÚÑEZ, J. *Tumba de el Arenal, Etzatlán, Jal.* (*Informes I.N.A.H.*, III). Mexico, 1955.

COVARRUBIAS, M. 'Tipología de la industria de piedra tallada y pulida de la Cuenca del Río Mezcala', *El occidente de México* (*S.M.A.M.R.*, IV). Mexico, 1948.

COVARRUBIAS, M. *Mezcala, Ancient Mexican Sculpture.* New York, 1956.

EKHOLM, G. 'Excavations at Guasave, Sinaloa', *A.M.N.H.A.P.*, XXXVIII (1942).

FURST, P. 'West Mexican Tomb Sculpture as Evidence for Shamanism in prehispanic Mesoamerica', *Antropológica*, XV (1965).

GAMIO, M. *Los monumentos arqueológicos de las inmediaciones de Chalchihuites.* Zacatecas, 1910.

GAY, C. *Mezcala Stone Sculpture: The Human Figure.* New York, 1967.

GAY, C. 'Oldest Paintings of the New World', *Natural History*, LXXVI (1967).

GAY, C. *Xochipala, The Beginnings of Olmec Art.* Princeton, 1972.

GIFFORD, E. W. 'Surface Archaeology of Ixtlán del Río, Nayarit', *U.C.P.A.A.E.*, XLIII (1950).

GROVE, D. C. 'Los murales de la Cueva de Oxtotitlan', *Invest. I.N.A.H.*, XXIII (1970).

GROVE, D. C. 'The Olmec Paintings of Oxtotitlan Cave', *D.O.S.*, VI (1970).

HRDLIČKA, A. 'The Region of the Ancient Chichimecs', *A.A.*, V (1903).

KAN, M., a.o. *Sculpture of Ancient West Mexico.* Los Angeles, 1970.

KELLEY, J. C. 'Archaeology of the Northern Frontier', *H.M.A.I.*, XI (1971).

KELLEY, J. C., and WINTERS, H. D. 'A Revision of the Archaeological Sequence in Sinaloa', *Am.A.*, XXV (1960).

KELLY, I. 'Excavations at Chametla', *Ibero-Americana*, XIV (1938).

KELLY, I. 'The Archaeology of the Autlán-Tuxcacuesco Area', *Ibero-Americana*, XXVI (1945), XXVII (1949).

KELLY, I. 'Excavations at Apatzingán, Michoacán', *V.F.P.A.*, VII (1947).

KELLY, I. 'Seven Colima Tombs: An Interpretation of Ceramic Content', *U.C.A.R.F.*, XXXVI (1978), 1–7.

LEHMANN, H. 'Le personnage couché sur le dos', *I.C.A.*, XXIX (1951).

LEHMANN, H. 'Cradled Infant Figurines', *Am.A.*, XIX (1953–4).

LISTER, R. H. 'Archaeological Synthesis of Guerrero', *H.M.A.I.*, XI (1971).

LUMHOLTZ, C. *Unknown Mexico.* New York, 1904.

MEIGHAN, C. W. 'Archaeology of Sinaloa', *H.M.A.I.*, XII (1971).

NOGUERA, E. *Ruinas arqueológicas del norte de México.* Mexico, 1930.

NOGUERA, E. 'Exploraciones en El Opeño, Michoacán', *I.C.A.*, XXVII (1943).

NOGUERA, E. 'Exploraciones en Jiquilpan', *Anales del Museo Michoacano*, III (1944).

POLLARD, H.P. 'An Analysis of Urban Zoning and Planning at Prehispanic Tzintzuntzan', *Proceedings of the American Philosophical Society*, CXXI (1977), no. 1, 46–69.

PORTER, M. N. 'Excavations at Chupícuaro', *Transactions of the American Philosophical Society*, XLVI (1956), part V.

REYES, J. M. 'Breve reseña ...', *Boletín de la Sociedad de Geografía y Estadística*, V (1881).

RUBÍN DE LA BORBOLLA, D. 'La orfebrería tarasca', *C.A.*, III (1944), no. 3.

TALADOIRE, E. 'Ball-Game Scenes and Ball-Courts in West Mexican Archaeology. A Problem in Chronology', *Indiana*, V (1978), 33-43.

TARAYRE, E. GUILLEMIN. *Exploration minéralogique des régions mexicaines.* Paris, 1869.

TOSCANO, S., KIRCHHOFF, P., and RUBÍN DE LA BORBOLLA, D. F. *Arte precolombino del occidente de México.* Mexico, 1946.

TUDELA, J. (ed.). *Relación de Michoacán* (1541). Madrid, 1956.

WINNING, H. VON. 'Escenas rituales en la cerámica policroma de Nayarit', *I.C.A.*, XLI (1976), vol. II, 387–400.

WINNING, H. VON. *The Shaft Tomb Figures of West Mexico.* Los Angeles, 1974.

WINNING, H. VON, and HAMMER, O. *Anecdotal Sculpture of Ancient West Mexico.* Los Angeles, 1972.

IV. MAYA

A. GENERAL

ANDREWS, E. W. 'Archaeology and Prehistory in the Northern Maya Lowlands', *H.M.A.I.*, II (1965).

ANDREWS V, E. W. 'Early Central Mexican Architectural Traits at Dzibilchaltun, Yucatan', *I.C.A.*, XLII (1976), vol. VIII (1979), 237–49.

Art of the Maya Civilization. Catalogue by H. J. Spinden of the exhibition at the Martin Widdifield Gallery. New York, 1957.

BALL, J. W. 'A Coordinate Approach to Northern Maya Prehistory', *Am. A.*, XXXIX (1974).

BALL, J. W. 'Southeastern Campeche and the Mexican Plateau: Early Classic Contact Situations', *I.C.A.*, XLIII (1976), vol. VIII (1979), 271–80.

BARTHEL, T. S. 'Die gegenwärtige Situation in der

Erforschung der Maya-Schrift', *J.S.A.*, XLV (1956).

BLOM, F., and LAFARGE, C. *Tribes and Temples.* 2 vols. New Orleans, 1926.

BLOM, F. 'The Maya Ball-Game *Pok-ta-pok*', *M.A.R.S.*, IV (1932).

BRAINERD, G. W. *The Archaeological Ceramics of Yucatan (Anthropological Records*, XIX, 26). Berkeley, 1958.

BRASSEUR DE BOURBOURG, C. (ed.). *Manuscrit Troano.* Paris, 1869–70.

DIESELDORFF, E. P. *Kunst und Religion der Mayavölker.* Berlin, 1926.

FERNÁNDEZ, M. A. *Los Mayas antiguos.* Mexico, 1941.

FÖRSTEMANN, E. *Die Maya-Handschrift der königlichen Bibliothek zu Dresden.* Leipzig, 1892.

GRAHAM, I. *The Art of Maya Hieroglyphic Writing.* New York, 1971.

GRAHAM, I. *Corpus of Maya Hieroglyphic Inscriptions*, I-. Cambridge, Mass., 1975–.

GRAHAM, J. 'Maya, Olmecs and Izapans at Abaj Takalik', *I.C.A.*, XLII (1976), vol. VIII (1979), 179–88.

GRAHAM, J. 'Discoveries at Abaj Takalik', *Archaeology*, XXX (1980), no. 3, 196–7.

GRAHAM, J., HEIZER, R. F., and SHOOK, E. M. 'Abaj Takalik, 1976: Exploratory Investigations', *U.C.A.R.F.*, XXXVI (1978), 85–110.

GREENE, M., a.o. *Maya Sculpture.* Berkeley, 1972.

HARTUNG, H. *Zeremonialzentren der Maya.* Graz, 1971.

HUNTER, C. B. *A Guide to Ancient Maya Ruins.* Norman, 1974.

JAKEMAN, M. WELLS. *The Origins and History of the Mayas.* Los Angeles, 1945.

KRAMER, G. 'Roof Combs in the Maya Area', *Maya Research*, II (1935).

KUBLER, G. 'The Design of Space in Maya Architecture', *Miscellanea Paul Rivet*, I. Mexico, 1958.

KUTSCHER, G. 'Wandmalereien des vorkolumbischen Mexiko', *Preussischer Kulturbesitz*, IX (1971).

MALER, T. *Bauten der Maya, aufgenommen in den Jahren 1886 bis 1905.* Berlin, 1971.

MAUDSLAY, A. P. *Biologia Centrali-Americana.* 4 vols. plates. London, 1899–1902.

MORLEY, S. G. 'The Correlation of Maya and Christian Chronology', *American Journal of Archaeology*, XIV (1910).

MORLEY, S. G. 'An Introduction to the Study of the Maya Hieroglyphs', *B.B.A.E.*, LVII (1915).

MORLEY, S. G. *Inscriptions of Peten.* 5 vols. Washington, 1937–8.

MORLEY, S. G. *The Ancient Maya.* Stanford, 1947.

POLLOCK, H. E. D. 'Architecture of the Maya Lowlands', *H.M.A.I.*, II (1965).

PROSKOURIAKOFF, T. *An Album of Maya Architecture*, plates 28–36. Washington, 1946.

PROSKOURIAKOFF, T. *A Study of Classic Maya Sculpture.* Washington, 1950.

RADA Y DELGADO, J. DE LA, and LÓPEZ DE AYALA, J. (eds.). *Códice Maya denominado Cortesiano.* Madrid, 1892.

RANDS, R. L. 'Jades of the Maya Lowlands', *H.M.A.I.*, III (1965).

ROSNY, L. DE (ed.). *Codex Peresianus.* Paris, 1887.

ROYS, L. 'The Engineering Knowledge of the Maya', *C.A.A.*, II (1934).

SATTERTHWAITE, L. 'An Appraisal of a New Maya-Christian Correlation', *E.C.M.*, II (1962).

SCHELLHAS, P. 'Representation of Deities of the Maya Manuscripts', *P.M.P.*, IV (1904–10).

SMITH, R. E. 'The Place of Fine Orange Pottery in Mesoamerican Archaeology', *Am.A.*, XXIV (1958).

SPINDEN, H. J. 'A Study of Maya Art', *P.M.M.*, VI (1913); reissued as Part I, *Maya Art and Civilization*, Indian Hills, 1957.

SPINDEN, H. J. 'The Reduction of Maya Dates', *P.M.P.*, VI (1924), no. 4.

STEPHENS, J. L. *Incidents of Travel in Central America, Chiapas, and Yucatan.* 2 vols. New York, 1841.

STEPHENS, J. L. *Incidents of Travel in Yucatan.* 2 vols. New York, 1843.

THOMPSON, J. E. S. 'Maya Chronology: the Correlation Question', *C.A.A.*, III (1935), no. 14.

THOMPSON, J. E. S. *Maya Hieroglyphic Writing.* Washington, 1950.

THOMPSON, J. E. S. *The Rise and Fall of Maya Civilization.* Norman, 1956.

THOMPSON, J. E. S. *Catalog of Maya Hieroglyphs.* Norman, 1962.

THOMPSON, J. E. S. *Maya History and Religion.* Norman, 1970.

THOMPSON, J. E. S. *Maya Hieroglyphs without Tears.* London, 1972.

THOMPSON, J. E. S. *A Commentary on the Dresden Codex.* Philadelphia, 1972.

TOTTEN, G. O. *Maya Architecture.* Washington, 1926.

VILLACORTA, C. and J. A. *Los códices Mayas.* Guatemala, 1930.

WAUCHOPE, R. *Modern Maya Houses.* Washington, 1938.

WILLEY, G. 'Mesoamerican Art and Iconography and the Integrity of the Mesoamerican Ideological System', *Iconography of Middle American Sculpture*, 153–62. New York, 1973.

WILLEY, G. 'The Rise of Maya Civilization: A Summary View', in R. E. W. ADAMS (ed.), *The Origins of Maya Civilization*, 383–423. Albuquerque, 1977.

ZIMMERMANN, G. *Die Hieroglyphen der Maya-Handschriften.* Hamburg, 1956.

B. CLASSIC MAYA

ADAMS, R. E. W. 'The Ceramics of Altar de Sacrificios', *P.M.P.*, LXIII (1971).

ANDREWS, E. W. 'Northern Maya Lowlands', *H.M.A.I.*, 11 (1965).

ANDREWS, E. W. *Dzibilchaltun.* New Orleans, 1965.

ANDREWS, G. F., a.o. *Edzná.* Eugene, 1969.

BARRERA, A. 'El parque ... de Cobá', *I.N.A.H., Boletín*, 11 (1976), no. 16, 9–14.

BARTHEL, T. 'Historisches in den klassischen Mayainschriften', *Zeitschrift für Ethnologie*, XCIII (1968).

BECQUELIN, P. *Nebaj.* Paris, 1969.

BERLIN, H. 'Late Pottery Horizons of Tabasco', *C.A.A.H.*, no. 59 (1956).

BERLIN, H. 'El glifo "emblema" en las inscripciones Mayas', *J.S.A.*, XLVII (1958).

BERLIN, H. *The Tablet of the 96 Glyphs at Palenque.* New Orleans, 1968.

BLOM, F. 'The "Negative Batter" at Uxmal', *Middle American Research Papers*, IV (1932).

BOLLES, J. *La Iglesia.* San Francisco, 1963.

BRAINERD, G. W. 'Fine Orange Pottery in Yucatan', *R.M.E.A.*, V (1941).

BUTLER, M. 'A Pottery Sequence from Guatemala', *The Maya and their Neighbors.* New York, 1940.

COE, M. D. *The Maya Scribe and His World.* New York, 1973.

COE, W. *Tikal: A Handbook of the Ancient Maya Ruins.* Philadelphia, 1967.

COE, W., a.o. 'The Carved Wooden Lintels of Tikal', *Tikal Reports*, VI (1961).

COGGINS, C. 'Teotihuacan at Tikal in the Early Classic Period', *I.C.A.*, XLIII (1976), vol. VIII (1979), 251–69.

COOK, C. 'Dos extraordinarias vasijas del Museo de Villahermosa', *Yan*, III (1954).

COOKE, C. W. 'Why the Mayan Cities of the Peten District, Guatemala, were Abandoned', *Journal of the Washington Academy of Sciences*, XXI (1931).

COWGILL, U., and HUTCHINSON, G. E. 'Archaeological Significance of a Stratigraphic Study of El Bajo de Santa Fe', *I.C.A.*, XXXV, vol. I (1964).

DELGADO, A. 'El arte de Jaina', *Artes de Mexico*, XII (1965).

EKHOLM, G. *A Maya Sculpture in Wood.* New York, 1964.

FERNÁNDEZ, M. A. 'Los dinteles de Zapote', *I.C.A.*, XXVII (1939), I.

FONCERRADA, M. *La escultura arquitectónica de Uxmal.* Mexico, 1965.

FONCERRADA DE MOLINA, M. 'El comerciante en la cerámica pintada del Clásico tardío Maya (600–900 D.C.)', *Del Arte, Homenaje a Justino Fernandez*, 45–52. Mexico, 1977.

FUENTE, B. DE LA. *La escultura de Palenque.* Mexico, 1965.

GANN, T. 'Maya Indians of Southern Yucatan and Northern British Honduras', *B.B.A.E.*, LXIV (1918).

GORDON, G. B. 'Prehistoric Ruins of Copan', *P.M.M.*, I (1896).

GORDON, G. B. 'The Hieroglyphic Stairway', *P.M.M.*, I (1902).

GRAHAM, I. 'Archaeological Explorations in El Peten', *Publication 33, Middle American Research Institute* (1967).

GUILLEMIN, G. 'Tikal Ceremonial Center', *Ethnos*, XXXIII (1968).

HABERLAND, W. *Die regionale Verteilung von Schmuckelementen im Bereiche der klassischen Maya-Kultur.* Hamburg, 1953.

KELLEY, D. H. 'Glyphic Evidence for a Dynastic Sequence at Quirigua', *Am.A.*, XXVII (1962).

KIDDER, A. V., and SHEPARD, A. 'Stucco Decoration of Early Guatemala Pottery', *N.M.A.A.E.*, II (1944).

KUBLER, G. *Studies in the Iconography of Classic Maya Art.* New Haven, 1969.

KUBLER, G. 'The Paired Attendants of the Temple Tablets at Palenque', *S.M.A.M.R.*, XII (1972).

LITTMANN, E. R. 'Ancient Mesoamerican Mortars, Plasters, and Stuccoes', *Am.A.*, XXIII (1957).

LONGYEAR III, J. M. 'A Historical Interpretation of Copan Archaeology', *I.C.A.*, XXIX (1951).

MALER, T. 'Yukatekische Forschungen', *Globus*, LXXXII (1902).

MALER, T. 'Tikal', *P.M.M.*, V (1911), no. 1.

MERWIN, R. E., and VAILLANT, G. C. 'The Ruins of Holmul', *P.M.M.*, III (1932).

MOEDANO KOER, H. 'Jaina: un cementerio Maya', *R.M.E.A.*, VIII (1946).

MORLEY, S. G. *Guide Book to the Ruins of Quirigua.* Washington, 1935.

MORLEY, S. G. and F. 'The Age and Provenance of the Leyden Plate', *C.A.A.H.*, V (1939).

NAVARRETE, C. 'Aportaciones a la iconografía post-Olmeca del altiplano central de Guatemala', *Anales de Antropología*, XIV (1977), 91–108.

OCHOA, L., and IVÓN HERNÁNDEZ, M. 'Los Olmecas y el valle del Usumacinta', *Anales de Antropología*, XIV (1977), 77–90.

PENDERGAST, D. 'Tumbaga at Altun Ha', *Science*, CLXVIII (1970), no. 3927.

PENDERGAST, D. *Actun Balam.* Toronto, 1969.

PENDERGAST, D. *Excavations at Altun Ha, Belize, 1964–1970*, I. Toronto, 1979.

POLLOCK, H. E. D. 'Architectural Notes on some Chenes Ruins', *P.M.P.*, LXI (1970).

PROSKOURIAKOFF, T. *A Study of Classic Maya Sculpture*. Washington, 1950.

PROSKOURIAKOFF, T. 'Historical Implications of a Pattern of Dates at Piedras Negras', *Am.A.*, XXV (1960).

PROSKOURIAKOFF, T. 'Historical Data in the Inscriptions of Yaxchilan', *E.C.M.*, III (1963), IV (1964).

RAINEY, F. 'The Tikal Project', *University Museum Bulletin*, XX (1956), no. 4.

RANDS, R. L. and B. C. 'The Ceramic Position of Palenque, Chiapas', *Am.A.*, XXIII (1957).

RANDS, R. L. and B. C. 'Pottery Figurines of the Maya Lowlands', *H.M.A.I.*, II (1965).

RICKETSON, O. G. and E. B. *Uaxactun, Guatemala. Group E. 1926–1931*. Washington, 1937.

ROBICSEK, F. *Copan*. New York, 1972.

ROBINA, R. DE. *Estudio preliminar de las ruinas de Hochob*. Mexico, 1956.

RUPPERT, K., and DENISON, J. H., Jr. *Archaeological Reconnaissance in Campeche, Quintana Roo, and Peten*. Washington, 1943.

RUPPERT, K., THOMPSON, J. E. S., and PROSKOURIAKOFF, T. *Bonampak*. Washington, 1955.

RUZ LHUILLIER, A. *Campeche en la arqueología Maya* (*Acta Anthropologica*, I: 2–3). Mexico, 1945.

RUZ LHUILLIER, A. 'Exploraciones en Palenque', *A.I.N.A.H.*, IV (1949–50); V (1951).

RUZ LHUILLIER, A. 'Estudio de la cripta del templo de las inscripciones en Palenque', *Tlatoani*, I (1952).

RUZ LHUILLIER, A. 'Presencia atlántica en Palenque', *R.M.E.A.*, XIII (1952–3).

SÁENZ, C. 'Exploraciones y restauraciones en Uxmal', *I.N.A.H.*, *Boletín*, XXXVI (1969).

SATTERTHWAITE, L., Jr, in *Piedras Negras Preliminary Papers*, III (1935).

SATTERTHWAITE, L., Jr. 'Some Central Peten Maya Architectural Traits at Piedras Negras', *Los Mayas antiguos*. Mexico, 1941.

SATTERTHWAITE, L., Jr. *Piedras Negras Archaeology: Architecture*, I–V (1943–54).

SATTERTHWAITE, L., Jr. 'A Stratified Sequence of Maya Temples', *Journal of the Society of Architectural Historians*, V (1946–7).

SATTERTHWAITE, L., Jr, and RALPH, E. K. 'Radiocarbon Dates and Maya Correlations', *Am.A.*, XXVI (1960), 165–84.

SAVILLE, M. H. *A Sculptured Vase from Guatemala*. New York, 1919.

SEGOVIA, V. 'Kohunlich', *I.N.A.H.*, *Boletín*, XXXVII (1969).

SELER, E. 'Die Ruinen von Uxmal', *Abhandlungen der königlichen preussischen Akademie der Wissenschaften* (*Phil.-hist. Kl.*) (1917).

SHARER, R. J. 'Archaeology and History at Quirigua', *Journal of Field Archaeology*, V (1978), no. 1, 51–70.

SHOOK, E. 'Oxkintok', *R.M.E.A.*, IV (1940).

SHOOK, E., and BERLIN, H. 'Investigaciones arqueológicas en las ruinas de Tikal', *Antropología e historia de Guatemala*, III (1951), no. 1.

SHOOK, E., and KIDDER, A. V. *Nebaj*. Washington, 1951.

SHOOK, E. 'The Tikal Project', *University Museum Bulletin*, XXI (1957).

SMITH, A. L. 'Two Recent Ceramic Finds at Uaxactun', *C.A.A.*, II (1934).

SMITH, R. E. 'Pottery from Chipoc', *C.A.A.H.*, XI (1952).

SMITH, R. E. *Ceramic Sequence at Uaxactun*. New Orleans, 1955.

STRÓMSVIK, G. 'Substela Caches and Stela Foundations at Copan and Quirigua', *C.A.A.H.*, VII (1942).

STRÓMSVIK, G. *Copan*. Washington, 1947.

STRONG, W. D., KIDDER II, A., and PAUL, A. J. D. 'Preliminary Report', *Smithsonian Institution, Miscellaneous Collections*, XCVII (1938), no. 1.

TAYLOR, W. 'The Ceremonial Bar and Associated Features of Maya Ornamental Art', *Am.A.*, VII (1941).

THOMPSON, J. E. S., POLLOCK, H. E. D., and CHARLOT, J. *A Preliminary Study of the Ruins of Cobá*. Washington, 1932.

THOMPSON, J. E. S. *Excavations at San José*. Washington, 1939.

THOMPSON, J. E. S. 'El area Maya norte', *Yan*, III (1954).

Tikal Reports, The University Museum, Philadelphia, nos 1–10 (1958–61).

TOZZER, A. M. 'Nakum', *P.M.M.*, V (1913).

TREBBI DEL TREVIGIANO, R. 'Personalità e scuole di architetti e scultori Maya a Palenque', *Critica d'arte*, XXVIII (1958).

TRIK, A. S. 'Structure XXII, Copan', *C.A.A.H.*, V (1939).

VAILLANT, G. C. 'The Archaeological Setting of the Playa de los Muertos Culture', *Maya Research*, I (1934).

WAUCHOPE, R. 'House Mounds of Uaxactun', *C.A.A.*, II (1934).

WEBSTER, D. L. 'Defensive Earthworks at Becan,

Implications for Maya Warfare', *M.A.R.P.*, XLI (1976).

WEBSTER, D. L. 'Warfare and the Evolution of Maya Civilization', in R.E.W. ADAMS (ed.), *The Origins of Maya Civilization*, 335–72. Albuquerque, 1977.

WILLEY, G. 'The Altar de Sacrificios Excavations: General Summary and Conclusions', *P.M.P.*, LXIV (1973), no. 3.

WILLEY, G. 'Artifacts of Altar de Sacrificios', *P.M.P.*, LXIV (1972).

WILLEY, G. R., and others. 'Excavations at Seibal', *P.M.M.*, XIII (1975), nos. 1, 2.

WILLEY, G. R., and SMITH, A. L. 'A Temple at Seibal', *Archaeology*, XX (1967).

C. TOLTEC MAYA

BARRERA VÁSQUEZ, A., and MORLEY, S. G. 'The Maya Chronicles', *C.A.A.H.*, X (1949).

BRETON, A. 'The Wall Paintings at Chichen Itza', *I.C.A.*, XIX (1917).

BULLARD, W. 'Topoxté', *P.M.P.*, LXI (1970).

CHARLOT, J. 'A XII Century Mayan Mural', *Magazine of Art*, XXXI (1938), no. 11.

Current Reports (Carnegie Institution of Washington), nos 1–41 (1952–7).

ESCALONA RAMOS, A. 'Algunas ruinas prehispánicas en Quintana Roo', *Boletín de la Sociedad mexicana de geografía y estadística*, LXI (1946).

FERNÁNDEZ, M. A. 'Las ruinas de Tulum', *A.M.N.A.H.E.*, III (1945).

LOTHROP, S. K. *Tulum*. Washington, 1924.

LOTHROP, S. K. 'Metals from the Cenote of Sacrifice', *P.M.M.*, X (1952).

MALER, T. 'Yukatekische Forschungen', *Globus*, LXVIII (1895), LXXXII (1902).

MILLER, A. 'Mural painting at Tancah and Tulum', *I.C.A.*, XL (1972).

MILLER, A. '"The Little Descent": Manifest Destiny from the East', *I.C.A.*, XLII (1976), vol. VIII (1979), 221–36.

MORLEY, S. G. *Quirigua*. Washington, 1935.

MORRIS, E., CHARLOT, J., and MORRIS, A. *Temple of the Warriors*. 2 vols. Washington, 1931.

PARSONS, L. *Bilbao*, II. Milwaukee, 1969.

POLLOCK, H. E. D., a.o. *Mayapan*. Washington, 1962.

PONCIANO SALAZAR, O. 'El Tzompantli', *Tlatoani*, I (1952).

PROSKOURIAKOFF, T. 'Mayapan', *Archaeology*, VII (1954).

RICKETSON, E. B. 'Sixteen Carved Panels from Chichen Itza', *Art and Archeology*, XXIII (1927).

ROBERTSON, D. 'Tulum Murals', *I.C.A.*, XXXVIII (1968).

ROYS, R. L. 'The Maya Katun Prophecies of the Books of Chilam Balam', *C.A.A.H.*, XII (1954).

RUPPERT, K. 'The Temple of the Wall Panels', *C.A.A.*, I (1931).

RUPPERT, K. *The Caracol*. Washington, 1935.

RUPPERT, K. *Chichen Itza, Architectural Notes and Plans*. Washington, 1952.

RUZ LHUILLIER, A. 'Chichén Itza y Tula: Comentarios a un ensayo', *E.C.M.*, II (1962).

SELER, E. 'Die Quetzalcouatl-Fassaden Yukatekischer Bauten', *Abhandlungen der preussischen Akademie der Wissenschaften* (*Phil.–Hist. Kl.*) (1916).

SMITH, R. E. 'Pottery of Mayapan', *P.M.P.*, LXVI (1970).

THOMPSON, E. H. 'The High Priest's Grave', *F.M.N.H.A.S.*, XXVII (1938).

THOMPSON, J. E. S. 'Las llamadas fachadas de Quetzalcoatl', *I.C.A.*, XXVII (1939).

TOZZER, A. M. *Landa's Relación de las Cosas de Yucatan. A Translation*, *P.M.P.*, XVIII (1941).

TOZZER, A. M. 'Chichen Itza and its Cenote of Sacrifice', *P.M.M.*, XI–XII (1957).

WILLARD, T. A. *City of the Sacred Well*. London, n.d.

WRAY, D. E. 'The Historical Significance of the Murals in the Temple of the Warriors', *Am.A.*, XI (1945–6).

V. THE SOUTHERN NEIGHBOURS OF THE MAYA

ACCOLA, R. M. 'Revisión de los tipos de cerámica del período polícromo medio en Guanacaste', *Vínculos*, IV (1978), no. 2, 80–105.

BADNER, M. *A Possible Focus of Andean Artistic Influence in Mesoamerica*. Washington, 1972.

BAUDEZ, C. F., and BECQUELIN, P. *Archéologie de Los Naranjos, Honduras*. Mexico, 1973.

BECQUELIN, P. *Nebaj*. Paris, 1969.

BORHEGYI, S. DE. 'Guatemalan Highlands', *H.M.A.I.*, II (1965).

BRAUN, B. 'Ball Game Paraphernalia in the Cotzumalhuapa Style', *B.-A.*, XXV (1977), 421–57.

COE, M. 'La Victoria', *P.M.P.*, LIII (1961).

DIXON, K. A. 'Two Masterpieces of Middle American Bone Sculpture', *Am.A.*, XXIV (1958).

EKHOLM-MILLER, S. 'Mound 30, Izapa', *Papers of the New World Archaeological Foundation*, no. 25. Provo, 1969.

HABEL, S. 'The Sculptors of S. Lucia Cosumal-

whaupa in Guatemala', *Smithsonian Contributions to Knowledge*, XXII (1880).

HEALY, P. F. 'Excavations at Selin Farm (H-CN-5), Colon, Northeast Honduras', *Vínculos*, IV (1978), no. 2, 57–79.

KIDDER, A. V., JENNINGS, H. D., and SHOOK, E. *Kaminaljuyu*. Washington, 1946.

LOWE, G., and AGRINIER, P. 'Excavations at Chiapa de Corzo', *Papers of the New World Archaeological Foundation*, no. 8. 1960.

MILES, S. W. 'Sculpture of the Guatemala-Chiapas Highlands', *H.M.A.I.*, 11 (1965).

ORELLANA TAPIA, R. 'Nueva lápida olmecoide de Izapa, Chiapas', *M.A.*, VIII (1955).

PARSONS, L. *Bilbao*, 11. Milwaukee, 1969.

QUIRARTE, J. *Izapan-Style Art*. Washington, 1973.

RANDS, R. and B. 'Pottery of the Guatemalan Highlands', *H.M.A.I.*, 11 (1965).

REYES MAZZONI, R. 'Posibles influencias epi-Teotihuacanas en petroglifos de Honduras', *Vínculos*, III (1977), 47–65.

RICHARDSON, F. B. 'Non-Maya Monumental Sculpture of Central America', *The Maya and their Neighbors*. New York, 1940.

SHARER, R. J., and others. *The Prehistory of Chalchuapa, El Salvador*. 3 vols. Philadelphia, 1978.

SHEPARD, A. O. *Plumbate*. Washington, 1948.

SHOOK, E. 'The Present Status of Research on the Pre-Classic Horizons in Guatemala', *I.C.A.*, XXIX (1951).

SHOOK, E., and KIDDER, A. V. 'Mound E-III-3, Kaminaljuyu', *C.A.A.H.*, XI (1952).

SMITH, A. L. *Archaeological Reconnaissance in Central Guatemala*. Washington, 1955.

SMITH, R. E. 'Tohil Plumbate and Classic Maya Polychrome Vessels in the Marquez Collection', *N.M.A.A.E.*, V, no. 129 (1954–7).

THOMPSON, J. E. S. 'Some Sculptures from Southeastern Quezaltenango', *N.M.A.A.E.*, I (1943).

THOMPSON, J. E. S. 'An Archaeological Reconnaissance in the Cotzumalhuapa Region', *C.A.A.H.*, IX (1948).

WAUCHOPE, R. *Excavations at Zacualpa*. New Orleans, 1948.

WOODBURY, R. B., and TRIK, A. S. *The Ruins of Zaculeu*. Richmond, 1953.

VI. EASTERN CENTRAL AMERICA

BAUDEZ, C. F. *Amérique Centrale*. Geneva, 1970.

BORHEGYI, S. 'Travertine Vase in the Guatemala National Museum', *Am.A.*, XVII (1952).

BOYLE, F. 'The Ancient Tombs of Nicaragua', *Archaeological Journal*, XXIII (1866).

BRANSFORD, J. F. 'Archaeological Researches in Nicaragua', *Smithsonian Contributions to Knowledge*, XXV (1881).

EASBY, E. *Pre-Columbian Jades from Costa Rica*. New York, 1968.

GLASS, J. B. 'Archaeological Survey of Western Honduras', *H.M.A.I.*, IV (1966).

HARTMAN, C. V. 'Archaeological Researches on the Pacific Coast of Costa Rica', *Memoirs of the Carnegie Museum*, III (1907).

LINES, J. A. *Los altares de Toyopan*. San José, 1935.

LONGYEAR, J. M. 'Archaeological Investigations in El Salvador', *P.M.M.*, IX (1944), no. 2.

LONGYEAR III, J. M. 'Archaeological Survey of El Salvador', *H.M.A.I.*, IV (1966).

LOTHROP, S. K. *The Pottery of Costa Rica and Nicaragua*. 2 vols. New York, 1926.

LOTHROP, S. K. 'Coclé', *P.M.M.*, VII (1937), VIII (1942).

LOTHROP, S. K. 'The Archaeology of Panamá', *H.S.A.I.*, IV (1948).

LOTHROP, S. K. 'Archaeology of Southern Veraguas, Panama', *P.M.M.*, IX (1950).

LOTHROP, S. K. 'Jade and String Sawing in North-eastern Costa Rica', *Am.A.*, XXI (1955).

MACCURDY, G. G. 'A Study of Chiriquian Antiquities', *Memoirs of the Connecticut Academy of Arts and Sciences*, III (1911).

MASON, J. A. 'Costa Rican Stonework', *A.M.N.H.A.P.*, XXXIX (1945), part 3.

RICHARDSON, F. B. 'Non-Maya Monumental Sculpture of Central America', *The Maya and their Neighbors*. New York, 1940.

SPINDEN, H. J. 'The Chorotegan Culture Area', *I.C.A.*, XXI (1924).

SQUIER, E. G. *Nicaragua*. New York, 1852.

STEWARD, J. (ed.). 'The Circum-Caribbean Tribes', *H.S.A.I.*, IV (1948).

STONE, D. 'Masters in Marble', *M.A.R.S.*, publ. 8 (1938).

STONE, D. 'Archaeology of the North Coast of Honduras', *P.M.M.*, IX (1941).

STONE, D. 'The Basic Cultures of Central America', *H.S.A.I.*, V (1948).

VII. THE NORTHERN ANDES

BENNETT, W. C. *Archaeological Regions of Colombia: A Ceramic Survey*. New Haven, 1944.

BENNETT, W. C. 'Archeology of Colombia', *H.S.A.I.*, II (1946).

BORHEGYI, S. F. DE. 'Pre-Columbian Cultural Connections between Mesoamerica and Ecuador', *M.A.R.S.*, II, no. 6 (1959)

BUSHNELL, G. H. S. *Archaeology of the Santa Elena Peninsula*. Cambridge, 1951.

CARLI, E. *Pre-Columbian Goldsmiths' Work of Colombia*. London, 1957.

COLLIER, D. 'The Archaeology of Ecuador', *H.S.A.I.*, II (1946).

COLLIER, D. 'Peruvian Stylistic Influences in Ecuador', *M.S.A.A.*, IV (1948).

CORBETT, J. M. 'Some Unusual Ceramics from Esmeraldas', *Am.A.*, XIX (1953–4).

CRUXENT, J. M., and ROUSE, I. *An Archaeological Chronology of Venezuela*. Washington, 1958.

CUBILLOS, J. C. *Tumaco*. Bogotá, 1955.

EVANS, C., and MEGGERS, B. J. 'Valdivia', *Archaeology*, XI (1958).

HARCOURT, R. D'. 'Archéologie de la Province d'Esmeraldas', *J.S.A.*, XXXIV (1942 [1947]).

HERNÁNDEZ DE ALBA, G. *Colombia, Compendio arqueológico*. Bogotá, 1938.

HERNÁNDEZ DE ALBA, G. 'Investigaciones arqueológicas en Tierradentro', *Revista de las Indias*, II (1938).

HERNÁNDEZ DE ALBA, G. 'The Archeology of San Agustín and Tierradentro, Colombia', *H.S.A.I.*, II (1946).

HERNÁNDEZ DE ALBA, G. *El museo del oro*. Bogotá, 1948.

JIJÓN Y CAAMAÑO, J. *Puruha*. Quito, 1927.

KROEBER, A. L. 'The Chibcha', *H.S.A.I.*, II (1946).

MASON, J. ALDEN. 'Archaeology of Santa Marta, Colombia. The Tairona Culture', *F.M.N.H.A.S.*, XX (1931–9).

MEGGERS, B. *Ecuador*. New York, 1966.

MEGGERS, B. 'Mesoamerica and Ecuador', *H.M.A.I.*, IV (1966).

MEGGERS, B., a.o. *Early Formative Period of Coastal Ecuador*. Washington, 1965.

NACHTIGALL, H. 'Tumaco. Ein Fundort der Esmeraldas-Kultur in Kolumbien', *B.A.*, N.F. III (1955).

OSGOOD, C., and HOWARD, G. D. *An Archaeological Survey of Venezuela*. New Haven, 1943.

PÉREZ DE BARRADAS, J. *Arqueología y antropología precolombinas de Tierra Dentro*. Bogotá, 1937.

PÉREZ DE BARRADAS, J. *Arqueología agustiniana*. Bogotá, 1943.

PÉREZ DE BARRADAS, J. *Colombia de norte a sur*. Madrid, 1943.

PÉREZ DE BARRADAS, J. *La orfebrería prehispánica de Colombia*. 6 vols. Madrid, 1954–66.

PREUSS, K. T. *Monumentale vorgeschichtliche Kunst*. Göttingen, 1929.

REICHEL-DOLMATOFF, G. *San Agustín*. London, 1972.

REICHEL-DOLMATOFF, G. *Colombia*. New York, 1965.

REICHEL-DOLMATOFF, G. 'The Feline Motif in Prehistoric San Agustín Sculpture', in E. BENSON (ed.), *Cult of the Feline*. Washington, 1972.

RESTREPO. V. *Los Chibchas antes de la Conquista*. Bogotá, 1895.

ROWE, J. H. 'The Potter's Art of Atacames', *Archaeology*, II (1949).

SAVILLE, M. H. *Antiquities of Manabi*. New York, 1907–10.

VIII. THE CENTRAL ANDES

A. GENERAL

BAESSLER, A. *Ancient Peruvian Art*. 4 vols. Berlin and New York, 1902–3.

BAESSLER, A. *Altperuanische Metallgeräte*. Berlin, 1906.

BENNETT, W. C. 'The Peruvian Co-Tradition', *M.S.A.A.*, IV (1948).

BENNETT, W. C., and BIRD, J. *Andean Culture History*. New York, 1949.

BENNETT, W. C. *Ancient Arts of the Andes*. New York, 1954.

BIRD, J. 'South American Radiocarbon Dates', *M.S.A.A.*, VIII (1951).

CALANCHA, A. DE LA. *Coronica moralizada*. Barcelona, 1658.

CIEZA DE LEÓN, P. *Travels 1532–1550*. London, 1864.

COBO, B. *Historia del Nuevo Mundo* (ed. M. Jiménez de la Espada). Seville, 1893.

COLLIER, D. 'Cultural Chronology and Change', *Fieldiana: Anthropology*, XLIII (1955).

COLLIER, D. *Irrigation Civilization: A Comprehensive Study (Social Science Monographs*, I). Washington, 1955.

COSSIO DEL POMAR, F. *Arte del Perú precolombino*. Mexico-Buenos Aires, 1949.

GARCILASO DE LA VEGA. *Comentarios reales*. Madrid, 1723.

HERRERA, F. L. 'El mundo vegetal de los antiguos peruanos', *R.M.N.L.*, III (1934), IV (1935).

KOSOK, P. 'The Role of Irrigation in Ancient Peru', *Proceedings of the Eighth American Scientific Congress*, II (1940).

KOSOK, P. 'Transport in Peru', *I.C.A.*, XXX (1952).

KOSOK, P. *Life, Land and Water in Ancient Peru*. New York, 1965.

KUBLER, G. 'Towards Absolute Time: Guano Archaeology', *M.S.A.A.*, IV (1948).

LANNING, E. R. *Peru before the Incas*. Englewood, N.J., 1967.

LARREA, J. *Arte peruano*. Madrid, 1935.

LINNÉ, S. *The Technique of South American Ceramics*. Göteborg, 1925.

LUMBRERAS, J. G. *The Peoples and Cultures of Ancient Peru*. Washington, 1974.

MASON, J. A. *The Ancient Civilizations of Peru*. Harmondsworth, 1957.

MEANS, P. A. *Ancient Civilizations of the Andes*. New York, 1931.

MENZEL, D. 'Style and Time in the Middle Horizon', *Ñ.P.*, II (1964).

NORDENSKIÖLD, E. *Origin of the Indian Civilizations of South America*. Göteborg, 1931.

NORDENSKIÖLD, E. 'Fortifications in Ancient Peru and Europe', *Ethnos*, VII (1942).

O'NEALE, L. M., and KROEBER, A. L. 'Textile Periods in Ancient Peru', *U.C.P.A.A.E.*, XXVIII (1930–1).

ROMÁN Y ZAMORA, J. DE. *Republicas del Mundo*. 2nd ed. Salamanca, 1595.

ROWE, J. H. 'Max Uhle, 1856–1944', *U.C.P. A.A.E.*, XLVI (1957).

ROWE, J. 'Urban Settlements', *Ñ.P.*, I (1963).

ROWE, J. 'An Interpretation of Radiocarbon Measurements on Archaeological Samples from Peru', in J. ROWE and D. MENZEL (eds.), *Peruvian Archaeology: Selected Readings*. Palo Alto, 1967.

ROWE, J., and MENZEL, D., in *Peruvian Archaeology*. Palo Alto, 1967.

SAWYER, A. R. *The Nathan Cummings Collection of Ancient Peruvian Art*. Chicago, 1954.

SAWYER, A. *Ancient Peruvian Ceramics*. New York, 1966.

SAWYER, A. *Mastercraftsmen of Ancient Peru*. New York, 1968.

SCHAEDEL, R. P. 'The Lost Cities of Peru', *Scientific American*, CLXXXV (1951), no. 2.

SCHMIDT, M. *Kunst und Kultur von Peru*. Berlin, 1929.

SELER, E. *Peruanische Alterthümer*. Berlin, 1893.

SQUIER, E. G. *Peru*. New York, 1877.

STUMER, L. M. 'Coastal Tiahuanacoid Styles', *A.M.A.*, XXII (1956).

TELLO, J. C. 'Wirakocha', *Inca*, I (1923).

TELLO, J. C. *Antiguo Perú*. Lima, 1929.

TELLO, J. C. 'Arte antiguo peruano', *Inca*, II (1938).

UBBELOHDE-DOERING, H. *Auf den Königsstrassen der Inka*. Berlin, 1941.

VALCÁRCEL, L. *The Latest Archaeological Discoveries in Peru*. Lima, 1948.

WILLEY, G. 'A Functional Analysis of "Horizon Styles" in Peruvian Archaeology', *M.S.A.A.*, IV (1948).

WILLEY, G. *An Introduction to American Archaeology. South America*, II. New York, 1971.

YACOVLEFF, E. 'Las falconidas en el arte y las creencias de los antiguos peruanos', *R.M.N.L.*, I (1932).

B. NORTHERN PERU

ANTZE, G. 'Metallarbeiten aus dem nördlichen Peru', *Mitteilungen aus dem Museum für Völkerkunde in Hamburg*, XV (1930).

BENNETT, W. C. 'The North Highlands of Peru. Excavations in the Callejón de Huaylas and at Chavín de Huántar', *A.M.N.H.A.P.*, XXXIX (1944).

BENNETT, W. C. *The Gallinazo Group, Viru Valley, Peru*. New Haven, 1950.

BENNYHOFF, J. A. 'The Viru Valley Sequence: A Critical Review', *Am.A.*, XVII (1952).

BENSON, E. *Mochica*. London, 1972.

BIRD, J. 'Preceramic Cultures in Chicama and Virú', *M.S.A.A.*, IV (1948).

BIRD, J. B. 'Pre-Ceramic Art from Huaca Prieta', *Ñ.P.*, I (1963).

BUENO MENDOZA, A., and SAMANIEGO, L. 'Sechin', *Amaru*, XI (1970).

CARRIÓN CACHOT, R. 'La luna y su personificación ornitomorfa en el arte Chimu', *I.C.A.*, XXVII (1942).

CARRIÓN CACHOT, R. 'La cultura Chavín', *R.M.N.A.A.*, II (1948).

COLLIER, D. 'Casma Valley', *I.C.A.*, XXXIV (1960) [1962].

CORDY-COLLINS, A. 'Cotton and the Staff-God: Analysis of an Ancient Chavín Textile', in *The Junius B. Bird Pre-Columbian Textile Conference*, 51–60. Washington, 1979.

DISSELHOFF, H. 'Zur Frage eines Mittelchimu-Stiles', *Zeitschrift für Ethnologie*, LXXI (1939).

DISSELHOFF, H. 'Hand und Kopftrophäen in plastischen Darstellungen der Recuay-Keramik', *B.A.*, N.F. IV (1955).

DONNAN, C. B. 'Moche Ceramic Technology', *Ñ.P.*, III (1965).

HORKHEIMER, H. *Vistas arqueológicas del noroeste del Perú*. Trujillo, 1944.

HOYT, S., and MOSELEY, M. 'The Burr Frieze', *Ñ.P.*, VII – VIII (1969–70).

IZUMI, S. *Dumbarton Oaks Conference on Chavín*, 49–72. Washington, 1971.

IZUMI, S., and TOSHIHIKO, S. *Excavations at Kotosh*. Tokyo, 1963.

KROEBER, A. L. 'The Uhle Pottery Collections from Moche', *U.C.P.A.A.E.*, XXI (1925).

KROEBER, A. L. 'Ancient Pottery from Trujillo', *F.M.N.H.A.M.*, II (1926), no. 1.

KROEBER, A. L. 'A Local Style of Lifelike Sculptured Stone Heads in Ancient Peru', *Festschrift R. Thurnwald*. Berlin, 1950.

KUTSCHER, G. 'Religion und Mythologie der frühen Chimu', *I.C.A.*, XXVII (1948).

KUTSCHER, G. 'Iconographic Studies as an Aid in the Reconstruction of Early Chimu Civilization', *Transactions of the New York Academy of Sciences*, N.S. XXII (1950).

KUTSCHER, G. *Nordperuanische Keramik (Monumenta americana*, I). Berlin, 1954.

LANGLOIS, E. 'De ci, de là, à travers le Pérou précolombien', *La Géographie*, LXV (1936).

LARCO HOYLE, R. *Los Mochicas*. Lima, 1938.

LARCO HOYLE, R. *Los Cupisniques*. Lima, 1941.

LARCO HOYLE, R. 'La escritura peruana sobre pallares', *Revista geográfica americana*, XI (1943).

LARCO HOYLE, R. *Cultura Salinar*. Buenos Aires, 1944.

LARCO HOYLE, R. 'La escritura peruana preincana', *M.A.* (1944).

LARCO HOYLE, R. *Cronología arqueológica del norte del Perú*. Buenos Aires-Chiclin, 1948.

LARCO HOYLE, R. *Checán*. Geneva, 1965.

LARCO HOYLE, R. *La cerámica de Vicús*. 2 vols. Lima, 1965–7.

LAVALLÉE, D. *Représentations animales dans la céramique Mochica*. Paris, 1970.

LOTHROP, S. K. 'Gold Artifacts of Chavin Style', *Am.A.*, XVI (1950–1).

LUMBRERAS, L. G. 'Towards a Re-evaluation of Chavin', *Conference on Chavin*. Washington, 1971.

LUMBRERAS, L. G., and AMAT OLOZABAL, H. 'Galerías interiores de Chavín', *R.M.N.L.*, XXXIV (1965–6).

MCCOWN, T. D. 'Pre-Incaic Huamachuco', *U.C.P.A.A.E.*, XXXIX (1945), no. 4.

MATOS MENDIETA, R. 'Estilo de Vicús', *R.M.N.L.*, XXXIV (1965–6).

MOSELEY, M. E. 'Assessing *mahamaes*', *Am.A.*, XXXIV (1969).

MUELLE, J. C. 'Lo táctil como carácter fundamental en la cerámica muchik', *R.M.N.L.*, II (1933).

MUELLE, J. C. 'Chalchalaca', *R.M.N.L.*, V (1936).

MUELLE, J. C. 'Filogenía de la Estela Raimondi', *R.M.N.L.*, VI (1937).

MUELLE, J. C. 'Del estilo Chavín', *B.A.*, XXVIII (1955).

REICHLEN, H. and P. 'Recherches archéologiques dans les Andes de Cajamarca', *J.S.A.*, XXXVIII (1949).

ROOSEVELT, C. 'Ancient Civilizations of the Santa Valley and Chavín', *Geographical Review*, XXV (1935).

ROWE, J. H. 'The Kingdom of Chimor', *Acta americana*, VI (1948).

ROWE, J. *Chavin Art*. New York, 1962.

ROWE, J. 'Influence of Chavin Art on Later Styles', *Conference on Chavin*. Washington, 1971.

SCHAEDEL, R. 'Stone Sculpture in the Callejón de Huaylas', *M.S.A.A.*, IV (1948).

SCHAEDEL, R. 'Mochica Murals at Pañamarca', *Archaeology*, IV (1951), no. 3.

SCHAEDEL, R. P. 'Huaca el Dragón', *J.S.A.*, LV (1966).

SCHEELE, H., and PATTERSON, T. C. 'A Preliminary Seriation of the Chimu Pottery Style', *N.P.*, IV (1966).

SCHULER-SCHÖMIG, I. 'Die "Fremdkrieger" in Darstellungen der Moche-Keramik', *B.-A.*, XXVII (1979), 135–213.

STRONG, W. D., and EVANS, C., JR. 'Cultural Stratigraphy in the Viru Valley, Northern Peru, The Formative and Florescent Epochs', *C.S.A.E.*, IV (1952).

TELLO, J. C. *Chavin, Cultura matriz de la civilización andina*. Lima, 1961.

TELLO, J. C. *El strombus en el arte Chavín*. Lima, 1937.

TELLO, J. C. 'La ciudad inkaica de Cajamarca', *Chaski*, I (1941), no. 3.

TELLO, J. C. 'Discovery of the Chavin Culture in Peru', *Am.A.*, IX (1941–2).

TELLO, J. C. *Sobre el descubrimiento de la cultura Chavín*. Lima, 1944.

TELLO, J. C. *Arqueología del valle de Casma*. Lima, 1956.

UBBELOHDE-DOERING, H. 'Ceramic Comparisons of Two North Coast Peruvian Valleys', *I.C.A.*, XXIX (1951).

UBBELOHDE-DOERING, H. 'Untersuchungen zur Baukunst der nordperuanischen Küstentäler', *B.-A.*, XXVI (1952).

UHLE, M. 'Die Ruinen von Moche', *J.S.A.*, X (1913).

VARGAS UGARTE, R. 'La fecha de la fundación de Trujillo', *Revista histórica*, X (1936).

VARGAS UGARTE, R. 'Los Mochicas y el Cacicazgo de Lambayeque', *I.C.A.*, XXVII (1942).

WEST, M. 'Community Settlement Patterns at Chan Chan', *Am.A.*, XXXV (1970).

WILLEY, G. 'The Chavín Problem: A Review and Critique', *Southwestern Journal of Anthropology*, VII (1951).

WILLEY, G. 'Prehistoric Settlement Patterns in the Virú Valley', *B.B.A.E.*, CLV (1953).

C. CENTRAL PERU

ENGEL, F. 'El Paraiso', *J.S.A.*, LV (1966).

GAYTON, A. H. 'The Uhle Collections from Nievería', *U.C.P.A.A.E.*, XXI (1924).

HARCOURT, R. D'. 'La céramique de Cajamarquilla-Nievería', *J.S.A.*, XIV (1922).

JIJÓN Y CAAMAÑO, J. *Maranga*. Quito, 1949.

KROEBER, A. L. 'Proto-Lima', *Fieldiana: Anthropology*, XLIV (1955).

LOTHROP, S. K., and MAHLER, J. 'A Chancay-Style Grave at Zapallan, Peru', *P.M.P.*, L (1957).

MUELLE, J. C., and WELLS, J. R. 'Las pinturas del templo de Pachacamac', *R.M.N.L.*, VIII (1939).

PATTERSON, T. C. *Pattern and Process in the Early Intermediate Period Pottery of the Central Coast of Peru*. Berkeley, 1966.

REISS, W., and STÜBEL, A. *The Necropolis of Ancón*. 3 vols. Berlin, 1880–7.

SMITH, J. W., JR. 'Recuay Gaming Boards: A Preliminary Study', *Indiana*, IV (1977), 111–38.

STRONG, W. D., WILLEY, G., and CORBETT, J. M. 'Archeological Studies in Peru, 1941–42', *C.S.A.E.*, I (1943).

STUMER, L. M. 'The Chillón Valley of Peru', *Archaeology*, VII (1954).

STUMER, L. M. 'Population Centers of the Rimac Valley of Peru', *Am.A.*, XX (1954).

STUMER, L. M. 'History of a Dig', *Scientific American*, CXCII (1955).

TABÍO, E. E. *Excavaciones en Playa Grande* (mimeograph). Lima, 1955.

UHLE, M. *Pachacamac*. Philadelphia, 1903.

VILLAR CÓRDOVA, P. E. 'Las ruinas de la provincia de Canta', *Inca*, I (1923).

VILLAR CÓRDOVA, P. E. *Las culturas prehispánicas del departamento de Lima*. Lima, 1935.

WILLEY, G., and CORBETT, J. M. 'Early Ancon and Early Supe Culture', *C.S.A.E.*, III (1954).

D. SOUTHERN PERU AND BOLIVIA

ASTETE CHOCANO, S., in *Revista del Instituto arqueológico del Cuzco*, III (1938).

BANDELIER, A. F. *The Islands of Titicaca and Koati*. New York, 1910.

BAUDIN, L. *L'empire socialiste des Inka*. Paris, 1928.

BENNETT, W. C. 'Excavations at Tiahuanaco', *A.M.N.H.A.P.*, XXXIV (1934).

BENNETT, W. C. 'Cultural Unity and Disunity in the Titicaca Basin', *Am.A.*, XVI (1950).

BENNETT, W. C. *Excavations at Wari*. New Haven, 1953.

BINGHAM, H. *Machu Picchu, A Citadel of the Incas*. New Haven, 1930.

BINGHAM, H. *Lost City of the Incas*. New York, 1948.

BIRD, J., and BELLINGER, L. *Paracas Fabrics and Nazca Needlework*. Washington, 1954.

BIRD, J. 'Samplers', *Essays … S. K. Lothrop*. Cambridge, 1961.

BRAM, J. *An Analysis of Inca Militarism*. New York, 1941.

CARRIÓN CACHOT, R. 'La indumentaria en la antigua cultura de Paracas', *Wira Kocha*, I (1931).

CARRIÓN CACHOT, R. *Paracas Cultural Elements*. Lima, 1949.

CASANOVA, E. 'Investigaciones arqueológicas en el altiplano boliviano', *Relaciones de la sociedad argentina de antropología*, I (1937).

CRÉQUI-MONTFORT, G. DE. 'Fouilles à Tiahuanaco', *I.C.A.*, XIV (1904), part 2.

DWYER, J. P. 'The Chronology and Iconography of Paracas-Style Textiles', in *The Junius B. Bird Pre-Columbian Textile Conference*, 105–28. Washington, 1979.

FEJOS, P. 'Archaeological Explorations in the Cordillera Vilcabamba, Southeastern Peru', *Yale University Publications in Anthropology*, III (1944).

FESTER, G. A., and CRUELLAS, J. 'Colorantes de Paracas', *R.M.N.L.*, III (1934).

GASPARINI, G., and MARGOLIES, L. *Inca Architecture*. Bloomington, 1980.

GAYTON, A. H., and KROEBER, A. L. 'The Uhle Pottery Collections from Nazca', *U.C.P.A.A.E.*, XXIV (1927).

GUAMAN POMA DE AYALA, F. *Nueva coronica y buen gobierno*. Paris, 1936.

HAGEN, V. W. VON. *The Realm of the Incas*. New York, 1957.

HARTH-TERRÉ, E. 'Incahuasi. Ruinas incaicas del valle de Lunahuaná', *R.M.N.L.*, II (1933).

IBARRA GROSSO, D. E., MESA, J. DE, and GISBERT, T. 'Reconstrucción de Taypicala (Tiahuanaco)', *C.A.*, XIV (1955).

JESSUP, M. K. 'Inca Masonry at Cuzco', *A.A.*, XXXVI (1934).

KIDDER, A. 'The Position of Pucara in Titicaca Basin Archaeology', *M.S.A.A.*, IV (1948).

KIDDER II, A. 'Some Early Sites in the Northern Lake Titicaca Basin', *P.M.P.*, XXVII (1943).

KING, M. E. 'Paracas Textile Techniques', *I.C.A.*, XXXVIII (1969).

KOSOK, P. 'The Mysterious Markings of Nazca', *Natural History*, LVI (1947).

KOSOK, P., and REICHE, M. 'Ancient Drawings on the Desert of Peru', *Archaeology*, 11 (1949).

KROEBER, A. L., and STRONG, W. D. 'The Uhle Pottery Collections from Ica', *U.C.P.A.A.E.*, XXI (1924).

KROEBER, A. L. 'Paracas Cavernas and Chavín', *U.C.P.A.A.E.*, XL (1953).

KROEBER, A. L. 'Toward Definition of the Nazca Style', *U.C.P.A.A.E.*, XLIII (1956).

KUBLER, G. *Cuzco, Reconstruction of the Town and Restoration of its Monuments*. Paris, 1952.

KUBLER, G. 'Machu Picchu', *Perspecta*, VI (1960).

LEHMANN-NITSCHE, R., in *Revista del Museo de La Plata*, XXXI (1928).

LOTHROP, S. K. 'Peruvian Pacchas and Keros', *Am.A.*, XXI (1956).

LOTHROP, S. K., and MAHLER, J. 'Late Nazca Burials in Chaviña, Peru', *P.M.P.*, L (1957).

MENZEL, D. 'Problemas en el estudio del horizonte medio de la arqueológia peruana', *Revista del Museo regional de Ica*, IX (1958).

MENZEL, D., a.o. *Paracas Pottery*. Berkeley, 1964.

MUTO, I., and AKASHI, K. *Textiles of Pre-Inca*. Tokyo, 1956.

O'NEALE, L. M. 'Textiles of the Early Nazca Period', *F.M.N.H.A.M.*, 11 (1937).

O'NEALE, L. M., and WHITAKER, T. W. 'Embroideries of the Early Nazca Period and the Crop Plants Depicted on them', *Southwestern Journal of Anthropology*, III (1947).

PARDO, L., in *Revista Universitaria del Cuzco*, XXII (1933).

PARDO, L. 'Maquetas arquitectónicas en el antiguo Perú', *Revista del Instituto arqueológico del Cuzco*, I (1936).

PONCE SANGINES, C. *Cerámica Tiwanacota. Vasos con decoración prosopomorfa*. Buenos Aires, 1948.

PORRAS, R. *El cronista indio Felipe Guaman Poma de Ayala*. Lima, 1948.

POSNANSKY, A. *Tihuanacu*. New York, 1945.

REICHE, M. *Los dibujos gigantescos en el suelo de las pampas de Nazca y Palpa*. Lima, 1949.

REICHLEN, H. 'Découverte de tombes Tiahuanaco dans la région du Cuzco', *J.S.A.*, XLIII (1954).

ROARK, P. 'From Monumental to Proliferous in Nasca Pottery', *Ñ.P.*, III (1965).

ROWE, J. H. 'An Introduction to the Archaeology of Cuzco', *P.M.P.*, XXVII (1944), no. 2.

ROWE, J. H. 'Absolute Chronology in the Andean Area', *Am.A.*, III (1945).

ROWE, J. H. 'Explorations in Southern Peru', *Am.A.*, XXII (1956).

ROWE, J. H. 'La seriación cronológica de la cerámica de Paracas elaborado por Lawrence E. Dawson', *Revista del Museo regional de Ica*, IX (1958).

ROWE, J. H. 'Two Pucara Statues', *Archaeology*, XI (1958).

ROWE, J. 'The Chronology of Inca Wooden Cups', *Essays ... S. K. Lothrop*. Cambridge, 1961.

ROWE, J. 'What Kind of a Settlement was Inca Cuzco', *Ñ.P.*, V (1967).

RUBEN, W. *Tiahuanaco, Atacama und Araukaner*. Leipzig, 1952.

RYDÉN, S. *Archaeological Researches in the Highlands of Bolivia*. Göteborg, 1947.

SAWYER, A. 'Paracas and Nazca Iconography', *Essays ... S. K. Lothrop*. Cambridge, 1961.

SAWYER, A. 'Tiahuanaco Tapestry Design', *Textile Museum Journal*, I (1963).

SAWYER, A. R. 'Painted Nasca Textiles', in *The Junius B. Bird Pre-Columbian Textile Conference*, 129–50. Washington, 1979.

SCHAEDEL, M. 'Peruvian Keros', *Magazine of Art*, XLII (1949).

SELER, E. 'Die buntbemalten Gefässe von Nazca', *G.A.*, IV (1923).

STAFFORD, C. E. *Paracas Embroidery*. New York, 1941.

STRONG, W. D. 'Paracas, Nazca, and Tiahuanacoid Cultural Relationships in South Coastal Peru', *M.S.A.A.*, XIII (1957).

STÜBEL, A., and UHLE, M. *Die Ruinenstätte von Tiahuanaco*. Leipzig, 1892.

TSCHOPIK, M. H. 'Some Notes on the Archaeology of the Department of Puno, Peru', *P.M.P.*, XXVII (1946).

TREBBI DEL TREVIGIANO, R. 'Tiahuanaco. Un caso esemplare per la storia dell'arte precolombiana', *Critica d'arte*, XXIII (1957).

UHLE, M. 'Explorations at Chincha', *U.C.P. A.A.E.*, XXI (1924).

URTEAGA, H. H. *El fin de un imperio*. Lima, 1933.

VALCÁRCEL, L. 'El gato de agua', *R.M.N.L.*, I (1932).

VALCÁRCEL, L. 'Vasos de madera del Cuzco', *R.M.N.L.*, I (1932).

VALCÁRCEL, L. 'Esculturas de Pikillajta', *R.M.N.L.*, II (1933).

VALCÁRCEL, L. 'Sajsawaman redescubierto', *R.M.N.L.*, III (1934), IV (1935).

VALCÁRCEL, L. 'Litoesculturas y cerámicas de Pukara', *R.M.N.L.*, IV (1935).

VALCÁRCEL, L. 'Cuzco Archaeology', *H.S.A.I.*, II (1946).

YACOVLEFF, E. 'La deidad primitiva de los Nazca', *R.M.N.L.*, I (1932).

YACOVLEFF, E., and MUELLE, J. C. 'Una exploración en Cerro Colorado', *R.M.N.L.*, I (1932).

YACOVLEFF, E., and MUELLE, J. C. 'Un fardo funerario de Paracas', *R.M.N.L.*, III (1934).

ZUIDEMA, R. T. *The Ceque System of Cuzco*. Leiden, 1964.

Pre-Columbian research is well served as regards both books and articles in the *Handbook of Latin American Stuties (H.L.A.S.)*. Founded in 1935, the *Handbook* offers critical remarks by specialists on every item mentioned. For brevity, this selection excerpts relevant works from the decade since 1980, when my writing stopped on the third edition. These items are cited by the volume of *H.L.A.S.* and the number therein; thus XLV:542 refers to item 542 in *H.L.A.S.*, vol. XLV, the article by P. Anawalt which is the first citation in the bibliography that follows these notes and that lists, alphabetically by the name of the author, most of the works referred to in this account.

In 1965 *H.L.A.S.* was divided into two volumes per biennial, odd numbers containing social sciences, and even numbers given to humanities. The social sciences begin with Anthropology, the humanities with Art. Thus the social scientists maintained a union of social science republics, with a paper curtain separating them all from wandering flocks of art historians, who grazed wherever they pleased in their quest for aesthetic (and anaesthetic) domains of value, from which social scientists mostly exclude themselves.

A rough count of books and articles shows art historians and anthropological archaeologists cooperating in longstanding projects reported in the social science volumes, in the expected ratio between university populations of social scientists and art historians: i.e., in 1982 social scientists outnumbered art historians by a multiple of 23 and in 1984 by a multiple of 12 (publications in *H.L.A.S.* during the four-year period; these ratios are not yet available for the years since 1987). The count is of summaries for over 2,600 books and articles, here reduced to the most relevant for art-historical use. They are discussed in relation to the chapters of *The Art and Architecture of Ancient America*, by volume and number in *H.L.A.S.* vols. XLIII, XLV, and XLVII.

CHAPTER I. INTRODUCTION

It is now widely agreed that the hemisphere was peopled from Asia long before 12,000 B.C. over the now-vanished Beringian land-bridge (B. Hayden, XLIII:347).

A calendar in Aztec use (Codex Borbonicus) has a cycle of 20,176 repeating years (Kubler, XLVII:520). Suggestive of a spatial world model, anciently shared in Mexico and Peru, is a vertical-circle trajectory of the sun evident in Maya sources and Andean as well (Guaman Poma, 1980 ed., p. 984). In both, the annual spiral of the sun's apparent motion between the tropics is depicted, not the European mapping on magnetic north.

CHAPTER 2. EARLY CENTRAL MEXICO

R. E. Blanton's idea of Monte Alban in Oaxaca as a 'disembodied capital' of the type of Washington (XLV:274) has been contested by R. S. Santley (XLV:348) and Gordon Willey (XLV:369).

E. Taladoire's study of ball-courts (XLV:360) describes the Mesoamerican with the Caribbean and North American examples. Taladoire does not force a conclusion other than to propose northward diffusion along coastal and interior routes (XLV:359).

R. S. MacNeish (XLV:326) summarizes the results of his long Tehuacan research (discoveries, ideas, and methods), following the lead of the 'new archaeology' of L. H. Binford and his colleagues.

D. C. Grove's excavations at Chalcacingo, the highland frontier of Olmec presence in the state of Morelos, are published in a book stressing local differences from lowland Gulf Olmec works (XLVII:388).

A long-term project at Teotihuacán, directed by René Millon (XLV:482), is based more upon a map of surface distributions than on excavations in depth. It is expanded by J. C. Berlo (XLV:356) with the figural censers found at Escuintla and Lake Amatitlan in the Guatemalan highlands. Hasso von Winning's definitive iconographic study was finished in 1981 as two typewritten volumes, 522 pages in length, entitled *La Iconografía de Teotihuacán: los dioses y los signos* (11 plates, 213 figures). It has been scheduled for publication by the Instituto de Investigaciones Estéticas at the Universidad Nacional Autónoma in Mexico City.

Kenneth Hirth's account of Xochicalco (XLVII:408), like Millon's of Teotihuacán, is based on a surface-mapping project at this mountain-top ruin in Morelos, west of Cuernavaca, where Maya sculptural values of epiclassic character appear in strength. Hirth's purpose is to define growth, social organization, and regional domain in the vacuum left by Teotihuacán.

Also of this era are the mountain-top mural paint-

ings of Cacaxtla (XLV:563) in the valley of Puebla, reflecting the pictorial traditions of both Teotihuacán and Classic Maya art before A.D. 800. In other studies the late M. Foncerrada de Molina connected the Cacaxtla murals, seen in relation to those of Teotihuacán (XLV:421), with Gulf Coast and Classic Maya styles.

CHAPTER 3. CENTRAL MEXICO AFTER A.D. 800

Tula (Náhuatl for a place of reeds) is both toponymic and mythological, leading to a confusion that has now subsided. Tula in Hidalgo has its historian in a field archaeologist, Richard Diehl, who places it securely after A.D. 800 in a Toltec context, as a place of encounter between urbanity and northern nomadism (XLVII:374). Closely related to Tula are the serpent-column doorways at Chichén Itza, studied by Kubler (XLVII:310), who related their frequent occurrence in northern Yucatán to expressions of local government within large cities (Mayapán, Tulum).

The Aztec horizon after A.D. 1250 attracted great attention with an international exhibition at the National Gallery in Washington during 1983 (H. B. Nicholson and E. Quiñones Keber, XLVII:442; this large volume is its catalogue). The major excavations directed by E. Matos Moctezuma at the great temple of Tenochtitlán (XLVII:431) revealed the early stages of construction. The most complete history of Aztec art to date, by Esther Pasztory (XLVII:448), provides a commentary to these events, as well as an explication of their meaning.

CHAPTER 4. THE GULF COAST

The 'Olmec horizon' (1300–100 B.C.) is now best understood in accordance with the views of M. D. Coe and R. A. Diehl (XLV:403), who focus on San Lorenzo Tenochititlan and relate the archaeology to a riverine model subsisting among present-day occupants.

Açcording to Fuente and Gutierrez Solana in a repertory of nearly four hundred works in stone (XLIII:334), post-Olmec sculpture of Huastec style after A.D. 1000 may be divided at the year 1200 as before and after Toltec and Aztec domination. The ceramic history is more continuous, as W. T. Sanders noted during excavations in 1957 (XLIII:379).

Costume analysis of the Borgia group of codices permits P. Anawalt (XLV:542) to assign three (Borgia, Cospi, Vaticanus B) to the area of Puebla and Tlaxcala and two (Féjerváry-Mayer, Laud) to the central area of the southern Gulf Coast.

CHAPTER 5. SOUTHERN MEXICO

The landmark study by K. V. Flannery, J. Marcus, and S. Kowaleski (XLV:296) of the Pre-ceramic and Formative periods of the valley of Oaxaca brings most known 'Archaic' data together until 500 B.C. The values of this epoch for prehistorians of art are still to be put in focus as preceding the Monte Alban chronology.

The Danzante reliefs are the sculptural expression of Period I and possibly II. John Scott (XLIII:382) arranges them in four stylistic phases with associations to Izapa and Dainzú, and Joyce Marcus, in a study identifying wars of conquest, genealogies, and other historical subjects (XLV:472), relates many of them to the history of Zapotec writing. Forty slabs at Dainzú carved in low relief east of Oaxaca are related by Ignacio Bernal (XLIII:319) to Monte Alban II, at the end of Olmec art. The subjects are thought to be figures of deities, although the content of Zapotec figural art is less theomorphic and more secular than in Olmec iconography.

Richard Blanton's computer-aided study of the habitation sites on the slopes of Monte Alban (XLV:276) seeks to show that the mountain was thickly covered with dwelling sites all the way to the temple platforms on the summit (see also his *Monte Alban: Settlement Patterns at the Ancient Zapotec Capital*, New York, 1978).

CHAPTER 6. WESTERN MEXICO

Since 1980 the number of projects and publications on West Mexican archaeology has diminished. Isabel Kelly's Capacha sequence at Colima (XLV:454), dated *c.* 1800 B.C., may show a South American relationship of northward direction. Florencia Müller's typological pottery study of the middle Balsas River region (XLV:486) covers twenty-two sites from 1600 B.C. to A.D. 1500.

The 'protohistoric' Tarascan state with its capital at Tzintzuntzan was studied by Helen P. Pollard (XLV:341) in connexion with its 'non-congruent civic ceremonial and economic settlement lattices'. The study continued (XLV:342) with 'commoner market exchange and state controlled asymmetrical exchange', and a third study, with Shirley Gorenstein (XLV:343), estimates the potential production of the Lake Patzcuaro basin before the Spanish Conquest.

CHAPTER 7.
THE MAYA TRADITION: ARCHITECTURE

El Mirador, near the northern Petén frontier with Mexico, excavated and mapped by R. T. Matheny (XLIII:361), is among the largest known Mayan sites.

Built from *c.* 150 B.C. to *c.* A.D. 150, it covers about 10 miles with pyramidal triadic platforms of pre-Classic date. It is like Tikal in terracing and orientation on dominant sunrise–sunset axiality. Later reoccupied, it was abandoned again after 500. (See, in addition to R. T. Matheny, *National Geographic Magazine*, CLXXII (1987), 317–39, B. H. Dahlin, XLVII:373.)

Dzibilchaltun, a major pre- and Late Classic site in north-east Yucatán, has been excavated by E. W. Andrews IV and V (XLV:375). E. W. Andrews V (XLV:376) also studies chronology and placement among Maya events, and Clemency Coggins (XLVII:370) analyses the decoration and assemblage of structure I-sub, of Classic date.

A factory aspect of Maya stone industries appears in the Colha reports (XLIII:324,325), directed by T. R. Hester, on chert-working from Mamom to post-Classic periods at one of the archaic workshop sites in the region.

The Quiriguá reports edited by Robert Sharer (XLVII:456) total fifteen papers on conservation, settlement pattern, and general context.

Gordon Willey, as director and editor (XLV:418), reports on the Late Formative and terminal Classic ceremonial centre at Seibal, marked by intrusive styles of architecture and sculpture.

The Puuc architectural survey by H. E. D. Pollock (XLIII:371) systematically covers the hill country of Yucatán and northern Campeche from *c.* A.D. 475 to *c.* 1000.

Lamanai, excavated in 1983 by D. M. Pendergast (XLIII:370, XLVII:450), is a large site of the pre-Classic to colonial periods. A Tulum-style structure here was used as a church in 1567.

The association at Chichén Itza, Tulum, Mayapán, and Tula of serpent-column doorways with Chacmool figures and platform seats on caryatids is studied by Kubler (XLVII:310). Lack of common orientation and platform seats suggest local seats of government in the largest centres.

CHAPTER 8.
THE MAYA TRADITION: SCULPTURE
AND PAINTING

Dieter Dütting (XLVII:289) takes the mythological 2Cib 14 Mol date at Palenque as relating to rituals of rebirth or resurrection of the ruler named Pacal. He also relates Gods I, II, and III to Morning Star, Reborn Sun, and Night Sun. Merle Greene Robertson's book (XLVII:387) celebrates the Temple of Inscriptions at Palenque as the funerary temple of Pacal (A.D. 615–83).

The catalogue of the finds from the sacred well at Chichén Itza begun by the late T. Proskouriakoff and edited by Clemency Coggins (XLVII:364) begins *c.* A.D. 800 and ends before the Spanish Conquest. It illustrates pieces from Costa Rica and Panamá as well as 'heirlooms' of Olmec and Maya jade. The *catalogue raisonné* by Linda Schele and Mary Miller accompanies the description of the objects displayed with a commentary on the meaning of Maya sculpture and painting as related to rites of sacrifice and rituals of rulership.

CHAPTER 10. THE NEIGHBOURS OF THE MAYA

P. D. Sheets (XLV:352) has studied the effects on Central American archaeological peoples of volcanic eruptions, notably those of Ilopango and Laguna Caldera. A more detailed study (XLVII:572; also XLVII:540) focuses on El Salvador's prehistory. For a later period, J. W. Michels (XLIII:301) attempts an analysis of Kaminaljuyú archaeology as of *c.* 300 B.C., using a conical clan model of sub-chiefdoms with differing status.

CHAPTER 11.
THE NORTHERN ANDES: COLOMBIA
AND ECUADOR

In Colombia, M. Veloz Maggiolo and Carlos Angulo Valdés (XLV:632) date a three-pointed stone carving of the Zemi type (known later on from the Antilles) between 400 and 200 B.C. Also in Colombia, L. Duque Gómez and J. C. Cubillos (XLV:805) date tombs and mounds near San Agustín between A.D. 100 and 600 by radiocarbon, correcting Cubillos's earlier estimate (XLV:804) of 10 B.C.–A.D. 690.

E. Sánchez Montañés (XLV:832) studies about two thousand Esmeraldas figurines in Ecuador, grouping them in styles each comprising 2–5 types and dating them from before 1500 B.C. until A.D. 500.

CHAPTER 12.
THE CENTRAL ANDES: EARLY NORTHERN PERU

The 1982 Dumbarton Oaks conference volume, edited by C. B. Donnan (XLVII:815), surveys the ceremonial architecture of 300 B.C. onwards in several valleys, notably at Cerro Sechín, as prior to the Chavín horizon.

Batán Grande in the Leche Valley was a burial and religious centre from the Chavín to the Inca periods. The excavator, I. Shimada (XLV:887,888), questions the present 'vertical' model of cultural development in the Andean region.

CHAPTER 13.
THE UPPER NORTH: MOCHICA AND CHIMÚ

Vicús pottery from the upper Piura Valley is analysed by L. G. Lumbreras (XLIII:743). He dates it beween 500 B.C. and A.D. 500, and sees it as transitional between Peruvian coastal desert and Ecuadorian forest.

The Chanchan excavations of 1969–74 were published in 1981 in a conference volume edited by Michael Moseley and Kent C. Day (XLV:849). In 1983 (XLVII:839) Moseley suggested that the collapse of agriculture at the site was caused by changing climatic conditions brought about by geological rises of the coast.

The chronology of the Ayacucho basin, from first peopling to Spanish Conquest, has been surveyed under the direction of R. S. MacNeish (XLV:866a,b). Seventeen periods are proposed, dated by radiocarbon. Volume III discusses lithic remains as having period durations of a century or less.

CHAPTER 15. THE SOUTH COAST VALLEYS

T. Morrison (XLIII:781) reviews knowledge of the Nazca desert lines and figures, amplified by those of Cuzco and the Titicaca basin. He concludes that sacred places (not astronomical or calendrical meanings) are intended.

CHAPTER 16. THE SOUTH HIGHLANDS

Five thousand years of Inca archaeological styles, including Ecuadorian developments, are reviewed by Henri Stierlin (XLVII:611), and colonial chronicles are used in support of the history of Inca building by an architect and a sociologist, Graziano Gasparini and Luise Margolies (XLIII:765, Spanish ed. 1977, reviewed XLII:1639).

ANAWALT, P. 'Costume Analysis and the Provenience of the Borgia Group Codices', Am.A., XLVI (1981), 837–52. [XLV:542]

ANDREWS V, E. W. 'Dzibilchaltun', in J. A. Sabloff and P. A. Andrews, eds., Archaeology (supplement to H.M.A.I., I), 313–41. Austin, 1981. [XLV:376]

ANDREWS IV and V, E. W. Excavations at Dzibilchaltun, Yucatán, Mexico. New Orleans, 1980. [XLV:375]

BERLO, J. C. Teotihuacán Art Abroad: A Study of Metropolitan Style and Provincial Transformation in Incensario Workshops. 2 vols. Oxford, 1984. [XLVII: 356]

BERNAL, I. The Ballplayers of Dainzú. Graz, 1979. [XLIII:319]

BLANTON, R. E. 'Cultural Ecology Reconsidered', Am.A., XLV:1 (1980), 145–51. [XLV:274]

BLANTON, R. E., and KOWALEWSKI, S. A. 'Monte Alban and After in the Valley of Oaxaca', in J. A. Sabloff and P. A. Andrews, eds., Archaeology (supplement to H.M.A.I., I), 94–116. Austin, 1981. [XLV:276]

COE, M. D., and DIEHL, R. A. In the Land of the Olmec: I, The Archaeology of San Lorenzo Tenochtitlan; II, The People of the River. Austin, 1980. [XLV:403]

COGGINS, C. Cenote of Sacrifice: Maya Treasures from the Sacred Well at Chichén Itza. Exhibition catalogue. Austin, 1984. [XLVII:364]

COGGINS, C. The Stucco Decoration and Architectural Assemblage of Structure I-sub, Dzibilchaltun, Yucatán, Mexico. New Orleans, 1984. [XLVII:370]

CUBILLOS, J. C. Arqueología de San Agustín: El Estrecho, El Parador, y Mesita C. Bogotá, 1980. [XLV:804]

DAHLIN, B. H. 'A Colossus in Guatemala: the Preclassic Maya City of El Mirador', Archaeology, XXXVII (1984), 18–25. [XLVII:373]

DIEHL, R. A. Tula: The Toltec Capital of Ancient Mexico. London, 1983. [XLVII:374]

DONNAN, C. B. (ed.) Early Ceremonial Architecture in the Andes: A Conference at Dumbarton Oaks, 26 and 27 October 1982. Washington, 1985. [XLVII:815]

DUQUE GÓMEZ, L., and CUBILLOS, J. C. Arqueología de San Agustín: Alto de los Ídolos, monticulos y tumbas. Bogotá, 1979. [XLV:805]

DÜTTING, D. 'Venus, the Moon and the Gods of the Palenque Triad', Zeitschrift für Ethnologie, CIX (1984), 7–74. [XLV:289]

FLANNERY, K. V., a.o. 'The Pre-ceramic and Formative of the Valley of Oaxaca', in J. A. Sabloff and P. A. Andrews, eds., Archaeology (supplement to H.M.A.I., I), 48–93. Austin, 1981. [XLV:296]

FONCERRADA DE MOLINA, M. 'Mural Painting in Cacaxtla and Teotihuacán Cosmopolitanism', in M. Greene Robertson, ed., Palenque Round Table, 3rd, 1978, part 2, 183–98. Austin, 1980. [XLV:421]

FONCERRADA DE MOLINA, M. 'Signos glificos relacionados con Tláloc en murales de la batalla en Cacaxtla', A.I.I.E., L:1 (1982), 23–33. [XLVII:513]

FUENTE, B. DE LA, and GUTIERREZ SOLANA, N. Escultura huasteca en piedra: catálogo (UNAM, Instituto de Investigaciones Estéticas. Mexico, [1980]. [XLIII:334]

GASPARINI, G., and MARGOLIES, L. Inca Architecture (trans. P. J. Lyon). Bloomington, 1980. [XLIII:765; XLII:1639 (review)]

GREENE ROBERTSON, M. The Sculpture of Palenque: I, The Temple of the Inscriptions. Princeton, 1983. [XLVII:387]

GROVE, D. C. *Chalcatzingo: Excavations on the Olmec Frontier.* New York, 1984. [XLVII:388]

GUAMAN POMA, F. *Nueva corónica* (ed. J. Murra). 3 vols. Mexico, 1980. [not in *H.L.A.S.*]

HAYDEN, B. 'A Fluted Point from the Guatemalan Highlands', *Current Anthropology*, XXI (1980), 702. [XLIII:347]

HESTER, T. R. (ed.) *The Colha Project, 1979: A Collection of Interim Papers.* San Antonio, 1979. [XLIII:324]

HESTER, T. R., EATON, J. D., and SHAFER, H. J. (eds.) *The Colha Project: Second Session, 1980 Interim Report.* San Antonio, 1980. [XLIII:325]

HIRTH, K. 'Xochicalco: Urban Growth and State Formation in Central Mexico', *Science*, CCXXV:4662 (10 August 1984), 579–86. [XLVII:408]

KELLY, I. T. *Ceramic Sequence in Colima: Capacha, an Early Phase.* Tucson, 1980. [XLV:454]

KUBLER, G. 'Portales con columnas serpiente en Yucatán y el altiplano', *A.I.I.E.*, LII (1983), 21–45. [XLVII:310]

KUBLER, G. 'An Aztec Calendar of 20,176 Nonrepeating Years in *Codex Borbonicus*, pp. 21–22', *Indiana*, IX (1984), 123–36. [XLVII:520]

LANGE, F. W., and STONE, D. Z. (eds.) *The Archaeology of Lower Central America.* Albuquerque, 1984. [XLVII:540]

LUMBRERAS, L. G. *El Arte y la vida Vicús.* Lima, 1979. [XLIII:743]

MACNEISH, R. S. 'Tehuacan's Accomplishments', in J. A. Sabloff and P. A. Andrews, eds., *Archaeology* (supplement to *H.M.A.I.*, 1), 41–87. Austin, 1981. [XLV:326]

MACNEISH, R. S., a.o. *Prehistory of the Ayacucho Basin, Peru: Excavations and Chronology.* Ann Arbor, 1981. [XLV:866a,b]

MARCUS, J. 'Zapotec Writing', *Scientific American*, CCXLII:2 (1980), 50–64. [XLV:472]

MATHENY, R. T. *El Mirador, Peten, Guatemala: An Interim Report.* Provo, Utah, 1980. [XLIII:361] (Also *National Geographic Magazine*, CLXXII (1987), 317–39.)

MATOS MOCTEZUMA, E. 'The Great Temple of Tenochtitlán', *Scientific American*, CCLI:2 (1984), 80–90. [XLVII:431]

MICHELS, J. W. *The Kaminaljuyu Chiefdom.* University Park, 1979. [XLIII:301]

MILLON, R. 'Teotihuacán: City, State, and Civilization', in J. A. Sabloff and P. A. Andrews, eds., *Archaeology* (suplement to *H.M.A.I.*, 1), 198–243. Austin, 1981. [XLV:482]

MORRISON, T., with HAWKINS, G. S. *Pathways to the Gods: The Mystery of the Andes Lines.* New York, 1978. [XLIII:781]

MOSELEY, M. E. 'The Old Days Were Better: Agrarian Collapse and Tectonics', *American Anthropologist*, LXXXV:4 (1983), 773–99. [XLVII:839]

MOSELEY, M., and DAY, K. C. (eds.) *Chan Chan: Andean Desert City.* Albuquerque, 1981. [XLV:849]

MÜLLER, F. *Estudio tipológico provisional de la cerámica del Balsas Medio.* Mexico, 1979. [XLV:486]

NICHOLSON, H. B., and QUIÑONES KEBER, E. *Art of Aztec Mexico: Treasures of Tenochtitlan.* Washington, 1983. [XLVII:422]

PASZTORY, E. *Aztec Art.* New York, 1983. [XLVII:448]

PENDERGAST, D. M. 'Excavations at Lamanai, Belize, 1983', *Mexicon*, VI:1 (1984), 5–10. [XLVII:450]

POLLARD, H. P. 'Central Places and Cities: A Consideration of the Protohistoric Tarascan State', *Am.A.*, XLV:4 (1980), 677–96. [XLV:341]

POLLARD, H. P., and GORENSTEIN, S. 'Agrarian Potential, Population, and the Tarascan State', *Science*, CCIX:4453 (11 July 1980), 274–7. [XLV:343]

POLLOCK, H. E. D. *The Puuc: An Architectural Survey of the Hill Country of Yucatán and Northern Campeche, Mexico.* Cambridge, Mass., 1980. [XLIII:371]

RIVERA DORADO, M., a.o. *Oxkintok*, I and II. Misión arqueológica de España en México, 1987, 1988. [not in *H.L.A.S.*]

SÁNCHEZ MONTAÑÉS, E. *Las Figurillas de Esmeraldas: tipología y función.* Madrid, 1981. [XLV:832]

SANDERS, W. T. *The Lowland Huasteca Archaeological Survey and Excavation: 1957 Field Season.* Columbia, 1978. [XLIII:379]

SANTLEY, R. S. 'Disembodied Capitals Reconsidered', *Am.A.*, XLV:1 (1980), 132–45. [XLV:348]

SCHELE, L., and MILLER, M. *The Blood of Kings.* Fort Worth, 1986. [not in *H.L.A.S.*]

SCOTT, J. F. *The Danzantes of Monte Alban*: part 1, text; part 2, catalogue (*D.O.S.*, XIX). Washington, 1978. [XLIII:382]

SHARER, R. (ed.) *Quiriguá Reports.* 2 vols. Philadelphia, 1979–83. [XLVII:456]

SHEETS, P. D. 'Volcanoes and the Maya', *Natural History*, XC:8 (1981), 32–41. [XLV:352]

SHEETS, P. D. 'The Prehistory of El Salvador: an Interpretive Summary', in F. W. Lange and D. Z. Stone, eds., *The Archaeology of Lower Central America*, 85–112. Albuquerque, 1984. [XLV:572]

SHIMADA, I. 'Horizontal Archipelago and Coast-Highland Interaction in North Peru: Archaeological Models', in L. Millones and H. Tomoeda, eds., *El Hombre y su ambiente en los Andes centrales* (*Senri Ethnological Studies*, X), 137–210. Osaka, 1982. [XLV:887]

SHIMADA, I. 'Temples of Time: The Ancient Burial and Religious Center of Batán Grande, Peru', *Archaeology*, XXXV (1981), 37–45. [XLV:888]

STIERLIN, H. *Art of the Incas and Its Origins* (trans.

B. and P. Ross). New York, 1984. [XLVII:611]

TALADOIRE, E. 'Routes d'échanges entre la Mesoamérique et le sud-ouest des États-Unis', *Bulletin* (Mission archéologiqe et ethnologique française au Méxique), 111 (1981), 55–70. [XLV:359]

TALADOIRE, E. *Les Terrains de jeu de balle: Mesoamérique et sud-ouest des États-Unis*. Mexico, 1981. [XLV:360]

VELOZ MAGGIOLO, M., and ANGULO VALDÉS, C. 'La Aparición de un ídolo de tres puntas en la tradición Malambo, Colombia', *Boletín del Museo del Hombre Dominicano* (Santo Domingo), X:17 (1982), 15–20. [XLV:632]

WILLEY, G. R. 'The Concept of the "Disembodied Capital" in Comparative Perspective', *Journal of Anthropological Research* (University of New Mexico, Albuquerque), XXXV:2 (1979), 123–37. [XLV:369]

WILLEY, G. R. *Excavations at Seibal, Department of Peten, Guatemala* (*Memoirs of the Peabody Museum of Archaeology and Ethnology, Harvard University*, XV, nos. 1–2). Cambridge, Mass., 1982. [XLV:418]

WINNING, H. VON. *La Iconografía de Teotihuacán: Los Dioses y los signos* (typescript). 2 vols. 1981. [not in *H.L.A.S.*[

LIST OF ILLUSTRATIONS

All dates are A.D. unless otherwise indicated. Where copyright credit in photographs is not specifically recorded, it is due solely to the gallery or collection given as the location. In elevation drawings the number of steps reproduced is in most cases approximate.

The drawings were made by K. F. Rowland; corrections and additions for the second edition were made by Sheila Gibson, Ian Stewart, and Richard Boon, and for the third edition by Sheila Gibson and Richard Andrews. The maps were drawn by Donald Bell-Scott

INDEX